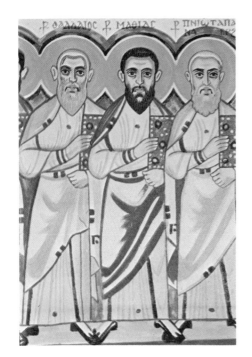

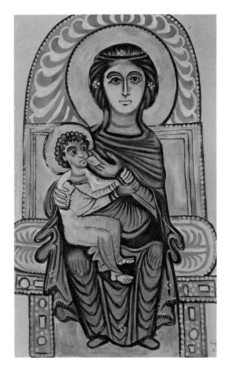

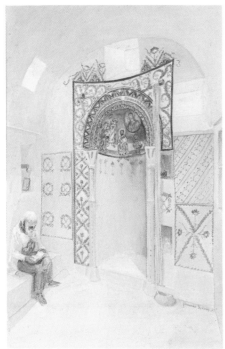

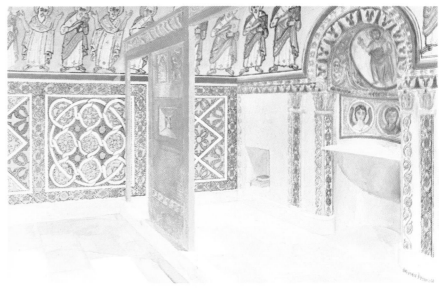

Coptic Art and Archaeology

The MIT Press
Cambridge, Massachusetts,
and
London, England

Coptic Art and Archaeology: The Art of the Christian Egyptians from the Late Antique to the Middle Ages

Alexander Badawy

This book was set in Univers Monotype,
printed on Mohawk Vellum Book
by Murray Printing Company and bound
by Murray Printing Company in the
United States of America

Library of Congress Cataloging in Publication Data

Badawy, Alexander.
 Coptic art and archaeology.

 Bibliography: p.
 Includes index.
 1. Art, Coptic. 2. Christian antiquities—Egypt.
I. Title.
N7382. B3 704.948'2'0962 77–25101
ISBN 0–262–02025–4

Contents

Preface

The subtitle of this book provides an explanation, if not a justification, for the interest I always felt in Coptic art, concurrently with my Egyptological research. To paraphrase a well-known saying: "Everything Egyptian is fascinating to me." The genesis of this book goes back to the 1950s, when I published monographs and articles on Coptic art and started photographing artifacts in the Coptic Museum, Cairo. Photographing in European museums, during five consecutive summers in the early 1960s, yielded a sizable harvest.

Access to the original artifacts, some not on display, was made easy through the friendly courtesy of colleagues. I would like to mention Professor S. Curto, of the Museo Egizio, Turin; Professor P. du Bourguet, of the Louvre; Dr P. Gilbert and Dr. C. de Wit, of the Musées Royaux d'Art et d'Histoire, Brussels; Dr I. E. S. Edwards and Dr. A. Shore, of the British Museum; Dr. O. Koefoed-Petersen, of the Ny Carlsberg Glyptothek, Copenhagen; Dr. Bosticco, of the Florence Museum, and the Keeper of the Allard Pierson Stichting, Amsterdam. Professor J. Leclant helped with the collection of Strasbourg University. I am especially grateful to Ms. R. Shurinova, of the Pushkin Museum, Moscow, for providing a number of beautiful photographs from the museum.

Before 1969 the manuscript benefited from the comments of Dr. Josephine M. Harris, then at Wilson College, Chambersburg, Pennsylvania, and of H. Torp, then at the Istituto di Norvegia in Rome; both gave most generously of their time and erudition. Dr. J. Beckwith, of the Victoria and Albert Museum, London, read the work. Mrs. Sarah G. Wright proved to be an enthusiastic copy editor. Special thanks are due to Professor P. du Bourguet, whose appreciation was most helpful, and to Professor T. Mathews, who did so much to smooth the way toward publishing.

The work, as it stands after shedding more than one hundred photographs, owes much to the original and airy layout by the designers of the MIT Press, and the understanding capability of its editorial staff.

I hope that the personal rewards of working on the project in its early stages will be complemented, after so many years of endeavor, by its contribution to understanding an interlude in art history —the story of the last descendants of the ancient Egyptians.

Alexander Badawy

Landmarks in History and Art

300 B.C.
Petosiris tomb chapel at Hermupolis West. Hemicycle of statues at Saqqara.

II– I B.C.
Wall incrustation painting.

30 B.C.
Egypt becomes a Roman province

27 B.C.–A.D. 14
Augustus' reforms. Strabo visits Egypt.

14–37
Tiberius builds Sebasteum in Alexandria.

37–41
Caligula. Disturbances between Greeks and Jews in Alexandria.

41–54
Claudius. Building of pronaos of temple at Esna; temple at Philae. Philo, the Jewish Apologist philosopher of Alexandria (20 B.C.–A.D. 54). Therapeutae in the Maryut. Tradition of St. Mark in Alexandria (40–49).

54–68
Nero. St. Mark possibly martyred in 68 by followers of Serapis and buried east of Alexandria.

69–79
Vespasian first proclaimed emperor by the army in Alexandria.

79–81
Titus starts an expedition against Palestine from Alexandria; destroys temple of Jerusalem in 70.

81–96
Domitian favors Isis-Serapis cult in Rome.

96–98
Nerva.

97–117
Trajan. Canal between the Nile and the Red Sea reopened.

117–138
Hadrian visits Egypt in 130, founds Antinoupolis. Catechetical School (Didascaleion) established in Alexandria. Earliest attempts to write Egyptian in Greek letters.

138–161
Antoninus Pius. Ptolemy the astronomer in Alexandria. Catacombs at Kom el Shugafa (Alexandria). The Gospel of the Egyptians, a Coptic Apocryph (150).

161–180
Marcus Aurelius visits Alexandria. Painted shrouds and mummy portraits. Painted tomb chapels at Hermupolis West.

180–192
Commodius. Pantaenus reforms the Catechetical School, which flourishes with Clemens Alexandrinus (c. 150–215). Gnostic Coptic codices of Chenoboskion.

193–211
Septimius Severus. Persecution and edict forbidding Romans to become Christians. Origen (185–253) heads the Catechetical School.

211–217
Caracalla visits Egypt. The Constitutio Antonina admits natives to Roman citizenship. Plotinus (205–270) of Assiut becomes the greatest Neo-Platonic philosopher with a system echoing the religious doctrines of the local priesthood.

217–218
Macrinus is recognized as emperor by the Egyptians.

249–251
Decius. Persecution of the Christians (250). Dionysius, Bishop of Alexandria (247–264).

253–260
Valerian. Persecution of the Christians.

260–268
Gallienus. Churches given back to Christians. Plague. Army of Zenobia of Palmyra occupies Lower Egypt (268). Anthony of Coma (251–356), the first hermit, retires to the east of Aphroditopolis, then into the desert, later organizes monastic life (305), speaks Coptic only.

284–305
Diocletian. Accession to throne marks the beginning of "Era of Martyrs" or Coptic calendar, because of his persecution (303). Tetrarchy (293) and mural paintings in the sacellum arranged in the temple at Luxor. Porphyry sculpture. Anchorites transform Egyptian rock tombs into dwellings and chapels.

305–313
Maximinus. Arius preaches (318). Porphyry bust of Maximinus from Athribis. Pachomius founds the first monastery at Tabennēse (323), and later a second one at Phbow where monks of all monasteries assemble twice a year.

324–337
Constantine. Egypt becomes a diocese subdivided into six provinces. The Council at Nicaea condemns the doctrines of Arius, who is exiled. Athanasius (328–373), Bishop of Alexandria, fights the Arians. Byzantium becomes the capital (330). Earliest communities of anchorites in the Sketian and Nitrian deserts (Makarius and Amun in Wadi Natrun), Deir Abu Hennis. Oratory built over St. Menas' grave in the Maryut. Antinoë sculpture.

337–361
Constantius favors Arianism and exiles Athanasius from Alexandria. Pachomius dies (346). The Bible is translated into Coptic (350).

361–363
Julian. Persecution of Christians. Crypt basilica built in the Maryut. Athanasius dies (373).

379–395
Theodosius the Great. Christianity declared religion of the empire. Pagans and Arians persecuted. Serapeum (391) and other temples in Alexandria destroyed by Patriarch Theophilus. Churches established in abandoned temples. Earliest tomb chapels at Bagawat. Soft style of sculpture at Ahnas, Oxyrhynchos, Antinoë. Embassy sent by Theodosius to the anchorite John of Lycopolis, who foretells victory of the emperor in civil war at Aquileia in 394. Empire divided between Arcadius (East) and Honorius (West).

395–408
Arcadius. Large basilica added by Theophilus east of earlier crypt church at Maryut. Octagonal baptistery, cemetery church. Shenute, nationalist abbot, builds Deir el Abiad (440).

408–450
Theodosius II. Hypatia, female pagan philosopher, is stoned to death in Alexandria (415). Patriarch Cyril of Alexandria (412–444) defends his doctrine of the Theotokos "Mother of God" against Nestorius, Patriarch of Constantinople, at the Third Council at Ephesos. Basilica at Ashmunein (440–450). Patriarch Dioscurus champions the Monophysite doctrine at the "Robber Council" of Ephesus. Cells built in Kellia, N. W. of Wadi Natrun.

450–457
Marcian. The Fourth Ecumenical Council at Chalcedon (451) condemns the Monophysite doctrine. The Egyptian Christians secede from Byzantium. Foundation of Apa Jeremias' monastery at Saqqara (c. 470). Monastery of Apa Apollo at Bawit. Glazier Codex. Ahnas hard style of sculpture.

474–491
Zeno endows St. Makarius' monastery in Wadi Natrun (482).

491–518
Anastasius. Famine (502).

527–565

Justinian. Paganism brought to an end. Philae temple closed. Missionary sent to Nubia. Monophysites are persecuted (537). Patriarch Theodorus of Alexandria dismissed. Topography of Cosmas Indicopleustes of Alexandria (545–550). Monastic sculpture and painting. Epiphanius builds a monastery with tower in front of Daga's tomb in Thebes West (c. 600).

610–641

Heraklius. Sassanian Persians invade Egypt (619) and rule it with moderation. They are expelled by Heraklius (626). Moslem Arabs are victorious over the Byzantines on the Yarmuk, and Damascus falls (636). They are victorious over the Sassanian Persians at El Qadisiya, and Ctesiphon falls (637).

640

'Amr ibn el 'As, general of Caliph Omar, enters through Pelusium and is victorious over the Byzantines at Heliopolis. He enters Babylon (641), founds Fostat (642), captures Alexandria. Egypt revolts against Caliph Othman, who is overthrown (644–656). "Chronicle of the History of the World."

658–750

Umayyad Dynasty in Damascus. Egypt is ruled by governors. Building of Great Mosque at Damascus (705). Moslems besiege Toulouse (721), Carcassonne (725). They take Spain (711–713), and Aquitaine (732). Building of monastery of Anba Sam'an at Aswan. First destruction of monastery of Apa Jeremias at Saqqara (750). Mural of cycle of David at Bawit (A.D. VII–VIII).

750–868

'Abbassid Dynasty. Foundation of Baghdad. The Copts are oppressed and revolt frequently against taxes (794, 802–829), ultimately quelled by El Ma'mun (813–833). Fusion between Arabs and Copts, who now speak Arabic. Iconoclastic controversy (764–843). Moslems take Palermo (830–831), found Samarra as capital (836), capture Bari, Messina, Tarento (840–842). They found the Great Mosque at Samarra (830). Stucco decorative relief at Deir Suryani similar to Jausaq el Khāqāni in Samarra (830).

868–905

Tulunid Dynasty, independent under Ahmad ibn Tulun, who extends his dominion over Syria to Mesopotamia. Moslems take Syracuse (878). Coptic town of Djimē abandoned.

935–969

Ikhshidid Dynasty. Monastery of Apa Jeremias at Saqqara is abandoned (960).

969–1171

Fatimid Dynasty. Shi'ite rulers from northwest Africa found capital in Cairo (969) and El Azhar mosque (970). The Coptic Patriarch Christodulos (1047–1077) removes the seat of the patriarchate from Alexandria to Cairo. Low Nile, pestilence, famine (1065). First Crusade by Baldwin (1095), who fails to conquer Egypt (1099). Monastery of Apa Apollo at Bawit abandoned (first half of twelfth century). Itinerant painter Theodoros decorates apse of White Monastery at Sohag (1124).

1171–1250

Ayyubid Dynasty. Founded by Salah el Din. Louis IX of France leads the Sixth Crusade, takes Damietta, but is captured at Mansura (1250). Monastery of Anba Sam'an abandoned (thirteenth century).

Coptic Art and Archaeology

The Nile Valley.

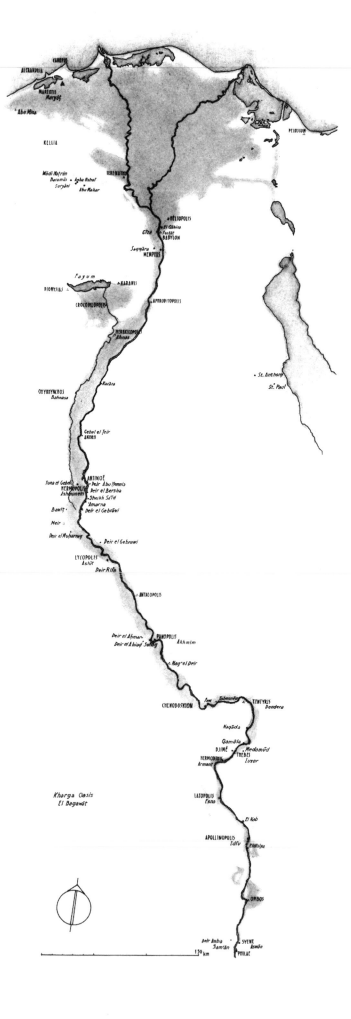

ALEXANDRIA
CANOPUS
MAREOTIS
Maryôt
Abu Mina
PELUSIUM

KELLIA

Wâdi Natrûn
Baramûs • Apba Bishoî
Suryâni • Abu Makar
TERENUTHIS

HELIOPOLIS
el Qahira
Gîza • Fostat
BABYLON

Saqqâra • MEMPHIS

Fayum
KARANIS
DIONYSIAS
CROCODILOPOLIS
APHRODITOPOLIS

HERAKLEOPOLIS
Ahnas

St. Anthony
Karâra
St. Paul

OXYRHYNCHOS
Bahnasa

Gebel el Teir
AKORIS

ANTINOË
Tuna el Gebel • Deir Abu Hennis
HERMOPOLIS • Deir el Bersha
Ishmunein • Sheikh Saîd
'Amarna
Bawît • Deir el Gebrâwi
Meir
Deir el Muharraq • Deir el Gebrawi

LYCOPOLIS
Asiût
Deir Rifa

ANTAEOPOLIS

Deir el Ahmar • PANOPOLIS
Deir el Abiad Sohâg • Akhmim
Nag' el Deir

Tabennesi
Iuoi • TENTYRIS
CHENOBOSKION Dendera

Naqâda
Qamûla
DJIMÊ • Medamûd
HERMONTHIS THEBES
Armant Luxor

Kharga Oasis
El Bagawât
LATOPOLIS
Esna

El Kab

APOLLINOPOLIS
Edfu • el Hôsh

OMBOS

Deir Anba
Sam'ân SYENE
Aswân
PHILAE

130 km

Introduction:
The Copts in Byzantine
and Islamic Egypt
until the Middle Ages

He forced them to accept the faith of Chalcedon except this monastery alone; for the inmates of it were extremely powerful, being Egyptians by race and all of them natives, without a stranger among them.

Sawiriss ibn el Muqaffa', Bishop of Ashmunein, 975. B. Evetts, ed., *A History of the Patriarchs of the Coptic Church*, Vol. 1, pp. 234, 498.

It is significant that the Christians of Egypt called themselves *NIPEMǸXHMI* "The people of Kēmi (Egypt)" after their ancestors. To the Greek historians the Egyptians were the *Aἰγύπτιοι*, and to the Jews, the Gibit,[1] a word the Arabs who conquered the country in 641 vocalized as *El Qobt*, hence "the Copts." The Egyptians never entirely submitted to the idea that they had been governed by foreign dynasties since the Persians had reoccupied the country in 341 B.C., for they were a race proud of their past and its monuments—a pride the Copts transformed into a fierce nationalism that, even in its least appealing aspects, was eventually misconceived as ubiquitous grandeur. In the sixth century they regarded the abhorred Diocletian[2] and the beneficent Theodosius alike as of Egyptian origin; the Empress Theodora,[3] the former circus girl who had actually lived in Alexandria, was considered an Alexandrian. Christ himself was born in Herakleopolis.[4]

After the Council of Chalcedon (451) this nationalism was intensified and could only be further aggravated by the Byzantine disdain for the monuments of the Egyptians and their

descendants. As turbulent as the populace of Constantinople, the Copts readily found pretexts to riot in Alexandria or to impose their decisions forcefully upon the councils, a policy that was used in turn against them by Byzantium, which forced more than one Coptic patriarch into exile. Sensitive to materialistic factors, especially financial ones, some Copts wavered in their faith to retain imperial favor, and later many converted to Islam to avoid the heavy burden of taxes and sumptuary laws.

Such a superficial Christianity degenerated into political opposition that crystallized around the Monophysite problem. It has been noted that never before had the concept of Egyptian patriotism been emphasized as strongly as it was in the Byzantine period with such expressions as Horapollo's "our *Πάτριοξ*, our land of birth."[5]

These idiosyncrasies of the Copts proved to be their great stumbling block.

1. Talmud, Schabbath 115 a (Baraita), Megilla 18 a. M. Roncaglia, *Histoire de l'Eglise Copte* (Beyrut: 1966), p. 276,n. 2. (Hereafter cited as *L'Eglise Copte.*)
2. John of Nikiu, Lib. 73. cap. 1. *The Chronicle of John, Bishop of Nikiu,* translated from Zotenberg's Ethiopic text by R. H. Charles (London: 1916).
3. *A History of the Patriarchs of the Coptic Church of Alexandria,* Arabic text edited and translated by B. Evetts, in *Patrologia Orientalis,* Vol. 1. fasc. 4, pp. 195, 459; cf. J. Maspero, *Histoire des patriarches d'Alexandrie* (Paris: 1923), p. 27. (Hereafter cited as *Histoire des patriarches.*)
4. J. Maspero, *Histoire des patriarches,* p. 25.

5. C. Diehl, "L'Egypte Chrétienne et Byzantine," in G. Hanotaux, *Histoire de la Nation Egyptienne,* Vol. 3 (Paris: 1933), p. 502. (Hereafter cited as "L'Egypte.") J. Maspero, "Horapollon et la fin du paganisme égyptien," *BIFAO,* Vol. 11 (Cairo: 1914), *pp.* 163–195.

The beginnings of Christianity in Egypt are shrouded in darkness.[6] The first news of the life and death of Jesus could have been brought to Alexandria and diffused by Jews returning to Alexandria after their pilgrimage to Jerusalem.[7] There was a large community of Jews in Alexandria, the descendants of those who had settled there when the city was founded by Alexander the Great and who prospered under the Ptolemaic dynasty. It was probably the most important minority in the capital and the first in the Jewish Diaspora. Deeply influenced by Hellenism, they translated the Bible into Greek—allegedly on an order of Ptolemy II—to ensure its broader diffusion. Just before A.D. 54 the active and turbulent Jews of Alexandria were restricted to the quarter between the royal palace and the theater. Philo (20 B.C.–A.D. 54),[8] a brilliant apologist for the Jews, contributed accurate information about the Essenes and the Therapeutae of Lake Maryut and wrote on biblical exegesis using allegorical expressions and symbols similar to those of the New Testament and the Epistle to the Hebrews, perhaps from the hand of Apollos of Alexandria.[9]

According to the unproved tradition of the Coptic Church reported by Eusebius,[10] Christianity was introduced into Egypt by St. Mark, who landed in Alexandria between A.D. 40 and 49 after accompanying his master, St. Peter, to Rome. Serving as the first bishop, St. Mark preached in Egypt, the Thebaid, and the Pentapolis, and established Christian centers throughout the country. He was martyred on Easter, April 24, in the year 68 by the followers of Serapis during the reign of Nero. He died in the desert near the shore at Boucolia, east of the city. His relics, buried in the church of the Boucolia, were stolen in 828 by Venetian traders who transported them to Venice.

While the mass of the population practiced a coarse paganism adulterated by magic, the enlightened classes sought the knowledge (*gnosis*) of God to achieve union with Him and ultimate immortality. This lofty mystical monotheism (inherent in pagan Gnosticism), the tradition of Philo, which still dazzled the Jewish schools, and Hellenistic science dispensed by the Museum and Library in Alexandria were some of the metaphysical concepts with which Christianity had to compete. Alexandria achieved the paradox of being the largest city of international trade and the most prominent center of Hellenistic culture, promoted by the scholars of the Museum and its many libraries: the Great Library endowed by Antony with 200,000 works from Pergamon, burned in A.D. 47 but partly reconstituted; the Library of the Serapeum and that of the Caesarion, later the Library of Hadrian; and those of the Mercouriou. These remarkable assets were taken advantage of by the Greek and Jewish intelligentsia as well as by the best of the Egyptian scribes, such as Chaeremon, who directed both the Grammarians' School and the Museum. Greeks and Greek-speaking Egyptians lived in the villages where there were gymnasia, but the Hellenic element gradually became concentrated in the metropolises. In the first century the Egyptians in the hinterland and in the native quarters of urban centers, such as Rakoti in Alexandria, could not understand Greek.[11] They spoke the Sa'idic dialect.[12] The official language was Greek, but Egyptian records were in Demotic, a very cursive and complicated form of Egyptian script. Toward the end of the first century appear the earliest Egyptian texts written in Greek letters with seven additional Demotic signs. A horoscope of a man written in Greek was translated in archaic Coptic. This marks the invention of the Coptic script.

By that time, at the end of the first century, the entire New Testament had been redacted in Greek. Epistles were written in columns on rolls, with short notes on separate sheets. In the second century there appeared codex manuscripts consisting of pages of the Gospel bound together, such as Papyrus Rylands 457 (John 18:31–33, 37, 38) inscribed recto and verso (first half of the second century), Papyrus Egerton (A.D. 180), and Papyrus Bodmer II (A.D. 200). It can be inferred from the dates

6. G. Bardy, "Les premiers temps du christianisme de langue copte," in *Mémorial Lagrange* (Paris: 1940), p. 203.
7. M. Roncaglia, *L'Eglise Copte*, pp. 39–40.
8. J. Daniélou, *Philon d'Alexandrie* (Paris: 1958).
9. C. Spicq, trans., *L'Epître aux Hébreux* (Paris: 1957), pp. 7–9.
10. Eusebius, *Hist. Eccl.*, Lib. 2. cap. 16.
11. H. Grapow, "Vom Hieroglyphisch-Demotischen zum Koptischen," in *Sitzungberichte der Preussische Akademie der Wissenschaften, Philosophische-Historische Klasse*, Vol. 28 (Berlin: 1938); p. 25.
12. P.E. Kahle, *Bala'izah. Coptic Texts from Deir el-Bala'izah in Upper Egypt*, Vol. 1 (London: 1954), pp. 256–257.

of these papyri that the fourth Gospel (John) was introduced in Egypt toward the end of the first century.[13]

The establishment of a Catechetical School and the teaching activity of the heretics of Christian Gnosticism Valentinus (before A.D. 140), Carpocrates, and Basilides (first half of second century) in Alexandria prove the existence of a considerable Christian community there in the second century. That Christianity had even reached Upper Egypt by the end of the second century can be inferred from a statement by Clemens Alexandrinus that it had spread to "every nation, village and town."[14] He himself had to leave Alexandria on account of the persecution by Septimius Severus in 202, when, according to Eusebius, Christians were brought "from Egypt and the Thebaid."[15] It is also in the Thebaid that the earliest works were written in Coptic. They are the Christian Gnostic codices dating from the fourth century which were found in 1945 at Chenoboskion (Nag' Hammadi) in Upper Egypt. Among the fourteen books are an Apocryphon of John, another of Thomas, the Letter of Eugnostos, and two Apocalypses of James. There were numerous Gnostic sects obsessed by the incompatibility of an evil world having been created by God. They believed it was the work

of a demigod. Though invented in Asia Minor, the gnosis found a most favorable environment in Egypt, combining the Iranian dualism of Good and Evil, Babylonian astrology, the sun creed of Asia Minor and Syria, Greek philosophy and Pythagorism, Judaism and the Old Testament, Egyptian creeds of Isis and Osiris, and Hermetic literature.[16] The Gospel of Truth is another Gnostic treatise ascribed by St. Irenaeus (A.D. 180–185)[17] to the disciples of Valentinus. Among the numerous apocryphal gospels compiled in Egypt, the Gospel of the Egyptians, fragments of which are recorded by Clemens Alexandrinus, was probably also of Gnostic origin, written in about A.D. 150 for the Egyptians. Although no historical clue can be derived from the heterodox confusion of the Egyptian secret Gnostic books, they form a valuable literature for the study of the early development of Christianity in Egypt. No other Coptic texts from the second century are available. The earliest documents we have are glosses on a Greek text of Isaiah dating from the third century. Toward the end of the third century budding monasticism brought with it a need for translating and publishing Christian books in Coptic.[18]

Toward the end of the second century the term "Egyptian" denoted more and more a Christian, while "Hellene" was a synonym for pagan.[19] The edict of Decius (A.D. 249–251) ordering all pagan and Christian adults to produce certificates (*libelli*) of sacrifice to the gods for their families led some Christians (*libellatici, lapsi*) to procure false certificates. The problem of their readmission to the Church was the sole cause of the Melitian schism. Christianity spread, however, and most of the nome capitals were episcopal sees: according to Eusebius' statement, corroborated by archaeological evidence, by the end of the third century Egypt was almost a Christian country. Yielding to the instigation of Galerius in 303, Diocletian ordered the Great Persecution that lasted until 311, causing thousands to perish and others to apostatize to paganism. The event left such a horrible memory that the Coptic Church chose the year 284, the first of this reign, as the starting point of its chronology or Era of the Martyrs. In 313 Constantine, in the Edict of Milan, proclaimed for all "the liberty to follow the religion they wished," and from the middle of the fourth century Egypt became mostly a Christian country.[20]

13. M. Roncaglia, *L'Eglise Copte*, p. 81.
14. Clemens Alexandrinus, *Stromata*, 6. 18, 167 ed. Stählin), quoted by H. I. Bell, *Cults and Creeds in Graeco-Roman Egypt* (Liverpool: 1957), p. 83. (Hereafter cited as *Cults.*)
15. Eusebius, *Hist. Eccl.*, Lib. 6. cap. 1.

16. W.C. van Unnik, *Evangelium aus dem Nilsand* (Frankfurt: 1960), pp. 46–47.
17. Irenaeus, *Adverses Haereses*, 3. 11. 9.
18. W.C. Till, *Koptische Grammatik (Saidischer Dialekt)* (Leipzig: 1955), pp. 29–33. W. E. Crum, "The Coptic Glosses on the Text of Isaiah," in F.G. Kenyon, *The Chester Beatty Biblical Papyri: Description and Texts of Twelve Manuscripts on Papyrus of the Greek Bible* (London: 1937), fasc. 6, pp. ix–xii.

19. A. Von Harnack, *Mission und Ausbreitung des Christentums in den ersten drei Jahrhunderten*, Vol. 2 (Leipzig: 1924), p. 702,n. 2. L. Mitteis and U. Wilcken, *Grundzüge und Chrestomathie der Papyruskunde*, Vol. 1 (Hildesheim: 1963), pp. 130–131.
20. H. I. Bell, *Cults*, p. 101.

Toward the end of the second century Alexandria[21] was still the center of Hellenistic knowledge because of its Museum and Library, the Jewish schools famous on account of Philo, and the Gnostic schools. Pantaenus, a Samaritan stoic, founded the Catechetical School as a counterpart to these other centers and also to counteract the ferments of Manichaeism and Gnosticism in the Egyptian Church. Clement (ca. 150–215), who succeeded him, was a broad-minded humanist from Athens widely read in Greek literature and philosophy but also influenced by Gnostic ideas. He was even surpassed by the Alexandrian Origen (185–253), a Platonist and brilliant theologian and exegete. Though influenced by Gnosticism, the latter established a critical edition of the Old Testament written in six columns (*Hexapla*) to make the Greek text conform to the Hebrew Septuagint. Having disagreed with his bishop Demetrius, he left and founded a school in Caesarea (232) and later another in Tyre, where he died in 251. After his death he was accused of heresy. Nevertheless, the Catechetical School still survived at the beginning of the fourth century during the great persecution.

Egypt's main contributions to Christianity[22] were the establishment of the canonical text of the Scriptures, the growth of theology achieved by the Catechetical School, and the beginning of monasticism. Christianity had grown in spite of, or perhaps was enhanced by, the persecutions; at the beginning of the fourth century Athanasius estimated the number of Egyptian bishops to be 100. While the Catechetical School taught in Greek, progress among the less-Hellenized native population was marked by the translation of the Bible in the third century and the redaction of theological works in Coptic. Fleeing to the desert to evade taxes or persecutions was a characteristically Egyptian response, and though there had been recluses of Serapis and Jewish Therapeutae, the ideological incentive in addition to more immediate ones was certainly a genuine love of ascetic life. The earliest ascetic, Paul, lived in a grotto near Mount Qolzum on the Red Sea during Decius' persecution. Antony forsook his property, living in tombs and then in a ruined castle at Qus Pispir (303), where many disciples following his example caused him to withdraw farther and eventually to found a settlement of hermits. A third type of religious life was established by Pakhom (Pachomius, 292–346)[23] with strictly ruled monastic communities of men and others of women directed by his sister Mary.

Other communities based on the Pachomian rule were founded by Patermuthios in the district of Hermupolis (Ashmunein), by Amon in the Wadi Natrun, by Macarius in Scitia, by Nilus and his son Theodulos in Sinai, by Jeremiah in Lower Thebaid, and by Shenute, who reformed the rule at Sohag. Monasticism was soon spread abroad by those who had come to admire the Egyptian monks and by St. Athanasius of Alexandria, who during his voyage in Rome (340) publicized a life of St. Antony. In Cappadocia St. Basil's rule, derived from that of Pakhom, served as a basis for the Benedictine order two centuries later.

Coptic monks were not addicted to theological disputation as were those of Byzantium, but followed the rulings of the Alexandrian see and synods and concentrated on ascetic austerities. Few among their founders could read Greek or Coptic, and this widespread ignorance among throngs of recruits from all strata of the native population explains the evolution of monasticism into a representation of nationalist trends against Hellenism and Byzantine rule. Unfortunately, however, Christian Egypt would have to fight not only Neo-Platonism and the last persecutions of a receding paganism under Maximinus Daia (305–313) but also sporadic schisms and the precedence of its latest rival, the capital city of Constantinople; for the bishop of this city, founded by Constantine in an obscure locality called Byzantium (330), had assumed the title of patriarch held traditionally by the leaders of the churches founded by the Apostles.

21. H. Munier, "L'Egypte byzantine de Dioclétien à la conquête arabe," *Précis de l'Histoire d'Egypte par divers historiens et archeologues*, Vol. 2 (Cairo: 1932), pp. 12 ff. (Hereafter cited as Munier, "L'Egypte byzantine.") Diehl, "L'Egypte," pp. 402 ff.
22. H. Munier, "L'Egypte byzantine." Diehl, "L'Egypte," Bell, *Cults*.

23. L. T. Lefort, *Les vies coptes de saint Pachôme et de ses premiers successeurs* (Louvain: 1943). (Hereafter cited as *Les vies coptes*.) P. Ladeuze, *Etude sur le cénobitisme pakhômien pendant le IVe siècle et la première moitié du Ve siècle*, (Louvain: 1898). Hereafter cited as *Etude sur le cénobitisme*.

The Church had fought against the Gnostic sects,[24] which propounded a mystical syncretism of Jewish, pagan, and Christian doctrines; it had fought against Manichaeism,[25] which was first preached on March 20, 242, as an ascetic ethic based on Christianity with elements of Zoroastrianism, Buddhism, and paganism; and it had then fought against the Meletian schism[26] caused in 304 by Bishop Meletius of Lycopolis (Assiut), who advocated excommunicating the *libellatici*. The clergy and churches established by Bishop Meletius survived until the eighth century,[27] after which the Church faced the more serious threats of Arianism, Nestorianism, and Monophysitism.

Arius, originally of Libya, was excommunicated because of his Meletian ideas; he taught the Scriptures in Alexandria at the beginning of the patriarchy of Alexander (312–326), describing Christ as created by God from the Logos, a view derived from the teaching of his master Lucian of Antioch. Condemned by the Synod of 320 in Alexandria, he left for Caesarea, where he obtained help from its Bishop, Eusebius. The heresy was finally condemned by the Council of Nicaea (325),[28] though it soon regained favor under Constantine. Athanasius, patriarch of Alexandria (328–373), was the dedicated champion of orthodoxy against Arianism; he was, however, condemned illegally by three synods—at Tyre, Jerusalem, and Constantinople—and was exiled to Trier. After Constantine's death (337) he was able to retrieve his see and was justified at the Council of Rome (341), but not for long; he was forced to flee twice from persecution by the emperors Constantius and his successor Julian after violent fights between his Alexandrians and the imperial soldiery. The nationalist feelings of the populace, backed by the monks and their leaders Antony, Pachomius, and Theodorus, were here manifested for the first time as they upheld the just cause of their patriarch, who was being persecuted by the emperors of Constantinople. This policy of demeaning the Alexandrian See to spite a people unwilling to part with their chosen faith was followed consistently by Constantinople until the Arab conquest.[29]

Although the second council at Constantinople (381) restricted the jurisdiction of the patriarch of Alexandria "only to the matters of Egypt" and ruled that "the bishop of Constantinople enjoyed first honors after the bishop of Rome because this city is the new Rome," the authority of the Alexandrian patriarch, enhanced by the prestige of Athanasius, was still well established over his 90 bishops. He could assume the title of pope and enjoy the alliance of the Pope of Rome. He appeared as a successor to Pharaoh, backed by his national Church and deriving rich income from a monopoly on mortuary services and trade monopolies in natron, papyrus, and salt reminiscent of those held by the Ptolemies. The Alexandrian Church happened then to be championed by three energetic and ardent heads: Theophilus (385–412), his nephew Cyril (Kyrillos, 412–444), and Dioscorus (444–451).[30]

After the brief revival of paganism under the emperor Julian (361–363) had failed, the Alexandrian patriarch asserted his authority, even going so far as to challenge that of the emperor Valens (364–378) and to dominate the Byzantine prefect, a policy that ultimately led to his decline. When Theodosius I (379–395) abolished pagan cults, the patriarch Theophilus (384–412) led hordes of Christians smash the statue of Serapis, a masterpiece of Bryaxis, and to destroy the Serapeum, the last bastion of paganism in Alexandria. Theophilus is represented as standing triumphant over the ruins of the Serapeum in a miniature of the

24. E. Amélineau, *Pistis Sophia. Ouvrage Gnostique de Valentin* (Paris: 1895). E. de La Faye, *Gnostiques et gnosticisme* (Paris: 1925). C. Schmidt, *Gnostische Schriften in koptischer Sprache* (Leipzig: 1892). P. D. Scott-Moncrieff, "Gnosticism and Early Christianity in Egypt," *Church Quarterly Review*, Vol. 59 (1909), pp. 61–83. H. C. Puech, "Les nouveaux écrits gnostiques découverts en Haute-Egypte," in *Coptic Studies in Honor of Walter Ewing Crum* (Byzantine Institute, Inc., Boston: 1950), pp. 91–154.
25. *Cambridge Ancient History*, Vol. 12, p. 504.
26. H. I. Bell, *Jews and Christians in Egypt. The Jewish Troubles in Alexandria and the Athanasian Controversy* (London: 1924), pp. 38–99. (Hereafter cited as *Jews and Christians in Egypt*.) H. I. Bell, "Athanasius: A Chapter in Church History," *Congregational Quarterly*, Vol. 3 (1925), pp. 158–176. (Hereafter cited as "Athanasius.")
27. H. Munier, "L'Egypte byzantine," p. 30.

28. N. H. Baynes, "Athanasiana," *JEA*, Vol. 11 (London: 1925), pp. 58–59. Bell, "Athanasius," pp. 158–176. F. Haase, *Die Koptischen Quellen zum Konzil von Nicaea* (Paderborn: 1920). E. Revillout, *Le Concile de Nicée d'après les textes coptes*, 2 vols. (Paris, 1873, 1881). W. Riedel and W. E. Crum, *The Canons of Athanasius of Alexandria. The Arabic and Coptic Versions* (London: 1904).
29. H. Munier, "L'Egypte byzantine," p. 29.

30. C. Diehl, "L'Egypte," pp. 432–433.

World Chronicle.[31] Churches rose above the pagan ruins and in abandoned temples. Unscrupulous Theophilus brought charges of Origenism against four monks of the Wadi Natrun and against John Chrysostom, the patriarch of Constantinople, whom he deposed for a short while. He also divested Alexandria of works of art, which he presented to the emperor Theodosius, a deplorable precedent to later similar liberalities.

Theophilus' nephew Cyril succeeded him, pursuing the same policy of violence; he incited riots against the Jews of Alexandria,[32] whose migration dealt a heavy blow to trade, and he persecuted the pagans, whose noble woman philosopher Hypatia (415) was dragged through the streets of Alexandria and finally murdered by hysterical monks (*parabalans*). Ironically nicknamed "Pharaoh" by his adversaries and always striving for more authority, Cyril fought the doctrine of Nestorius, the patriarch of Constantinople who propounded that the Virgin Mary was not the Mother of God (*Theotokos*) but the mother of man. Backed by his zealous monks, who were led by Victor of Tabennēse and Shenute of Atripe, Cyril triumphed at the third Council at Ephesus (431).[33] Though deposed in

turn a few days later and even arrested, Cyril resumed his see at Alexandria and through his largess[34] in distributing rich gifts such as ostriches, ivory chairs, furniture, hangings, and tapestries among the influential retainers of the emperor's sister Augusta Pulcheria, he turned the tables in his favor.

During the reign of Theodosius II, Cyril's successor Dioscorus, possibly backed by Shenute, presided over a council at Ephesus (449), which without even opening the condemning letter of Pope Leo of Rome, approved the doctrine of Eutyches, an archimandrite of Constantinople who claimed Christ was endued with one person but two natures (*physis*) united into one divine nature.

The next emperor, Marcian, who backed the Pope of Rome, called a council at Chalcedon (451)[35] and had

Dioscorus exiled, thus establishing the pre-eminence of the See of Constantinople over all others in the Orient, a decision contested by Pope Leo. Partisans of the doctrine of Eutyches called themselves "orthodox," a name they still bear; they never acknowledged the term "Monophysite" and called their adversaries Nestorians and Melekites (Arabic *Malek* "king") because of their faithfulness to the emperor. From this Council of Chalcedon dates the division of Egypt under two patriarchs—a division that the Emperor Zeno's decree, called Henotikon (482), though accepted in Egypt, failed to bring to a compromise. Indeed, the situation was the result of Egyptian nationalism aroused by the pretensions of Constantinople rather than a matter of doctrine. Under Justinian (527–565) the Alexandrians more than once opposed the installation by the imperial forces of the Melekite candidate to the See, preferring the hazards of a riot to encroachment of their religious freedom. Eventually the Church of Egypt sought an ally in the Church of Antioch.

Justinian was more successful against paganism, which he brought to an end. During the fourth century Hellenistic literature had been revived through the efforts of the poets Nonnos of Panopolis (Akhmim), Collouthos of Lycopolis (Assiut), and Tryphiodorus the Egyptian, who described in verse the loves of the gods of Greek mythology; this literary trend was echoed in the

31. Ibid., fig. p. 436. A. Bauer and J. Strzygowski, "Eine alexandrinische Weltchronik," in *Denkschriften der Wiener Akademie* (philosophisch-geschichtliche Abeteilung), Vol. 51 (1906), pp. 169 ff.
32. H. I. Bell, *Jews and Christians in Egypt*. E. Breccia, *Juifs et Chrétiens de l'ancienne Egypte* (Alexandria: 1927).
33. U. Bouriant, "Actes du Concile d'Ephèse," Texte Copte traduit et publié, *Mémoires de la Mission archéologique du Caire*, Vol. 8 (Cairo: 1892).

34. P. Battifol, "Les présents de saint Cyrille à la Cour de Constantinople," in *Etudes de liturgie et d'archéologie chrétiennes* (Paris: 1919), pp. 154–179. P. Battifol, "Un épisode du concile d'Ephèse (Juillet 431) d'après les Actes coptes de Bouriant," in *Mélanges Schlumberger* (Paris: 1924), pp. 28–39.
35. E. Amélineau, "Monuments pour servir à l'histoire de l'Egypte chrétienne aux IVe et Ve siècles: Le panégyrique de Macaire de Tkoou par Dioscore d'Alexandrie; IV Lettres de Pierre Monge et d'Acace," in *Mémoires de la Mission archéologique du Caire*, Vol. 4, pp. 62–114, 196–228. W. E. Crum, "Coptic Texts Relating to Dioscorus of Alexandria," in *Proceedings of the Society of Biblical Archaeology* (London: 1903). F. Haase, "Patriarch Dioskur I von Alexandria. Nach monophysitischen Quellen," in Max Sdralek, *Kirchengeschichtliche Abhandlungen*, Vol. 6 (Breslau: 1908). H. Thompson, "Dioscorus and Shenoute," in *Mélanges Champollion* (Paris: 1922), pp. 367–376.

nudes of comtemporary sculpture. A group of philosophers such as Asklepiades, Horapollo, and Olympiodorus of Thebes, teaching in Alexandria and the metropolises, maintained the doctrines of the Alexandrian school. Though Egyptian rather than Hellenic paganism was still followed, especially in secluded areas, it was doomed to disappear in face of the activity of Shenute (A.D. V), Macarius of Antaiopolis (A.D. VI), Moses of Abydos, and Pisentios of Coptos (A.D. VII), and in view of Justinian's decree ordering that the last temples at Philae be closed (543). Christianity spread to Abyssinia and Nubia with the help of Empress Theodora. Although discord reigned within the Alexandrian Church itself and more than once between it and Antioch under Damianus (578–604), all attempts made by Constantinople toward a reconciliation failed, even after such political upheavals as the seizure of imperial power by Heraklius (610–641).

Despite the establishment by Justinian of buffer states and fortresses along the eastern *limes romanus*, the Persians marched down the Levantine coast, invaded Egypt through Pelusium (619), took Babylon and Alexandria by treason after a siege of few months, and reached south to Nubia, appropriating monasteries and churches and killing their monks. This reign of terror soon subsided, however, and there followed a peaceful interlude (619–629) during which the Monophysites were much better treated than they had ever been by Constantinople. This experience was

an important factor in the optimistic attitude of the Copts toward the next invaders, the Arabs.

At that time the Melekite patriarch Cyrus, who was cumulating the functions of governor, restored the fortresses and tried without avail to unite the Christians. Known later as El Muqawqas (Arabic from Coptic "Khaukas"), he was the representative who negotiated with the Arab conquerors. These bedouins, led by 'Amr ibn el 'Ās, had followed the same route as the Persians and all previous invaders, first subduing Palestine, then marching through Gaza (640), Pelusium (Farama), and Belbeis to Babylon (Qasr el Sham'), which capitulated after a siege of six months (641).[36] A few fortified towns fell to the Arabs marching against Alexandria, and the capital itself—divided between the Greek faction, the Greens, and the Copt faction, the Blues—capitulated in 641; its garrison embarked for Constantinople in 642. The report of the destruction of the Alexandrian Library cannot be regarded as trustworthy, for it is found only in late Arab chronicles of the thirteenth century. The Arabs were welcomed as liberators by the Copts, who still remembered the brief respite they had enjoyed under the Persians and hoped for an improvement over the hated Byzantine rule.

Their hopes were at first fulfilled; the Copts were governed by their own nationals, and those who became Muslims did so only to escape the poll tax. Soon, however, it became apparent they had jumped from the frying pan into the fire; the system of government in the new province of the caliphate was patterned on that of Rome, though perhaps with lighter taxes, but it imposed the significant new burden of religious-minded rulers of another religion and nationality.[37]

When Alexandria was seized again by the Byzantines in 645, the Copts appealed to 'Amr,[38] who had outlined his policy toward them in his letter to the caliph: "The Muslims do not yet really know the country and they are unable to assess the taxes that are applicable to it. I therefore appoint in my service a Christian competent and known for his honesty: we will replace him when we know well the country."[39] In fact, records show that all the provincial officials were Christians until the end of the Umayyad dynasty (c. 750). Among a population of two-and-a-half million adult males around 670 A.D. most were still Christians;[40] the patriarch Benjamin and his bishops had resumed their sees; and everyone was enjoying the mild rule except those wealthy Copts who tried to evade taxes, no one apparently concerned at the internal dissensions of the caliphate. In discussing the Arab rulers a Nestorian bishop could write that

36. A. J. Butler, *The Arab Conquest of Egypt* (Oxford: 1902). S. Lane-Poole, *A History of Egypt in the Middle Ages* (London: 1936). (Hereafter cited as *History of Egypt.*) G. Wiet, "L'Egypte Musulmane de la Conquête Arabe à la Conquête Ottomane," in *Précis de l'Histoire d'Egypte par divers historiens et archéologues*, Vol. 2 (Cairo: 1932), pp. 109 ff. (Hereafter cited as "L'Egypte Musulmane.")

37. G. Wiet, "L'Egypte Musulmane," p. 119.
38. S. Lane-Poole, *History of Egypt*, pp. 20–21.
39. G. Wiet, "L'Egypte Musulmane," p. 128.
40. S. Lane-Poole, *History of Egypt*, p. 19, n. 1.

"they do not fight the Christian religion, nay they protect our faith, they respect our priests and holy men and present gifts for our churches and our monasteries."[41] When the governor 'Abd el 'Aziz ibn Marwān, burdened with elephantiasis, settled in the Coptic monastery of Tamweyh near Helwan to use the sulfur baths, he paid the monks 20,000 dinārs (686). Yet his successor forbade Christians to wear the *burnoose*, ordered Arabic to be used instead of Coptic in public documents, required monks to wear badges, and imposed other vexations,[42] such as the destruction of religious emblems outside churches (689). Male Christians had to pay a proportional poll tax from 40 dirhems to 4 dinars; provide wheat, oil, and honey as well as linen for the army; and provide habitation for a Muslim for three days. Monks were later subjected to an annual income tax (*djizya*) of 1 dinar even before 705.[43] Lower officials were then appointed from among the Muslims; churches and monasteries had become so impoverished that glass chalices had to be used, and finally sacred images were destroyed (722) just four years before the onset of iconoclasm and the bodily persecution of nuns. Seeing that the Copts held steadfast to their faith and still numbered five million (725),[44] the Arabs time and again imported whole tribes from Arabia, who always formed hotbeds of rebellion.

Although the Copts finally revolted seven times between 725 and 830, they never achieved cohesion or that *esprit de corps* essential to a national movement, but rather joined local riots. Christians were required to wear a certain cloth (*ghiyar*) and a girdle (*zunnar*) that was a symbol of femininity; they could use only a yellow turban and wooden stirrups, and were forbidden to ride horses.[45] No new church could be built nor a ruined one restored. It was, however, the heavier burden of taxes that caused apostasies to Islam in such masses that poll taxes decreased from five million dinars under Mu'āwiya (661–680) to four million under Harun el Rashid (786–809) and later to three million. A concurrent movement was the growth of Arabic to supersede the Coptic language, which for a short while had been revived in church offices, epigraphy (A.D. VI), and toponymy. Arabic names of cities were derived from the Coptic forms that had replaced their offical Greek names: Akhmim for Panopolis, Ahnas for Heracleopolis, Ashmunein for Hermupolis. Only infrequently were Coptic records accepted, and from 706 Arabic became the only language used in official transactions.[46] From the wild repression of the rebellious Copts by El Ma'mun in 832 date the preponderance of Muslims and the settlement of the Arabs in rural districts.[47] Despite such discriminatory conditions the Christian religion was always tolerated as were rites and customs deriving from the ancient Egyptian cult of the Nile, such as lowering a reliquary containing the finger of a martyr into the river, a rite replacing the propitiatory sealed papyrus and figurines or amulets thrown in pagan times. The feast of the seventeenth of Thot was adopted by the Muslims as 'Id el Wafa, "Festival of the Promise." Public prayers during a low inundation were held both by the Muslim governor, who recited the prayer for rain in the mosque of 'Amr (742), and by the Copts, who formed a procession to the riverbank and for three hours shouted *Kyrie eleison* (756).[48]

Under the caliphate the Copts were still the active and able craftsmen they had proved to be previously; they were often hired for official projects in Egypt or abroad in Jerusalem or at Tunis, where 3,000 Copts were sent by 'Abd el 'Aziz ibn Marwān, or at Mecca, where Pakhom built the roof of the Ka'ba. The basic industries remained in the hands of the Copts: paper at the beginning of the eighth century still bore the watermark "Father, Son, and Holy Spirit"; scribes still marked the official records with the sign of the cross; wood carving produced pieces very similar to those of the sixth century, though occasionally engraved with a Koranic verse; and textiles were still called *qabati* after *Qobt*, "Copt,"

41. G. Wiet, "L'Egypte Musulmane," p 131.
42. S. Lane-Poole, *History of Egypt*, pp. 26–27.
43. G. Wiet, "L'Egypte Musulmane," p. 132.
44. El Kindi in *Abu Salih the Armenian*, p. 266; cf. S. Lane-Poole, *History of Egypt*, p. 28, n. 2.

45. G. Wiet, "L'Egypte Musulmane," p. 134. S. Lane-Poole, *History of Egypt*, p. 39.
46. Wiet, "L'Egypte Musulmane," p. 137-138.

47. S. Lane-Poole, *History of Egypt*, p. 38.
48. G. Wiet, "L'Egypte Musulmane," p. 145.

the same name given to the Christian Egyptians by the Arabs.[49] The Arabs had no scruples about establishing their mosques in abandoned churches, placing the *miḥrāb* at the entrance doorway, and later plundering the columns and marbles from those structures that they had forbidden the Christians to restore.

Under the Tulunids (868–905) and Ikhshidids (905–969) Christians fared well. Ibn Tulun had commissioned a Christian (*naṣrāni*) architect to build near Fustat his aqueduct and mosque; his son Khumaraweyh used to admire at length a glass mosaic of the Madonna surrounded by angels and the twelve Apostles in the monastery of El Qusair, where he built a belvedere with four bays open to the four cardinal points.[50] This favorable atmosphere continued under the Ikhshidids, who originated from Turkey; Christian bishops, monks, and needy laymen were exempted from the poll tax, and the rulers presided in person at the feast of the Nile, which coincided with Epiphany (942, after Mas'ūdi).[51]

Never, however, did the Christians and particularly the Copts enjoy such liberalism as under the Fatimids (969–1171), who allegedly descended from the Prophet through his daughter Fatima. The founders of this dynasty came from Tunisia and professed the Shi'a doctrine. The caliph 'Azīz (975–995) caused the two brothers of his Christian wife to be appointed as Melekite patriarchs of Alexandria and

Jerusalem. He granted the Coptic patriarch Ephraim permission to rebuild the church of Abu el Sefein, and he encouraged Severus, Bishop of Ashmunein, to hold religious disputation with Muslim divines. His vizier 'Isa the Nestorian was a Christian. His son El Ḥākim (996–1021), a mad reformer, persecuted the Christians and Jews after his first ten peaceful years, obliging the Christians to wear black robes and to wear heavy crosses in the baths, and also destroying their churches and confiscating their property (1005). Many accepted Islam, while those who remained faithful had to wear a heavy cross and were forbidden to ride horses, keep Muslim serfs, or be rowed by Muslim boatmen.[52] Christians were still indispensable, and many, such as Ibn 'Abdun and Zur'a, were appointed to the highest posts. The persecution subsided as abruptly as it had started; Christians were allowed to profess their creed and restore their churches, and many apostates reverted to their original faith (1021). El Yazuri (1050–1058), one of the viziers of El Mostansir, closed and destroyed the churches, imprisoned the Coptic patriarch and bishops, and enforced among other exactions fines of 70,000 dinars.[53] Radwan, another vizier noted for his oppression of the Christians in the caliphate of El Ḥāfez, raised the poll tax one and one-half to two dinars.[54] El Ḥāfez himself was tolerant of the Copts; one of his favorite monasteries, where belvederes (*manzara*) with a

view of the gardens or the Nile were erected, was that of St. John with its beautiful gardens designed by Temim, the son of the caliph El Mu'izz.[55] His predecessor, the caliph El Amir, had tried to do away with the office of vizier, employing only the monk Abu Nagah ibn Kennar as general collector of the revenue. Although the monk farmed the taxes on the Christians for 100,000 dinars, he was nonetheless flogged to death.[56] El Amir also liked the gardens and monastery of El Nahya, west of Giza, and each time he visited he gave the monks 1,000 dirhems. He used to enter the low doorway into the church backward and stand in the priest's place. Many of the viziers were Armenians who protected Christians, and Copts were always put in charge of the highest offices, such as tax farmers (*damin*) or controllers of accounts. Many details about the later Fatimid period are recorded in the contemporary history of Abu Salih the Armenian. Coptic churches had an annual revenue of 2,923 dinars and 4,826 sacks (of 5 bushels) of grain, mostly derived from Fatimid gifts, and they owned 915 acres of land (1180). Whatever their faults, the Fatimids, bent as they were on seeking pleasure, and their viziers, eager to gather money, produced a dynasty that marked what was undeniably the brightest apogee in art. The liberal treatment the Copts received during these two centuries

49. Ibid., pp. 147–149.
50. Ibid., p. 162, after Abu Salih and Maqrizi.
51. Ibid., p. 170.

52. S. Lane-Poole, *History of Egypt*, p. 127.
53. Ibid., pp. 143–144.
54. Ibid., pp. 151–152, n. 2.

55. Ibid., pp. 140, 170.
56. Ibid., p. 166.

gave them the incentive to acquire the Arabic language, so much so that around the end of the dynasty the patriarch Gabriel II (1132–1145) had the liturgical works translated into Arabic. The earliest Islamic architectural monument in stone was the Nilometer in Rodah Island; from its carved ornament a whole collection of Coptic sculptures was recently extracted. Ignoring the restrictions of Islam against human representations, the art of the Copts allied genre scenes in bronze, wood, mosaics, and painting to a rich ornament. An abbot of Monte Cassino imported Greek and Saracen mosaicists from Constantinople. Profuse figured ornament is also characteristic of Fatimid fabrics, which derived from Coptic textiles. Private weaving factories were heavily taxed, and according to Muqaddasi "taxes are particularly heavy at Tinnis and Damietta. No Copt may weave a piece of fabric at Shata without having it marked with a government stamp. It cannot be offered for sale except by agents recognized by the State, whose officer inscribes sold pieces in a record."[57] Wood friezes carved with genre scenes of a style identical to that of the doors of the St. Barbara church were probably the work of Coptic sculptors. Perhaps the best evidence of the recognized standing enjoyed by Copts in Fatimid society is found in the general celebration of the Coptic New Year (*nawruz*), in cutting the dam of the canal of Cairo and anointing the column of the Nilometer, and also in the observance of such properly religious feasts as Christmas, Epiphany, and Holy Thursday, on which occasions a special mint was struck.[58]

Under the Ayyubids (1171–1250) the Copts were still treated with enlightened tolerance, though they were forbidden to practice as doctors or secretaries by Salah el Din. Their religious festivals were no longer presided over by the new sultans, but their churches were restored, and the thirteenth century was the golden period of the Christian Arabic literature that had replaced the Coptic.[59] Sultan Malik el Kāmel (1218–1238) was acknowledged by the Church of Egypt as "the most generous and beneficent sovereign they ever had."[60] a magnanimous attitude in the face of the double invasion of Egypt by the Franks (1218, 1250).

The period the Mamluks (1250–1517), foreign slaves vying with one another and using any means to achieve power, marked the lowest ebb in the status of the Copts. Though they still peopled the offices of the government and private estates of the Mamluks, their churches and monasteries fell to ruin, the Coptic language disappeared, and the number of Copts decreased to its present proportion. Between the ninth and fifteenth centuries, eleven decrees prescribed the revival of sumptuary laws against Copts and Jews, destroying whatever prosperity a beneficent interlude might have brought.

Characteristic of the times was the alien interest in the status of the Copts: an envoy from Morocco could remonstrate with the emirs about the obvious wealth of the Christians, causing a renewal of restrictions against them (1301), while an emissary from the Pope would urge Nāṣir to treat Christian subjects humanely (1327). During Nāṣir's third reign churches were protected, but he had to yield to public opinion and enforce the former decrees. The most vicious of these calamities was the secret plot to destroy churches throughout the country upon the call of the divines in all mosques on Friday the eighth of May 1321.

57. G. Wiet, "L'Egypte Musulmane," p. 211.

58. Ibid., p. 215
59. Ibid., p. 228.
60. S. Lane-Poole, *History of Egypt*, p. 241.

Augustus wished to keep Egypt as a place apart (*Aegyptus seposita*).[61] It was the private domain of the emperor. Because of its special annona and military significance it was put under his direct jurisdiction at the subdivision of A.D. 27. No senator or *Equites illustres* could enter the country without a special permission from the emperor. It was governed not by a procurator but by a *Praefectus Alexandriae et Aegypti*, a kind of viceroy. He was endowed with absolute power although he did not live in the Brouchion, the palace of the Ptolemaic dynasty in Alexandria.

Josephus' estimate of seven million for the population of Egypt cannot be taken seriously. He had sidestepped Diodorus' suggestion that about 60 B.C. it could not have been less than three million. Evidence based on tax assessments gives four and a half million for the population at its highest point in the first century A.D.[62] A pestilence struck the Empire in the second century, and as a result the population decreased to about 3.2 million at the end of the third century. After the great plague of 542–600 the population might have dropped from 3.5 million to 2.6 million. Contributing to this catastrophe were low Niles and the submergence of part of the Delta, so that an estimate based on land tax and poll tax under 'Amr ibn el 'As would give a non-Muslim population

of about 2.5 to 3 million before A.D. 650. A sharp decline in the number of Christian and Jewish taxpayers under Caliph Mu'awiya (661–680) suggests a change of religion for taxation advantages. This halting of Christian growth is corroborated by the small number of 200 churches, mostly in Alexandria, in the nomes of Oxyrhynchos, Aphroditipolis, and Arsinoe. The Christian population declined steadily, reflecting the general decrease from 2.2 to 2.6 million in the eighth and ninth centuries to 1.5 million in the tenth and eleventh centuries, a period of low Niles. With the colonizing activity to the south and to the west, population rose rapidly in the twelfth and thirteenth centuries to about 3.6 million until the outbreak of the plague (1348–1350) and its later ravages, coupled with devastation by high floods (1322–1421) and ensuing famines (1374–1375, 1394–1396, 1403–1404).

Papyri enable us to analyze very adequately the demography of Greco-Roman Egypt.[63] Augustus' economic improvements were counteracted by his creation of large estates for absentee landlords. The development of a class of landowners with medium-sized holdings resulted in the prosperity of the metropolises rather than the villages, and ultimately in rural depopulation. The decay that spread to the towns was increased by the Severan urbanistic reforms, which created a *bourgeoisie* trying to maintain its privileges. By the end of the third century,

there occurred a drift of population from the towns back to the villages. In the early fourth century the government forbade transfer from village to city, and population movements ceased. As a result of the differentiation between town and country, enhanced by Severus' reforms and Diocletian's municipalization, the Hellenistic culture of the towns and the native culture of the country drifted apart, a split from which originated the nationalistic trends manifested by the Copts. Egypt was subdivided into three districts—the Delta, the seven nomes and Fayum, and the Thebaid—each governed by a *procurator ad epistrategiam*. The *epistrategia* consisted of nomes under a *strategos* each. In the village the *comarchos* was replaced by a body of elders, but there was a *comogrammateus* in charge of the fisc. This privileged status was bestowed by Augustus upon Egypt because he planned to exploit its fertile valley so easily controlled by his legions as the granary of Rome. Twenty million modii (one modius = 8.536 liters) of wheat were to be sent yearly from Alexandria to Ostia or Pozzuoli. However beneficent the privileged status might have been, it was used by some Coptic patriarchs as a means of applying pressure on the emperor.

Diocletian, on the contrary, trying to bring Egypt into uniformity with the rest of the empire, reformed completely its institutions. He municipalized the country (297), dividing it into smaller provinces which were later subdivided. The nomes were converted into cities with territories, *chora* ($\chi\omega\rho\alpha$),

61. A. C. Johnson, *Egypt and the Roman Empire* (Ann Arbor: 1951), p. 11.
62. J. C. Russell, "The Population of Medieval Egypt," *Journal of the American Research Center in Egypt*, Vol. 5 (Cambridge, Mass: 1966), pp. 69–82.

63. H. Breunert, *Die binnenwanderung. Studien zur Sozialgeschichte Ägyptens in der Ptolemäer- und Kaiserzeit* (Bonn: 1964).

a terminology preserved with the Byzantine system itself in the early centuries after the Arab conquest in the Arabic *qura*.[64] At the head of each of the three provinces (four since 341) was a *dux*, helped at the start by several civil and military officers, but since Justinian's Edict XIII (538) responsible alone for police, army, justice, and finances. The *dux* of Alexandria, the capital until the fall of Byzantine Egypt, collected taxes in wheat and sent them to Constantinople. Egypt became a group of provinces whose governors were nominated by, and dependent upon, the emperor through a prefect. The *dux* was chosen increasingly from among the Egyptians, a custom legalized by Justin II (569), who approved his nomination by the bishops and the notables. He was helped by a numerous *officium*, that of the *augustal* of Egypt comprising no less than 600 officers, the most important being the two *praeses* (tax-collectors) and *the pagarch* or general inspector appointed by the emperor from among the large estate owners and dealing with taxes. In the cities they were assisted by the *curiales*, whose assembly was presided over by a *defensor civitatis*, essentially a municipal magistrate. The villages were ruled by a body of notables, *protocometes*, responsible for finances and rural police.[65]

Roman and Byzantine financial policy was aimed, as the Ptolemaic policy had been, at exploiting the country, with the detrimental difference that income served to enrich Rome and Constantinople. Diocletian abolished the poll tax on urban population and instituted a system of indiction or assessments of taxes in kind for a period of five years (297), later extended to fifteen years (312). This indiction cycle, lacking even mention of the emperor's reign, is the only chronology that appears on Coptic epitaphs. The peasant became the owner of his former leasehold, and taxes were levied uniformly on all arable land.[66] Much is known about administration from Justinian's Edict XIII, which adhered to Diocletian's system. There were indirect taxes (customs, trades) and direct ones, for example, a flat tax on land per *aroura*. In addition, Egypt was required to pay a special tribute in wheat (*annona civica*), assessed according to the inundation by the imperial geometers and stored in Alexandria. From Alexandria it was transported twice a year to Constantinople, which waited impatiently for provisions. [67] Probably there were, as before, additional charges and liturgies, such as work on canals and embankments, later mentioned by Arab historians. Part of the annona was, however, kept in Egypt and distributed as *alimonia* to the needy of Alexandria.

Civic administration was in fact weak, and the army was no better. Diocletian had separated the military from the administration, but Justinian placed the army under the provincial prefects, whose civil duties kept them away from the camps. Never stronger than 30,000, the army was recruited locally and the soldiers could marry and ply a trade. They manned the three forts at the apexes of a huge triangle encompassing the country at Pelusium-Rhinocolura to the east, Alexandria to the west, and Babylon to the south, as well as in *castra* in important centers along the valley such as Coptos, Opheion, Syene and Philae, and other islands of the cataract, or on the outskirts of the desert at Dionysias and the oases. Such an army led by incompetent commandants could hardly withstand any serious attack even by smaller forces such as those of the Arabs.

Egypt was the most densely populated country, numbering 7,000,000 in the late-antique period excluding Alexandria, whose 300,000[54] (600,000)[55] inhabitants, mostly Egyptians and Greeks, but also Jews, Syrians, and Ethiopians, gave to the capital a variegated cosmopolitan aspect. Always ready to riot, these chattering loiterers, described as most vicious by the rhetor Eunapus ("if there is anything more vicious than an Alexandrian"), were always eager since the triumph of Christianity for religious disputation. It seems that the emperors sought to bribe the populace, greedy for entertainments such as the circus with its two factions, the Greens and the Blues, maintaining dancers even when they were expelled from the other cities of the Orient by Justin I.[68] One resource for quelling the riots was to cut the *alimonia*, forbid the use of weapons,

64. A. H. M. Jones, *The Cities of the Eastern Roman Provinces* (Oxford: 1937), pp. 338–339, 349.
65. C. Diehl, "L'Egypte" pp. 461–466.

66. A. C. Johnson, *Egypt and the Roman Empire*, p. 118.
67. C. Diehl, "L'Egypte," pp. 465–471. H. Munier, "L'Egypte byzantine," pp. 75–77. G. Rouillard, *L'organisation civile de l'Egypte byzantine* (Paris: 1928), pp. 75–148.

68. C. Diehl, "L'Egypte," pp. 483 ff.

and keep track of leaders in hiding in the Mareotis (Maryut). The rich patriarch, that late "Pharaoh," ruler of a numerous army of officials and monks, vied with the government in trying to satisfy the Alexandrians, distributing allocations and feeding more than 7,500 needy, exploiting a navy of thirteen large ships trading in the Adriatic, and occasionally, as with Cyril, showering the imperial court with precious gifts. Alexandria was still a most splendid capital whose architectural and artistic styles were imitated in other cities, as well as an important market trading with Ceylon, the Indus Valley, and China. Refined luxury and fashions; purple fabrics woven with scenes from the circus, with dancing figures, or with religious subjects; beautiful jewelry; high coiffures or wigs; and cosmetics adorned Alexandrian ladies and women of loose morals alike, reminiscent of Clement's description of Alexandrian life in the second century. Besides this lighter, mundane aspect, however, the capital still nurtured an intense scholarly activity centered in the University, where pagan authorities like the grammarian Theodolos, the lexicographer Orion, the Neo-Platonician Hypatia, Heraiskos, and Horapollo (A.D. V) attracted enthusiastic pagan and Christian disciples who engaged in religious controversy. Christian professors also appeared, especially after the persecution of pagan teachers by Zeno. These Christians, such as John Philoponos and Stephen (A.D. VI), still based their teaching on Aristotle. Lighter aspects of intellectualism produced pagan and Christian poetry and romantic

literature like that of Achilaeus Tatius and Museus, while earlier authors—Homer, Hesiod, and Lucianus—were still read, as evidenced by the numerous texts retrieved throughout Egypt. Christian writers on philosophy and exegesis such as Athanasius and Cyril wrote in refined Attic Greek. Original works such as the Christian Topography of Cosmas Indicopleustes and the Alexandrian Chronicle were produced in beautifully illuminated manuscripts.

In Egypt itself the natives were in the hands of a class of estate owners who grew more numerous and powerful, creating a kind of landed feudality in the fifth and sixth centuries. At Oxyrhynchos the history of the Apion family can be traced for a century and a half;[69] some members of this family rose to the prominent offices of prefect (518), count of the sacred largess (533–538), consul (539), *dux* of the Thebaid. They owned villages and land cultivated by serfs on which they levied taxes; they owned a navy and a private guard. Many were hostile to the Byzantines. The other power in the country was the church, whose clergy outside Alexandria was recruited from the peasantry and conformed, as did the people, to the opinion of the patriarch. The clergy depended upon the Coptic masses, hardy, black-haired with intense eyes, living an average of 32 years[70] as their dynastic ancestors had done in mud houses huddled together above the flood waters at the top of mounds, illiterate and ignorant.

Even their theologians possessed "intelligences of the Egyptian type, that neither know nor comprehend things" (Anastasios the Sinaitic).[71] Those Coptic bishops who were urged to vote against Dioscoros in the council of Chalcedon wailed in fright: "We will never again be able to live in the country: we would be killed!"[72]

Monastic communities[73] had grown from the earlier cenobitic settlements into powerful and rich landowners led by energetic abbots always ready like Shenute of Atripe to back the patriarch forcefully in councils and occasionally to destroy even in Alexandria itself the remnants of a dwindling paganism. One of the early provincial monasteries, that of Epiphanius in western Thebes,[74] provides both archaeological and palaeographical data about the life of the Coptic monks. About A.D. 600 Epiphanius built the first massive three-storied tower on the bedrock of the court fronting the ancient Egyptian rock tomb of Daga, which had been inhabited by anchorites

69. Ibid., pp. 503 ff.
70. F. A. Hooper, "Data from Kom Abou Billou on the Length of Life in Graeco-Roman Egypt," Chronique d'Egypte, XXXI (Brussels: 1956), pp. 332–338.

71. C. Diehl, "L'Egypte," p. 497.
72. Ibid., p. 506.
73. M. Krause, Mönchtum in Ägypten," in Koptische Kunst (Essen: 1963), pp. 77–84. P. Ladeuze, Etude sur le cénobitisme. W. H. Mackean, Christian Monasticism in Egypt to the Close of the Fourth Century (London: 1920). P. van Cauwenbergh, Etude sur les moines d'Egypte depuis le concile de Chalcédoine (451) jusqu'à l'invasion arabe (Paris: 1914). D. J. Chitty, The Desert a City: an Introduction to the History of Egyptian and Palestinian Monasticism Under the Christian Empire (Birbeck Lecture, 1958–1959).
74. H. E. Winlock and W. E. Crum, The Monastery of Epiphanius at Thebes, 2 vols. (New York: 1926–1933.). (Hereafter cited as Monastery of Epiphanius).

(Fig. 1.1). A second, smaller tower and two boundary walls formed with the ancient tomb the central dwelling, refuge, and cemetery for the elders of the community; outlying cells fronting other rock tombs were added, each consisting of a court and vestibule complete with benches, looms, granaries, and inscribed niches. Except for the towers and canopy tomb, where arches, vaults, and domes roofed brick walls, the other structures were of coarse boulders and brick. The primitive architectural equipment consisted of native grain bins of mud similar to those modern peasants call *sawma'* and set above or beneath the floor; two bakery ovens beehive in shape; fragments of a bow drill and lathe-turned woodwork (Fig. 1.2); balusters from screens of latticework for furniture and windows, similar to the Arab *mashrabiya* but intended to be seen from the outer face only; leaves for doors and cupboards hinged on pivots fitted in sockets of sills and lintels like dynastic and modern ones; sycamore locks secured by means of pins dropping into the sliding bolt and similar to the Greek Laconian lock. Agricultural equipment featured winnowing scoops, sieves, palm leaf work baskets (50–55 cm. in diameter, 30–40 cm. deep), wooden pulleys for packsaddles, the *norag* threshing cart, perhaps derived from the "Punic cart" (I B.C.), *shaduf* hooks, ribbed red earthenware *qadus* or waterwheel pots (Fig. 1. 3, part 2)—all very similar

to modern items. The monks kept busy making mats of halfa grass and baskets of palm leaf, leather sandals, black kidskin aprons and girdles; they also spun flax and linen and wove linen cloth and woolen shroud tapes, for eight looms had once been set against the walls above their treadle pits.

Pottery types (Fig. 1.3) included the waisted ribbed amphora with a small hole as a vent in the neck stopped with a mixture of black earth and chopped straw and stamped with round impressions; a water bucket similar to the modern *ballas*, pseudo *terra sigillata* ("Samian"), fine-grained reddish dishes; cups and bowls stamped with monograms; terra-cotta lamps shaped like small cups (7–8 cm. in diameter) or elongated ovals with handle or variants from the classical type but taller; bowls imitating Samian ware; cooking pots; water bottles like the modern *qulla* with the characteristic sieve in the neck; and some pottery decorated with dark-brown and light-red designs on a white slip. Among miscellaneous objects were reeds (1 cm. in diameter) pointed and split to be used as pens identical to Roman ones of the third century B.C. and probably adopted by the Copts along with the Greek alphabet they used in their script.

Contrasting with the utilitarian character of the entire store of equipment was a bronze incense burner found hidden above an oven; the ornamental sliding lid, cast hollow in the shape of a lioness attacking a boar, fitted over a perforated box decorated on its front with an elephant. It was so designed

that incense fumes would emanate from the mouths and ears of the lioness and boar. Nearly identical pieces exist in various Coptic collections (see Fig. 5.20). Small ostrace were trial pieces, with drawings of a lion and the constructional scheme of a guilloche as three rows of circles marking the joints of the interlace (Fig. 1.4). Perhaps the most interesting piece, though of little intrinsic value, was a palm stick from the monastery of Cyriacus graduated by notches into seven divisions, each 3.5 cm. in length and separated by blank intervals of 0.9, 0.9, 0.95, 1.3, 2.15, and 3.6 cm.; plotted by their coordinates, these intervals develop a regular curve[75] identical to that of the catenary curve of dynastic and Coptic arches and vaults, exemplified in the second tower of Epiphanius' monastery.[76] This comprehensive body of finds is of invaluable interest as firsthand evidence relating to material life in a Coptic monastery in the Thebaid during the sixth and seventh centuries and also to those technical innovations introduced in Roman times which have been retained in rural life into modern times.[77]

Not much is known about the garb of the monks, for their corpses, sprinkled with coarse salt and juniper berries, were carefully wrapped in four or six linen shrouds within an extra outer covering closely bound with tapes, but always wearing the leather apron and

75. Ibid., Vol. 1, p. 95, Fig. 51.
76. Ibid., Vol. I, pl. VII.
77. Ibid., Vol. I, pp. 46–50, pl. XII.

1.1
Restored view of the monastery of Epiphanius
in Western Thebes.

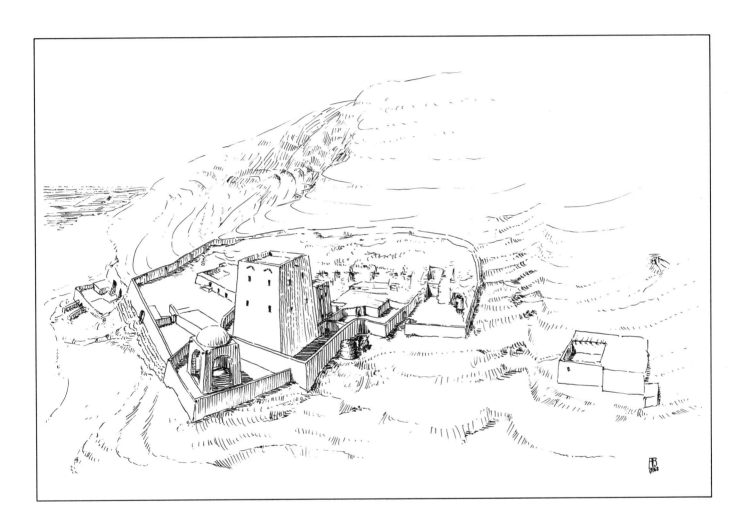

1.2
Details of lattice wood screen and lock from the
monastery of Epiphanius, (H. E. Winlock and
W. E. Crum, *Monastery of Epiphanius*, Vol. 1,
Figs. 17–19.)
1.3
Types of pottery from the monastery of
Epiphanius, (H. E. Winlock, and W. E. Crum,
Monastery of Epiphanius, Figs. 23, 32, 37, 38, 40.)

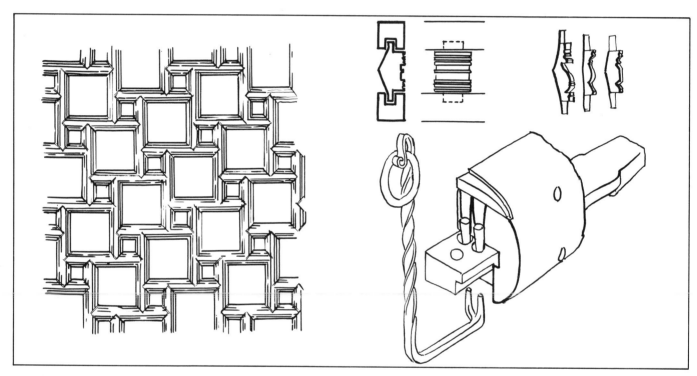

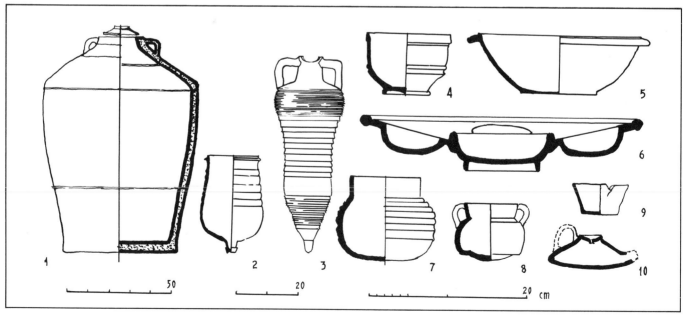

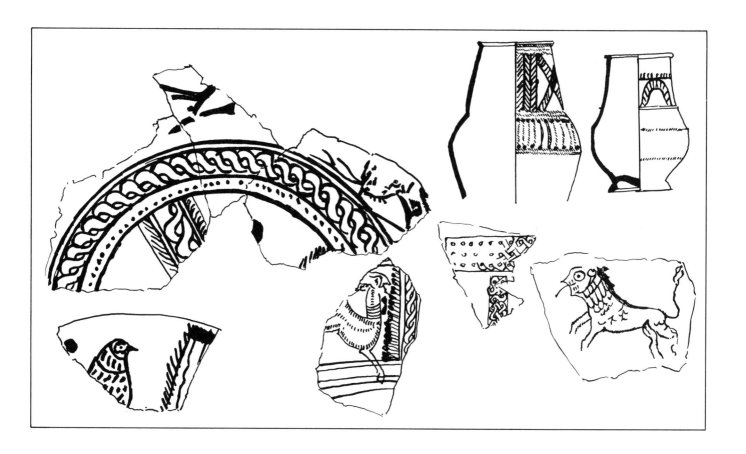

girdle. These aprons[78] were long trapezoidal pieces of black kidskin hanging from the shoulders to the knees and terminating in a red fringe; the apron was suspended on two straps that crossed on the back and ended in a plaited leather cord tied round the waist. A shield-shaped pocket with a flap was sewn inside in the left-hand corner. The apron seems to correspond to the *schima,* a garment mentioned in some texts. The leather girdle was part of the monastic habit of the fourth and seventh centuries as described in various texts (Macarius, Lib. 33; Abba Samuel); it was made from a broad (3.2–4.5 cm.) strap of black leather stamped on the outside which ended in two loops through which a thong was knotted.[79] Whatever the monk's uniform—a patchwork of rags or a tunic (*lebitwn*), as in monasteries, or a hair coat, hood, and *schima,* as in Nitria—he was arrayed in it when first consecrated, with the laying of leathern straps or braces ("bound with the schima") forming the culminating act. Shenute's monks were "harnessed like asses."[80] Pachomius' monks were not allowed to spread anything but a mat on their beds; they could not change any item of their outfit without the permission of their house-chief; they had to wear the *rahtou* (*pellis*) and the hood (*cuculla*), but never their blanket.[81]

In the apocalyptic description by the monk Tsharour of the defects in the monastery at Phbow, it is recorded that the Abbot Besarion once threatened his disobedient monks, saying: "By the girdle that binds me, if you do not proceed with the brethren there will be no *tshatshe* [kind of bread] in the bread-basket, no vegetable in the garden, no *lapsane* in the bowl, no olive in the *gaon,* no oil in the *sikelle* [oil jar], no cheese in the *hemebason* [cheese container], no mustard in the *ankouladje* [vessel]."[82] Though Besarion's mention of food ingredients was concomitant with symbolic interpretation, as "No vegetable in the garden," that is, "The weak may eat vegetables" (Rom. 14:2), the list still throws some light on those food items known to a Coptic monk. In the rules of Horsiēse, who succeeded Theodoros, the disciple preferred by Pachomius, there are instructions regarding the preparation of what seem to be basic food items: "loaves should not be left to rot in water, brine should be made fresh daily, dates should not be soaked to produce date juice for two or three days lest they become sour, lupine should not be boiled in quantities exceeding what is needed for the week after washing it once or twice or preferably a long time, vegetables should not be left to spoil."[83]

We are better informed about the monks' diet from texts and actual remains. Drinking water was supplied from the monastery well or tank or from the river or canal bank. Salt and bread baked from wheat at Ascension and Pentecost and stored in bins formed the common fare of the anchorites and Pachomius' monks. Oils from gourd, castor, and olive are mentioned, but seldom were used for food. Greens and vegetables seem to have been cooked on special occasions but were usually pickled. According to the Life of Pisentios, fish was allowed for hermits in ill health; it was eaten by Shenute's monks,[84] and some fish paste kept in jars was found in Jeremias' monastery at Saqqara.[85] Butter, milk, eggs, fruit, and honey seem to have been but rarely eaten, and then on special occasions, though dates were the usual fare of the early anchorites. Wine was essential at the church's festivals, but otherwise mostly used as workmen's wages or gifts. As prescribed in Pachomius' and Shenute's rules, meditation and recitation accompanied manual work, which implies that learning the Scripture by heart and long arduous prayers with prostrations at fixed intervals day and night were obligatory, at least in cenobitic communities.[86] Horsiēse's rules specify prayers when the monks gather and six times in the evening. The canons of Pachomius, Athanasius, and

78 Ibid., pp. 76–78, Fig. 30, pp. 150–151.
79. Ibid., p. 78, Fig. 31.
80. Ibid., p.151.
81. L.T Lefort, *Oeuvres de S. Pachôme et de ses disciples* (Louvain: 1956), pp. 32–33.
82. Ibid., pp. 106–107.
83. Ibid., p 88.
84. H. E. Winlock and W. E. Crum, *Monastery of Epiphanius,* Vol I, p. 148.
85. J. E. Quibell, *Excavations at Saqqara (1908–1909, 1909–1910)* (Cairo: 1912), p. 27.
86. H. E. Winlock and W. E. Crum, *Monastery of Epiphanius,* Vol. 1, pp. 166–167.

Shenute's amplification of those of Pachomius were known in southern monasteries. Pachomius' monks were told to avoid solitude and caresses (see p. 39), and three monks occupied each cell.[87] A cenobitic monastery such as that of St. Phoibammon at Djimē or those in the valley were called *monasterion* (μοναστήριον) or *heneete* (qeneete), while the more primitive community of Epiphanius which had no church was a *topos* (place).[88] The anchorites of Epiphanius were not all Egyptians, for Syrian names appear and elsewhere Persians, Nubians, and Ethiopians can be identified.

The monastery at Phbow was called in the texts a "village" with streets. Tsharour describes these: "the streets of Phbow have become as the streets of Akhmim; that is, we have talked shouting as in the agora of Akhmim."[89] The rules of Pachomius and Horsiēse always prescribed silence in the dark, or at work kneading dough, or baking at night, or setting the loaves on the planks in the morning.[90]

Even such a small community as that of Epiphanius had its library of books in Coptic, the native spoken language written since the second century in Greek letters with seven additional Demotic signs. A list on a limestone flake enumerates 79 titles of books, of which 33 are Biblical, 24 patristic, and 22 miscellaneous.[91] Pachomius ruled: "No one will leave his book open when gathering at the assembly or in the refectory (Rule 100). As to the books of the library, the second will bring them back daily at night, and will set them in their compartments" (Rule 101).[92] Christian books[93] formed almost exclusively the contents of other monastic libraries at Deir Abiad (Sohag), St. Mikhail at Hamouli (Fayum), and Apa Macarius (Wadi Natrun). They were the only library centers where learned monks translated from the Greek and copied Biblical books, the Apocrypha, the Apocalypse, Acts of the Martyrs full of imaginary wonders, translations of theological and patristic works (Peter of Alexandria, Basilius the Great, Gregory Nazianzen, John Chrysostom, Ephraim, and Athanasius), the acts of the councils, and the lives and canons of the founders of monastic orders. Among the last group those of Shenute are the most prominent because of their clear-cut, aggressive style and rich vocabulary. Of the remarkably detailed history of the patriarchs only fragments remain,

though the Arab versions are quite complete. Lay literature comprises a few fragments of the romance of Alexander the Great, the life of Cambyses, and a collection of animal stories (Physiologus).[94] Poetry produced religious and Biblical themes or the later Theotokia praising the Virgin in Bohairic dialect. The last achievement of Coptic literature is a long Biblical poem (Triadon) of 732 strophes of 4 lines urging study of the Coptic language at a time when it was disappearing (A.D. XIII). Scientific works are very poorly represented by an empirical calculation book and a collection of medical recipes and pharmacopeia,[95] which is often mixed with magical spells. Coptic legal documents[96] and letters on ostraca form a considerable segment of Coptic literature. To these must be added two recently discovered groups of Manichaean (from Medinet Fayum, 1930) and Gnostic codices on papyrus (from Nag' Hammadi, 1945–1946) which complement similar works in Greek. The obscure, incompatible systems reflect strikingly the fluid state of early concepts of Christianity in the Egyptian hinterland.

87. Ibid., pp. 137–138.
88. Ibid., p. 127. P. Barison, "Ricerche sui monasteri dell'Egitto bizantino ed arabo secondo i documenti dei papiri greci," *Aegyptus*, Vol. 18 (Milan: 1938), pp. 29–148.
89. L. T. Lefort, *Les Vies Coptes*, p. 103.
90. Ibid., p. 33.

91. H. E Winlock and W. E. Crum, *Monastery of Epiphanius*, Vol. 1, pp. 197 ff.
92. L. T. Lefort, *Les Vies Coptes*, p. 31.
93. W. C. Till, "Koptische Literatur," in *Koptische Kunst* (Essen: 1963), pp.109–112. W. C. Till, "Coptic and Its Value," in *Bulletin of the John Rylands Library*, Vol. 40 (Manchester: 1957); pp. 229–258. H. Munier, "L'Egypte byzantine," pp. 87–90. S. Morenz, "Die Koptische Literatur," in *Handbuch der Orientalistik*, Vol. 1 (Leiden: 1952), part 2, pp. 207–219.

94. E. Amélineau, *Contes et Romans de l'Egypte Chrétienne*, 2 Vols. (Paris: 1888). N. A. Giron, *Légendes Coptes* (Paris: 1907).
95. E. Chassinat, "Un papyrus médical copte." MIFAO, vol. 32. Cairo: 1921. W. C. Till, *Die Arzneikunde der Kopten* (Berlin: 1951).
96. A. Steinwenter, "Das Recht der koptischen Urkunden," in *Handbuch der Altertumswissenschaft*, Abt. 10, Vol. 4, part 2 (Munich: 1955). W E. Crum, *Koptische Rechtsurkunden des 8. Jahrhunderts aus Djême (Theben)*, Vol. 1, Texte und Indices (1912). A. A. Schiller, "Koptisches Recht," in *Koptische Kunst* (Essen: 1963), pp. 113–115.

It has been contested by G. Lefebvre[97] that Christianity ever changed the Coptic race, for "the souls never were sincerely and entirely Christian." It is certainly true that the Coptic masses, mostly illiterate, blindly followed their patriarch less by conviction than through national pride. Their faith[98] was encumbered with lingering aspects of Egyptian religion and magic; they used amulets inscribed with Christian spells, appealed to God or His holy men for exorcism and foreknowledge as if to an oracle inquiring "whether He will suffer(?) me to raise my eye, for it is deceased,"[99] and represented Christ standing on crocodiles in the Alexandrian catacombs as an interpretation of the god Horus. The early cult of the relics in Egypt could be reminiscent of that of the dismembered Osiris, whose parts were dispersed in various shrines throughout the country. Many elements in the Coptic Apocrypha describing the nether world and in the funerary ritual and magic have Egyptian origins syncretized with Jewish and Greco-Roman components.[100] The absence of any theological or philosophical achievement in Coptic contrasts sadly with the remarkable works in Greek of a high style by Athanasius and Cyril.

97. G. Wiet, "L'Egypte Musulmane," p. 116.
98. C. Diehl, "L'Egypte," pp. 501–502.
99. H. E. Winlock and Crum, W. E. *Monastery of Epiphanius*, Vol. 1, p. 164, also p. 213, n. 3.
100. W. Budge, *Coptic Apocrypha in the Dialect of Upper Egypt* (London: 1913). S. Morenz, *Die Geschichte von Joseph dem Zimmermann* (Berlin: 1951). M. Cramer, *Die Totenklagen bei den Kopten* (Vienna: 1941). Most of these parallels are denied by J. Zandee, *Death as an Enemy* (Leiden: 1960), pp. 303–342.

Still in use from the body of Coptic literature is its liturgy, in the Bohairic dialect of Lower Egypt, which superseded the Saidic dialect of Upper Egypt. The Mass follows the Byzantine liturgy in three texts (*Anaphora*) of Mark, known as those of Cyril (Kyrillos), Basilius, and Gregorius.[101] It shows an active participation by the faithful, with the help of the deacon (*shammas*, from the ancient Egyptian *shemes* "to follow, serve") facing them and the accompaniment of chanters and sacred music. The unique interest of the music lies in the fact that it was derived mostly from the music of ancient Egypt without the foreign influences that can be traced in other aspects of Coptic art. Now restricted to liturgical use since its last revival around A.D. 1000, when notation borrowed from the Byzantine music appears in manuscripts, Coptic music[102] had formerly consisted of folkloristic hymns and lay and cult pieces. It is noteworthy that the alternation of musical and chanted responses as practiced in Antioch and Constantinople and borrowed by Ambrosius of Milan derives from ancient Egypt through Coptic music. Another aspect that can be ascribed to the same filiation is the use of numerous percussion instruments such as bells and the *naqus*—a hand-held bell struck from outside—which are reminiscent of the castanets, clappers, round tambourines,

101. H. Engberding, "Die koptische Liturgie" in *Koptische Kunst* (Essen: 1963), pp. 95–103.
102. H. Hickmann, "Koptische Musik," in *Koptische Kunst* (Essen: 1963), pp. 116–121. H. Hickmann, *Catalogue général des antiquités égyptiennes du Musée du Caire* (Cairo: 1949).

and the ancient Egyptian sistrum used in Egyptian temples. To the Egyptian wind instruments of wood, single- or double-barreled, were added in the sixth and seventh centuries others made of bone and lutes with concave sides.

This is a brief sketch of the people who created the art that is the subject of this work, a people who inherited with the richest legacy of the Egyptians and Greco-Romans some of the native traits of the former: a deep religiosity, a proud nationalism, and the burden of traditionalism.

The activating spark of Hellenism produced in Alexandria with its Pharos the brightest light in a world on the decline, this Hellenistic culture with all its refinements and its weaknesses. Rome lived on its acquisitions, rationalizing and exploiting Egypt. When the new religion thrust its roots deep into the Egyptian soil, fertile though creviced with superstitions, it produced strong stems often bearing hybrid offshoots that occasionally assumed the aspect of the original species—pagan themes in spiritual syncretism or sculpture with alluring nudes in adaptations of pagan mythological scenes to Christian ideologies.

A proud nationalist still hoping to retrieve his lost prestige, the Copt relentlessly appropriated any grand style, without regard to the morality involved. To Shenute his "monastery is Jerusalem," and to prove that he

could rival this pagan architecture he had destroyed with such energetic zeal, he modeled the exterior of his church after an Egyptian temple and its interior after a late-antique palace.

Traditionalism had ruled the art of Egypt for four millennia. Yet it was the Copt who cast off its burden, free as he felt from any ruler-directed eclecticism. His deprived position as a subject for exploitation and a victim of vexatious laws was actually his salvation, for it encouraged his nature to assert itself in a vigorous flourish of folk expression. Deprived of luxurious marbles and woods, he trusted to his originality, modeling sparkling rows of egg-shaped domes for his roofs, crystallizing light in sculptured columns, friezes, and niches of limestone and wood, inventing colored murals for his walls, and turning lathe and balusters of local timber for his lattice screens and furniture.

Soon there remained no trace of pagan hybrids. The Copt, drawing on his own resources sometimes seasoned with some Syrian or Mesopotamian flavor, exteriorized his mystical world in literature and in an abstract concept in art, which was profusely ornamented with geometrical foliation and design, producing a well-balanced pattern of light and shade. This concept conformed to that of his new ruler, the lately urbanized Arab.

To suggest a chronological classification in any new field of art history is always hazardous. This might be even more so with the history of Coptic art because of the character of this cultural manifestation, emanating as it did from a people in the process of converting to Christianity under difficult circumstances and still using the elements of pagan art. In Christian Egypt there never was a centralized directing discipline such as that of an artistic school patronized by an imperial court as in Rome or Byzantium. This lack could only add to the confused syncretism resulting from the groping of private initiative toward a new art.

The following terms adopted in this work reflect this uncertainty, especially felt in the earliest stages:

1. *Forerunners of Coptic art* comprise the aspects of pagan art in Egypt in the first three centuries of our era. These aspects formed the heritage from which elements and styles were adopted by the Egyptians.

2. *Proto-Coptic art* defines, according to E. Drioton and P. du Bourguet,[103] the art of the Egyptians from the pagan and Christian middle class, from the second half of the third century to the first half of the fifth century.

3. *Coptic art proper* is the art developed by the Copts, then mostly Christians, for their own use from the second half of the fifth century to the end of the seventh century.

4. The ultimate period after the Conquest by the Arabs is termed by P. du Bourguet as *"Art of the Copts,"* when the Copts worked on their own projects as before, but also on those sponsored or commissioned by the Muslims, from the eighth century to to twelfth century.

103. P. du Bourguet, *L'Art Copte*. Petit Palais, Paris, 17 Juin–15 Septembre 1964. (Paris: 1964), pp. 32, 36, 42. *Die Kopten* (Baden-Baden: 1967), pp. 73–77, 109, 149–154.

This monastery is Jerusalem.

Shenute about Deir Abiad, first half of
fifth century A.D.

The movement of the rural populations fleeing taxes and charges during the first century of our era could not be reduced by the edicts of the second century. This movement, the deterioration of the economic background, and the de-Hellenization of the country led to a dwindling of the urban centers. A concurrent shift in the importance of these centers was caused by the abolition of the nomes and the establishment of self-governing municipalities (*civitates*), each with its own rural area (*territorium*)[1] subdivided into cantons (*pagi*). The major towns were the sees of bishoprics, and, according to Georges of Cyprus (606), differed from the capitals of the nomes. The Fayum Lake shrank and the Bahr Yusef, which flows into it, was depopulated as towns disappeared while new ones grew from villages.

As to large towns, whether Greek cities or native urban centers, the general orientalizing process that characterized the Byzantine Era had no immediate effect on their layout. "Alexandria off Egypt" as the Romans called it (*ad Aegyptum*), had become the second capital of the world, the seat of the Church and of a catechetical School founded by Pantaenus (190) which rivaled the Museum with such brilliant names as Clemens and Origen. Alexandria suffered from persecution (250, 257) and plague and was forced to yield to Constantinople in 330. The religious controversies between Archbishop Athanasius (328) and the Arians, further persecutions (361–363), and the supremacy of the Chris-

tians under Theodosius (379–395), with the persecutions of Arians and pagans, and the destruction of temples by Theophilos the Patriarch and Shenute in the fourth and fifth centuries, reduced material prosperity to such an extent that the municipality could not cleanse the Nile and the canals. More blows were dealt to the moral prestige of Alexandria with the stoning of the female pagan philosopher Hypatia in 415 and to its financial system when the Jews were expelled by the Patriarch Cyril (who died in 449).

The study of the urbanism of Alexandria during the Christian period is hindered by the same drawbacks as that of the earlier stages of the pagan city, namely, the gradual subsidence of the coastline and construction of the modern city on the ancient remains. Excavation carried out at the turn of the century has brought to light segments of the ancient city walls, whose outline had shrunk considerably in the Byzantine period,[2] as happened with most Roman cities round the Mediterranean. The urban layout still retained some of its earlier splendor, according to Achilaeus Tatius (fifth century), with columned porticoes framing with their dynamic rhythm the main arteries between the Sun Gate (east) and the Moon Gate (west) and the crossing streets (Fig. 2.1). Such porticoed streets formed

one of the characteristics of late-Roman town plans in the East (Gerasa, Palmyra) and in North Africa (Cuicul, Timgad). Transverse streets with colonnades dating from Justinian connected the harbor on the southern canal to the Great Harbor north near the Caesarion, passing along the Museum, the Soma, the tetrapylon, the temple of Isis of Abundance, and the governor's palace (until the fourth century). The enclosure walls of Hadrian were built on a shrunken perimeter, especially to the east, and at the end of the third century a still smaller enclosure could encompass the urban settlement inhabited at the time.

Excavations have shown that some urbanistic activity occurred to the west and southwest in the late antique and pre-Byzantine periods, probably the last transformations of that important city.[3] To Diodorus (Lib. 17. cap. 52) Alexandria about 30 B.C. appeared as the foremost city in the world, with a free population of more than 360,000. As late as the fourth century the author of *Expositio totius mundi* defined its layout as *eminens in dispositione*, interpreted by Lumbroso[4] as order and symmetry. These were not isolated appreciations, for papyri and inscriptions between the third century B.C. and the fourth century A.D. are pregnant with eulogistic comments.

The plan surveyed and published by Mahmud pasha el Falaky in 1866,

1. H. I. Bell, *Egypt from Alexander the Great to the Arab Conquest* (Oxford: 1948; reprint, 1956), p. 101. (Hereafter cited as *Egypt*.)

2. T. D.Neroutsos bey, *L'Ancienne Alexandrie. Etude archéologique et topographique* (Paris: 1888). (Hereafter cited as *L'Ancienne Alexandrie*.) F. Cabrol and H. Leclercq, *Dictionnaire d'archéologie chrétienne et de liturgie*, Vol. 1 (Paris: 1924), cols. 1098–1156. (Hereafter cited as *Dictionnaire*.)

3. A. Adriani, *Repertorio d'Arte dell'Egitto Greco-Romano* (Palermo: 1966), Series C, Vol. 1, p. 35. (Hereafter cited as *Repertorio d'Arte*.)
4. G. Lumbroso, ed., *Expositio totius Mundi* (1903), p. 35.

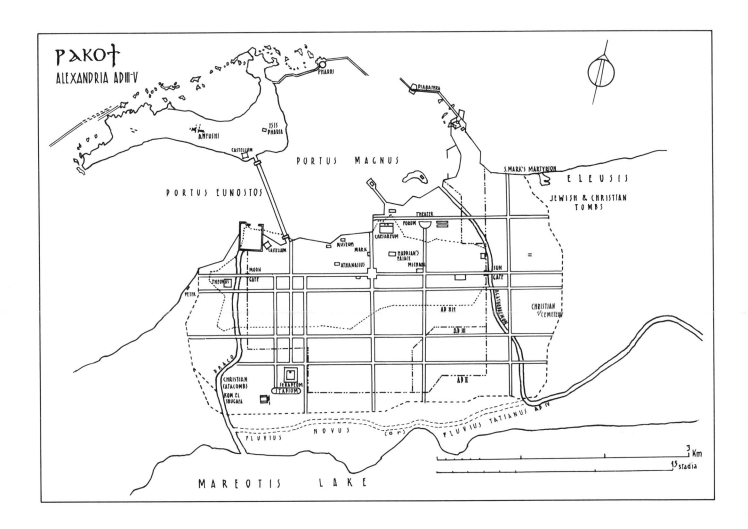

still the most adequate among other attempts, gives the layout of the city as restored in the second century by Hadrian and Antoninus Pius after its destruction by the Romans. Hadrian, the phil-Hellene and phil-Egyptian emperor, probably restored the Nemeseion, enlarged the Serapieion, and built a library. An important quarter bore the name of Hadrianon, according to the Syriac *Notitia Urbis Alexandrinae*[5]— probably derived from an official *anagraphē*—dated between 138 and the end of the fourth century. This statistical survey gives for a part of Alexandria a total of 47,790 houses, 2,393 temples (and shrines), 1,561 baths, 935 taverns, and 456 porticoes; a division into five *grammata* called as was customary in the Hellenistic age after the first five letters of the alphabet; and finally a list of quarters: Hadrianon, Lochias, Antirrhodos, Serapeum area, Zephyrion, Canopus, Nicopolis, Eleusis, and Bendideion. The record ends with this comment: "Alexandria is the greatest of the cities of the inhabited world." The figures seem reasonable enough when compared with those given for Rome at the same date: 48,392 houses, according to the *Curiosum Orbis Romae*, and 856 baths as rated in the *Codice Topographico*.

El Falaky's plan shows an orthogonal system of streets with two main arteries. The width of 1,400 meters at the height of the Canopic Gate, corresponding to 1,150 meters at the height of the Heptastadion and 2,250 meters at the height of Cape Lochias seems much larger than the seven or eight stadiae of Strabo (Lib. 17, 1.8), or even the ten stadiae of Flavius (*Bell. Jud.* Lib. 2, 16. 4) and Philo (*Flacc.* 92). The main artery, thirty meters wide (1 *plethra*), in the time of Strabo called *plateia* by Diodorus (Lib. 17, cap. 52) and later *dromos*, was lined in Roman times by two columned porticoes. At the crossing of the two arteries 14 meters wide was an open place (*pedion*), and in the center of the city another *mesopedion*, probably the agora, besides other places. Secondary streets were 7 meters wide and several of their names are recorded. They formed rectangular blocks in the shape of bricks (*plintheia* or *insulae*) after the original Hellenistic plan designed by Dinokrates. The *insula*, 330 × 278 meters, was perhaps subdivided into 9 plots. The perimeter of Hadrianic Alexandria was 18 kilometers, very close to the figure for the wall of Aurelian Rome (19 km.).

To the south the city was delimited by the Nile canal, called Drachon by Pseudo-Callisthenes for its western stretch and Agathodaimon Fluvius for its eastern end. It flowed parallel to the bank of the lake Mareotis.

Alexandria must have offered a varied cityscape with its hill of the Paneion, the massive marble complexes glittering in the sun, the dark spots of the gardens, the animated quarters of the harbor, the tall tower houses echoing the Pharos itself. It contributed the "earliest complexity in a cityscape and monumental grandeur in urban architecture."[6]

The Arabs,[7] however, beginning with the conqueror 'Amr ibn el 'As, when they beheld the city were amazed as much at the lofty colonnades, gardens, buildings, and dazzling marble as at the labyrinth of cisterns, some as deep as four or five stories. The Pharos lighthouse lost its mirror through a stratagem of the Romans, who were annoyed at the advantage it gave the Muslims in the eighth century. One of the courtiers of the emperor pretended to convert to Islam and succeeded in exciting the greediness of Caliph Al Walid ibn 'Abd el Malik with stories of treasure buried beneath the Pharos.[8] At least one-third of the tower was pulled down during the search. The mirror either was destroyed or could not be replaced on the brick tower, which was restored and remained until the fourteenth century.

Recent excavation of the mound of Kom el Dik, the ancient Paneum in the center of the city, revealed Roman baths of the third century and a theater of the sixth century.[9] The plan of the latter structure, which could seat six hundred, is deeper than half a circle. Corinthian columns perhaps carried impost blocks carved with the *crux immissa* so characteristic of Coptic art and found also at Maryut.

5. P. M. Fraser, "A Syriac *Notitia Urbis Alexandrinae*," *JEA*, Vol. 37 (London: 1951), pp. 103–108.

6. R. Martin, *L'Urbanisme dans la Grèce Antique* (Paris: 1956), p. 118.
7. A. Adriani, *Repertorio d'Arte*, p. 45, n. 145.
8. A. J. Butler, *The Arab Conquest of Egypt and the Last Thirty Years of the Roman Dominion* (Oxford: 1902) pp. 396–397. (Hereafter cited as *Arab Conquest*.)
9. K. Michalowski, "Roman Theatre in Egypt," in *The Illustrated London News*, Nov. 19, 1966, p. 32.

Several of the pagan temples had been transformed into churches, such as that of St. Michael (Saturn) under Bishop Alexander (313–326) and the cathedral (Caesarion or Sebasteum), twice sacked by pagans, restored by Athanasius (368), and burned to the ground in 912. Of the two obelisks that stood before the Caesarion on two brazen crabs one remained *in situ* until the fourteenth century, the second until 1877 when it was transported to New York. Among the churches was that built by Theonas (282–300), probably the earliest to follow the shrines arranged in crypts and cemeteries; it was rebuilt and enlarged by Alexander, used as a cathedral dedicated to Mary (Tamautha) until this prerogative passed to the Caesarion at the end of the fourth century, and finally transformed after the Islamic conquest into the "western mosque" with 1,000 columns. A similar fate waited for the church built by St. Athanasius (370) in the ancient agora on the main east-west artery. Now called Souq el ʿAttarin mosque, this edifice is conspicuous for its varied ancient columns, Byzantine capitals, and a monolithic reservoir more than 3 meters long and 1.15 meters high of polished breccia, which was probably the earlier baptistery. On the site of the Serapis temple a church built in honor of Honorius was later dedicated to Cosmas and Damian. The founder of the Egyptian Church, St. Mark, had a martyrium on the coast east of Alexandria around which numerous martyrs were buried, and a church built by Peter in the quarter of Necropolis

(nowadays Gabbari). The larger church of the Tetrapylon was renowned for its "Imago" representing Christ surrounded by the Virgin and saints receiving the prayers of Apa Cyrus and John, two martyrs whose cult was substituted by Cyrillus for the pagan Isis Medica at Menuthis, 18 kilometers east of Alexandria. The Chronicle of John of Nikiou, the Acts of the Martyrs, and the life of Macarius give us the names of several quarters, mostly the same names as in Roman times, such as Nicopolis east of the walls with the Boucolon ("Land of the Shepherds") where Mark was martyred, the Dromos or hyppodrome, Leukates in Rakoti, and the Bruchium.

Several Christian catacombs were hewn underground behind the Serapeum on the site of the earlier Rakoti; these followed the design invented for the pagan Alexandrian catacombs (Kom el Shugafa), characterized by well-planned monumental layouts so different from the irregularity of the much larger ones in Rome. A round or square shaft faced with stone or brick and equipped with footholds led down to a burial vault for single or multiple burials. In one catacomb appended to an Egyptian tomb at Abu el Hashem, there appears to have existed a basin filled from a channel and perhaps used as a baptistery. In another at Gabbari several loculi were painted with the names of clerics, while earlier ones mentioned a prayer to Osiris. This same mixture of pagan and Christian elements is found in the hypogeum at Gabbari (fourth century), where the rear apse was flanked by Egyptian pilasters with uraei plastered and

painted with a bucranium and garlands, the name of Christ, and symbols featuring the looped cross and the Coptic cross. In the eastern cemetery, burials since the Ptolemies comprised hypogeae and later numerous martyria. Decline set in rapidly after the capture of the town by Chosroes II (619), and Heraclius (626) and after the Arab conquest by ʿAmr ibn el ʿĀs (642). The Arab wall of 811 enclosed only one-third of the larger town surrounded by the Hadrian enclosure.

Prominent cities in the third century imitated Alexandria, and Greek cities rivaled Egyptian metropolises in municipal activity. When the Roman Empire was in trouble (256–260), Hermupolis[10] remodeled an artery flanked by columned porticoes crossing it along its whole length from the Sun Gate to the Moon Gate, passing by three tetrapylons, a triumphal arch, an Aphrodision, and a Tychaeum. It was divided into four quarters delimited by subsidiary porticoed streets. It was surrounded by a wall 5,298 meters long. Opposite, on the eastern bank of the Nile, the newly founded Greek city of Antinoupolis, built by Hadrian in two to three years, had two arteries 20 meters wide crossing at right angles and bordered by beautiful Doric vaulted porticoes,[11] still extant in the eighteenth century, which led to four gateways. The crossing of the two arteries was marked by a tetrapylon whose

10. P. Jouguet, *La Vie municipale dans l'Egypte romaine* (Paris: 1911). G. Méautis, *Hermoupolis-la-Grande* (Lausanne: 1918), pp. 42–55, 162–164.
11. E. F. Jomard, *Description de l'Egypte* (Paris: 1817), Vol. 4, *Antiquités*, Planches, Tome IV, pls. 50–54. E. Kühn, *Antinoupolis* (Gôtingen: 1913).

bases bore inscriptions of Severus Alexander (A.D. 222–235).[12]

Oxyrhynchos,[13] "illustrious *and* most illustrious" as it is called in its official title, rose in relative importance to other towns in the Roman age. Its levy in gold was fixed about A.D. 312 at thirty-eight pounds, four times the average of a Delta nome. According to Ammianus (22. 16. 6) it was, in the fourth century, one of the chief towns of Egypt. It became the capital of Arcadia, the see of a bishop, and had forty churches. Placed on the western bank of the Bahr Yusef, 70 kilometers south of Ahnas, the city at the entrance of the Fayum, Oxyrhynchos was traversed by the military road to Upper Egypt and had a Roman garrison. The city was surrounded by a wall with at least five gates. The dimensions of the site were computed as $1\frac{1}{4}$ miles by $\frac{1}{2}$ mile. Its population must have exceeded the capacity of its theater estimated at 11,200 by Petrie, probably much more than twice 5,000 or 6,000, known to have been the average population of a village in the Arsinoite nome in the middle of the second century (Papyrus Rylands IV, 594). No systematic excavation has been carried out, but the papyri allow glimpses of its urban layout. Its new street, built

in A.D. 283 at the city's cost, was 6.2 meters wide, bordered by colonnades of nummulitic stone, and had wooden roofs similar to the large colonnaded arteries of Antinoupolis. There was an Eastern Stoa, and a southern paved way. The regions of the city were named after their inhabitants, Cretans or Jews, according to their trades—Gooseherds, Shepherds, Cobblers' Market—or after public buildings. Houses were two or three stories high, with a cellar, and a courtyard about 15 meters square containing a well.

Oxyrhynchos had several great temples of Egyptian gods in which Egyptian priests performed traditional rites. The largest of these temples was the Serapeum, the center of business life. There were also an Osireion, two temples of Isis, one of the Syrian Atargatis, and four temples of Thueris. The other temples were shrines of Greek rite. In addition to the twenty temples, there were at the end of the third century a north church, a south church, and a Jewish Synagogue.

On the east edge of the town of Oxyrhynchos there were two quays, a Nilometer, the Treasury, the Gymnasium—the center of Hellenic life, with its ball court—and the Hadrianic and Antonine baths. In the theater on the southwestern side of the town were held official festivals, the anniversaries of Hadrian's victory over the Jews, ephebic displays, performances of mimes and recitals of Homer. The literary papyri found at Oxyrhynchos bring testimony to a genuine scholarship of its inhabitants whose tradition goes back to the second century B.C., when Satyrus the biographer settled

there. With the introduction of Christianity as religion of the empire by Theodosius the Great (379–395), Oxyrhynchos—Coptic *Pemdje*—became a city of monasteries and monks. In the fifth century the diocese of Oxyrhynchos may have had as many as 10,000 monks and 12,000 nuns. The town was still inhabited in the sixth century, on the evidence of the cemetery of that date extending north.

Topographic quarters in Byzantine cities were called *laura* and sometimes coincided with the administrative *amphoda*, as at Arsinoe and Oxyrhynchos. With the gradual orientalization of Hellenic institutions the Greek magistrates disappeared, and in the fourth century municipal activities dwindled while the houses of the middle-class residents, that class once versed in Greek literature, fell to ruins and were soon covered by piles of rubble. Hermupolis was required to provide for a Moorish corps from 340 until the sixth century. According to Coptic texts, tetrapylons existed also at Athribis[14] and Oxyrhynchos (Bahnasa),[15] and there were public baths at Bousir.[16]

It seems that a large town called Babylon extended north of the fortress of that name, and according to the Egyptian Ptolemy (151) the town was

12. U. Monneret de Villard, "The Temple of the Imperial Cult at Luxor," *Archaeologia*, Vol. 95 (London: 1953), p. 97. (Hereafter cited as "Temple of the Imperial Cult.")
13. Jomard, *Description de l'Egypte*, pl. 52. W. F. Petrie, *Tombs of the Courtiers and Oxyrhynkhos* (London: 1925), pp. 12–13, pls. XXXV–XXXIX. (Hereafter cited as *Oxyrhynkhos*.) E. G. Turner, "Roman Oxyrhynchus," in *JEA*, Vol. 38 (London: 1952), pp. 78–93. H. Rink, *Strassen und Viertelnamen von Oxyrhynchos* (Giessen: 1924).

14. E. Amélineau, *La Géographie de l'Egypte à l'époque copte* (Paris: 1893), p. 66. (Hereafter cited as *Géographie*.) J. Maspero and G. Wiet, "Matériaux pour servir à la géographie de l'Egypte," *MIFAO*, Vol. 36 (Cairo: 1919).
15. E. Amélineau, *Géographie*, p. 91.
16. Ibid., p. 73.

intersected by a canal. In the fourth century Babylon was the see of a bishopric; its name was gradually displaced after the Arab conquest by a new name of Arab origin, Fustat (from *fossatum*, "tent");[17] later the town was known as Misr. According to the marveling Persian Nasir-i-Khusrau (1046–1049) it looked "like a mountain" with houses of 7 to 14 stories, 30 cubits square and holding 350 people. Some of the streets were covered and were lit by lamps. The town was connected to Roda by a bridge of 36 boats.[18]

An idea about the appearance of such town houses can be gathered from an interesting bridal chest dated to the fifth century from Qustul in Nubia.[19] It is in wood elaborately inlaid on one face with bands of ivory and ebony bosses alternating with rows of ivory panels engraved with erotic figures appearing within arched doorways or pedimented windows. This side could well represent a typical facade of a town house. At the bottom a series of arched doorways forms an arcaded portico along the street as was common in large imperial cities. Above are three stories, the first one with windows framed by two torsaded columns carrying a pediment, triangular and segmental, with acroteria. The segmental pediment occurs in the second floor

and an arched squat window in the third uppermost floor. The segmental pediment and torsaded column are certainly characteristic elements of Greco-Roman architecture in Egypt, used in the catacombs in Alexandria and the tomb chapels at Hermupolis West. This facade allies the style of towerlike multistoried apartment houses represented by Greco-Roman models from Egypt and the monumental style of the two-storied structure represented on an ivory in Trier.[20]

It may be that rural settlements in the *chora* were not much different from what they have always been—mud houses usually no more than one story, huddled together near a water supply and inhabited by the peasants and their cattle. The pattern was the same whether in villages, hamlets, or even on estates known by the name of their owner (*sunoichia*). Greek authors, as well as Arab chroniclers who judged by their own standards of urban planning, had often given to semiurban settlements the designation of city (*polis*).[21]

While the metropolises and the larger towns were obviously products of Hellenistic and Roman urbanism, those smaller towns and villages inhabited by the Christian population could hardly claim any foreign influence. They are differentiated here as Coptic towns.

Many of the Coptic towns and villages were the shabby successors of native ones of the Greco-Roman period, growing upon the remains of the former settlements without an apparent break in occupation of the sites. Some urban settlements availed themselves of the existence of pagan ruins, and as it had been customary for the earlier Egyptians to settle around their temples, their Christian descendants continued to live in the vicinity of, or even within, the vacated temples. A good example of such a continuous urban occupation is the mortuary temple of Ramses III at Medinet Habu.[22] Partly destroyed at the end of the Twentieth Dynasty, the temple was occupied by settlers who built houses, first outside the temple proper, then within it; rubble from these settlements piled up into distinct occupational layers. The Coptic town of Djimē was built over the late Roman one, even spreading outside the enclosure walls about 2.5 or 4 meters above the Rams-side level, with blocks of narrow, tall, multistoried, contiguous houses abutting against one another back to back. Narrow streets (1.5–1.8 m.), branching off into still narrower alleys (0.95 m.), some ending in cul-de-sacs

17. A. J. Butler, *Babylon of Egypt* (Oxford: 1914), p. 63.
18. S. Lane-Poole, *A History of Egypt in the Middle Ages* (London: 1936), pp. 140–141. (Hereafter cited *History of Egypt*.)
19 W. B. Emery, *The Royal Tombs of Ballana and Qustul* (Cairo: 1938), Vol. 1, pp. 383–384: Vol. 2, pl. 109. *Egypt in Nubia* (London: 1965), pp. 74–75, pl. XXI.

20. A. Hermann, "Mit der Hand singen. Ein Beitrag zur Erklärung der Trierer Elfenbeintafel," in *Jahrbuch für Antike und Christentum*, Vol. 1 (Münster, Westphalia: 1958), pl. 7 b-c.
21. E. Amélineau, *Géographie*, p. xxxii.

22. U. Hölscher, *The Excavation of Medinet Habu, V* (Chicago:1954), p. 45. (Hereafter cited as *Medinet Habu, V.*) Folio, pl. 32.

(0.75 m.), crossed one another in a surprisingly regular grid pattern following the orientation of the girdle wall and temple (Fig. 2.2). Dwellings nested over both, but as they had no openings to the outside of the town, they formed a defensible rampart, replacing the two fortified towers that had protected the late Roman town at its northwest and southeast corners. Streets were far from level, sloping upward toward the west; some cul-de-sacs reached a gradient of 3 meters within a 12-meter stretch (between Houses 92 and 94), probably with steps (as alley near Houses 101–103 or 5–4). The ancient well of Ramses III was still the main supply of water in this desert area, and its location accounts for the irregular street pattern in its vicinity. We know some street names from contemporary contracts describing the location of houses such as that of the blessed Syrus, delimited east by the house of Philotleus, north by that of Antonius son of Paulus, west by the street Koulol and the gate of Authentis.[23] On the same street was the house of Germanus.[24] The name Djimē occurs concurrently with Castrum Djimē,[25] which might have defined the town over the late Roman fortified area; a similar differentiation was also found in Memnonia and Castra Memnonia, both connected to the mortuary temple of Amenhotep III (Memnon). A rough estimate places the town area above the girdle wall at 314 × 210 m. or 66,000 sq. m.; this estimate suggests a corresponding population *intra muros*

of about 18,860 inhabitants. The town of Djimē was abandoned about the ninth century.

Only a small area of Coptic Armant[26] from the fourth century, the least significant in regard to layout, was excavated (Fig. 2.3). Abutting against the north side of the pylon of Thutmose III and the Roman temenos east, the quarter featured a main street running north-south as a continuation of the portal of the Egyptian pylon; along the street was a terra-cotta water pipe that conducted water from the *saqqia* to the lower gardens outside the pylon south. A cross street running east-west serviced one row of small houses abutting on the pylon and another row of larger houses along the temenos wall. A reservoir (CT 21), which filled from a well reached by a stairway continuing the western stairway of the pylon, was the main source of water for this quarter (CT 2). The industries and crafts that gave Armant its renown as a center of chemistry are attested to by several remaining furnaces (HT 84) and crucibles. A bucket latrine (HT 30) accessible from the street had a window opening on to a room (HT 26). All the buildings were contiguous and built of brick; some were multistoried. It has been suggested that the larger houses against the temenos might have formed part of a monastic compound with a communal refectory (HT 33). The more significant area as to layout located south of the pylon toward the destroyed church was not preserved.

Other Coptic towns in the vicinity of Egyptian temples continued to flourish during the Islamic period with a mixed population of Copts and converts to Islam. Such was Atbo or Tell Edfu (Fig. 2.4),[27] which as indicated by its Arabic name was built on an artificial mound (*tell*) surrounding the temple of Horus; the mound was composed of occupational strata dating back to the tenth century and even earlier to Egyptian epochs. The topography of this Copto-Islamic town, built over a properly Coptic one, which itself followed a late Roman settlement, shows an extremely regular orthogonal pattern of streets (3.2, 1.1, and 0.9 m.) oriented north-south and east-west, perhaps after the temple, following the slope of the terrain from north to south and west to east (about 3.3 m. difference). The rectangular blocks directed lengthwise east-west consist of contiguous houses mostly in single rows. Unlike those in Djimē, these houses seem to have had only one story, which was sometimes built over an underground cellar. The town was protected against incursions from the desert to the west by a Byzantine enclosure wall that followed the ridge of the mound ranging north and south. Obviously less densely populated than Djimē, the town of Atbo could have been inhabited by 11,150 people, assuming an approximate number of rooms of 75 × 5 × 3 × 2 or 2,250 and an average of 5 persons per room, a figure similar to that of the town in 1925 (5,790 in 1884).[28]

23. E. Amélineau, *Géographie*, p. 112.
24. E. Revillout, *Actes et Contrats des Musées égyptiens de Boulaq et du Louvre* (Paris: 1876), p. 90 bis.
25. E. Amélineau, *Géographie*, pp. 112, 151–153.

26. R. Mond and O. H. Myers, *Temples of Armant* (London: 1940), pp. 36–37, plan 4.

27. H. Henne, *Rapport sur les Fouilles de Tell Edfou (1923–1924)* (Cairo: 1925), pp. 3–5, pl. XXXIII. (Hereafter cited as *Tell Edfou*.)
28. E. Amélineau, *Géographie*, p. 157, after *Recensement général de l'Egypte* (1884).

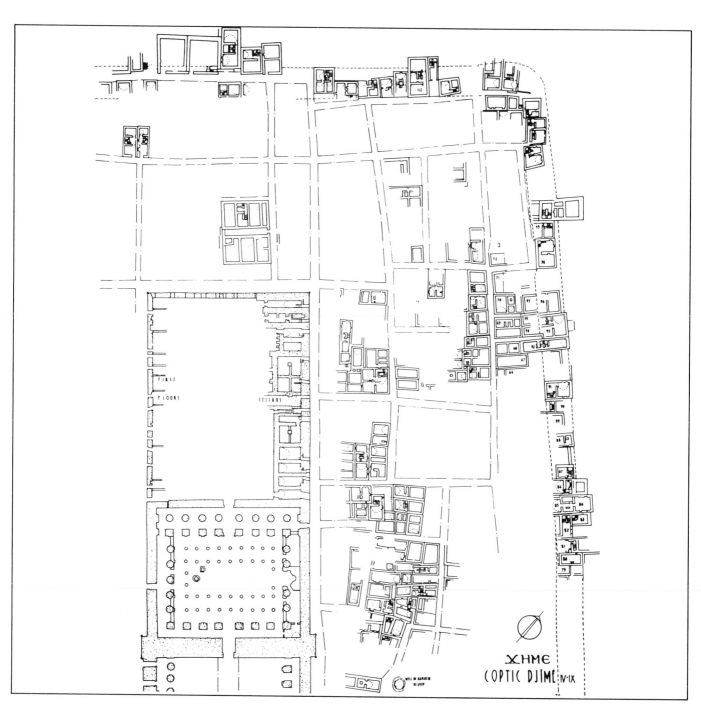

FIRST
FLOORS

CELLARS

WELL OF RAMSES III
RE USED

ⲬⲎⲘⲈ
COPTIC DJIME IV-IX

2.3
Plan of Christian Armant. (After Sir R. Mond
and O. Myers, *Temples of Armant*, plan IV.)

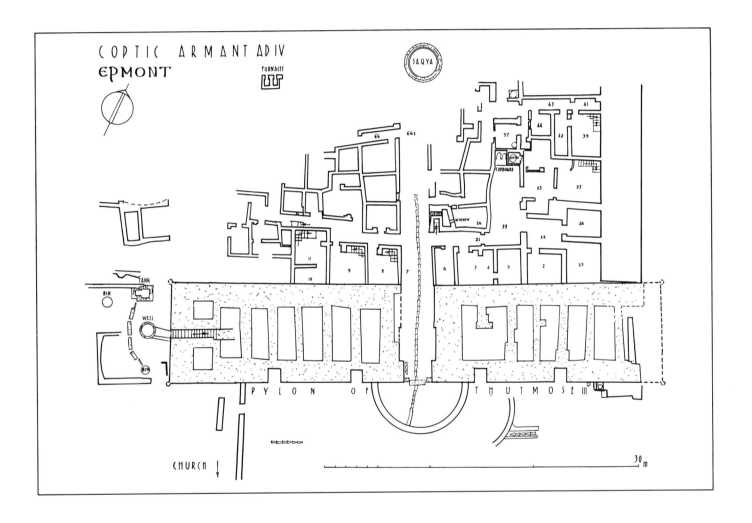

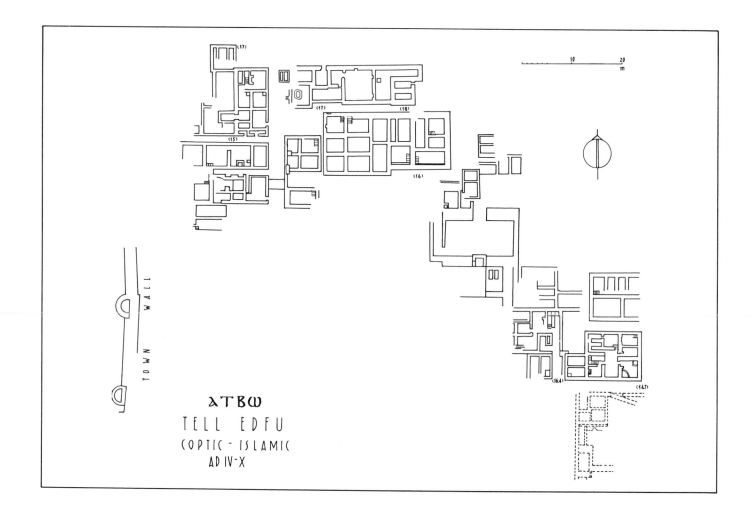

In brief, Coptic towns compare favorably with secondary towns in Roman Egypt such as Karanis (D.A. I-III)[29] in the Fayum, where streets ran north-south and east-west, forming roughly quadrangular blocks of contiguous houses.

Typical of the fortified ancient towns along the Nile in Nubia was Ikhmindi (between El Sebu'a and Garf Hussein)[30] taken over by the Romans and

inhabited by the Christianized Egyptians (Fig. 2.5). The town's narrow streets were often vaulted and they crossed orthogonally, running parallel to the fortified enclosure wall. Along the streets were multistoried houses with one or two vaulted rooms on every floor. A small church was built in the middle of the town. The ingenious system of streets roofed with vaults offering protection against the dust and the scorching sun was also employed in Misr, where some streets were vaulted and lit with lamps, according to the Perisian traveler Nasir-i-Khusrau (1046–1049).

Meager exploration of the two towns (inland and maritime) at Ostracina (El Flusiya)—one of the principal Roman cities, and see of a bishopric, probably remodeled by Justinian, on the eastern boundary with Palestine—has yielded some data about two churches and a large citadel with contiguous multistoried houses abutting on its west side.[31] Built entirely of stone adorned with marble facings and mosaics, the town spread in two settlements, the northern one with a harbor on the north shore of Lake Serbonis. A canal branching off the Nile provided drinking water.

Though no significant architectural achievement could be expected from the early anchorites who withdrew into rock-cut tombs to dwell there or pass a retreat under the assaults of spirits and demons, many of these settlements show interesting remodeling. In the Byzantine-Coptic literature the word anchorite designates the man "who had gone up," retreated to the mountain, a word derived from the Greek anechoιesan (lit. "they have gone up").[32] "Going to the mountain, going to the interior" meant in the dialect of Thebes "to retire for ascetic practice into the desert."

Anchorites dwelled in cells scooped from the enclosure walls at Abydos, in superstructures of tombs (Pesiur in Western Thebes), or even within the ancient Egytian tomb chapels (Abydos D 68). Even such an uninspiring hole in the rock as that at Abydos (Fig. 2.6)[33] was transformed by a hermit of the fifth or sixth centuries into a comfortable and tidy habitation. A rubble wall across the gaping south mouth of the cave formed a front living room furnished with a bench cut in the bedrock, an oven, and a closet for provisions. Beyond this room was an oratory with a niche oriented east for the altar and a window admitting a faint ray of light. Approximately 39 pegs and hooks in neat array on the walls and several sacred designs and texts revealed the order and godliness of the

29. A. E. R. Boak and E. E. Peterson, *Karanis. Topographical and Architectural Report of Excavations during the Seasons 1924–1928* (Ann Arbor: 1931).

30. S. Clarke, *Christian Antiquities in the Nile Valley* (Oxford: 1912), pl. XXII, pp. 82–85. (Hereafter cited as *Christian Antiquities.*) U. Monneret de Villard, *La Nubia Medioevale*, Vol. 1 (Cairo: 1935), pp. 66–72. Though not pertaining to Coptic Egypt, the study of Christian Nubia of undefined chronology could still be of interest for comparative purposes. The architect A. Stenico, "La Citta," in *Sabagura (1960)*, in *Oriens Antiquus*, I, 1 (Rome: 1962), pp. 62–63, differentiates between fortifieid towns conforming to the terrain and existing nuclei (Qasr Ibrim, Gebel Adda, Philae), or not conforming to the terrain (Serre, Faras), or set out on a new layout over an earlier settlement (Kalabsha), or on virgin soil (Ikhmindi, Dibger, Sheikh Dawd, Sabagura), or urban settlements around temples reused by the Christians (mostly between the First and Second Cataracts: Qurta, Maharraqa, El Sebu'a, 'Amada). The fortification consists as a rule of a trapezoid rubble enclosure protected by angular towers, square bastions, and scarp accessible through tower gates with winding entrance in the middle of the long sides. The plan can be laid out parallel (Faras, Kalabsha) or perpendicular to the Nile (Sabagura, Ikhmindi, Sheikh Dawd). Sabagura was 143–148 × 40–68 meters, with this enclosure wall 4 meters thick. Cf. E. Bresciani, *La Cinta Muraria*, in *Sabagura*, pp. 81–86. Also: U. Monneret de Villard, *La Nubia Medioevale*, 3 vols. (Cairo: 1935–1957); *Storia della Nubia Cristiana* (Rome: 1938).

31. J, Clédat, "Fouilles à Khirbet el-Flousiyeh (Janvier-Mars 1914)," *ASA*, Vol. 16 (Cairo: 1916), pp. 1–32. (Hereafter cited as "Flousiyeh.")

32. W. L. Westermann, "On the Background of Coptism," in *Coptic Egypt* (Brooklyn Institute of Arts and Sciences: 1944), p.12.

33. Lady Petrie, in W. F. Petrie, *Oxyrhynkhos*, pp. 20–24, pls. XLIX-LX.

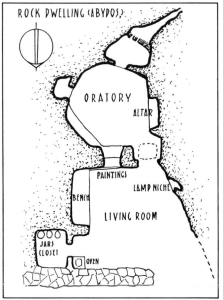

ROCK DWELLING (ABYDOS)
ORATORY
ALTAR
PAINTINGS
LAMP NICHE
BENCH
LIVING ROOM
JARS CLOSET
OVEN

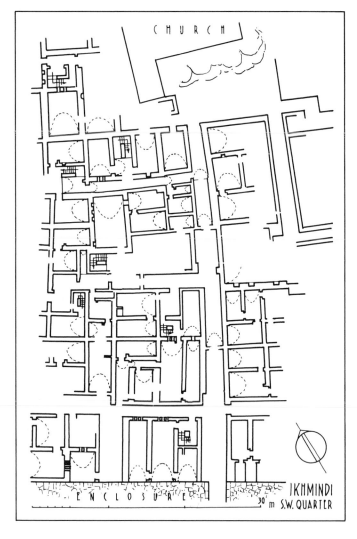

CHURCH

ENCLOSURE

IKHMINDI
30' m S.W. QUARTER

hermit Mena. A similar arrangement[34] transformed rows of rock-cut tombs from the Middle Kingdom (2000–1800 B.C.) at Beni Hassan, Bersha, Sheikh Sa'id (Fig. 2.7), 'Amarna or Western Thebes. Remodeling usually involved building a wall in front of or between the columns of the entrance portico, widening the doorway for more light, hacking away the columns of the main hall or even cutting away the rock between contiguous tombs for more space, and carving benches and cupboards complete with shelves, frame, and doors. These laurae, consisting of a group of caves with a common church and sometimes a refectory, accommodated a small community of several cenobites who worked at weaving in the front living room, which was paved with mud, flagstones or red brick in a herringbone pattern and roofed over with an awning on wooden rafters. Today one can still find inhabited villages, such as that at Rifa, which consist of similarly remodeled rock-cut tombs clinging precariously to the cliff. Copts usually treated the ancient Egyptian murals with relative moderation, hiding their unseemly scenes beneath a coat of plaster and chaff or whitewash, upon which their unschooled artists painted a text from the Fathers, interspersing their names with crosses or even more sophisticated religious motifs.

The origins of groups of Coptic ascetics can perhaps be traced back to the recluses (*katochoi*) of Serapis and the Jewish Therapeutae.[35] We are informed about the Therapeutae by Philo, the Greek philosopher of Jewish origin who lived in Alexandria at the beginning of the first century. In "De Vita Contemplativa"[36] he describes them as people called upon by divine vocation to abandon urban life, seeking friendship with God and curing the(ir) passions. After having donated their property to relatives they retired to meditate. One important settlement of Therapeutae was on a hill, in a safe and healthy location, on the coast north of Lake Maryut about two hours walking distance west of Alexandria. They had independent dwellings containing a sanctuary (*semneion*) or hermitage (*monasterion*) in the vicinity of gardens. They lived austerely, wearing a heavy robe in winter and a tunic in summer, eating frugally at sunset bread, salt, and hyssop, abstaining from food containing blood, and drinking spring water. They prayed in the morning, lifting up their hands and facing east. They sat and reclined on mats, using as a pillow a papyrus bundle probably similar to the one made by Coptic monks

(*embrimion*, from Coptic *ēmrom*; 31 cm. centimeters long). Every seventh day after washing and anointing with oil they gathered in a hall, men separated from women by a fence, to listen to a preacher. They celebrated a feast every fiftieth day.

There is some similarity between the Therapeutae and the Essenes. There are also precedents recorded ancient Egyptian inscriptions of people seeking God (Amun) in the seclusion of a desert west of Thebes. In the Serapeum of Memphis Greeks and Egyptians of the Ptolemaic period devoted their lives as recluses (*katochoi*). It would also be interesting to draw parallels from the life of Egyptian priests, as described by Chaeramon during Nero's reign. There had, undoubtedly, been a spiritual climate favorable to mysticism and meditation in Egypt, but the immediate influence of the Therapeutae on the growth of monachism cannot as yet be clearly defined.

This native propensity toward a spiritual life allied to the decline of the nome capitals (III A.D.), the abandonment of villages (II A.D.)[37] by their population fleeing from taxes and liturgies (I A.D.), the feud of the Alexandrians against the government and the Jews —all were factors concomitant with the Christian ideology of self-denial.

34. Alexandre Badawy, "Les premiers établissements chrétiens dans les anciennes tombes d'Egypte," in *Publications de l'Institut d'Etudes Orientales de la Bibliothèque Patriarcale d'Alexandrie*, No. 2 (Alexandria: 1953). (Herefter cited as "Les premiers établissements Chrétiens.")

35. W. Schneemelcher, "Erwägungen zu dem Ursprung des Mönchtums in Ägypten," in K. Wessel, ed., *Christentum am Nil* (Recklinghausen: 1964), pp. 131–141. The author does not accept the interpretation of S. Morenz that there is no similarity between the *katochoi* and early Coptic monks, such as those of Shenute.
36. Philon d'Alexandrie, *De Vita Contemplativa*. Introduction et Notes de F. Daumas. Traduction de P. Miquel (Paris: 1963). J. Danielou, *Philon d'Alexandrie* (Paris: 1958).

37. A. C. Johnson, *Roman Egypt to the Reign of Diocletian*, Vol. 2 of T. Frank, *An Economic Survey of Ancient Rome* (Baltimore: 1936), pp. 245–246. H. I. Bell, *Cults and Creeds in Graeco-Roman Egypt* (Liverpool: 1957), pp. 77–79.

2.7a
Group of *kellia* in their latest stage (A.D. VIII)
within an enclosure wall and details of two
mural paintings. (F. Daumas, "L'activité de
l'Institut Français d'Archéologie Orientale durant
l'année 1965–1966, "*Comptes Rendus de
l'Académie des Inscriptions et Belles-lettres,
1966* [Paris: 1966], pp. 298–309, Figs. 1, 2, plan.)

2.7b
Plan of an individual hermitage at Kellia (After,
F. Daumas, "Les travaux de l'Institut Français
d'Archéologie Orientale pendant l'année 1966–
1967," *Comptes Rendus de l'Académie des
Inscriptions et Belles-Lettres, 1967* [Paris:
1968], Fig. 1.)

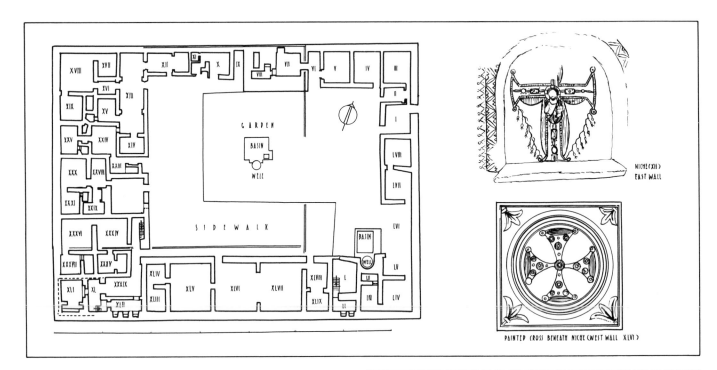

NICHE (XII)
EAST WALL

PAINTED CROSS BENEATH NICHE (WEST WALL XLVI)

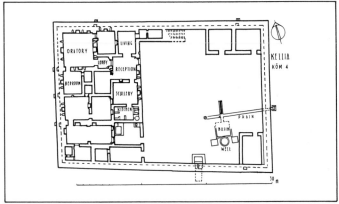

The new converts even "went to the interior" to challenge the powers of evil and the demons in their own haunting places in the desert, still the "land of evil" ("the red," *desheret*) as it had been to the ancient Egyptians.

There had been anchorites before Paul of Thebes, an Egyptian educated in both his native tongue and Greek who had retired to the desert during the persecution of Decius (250). Antony[38] from Coma, near Herakleopolis in Middle Egypt, gave away the property he had inherited; he lived first near his house, but later, seeking knowledge from elderly anchorites, he withdrew to tombs in the vicinity of his village. About 285 he settled in a ruined building in the desert, provisioned twice a year with bread. Ultimately toward 305 he encouraged visitors, many of whom imitated him, living in individual cells and meeting in a common place. In 356 he joined a caravan, but at the end of the third day he fell behind in the desert of the Red Sea and died at the age of 105.

The system of a group of individual cells (*lavra*) was followed by Amun (315) in Nitria and also in the Kellia, sites known to Palladius and Rufinus and now designated as about twenty-five kilometers from cultivation northwest of Wadi Natrun in the western desert. They are formed of groups of independent anchorites' cells earlier known as *kellia*

("cells"). Several hundred of these cells dot the desert with *kōm* (Arabic "mound"). Two great settlements not yet encroached upon by cultivation remain to the northwest: Qusur el Rubayat and, farther east, Qusur el Izeila, separated by a depression two kilometers wide. Qusur el Rubayat is three kilometers long by two kilometers broad north-south with an appendage 500 meters long to its east.

One group of *kellia* was excavated by A. Guillaumont and F. Daumas in 1965–1966.[39] Originally the cells, dated by an inscription to the mid-fifth century, were independent and not surrounded by any wall. A concrete floor formed a sidewalk on the west and south sides of a court with a well. Later a wall enclosed the structures. In the final stage, dated to the eighth century (Fig. 2.7*a*) a larger wall enclosed the group, which had expanded eastward and southward, forming a rectangle 70 meters long (E.-W.) by 55 meters (N.-S.), oriented to the compass points, opening through a doorway in the east side. A second

well was sunk in the southeast coast of the larger court and the later compound was built at a higher level (0.30 m. above the earlier one). The denser group of structures stretched along the west side. There were several large halls (XLV–XLVII), originally vaulted, which were remodeled into smaller ones, two latrines built at a higher level along the south side (XLII, LI) draining outside the wall, accessible through stairs, and two large kitchens (XIV, XLIII–XLIV). The typical individual dwelling consists of two (X–XII, XL, XLI) or three to four rooms, one inside the other. In the innermost bedroom a well-closed storage place served for keeping provisions. In the larger dwellings a flagstone seems to indicate the east orientation for prayer. Square beds for growing vegetables and irrigation channels in brickwork in front of the central well form the remnants of an enclosed garden. The material is mainly brick, made locally of sand and lime. The concrete sidewalk runs in front of the structures west and south and a long bench of red brick plastered and painted red with white joints abuts against the façade. This bench is provided near the doorways with arms for reclining, in half-cylinder or quarter-cylinder shapes. These arms are similar to those in St. Menas' monastery in the Maryut,[40] derived from those of a more elaborate shape built at the ends of benches on either side of the entrance vestibule to late antique fortresses, such as that at Dionysias (A.D. IV).

38. R. T. Meyer, *Saint Athanasius. The Life of Saint Antony*, in the series *Ancient Christian Writers* (Westminster, Maryland: 1950). N. H. Baynes, "St. Antony and the Demons," in *JEA* Vol. 40 (London: 1954), pp. 7–10.

39. F. Daumas, "Rapport sur les travaux scientifiques de l'I. F. A. O. durant l'année 1964–1965," *Comptes Rendus de l'Académie des Inscriptions et Belles-Lettres, 1965* (Paris: 1966), pp. 384–390. "L'activité de L'Institut Français d'Archéologie Orientale durant l'année 1965–1966," *Comptes Rendus de l'Académie des Inscriptions et Belles-Lettres, 1966* (Paris: 1966), pp. 300–309. F. Daumas, "Les travaux de l'Institut Français d'Archéologie Orientale pendant l'année 1966–1967," *Comptes Rendus de l'Académie des Inscriptions et Belles-Lettres, 1967* (Paris: 1968), pp. 436–451, Fig. 1. S. Sauneron, "Fouilles d'Esna (Haute Egypte): Monastères et ermitages," *Comptes Rendus de l'Académie des Inscriptions et Belles-Lettres, 1967* (Paris: 1968), pp. 411–418.

40. K. M. Kaufmann, *Die Menasstadt und das Nationalheiligtum der altchristlichen Ägypter* (Leipzig: 1910), pl. XLIV. (Hereafter cited as *Die Menasstadt.*)

In addition to a funerary inscription giving the dates 716, 736, and 739, several interesting mural paintings with ornamental patterns were uncovered. The most impressive one is certainly a bejewelled *crux immissa* within a square (XLVI, west wall) surrounded by a floral frame of a style akin to that at Bawit. A unique iconographical motif in a niche with a stone sill (XII) represents a bejewelled Latin cross with strings of pomegranates stretching between the ends of the arms and the foot and on its center a bust of Christ holding the book and blessing. This motif is related stylistically to the corona with Christ blessing often painted in the center of a cross on later Coptic manuscripts (Vatican 9: A.D. 1345). The *kellia* are reported as the abandoned site of El Mouna in the Arab chronicles of Ya'qubi (A.D. IX) and Abu 'Ubeid el Bakri (A.D. XI).

The small mounds (*kōm*) at Kellia cover individual dwellings of a uniform type. A rectangular wall (33 × 26.5–22.5 m.; Fig. 2.7b), usually without doorway, contains a courtyard with a water installation, and to the west the house consisting of a large and a small apartment (southwest) connected through the common scullery and kitchen. In the main apartment the front rooms for reception and living, which also often accommodated weaving and ropemaking, are separated by a lobby from the oratory, the largest room in the house, conspicuous for its eastern niche and floor slabs indicating the

eastern orientation for prayer, and one or two bedrooms with closet. The plan is vaguely reminiscent of the small villa at 'Amarna. Latrines open onto the court. In the roofless kitchen are built a terra-cotta bread oven and fireplaces above cinder boxes possibly used for hatching. The smaller apartment was for one or two disciples.

The vessel sunken in the concrete floor near the entrance doorways was probably a receptacle for sweeping detritus similar to those in the large monasteries at Saqqara and Bawit. There are many niches and vessels embedded in the brick walls. These walls are plastered and often painted below the level of the niches with a dado of geometric interlace. Graffiti on the walls of the living room are mementos of amounts of *keratia* representing work to be done. Among the many crosses there appears eventually a spirited sketch of one imaginary quadruped preying upon another.

The hydraulic installation in the court provided for the storage of water drawn from a well and the irrigation of a small vegetable garden and orchard, as well as a small trough outside the wall for donkeys. A stairway rose to the terrace where the hermits could relax and sleep during the hot months.

Such an apartment of no less than 100 square meters in area, well built and provided with means of comfort, shows that the hermit's life in the fifth and sixth centuries had evolved from the heroic

stage of the early installations in disused tombs and quarries to a well-organized discipline of work and meditation.

A similar picture is displayed in the hermitages cut in the southern cliff 8 kilometers west of the Nile in the desert of Esna. Nine hermitages within sight of one another stud the western mountain in an area of 4 kilometers north-south by 1 kilometer east-west. Each consists of a court 4 to 6 meters wide to which descends a stairway. On the north is the oratory, provided with niches, murals, and inscriptions above an underground chamber or magazine containing vessels set in a mud socle. On the court open a cellar with numerous (60 to 80) water jars and amphorae on a mud socle, a kitchen with built-in fireplaces, wall-embedded vessels, and bread oven. While most of the hermitages cover an average of 100 square meters, are individual, and are entirely whitewashed even to the ceilings and floors, well lit by widely splayed windows and kept cool by ventilators opening to the north, two hermitages are duplicated with a smaller apartment for a second hermit. The relative comfort of these rock dwellings shows the last stage in the development of anchorites' life in the sixth century.

The earlier settlement of the *kellia* forms the initial stage in the development of the community type of establishment of monks (*coenobium*) of Pachomius. Macarius founded monasticism in Scetis, the present Wadi Natrun (330), where several monasteries were built; these were designed

with individual cells, and from the end of the fourth century, a guesthouse was also included.[41] After the sacks by the western Berbers (404, 434, 444) a massive dungeon was built, but it was not until the ninth century that each monastery was surrounded by a wall. In the Wadi Natrun it was only in the fourteenth century that each settlement was protected by a massive enclosure and became a fortified monastery with set rules. Numerous hermits imitated the earlier anchorites, settling in ancient Egyptian rock-cut tombs and seeking the challenge of harassment by pagan spirits.

We are, happily, well informed about the story of Pachomius (Pakhom or Bakhoum, Coptic "the eagle") and his institutions from his own writings and those of his disciples,[42] soon

41. H. G. Evelyn-White, *The Monasteries of the Wâdi 'n Natrûn*, 3 Vols. (New York: 1926–1933). (Hereafter cited as *Monasteries*.)
42. Martin Krause, "Mönchtum in Agypten," in *Koptische Kunst* (Essen: 1963), pp. 77–84. The history of anchorites, coenobites, and monks was recorded in the *Coptic Chronicle: The Paradise of the Holy Fathers*, ed. and tr. by E. W. Budge (London: 1907). (Hereafter cited as *Paradise*.) Also: W. H. Mackean, *Christian Monasticism in Egypt* (Society for the Propagation of Christian Knowledge. 1920). W. E. Crum, "Theban Hermits and Their Life," in H. E. Winlock and W. E. Crum, *The Monastery of Epiphanius at Thebes*, Vol. 1, (New York: 1926), pp. 125–185. (Hereafter cited as *Monastery of Epiphanius*.) P. Van Cauwenbergh, *Etude sur les moines d'Egypte depuis le concile de Chalcédoine (451) jusqu'à l'invasion arabe (640)* (Paris: 1914). L. T. Lefort, *Oeuvres de S. Pachôme et de ses disciples* (Louvain: 1956). *Les vies coptes de saint Pachôme et de ses premiers successeurs* (Louvain: 1943). (Hereafter cited as *Les vies coptes.*) H. Bacht, "Antonius und Pachomius. Von den Anachoresen zum Cönobitentum," in *Studia Anselmiana*, Vol. 38 (Rome: 1956), pp. 66–107.

translated into Greek by Evagrius (399) and other ascetics, and in Latin (St. Jerome) and Syriac (A.D. VII). By Pachomius himself there are a catechesis (teaching), fragments of an ascetic anthology, and most of his rules. Of his preferred disciple Theodorus, there are fragments of a catechesis; of Horsiēse, who headed the congregation for half a century, several catecheses, two letters, and some of his rules; and of Tsharour, an apocalyptic description of the defects that marred the administration of the institution at Phbow.

As a recruit in Thebes Pachomius came into contact with Christians. He was soon baptized and joined the elder anchorite Palamon. After he had a vision in 320 he encouraged other anchorites to gather around him, and he started at Tabennēse near Dendera his earliest cenobitic settlement with a church he built for this purpose. He drew strict rules, the first of their kind, soon adopted by other founders of monastic institutions in Egypt and abroad. The monastic community consisted of from thirty to forty "houses," each of about forty monks engaged in the same manual chore (cooking, medical care, novices, quests, agriculture, wickerwork). Every house was led by a "house-chief" assisted by a "second." A badge sewn on the hoods of the monks differentiated the houses. Though the location of his foundations are known none has yet been uncovered, but according to various texts the monastery was surrounded by an enclosure guarded by a doorkeeper.

Pachomius' rules give a vivid insight into the life of his communities. They encompass every aspect of the monks' activities and rest, mostly as a list of forbidden acts: speaking in the dark or in the cell, proceeding to work or to the refectory ahead of time, entering a neighbor's cell before knocking, walking through the "village" (monastery) before the signal, anointing with oil without another brother being present, holding hands with one another or sitting closer than one cubit apart, cutting hair without the presence of the house-chief, leaving a blanket in the sun after meal time, eating in the cell, sleeping behind a locked door, entering the stable or the planks' room (where loaves were exposed) without permission, riding two on an ass, and riding within the monastery. Every minute activity of daily life, or even an exceptional pursuit such as "going to the mountain" to bury a monk, or ferry a "fragile vessel" (woman) was encompassed by the rules.

Despite these strict rules of austerity Pachomius' monastery thrived to such an extent that a second one was founded at Phbow, and later two others and two women cloisters headed by Pachomius' sister. These monasteries were a few kilometers apart. Petronius headed the monasteries for only a couple of months after Pachomius' death in 346, followed by Horsiēse, the abbot of Shenesit, who withdrew after four years in favor of Theodorus. He retrieved his post after Theodorus' death in 368. The Pachomian establishments seem to have been abandoned when Justinian

tried to enforce in Phbow the rulings agreed upon at the Council of Chalcedon. Monasteries pooled their products in the head establishment at Phbow, and from there these products were exported on monastery boats to trading centers. After the abandonment of the original monasteries some of the monks founded new monasteries. One such community, established by Abraham, followed the stricter rule of Shenute, which was based on that of Pgol, who borrowed heavily from Pachomius.

Shenute,[43] who had joined his uncle Pgol about 370, succeeded him as abbot of the White Monastery near Sohag, enlarging it to accommodate 2,200 monks and 1,800 nuns, who tended a surrounding domain of fifty square kilometers. Only the monumental church now remains. The drab architectural style enforced by Pachomius, who even built his church in mud brick, soon gave way to the use of richer materials and ornament as seen in the church at Phbow, in that of Shenute, and in the few monasteries from the fifth century which have been excavated, such as those of Jeremias at Saqqara, Apollo at Bawit, and Simeon at Aswan. Of the hundreds of monasteries which then studded the green valley, only a few are known; they are still inhabited but extensively remodeled. When the monasteries were subjected to a capitation tax they devised various means for providing money, such as selling the posts or

even the buildings to willing candidates. In the monastery founded about 385 or 390 by Apollo[44] at Bawit (approximately 500 monks), miniature units, each consisting of groups of cells, church, and structural dependencies, could be acquired by monks, who were free to exploit or sell them. However, this property reverted to the monastery at their death.

Much information can be derived from transactions and bureaucratic documents in Greek papyri from the fifth and sixth centuries.[45] A monastery was named after its founder, such as that of Apa Apollo, or an early abbot who eclipsed the notoriety of the founder such as Apa Shenute of Atripe. A monastery could also be named after a lay person who had donated his property to the congregation such as Apa Sourous. Some monasteries were known after the name of the komē (village) where they were located, such as Oros Aphrodites, or the earliest coenobium of Pachomius called Tabennese. Names of monasteries are rarely compound with those of sacred personages, St. Mary, St. Michael the Archangel, St. Victor, and St. Phoibammon. Among the nomes densely populated with monks were the Aphroditopolite nome that boasted about fifty monasteries, and the Oxyrhynchite nome

with approximately twenty monasteries with numerous monks in Oxyrhynchos itself. The Greek papyri give the title of hegoumenos for the head of a monastery until mid-fourth century, when it was superseded by that of the archimandrites, who acquired a higher authority. The title proestos also denotes the head, occurring concomitantly with coenobiarches and pater, as for the monastery of St. Jeremias. According to the same papyri the monks were either coenobites, such as the Tabennesites, or hermits living in solitude yet in organized groups, as in the monastery of Apa Apollo at Aphrodite, or independently, enjoying their personal property. Pachomius had discouraged his monks from seeking holy orders, and only occasionally do the papyri mention monks belonging to the ecclesiastical hierarchy, such as Abraham, head of the monastery of St. Phoibammon and Bishop of Hermonthis (Armant).

Monasticism in its flourishing period (A.D. IV-VI) played a prominent role, which despite its versatility was not always constructive. Thus Shenute organized the destruction of pagan monuments, and monks helped in the demolition of the Serapeum of Alexandria. Besides their activity in theological discussions and councils, the monks evolved a distinctive artistic style that influenced monastic foundations abroad, where it was introduced by pilgrims who had enjoyed the hospitality of the guesthouses or by abbots who derived the rules of their orders from those of Pachomius (Basilius the Great, Cassian, Caesarius of Arles, and Benedict of Nursia). Even

43. J. Leipoldt, Schenute von Atripe und die Entstehung des national ägyptischen Christentums (Leipzig: 1903).

44. H. Torp, "La date de la fondation du monastère d'Apa Apollô de Baouît et de son abandon," in Ecole Française de Rome, Mélanges d'archéologie et d'histoire, Vol. 77 (Paris: 1965), pp. 153–177. On the commercial transactions regarding miniature monasteries, see M. Krause, "Mönchtum in Ägypten," p. 82.
45. P. Barizon, "Ricerche sui monasteri dell'Egitto bizantino ed arabo secondo i documenti dei papiri greci," in Aegyptus, Vol. 18 (Milan: 1938), pp. 29–148.

in the well-developed ideal layout of a western monastery preserved in the Chapter Library of St. Gall in Switzerland (819–830) the basic organization and many details are strongly reminiscent of the earlier Coptic monasteries at Saqqara and Aswan.

Later, in the sixth and seventh centuries, several *lavrae* and monasteries developed from the reuse of rock-cut tombs in Western Thebes;[46] among these were Deir el Roumi, the monastery of Cyriacus (from 4 tombs), and the monastery of Epiphanius (from the tomb of Daga of the Eleventh Dynasty and Tomb 2, later also Tomb 3; Fig. 2.8). In addition to the long, narrow living room with benches formed from the blocked pillared portico of the rock-cut tomb, a room was added in front of it (Tomb of Hapu). A massive square tower three stories high (17–20 m.) with three rooms in each story was also built of ancient Egyptian bricks, and later a second, smaller tower surrounded by an enclosure wall was added. Lower down other tombs were remodeled into secondary *lavrae*. Almost all the elements essential to the comfort of a religious community were provided: a living room, silos or underground cellars, stables, a school, looms, and wickerwork equipment. The only item missing was a church, and it is probable that the monks had to go down for their devotions to the outskirts of the desert at Djimē, an arrangement known to have been followed by other monasteries.

46. H. E. Winlock and W. E. Crum, *Monastery of Epiphanius*.

Of the hundreds of monasteries recorded in Greek, Coptic, and Arabic writings whose ruins can still be recognized, only a few have been excavated. While not qualifying as towns, the Coptic monasteries, especially the larger ones of the sixth century, provide interesting examples of self-sufficient community settlements similar in many aspects to urban centers, but isolated in the desert.

In the earliest establishments of Pachomius at Tabennese, Phbow, and other localities which flourished until the reign of Justinian, only isolated elements have been studied. From the Pachomian literature we know that it was on the order of God and through His revelation of the sites that the saint founded his monasteries. Pachomius himself objected to any embellishment of his buildings, even going so far as to lay out their plans askew or to destroy a cupola he was building because he apprehended it was too beautiful. It is related in *The Paradise of the Holy Fathers*[47] that

"The blessed man Pakhomius built an oratory in his monastery, and he made pillars and covered the faces thereof with tiles, and he furnished it beautifully, and he was exceedingly pleased with the work because he had built it well: and when he had come to himself he declared, through the agency of Satan, that the beauty of the oratory was a thing which would compel a man to admire it, and that the building thereof would be praised. Then suddenly he rose up, and took ropes, and fastened them round the pillars,

47. *Paradise*, ed. and tr. by E. W. Budge, Vol. 1, p. 310.

and he made a prayer within himself, and commanded the brethren to help him, and they bowed their bodies, and the pillars and the whole construction fell, and he said to the brethren 'Take heed lest ye strive to ornament the work of your hands overmuch, and take ye the greatest possible care that the grace of God and His gift may be in the work of each one of you, so that the mind may not stumble towards the praises of cunning wickedness, and the calumniator may not obtain [his] prey.'"

When Pachomius transferred his first group of anchorites to a *coinobia*, where they could live a communal life, *koinos bios*, he built a girdle wall around the complex despite his brother John, who destroyed his work.[48]

The immediate successors of Pachomius, however, provided the church they were commissioned to build by Emperor Theodosius II at Phbow with rich ornamentation and granite columns. Later Coptic churches evidenced some striving toward ornamentation in carved elements of stone or wood or in mural paintings, since luxury materials were not procured as before by Constantinople. The cell in the White Monastery at Sohag was shared by two monks. Shenute's church has been studied (see p. 73), but his

48. T. H. Lefort, *Les vies coptes*, p. 61. H. Torp, "Murs d'enceinte des monastères coptes primitifs et couvents-forteresses," in Ecole Française de Rome, *Mélanges d'archéologie et d'histoire*, Vol. 76 (Paris: 1964), pp. 173–200, p. 181. (Hereafter cited as "Murs d'enceinte.")

2.8
Plan of the monastery of Epiphanius, (H. E. Winlock and W. E. Crum, *Monastery of Epiphanius*, Vol. 1, pl. III.)

2.9
Plan of some of the structures in the monastery of Apollo at Bawit, (J. Maspero and E. Drioton, "Fouilles executées à Baouit," *MIFAO*, Vol. 59 [1943],

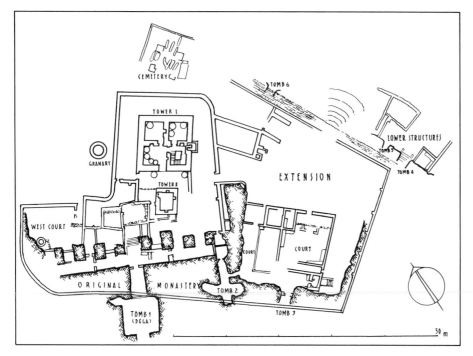

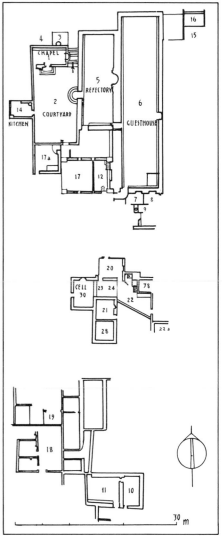

extensive monasteries consisting of Pgol's structures enlarged and remodeled still await investigation.

The results of the excavation of Apollo's monasteries at Bawit (Coptic, "The Monastery") have not been adequately published.[49] Apparently the structures, set in sparse groups, were oriented to the compass points; they were built of brick and richly painted with beautiful murals representing subjects from the Old Testament (cycle of David and Goliath) and from the New Testament (Christological cycle), saints and monks, allegories and virtues, and lion hunts, allied to ornamental motifs. The church, built of dressed limestone richly decorated with stone and wood in low relief, was of a style closer to the Greco-Roman heritage than that at Saqqara. There were at least two monasteries within the enclosure wall, the northern one of St. Apollo and his brethren and the southern one for nuns. The most extensive group in the northern settlement (Fig. 2.9) featured a brickwork complex consisting of a courtyard (2) with a central ablution basin surrounded by the refectory east (5), its chapel north (1; 2.65 × 5.75 m.), and its kitchen west (14). A similar complex existed in the monastery of Jeremias at Saqqara.

The courtyard and refectory hall at Bawit were oriented North-South. Adjacent to the refectory on the east

was a still larger rectangular hall (6; 29 × 7 m.) that had originally been vaulted and used as the refectory. Along the walls of this hall was a ledge that had been painted by a certain John with a dado of panels imitating incrustation. A niche which had been added later in its east side was decorated with Christ in glory and a Madonna surrounded by the twelve Apostles and two abbots. This refectory was later converted into a guesthouse or hostel for the accommodation of the pilgrims whose graffiti cover the walls, and a smaller refectory was built adjoining it (5). The new refectory was decorated with a mural pattern of floral lozenges and a niche painted with a Pantocrator, the Virgin, and personages framed within a pylon buttress with battered sides—a curious element borrowed from Egyptian architecture. The wooden icon of Hor was found here. Three semicircular steps led down to the courtyard, a type of stairway occurring in the pre-Justinian basilica at Ephesus (A.D. V),[50] in the atrium of that at Meriamlik in Asia Minor (A.D. V).[51] To the right side of the apsidal chapel (1) were two small niches at two levels connected to the apse, perhaps to admit light and incense. The cells had an eastern apsidal niche painted and used as an altar, large murals on one or more walls, windows and cupboards at various levels, perhaps distributed with lesser order than at Saqqara. Terra-cotta jars sunk in the floors of rooms (1) or courts (2) or through the walls (west court 2)

were probably receptacles for waste water that remained after washing floors or after ablutions.

Decadence set in in the monastery of Bawit in the eighth century. Sand began to invade the periphery and the small community could not have resisted very long after the columns of the north church were painted with figures of Christ, the Virgin, the archangels Michael and Gabriel by an itinerant painter, probably the Armenian Theodoros, who decorated the central apse in the White Monastery at Sohag in 1124.

The monastery of Apa Jeremias at Saqqara,[52] mentioned in the chronicles as early as the fifth century, was founded probably about 470, enlarged in the first half of the sixth century, damaged in the latter half of the seventh, destroyed in 750, remodeled and ultimately abandoned by 960. There is no master plan (Fig. 2.10) for the large complex (c. 210 × 100 m.), and the process of building by accretion and restoration—abutting brick buttresses onto leaning walls, rebuilding over filled-in rooms, and blocking doorways and passages—added to the irregularity of the complex. Despite this apparent confusion the streets have north-south and east-west directions, probably following the orientation of the four churches. Mud brick was used throughout, except for apses, columns, pavements, and similar elements in churches and in larger buildings. Cells and magazines

49. J. Clédat, "Le Monastère et la nécropole de Baouît," *MIFAO*, Vol. 12 (Cairo: 1904); Vol. 39 (Cairo: 1916). E. Chassinat, "Fouilles à Baouît," Vol. 1, *MIFAO*, Vol. 13 (Cairo: 1911); J. Maspero and E. Drioton, "Fouilles exécutées à Baouît," *MIFAO*, Vol. 59 (Cairo: 1932, 1943). Numbers between parentheses refer to rooms as designated by the excavator.

50. P. Testini, *Archeologia cristiana* (Rome: 1958), Fig. 340.
51. Ibid., Fig. 274.

52. J. E. Quibell, *Excavations at Saqqara* (1906–1907, Cairo: 1908; 1907–1908, Cairo: 1909; 1908–9, 1909–10, Cairo: 1912) Throughout the text numbers between parentheses refer to rooms as they were designated by the excavator.

2.10
Plan of the monastery of St. Jeremias at
Saqqara, (J. E. Quibell, *Excavations at Saqqara*
[1908–9, 1909–10], pl. I.)

2.11
Water tanks and baptistry in the monastery at
Saqqara, (J. E. Quibell, *Excavations at Saqqara*
[1908–9, 1909–10], pls. XXIX, XXX.)

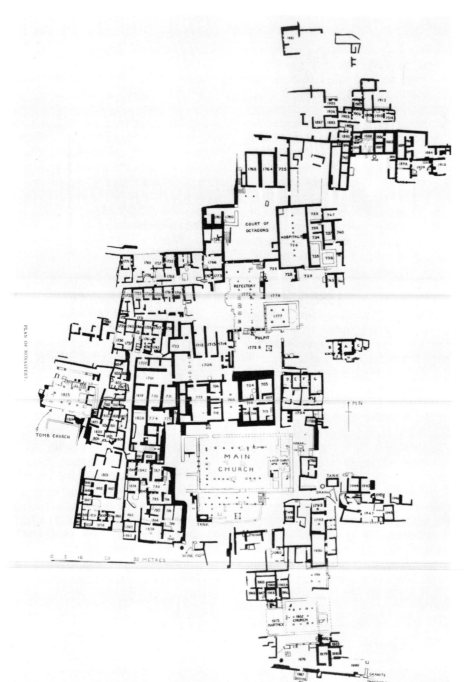

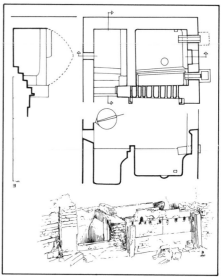

were vaulted in brick but wood was used in barrel vaults over the churches (?), in ceilings of some cells, and in screens, door valves, and frames. Water was carried by camel from a canal at the foot of the plateau and stored in tanks (southeast and southwest of main church, column in mandara 1976, of earlier church 1952) and in a baptistery (1783; Fig. 2.11). At some time the complex seems to have been enclosed by an unfortified wall accessible from the south end through at least two gates fronted by a few steps (1987, 1990). Latrines projected outside this wall. There were two other important gateways southwest of the main church; one (1796) served as an approach to this church, and the second (1861) to the long north-south street servicing the quarter of cells. In the southwest corner were a latrine (1848) and a cesspool (1855). It will be observed that the latrines were located near the gates on the southern boundary of the complex below the prevailing winds from the north as in the monastery of the Kellia and that at Aswan. A large stable with a stone tank for water was built just south and flanked by the two paved alleys leading to the main church. An oil press (2051) and a mill (2052) were located to the east of the complex.

The four basilican churches will be studied with religious architecture. The walls of the buildings on the paved passage surrounding the main church were later reinforced with heavy buttresses, leaving two passages (705) between it and the north part of the complex. Along the west passage there was "the place where Apa Jeremias

used to sit" marked by a dais with two columns (773) and painted walls; it was perhaps his reception room rather than his cell. Opposite, to the east, were a bakery (704) and a room painted with murals (709) representing allegorical figures of virtues. Within a so-called refectory 22 m. long (1772) were three rows of slender columns that probably supported a wooden ceiling 4 m. high. On the main south façade of the refectory was a courtyard with a stone pulpit flanked by two columns carrying a vaulted awning derived from the Egyptian Hebsed pavilion. The courtyard also had an ablution fount, enclosed in a kiosk (Fig. 2.12) with four granite columns and limestone capitals. Accessible from the pulpit court and opening onto the refectory was a small chapel (1777). The similarity of this complex of refectory hall, chapel, and court with an ablution basin to the complex in St. Apollo monastery at Bawit is noteworthy. Still farther north and accessible through the north door of the refectory was a large court with octagonal compartments sunken along pathways. To the north of the court were two magazines supervised by men seated in two built-in chairs. A large hall (726) with one axial row of columns carrying two contiguous vaults was called the "hospital" by the excavator on the evidence of an inscription mentioning the "father of the place of the sick."

The monks were accommodated in separate, contiguous houses built in single rows along east-west streets (Fig. 2.13). A typical house (9 × 3.4 m. axis to axis), accessible from a south courtyard, consisted of a main vaulted room (3.5 × 3 m.) with a brick tank or

basin sunk in the floor and lined with white plaster as a container for clothes. A few steps led to a small cellar. Some of the houses had a secondary magazine opening on the court. A stairway led to an upper floor where a bedroom or an awning was arranged. Most of the main rooms, which were intended to be used as oratories, were provided in their east walls with a semicircular niche forming an altar and painted with a madonna (A, 1725, 1719), Christ (B, 709, 733), saints (D), or the Virgin and Christ (1727, 1723). On either side of the niche were two or more cupboards with wooden shelves. A lamp shelf or console was arranged quite adequately between the door and the altar (1719). Usually all the walls of the oratory (see Fig. 4.43) were painted with a dado of ornamental patterns surmounted by a row of figures depicting saints and abbots and occasionally a scene from the Old Testament (Three Hebrews in the Fire, F) or a stylized palm tree (709). Windows set high in the walls (1727) were closed with stone or wood grills, with round sheets of clear or colored glass sealed in place with mud, or even with colored glass patterns set in a plaster framework similar to those made in Islamic Cairo. A most ingenious system of ventilation (Fig. 2.14) employed two air-shafts slanting from 0.8 meter above the floor upward to open on the outer face of the wall (1724, 1730, 733, 787, 1725). They were built in groups of two or more within the thickness of the north and south walls, and some were provided with wooden shutters (1723). Besides there were vertical shafts rising through

2.12
Restored perspective of Court 1772 in the
monastery at Saqqara, looking northeast to the
refectory and chapel. There is a fountain under
the cupola on four columns (right), and the
pulpit abuts against the facade of the refectory
(left).

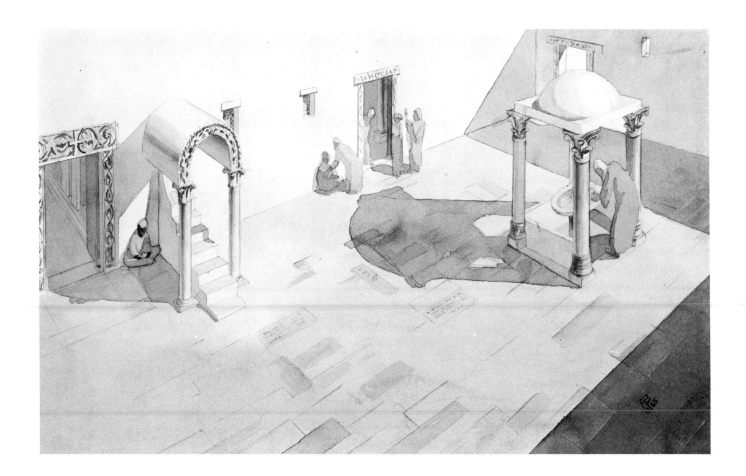

2.13
Plan of the northwest quarter of cells, restored
perspective of the inner court of a cell, and
details of air-shafts in the walls of Cell 1723,
(J. E. Quibell, *Excavations at Saqqara* [1908–9,
1909–10], pls. II, XXI.)

2.14
Air-shaft in the north wall of Cell 1723 at
Saqqara, (J. E. Quibell, *Excavations at Saqqara*
[1908–9, 1909–10], pl. XXI.)

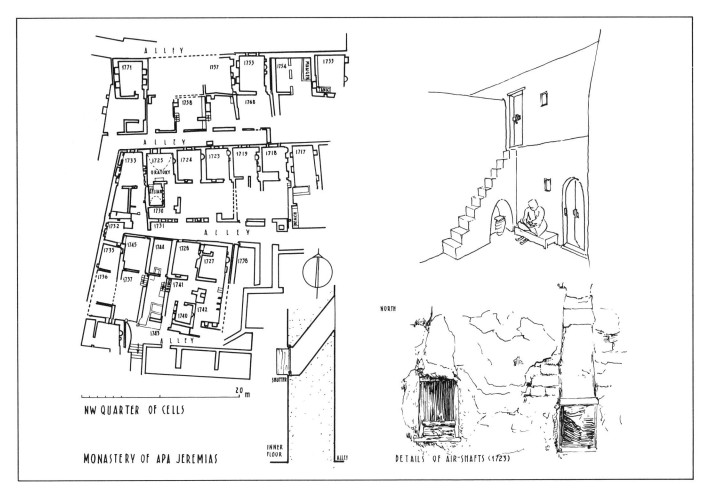

NW QUARTER OF CELLS

MONASTERY OF APA JEREMIAS

DETAILS OF AIR-SHAFTS (1723)

the wall from a cupboard (B). They are reminiscent of the ventilators which opened in the roofs of ancient Egyptian houses and of the modern *mulqafs*. Drains carved in limestone (1758) or built as vertical channels in the brickwork (2054), reminiscent of those in Egyptian temples, carried off waste into large underground terracotta vessels, a system more elaborate than that found at Bawit. Earthenware water pipes were made in sections (38 × 7 cm. diam.) narrowing at one end to fit into the next.

Let us point out, before leaving this important monastery, various characteristics reminiscent of the ancient Egyptian preplanned towns for artisans; for example, the approach from the south, the street system running north-south and east-west, and single rows (mostly east-west) of contiguous houses with an upper room or awning of uniform plan, itself a simplified version of the ancient Egyptian tripartite plan.

Some of the later unfortified monasteries known by the name *deir* (Arabic, "enclosure"), a name given to many localities on the edge of cultivated land or near urban settlements, are still occupied, having often been remodeled around structures from the Middle Ages, such as the keep (*qasr*) from the twelfth century at Deir el Muharraq. Other such monasteries are inhabited by a community of monks and laity (Deir Gebel el Deir, Deir Anba Bakhôm at Medamud); while in others only the church is still used on

Sundays or feast days, as at Deir Abu Hennis with its chapels arranged in early anchorites' caves or at Deir el Abiad and Deir el Ahmar near Sohag. Many, however, are abandoned ruins (Deir el Bahari, Deir el Medina) which may have once marked pilgrimage sites such as the vast complex of St. Menas at Maryut or that at Menuthis (Abukir). In the latter site the monastery and church of Kyros and John, succeeding an Isis shrine, are buried beneath sand, but at St. Menas[53] enough sand has been cleared to show that among the various structures covering 40,000 sq. m. were *cenobiae* in the shape of contiguous units along streets, shops, and probably a hospice for pilgrims. These quarters were briefly described by the Coptic Encomium of St. Menas which mentions that under Athanasius (491–518) a Praetorian Prefect, Philoxenus, ". . . built hospices by the lake and rest-houses for the multitude to stay at. And he had the market-place established among them in order that the multitudes might find and buy all their needs. He had spacious depositories constructed where the multitudes could leave their clothes and baggage and everything which they brought to the shrine. When he had completed everything, he called it Philoxenite after himself. He also set up porticoes at different places where people might rest. And he established watering-places along the roads."[54]

53. C. M. Kaufmann, *Die Menasstadt*, M. Krause, "Die Menasstadt," in *Koptische Kunst* (Essen: 1963), pp. 65–70.
54. J. Dresher, *Apa Mena* (Cairo: 1946), p. 148.

Bedouin raids forced the monasteries located in the desert to seek protection during the ninth century behind massive enclosures, hoping for relative immunity to scaling of their walls or penetration of the ultimate refuge of their keep (Arabic *qasr*). The two early, and still inhabited, monasteries of St. Anthony (251–356) and St. Paul (Fig. 2.15) in the desert of the Red Sea at the height of Ahnas were thus fortified at a later date. At St. Anthony a terrace was constructed in front of the *lavra* of the saint which overlooked the monastery. The fortified gate in the enclosure (north at St. Anthony, south and east at St. Paul) was seldom opened, and access was gained by means of a basket hauled up through a hatch in the floor of a machicolated balcony (Fig. 2.16). A spring still provides for the irrigation of a small garden and the needs of a small community dwelling in contiguous, two-storied houses arranged along streets running north-south and east-west on an orthogonal pattern. This arrangement, together with the batter in the brickwork, the shape of the residential multistoried tower (Fig. 2.17), and the channeled palm trunks projecting as rain spouts beneath the upper edges of the walls, are reminiscent of ancient Egyptian architecture (orthogonal system of streets, multistoried houses in Thebes during the New Kingdom, models of residential towers from the Greco-Roman period, gargoyles over the portico in the house model of Meketre' from the Eleventh Dynasty).

2.15
The monastery of St. Paul in the desert near the
Red Sea. (Photograph by J. Doresse.)

2.16
Machicolated balcony near the entrance
doorway to the monastery of St. Paul.
2.17
Multistoried keep in the monastery of St. Paul.
On the lateral wall are gargoyles made of
palmtree wood.

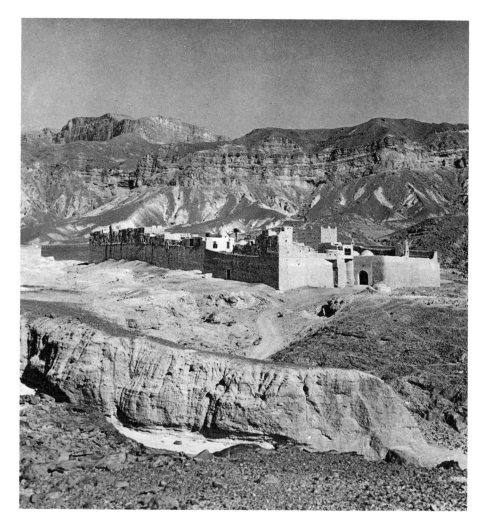

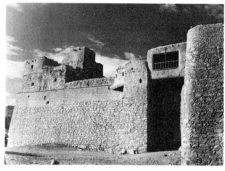

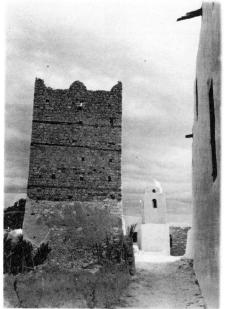

Very similar and still larger are the monasteries in the Wadi Natrun[55] which developed from eremitic settlements into complexes with the addition of guesthouses toward the end of the fourth century and the erection of towers in the fifth century; later, in the ninth century, the complexes were surrounded by enclosure walls. It is significant that this fortification was done by Shenudeh I, patriarch of Alexandria (859–880), probably imitating the defensive policy of the Byzantine emperors on the periphery of their empire.[56] It was only in the fourteenth century that monastic communities in the Wadi Natrun, following an established rule, withdrew within fortified walls. Four of these monasteries on the south side of the depression are still inhabited: Deir Baramus (Romeos), Deir Anba Bishoi, Deir Suryani (Syrian), and Deir Abu Makar (Macarius). The earliest stage in the development was marked by the growth of a *topos* (Greek, "place"), named after the founder of a community and located around the cave where he had lived. A tower was added in at least one settlement in which the monks sought refuge (444). The endowments by Emperor Zeno (482) to St. Macarius' monasteries were augmented by others from private benefactors, and the *lavra* expanded; eventually a refectory and housing units

55. H. G. Evelyn-White, *Monasteries*, Vol. 3, *The Architecture and Archaeology* (New York: 1933).
56. H. Torp, "Murs d'enceinte," p. 178.

(*manshubeh*, "place of living") were built around a central court within a small enclosure. It was only in 870 that the monastery was equipped with "high towers and strong walls," forming a kind of citadel with the *manshubehs* outside it. The massive fortified walls (about 10 or 12 m. high, 2 m. thick) on various quadrangular outlines were accessible from one gate surmounted by a hauling system.

The monastery of Deir Anba Bishoi (about 115 × 93 m.) is the most characteristic (Fig. 2.18). Near the gate and accessible from a drawbridge was the *qasr*, a massive square tower two to three stories high, which contained all the rooms essential to the life of the community during an emergency. These were set on either side of a central corridor dividing the square floor into a section containing chapels which was about two-thirds of the total area, and another section one-third of the total containing storeroom, cells, well, and library (Fig. 2.19). Rather subdued light was admitted through windows opening high in the walls and constructed with splayed sides and very steep sills, probably as a means of protection. Hiding places for valuables and manuscripts were arranged in the space between the floors and the domes beneath them and were reached by hatches. Latrines were apparently installed in the *qasr* only, usually at the farther end of the corridor on the various floors. There was no bathing equipment, but a water tank near the kitchen supplied water for drinking and for irrigating a garden within the walls.

Toward the center of the layout was the main church, and at the western end was the refectory, which was used only occasionally. This long, narrow vaulted or domed hall was furnished along its axis with a brick table flanked by two low brick benches (Fig. 2.20). There were also several small chapels. Cells in the shape of contiguous houses, deep and narrow (7 × 4 m. axis-to-axis at Deir Anba Bishoi), were set in a row abutting on the enclosure. The bipartite plan of one house oriented north-south as in the Syrian monastery featured two rooms, the inner one without a window and sometimes surmounted by an identical floor. It is noteworthy that in order to insure privacy the doorways have been arranged so as not to open opposite one another, a refinement already known in artisans' towns in ancient Egypt (El Lahun, 'Amarna East). In addition, there were independent structures equipped for various purposes: an oil press, a wine press, a bakery with two adjacent storerooms for grain and flour, and even a lime kiln. All structures were built of brick and roofed with vaults or domes, pierced at their crown with vertical pipes for ventilation. Some large windows (Fig. 2.21) admitted variegated subdued light through openwork slabs or plaster tracery which held colored glass arranged on a scale pattern of Roman style or a later Arabesque—a modest forerunner of Gothic stained-glass variegated and ethereal lighting. The Deir Suryani is so called because its secondary monastery, Theotokos (Mother of God), was purchased and occupied by Syrians (A.D. VIII–XVII) who decorated its main church with deeply carved

2.18
Plan of the monastery of Deir Anba Bishoi in the Wadi Natrun, (H. G. Evelyn-White, *The Monasteries of the Wâdi 'n Natrûn*, (Vol. 3, pl. XXXVII.)

2.19
Plan and section of the *qasr* of Deir Anba Bishoi, (H. G. Evelyn-White, *The Monasteries of the Wâdi'n Natrûn*, pl. XXXVIII.)

2.20
The refectory of Deir Anba Bishoi, looking north, (H. G. Evelyn-White, *The Monasteries of the Wâdi'n Natrûn*, pl. XLIX.)

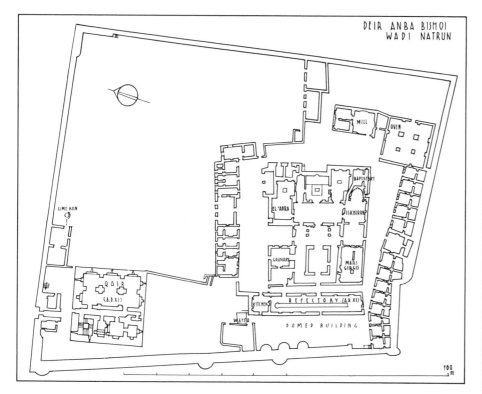

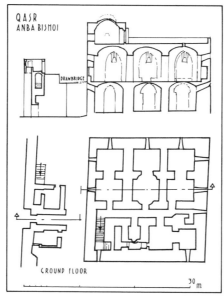

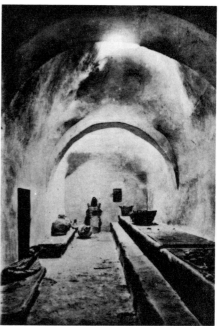

2.21
Typical tracery in windows of Coptic structures
at Saqqara (J. E. Quibell, Excavations at Saqqara
[1908–9, 1909–10], pl. XLIV), Dekheila, and Wadi
Natrun, (H. G. Evelyn-White, *The Monasteries of
the Wâdi'n Natûn*, Vol. 3, pls. V, LXXXVII.)

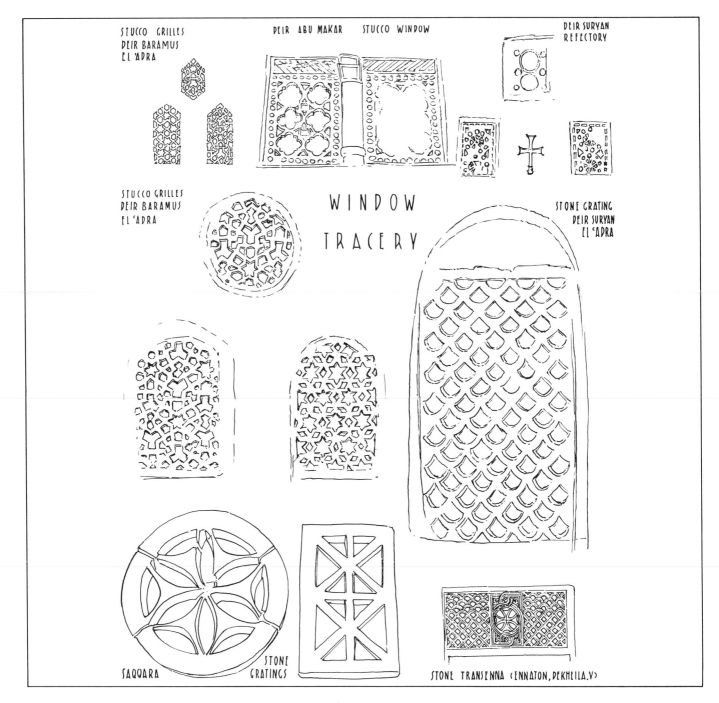

stucco elements after plant motifs in a Mesopotamian style reminiscent of the sculpture at Samarra.

Similar features are recognizable in the monastery of Anba Sam'an,[57] which rises as a lonely bastion of Christian asceticism in the parched desert west of Aswan (Fig. 2.22). Originally dedicated to Anba Hadra, a local saint of the fifth century, it was built in the eighth century, rebuilt in the tenth, and abandoned in the thirteenth because of the Bedouin raids and the difficulty of securing water, the nearest canal still being a considerable distance down in the valley. The monastery was laid out on two terraces at two levels within a trapezoid enclosure oriented north-south (Fig. 2.23). On its lower terrace fronting the original grottoes of saints was a large church, and near the entrance gate (east) was a row of contiguous rooms, each 5 × 4 m. axis-to-axis. The rooms contained three couches 1.7 × 0.7 m. designed with the concave upper curve derived from the ancient Egyptian bed and arranged after the plan of a Roman triclinium around a central base for a platter. This lower terrace answered the requirements of the pilgrims.

A stairway along the north wall of the church rose to the upper terrace (Fig. 2.24) where a massive three-storied keep on a vast rectangular plan provided permanent quarters for the community. On its main floor, flanking a central

57. U. Monneret de Villard, *Il monastero di S. Simeone presso Aswan*, Vol. 1 (Milan: 1927). Numbers between parentheses refer to the excavator's ones in Latin for rooms on the lower terrace and Arabic for those on the upper terrace.

vaulted gallery, were a refectory (Fig. 2.25) and rows of cells (5 × 4–4.5. m. axis-to-axis). It should be noted that the cells were oriented east-west as were the guest rooms on the lower terrace, a more functional arrangement than the north-south orientation (Wadi Natrun) but again reminiscent of that in the artisans' village at 'Amarna East (c. 1365 B.C.). In the refectory (III) a central row of four columns (0.4 m. diameter) with beams at the level of their *abaci* carried two rows of contiguous cupolas on pendentives. On the pavement built of baked brick on a herringbone pattern were seven mud-brick rings (0.2 m. thick by 0.3 m. high), each with an aperture similar to those found in the refectory at Saqqara; these rings probably formed an arrangement for the monks to sit in groups, each around a common platter (*tryblion*; Arabic, *tablya*).[58] Along the north wall a system of two pairs of twin basins was connected to a drain in the floor. This type of keep, so different from the square *qasr* of other monasteries, was perhaps derived from the Mesopotamian caravanserais or the Byzantine forts (*pyrgocastellon*).

South of the keep, laid out according to their respective uses, were three groups of outbuildings: settling tanks for salt, an oil press, and ovens; to the southeast, a filtering system for water, two opposed rows of latrines, and a bathroom; to the southwest, a two storied wine press and an oil press. In spite of or perhaps on account of the difficulty met in maintaining a water supply, a

58. A. Hermann, "Kernos oder Tryblion?" *Jahrbuch für Antike und Christentum*, 8/9 (Münster, Westphalia: 1965–1966), pp. 203–213, especially p.211, Fig. 15.

very elaborate distribution system was installed throughout the upper terrace, mostly in the outbuildings but also in the keep, though not in its cells. Two reservoirs, one at either end of the terrace, formed the mains for water supply (see Fig. 2.23). The reservoir to the south (43) was a basin along the east wall of the court (40), supplying a western group of structures by means of a channel crossing the courtyard and supplying a bathroom to the south by a terra-cotta pipe (5 cm. in diameter). This bathroom (41), built in well-dressed granite blocks, its floor partly cut in the bedrock, would be the only instance of such an installation in a monastery. The latrines (45) were set adjoining one another on a platform (1.35 m. wide by 0.35 m. high); each consisted (Fig.2.26) of a vertical pipe (0.2 m. in diameter) discharging on to an incline and a front basin (0.7 × 0.6 n.; 0.3 m. high) for ablutions. In front of the reservoir was a row of four square socles for large water jugs (*zīr*); these were surrounded by an open channel draining water filtered through the jugs into a collecting basin (65; see Fig. 2.26), the only reserve for drinking water in the monastery. Along the west of the keep was a long room (132) containing a shallow, well-plastered reservoir that fed the kitchen (131), its dependencies, and the refectory (111). The ten apertures in a row in the wall above the reservoir were perhaps for suction taps accessible from the courtyard, similar to those in the monastery of Apa Jeremias at Saqqara.

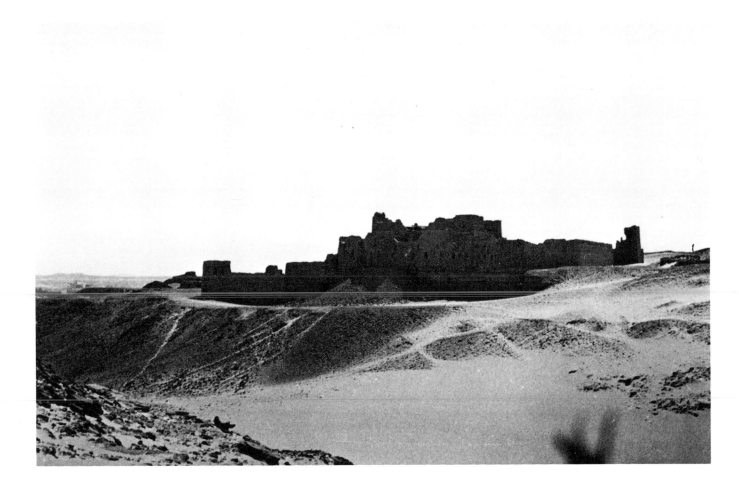

2.23
Layout of the two terraces of the monastery of
St. Simeon at Aswan. (U. Monneret de Villard,
Il monastero di S. Simeone presso Aswan,
Vol. 1.)

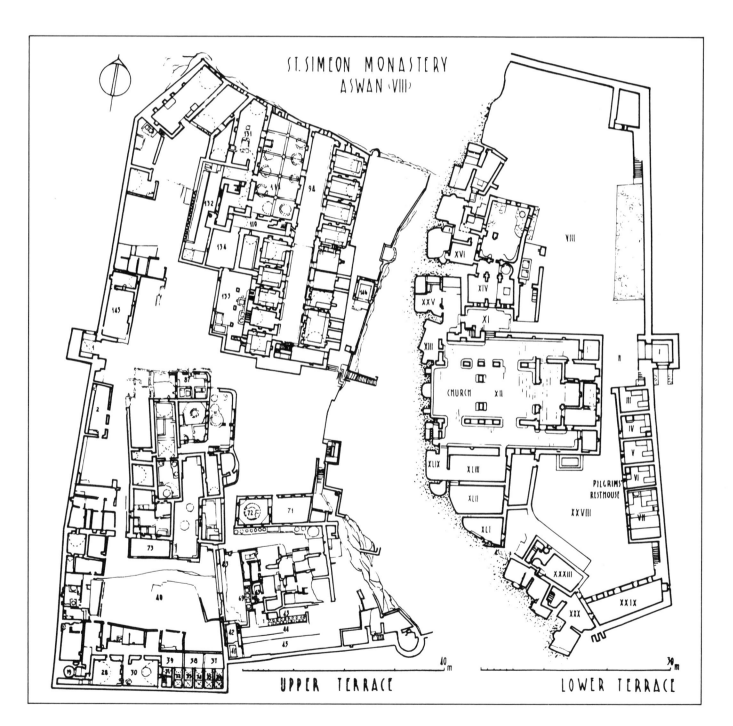

ST. SIMEON MONASTERY
ASWAN (VIII)

UPPER TERRACE

LOWER TERRACE

2.24
View of the central part of the monastery at
Aswan looking north. In the foreground are the
southernmost structures of the upper terrace.
Beyond rises the stairway from the lower terrace
to the south corner of the *qasr* (left). Overlooking
the lower structures is a kiosk with arched bays
(middle).

2.25
The great gallery of the *qasr*, looking north. The
brick vaults are supported by modern iron struts.
2.26
Detailed plans of Room VI in the pilgrims'
resthouse on the lower terrace and restored
perspective of its interior, and plans and sections
of the wine-press (19), latrines (45), stand for a
row of jars (69), and basins for salt decantation
(87). (U. Monneret de Villard, *Il monastero di S.
Simeone presso Aswan*, Figs. 25, 26, 96, 22–23).

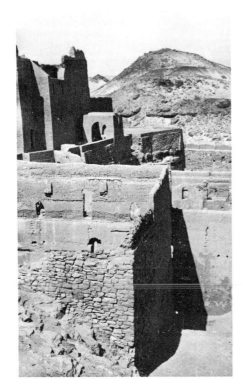

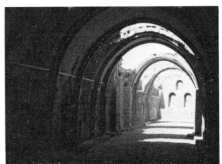

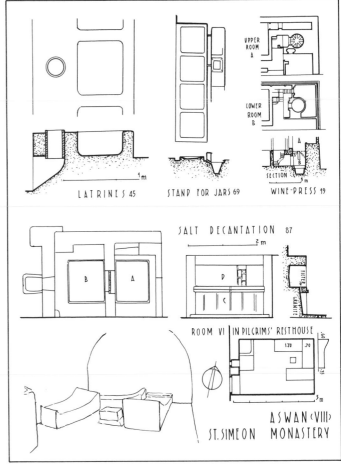

The importance of salt in the ascetic diet of the monks is illustrated by the occurrence in the personnel at Saqqara of a special monk in charge of salt provisioning and by the decantation system at Aswan (87 in Fig. 2.26). Square twin basins separated by a wooden valve served during the preliminary stage of decanting of a saline solution (A to B) from rock salt brought by caravan dealers; two other shallow twin basins paved in granite were used during the second stage (C to D) in which the solution was passed through a filter, producing by evaporation a refined salt (see Fig. 2.26). In contrast with the salt, which had to be acquired by the monks, the grapes for the wine press were probably grown locally. The wine press at the southwest corner of the upper terrace was an ambitious contraption made of mud brick: the grapes were trodden under foot in an upper cylindrical room (1.85 m. in diameter) whose floor consisted of a stone slab (.12 m. thick) pierced with holes and carried on 8 cross arches above a lower collecting reservoir (see Fig. 2.26). Here, therefore, we find in a two-storied structure the various elements of the wine press of Hellenistic Egypt used also in the monastery of St. Menas in the Maryut—the upper basin for treading the grapes (*lēnos*) and the collecting basin (*pithos*) derived from the ancient Egyptian wine press. The oil press for sesame (28, 30 in Fig. 2.23) had a circular base and a massive granite millstone decorated with three crosses. Near the oil press were small contiguous rooms (32–36), each roofed with a cross vault over the part abutting on the enclosure wall but

continued into a simple vault. Among other interesting outbuildings was a kiosk (146) open to the south, roofed with a cupola on four squinches, and with a bench running along three walls; located on the east edge of the upper terrace, this structure was probably used as a belvedere (Arabic, *mandara,* "viewing-place"). There was also a long stable with a manger along its wall near the west gate and at the southeast angle of the upper terrace was an observation tower that provided a view of the whole desert.

The entrance gateways projecting from the enclosure to the east and to the west showed a bent-up approach similar to that invented in the fortresses of archaic Egypt. Among other elements borrowing from an ancient heritage are the catenary vaults, here reinforced at midheight by smaller, flanking ones, perhaps after a Sassanian system (see Fig. 2.25).

The precarious conditions of life in Coptic communities, mirrored in their dense urban settlements enclosed within protective walls, no doubt provided the incentive for the development of multistoried houses similar to those of Greco-Roman Egypt on exceedingly small, deep, and narrow plots (8 × 4 m.; 6.5 × 6.5; 9 × 3.5 at Djimē;[59] or 6 × 2.3–3; 10.5 × 9 at Tell Edfu).[60] The typical house at Djimē (Fig. 2.27) had in the center a newel staircase flanked by a room on either side; the staircase rose from an underground cellar to three upper stories, and was connected to the street by a corridor. Sometimes the staircase abutted on one room only on every floor in tower-like houses. Mud brick (30 × 14 × 6–31 × 15 × 7 cm.) was used throughout in relatively massive walls (1 1/2 bricks thick) and in vaults of catenary shape (brick: 24 × 15 × 5.5 cm.) springing at floor level or slightly above to a normal height (3.6 m. at the crown). The staircase was very narrow (0.6–0.8 m.) and steep; the steps, made of baked brick often overlaid with stone slabs (0.22 m. rise; 0.20 m. tread), were carried on short stretches of vaults stepped according to the gradient of the flight. Both head room and doorways were often lower than the stature of a person. Arched doorways to cellars were very narrow and no more than 1.1–1.5 meters high; even the entrance doorways to the houses were only 0.6–0.8 meters wide, spanned by stone lintels decorated in relief with rosettes, crosses, and occasionally a

59. U. Hölscher, *Medinet Habu, V* (Chicago, 1954), pp. 45–51, pls. 30–31, 36–37, 41–44.
60. H. Henne, *Tell Edfou,* pp. 6–11. M. Alliot. *Rapport sur les Fouilles de Tell Edfou (1932)* (Cairo: 1933),pp. 6–11. (Hereafter cited as *Tell Edfou.*)

2.27
Plans and sections of Houses 4, 53, 77, and 78
at Djimē (U. Hölscher, *Medinet Habu, V*, Fig. 53,
pls. 41, 43) and a funerary chapel (No. 5) at
Hermupolis West, (Author's drawing in S. Gabra,
*Rapport sur les Fouilles d'Hermoupolis Ouest
(Touna el-Gebel)*, pl. XXXIX.)

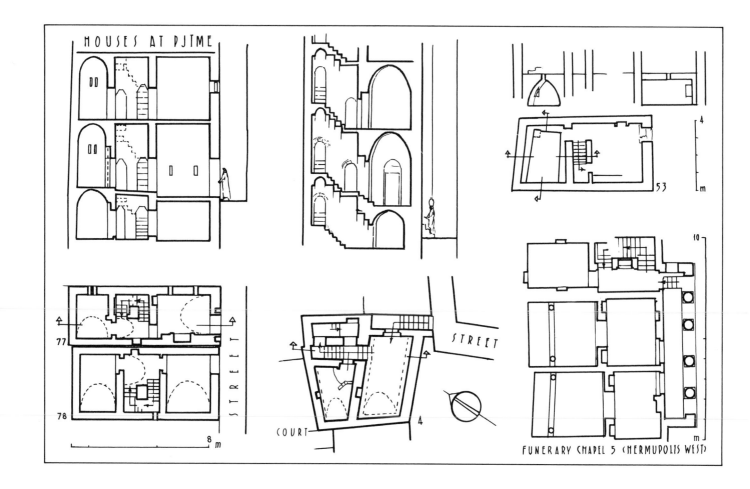

HOUSES AT DJIME

STREET

77

78

8 m

COURT

STREET

4

53

m

10

FUNERARY CHAPEL 5 (HERMUPOLIS WEST)

m

floral pattern or a bird with outstretched wings. This reduced scale for elements designed for traffic denotes an attempt at economy and also probably a search for security.

Low cellars extending beneath the entire floor or a part thereof were accessible through a hatch in the crown of the vault at the small end of the room above. Beneath the hatch, sometimes at the bottom of a funnel in the thickness of the wall, a few steps were set to help one alight (Fig. 2.28). A remarkable feature was a system of ventilation consisting of a terra-cotta pipe (10–12 cm. in diameter) set vertically in the crown of the cellar vault; this simple system was used also in later vaults and domes of monasteries and churches. On the first floor windows (0.4 × 0.2 m.) were mere slots opened on the upper part of the walls, while larger windows with small mullions were probably used on the upper floors. The outside walls were plastered and the inside walls were plastered and whitewashed and sometimes ornamented with simple motifs (cross, monogram of Christ) scratched or imprinted with the fingers or painted. Occasionally small courtyards were arranged at the rear above a cellar. Floors were paved either with mud brick and a thick plaster of mud or with baked brick and white plaster. Vaulted cupboards under the stairs were similar to those in Ptolemaic Egypt (Hermupolis) and Roman Egypt (Karanis) and are still commonly built in rural houses. Doors were hung on pivots turning on hard stone sockets (Armant).

Though small and rather shabby these houses were often provided with a water jug stand that also served as the main ornament (Fig. 2.28a). Set at the small end of the front room near the entrance, it consisted of an arched niche sometimes topped with half a dome; in front of the niche was a brick stand with two round depressions draining seepage water from jugs set in them to a collecting vessel below. Waterproof plaster (lime mortar and powdered red brick, now called homra, "mortar") was used in the stand itself and in the basin in front of it. Protection against dust and insects was provided by curtains or mats suspended across the stand on wooden or stone brackets elaborately and tastefully carved and projecting at the springing of the arch of the niche. Similar though less elaborate water-jug stands were known elsewhere (Tell Edfu, M 1).

While no evidence of a bathroom was found at Djimê, elements interpreted as such were extant at Tell Edfu (Fig. 2.29):[61] an oval sitting tub that was set on a platform and was built of baked brick with arms finished in waterproof plaster and a larger oval tub (I') with two ducts issuing from the outer wall of the room. A fireplace (I'') was also found in the vicinity. The sitting tub was similar to, and perhaps contemporary with, Roman public baths at Dionysias in the Fayum. Bathing was no more vehemently proscribed by the Copts than by other

61. H. Henne, Tell Edfou (1921–1922), pp. 16–17, Fig. 7; ibid.(1923–1924), p.10, pls. XI, XXXII.

Christians, for we know about Pachomius' prescriptions to his monks[62] regarding anointing with oil and obligations imposed on the Copts in public baths by the Caliphs.[63] In Coptic Armant (A.D. IV; see Fig. 2.3) a footbath was built inside the door (HT 9, 11), a remnant of ancient Egyptian habits of cleanliness.[64]

The type of plan featuring a lateral staircase such as that found at Djimê had already appeared before in the Greco-Roman necropolis of Hermupolis West (House 5, see Fig. 2.27), while that at Edfu is reminiscent of certain houses at Karanis and of the contiguous units in monasteries. The underground vaulted basements in the stone funerary chapels at Hermupolis (Temple 12)[65] were reached by means of hatches similar to those in Coptic houses. Houses might be as small as one room on each floor (3.2 × 2.8 m. At Armant HT 8) with an internal stairway, or they might be much larger, comprising as many as four rooms (HT 2, 22, 23, 24 at Armant). Rooms without stairs were probably shops. The suggestion that a group of such large houses found at Armant was a monastic complex is not substantiated.[66]

62. W. Wilcken, "Chrestomathie," in L. Mitteis and U. Wilcken, Grundzüge und Chrestomathie der Papyruskunde (Leipzig and Berlin: 1912), p. 144, n. 3 (not to stand nude while bathing in front of someone; to avoid baths except when ill).
63. S. Lane-Poole, History of Egypt, p.127.
64. R. Mond and O. H. Myers, Temples of Armant, p.38, also pp 36–37.
65. Author's plan in S. Gabra, Rapport sur les Fouilles d'Hermoupolis Ouest (Touna el-Gebel) (Cairo: 1941), pl. XXXIX. Hereafter cited as Hermoupolis Ouest.
66. R. Mond and O. H. Myers, Temples of Armant, p. 37.

2.28
Funnel, hatch, and steps to the cellars in houses,
(U. Hölscher, *Medinet Habu, V.* p. 46, Fig. 52).

2.28a
Restored perspective of the entrance room in
House 3 at Djimē, looking north. Built against
the rear wall is the typical water jug stand
supporting two vessels sheltered under an arch
and behind a curtain. Seepage water drains in a
bowl beneath.

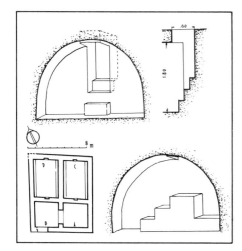

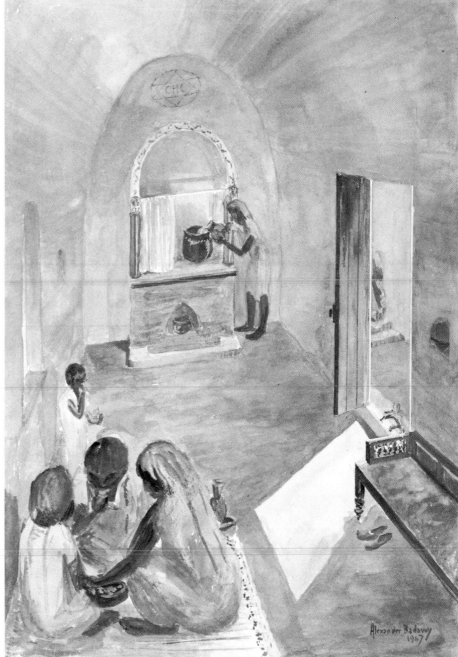

2.29
Details of baths at Tell Edfu. (H. Henne, *Rapport sur les Fouilles de Tell Edfou* [1921–1922], Fig. 7; [1923–1924], pls. XI, XXXII.)

2.30
Plan of houses abutting against the west wall of the town of Ostracina, and details of niches and columns. [J. Clédat, "Fouilles à Khirbet el-Flousiyeh," pp.6–20.)

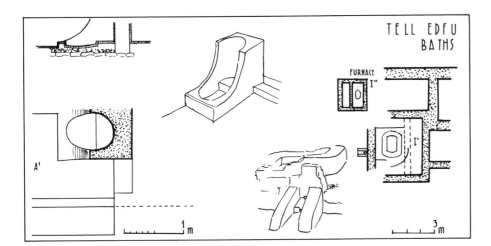

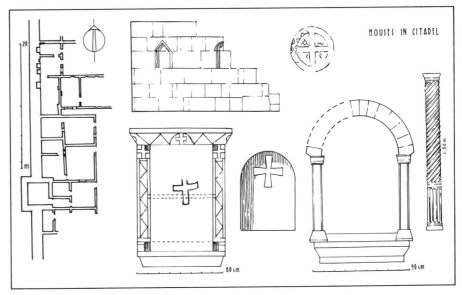

A unique type of house construction at Ostracina (Ostrakinē) employed stone walls (0.4–0.5 m.) in two facings; these were plastered or even faced with marble slabs. The houses set adjoining one another against the west wall of the citadel (Fig. 2.30) consisted of two or three rooms each; only the outer houses were lit through upper windows. Cupboards and niches, some within an architectural frame with pilasters and columns (1.5 m. high) carrying lintels or archivolts of a type derived from Greco-Roman architecture (as Hermupolis chapels), others with openwork slab forming the rear wall, opened into the walls built of huge ashlar masonry. Mural painting in red over the plaster represented the cross within medallions.[67] It has been remarked by the excavator that the large well-dressed blocks of masonry are reminiscent of Syrian techniques.

Domestic architecture in Coptic Egypt does not display a break between the late Roman and the Coptic periods. The same elements and techniques were used in much the same style, though with a decrease in scale and ornamentation corresponding to the reduced means and uncertainties of the times. It is, however, noteworthy that mural decoration seems to have been forgotten since the isolated small items in relief and painting are only Christian symbols such as Christ's monogram, the cross, or the crux ansata. The asceticism of Pachomius as applied to architecture is particularly obvious in the absence of decoration,

though this could have been simply a result of the meager economy rather than the craftsmen's lack of ability or their unwillingness to adorn the houses. The latter interpretation is corroborated by the fact that the very houses that should have conformed to Pachomius' restrictions on ornamentation and aesthetics, those of the monks, contrast sharply with the dwellings of the lay people, whether in towns or country, by their quite elaborate sophisticated mural paintings.

Herodotus' remark (450 B.C.) that the Egyptians were the most religious of men could also have described their Christian descendants six centuries later. There were, however, basic differences both in scope and in character between the Egyptian temple and the Coptic church. Churches were never, except in the earliest period, commissioned by autocratic rulers or a rich clergy as the Egyptian temples had been. The temple was the "castle of god," where sacred ritual was performed by the pharaoh or his representative, the high priest, and where the populace had no access; in contrast, the Christian church was essentially the place of assembly for a congregation who participated in the agapē.

At the dawn of Christianity the church might be located in any place sheltered from the emperors' persecutions, but preferably in far-off grottoes or rock-cut tombs in the mountains bordering the desert; near urban centers it might be located in martyriums, catacombs, or even, after the edict of Theodosius, in abandoned temples. Nothing more than an intuitive functionalism could be expected in the architecture of the hermits who transformed numerous Egyptian rock-cut tombs into chapels and dwellings. Usually the front room of the tomb chapel was enlarged by cutting off the columns and quarrying a lateral recess. A semicircular niche was next scooped out approximately in the middle of the rear wall to serve as the apse of the chapel (tomb of Urarnu at Sheikh Sa'id) or as a baptistery with a basin connected by a low passage through its wall to the rear room (Panehsy at 'Amarna; Fig. 2.31).[68]

67. J. Clédat, "Flousiyeh," pp. 6–20.

68. A. Badawy, "Les premiers établissements Chrétiens," pp. 11, 15–20.

2.31
Chapels installed in modified Egyptian tombs and quarries at Amarna (Tomb of Panehsy), Ganadla, Rifa, and Abydos. (A. Badawy, "Les Premiers établissements Chrétiens," Figs. 2, 5, 8, 9, 20.)

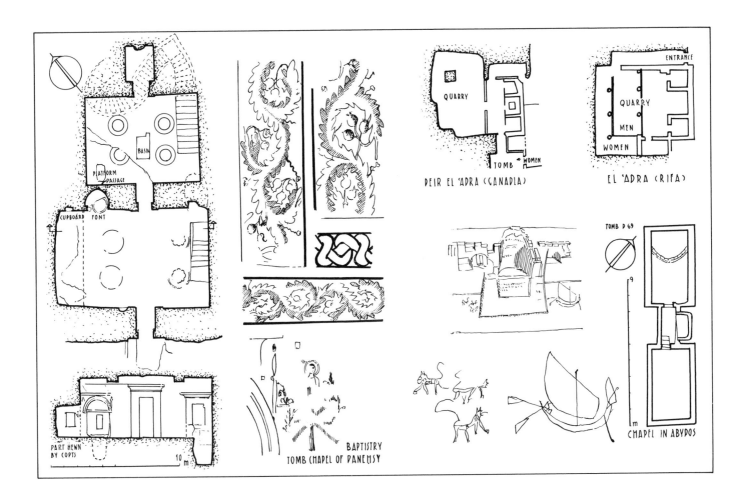

Occasionally a rock tomb was connected to a quarry, and a chapel with two sacristies was built in front, leaving on either side an entrance for the men and the women (Deir el 'Adra at Ganadla, at Dronka, at Rifa; see Fig. 2.31). A simple archivolt on two Corinthian pilasters of stucco which flanked the niche of the altar and mural painting in and around the niche provided an adequate religious setting. The elements of the murals were basically symbolic, such as a bird with halo and tripartite wings, continuous scroll with pomegranate bunches, and a frontal view of an angel surmounting the monogram of Christ. The style was still very similar to that of late Roman period (Panehsy). In Urarnu's tomb a mural represented St. George as a rider spearing a dragon; it also depicted a unicorn, an antelope, and a wreath-encircled *crux ansata* derived from the hieroglyph *'ankh* (\male).

Two rock tombs in the district of Assiut[69] consisting of two rooms each contain red line drawings in a good style characterized by harmonious proportions and supple design, dated to the sixth or the beginning of the seventh century. A beardless standing figure, small arched niches framed by a continuous scroll, and larger apses flanked by two columns either painted or modeled enclosing symbolic motifs form the decoration. These motifs are a cross within a medallion, or a youthful Christ holding a book inscribed "Light" and "Life" in a clipeus which an angel with outstretched wings balances with both arms above his head. Two peacocks ascend on either side of the elaborate archivolt decorated with a zigzag band.

69. J. Clédat, "Notes d'archéologie Copte," *ASA*, Vol. 9 (1908), pp. 213–223, Figs. 1–7.

Brick superstructures of Egyptian tombs were also appropriated by the Copts. At Abydos (Tomb D 69; see Fig. 2.31) two rooms flanking a central shaft were transformed into a Coptic chapel by building in the east wall of the shaft two small cupboards and a niche for the altar. Sketchy line paintings of lions and a sailboat symbolized the desert and the valley, a contrast often alluded to by the ancient Egyptians in their own tomb murals. Since the majority of the rock-cut tombs in Nubia are on the west bank, the Christian churches installed in them contained an apsidal sanctuary built just beyond the east entrance, which was often widened to receive a stone arch.

Whenever Egyptian temples were taken over, the Copts had no scruples about transforming the most spacious rooms into churches. They chose for this purpose the pronaos with open façade in Egyptian temples from the Greco-Roman period (Dendera, Edfu, Esna, Philae). In a small hypostyle hall the axial nave was blocked with an apsidal niche (Sebu'a); a large hypostyle hall in which the columns were less obtrusive than usual would be used without much alteration (Festival Hall of Thutmose III at Karnak). Paintings of frontal representations of saints (Karnak) were applied to the plaster or whitewash that had been used to cover the Egyptian low reliefs. Most of the rock-cut temples in Nubia were remodeled as churches. In the two chambers of the temple dedicated to Amun-Re' and Thot, dating from the reign of Horemheb (Nineteenth Dynasty) and located at

Gebel Adda (Aba Hoda)[70] on the east bank south of Abu Simbel, the low reliefs were covered with mural paintings representing Epimachus and rider saints (right wall) and Christ and an apostle (ceiling).

At Abu Simbel[71] the innermost hypostyle hall was separated from the sanctuary by a partition with three doorways, and the small temple at El Sebu'a (Fig. 2.32)[72] was transformed into a church by building, across the widened doorway of the innermost pillared hall, twin arched doorways separated by an axial partition wall. This device channeled the congregating men and women to their respective aisles. An apse with a bema fronted by a choir was arranged between the easternmost massive rock-cut pillars while a corner was curtailed in the same way for a baptistery and an ambo was set abutting against a pillar (Fig. 2.33). All the walls had been plastered and painted. On the cupola of the apse was a painting of Christ and the twelve apostles; on the west wall outside the sacristy, a scene of the Nativity; on the doorjambs between the transverse hall and the Egyptian sanctuary, St. Stephen to the right and St. Peter with the huge keys of Paradise to the left, represented again on the wall of the niche of the sanctuary.

70. G. Steindorff, *Egypt* (Baedeker, 1929), p. 437. A. Weigall, *A Report of the Antiquities of Lower Nubia,* (Oxford: 1907), pp. 139–141. U. Monneret de Villard, *La Nubia Medioevale,* Vol. 1, pp. 170–175. S. Curto, *Nubia, storia d'una civilta favolosa* (Novara: 1965), Figs. 258–260. (Hereafter cited as *Nubia.*)
71. G. Steindorff, *Egypt,* p. 436.
72. U. Monneret de Villard, *Les couvents près de Sohâg.* Vol. 2 (Milan: 1926), Fig. 138. (Hereafter cited as *Sohâg.*) *La Nubia Medioevale,* Vol. 1, pp. 84–89. Curto, *Nubia,* Figs. 134–136.

2.32
Plan of the church installed in the temple at Wadi el Sebu'a and sketches showing the twin arched doorways, and the monogram carved on the voussoir. (U. Monneret de Villard, *Les Couvents près de Sohâg*, Vol. 2, Fig. 138; H. Gauthier, *Le temple de Ouadi Es-Seboua* [Cairo: 1912], Vol.2, pls. XL, XLIII.)

2.33
Ambo and bench built in the transverse hall at Wadi el Sebu'a. (U. Monneret de Villard, *La Nubia Medioevale*, Vol. 3, pl. CXVI.)

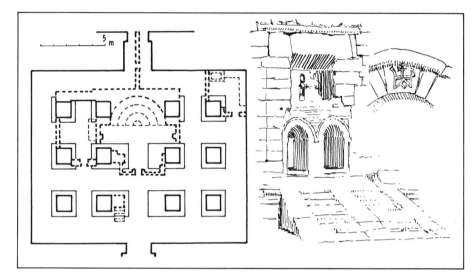

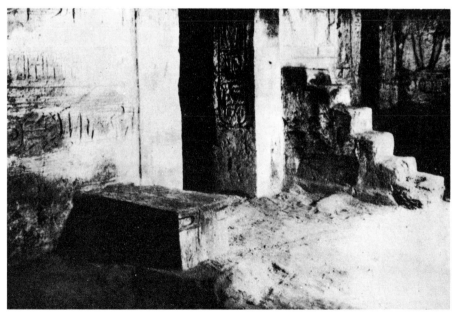

The date A.D. 795 inscribed on one painting indicates that these paintings were already in existence at that time.

In the temple of Beit el Wali[73] the church was built in the court and included a vestibule, a rectangular sanctuary oriented east, an altar within a choir, and a second altar in the doorway to the hypostyle (Fig. 2.34). Two domes on squinches probably roofed the vestibule and the church proper. In the temple of Augustus at Kalabsha[74] the apsidal sanctuary flanked by two sacristies abutted against the façade of the pronaos.

The inhabitants of Djimē, the Coptic city built over the mortuary temple of Ramses III at Medinet Habu, transformed its second court into a spacious church dedicated to St. Menas (Fig. 2.35);[75] the church served their urban community and the monks of Epiphanius in the vicinity. In remodeling the temple they hacked away the objectionable Osiride pillars, established a floor at the level of the west portico of the court about 1.1 or 1.2 meters above its central floor, and erected two rows of columns with returning end aisles. The columns had monolithic sandstone shafts carrying Corinthian capitals (4.85 m. high), a wooden ceiling, and perhaps a gallery above. The central nave of 9.50 meters clear span was probably left hypaethral. A wall built between the Osiride pillars and in front of both rows of Egyptian columns with a large apse in the middle of its northeast side delimited the

church proper. The two rooms located on either side of the apse were the sacristies, and the third smaller vaulted chamber was the baptistery at the traditional north end of the eastern side. At the western end of the nave was a well of baked brick (28 × 13 × 6.5 cm.), circular in cross-section at the bottom (1 m. in diameter) and square at the top; also at this end of the nave was an octagonal font for the Epiphany "renewal of baptism." A second church was arranged in the small temple at Medinet Habu with murals representing St. Menas. Outside Djimē two smaller churches were built to meet the needs of the growing community.

At Deir el Medina the small temple of Hathor, with its *mammisi* and kiosk of Isis, was remodeled by the Ptolemies and a Roman emperor, Caesar Autocrator. Its massive brick enclosure square wall (52 m. or 100 cubits) and its desert site encouraged Coptic monks to transform the complex into a monastery.[76] Its "church of the martyr Isidoros," a name evidenced between 515 and 540, was installed in the columned pronaos and the *mammisi* enlarged with a vaulted hall preceding it. Wall scenes of pagan worship were hammered while others were only covered with whitewash. Brick houses, kitchens, and silos were built and a well fifty-five meters deep sunk through the Ramesside and Ptolemaic strata to the subsoil water. The chief monks were buried individually in vaulted graves in front of the temple, or in rows along the northeast side. Their mummies were clad in liturgical vestments, a leather

apron with a bottom fringe, and a linen turban with yellow border. They were wrapped in a coarse linen shroud covered by a lozenge-mesh net.

On the south doorjamb of the entrance gate of Ptolemy Neos Dionysos, the Copts painted several scenes, the most important representing Isidoros, with a beardless face framed by long hair partially sculpted, seated, wearing a long robe. He holds a long staff ending in the Isiac emblem of a horned sun disk, perhaps symbolic for his name.

A door was opened in the north side of the temenos wall and led to the rock tomb of the Saite princess 'Ankhnesneferibre', transformed into an annex to the monastery. The monastery may have been abandoned in the eighth century.

There is no doubt that in Egypt, as in Rome and even in Dura Europos of the third century,[77] houses were used as chapels, such as the one at El Ḥaiz (Baḥria Oasis;)[78] where an altar built in a lobby formed a simple sanctuary while the two transverse halls formed convenient aisles for men and women. The beautiful stucco decoration with incised geometric patterns of late Roman style was retained, enriched on the doorjambs to the sanctuary by paintings in red lines of a bearded Christ and on the rear wall behind the altar by a painting of a cross with a face in the center and representations of lamps hanging from its horizontal arm.

73. U. Monneret de Villard, *La Nubia Medioevale*, Vol. 1, pp. 30–35.
74. Ibid. pp. 36–39. S. Curto, *Nubia*, Fig. 95.
75. U. Hölscher, *Medinet Habu, V*, pp. 51–55, pls. 45, 33 B.

76. B. Bruyère, *Rapport sur les Fouilles de Deir el Medineh (1935–1940)* (Cairo: 1948), pp. 35–39, pl. VI.

77. P. Lassus, *Sanctuaires Chrétiens de Syrie* (Paris: 1947), p. 80.
78. A. Fakhry, *Bahria Oasis*, 2 vols, (Cairo; 1949–1950), p. 64, Figs. 41, 43.

2.34
Plan and section of the church installed in the temple at Beit el Wali. The cupolas are restored. (U. Monneret de Villard, *La Nubia Medioevale*, Vol. 1, Figs. 23, 25.)

2.35
Restored plan and section of the church of St. Menas in the second court of the mortuary temple of Ramses III at Medinet Habu. (U. Hölscher, *Medinet Habu, V*, pls. 33B, 45.)

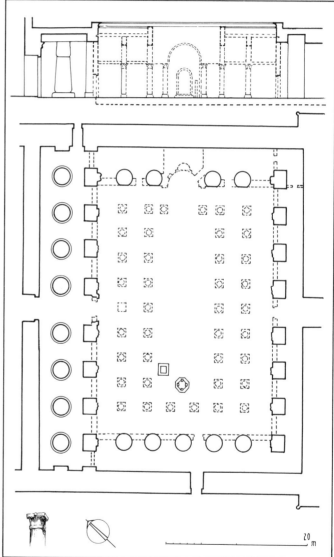

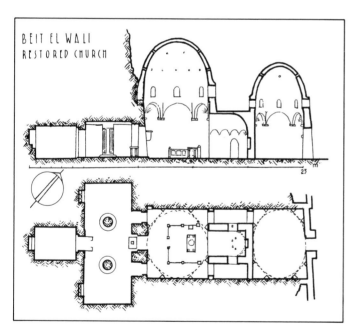

The Earliest Churches[79]

In Egypt Christians first gathered to pray over the tomb of a martyr. This was not always possible, since access to cemeteries was forbidden as part of the policy of persecution formulated in edicts under Valerian in 257 and Maximinus in 311. The martyrium of St. Mark on the shore east of Alexandria attracted so many devotees that a shrine was built, later enlarged into the church mentioned in the Coptic Synaxarium (date of 4 Abib). In addition to the pagan temples that had been adapted for the Christian cult, new structures planned as churches were built, such as that founded by Theonas (282–300) at the western end of the Canopic street. Unhappily no architectural data can be derived from the descriptions, and the aspect of Christian Alexandria is lost to us, even more so than is that of Antioch. This is the more to be deplored because of its bearing on the development of art in Christian Egypt as the second capital of the Byzantine world and the seat of the Patriarchate, and also on account of the unique cultural heritage Christian Alexandria must have acquired from its pagan predecessor. The vacuum resulting from the destruction of Christian Alexandria can be partially filled by studying the architecture in other centers in the marginal districts of the Mediterranean in its immediate sphere of influence, such as St. Menas in the Maryut (Abu Mina), the national

shrine of Christian Egypt.[80] St. Menas, who was possibly a local saint buried in a pagan catacomb, attracted so many pilgrims that "an oratory in the shape of a tetrapylon," probably a domed chamber on four arches, was built over his grave (mid-fourth century); this was soon replaced by a spacious memorial church in stone on a simple basilican plan with transepts, built by the patriarch Athanasius (373) over part of the catacomb converted into a crypt. Under Emperor Arcadius (395–408) a larger cross-transept two-aisled basilica (Fig. 2.36) was added to the east by Patriarch Theophilus from 400 to 410. The transept contained two aisles with returning terminal aisles. One buttressed apse protruded axially from the east end. The overall dimensions are 66.50 meters in length and 51.50 meters in width across the transept. An altar stood beneath a canopy in the middle of the chancel screen at the crossing of nave and transept. A raised, stepped dais (synthronon) formed the eastern end of the crossing, and a narrow passage led west, probably to an ambo. Along the nave and transept were two superimposed orders—the lower

trabeated as in the St. John basilica built by Studios in Constantinople (463)—in white marble (Fig. 2.37), a material also used for the variegated pavement and polychrome wall paneling that lined the masonry of stone bonded with courses in baked brick (25 × 12 × 6 cm.). The extensive span of the nave (14.8 m.) and the absence of any provision in the plan suggesting a concentration of weights at the corners of the crossing would indicate that it was hypaethral or roofed over with wood. At the western end an ingeniously designed arcaded colonnade reminiscent of a narthex with open exedrae connected this newer structure with the earlier Athanasius crypt church without disrupting space unity or hindering circulation between both. The two ends of the colonnade curved around the semicircular screen of the confession above the tomb of St. Menas.

Recent excavation[81] has added more data to the architectural history of the complex. It has been proved that the catacomb where St. Menas was interred was part of a necropolis that had been in consistent use and that the great basilica occupied a site built up in the third century B.C. Provision of water was mainly by means of an elaborate system of pipes collecting rain water into cisterns. The great basilica seems to have had only a nave, a transept, and an eastern apse in the first phase of its construction. Later an aisle was added on either side by removing the walls of the nave and embedding in their foundations reused

79. U. Monneret de Villard, "La basilica in Egitto," in *Atti del IV Congresso internazionale di archeologia cristiana*, Vol. 1 (Rome: 1940), pp. 291–319.

80. C. M. Kaufmann, *Die Menasstadt, Die heilige Stadt der Wüste. Unsere Entdeckungen, Grabungen und Funde in der altchristlichen Menasstadt,weiteren Kreisen in Wort und Bild geschildert* (Kempton: 1924.) J. B. Ward Perkins, "The Shrine of St. Menas in the Maryut," in *Papers of the British School at Rome*, Vol. 17 (Rome: 1949), pp. 26–71. A. Badawy, "Les premières églises d'Egypte jusqu'au siècle de St. Cyrille." In *Kyrilliana* (Cairo: 1947), pp. 335–350. (Hereafter cited as "Premières églises.") R. Krautheimer, *Early Christian and Byzantine Architecture* (Harmondsworth: 1965), pp. 85–86, Fig. 31, pl. 29c.

81. H. Schläger, "Die neuen Grabungen in Abu Mena," in K. Wessel, ed., *Christentum am Nil* (Recklinghausen: 1964), pp. 158–173.

Plan of the main complex of St. Menas in the
Maryut, (J. B. Ward Perkins, "The Shrine of St.
Menas in the Maryut," in *Papers of the British
School at Rome* (Vol. 17 [1949], pp. 26–71.)

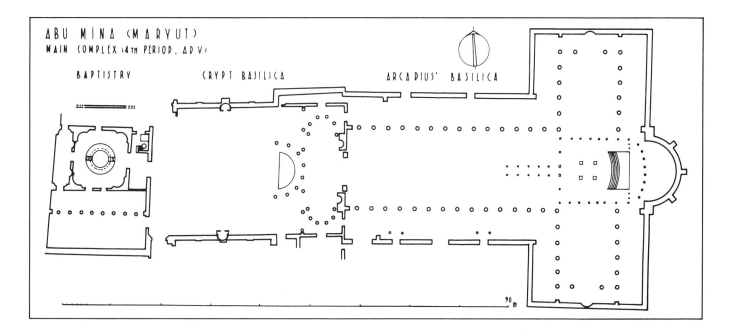

2.37
Basilica of Arcadius at Abu Mina: 1. Hellenistic
low relief. 2. Restored perspective of part of the
nave. 3. Base of column in the ciborium. 4–6.
Corinthian capitals. (Alexandre Badawy, "Les
premières églises d'Egypte jusqu'au siècle de
Saint Cyrille," in *Kyrilliana* [Cairo: 1947], pl. II.)

2.38
The baptistery at Abu Mina: 1. Detail of plan. 2.
Sketch of the piscina for baptizing. 3. Capital
with four doves. 4. Decorative relief. (A. Badawy,
"Premières églises," pl. IV.)

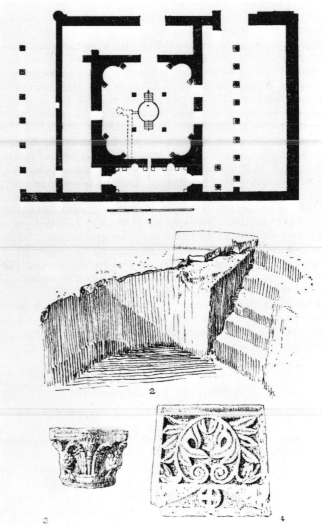

nummulitic blocks instead of sandstone under the new columns. A new eastern apse was built. Because of the similarity between the foundations of the crypt church and those of the great basilica it has been suggested that the crypt was built contemporaneously with the second phase of the great basilica, ending under the patriarch Thimotheus in Zeno's reign (474–497). The third building phase saw the addition of niches in the transept of the great basilica and the large enlargement of the crypt, perhaps in the last years of Zeno or even later under Emperor Anastasius (491–518).

Theophilus also built a baptistery (25 × 26 m.) next to the west end of the crypt church, an octagonal domed hall with four large angle niches flanked by columns (Fig. 2.38). Beneath a canopy a central circular basin accessible from two opposite stairways formed a font identical to that in the cemetery church (cf. succeeding paragraph). The design of the octagon within a square perimeter with an independent peribolos is similar to that in Aix-en-Provence (c. 400)[82] and at Riva San Vitale (c. 500) on Lake Como. Colored marble lined walls and floor, and gold mosaics covered the half-dome of the apse. It was bounded by a columned hall to the south and by passages on the other sides. Under the Caliph El Mutawakkil the Melkite architect Lazarus stripped the churches of their marble. The structure built by Patriarch Joseph (833–849) on the site of the Athanasius crypt basilica was smaller than the former church and its roof was supported by brick arcades and pillars; a sanctuary was built apart from the body of the church and marked by a projecting apse. The large basilica of Arcadius was abandoned.

With the growth of the urban settlement and its cemeteries a cemetery church (Fig. 2.39) had to be added under Arcadius, on a basilican plan with two returning aisles and a large apse within the rectangular perimeter fronted by a deep peristyle atrium. Several chapels abutted onto the church; in the chapel to the south were three contiguous apses—a style characteristic of later Coptic churches —and a baptistery. The increasing popularity of the sacred waters for healing purposes was an incentive to the establishment of thermae with a trefoil apse and a bath basilica (fifth century; Fig. 2.40) whose nave curved at both ends into two opposed apses, an arrangement known only in the destroyed Christian basilica at Armant and reminiscent of the late Roman Severan basilica converted into a church by Justinian at Leptis Magna.[83] The sacristies on either side of the western apse were connected by a corridor behind the apse, a characteristic found in the Severiana and late Nubian churches.

The importance of the complex at Abu Mina to the study of religious architecture in early Christian Egypt lies more in the rich variety of its plans than in its huge scale and its richness and methods of construction, which are similar to late antique ones. Here are found the major styles of Coptic religious architecture, in chronological sequence from the end of the fourth to the fifth centuries: the T-shaped cruciform basilica with protruding apse, the octagon-central plan, the normal basilica with recessed apse within a rectangular perimeter fronted by an atrium, and the basilica with opposed apses and rear passage behind the sanctuary. Most of these types form part of the repertory of all Early Christian architecture pertaining to the tradition of Constantinople and the Aegean coastlands, an identification corroborated by the forms and style of architectural sculpture (Theodosian Corinthian, palmette and acanthus, impost capitals, Hellenistic Alexandrian relief) found at Abu Mina. The columns rising from pedestals with classical moldings are like those in the propylaeum of the early Hagia Sophia in Constantinople. The close resemblance of the architecture of Abu Mina to that of the capital is not surprising if we remember the proximity of the pilgrimage center to Alexandria and the favor it enjoyed at the imperial court, even perhaps to having been designed by the Imperial Office of Works as were St. John at Ephesus (400) and the cross church of Empress Eudokia at Gaza (401).

At Ashmunein (Hermupolis Magna)[84] a structure excavated recently and

82. A. Katcharian, *Les baptistères paléochrétiens* (Paris: 1962), pp. 63, 105.

83. P. Testini, *Archeologia Cristiana*, Fig. 372.

84. A. J. B. Wace, A. H. S. Megaw, and T. C. Skeat, *Hermopolis Magna, Ashmunein, The Ptolemaic Sanctuary and the Basilica*, Alexandria University, Faculty of Arts, Publication No. 8 (Alexandria: 1959).

2.39
Cemetery basilica at Abu Mina: 1. Plan. 2.
Pilaster capital. 3. Grave· (A. Badawy, "Premières
églises," pl. V.)

2.40
Basilica of the baths at Abu Mina: 1. General
plan of the thermae. 2. Decorative relief. 3.
Corinthian capital and base. 4. Semicircular bath.
(A. Badawy, "Premières églises," pl. VI.)

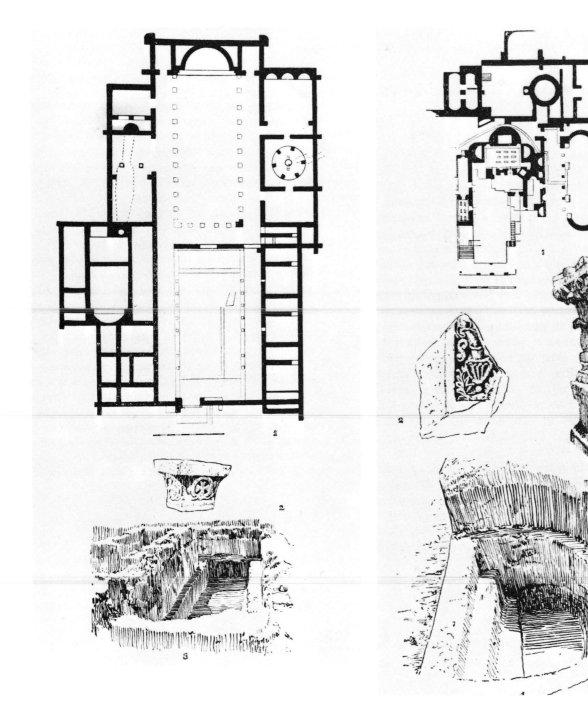

interpreted as a church (Fig. 2.41), presumably dating from between 430 and 440, featured a huge cruciform two-aisled basilican plan (nave span 13 m.; 68 × 29 m.) similar to that of the basilica of Arcadius in the Maryut, but with the two-aisled transept curving at both ends into apses with colonnaded aisles continuing those flanking the nave to form curving ambulatories. The axial eastern apse was almost completely encased within the rectangular perimeter, marked only by a slight prismatic protrusion. The basilica, axial except for an approach on its north side and an asymmetrical narthex connected by three doorways (*tribelon*) was encompassed within a complex of monumental character. The plan is unique even among the elegant complexes of imperial forums, nymphaea, and villas (triclinum of Hadrian's villa at Tivoli). Though of the cross-transept plan, it is allied to the trilobe chancel characteristic of the basilicas in Roman North Africa as at Tebessa, Kherbet Abu Aduffen (Apollonia), and the Egyptian baths (Maryut) and basilicas at Sohag and Dendera.

Somewhat similar but on a smaller scale is the basilica at Luxor,[85] especially in the unique disposition of its columns forming an apsidal east end surrounded by an ambulatory and the offset entrances. It had an apsidal baptistery along its north side, anticipating the typical location of the font in baptisteries in Palestine, Syria, Mesopotamia, Asia Minor, and Greece.

Farther north near Sohag the nationalist and proselyte Abbot Shenute built about 440 a church for his monastery, which he defined as "Jerusalem."[86] It was a huge basilica (36.75 × 74.60 m.; a proportion of nearly 1:2; Fig. 2.42) with two aisles returning at the west end and a triconch chancel similar to that at Ashmunein but separated from the nave by three steps flanked by the tall columns of the triumphal arch and retracted within the rectangular outline. Here the orders are applied to the walls (a sixth century remodeling). A western narthex ended in a colonnaded exedral screen as an apse to the north and a staircase with an apsidiole to the south, leading to the gallery, and there was also a long hall on the south side. Built in white stone, hence its Arabic name El Deir el Abiad (White Monastery), the church was designed with the characteristic external elements of Egyptian temples, such as the batter (1:15), the topping cavetto cornice that recurred also in the doorways, and the waterspouts. Internally, however, the Corinthian columns on high pedestals of the main nave, paved with white marble and granite plaques, and the two superimposed orders of columns alternating with niches along the curving walls of the three apses in a rich articulation were reminiscent of the late antique architecture as exemplified by Diocletian's palace at Spalato, and presented a strong contrast to the austere massive façades. The method of construction, with two facings enclosing a rubble filling, imitated Egyptian techniques. It has been debated whether the nave (11.5 m. span) was

ever roofed with wooden trusses[87] as implied by the reference to these elements (Arabic *gamalōn*) in Besa's biography of Shenute. In the eleventh century a dome was placed over the square bay of the triconch chancel. Later a wall was built in front of the chancel to transform it into a small church while the nave was invaded by the dwellings of priests and laity.

Another basilica built somewhat later in the vicinity is called Deir el Ahmar (Red Monastery)[88] because of its red brickwork. It was similar to Deir Abiad but smaller (22.9 × 43.6m.; Fig. 2.43), with monolithic columns and more uniform richer ornament. The chancel assumed an accurate triconch shape with the three equal conches fitting tightly around the three sides of a central square, a design followed in the basilica at Dendera (Fig. 2.44).[89] Dating from the end of the sixth century, the church at Dendera (18.2 × 36.5 m., nave span 9.50 m., proportions 1:2) exemplifies the most perfect achievement in religious architecture in Egypt, as it is characterized by rhythm, ade-

85. P. Testini, *Archeologia Cristiana*, Fig. 379, pp. 630, 713.

86. U. Monneret de Villard, *Sohâg*, Vol. 1. A. Badawy, "Premières églises," pp. 351–356.

87. Hans-Gerhard Evers and Rolf Romero, "Rotes und Weisses Kloster bei Sohag. Probleme der Rekonstruktion," in *Christentum am Nil* (Recklinghausen: 1964), pp. 175–199. (Hereafter cited as "Kloster bei Sohag.")

88. U. Monneret de Villard, *Sohâg*, Vol. 2, pp. 124–125. A. Badawy, "Premières églises," pp. 256–259, pl. 8.

89. U. Monneret de Villard, *Sohâg*, Vol. 1, pp. 32–33, 48, Fig. 49. A. Badawy, "Premières églises," pp. 359–363, pl. 9. S. Clarke, *Antiquities*, pp. 18, 140, pl. XLI. For the argument about the origin of the triconch see R. Krautheimer, *Early Christian and Byzantine Architecture*, pp. 88–90. Alexandre Badawy, *L'Art Copte. I. Les Influences égyptiennes* (Cairo: 1949), pp. 3–4, Fig. 1.

2.41
Restored plan of the basilica at Ashmunein.
(A. J. B. Wace, A. H.S. Megaw, and T. C. Skeat,
*Hermopolis Magna, Ashmunein, The Ptolemaic
Sanctuary and the Basilica,* Alexandria
University, Faculty of Arts, Publication No. 8
(1959), pl.)

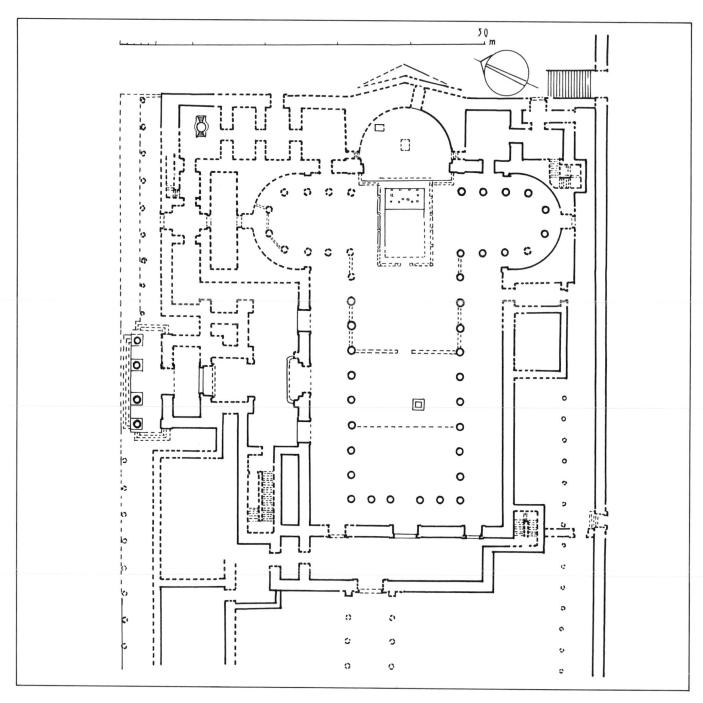

2.42
Deir el Abiad near Sohag: 1. Restored plan.
2. Transverse section of the trefoil sanctuary.
3. Section of the external wall. 4. Transverse
section of the long narthex. 5. Detail of the top of
a niche. 6. Painting in the apse. 7. Block carved
to take the end of a beam. 8. Decorative relief.
(A. Badawy ,"Premières églises," pl. VII.)

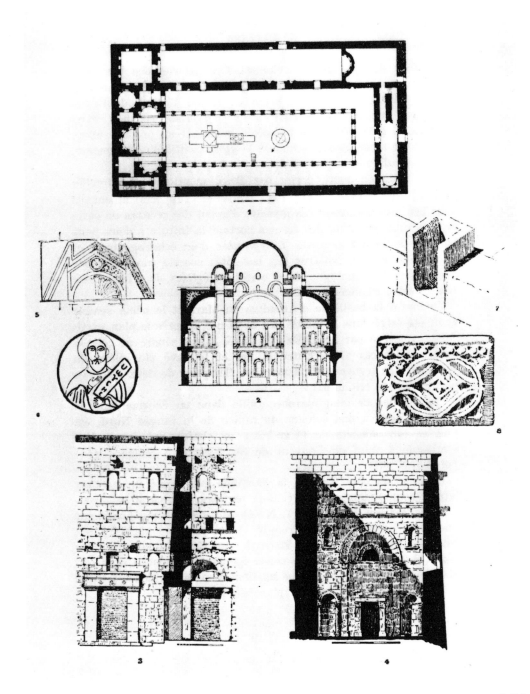

2.43

Deir el Ahmar at Sohag: 1. Present plan. 2.
Restored transverse section of the nave. 3.
Restored longitudinal section of the nave. 4.
Elevation and section of a window. 5. Column
base. 6. Painting on the archivault of the south
apse. 7. Profuse carving above an outer
doorway. 8. Present view. (A. Badawy,
"Premières églises," pl. VIII.)

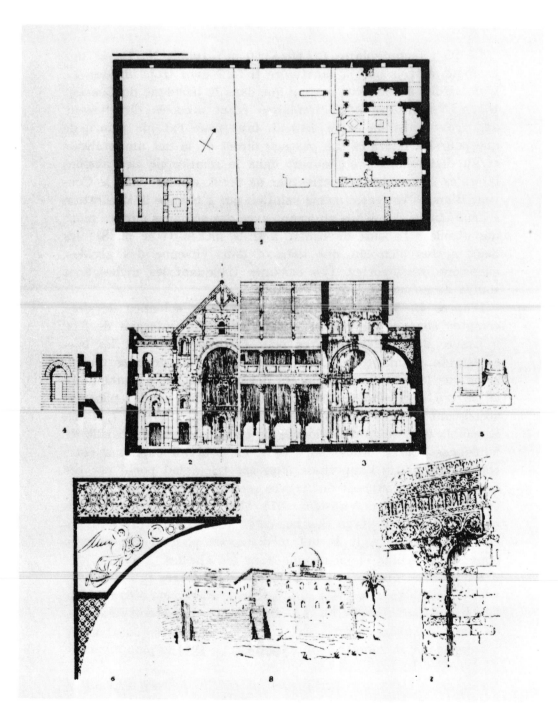

2.44
Basilica at Dendera: 1. Restored plan. 2. Entrance
doorway. 3. Niche in the aisle. 4. Top of a niche.
(A. Badawy, "Premières églises," pl. IX.)

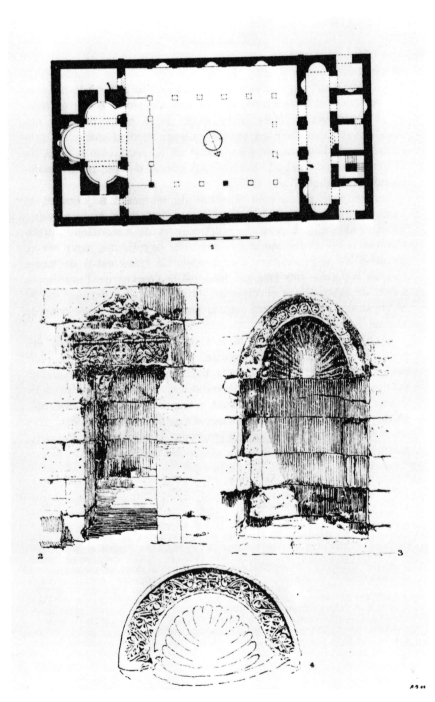

quate planning, and exquisite richness of the carved niches articulating its inner walls (Fig. 2.45). An elaborate entrance device consisted of two lobbies with winding access at both western ends on to the narthex— a device reminiscent of the ancient Egyptian entrance to fortresses, temples, and villas. The triconch chancel was fronted as at Deir Ahmar by two or perhaps four columns securing partitions in front of the triumphal arch. The design in its simplicity with such refinements as niches echoing the axes of the doorways opposite is indeed a masterpiece of its kind (see Fig. 2.45), and the careful construction from ashlar masonry bonded with wooden dovetails exhibits an interesting link with ancient Egyptian methods. In the plan of this church duplicated in engraved outline on the pavement of the nearby court of the *mammisi* at Dendera a circle inscribed within the central square of the triconch could well be interpreted as an indication of a domed roof.

A suggestion has been made by some specialists in Byzantine and Early Christian art regarding the origin of the triconch chancel. The trefoil plan was current in early martyria, and occurred in the baths at Abu Mina and in the lateral shrine in the basilica at Ashmunein. As a chancel at the east end of a basilica it is characteristic of early religious architecture in Egypt and North Africa. In this instance the basilica built in 401 and 402 by Paulinus at Nola, outside Naples, has been mentioned. Yet the amorphous plan

of its trefoil apse is far from attaining the clear articulation of the Egyptian examples, which are superior in this respect to similar solutions in North Africa. Though Nola is admittedly earlier by forty years than the triconch chancels in Egypt, this short lapse of time does not justify the ascription of the origin of the element to Italy. In Egypt the rich tradition inherited from Alexandria and pharaonic architecture could well account for its local invention despite the lack of concrete data. Several other Coptic basilicas display a triconch chancel (Deir Ahmar, Dendera) or a trefoil chancel with three rectangular bays (Aswan). The latter solution is even closer to the trefoil terminating Greco-Roman catacombs (Mex, Kom el Shugafa) and tombs (Sidi Gaber) in Alexandria.[90] The idea was not alien to Egypt, for a trefoil with rectangular bays formed the end of the deep hall in rock tombs of the New Kingdom in Thebes West (Ipi No. 41; Djoi No. 23; Nineteenth Dynasty). The motif of the triconch was certainly more deeply rooted in Egypt than in North Africa or southern Italy.

A basilica at El Ḥaiz (Bahria Oasis; Fig. 2.46)[91] resembles in several respects those at Sohag (batter), Dendera (proportions of plan 1:2, entrances north and south, walls articulated with niches, returning aisles), and the chapels at Bagawat (mud, brick, arcades, engaged columns, small size).

While the cruciform and the rectangular basilicas with triconch chancel are not found in other Egyptian sites, the basilican plan with one eastern apse and a nave without transept but ending in a terminal aisle seems to have been used consistently in monastic churches between the fifth and seventh centuries. Monastic elements in Egypt, both ethnographic and cultural, imply a strong nationalistic spirit ready to oppose any foreign trend and after the Council of Chalcedon to manifest a strong aversion to Constantinople itself.[92] This attitude is echoed in the uniform type of simple basilica evolved for the monastic communities.

The aversion to Constantinople was the common denominator between the border peoples in the Levant and North Africa, engaging them in closer relations and cultural exchanges. It has been suggested by Krautheimer[93] following U. Monneret de Villard that the simple basilica with one apse, semicircular or square, flanked by lateral rooms typical for Coptic architecture, was brought into Egypt by the monastic congregations of the Tur Abdin, on the south slope of the Taurus range. There are, however, basic differences between the so-called "Syrian" plan and the Coptic basilica. The churches at Tur Abdin, Ctesiphon

90. A. Adriani, *Repertorio d'Arte*, p. 171.
91. A. Badawy, "Premières églises," p. 362, citing A. Fakhry, *Recent Explorations in the Oases of the Western Desert* (Cairo: 1942), pl. XXI *Bahria Oasis*, Vol. 2, pp. 55 ff., Fig. 38, pl. XXXVI.

92. H. I. Bell, *Egypt*, pp. 113–114.
93. R. Krautheimer, *Early Christian and Byzantine Architecture*, p. 218. U. Monneret de Villard, *Sohâg*. For my former remarks about the origin of the basilican church in Coptic Egypt, see Alexandre Badawy, "L'Art Copte. Les Influences hellénistiques et romaines," *Bulletin de l'Institut d'Egypte*, Vol. 34 (Cairo: 1951–1952), p. 167.

2.45
Restored internal perspective of the basilica at Dendera.

Plan, section, and detail of the two-storied
orders in the basilica at El Ḥaiz (Baḥria Oasis).
(A. Fakhry, *Baḥria Oasis*, Fig 38, pl. XXXVI.)

Underground chapel at Deir el Bakara. (U.
Monneret de Villard, *Les Couvents près de Sohâg*,
Vol. 1, Fig. 105.)

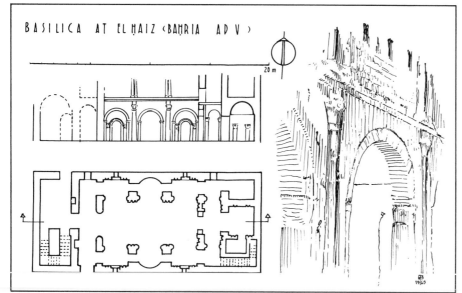

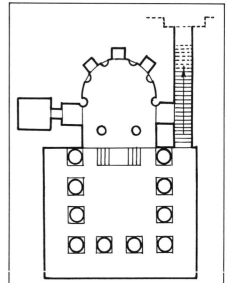

(600), and Qartamin (512) are longitudinal halls without aisles, roofed with a barrel vault and ending in three contiguous sanctuaries. In Egypt the church of the monastery of St. Simeon at Aswan is the only one that has no aisles and was roofed with a brick vault. All the others are clear deviations from the simple basilica with one apse flanked by two rooms (prothesis, diaconicon) as Deir el Bakara, the monastery of Apa Jeremias at Saqqara, both churches at Djimē, Ostracina, and Deir Abu Hennis. Some show variants from a trefoil chancel (Aswan, Deir Anba Bishoi). All, however, had timber roofs as is clearly implied in the design of their stylar supports. Here again the Copts of the fifth century adopted, as did their immediate predecessors with the trefoil in the fourth century, a plan with which they were familiar from the late antique structures of Egypt. In palatial and civic compounds, basilicas were certainly built; in fortresses such as those at Dionysias (A.D. IV) and El Kab, the *via porticata* with a terminal apse flanked by rooms as in a *basilica discoperta* formed the central element of the design (see Fig. 2.72, p. 107). The basilican plan with its emphasis on a central nave lined by aisles and leading to a shrine in the longitudinal axis flanked by rooms was very close to the solution devised by the Egyptian architects of the Middle Kingdom in their rock tomb chapels (Beni Hassan) and in the smaller temples. It was this typological affinity that was instrumental in the transformation into churches of the basilican plan from rock tombs and temples.

South of Samalut at Deir el Bakara (Fig. 2. 47),[94] a small church partly cut into the eastern cliff and perhaps dating from the empress Helena, the characteristic elements have been condensed into the square nave with returning aisles, the deep apse at a higher level fronted by two columns, and the walls articulated with engaged columns and alternating niches. The same elements are found in the main basilica in the monastery of Apa Jeremias at Saqqara (A.D. 470; Fig. 2. 48)[95] and also that of the monastery's memorial church, where the sanctuary is rectangular (Fig. 2.49). The main basilica (25.5 × 18.05 m.; span 10 m.), ruined in 700, had a narthex to the west and an atrium reduced to a columned portico along its south side, a kiosk with suction taps, and a basin for the pilgrims. The original marble columns exceeding 3 meters in height were replaced in the later structure by limestone shafts that were later painted with figures of saints and topped with capitals of various styles. The earlier capitals were of normal Corinthian (No. 9) and Egyptianizing pseudo-Corinthian styles (No. 5); the later ones were of bulbous shapes with vine ornament sharply drilled against a deep ground (No. 10), or of a palmette-and-Corinthian hybrid style (No. 4). As in the monastery church at Bawit, carved bands of scrolls enclosing in the eyes of their helixes a fruit (No. 3) or the fore part of an animal (No. 7),

some of crystalline sharpness and painted red and blue on a yellow ground, were inserted in the internal and external faces of the walls of the basilica at Saqqara. The apse was decorated with glass mosaics on a golden ground. Similarities in both plan and architectural sculpture to the Maryut as well as an imitation of the broken pediment of Sohag prove that the style at Saqqara was related to both, perhaps because of its geographical location.

The churches at Djimē (Medinet Habu) were of the same type. The larger one, however, was given a double aisle to form a slender nave within the quadrangular second court of the temple of Ramses III. Otherwise it conformed to the style employed at Saqqara and adopted for the small church (Fig. 2.50)[96] outside the eastern fortified gate. The plan of the small church (16.3 × 31 m.) featured a deep apse flanked by sacristies and fronted by a triumphal arch on two columns and piers set askew. A nave bordered by returning aisles was connected by two doorways to a narthex accessible through a lobby with winding entrance; a broad stairway rose to the galleries. A subsidiary entrance was located at the east end of a vestibule abutting on the south side. As in the large church, a well and a baptismal font were sunk in the nave floor. A niche was probably built in the axis of the apse and surmounted by carvings of a shell pattern and a hovering dove within an archivolt engraved with grapevine design. The fact that Coptic Djimē adopted for its churches,

94. A. J. Butler, *The Ancient Coptic Churches of Egypt*, (Oxford: 1884), Vol.1, pp. 348–350. (Hereafter cited as *Coptic Churches*.) U. Monneret de Villard, *Sohâg*, Vol.1, Fig. 105. A. Badawy, "Premières églises," pp. 371–373, Fig. 2.
95. J. E. Quibell, *Excavations at Saqqara*, (1908–9, 1909–10,) (Cairo: 1912), pp. II–IV; (1907–1908), (Cairo: 1909), pp. 1–8.

96. U. Hölscher, *Medinet Habu V*, pp. 55–56, pl. 46.

2.48
Main basilica in the monastery of St. Jeremias at Saqqara: 1. Plan. 2–3. Carved bands. 4. Composite capital with acanthus and palms. 5. Egyptianizing capital with Corinthian top. 6. Ambo flanked by two columns in the refectory. 7–8. Carved bands. 9. Corinthian capital with acanthus. 10. Vine capital of Syrian influence. (A. Badawy, "Premières églises," pl. XI.)

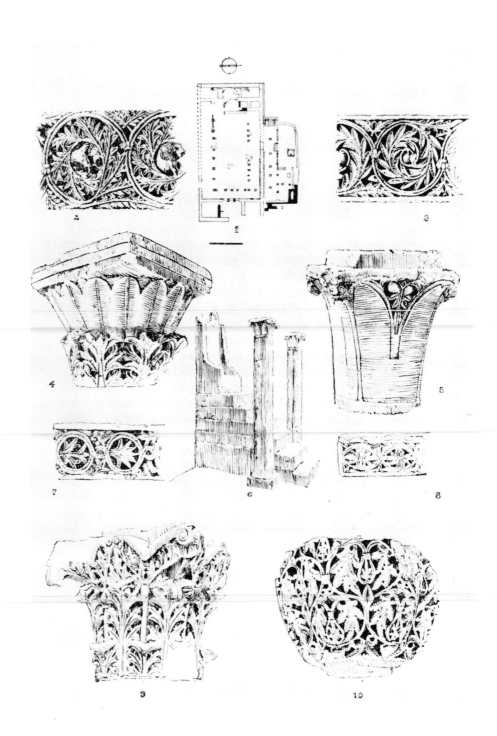

2.49
Funerary basilica in the monastery of St. Jeremias at Saqqara. (A. Badawy, "Premières églises," pl. X.)

2.50
The small church at Medinet Habu. (U. Hölscher, *Medinet Habu,* V, pl. XLVI.)

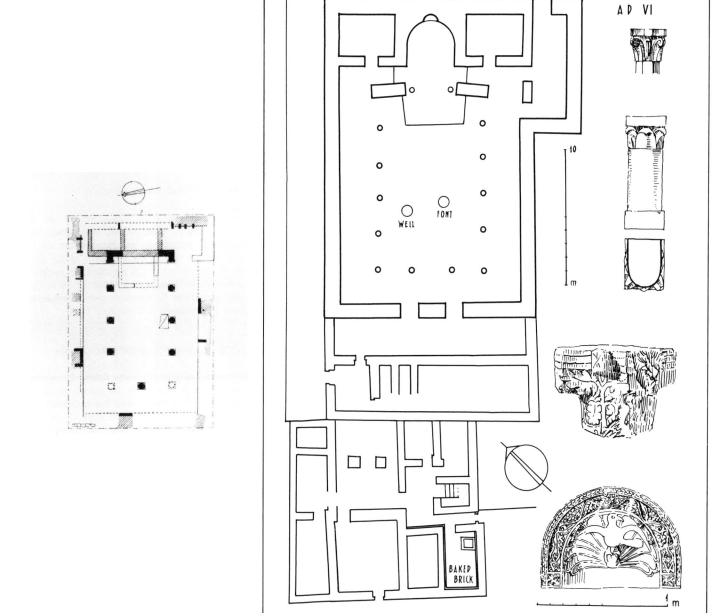

which would have served the monks of Epiphanius, the same style as that employed at Saqqara corroborates the definition of that style as indigenous.

It is probably to the same group of fifth century basilicas, if not to an earlier group, that the large basilica (south, 22 × 62 m.) and the smaller one (north, 11 × 31 m.) at Ostracina (Ostrakinē; now known as El Flusiya; Fig. 2.51)[97] should be ascribed. The only extraneous date from coins is the first half of the sixth century (Emperors Anastasius and Justinian). Both churches present the most complete type of plan with one apse preceded by a bema; a nave with cancella and two aisles; a narthex and an atrium. Only the south basilica has a terminal aisle. The masonry core faced with limestone and marble slabs fastened by copper nails, and the use of marble mosaics for the floor in front of the altar, are reminiscent of the complex at Maryut, while the trefoil shape of the baptistery behind the sanctuary in the smaller church was used for the sanctuary itself at Maryut, at Dendera, and at Sohag. It might also be noted that the location of the baptistery, axially at the easternmost end behind the sanctuary, is similar to that at Emmaus (A.D. VI).[98] This smaller church had a well-preserved cancella surrounded by marble panels in openwork and relief which were held between balusters; an alley of marble mosaics led to the altar; and in the apse was a monumental bema with a three-stepped synthronon lined in marble with a central partition, and a front of two columns (Fig. 2.52). The apse of the large church contains a variant of this bema, broader and shallower and similar to the bema of the basilica of Arcadius at Maryut. Here, as in the basilica of Arcadius, a canopy on four columns sheltered the altar. Some other features of this church, such as the apse in the eastern wall of the sacristies, the narthex opening onto the nave, and the lateral entrances— all of which occur in the churches of Babylon—should point to a somewhat more recent date than that of the smaller basilica. All the Corinthian capitals are of one type that has been tentatively dated to Justinian. Several elements, such as the atrium, the absence of terminal aisle, the cancella within the nave, and the marble work, mark an affiliation to types occurring along the marginal districts of the Delta with strong influences from the Aegean coastline style, as at Maryut. The similarity of these programs to those of Europe, especially in the basic features of the cancella and bema, is striking.[99]

Whether we should interpret the adoption of an even simpler variant of the plan at Deir Abu Hennis (Fig. 2.53),[100] which omitted the terminal aisle as did Ostracina, in terms of restricted means and an even stronger indigenous spirit may prove controversial. The original layout (fifth century), before the addition of transverse walls to carry domes instead of the wooden roof, was a simple basilica: the deep apse was of the same width as the nave and was articulated, as were the walls of the aisles, with niches. Each niche was flanked by two Corinthian pilasters topped with impost blocks carrying a curved tympanum (No. 2). Here for the first time the sacristies are two rectangular rooms the same depth as the apse, each opening axially onto an aisle—an arrangement that enabled the sacristies to be easily converted into two subsidiary chapels by connecting them to the aisles and curving their east end into a small apse as in the larger basilica at Ostracina.

This was actually done in basilicas built in Babylon and Old Cairo. Though they were often destroyed and rebuilt, their basic basilican scheme is easily recognizable, and is characterized by a rectangular perimeter, a narthex opening onto the nave and its aisles through several bays and closely resembling a terminal aisle, and the use of monolithic marble columns with Corinthian capitals carrying a continuous timber architrave surmounted by arcades and a gallery. The roof was a vault of timber or stone (Mari Mina). A typical example may be the church of Abu Sarga (Sergios)[101] in Babylon, a two-aisled basilica (17 × 27 m.; 15 m. high) with narthex, a choir preceded by an iconostasis, and three sanctuaries (Fig. 2.54). Beneath the church, and accessible from an entrance in the choir, is a crypt that marks, according to tradition, one of the resting places of the Holy Family in Egypt. It is a small basilica

97. J. Clédat, "Flousiyeh," pp. 6–34.
98. P. Testini, *Archeologia Cristiana*, Fig. 313.

99. Ibid., Figs. 288, 289.
100. G. Steindorff, *Egypt* (Baedeker 1929), p. 222. S. Clarke, *Antiquities*, pp. 181–186. A. Badawy, "Premières églises,," pp. 369–371, pl. 12.

101. A. J. Butler, *Coptic Churches*, Vol. 1, pp. 181–205. Alexandre Badawy, *Guide de l'Egypte Chrétienne* (Cairo: 1952), pp. 28–29 (hereafter cited as *Guide*); "Premières églises," pp. 376–377.

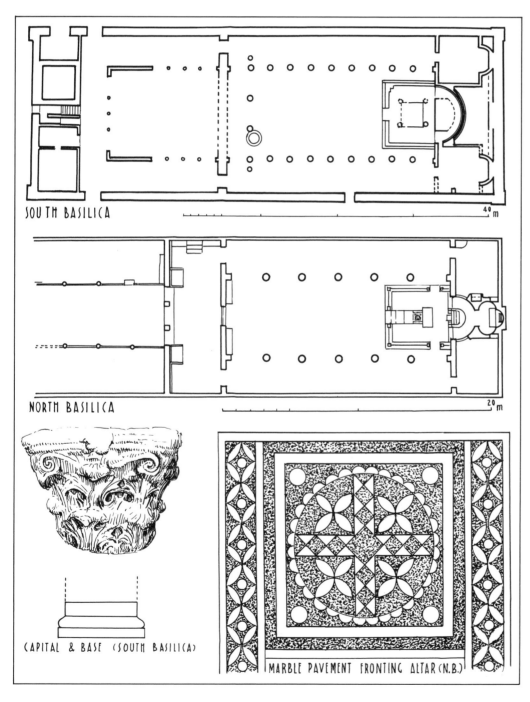

2.51
Plans of the two basilicas at Ostracina, and
details of capitals (south basilica) and marble
pavement in incrustation work (north basilica).
(J. Clédat, "Fouilles à Khirbet el-Flousiyeh,"
pls. II, III.)

SOUTH BASILICA

40 m

NORTH BASILICA

20 m

CAPITAL & BASE (SOUTH BASILICA)

MARBLE PAVEMENT FRONTING ALTAR (N.B.)

2.52
Restored perspective of the sanctuary of the
north basilica at Ostracina.

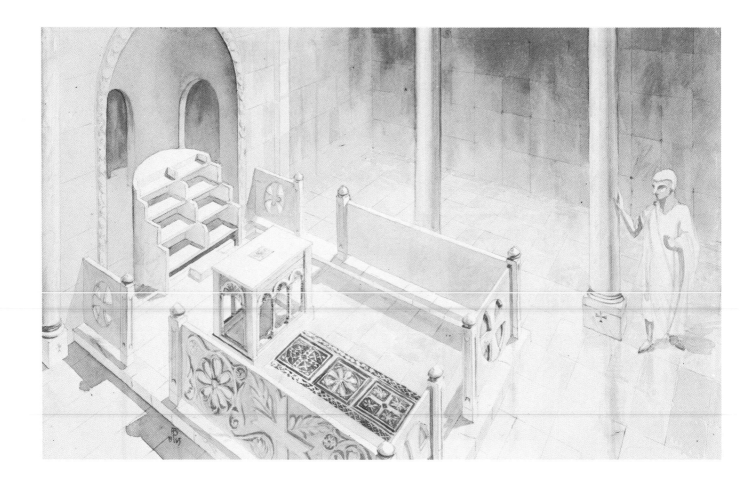

2.53
The church at Deir Abu Hennis: 1. Original plan.
2. Elevation and section of a niche in the
aisle. 3. Capital. 4. Present perspective. (A.
Badawy, "Premières églises," pl. XII.)

2.54
The church of Abu Sarga at Babylon: plan and
section of the early crypt, and plan of the
church. (A. J. Butler, *The Ancient Coptic
Churches of Egypt*, Vol. 1.)

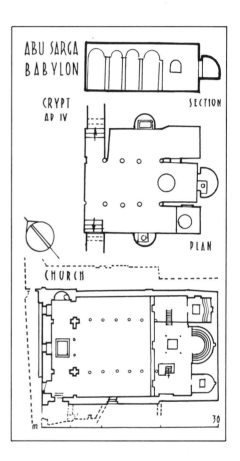

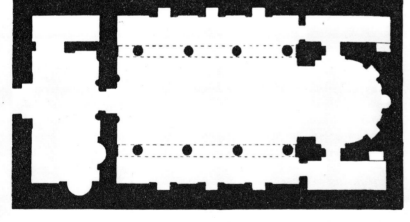

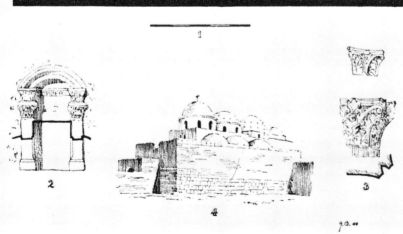

(5 × 6 m.; 2.5 m. high) dating perhaps from the fourth century, with slender columns, an altar niche similar to those in the monks' cells in the monastery of Jeremias, and single niches in the north wall and in the south wall. Very similar is the church of Sitt Barbara,[102] also in Babylon and built in 684 (Fig. 2.55). Here again (14.50 × 26 m.; 15 m. high) the narthex could be mistaken for a terminal aisle, were it not for the emphasis laid on its longitudinal axis, marked at one end by a door and at the opposite end by a niche. The main sanctuary alone is apsidal while the two others flanking it are deep rectangular rooms reminiscent of the sacristies at Deir Abu Hennis.

The simple basilican plan was occasionally varied by adding a staircase in one of the rooms flanking the apse, as in the small church at Philae (before 753), or by substituting for the apse a shallow rectangular recess in the eastern wall of a transverse choir, as in the south church in the monastery of Apa Apollo at Bawit (sixth century; Fig. 2.56)[103] near Deirut in Middle Egypt. This latter variant could be interpreted as a concession to the rigid concept of the native monks, perhaps a subconscious dislike for the curved plan alien to ancient Egyptian architecture. The south church at Apa Apollo is a two-aisled basilica (12.7 × 16.5 m.) surrounded on the north, south, and west by a broad ambulatory of the same

style which could have formed an intrinsic part of the church. No amount of praise is adequate for the carved friezes of stone and wood which run along the walls and meet the engaged columns and pilasters carrying tympana above doorways. It should be remarked that the distribution of the friezes is not as architectonic as is that of Deir el Abiad, Deir el Ahmar, or Dendera, for they do not tend to emphasize the architectural design, though they form a unifying factor in the mural composition. On the outside of the main chapel (B) two engaged columns with shafts carved in scale and zigzag patterns, topped by elaborate Corinthian capitals and probably spanned by carved tympana, were set, each on the fore part of a lion on either side of the north and south doorways (Fig. 2.57). Corinthian pilasters on pedestals flanked other doorways, arched niches meeting at the level of their capitals, with a carved stone molding and frieze set on a wooden tie beam, also carved; farther down were two similar tie beams. On the other walls only the molding or even a painted band ran at the level of the capitals (Chapels A, C), forming a unifying factor accentuating a horizontal movement. A semicircular window with splayed sides opened in the center of the lunette of the axial eastern niche above the altar; this window was marked in the frieze running just below it on the external wall by a carved panel representing two angels holding a *crux clippeata*. This may have been the only source of light in the small church, which was probably roofed with a timber ceiling. The capitals of the six columns show variety in styles and techniques.

The basilica with a flat axial sanctuary appears also in the cemetery church at Bagawat and at Saqqara. While the latter shows a terminal aisle, the basilica at Bagawat (fifth century; Fig. 2.58)[104] has a unique trapezoid plan (11 × 17 m.) surrounded by a peripteros with rounded off corners and three small exedrae. It was a two-storied structure with a staircase and winding entrance to the west. The only other occurrences of such a peripteros were in the pagan basilicas in the Roman Forum.

The flat sanctuary came into more frequent use after the Arab conquest of Egypt: it appeared in several monasteries together with new types of plans of churches evolved as a result of the conquest.

To this group of early churches may be tentatively added, contingent on further excavation, an underground complex in the desert west of Esna.[105] It consists of no less than two rooms (3.6 × 3.3 m. for the front one) whose walls are articulated with niches and plastered. In the main niche is a cross painted within a circle. Above each of the two niches flanking the central one are three rows of crude portraits of beardless heads, each surrounded by a nimbus and a name of saint or monk. The rooms formed perhaps a tomb chapel for the use of a monastic community.

102. A. J. Butler, *Coptic Churches*, Vol.1, pp. 235–247. A. Badawy, *Guide*, pp. 30–32.
103. E. Chassinat, "Fouilles à Baouît," pl. VII. For the decoration cf. pls. VIII-XXIV; LX-LXIII; LXIX-LXXXI.

104. A. Fakhry, *The Necropolis of El-Bagawāt in Kharga Oasis* (Cairo: 1951), pp. 157–159. (Hereafter cited as *Bagawāt*.)
105. F. A. Gattas, "Découverte d'un ensemble souterrain copte dans le désert d'Esné," *ASA*, Vol. 54 (Cairo: 1957), pp. 245–249.

2.55
Church of Sitt Barbara at Babylon, (A. Badawy,
Guide de l'Egypte Chrétienne Figs. 11, 12.)

2.56
South church (B) in the monastery of Apa
Apollo at Bawit, (E. Chassinat, "Fouilles à
Baouît'" Vol. 1, *MIFAO*, Vol. 13, pl. VII.)

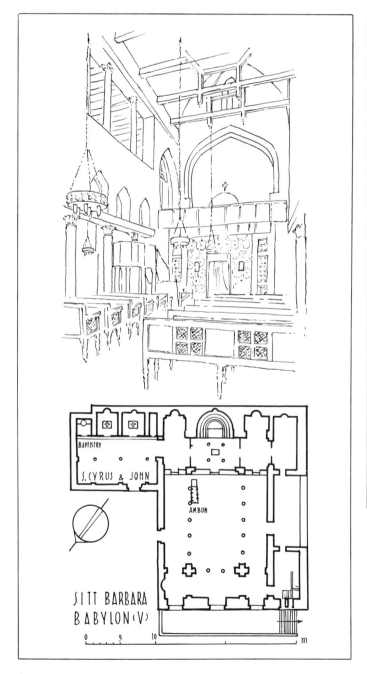

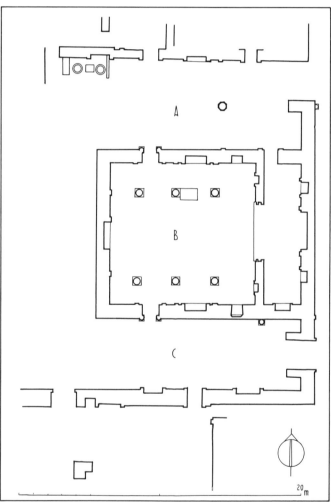

2.57
Restored perspective of the north wall of Chapel
B at Bawit, looking east.

2.58
Plan of the church (A.D. 180) at Bagawat. (A.
Fakhry, *The Necropolis of El-Bagawāt in Kharga
Oasis*, Fig. 113.)

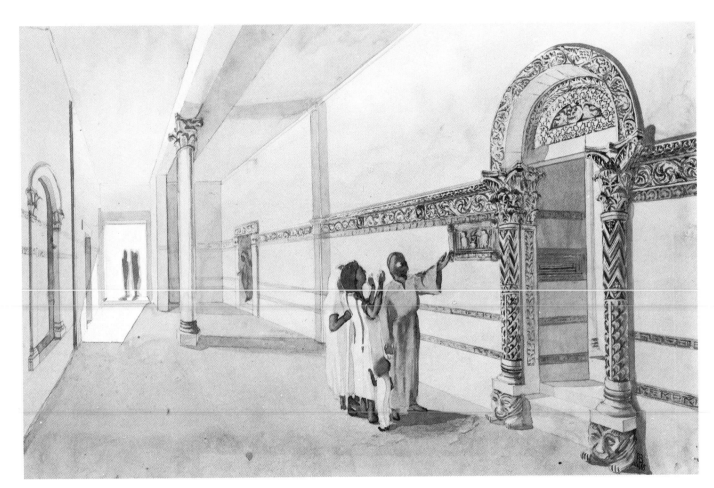

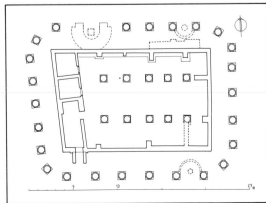

Later Churches (From the Eighth Century to the Middle Ages)

Even after the Copts had asserted their dogmatic secession from Constantinople by following Monophysitism after the Council of Chalcedon in 451, endowments were occasionally bestowed on Coptic monasteries, such as that of Emperor Zeno to the shrine of St. Menas and to St. Macarius in the Wadi Natrun (482), but no imperial commissions comparable to those of Arcadius in the Maryut are recorded. This forced isolationism did not mean an immediate recession, for the monastic institutions which constituted the backbone of the Church were provided for in the sixth century by certain shares of the taxes or donations in lieu of taxes. Village churches on an estate received annual payments from their estate. As a result church property in the sixth century was extensive and was leased and expanded by the monks, whose handicraft production was considerable but admittedly not of high quality. Alexandrian churches, sailing their own fleets, engaged in foreign trade in the Adriatic and with Britain in the sixth century, or perhaps earlier. Church boats appeared on the Nile in A.D. 390.[106] At Alexandria the patriarch was granted by Constantine a supply of grain for the poor; Sozomen records that Constantine had allowed a percentage of taxes everywhere for the benefit of the clergy, a law still observed c. 450.[107] The participation of the monasteries in the taxes is more definite in the sixth century. Along the Nile valley, hostels (*xenodocheia*) for the guests of monasteries and hospitals (*nosokomeia*) were provided by the Church. Alexandrian churches built by the patriarchs were named after emperors,[108] and churches, hospitals, and monasteries were built, mostly through private initiative.[109] Building materials in the fifth and sixth centuries were mainly fired brick and limestone, although alabaster quarries had already been exploited before in the fourth century; it is suspected that most of the harder stones such as granite and marble found in monastic churches were reused from earlier structures. The column bases of Asia Minor marble in Apa Jeremias monastery at Saqqara were probably reused older blocks.[110] As might be expected, timber imports had decreased considerably and prices were relatively high when compared to those of marble.[111] Nonetheless, trade centered on raw materials, which were imported to be transformed into luxury items for export. Workmen in the building trades were apparently sometimes organized in guilds.

The decline in monumental architecture which occurred in the sixth and seventh centuries and affected the churches almost exclusively was partly a result of the gradual dwindling of resources to the indigenous supply, but it was hastened by the Arab conquest of Egypt.[112] Christianity was no longer the state religion and the impoverished Church could not plan extensive building programs. Not only were the natural riches exploited for Islamic projects, but Coptic artisans and architects were engaged to work on such edifices as the Ibn Tūlūn mosque and palace aqueduct (870); they were even sent abroad to work on the Dome of the Rock in Jerusalem (678–691), and at Mecca and Medina. There was no relief from the increasingly unfavorable environment imposed by the Arabs: the institution of a poll-tax (Diocletian had abolished it at least in theory), replacement of Coptic by Arabic in official documents, branding of monks and intermittent persecutions accompanied by demolition of Coptic churches or their appropriation for secular uses such as sugar warehouses. Under Fatimid rule (969–1171), however, the Christians of Egypt were relatively favored; they had access the highest offices of state, and the revenue of churches and their property increased. The building and restoration of churches under the later Fatimid Caliphs, as recorded by Abu Sālin the Armenian (end of twelfth century),[113] were always marked by the substitution of brick cupolas for earlier timber roofs and brick pillars for columns. This shift in the choice of building materials dictated by the dearth of imported timber and stone and reduced means had a radical effect on the plan and style of churches. Those earlier basilicas which could be restored had the roof over the nave and aisles converted into three contiguous brick vaults or a

106. A.C. Johnson and L. C. West, *Byzantine Egypt: Economic Studies* (Princeton: 1949), pp. 70, 158.
107. Ibid., p. 252.

108. Ibid., pp. 66–72.
109. Ibid., p. 106.
110. Ibid., p. 145.
111. Ibid., p. 141.
112. S. Lane-Poole, *History of Egypt;* see under Churches.

113. Abu Salih, *The Churches and Monasteries of Egypt,* ed. and tr. by B.T.A. Evetts with added notes by A. J. Butler (Oxford: 1895); reprint, 1969.

series of brick cupolas; because of the heavier loading, it was often necessary to encase the existing columns within brick pillars or to build new arcades. The round plan of the cupola implied a subdivision of the area to be roofed into a series of square bays marked at their corners by supports forming in fact a grid pattern, very likely a local invention similar to the one used in mosques. The obvious advantage of such a simple modular plan for monastic churches, where several altars were required, as well as its primary design and relatively cheap construction in brick without wood centering, explain why it met with widespread favor in the twelfth century throughout Upper Egypt. The typical church consisted of three to six contiguous chapels in a row forming the chancel (*haikal*); a brick screen (Arabic, *ḥigāb*) to the west, separating the chapels from a transverse room of the same breadth but only one span deep which was used for the choir; and one or two similar transverse rooms beyond for the public. Such were the Deir el Shuhada at Esna (A.D. VIII), the monasteries at Naqada and Qamula, Deir Theodorus at Medinet Habu, Deir Bakhum boasting 29 cupolas at Medamud, Deir Nag'el Deir, el Muharraq with its *qasr* (A.D. XII). The rhythm of the similar cupolas, dazzling in their immaculate whitewash and surging above the quadrangular mass of the walls, differs from the emphatic contrast between large and subsidiary domes and profuse richness of forms and decoration which characterized the Byzantine search for aesthetic effect. The interior with its diffused light from slot windows in the domes evokes a peaceful atmosphere reflecting across

the centuries the spirit of asceticism which had burnt within Pachomius.[114]

Several churches in Upper Egypt show the process of conversion from the basilican plan with the building of two transverse walls between the easternmost columns and at the western end. The earliest church of Deir el Salib (Naqada; Fig. 2.59)[115] exemplifies this process: a *ḥigāb* stood before the central apsidal sanctuary, which was flanked by two square chapels; a wall built between the columns of the triumphal arch delimited the choir, and another farther west in the nave shortened it. The wall abutting on the south side served as a reinforcement to take the additional stresses from the new roof of cupolas and vaults. A similar process transformed the basilica of Mari Girgis (Naqada).

That the Copts readily transformed their earlier basilicas into this later (A.D. VIII–XII) standard type of church by changing the prothesis and diaconicon into two chapels can be used as an argument against its presumed Mesopotamian origin.[116] Unlike the Mesopotamian churches, in the Coptic ones each chapel was always covered with a cupola. The idea of developing a row of contiguous chapels at the rear of the church could not have been alien to the Copt, who might have derived it from the contiguous shrines (three to nine) built in a row at the rear of Egyptian temples.

Some of the new foundations that derived from the modified basilican schemes emphasized a transverse choir as an entity (fore-choir) preceding the sanctuary, which was always quadrangular. The larger church at Philae[117] on a trapezoid perimeter could have been a simple pagan basilica that was later transformed into a church with quadrangular sanctuary and one row of columns, doubled with pillars in one row (north) or two rows (south) forming a western terminal aisle. The small staircase opening from the sanctuary and the position of two doorways north and south at the eastern end are not normal features. The building might be compared to the church at Bagawat.

A unique church in the monastery of St. Simeon at Aswan[118] (late tenth or eleventh century) may be described as having a trefoil sanctuary with three rectangular compartments, although the two opposing compartments could have been intended as a choir connected to the nave by a relatively narrow arch (3.2 m.). Flanking the central sanctuary covered with half-domes were the prothesis and diaconicon, and behind it a rear room, perhaps a variant of the corridor behind the sanctuary typical of Nubian churches. The nave (7.6 m.) was separated from its vaulted aisles by brick pillars. It has been implied before that the trefoil sanctuary with three quadrangular bays was adopted in monastic churches because it was so similar to the rear

114. *Paradise*, ed. and tr. by E. W. Budge, Vol. 1, p. 310.
115. S. Clarke, *Christian Antiquities*, pl. XXXVIII, pp. 126–129.
116. R. Krautheimer, *Early Christian and Byzantine Architecture*, p. 219.

117. S. Clarke, *Christian Antiquities*, pl. XXIV, pp. 89–90.
118. Ibid., pl. XXXI, pp. 101–102.

part of the chapels in rock-cut Egyptian tombs (Ipy, Djoi at Thebes) and temples (Re'Horakhty at Abu Simbel).[119]

A further stage in the evolution of the modified basilica featured a definite separation into transverse segments—the chapels, the choir, and the nave as at Deir Anba Bishoi (Wadi Natrun, ninth century; Fig. 2.60)—possibly followed by a stage with three squareish identical chapels and the subdivision of the nave into two square bays (Mari Boqtor at Naqada; Fig. 2.61).[120] This tentative distribution in time of the modified basilica should be checked by further archaeological investigation since the chronology of religious architecture after the Arab conquest is practically unknown. One date, however, should be taken into consideration: one of the mural paintings at Deir el Shuhada (Esna)[121] was inscribed 786.

The modified basilican plan was ultimately abandoned and replaced by the grid plan. Could the churches of the later type with apsidal chapels denote a lingering basilican tradition and be ascribed to an earlier date than the ones using squareish chapels? Deir Mari Girgis (near Akhmim; Fig. 2.62)[122] consisted of three contiguous apsidal chapels with niches fronted by screens (higāb) and two transverse series of domed bays separated by wooden screens between columns. Similar

arrangements were devised at Deir el 'Adra (Akhmim)[123] and Deir el Malāk Mikhail (Qamula).[124]

Whatever may have been the sequence, the grid plan with square bays was the only one used in rural churches in Upper Egypt and in the later churches in the Wadi Natrun monasteries. The simplified scheme of its design and construction, the shortness of its axial dimension, and the possibility for lateral accretion were the basic advantages that led to its adoption for small assemblies in limited space, as in the compact layouts of the fortified monasteries (Wadi Natrun). A typical example is Deir Theodoros (Tawdros, Medinet Habu; see Fig. 2.62),[125] where five contiguous chapels roofed with semicupolas are preceded by a choir of one row of domed square bays; a masonry screen separates the choir from a central transverse columned hall of two series of domed bays connected beyond a second masonry screen to the westernmost row of domed bays, which was used as the women's aisle. Similar churches are Deir Nag'el Deir,[126] Deir Bakhum (Pachomius at Medamud),[127] and in the Wadi Natrun Sitt Mariam (Deir el Suryan), Abu Iskhirun, and El Shuyukh (Deir Abu Makar).

Rural churches on this grid plan, roofed with identical cupolas, form probably the only type of Coptic architecture which is still carried on.

The Christian dogma of universal resurrection marked a liberal improvement upon the ancient Egyptian doctrine, for it did away with the restriction of resurrection to a well-preserved body kept alive through a funerary offering ritual. Several Christian texts speak of the "cemetery (lit. resting place) till resurrection."[128] Such a hope, a real boon for the poor, is expressed in an apocryphal saying of Jesus found written on a wrapping bandage in a burial in Oxyrhychos: "Jesus says 'Nothing is buried that will not be resurrected.'"[129] Yet it is another significant trait of the durability of Egyptian traditions that the Coptic monks of the sixth century who conversed with mummies undoubtedly did so in the belief that these mummies were living entities. Embalming persisted well into the Coptic period, though using less elaborate techniques and ingredients, for example, layers of berries and salt between linen bandages. The use of a wooden coffin painted with Christian symbols and beautiful ornamental patterns such as the one from Karāra[130] was exceptional. The method of bandaging mummies to form geometrical patterns and the use of the funeral bier derived from ancient Egypt, while the wooden plank upon which the body was often set in modest burials formed part of the Greco-Roman equipment. Whether the dead were interred in simple graves in the gravel or in mass burials, the bodies were as a rule placed with the head to

119. Alexandre Badawy, *L'Art Copte. Les Influences égyptiennes*, p. 4, Fig. 1.
120 S. Clarke, *Antiquities*, pl. XXXVII, pp. 123–126.
121. Ibid., pl. XXXIII, pp. 113–116.
122. Ibid., pl. XLII, pp. 142–144.

123. Ibid., pl. XLII, pp. 144–145.
124. Ibid., pl. XXXVI, pp. 121–123.
125. Ibid., pl. XXXIV, pp. 116–118.
126. Ibid., pl. XLI, pp. 140–142.
127. Ibid., pl. XXXV, pp. 118–120.

128. C. M. Kaufmann, *Handbuch der christlichen Archäologie* (Paderborn: 1913), p. 124. (Hereafter cited as *Handbuch*.)
129. H. C. Puech, *Revue de l'histoire des religions*, 147 (Paris: 1955), pp. 126 ff.
130. H. Ranke, *Koptische Friedhöfe bei Karâra* (Berlin: 1926), pp. 2 ff., frontispiece, pl. I. (Hereafter cited as *Karâra*.)

2.59
Plan of the church of Deir el Salib at Naqada,
(S. Clarke, *Christian Antiquities in the Nile
Valley*, pl. XXXVIII.)
2.60
Church of Deir Anba Bishoi in the Wadi Natrun.
(H. G. Evelyn-White, *The Monasteries of the
Wâdi'n Natrûn,* Vol. 3, Fig. 13.)

2.61
Plan and section of the church in Deir Mari
Boqtor at Naqada, (S. Clarke, *Christian
Antiquities*, pl. XXXVII.)

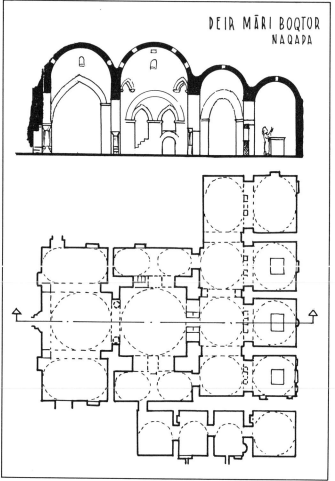

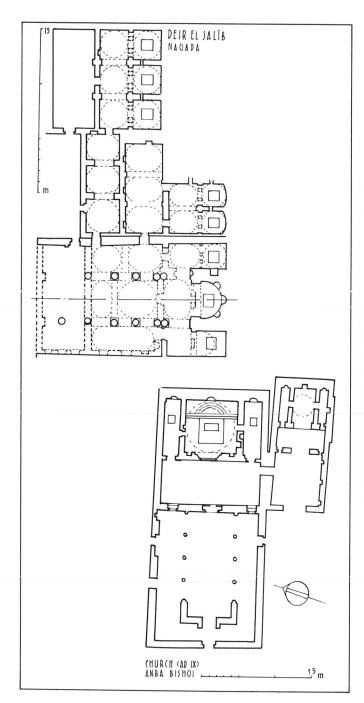

2.62
Churches of Deir Mari Girgis near Akhmim and
Deir Tawdros (Theodoros) at Medinet Habu. (S.
Clarke, *Christian Antiquities,* pls. XXXIV, XLII.)

2.63
Plan, Section, and detail of pilaster of the
catacomb at Karmuz. (F. Cabrol and H. Leclercq,
*Dictionnaire d'archéologie chrétienne et de
liturgie,* Vol. 1, cols. 1127–1138.)

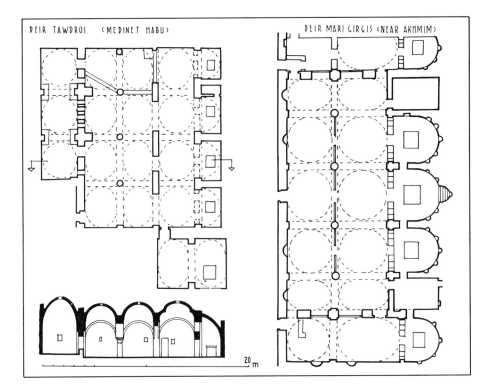

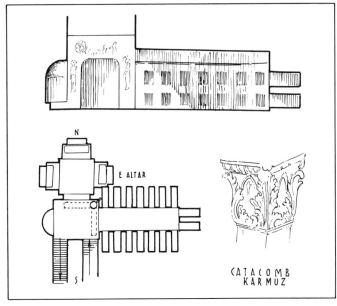

the west so that they could behold the first rays at sunrise. They were equipped with various items besides jewelry, such as a large ladle, a balance, needles, a writing set and papyrus, a weaving comb, vessels, and lamps. Both the orientation of the burial and its equipment are reminiscent of the ancient Egyptian creed regarding the afterlife. A similar persistence of pagan traditions is recognizable in the provision of the dead with prophylactic texts, such as a parchment (A.D. VIII) inscribed with a text from the so-called Peter's apocalypse.[131] While the Coptic custom of embalming, still occurring in the fourth century despite St. Anthony's preaching, could find some justification in the precedent of Christ himself, that of setting funerary equipment in the grave was certainly pagan.

Pagan tradition was also responsible for the types of funerary structures in catacombs and chapels. The early impoverishment of the Copts accounts for the simple graves forming the majority of burials, and the prevalence of Christian ideology led to the gradual disappearance of embalming (A.D. VIII) and funerary equipment, and the construction of relatively expensive chapels.

The most elaborate Christian catacombs occurred in Alexandria and proceeded directly from the pagan Greco-Roman ones in that city (at Kom el Shugafa), for they were in the same location in the native quarter of Rhacotis, and some even showed a mixture of pagan and Christian burials such as that of Abu el Hashem. In

general, however, the Christian catacombs were much smaller than their predecessors, and apparently originated as family catacombs. That at Karmuz (Fig. 2.63),[132] the only one about which anything was published before they were all destroyed at the turn of this century, consisted of a vaulted stairway of 24 steps leading down to the *cella memoriae* (4 × 6 m.) where the mourning relatives met for the *agapē*. An apse, its western wall covered with a plaster shell, had a bench along its base and was painted with a representation of Christ at the *agapē*. Opposite the exedra stretched a long hall (*cubiculum*) flanked by 32 loculi in two rows. The *cella* opened widely at the north onto a square room with a flat vaulted recess in three of its sides (*arcosolium*) according to a cruciform plan. Its walls were painted with remarkable scenes from the Christological cycle and with personifications, which will be analyzed later (Chapter 4), as well as with more figures and rosettes. In the northeast corner of its floor was a shaft that led to two lower rooms ventilated by vertical terra-cotta pipes connected to a channel cut in the angle of the rock chamber. A flight of steps parallel to the entrance stairway led to a lower, now inaccessible, story. It is noteworthy that the plan was designed after a unit occurring in the much larger pagan catacombs at Kom Shugafa (A.D. II). Contrasting with most of the vast catacombs[133] in Rome, Naples,

Syracuse, or Cyrene, those in Alexandria were characterized by their monumental layout featuring axial units connected to a central *cella*—a layout derived from the beautiful designs of Hellenistic and Greco-Roman Alexandrian tombs. In the Maryut the body of St. Menas had been laid in a catacomb that later building partially destroyed.

The catacomb was marked above ground by an "oratory like a tetrapylon." The shape of this superstructure was characterized, as its name implies, by a square room formed by a four-way arch similar to an *arcosolium* or a *baldachino* tomb (Malta)[134] or mausoleum (Syria)[135] adopted in Islamic tombs of saints (sheikhs). The funerary chapels where the relatives met on anniversaries soon became meeting places for the brotherly *agapē*, sporadically tolerated or forbidden by the imperial whim until the reign of Constantine, and were used as refuge during persecutions. This could have been the simplest typical *martyrion* (*martyrium*) similar to the basic elements in the funerary chapels of the Christian necropolis at El Bagawat (A.D. IV–VII) in the Kharga Oasis.[136] Here in a valley stretching north-south between two ridges sloping down to the south (500 × 200 m.) mud brick superstructures (about 263 in number) were built; these superstructures were often contiguous in one row opening east or west onto the valley, and some to the south but hardly any to the north. At the northern

131. S. Morenz, "Fortwirken altägyptischer Elemente in christlicher Zeit," in *Koptische Kunst* (Essen: 1963), p. 58.

132. T. D. Neroutsos bey, *L'Ancienne Alexandrie*, pp. 41–54. Cabrol and Leclercq, *Dictionnaire*, cols. 1127–1138. A. Adriani, in *Annuaire du Musée Gréco-Romain (1935–1939)* (Alexandria: 1940), pp. 128 ff.
133. P. Testini, *Archeologia Cristiana*, pp. 163–316.

134. C. M. Kaufmann, *Handbuch*, Fig. 13.
135. P. Testini, *Archeologia Cristiana*, pp. 299–300, Figs. 109–110.
136. A. Fakhry, *Bagawāt*.

end the large funerary basilica surrounded by a peripteros may have been the prototype for the façades of the chapels. One of the rooms of the chapel may have served as funeral banquet hall. The blind arcades on engaged columns recurring with some monotony could very well have imitated the arcaded colonnade forming the peripteros of the church (see Fig. 2.58), much as the façades of the funerary chapels in the Greco-Roman necropolis at Hermupolis West (Tuna el Gebel) imitated with their engaged columns, blind windows, cavetto cornice, and *torus* (the typical open façade of the Ptolematic temple exemplified on the site itself by the early mortuary temple of Petosiris.[137] The types of tombs at Bagawat (Fig. 2.64)[138] could be classified into (a) tombs built to imitate the shape of a vaulted sarcophagus with acroteria; (b) brick chapels, mostly with shaft burials, some sepulchers, consisting of one (No. 8) or two square, domed rooms. Both types might be fronted by a courtyard (No. 150) or an alley flanked by pillars (No. 7) or a porch (No. 252). Some of the better-built chapels were small basilicas with an eastern apse either protruding (Nos. 192, 206, 208) or within the rectangular perimeter according to the type of Coptic church (Nos. 66, 90, 117). There were a few circular chapels (Nos. 154, 181, 248) and an octagonal one (No. 213). The shafts oriented to the four cardinal points and reveted with brick or stone led down to a room for one or more burials still containing embalmed bodies. There might be more than one shaft in the larger chapels. The

type is reminiscent of the Egyptian shaft tombs.

As for the façades, at least one imitated an Egyptian elevation, both doorway and wall being crowned by a cavetto cornice (Nos. 30, 192) with angle pilasters (No. 8). Others varied from bare walls to the simple arch above the doorway, sometimes flanked by angle pilasters (No. 45), or more often with arcading (Nos. 7, 21, 23, 150) which could assume real sophistication (Nos. 66, 90), even forming a pyramidal (Nos. 71, 252) or a two-storied composition (No. 161). Blind arcading was also used in the interior of the circular chapel (No. 192) and the round peripteros with screen walls (No. 181). Some of the structures were roofed with ceilings or vaults, but most carried a cupola or spherical vault on pendentives reaching the spandrels of the shallow arched recesses in the four walls beneath. The brick measured 42 × 16 × 9; 40 × 15 × 8; 35 × 17 × 10 centimeters or 30 × 12 × 6 centimeters for cupolas. The cupola seldom showed above the skyline of the façades, which were topped with parapets (Nos. 71, 80, 258), a trait that proves the style aimed at the monumental effect of trabeated architecture. Several chapels were painted with unique murals from the Biblical cycle, allegories, and patterns of orthostats and floral motifs of Greco-Roman style, which will be studied later in this book (Chapter 4). In spite of many similarities, the necropolis of Bagawat differs from that at Hermupolis in its smaller scale, exclusive use of brick, arcaded style, and its repertory of murals, which, besides its Christian iconography, is

of a representational rather than a ritualistic character (as those in Hermupolis; Book of the Dead in House 21; Dionysiac mysteries in House 4). One dome (No. 211) featured on its cupola and nearest wall an ornamental pattern made from the bottoms of glass vessels and dishes applied to the plaster. Bagawat marks a transition stage from the late antique.

It is possible that this remote oasis was chosen by the Copts as their necropolis because of some affinity with its former religious history. It has been suggested that it was the seat of a monastic community occupying an agglomerate of structures at the northern end of the site[139] consisting of the earliest nucleus of the layout (Nos. 29, 30), double hall (No. 23), apsidal hall (No. 24), and later structures with a tomb chapel (No. 25).

Of little architectural interest are the mass burials, which are similar to Greco-Roman ones, though the Copts allowed for burials set over one another (Antinoë). Some were in lateral rooms at the bottom of deep shafts. At Oxyrhynchos some tomb chapels (No. 42) were small basilicas on rectangular perimeter. Its apse, flanked by two sacristies, was fronted by a choir separated from the body of the structure, which consisted of nave and aisles defined by four columns. The burials were in shallow graves in the central room. Stairs rose at the rear to an upper room or terrace. A low screen as a parapet delimiting the apse was painted to imitate an orthostat. The elaborate Corinthian capitals carrying impost blocks carved with a cross of Justinian type within a floral

137. Author's drawings in S. Gabra, *Hermoupolis Ouest*.
138. C. M. Kaufmann, *Handbuch*, p.163.

139. Ibid., pp. 227–228, Fig. 74.

2.64
Typical chapels at Bagawat. (A. Fakhry,
Bagawāt, Figs. 89, 103, 109, 114, 116, 123.)

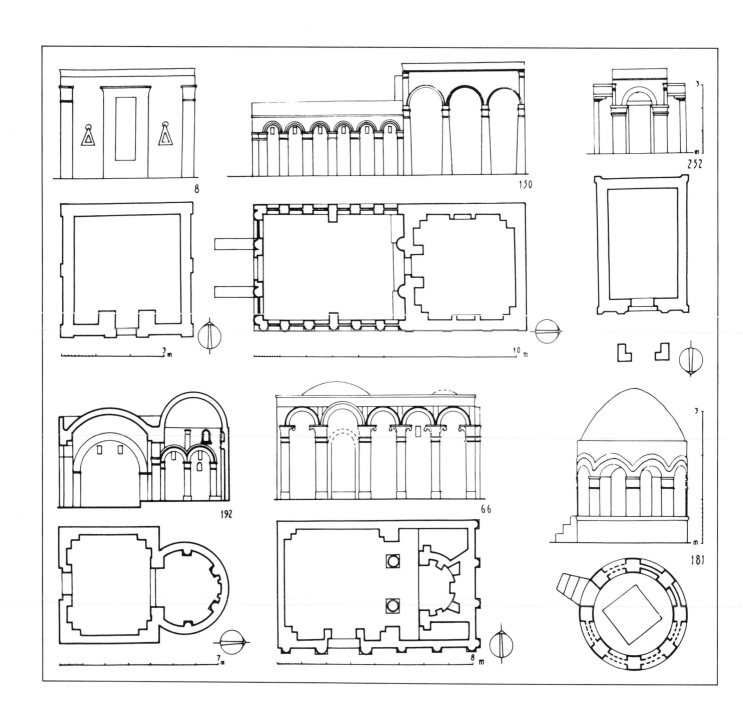

wreath and the floral friezes were of an excellent quality (Fig. 2.65). In other tomb chapels, one containing the remains of a painted dado with geometric patterns (No. 17) had subterranean chambers accessible from staircases enclosing the graves covered with a benchlike massif (Nos. 48, 36, 32, 17). A third and simpler design consisted of a vestibule and rooms with burials under benchlike masonry (Nos. 24, 27, 29, 30, 40).[140] The column in the middle of a broad doorway (No. 27) is reminiscent of that erected at the west end in the basilica at Luxor. Whether this column could be attributed to Syrian influence, possibly traced back to the *hilani* type of façade of North Syria, is controversial. These types of tomb chapels are similar to, but more developed than, those at Bagawat in their use of stone construction ornamented with sculpture rather than mud brickwork with painted decoration.

In northwest Alexandria a vaulted square chamber carved in the rock (3.24 m. sq.; 4.46 m. high) featured a central circular altar similar to the horned Ptolemaic type and ending in an axial apse flanked by two pilasters in colored mortar which carried Egyptian capitals with uraei. On the lower part of the apse was painted a bucranium with a garland on either side. Above in Greek was the dedication "Christ Jesus, son of God, Savior," and at the top within a tympanum formed by two curving wreaths were crosses and the Eucharistic symbols, a fish, a raised arm, and loaves.[141] One single loculus

never used and marked for sale opened on the right side.

Better, individual burials were in rectangular sepulchers in well-dressed masonry covered with a heavy stone slab beneath the pavement of a church as in the cemetery basilica in the Maryut (see Fig. 2.66).[142] Other burials in the south cemetery were large underground family chambers, accessible from a stairway of three to fifteen steps (4 m. deep), where three to four bodies, sometimes double that number, were set in two layers. Along the walls of one chamber (3.86 × 6 m.) ran a low bench. The scant jewelry, Menas ampulae, and lamps date the burials to the fifth and sixth centuries. In the northern cemetery the tombs were laid out in series at 0.5–2 m. depth and covered with from 4 to 7 slabs indicated by cippi, some in the shape of crosses.

In general the vast majority of Coptic burials were set in graves without coffins. At Antinoë[143] the earlier Byzantine tombs and the Coptic ones were at about 1.8 m. depth without any sign. The well-preserved body with ankles and wrists tied with ribbons was wrapped in a shawl, then given the shape of a mummy by stuffing bundles along the ridge of the nose, the breast, arms, and feet, and finally wrapped in as many as 15 or 20 layers of shrouds. There is no definite evidence that the plaster mask and painted portraits found there were Coptic and not

Greco-Roman. Among some 10,000 burials only those of Colluthus and Tissoïa were found in coffins. Several elements of the equipment in the tomb of Thaias dated it to the fourth century (0.8 × 2 m.; 0.6 m. high, at 1.8 m. depth). Such equipment pertained to pagan customs, for example the wickerwork basket for bread and the sheath for a goblet, indicating that the *agapē* was interpreted as an actual funerary repast in which the deceased partook; the rose between the fingers as symbolizing resurrection, the *crux ansata* with palms; and a gaming board.

At Bawit the earlier excavator could define three types of tombs.[144] On the mountain a shaft of the Egyptian type ending in an underground burial chamber was topped with a chapel. At the foot of the cliff the tombs were rectangular structures in brick, oriented North-South and sunken into the ground so that only their vault would emerge; they consisted of a higher room as *arcosolium* for the actual burial preceded by a second room that was reached through an aperture made in the tympanum and probably closed after the funeral by a stela. South of the monastery there were graves 0.3 to 1 meter deep, plastered to assume the outline of a figure at their bottom and roofed entirely or above the head of the burial with slabs. Some were topped with a chapel, others marked by a tall wooden upright held by a transverse bar at the bottom and inscribed with a short invocation but without name. From this type of simple grave came the majority of burials, the deceased often dressed in four tunics, some with very rich tapestry, then wrapped in one or

140. W. F. Petrie, *Oxyrhynchos*, pp. 16–18, pls. XXXIX-XLVII.
141. T. D. Neroutsos bey, *L'Ancienne Alexandrie*, pp. 76–78, Fig.

142. C. M. Kaufmann, *La Découverte des Sanctuaires de Ménas dans le désert de Maréotis* (Alexandria: 1908), pp. 146–149.
143. F. Cabrol and H. Leclercq, *Dictionnaire*, under Antinoë, Vol.1, part 2, cols. 2330–2337.

144. Ibid., Vol. 2, part 1, cols. 213–215.

2.65
Restored perspective of a funerary chapel
at Oxyrhynchos (No. 42) and details of its
sculpture. (W. F. Petrie, *Tombs of the Courtiers
and Oxyrhynkhos*,

2.66
Layout of tombs in the cemeteries at Karâra and
Djimē. (H. Ranke, *Koptische Friedhöfe bei
Karâra*, plan 2; U. Hölscher, *Medınet Habu, V,*
Figs, 60–61.)

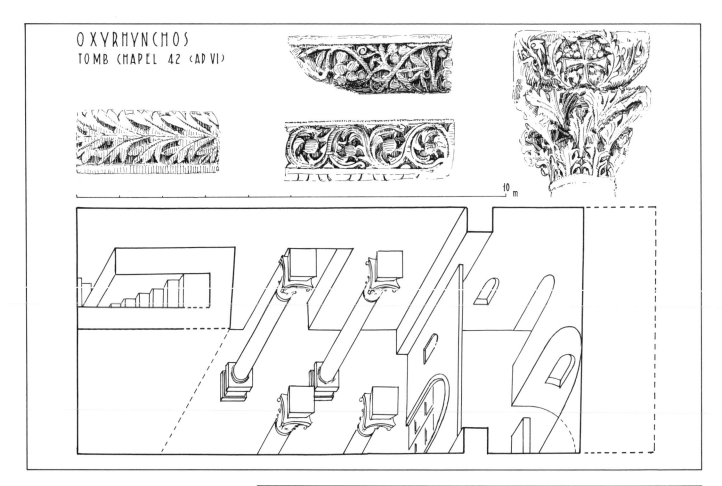

two white linen shrouds bound with palm fiber, the head being shaped into a rectangular mass by means of palm fiber piled over the face. The mummy-shaped body was finally wrapped in colored bandages in geometric patterns and set to rest with a few items such as lamps, a flat dish, crooked staff, and comb; bodies of women and children were adorned with bracelets and other cheap jewelry or trinkets.

At Karāra, on the east bank near Maghāgha (Fig. 2.66)[145] most of the graves in the two cemeteries (dated to the beginning of the sixth century) were for individual burials, 0.5 to 1 meter deep, some with two adults and a child; occasionally the graves were enclosed by a low brick wall, and one was built into an underground chamber with two compartments. The bodies were laid on their backs, close together, one upon another, and oriented with the head westward as at Kubania South, so that the deceased could see the sunrise—a reminiscence of a pagan creed already evidenced in the Middle Kingdom. The head was given a prismatic envelope of stuffing within a palm-frond or wood framework bound with colored bands (1–3 cm.) in a diamond or grid pattern and finally secured with cords, and the corpse was often set on a wooden plank shaped to the outline of a body. Sometimes the two large toes of the feet were bound together, possibly in an attempt to prevent the deceased from coming back, a fear expressed in ancient Egyptian customs and letters

to the dead. The funerary equipment showed variety and relative richness often adorned with Christian symbols. From Karāra comes the unique coffin dated from the fifth to the seventh centuries, made of wood with a flat vaulted lid and tall prismatic headroom (0.65 m.) painted on either slanting face with floral patterns, rosettes, and the symbolic elements of the cross and the peacock holding in its beak a chain of semiprecious stones. These splendid paintings will be studied later in this work.

At Djimē (see Fig. 2.66)[146] numerous graves were found outside the small church north of the girdle wall, oriented east-west or north-south. Three graves were lined in brick following the outline of a body; the space beneath the head was bridged with a headrest made of a board or bone, a device more elaborate than the bundle of palm fiber used at Karāra but still not as refined as the ancient Egyptian headrests.

A study of Coptic funerary architecture would not be complete without a survey of the funerary stelae with architectural motif,[147] an essentially indigenous invention with significant aesthetic achievement. Intended as a cheap substitute for the tomb chapel, it was shaped like a stone stela representing in relief the façade of such a chapel or oratory (Fig. 2.67). Its stylized architectural motif consists of two supports (pillars or columns) topped with a triangular or rounded pediment framing an

aperture, in which sometimes appear an *orant*, a cross, or other Christian symbols. The simpler motifs feature a triangular pediment (C.M. 8414, 8449) or arch on two angle columns (C.M. 8635, 8687), obviously a Greco-Roman element, and an arch or tympanum on angle columns (C.M. 8587, 8586) which had been known in the façades of Egyptian shrines. As for complex motifs, these offer a versatile composition of façades topped with triangular or curved pediments fronted by an arched doorway with pilasters (C.M. 8592, 8691), or of pedimented façades with angle columns or arcaded portico (C.M. 8672). Ornament is always used, with floral patterns as architectural modified moldings, sometimes very profuse, allied to other motifs. The idea of substituting a carved representation of a structure for the structure itself had an age-long tradition in Egypt,[148] where, for example, the false door represented the doorway through which the soul could emerge to partake of the offering ritual in the tomb chapel, the Abydian stela profiled as a vaulted funerary chapel was erected in the precincts of Osiris, and the palace façade stela was carved with a stylized plan of the courtyard and façade of the entrance gateway to the Pharaoh's palace. A three-dimensional representation of structure as in models of clay or wood, the so-called "soul houses," was also used in ancient Egypt and has survived at Armant and elsewhere down to modern times.[149]

145. H. Ranke, *Karâra*, pp. 2ff. Abel, ibid., pp. 16 ff.

146. U. Hölscher, *Medinet Habu, V*, pp. 56–57, Figs. 60–61.
147. Alexandre Badawy, "La Stèle funéraire Copte à motif architectural," *BSAC*, Vol. 11 (Cairo: 1947), pp. 1–25.

148. Alexandre Badawy, "La Stèle funéraire égyptienne à ouverture axiale, "*Bulletin de l'Institut d'Egypte*, Vol. 35. (Cairo: 1953), pp. 117–138.
149. R. Mond and O. H. Myers, *Temples of Armant*, pl. VI.

2.67
Typical Coptic funerary stelae representing
façades of churches and restored perspective of
two churches, (A. Badawy, La stèle funéraire
copte à motif architectural, *BSAC,* (Vol.11
[1947], Figs. 1, 2, 3, 5, 7, 14, 15.)

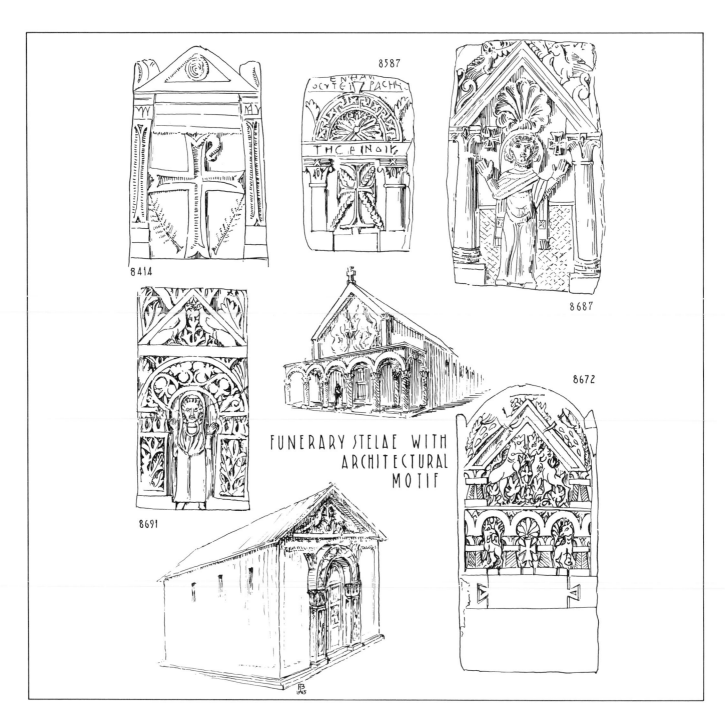

This discussion of military architecture pertains primarily to Byzantine fortifications in Egypt; there is very little Coptic work of this type, since the Copts never had to take the initiative in any warlike activity. Even the walls they flung around their monasteries after the Arab conquest were for defense against the raids of the Bedouins, which purpose they often did not achieve.

A long valley bordered on both sides by extensive deserts did not require a continuous belt of fortifications such as the Byzantine *limes* in northern Africa.[150] There were, however, the usual fortified cities (*polis*), capitals of pagarchies, and the forts (*castrum* or *fossatum*) built at shorter intervals, sometimes near a hamlet. The approach to the diocese of Egypt from the northeast border was guarded by fortified cities isolated near the coast along the route to Syria; these included Klysma, Rhinocolura, Ostracina, Kasion, and Pentaschoinon. Ostracina (Ostrakinē)[151] in the eastern desert had a citadel probably built by Justinian. Surrounding the citadel was an enclosure wall on a pentagonal plan (c. 275 m. east-west) which consisted of a concrete filling reveted with dressed stone in regular courses (c. 0.4 m. high) as stretchers with occasional headers. This enclosure (1.85 m. thick) was reinforced after the Egyptian method with horizontal balks of timber.

The actual line of fortifications, however, most akin to a true *limes* con-

sisting of a double row of castra and several *poleis*, followed the edge of cultivated land of the Delta to its apex, where the *polis* of Heliopolis and the castra of Antonias and Babylon marked the strategic key to Egypt. The invading armies of both the Sassanian Persians (617) and the Arabs had avoided crossing this *limes* into the inextricable mesh of canals, preferring the itinerary Pelusium-Babylon-Nikious-Alexandria.[152]

An etymological explanation of the name Babylon[153] traces it to the Greek phonetic rendering of Per-Ha'py-ēn-Iwnw, "Nile House of Heliopolis," the ancient Egyptian fortress which stood on the site. To differentiate it from the Mesopotamian city the Copts called it Babylon ēn Kēmi, "Babylon of Egypt," and the Arabs Qasr el Kemi, whence its modern name Qasr el Sham'. Another explanation of the name is that the fortress built by Trajan (c. 100) as a citadel on the east bank of the Nile, opposite the south end of Rodah island and Persis (modern Giza) on the west bank was meant to replace the earlier Babylonian settlement Al Rasad to the south. The name Babylon in turn was borrowed by the extensive town spreading north, probably as far as Heliopolis.

A mosaic pavement in a Byzantine structure (sixth century, now destroyed,

Fig. 2.68) from Umm el Munabia' in Jordan represented to the left a personification of the Nile *Nilwc*, in the middle a Nilometer column inscribed in Greek letters with levels eleven to eighteen (cubits), and to the right between two battlemented towers a multi-storied apparently hexagonal structure roofed with a dome with a rosette lantern. Below was represented the river bank with a sailboat and fish. The building labeled *Egyptwc* has been interpreted because of its context as El Mu'allaqa ("The Suspended") church at the Harbor Gate. Another mosaic map from Haditha in Palestine represents a bird's-eye view of three structures, two gabled and one domed, within a polygonal wall fortified by six towers. The arched gateway opens between two towers in front of the end of a canal from the riverbank and is inscribed *Egyptoc*. Here has been recognized the Christian fortress Babylon-Egyptos, chosen in the mosaic maps of Byzantine cartography as the most characteristic element to represent Egypt.

The fortress, rebuilt by Arcadius (395), sadly ruined at the turn of the century, consisted of walls battered externally, of stone courses alternating with brick (c. 2.75 m. thick; brick course 0.33 m.; stone course 1 m.) bound with a mortar of sand, lime, pebbles, and charcoal. The type of building construction is known during the tetrarchy (c. 300). These walls probably reached 20 meters in height and were on an irregular five-sided layout (Fig. 2.69); they had no bastion on the west along the Nile but two massive circular towers (c. 33 m.

150. J. Maspero, *Organisation militaire de l'Egypte Byzantine* (Paris:1912), pp. 17–42. (Hereafter cited as *Organisation militaire*.)
151. J. Clédat, "Flousiyeh."

152. A. J. Butler, *Arab Conquest*, pp. 238–248, plans 1, 2. *Coptic Churches*, Vol. 1, pp. 155–181.
153. A. Hermann, "Ägyptologische Marginalien zur spätantiken Ikonographie," in *Jahrbuch für Antike und Christentum*, Vol. 5 (Münster, Westphalia: 1962), pp. 79–91. The mosaics are published in Fig. 10 and pl. III.

2.68
Sketches of two mosaics representing Babylon.
(A. Hermann, "Ägyptologische Marginalien zur
spätantiken Ikonographie," in *Jahrbuch für
Antike und Christentum*, Vol. 5 [1962], Fig. 10,
pl. III.)

2.69
Sketch plan of the Roman fortress at Babylon,
(A. J. Butler, *The Arab Conquest of Egypt
and the Last Thirty Years of the Roman
Dominion*, plans 1, 2.)

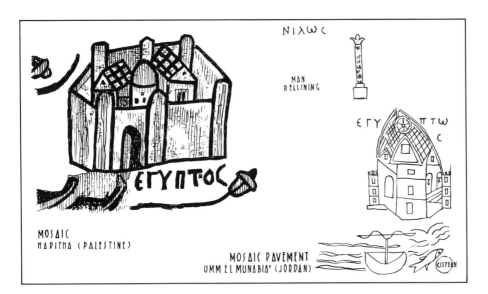

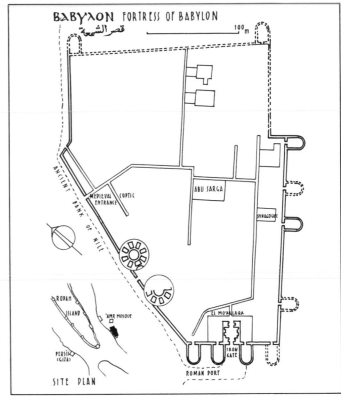

in diameter), rising higher than the walls, built of two concentric rings connected by radiating walls forming eight rooms roofed with brick vaults, the southernmost containing the staircase. A central shaft sank to the sewer. No trace has remained of the gateway between the two towers, but it must have been similar to the south gate, which was flanked on either side by two boldly projecting bastions. This was the Iron Gate of Arab legend, still used in 1400, and provided with a portcullis shutting the entrance from a quay graduated with steps along an artificial inlet forming a port. It is above this gateway that the church of El Mu'allaqa was built, hence its Arabic name "The Suspended." On the eastern side there were at least four bastions. The fortress was surrounded by a moat with drawbridges. Its strategic position governed the intake of the canal of Trajan, blocking the narrow neck of the valley in conjunction with the strong fortifications of walls and towers on Rodah island which were torn down by the Arabs of 'Amr but rebuilt by Ibn Tulun (876). In the fortress were three of the earliest churches: Abu Sarga where bishops were consecrated, El Mu'allaqa, and the one transformed by the Jews into a synagogue pulled down at the turn of the century. There was also a Nilometer in Deir el Banāt.

A continuous chain of fortresses fronting the fortified cities stretched along the frontier with the two eparchies of Libya. Justinian repaired the capital Paraetonion and several cities and forts including Antipyrgos, Teucheira, Berenikē, and Ptolemais. On the southern boundaries of Egypt, where the Nile

gulley encased between two granite banks was easier to control, there were the *polis* of Philae restored in 577, the castra of Elephantine and Aswan, and perhaps even the monastery of St. Simeon. Farther south in Nubia, converted to Christianity in 543, towns were fortified with rubble walls, such as the enclosure walls of Ikhmindi,[154] which could be Roman and consisted of two facings of rough stonework enclosing a core of well-laid, presumably Egyptian, brick.

As for fortifications in the cultivated land, records mention those of Thebes, Panopolis, Antinoë, Herakleopolis (Ahnas), and Oxyrhynchos (Bahnasa), the guardian city of the Fayum with crenellated towers that withstood a long siege by the Arabs (according to Futūḥ el Bahnasa). The Byzantine rampart stretching west of Tell Edfu (see Fig. 2.4)[155] was only partly excavated and consisted of a wall in mud brick (3 m. thick) with semicircular bastions (4–4.5 m. in diameter) spaced 13.5 meters. The two facings, external and internal, feature alternate courses of headers and stretchers set perpendicularly to them. The bastions had foundations reaching 1.5 meters deeper than those of the enclosure and were reinforced internally by a retaining wall parallel to that enclosure.

Coptic towns do not seem to have been surrounded by properly fortified enclosures. At Djimē the two towers that had been built in the Roman period at the northwest and southeast corners

of the temple were no longer standing, but an attempt to prevent access into the closely crowded settlement was made by building on the old enclosure tall, contiguous houses whose outer façades without openings formed an obstacle overlooking the precipitous ground around the settlement.[156] Such a slight obstacle as the unfortified enclosures of the monasteries proved useless against the harassing raids of Bedouins, and the main buildings of each monastery, as exemplified by those in the Wadi Natrun, were surrounded by a brick wall approximately 2 meters thick and 10 meters high; the wall had a battered external face, one or two gates, and was lined along its bottom with limestone (see Fig. 2.16). These gates were shut with massive doors seldom opened, and the monks, provisions, and even visitors were brought up in a basket by means of a winch to a hatch in a machicolated chamber above the entrance. Just inside the gate and accessible from the enclosure by a drawbridge stood a square keep (Arabic *qasr*) three or four stories high with battered faces and few windows and slots (see Fig. 2.19). The inner arrangement has been described before in the section on monasteries, but a remark should be added about the occurrence of so-called light shafts adjacent to the staircase (at Baramus) or in the thickness of the wall (Suryani) which could have served as an earlier means of ascent with a succession of ladders floor to floor, later replaced by the stairs.[157] It has already been noted

154. S. Clarke, *Christian Antiquities*, p. 82. U. Monneret de Villard, *La Nubia Medioevale*, Vol. 2, pls. XXVI-XXX.
155. M. Alliot, *Tell Edfou*, p. 11.

156. U. Hölscher, *Medinet Habu*, V, p. 45.
157. H. G. Evelyn–White, *Monasteries*, pp. 232–233, pl. LI.

(p. 50) that the keep within a high enclosure could well have been imitated from the Egyptian royal castle or the mansion in the country (Fig. 2.70), which possessed both elements.

Little is known about the technical details of the fortifications of Alexandria, apparently built with much skill, doubled with ramparts, towers, and bastions; but they still inspired medieval travelers with admiration,[158] despite their partial destruction by 'Amr when he defeated Manuel (645).[159] According to the tradition recorded by El Baladhuri that El Muqawqas during the siege by 'Amr ibn el 'As ordered the women to stand with the men on the top of the walls but looking inward, it can be inferred that the walls were so tall and remote beyond scarp and counterscarp that the strategem could not have been discovered by the besiegers. It seems from an anonymous Syriac chronicle that a fortified wall ran along the shore as at Constantinople, accessible as was the shore itself from gateways, a system akin to that described by Abu Sālih (fol. 56b, end of twelfth century) for Rhinocolura. According to the chronicler John of Nikious a canal was cut by the prefect Tatianus (A.D. IV) branching southward off the main southern canal which flowed along the girdle wall and passed in the quarter of Brouchion through two mighty gates in stone. As a result Alexandria was an island completely surrounded on its four sides by water and beyond by a chain of forts (castella),

three of which were known at the date of the Arab conquest (Helwah, Qasr Faris, and Kopreon).[160] The only practicable route to Alexandria between the marshes of Abukir and the Mareotis was guarded by the castrum of Khairon, which withstood the Arabs' siege for 20 days. This picture of the fortifications of Alexandria explains why El Suyūti described it as an invincible place; in fact, the Count of the East Bonōsus could not enter it (610), and Nicetas (609), the Persians, and ultimately the Arabs were able to enter only with the help of traitors.

A large castrum was built by Diocletian around the temple of Amun at Luxor.[161] Its north façade (410 cubits or 214 m.) was in a line with that of the pylon of Ramses II. At each end was a square angle tower, and between the latter and the pylon opened a gateway flanked by two boldly projecting round towers, each with a postern leading onto a circuitous passageway to the vestibule behind. This plan is identical with that of the gates in the castrum at Babylon. Similar towers stood in the girdle wall. A larger gate opened in the eastern side onto a colonnaded street (15 cubits or 8 m. wide between the colonnades) whose south side was in a line with the façade of the court of Amenhotep III. It crossed a similar street coming from the east gate in the north façade of the castrum. The crossing was marked by a tetrastyle with four-column bases inscribed in Latin by a certain Aurelius Maximinus to the two Augusti, Licinius

and Galerius, and to the two Caesars, Constantius and Maximin Daia. The obliteration of the name of Maximin Daia must have been the work of Licinius in 308–309. From the western gate in the north façade a colonnaded street flanked on either side by mud brick walls ran southward and crossed a transverse street leading from the court of Ramses II to a gate in the western side of the girdle wall, outside which stood a Nilometer (Fig. 2.71). At the crossing was a tetrastyle on a platform at the same level as the court of Ramses II, similar to the one in the eastern part of the castrum, with four bases inscribed in A.D. 300 by Aurelius Reginus to Diocletian, Maximian Herculeus, Constantius Chlorus, and Galerius. The south area of the castrum was not excavated, but the fact that the gate in the eastern side opens at midlength of the temple strongly supports the presumption that the length of the castrum from north to south corresponded to it (500 cubits or 260 m.). The south side of the girdle wall was probably in a line with the end of the temple. The system of the two main streets with colonnades running parallel to the sides of a square girdle wall and crossing at right angles under a tetrapylon or a tetrastyle is typical for Hellenistic town plans in the east, as at Palmyra, and was borrowed by Roman urbanism in North Africa as at Thamugadi, Lambaesis, Volubilis, and in the west as in the palace of Diocletian at Spalato.

The main gate in the north side of the girdle wall must have been that of the temple itself. There was no cult ritual

158. A. J. Butler, Arab Conquest, p. 399, n. 1.
159. S. Lane-Poole, History of Egypt p. 21.

160. J. Maspero, Organisation militaire, pp. 35–39.
161. U. Monneret de Villard, "Temple of the Imperial Cult," pp. 85–105, pls. XXX–XXXIV.

2.70
Model of an estate with residential tower from the Middle Kingdom (left), and model of a multistoried town house from the Greco-Roman period. (Ahmed bey Kamal, in *ASA*, Vol. 2, p. 31: R. Engelbach, "Four Models of Graeco-Roman Buildings," *ASA*, Vol. 31, p. 130.)

2.71
Restored plan of the castrum embodying the temple at Luxor. (Diocletian's reign; U. Monneret de Villard, "The Temple of the Imperial Cult at Luxor," *Archaeologia*, Vol. 95 [1953], pl. IV.)

2.72
Plans of the late Roman fortresses at Dionysias and El Kab. (A. Badawy, "Fouilles d'El Kab [1945–1946]. Notes architecturales, "*ASA*, Vol. 46 [1947], Fig. 32; author's plan in J. Schwartz, "Die Römische Basilika als Vorbild Koptischer Kirchen," in K. Wessel, ed., *Christentum am Nil* [1964], p. 201.

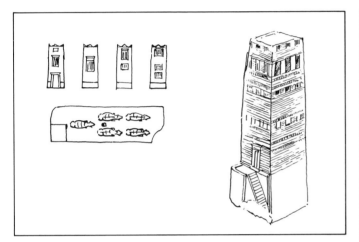

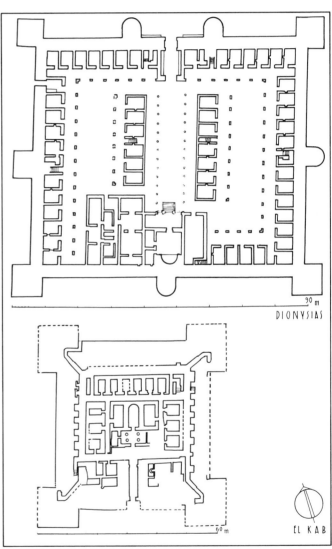

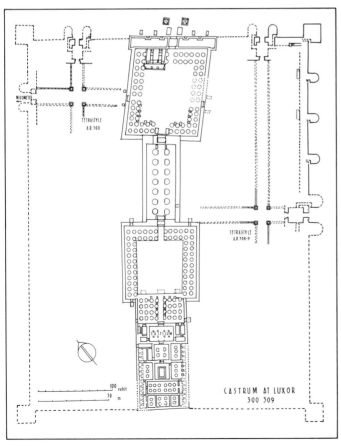

performed any longer, but the Romans transformed the open hypostyle hall of Amenhotep III into a basilican approach lined with statues of Constantine and Galerius to the *sacellum* of the legionary insignia, the sanctuary of the *genius castrorum* installed in the pronaos of the temple as elsewhere in the south center of the castrum (Lambaesis, Dionysias). The walls of the *sacellum* were painted with murals representing a procession in honor of the Emperors portrayed in the niche built at the back to block the doorway to the sanctuary (see Graphic Arts, pp. 233–236). The Arabic name El Uqsur, "the castles," or El Uqsurein, "the two castles," might well have defined the two parts of the castrum flanking the temple.

An adequate idea of the typical small castrum in Byzantine Egypt can be gained from those surveyed and studied by the author at El Kab[162] and Dionysias (Qasr Qarun)[163] (Fig. 2.72). It is a square structure with massive mud brick walls (53 × 51.5 m. at El Kab; 70 × 83 m. at Dionysias), fortified at its four corners with square towers and sometimes with additional rounded bastions in the middle of each side and flanking the gateway (Dionysias). The plan is axial, consisting of a deep entrance passageway bordered by

benches (Dionysias) opening on to the *pomerium* running along a series of cells within the thickness of the enclosure (El Kab) or abutting it on three or four sides (Dionysias). The central area features the axial *via porticata* (as at Spalato) of the *praefectus castorum* fronted by a columned transverse hall (El Kab) or leading through a long room probably open to the sky and flanked by two colonnades to a stairway rising to a bema ending in a rear apse (Dionysias). On either side is a row of contiguous rooms and also a long courtyard (Dionysias). It is noteworthy that the construction of the contiguous cells features L-shaped walls with one niche abutting on the inner face of the enclosure, a system reminiscent of the ancient Egyptian towns for artisans ('Amarna East) and probably imitated in the Coptic monasteries. We know that in the Pentapolis, and probably also in Egypt, monasteries were fortified to serve as castra.

The style of Byzantine fortification in Egypt was strongly echoed in Coptic architecture, in the design and layout of the cells of monasteries, their fortified enclosures, and in the type of basilica adopted as the original church of the earlier period. The theory advanced recently[164] that the earlier churches of Egypt (A.D. IV) proceeded from those in North Syria, themselves imitations of the basilicas in Diocletian's castra there, seems futile when one considers that Egyptians had invented the hypostyle hall whose simplest type, as exemplified in the rock-cut tomb chapels from the Middle Kingdom, forms an indigenous axial plan, with

nave and aisles separated by two rows of columns and a rear shrine, very similar to that of the early basilica.[165] The replacement of the quadrangular shrine, though maintained in many of the Coptic basilicas, by an apsidal one was a simple concession to the Greco-Roman fashion in pagan tomb chapels (Hermupolis, Mustafa Pasha).[166] In some of the castra reused architectural elements from Greco-Roman or even earlier Hellenistic structures such as the beautiful capitals in the basilican hall at Dionysias were certainly seen and admired by Coptic artisans and could well have been activating factors in the development of monastic sculpture in Coptic Egypt.

In contrast to Coptic towns, those in medieval Nubia were always fortified with walls battered on their external face, and with angle bastions and towers built in dry rubble parallel to the Nile bank or perpendicular to it. The main gateways in the north and south sides were accessible through a bent-up approach reminiscent of those in ancient Egyptian fortified enclosures.

162. Alexandre Badawy, "Fouilles d'El Kab (1945–1946). Notes architecturales," *ASA*, Vol. 46 (Cairo: 1947), pp. 357–371. "L'Art Copte. Les Influences hellénistiques et romaines," p. 174.
163. Author's plan in J. Schwartz," Die Römische Basilika als Vorbild Koptischer Kirchen," in K. Wessel, ed., *Christentum am Nil* (Recklinghausen: 1964), p. 201.

164. Ibid., pp. 200–206.

165. Alexandre Badawy, *L'Art Copte. Les Influences égyptiennes*, pp. 2–3.
166. A. Badawy, "L'Art Copte. Les Influences hellénistiques et romaines," pp. 160–163.

Nowhere in the art of Christian Egypt do we find such sharp contrast as between the building construction of a program sponsored by Byzantium and that of a native program. In the religious complexes favored with imperial help as in the Maryut, in urban settlements, in marginal districts like Ostracina, or even in major castra like Babylon, stone was the predominant material, either local varieties of limestone or imported marbles. Larger walls consisted of a concrete core (enclosure in Ostracina citadel) faced with large stone slabs set with plaster in regular courses 0.40 meter high. Ordinary walls (.4–.5 m. thick) were formed of two abutting facings of ashlar masonry with plaster mortar and occasional headers to secure bonding.[167] Columns, bannisters, and other architectural elements in religious structures were of white marble. Sometimes even small rooms were revetted with slabs held in place by iron nails. Floors were of marble mosaics, black and white or polychrome. Mosaics of glass cubes after the Roman technique covered cupolas (Maryut, Saqqara). Similar materials and methods were used in the Maryut.[168]

Byzantine castra (El Kab, Dionysias) and fortified enclosures (Tell Edfu)[169] were of mud brick, except Babylon, which was built of ashlar masonry and baked brick. Occasionally stone blocks from an Egyptian temple were reused in a wall around a town (Armant).[170]

Timber was still imported and could have been used in gable roofs on trusses over large halls and churches, though wide-spanned ones seem to have been hypaethral (Medinet Habu, Sohag).[171]

The majority of religious projects, hospitals, and monasteries, however, even in the early period, were the result of private initiative, usually the Church. "Building for eternity," as sought by the ancient Egyptians, was not the aim of Coptic architects, and even Shenute's euphoric description of his monastery near Sohag, "This monastery is Jerusalem," can hardly be interpreted in terms of perpetuity. Still less could such an incentive have been allied with Pachomius' deliberate attempts to avoid perfection in architecture, even to laying out his buildings on crooked plans. Local stone, possibly from destroyed temples, or eventually baked brick (Deir el Ahmar, Hermupolis, Antaepolis, Saqqara)[172] were chosen for the churches themselves (Armant, Deir el Abiad, Dendera, Saqqara), while other structures were of brick roofed with vaults or cupolas. Tie beams carried the architraves (Sohag), and reinforcing beams carved with ornamental friezes were set flush with the stone walls, perhaps more in an aesthetic pursuit of unity in the composition than for structural purposes (Bawit).

In the later period, especially after the Arab Conquest when available build-

ing materials were reduced to local varieties, even large structures were entirely built of mud brick, plastered and painted (Upper Egyptian churches, Old Cairo churches, Wadi Natrun monasteries). Occasionally, however, plaster was worked into ornamental panels in openwork and beehived technique (Deir Suryan) or in openwork window panels holding stained glass. Baked brick was reserved for elements subject to damage from wear (treads of steps and bottom courses at Armant; Fig. 2.73) or from fire and damp (room and socles of water-jug stands at Djimē). Stone slabs were sometimes used as structural elements in brickwork (lintels, sills, doorjambs, treads, door sockets at Djimē and Armant). Ornament still employed carved stone elements set in the brick walls (consoles, capitals, or pilasters at Djimē). The batter given to walls, enclosures, and keeps, whether of stone (Deir el Abiad) or brick (Deir el Ahmar, Wadi Natrun, St. Anthony, St. Paul), the palm logs channeled as waterspouts at the top of the walls (Wadi Natrun, St. Anthony, St. Paul), the stairs rising over vaulted recesses or cupboards, the prevailing laminated vault of catenary curve, not to mention the universal use of mud brick sometimes reinforced with timber balks— all were remnants of ancient Egyptian methods.

Mud brick, however, had gradually deteriorated into smaller molds of lesser quality of mix (increase of chaff and organic detritus) from the Egyptian, through the Greco-Roman, to the Coptic periods, according to the evidence found in sites of continuous occupation such as Medinet Habu. Here are

167. J. Clédat, "Flousiyeh," pp. 14–15, 18 ff.
168. A. Badawy, Premières églises, pp. 330–331.
169. M. Alliot, Tell Edfou, p. 11.
170. R. Mond and O. H. Myers, Temples of Armant, p. 10.

171. H.-C. Evers and R. Romero, "Kloster bei Sohag," pp. 175–199.
172. A. C. Johnson and L. C. West, Byzantine Egypt: Economic Studies, p. 108

2.73
Typical brick bonds in Coptic structures. (M.
Alliot, *Rapport sur les Fouilles de Tell Edfou
(1932)*, p. 5; R. Mond and O. Myers, *Temples
of Armant*, pls. XXXIV–XXXIX.)

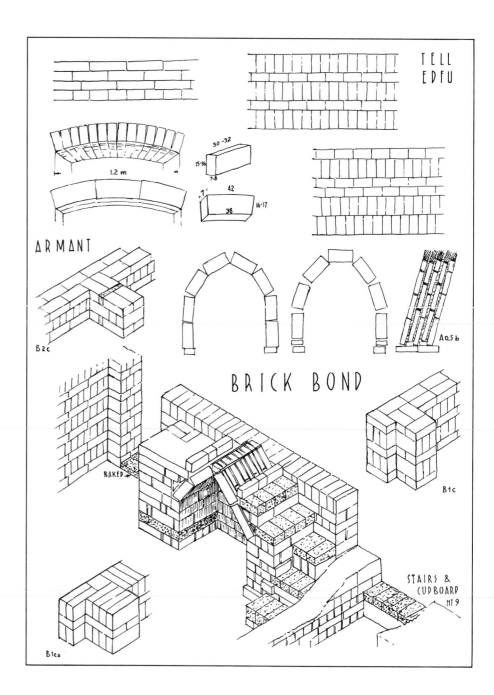

some typical dimensions from two Coptic towns:

Djimē: 30 × 14 × 6; 31 × 15 × 7 centimeters;
Tell Edfu: 30–32 × 15–16 × 7–8 centimeters; 27 × 12 × 7 centimeters; 29 × 14.5 × 7 centimeters.

The usual brick bond (see Fig. 2.73)[173] was, however, more varied than in the Roman period and featured bricks laid horizontally as headers or stretchers, or bricks laid horizontally which alternated with bricks on edge transverse to the wall face. Vaults were built of special curved bricks placed parallel to the face of the vault as in Roman construction or of ordinary bricks set radially. Vaults sprang from a ledge at some height above the floor, and the vacuum between their extrados and the core was filled in, as in the splayed-out joints of radiating arches, with sherds, gravel, and earth, which weakened the structure. Besides mud plaster for ordinary walls, waterproof cement made of pounded red brick and lime mortar or charcoal and lime (Babylon) was used in hydraulic structures like baths (Tell Edfu), water reservoirs (Armant, Saqqara), and water-jug stands (Djimē). Occasionally the harder variety of mortar for baked brickwork was also used in mud brick arches for quick setting (Armant). Ventilation was supplied by small windows (0.2 × 0.4 m. at Djimē) opening high in the walls, often reduced

to splayed apertures given steep sills for protection (Wadi Natrun), or to mere slots in the walls (Djimē), and by terra-cotta pipes in the crown of vaults and domes (Djimē, Tell Edfu, Wadi Natrun). Terra-cotta pipes (Bawit) in tronconical sections luted together (Saqqara) or channeled stone blocks (Saqqara) and terra-cotta jars sunk in the floors of courtyards and rooms (Bawit) provided a simple system of drainage. Small pieces of local wood (acacia, sant) formed shelves in cupboard niches (Djimē, Bawit), beams under steps (Armant), and brackets (Djimē, Bawit). Coptic master builders still used the royal cubit[174] inherited from ancient Egyptian metrology.

Except for the early basilicas roofed with timber, the large halls were covered with brick vaults of the ancient Egyptian catenary, barrel, or flat curves.[175] The plan was even adapted to that method of roofing consisting of one or more narrow long halls, a characteristic most obvious in the refectory or guesthouse of the later monasteries (Bawit, Wadi Natrun, Aswan). The use of small vaults abutting on the very large ones at mid-height of their extrados for shoring (Aswan) is perhaps reminiscent of Sassanian methods, though the accuracy of this suggestion can only be relative in the absence of adequate evidence concerning ancient Egyptian large vaults. Small rooms of squarish plan were covered with cupolas of various forms, such as domical vaults where the curved surface of the cupola

blended with the walls carrying it or a true cupola on spherical triangular pendentives or on squinches. The occurrence of a brick dome on fully developed spherical triangular pendentives in the substructure of the church of Period IV at Abu Mina (c. 400) and of squinches supporting the half-dome in the chapel of the crypt (c. 415) proves that both were familiar in Alexandria in the fourth and fifth centuries, and probably had been carried on from native craftsmanship in Roman Egypt. Squinches occur in the Greco-Roman funerary chapels at Hermupolis West. Roofing with rows of contiguous identical cupolas created the grid type of plan characteristic of the period after the Arab conquest. As columns could not take the relatively heavier load of the cupolas, they were encased in brick pillars, which became the regular type of supports in later Coptic structures.

The vertical edges of façades were sometimes reinforced with stone blocks after a Greco-Roman technique inherited from ancient Egypt (Old Kingdom). From the method of placing an architrave over timber beams (Deir el Abiad, Deir el Ahmar) could have evolved the use of relieving arches over the spans between the supports (El 'Adra at Haret Zuweila) and ultimately the reduction of these timber carriers into ties (Abu el Sefein, at Haret Zuweila) characteristic of Byzantine construction.[176] Floors were of rammed earth plastered, or of red brick set in a herringbone pattern (as in Greco-Roman construction), or of

173. M. Alliot, Tell Edfou (1932), p. 5. R. Mond and O. H. Myers, Temples of Armant, pls. XXXIV-XXXIX.

174. Ibid., p. 39.
175. Alexandre Badawy, L'Art Copte. Les Influences égyptiennes, pp. 11–13.

176. Alexandre Badawy, "L'Art Copte. Les Influences hellénistiques et romaines," pp. 175–184.

flagstones set longitudinally (Sohag, Saqqara), transversely (Saqqara), or parallel to the alignment of the apse of a church (Deir el Ahmar). Sometimes ornamental compositions in the pavement emphasized the important crossings (sanctuary at Deir el Ahmar).

It has been shown how Coptic architecture answered the needs of urban and rural populations for towns with town houses, shops, churches, and cemeteries, and the needs of religious communities for monasteries with cells, oratories, workshops, monastic churches, and chapels. This achievement covers only a segment of the normal architectural requirements of civilization, for both town planning, palatial and military architectures are not represented. But Coptic civilization was abnormal in this respect, since it started as an offshoot of the late antique civilization in Egypt and never benefited from the enlightened control of a local dynasty. The large Greco-Roman towns were admittedly still endowed with monumental features, though the later additions were of poor scale and style. Their colonnades, tetrapylons, cisterns, and fortified girdle walls on the model of Alexandria were allowed to crumble away. The only military works, and these on a very restricted scale, were the *qasr* and the girdle walls that the monks fortified against the raids of Bedouins.

Yet this achievement, deficient as it was, produced a style of its own; and insofar as the value of an architectural style lies in its correlation to function, that of Coptic architecture ranks high, for it is essentially functional. It was adapted to the needs of an impoverished community to whom truthfulness to faith often meant persecution and, except under the Fatimids, nearly always discrimination. It is, indeed, to the credit of the Coptic architect that he succeeded in creating independently from Byzantium out of very inchoate means such a functional style that at its best (the church at Dendera, architectural sculpture) is endued with as much aesthetic quality as the best Byzantine one; this in spite of erratic factors such as Pachomius' banning of aesthetic pursuits in architecture. The success of Coptic architecture is as much due to creative inventiveness as to the borrowing, often unconsciously, from a rich Egyptian and late-antique heritage.

Coptic towns grew over Egyptian sites or remains of towns, and their unexpected regularity could as well be an Egyptian or a late-antique heritage. The continuous façades of contiguous houses are not a new feature, though the steps intercepting the narrow slanting streets (Djimē) reminiscent of Asia Minor and the Byzantine girdle walls (Edfu) or rows of houses arranged on the fringes of the urban settlement (Djimē) are original solutions to vital problems. In this rainless climate the water supply is drawn from the same immemorial sources as elsewhere in the Near East: a canal (Edfu, Ostracina), a water wheel (Armant), or once even an ancient Egyptian well of Ramses III (Djimē).

The Coptic monasteries and the artisans' towns built by the Pharaohs have much in common: the layout of their streets running north-south and east-west, though with less regularity in the Coptic settlement; the contiguous houses of a uniform plan oriented north-south at Saqqara (as in Egyptian Lahun) or east-west at Aswan (as Egyptian 'Amarna), with stairs to an upper floor, their niches in the oratories

(as the house altars at Deir el Medina) and the zoning system for workshops and storerooms with the latrines located at the southernmost edge (Kellia, Saqqara, Aswan). Other elements reminiscent of ancient Egypt pertain to ornament, such as the extensive murals on the walls of cells and larger halls and an occasional pylon(Bawit). It is also here in Coptic monasteries that we find the bent-up approach, the battered walls, the hatch in a machicolated tower above the entrance gateway, and the *qasr*, all of which derive from ancient Egypt.

If the Coptic town house assumes the shape of a lofty tower above underground cellars (Djimē), it is only that it follows a tradition transmitted through Greco-Roman times (Karanis and models of houses) from ancient Egypt (painted representation of town house of Thutnefer at Thebes [Eighteenth Dynasty], models). The stairs always rise in an independent stair well. A water-jug stand in a niche forms the main feature of the entrance room (Djimē); lamp niches and cupboards open in the walls as in the Egyptian artisans' town at 'Amarna or Deir el Medina.

Although the Coptic church planned for congregational worship differs in principle from the ancient Egyptian temple designed for processions, it assumes the basilican plan with returning aisles (Dendera, Abu Hennis) that could well be a variant of the "Egyptian *oecus*." This element, so called by Vitruvius (Lib. 6. 5) because of its superimposed orders on the sides of the nave and windows above the aisles, is

itself inspired from the hypostyle hall of the temple of the New Kingdom, with nave, returning aisles, and clerestory windows (Festival Hall of Thutmose III at Karnak).[177] This stylistic filiation could well have had a Hellenistic intermediate stage between the Eyptian prototype and the Roman basilica as exemplified in the Roman triconch chancel in the basilica at Ashmunein, occurring also in Christian basilicas in North Africa (Tebessa, Kherbet Abu Aduffen [Apollonia], Damus el Karita [Carthago]) or Asia (Ancyre) and in Coptic ones in the Maryut, Deir Abiad, Deir Ahmar, and Dendera. While some scholars ascribe the triconch to a Syrian prototype,[178] it is undeniable that the cruciform plan had formed the terminal feature of rock-cut chapels in Egyptian and Greco-Roman tombs.[179] These, admittedly, do not have apses but rectangular niches, which are, however, echoed in Coptic monastic churches and at Babylon and Philae. Let us also mention that the Coptic apse never projects beyond the rectangular periphery, a basic characteristic of the Egyptian temple. The definition of this stylistic feature as local is corroborated by the fact that basilicas in marginal districts such as Maryut and Ostracina do have, as in Western Europe, protruding apses and a transept (Maryut). The same churches make use of imported marbles for facings and pavements seldom found in true Coptic churches.

Coptic style does not emphasize the external façade but concentrates on internal effect, yet the blind arcades on

pilasters on the façades of the tomb chapels at Bagawat deriving from the late antique are curiously reminiscent of the recessed paneling in Egyptian walls.[180] Properly Egyptian is the architectural style of the external façades of Deir Abiad which imitate a temple with battered blank walls crowned by a cavetto cornice (Deir Abiad) and gargoyles and of the doorframes with cavetto (Deir Abiad, Deir Ahmar, El Deir, Bagawat). Among other stylistic elements borrowed from ancient Egypt one finds the claustra windows with openwork in stone or wood, the ramp bordered by two parapets leading to an entrance doorway (Bagawat), and the unique type of ambo at Saqqara derived from the Heb-sed platform and accessible by a few steps.[181] Some altar slabs are reminiscent of a typical Egyptian offering table.[182]

While Coptic architecture is certainly indebted to the Egyptian one it also derived inspiration from its immediate Hellenistic and late-antique predecessors. It is also in the monastery that we find some of these elements, such as the typical housing unit *prostas-and-oikos* fronted by a courtyard, the doorway to the oratory opening in a corner adjacent to the wall containing the niche in much the same manner as in Roman fortresses in Egypt (El Kab, Qasr Qarun), and the arrangement of brick couches (Aswan) like those in a Pompeian

177. Badawy, *L'Art Copte. Les Influences égyptiennes*, pp. 2–3.
178. Ibid., p. 3.
179. Ibid., Fig. 1.

180. Ibid., p. 12, Fig. 4.
181. Ibid., pp. 19, 23, Figs. 8, 12.
182. M. Cramer, "Ein Beitrag zum Fortleben des Altägyptischen im Koptischen und Arabischen," *Mitteilungen des Deutschen Insituts für Altägyptische Altertumskunde in Kairo*, Vol. 7 (Cairo: 1937), p. 121.

triclinium.[183] Let us mention here a curious analogy between the typical altar niche of the oratory in monasteries or those in a reused Egyptian tomb (D 69 Abydos), or the crypt at Abu Sarga church and the house altar at Delos, which also demonstrated the shape of a small, round-topped, semicircular niche above a slab.[184] The most important Roman feature in the design of the Coptic church is certainly the apse, sometimes duplicated at both small ends as in the Roman civil basilica. Others are the galleries above the aisles accessible from a staircase with flights at right angles as in the Egyptian temples from the Greco-Roman period (Dendera, Edfu, Philae), the narthex lateral or along the front, the bema with several steps, and the altar adapted from the civil basilica. The orientation of the sanctuary to the east followed the orientation employed in Western Europe after the fifth century.[185] The apse contained within the periphery of a rectangular plan is perhaps a direct copy from that of the central basilican hall open to the sky in Roman forts of Egypt (El Kab, Qasr Qarun).[186]

It is in the articulation of internal walls and the arrangement of decoration that Coptic style is most heavily indebted to the Hellenistic and Greco-Roman. A scenic effect similar to that in Hellenistic architectural design appears at the rear end of the basilica of Deir Ahmar, culminating in its triumphal arch.[187] Similarly, the articulation of the walls with niches emphasizing the axes of the doorways opposite them (Dendera) or with intercolumniations (Dendera, Abu Hennis) often flanked by pilasters carrying a pediment is properly Hellenistic. When the niches are arranged between the columns set in two superimposed orders around an apse (Deir Abiad, Deir Ahmar) they copy the Roman and late-antique treatment (nymphaeum at Gerasa, Temple of Diana at Nîmes)[188] characteristic, according to Butler, of the Mausoleum of Diocletian at Spalato.

Among secondary stylistic elements borrowed from the late antique let us mention the broken pediment and the relieving arch often shaped as a window or a niche within its own frame opening above a lintel (Deir Ahmar). The Hellenistic shell is most commonly used as a headpiece for niches, and the Corinthian capital is adapted in composite types of the figured or basket varieties similar to, if not surpassing, Byzantine work, as well as in simpler geometrized types deprived of one row of acanthus (see Chapter 3).

Decoration employs facing with slabs of imported marbles in the basilicas of the marginal districts (Maryut, Ostracina) and local stone applied to brickwork or stonework (Apa Jeremiah at Saqqara) or edging pecked stone with a smooth listel (Dendera). The incrustation style affected in Greco-Roman mural painting is geometrized into highly sophisticated dadoes (Bawit).

In building construction there are many late-antique characteristics: the common use of baked brick in walls, vaults, and domes, or in pavements in a herringbone pattern; the insertion of a wooden framework within the masonry similar to the *graticcio* at Herkulanum (Deir Ahmar, south church at Bawit); the wooden tie beams running beneath the architrave (Deir Abiad, Deir Ahmar) developing into independent structural members above the capitals from which spring an arcade (El 'Adra and Abu el Sefein at Haret Zuweila). It could well be that the principle of Byzantine construction, using arches on supports connected by wooden tie beams taking tension, was developed simultaneously with, or derived from, that in Roman Egypt.[189]

183. A. Badawy, "L'Art Copte. Les Influences hellénistiques et romaines," pp. 173–174, Figs. 5, 6.
184. Ibid., p. 172, Fig. 4.
185. Ibid., pp. 162–172.
186. Ibid., p. 161.
187. Ibid., pp. 186–187, Fig. 11.
188. Ibid., pp. 190–192, Figs. 13–15.
189. Ibid., p. 182, Fig. 10.

Conclusion

The style of Coptic architecture appears as a curious prince-and-pauper hybrid; this is doubtless a result of its humble beginnings when many among the Christian Egyptians, following their ascetic leaders to the desert, remodeled caves and ancient tombs into modest dwellings, and of its first period of freedom after Theodosius' edict when they appropriated the monumental Egyptian temples and the luxurious late-antique palaces and shrines, transforming them into Christian basilicas. Traits from both styles appear isolated but also superimposed. The functional, comfortable, easily defensible though extremely modest town houses are reminiscent of the primary desert installations. So are the humble graves containing burials wrapped in worn robes and nearly anonymous except for the small stelae elaborately carved with an epitaph framed by architectural or other motifs, a remnant of an ancient Egyptian funerary tradition. Functional also are the working installations and contiguous individual houses in the self-supporting monastic communities reminiscent of the much earlier artisans' towns in ancient Egypt. These monks' houses would be defined as nothing but modest were it not for the overwhelming richness of the mural paintings that cover the walls and vault of each monk's small oratory. For, being as religious-minded as his pagan ancestor and ignoring Pachomius' injunction to modesty, the Copt liked to lavish ornament on his religious structures. When stone is used, usually such local varieties as discouraging to architectural sculpture as nummulitic limestone, most elaborate friezes run at various levels on the walls together with carved wooden bands introducing unity among the arched tympanums on pilasters framing doorways and niches. Even such a jewel of a basilica as Dendera is of nummulitic stone with brocaded niches enriched with variegated colors. When Shenute gives to his basilica Deir Abiad, which he identifies with Jerusalem, the external monumentality of an Egyptian temple and the internal superimposed orders and rich articulation of a late-antique palace, he certainly intends to defy both pagan styles. The use of rich materials is not characteristic of Coptic construction, and when wood and even local stone can no longer be procured its inherent inventiveness devises for the roofs of churches a system of mud brick domes on a grid pattern achieving an impressive interplay of light and chromatic effects.

While Coptic architecture allied to architectural sculpture will never rank among the great historical styles, it has a charm of its own, for when it is true to itself, it can achieve with restricted means the grandeur of pagan monuments or the mysticism of ascetic dedication.

Sculpture is nothing but a trap for light.

Bernard Berenson, 1866–1959

Sculpture, in addition to textiles, is the most characteristic production of Coptic art; both show at its best the genuine modified form of Hellenistic style, still Alexandrian until the fifth century but later differing from the international late antique. Such a generalized statement should not, however, imply that style alone is a reliable criterion for dating Coptic sculpture, for nothing is more elusive, especially since the majority of the monuments are fragments isolated from their original context. What strikes one at first glance is the fact that statuary, as in most early Christian provinces, is only slightly represented, perhaps because it is more prone to destruction than architectural sculpture, friezes, bands, niches, pediments, consoles, and columns. Of all the works on Coptic sculpture none even mentions its original distribution in the architectural context, thus ignoring a factor of basic importance bearing upon the lighting, perspective, and subject of the carving. Let us also remember that most of Coptic sculpture, as its Egyptian and Hellenistic predecessors, was painted, thus adding the chromatic effect to the tactile one.

Distribution of sculpture is strictly architectonic, tending to emphasize the design of the structure. This purpose is obvious in monumental architecture such as the churches at Bawit, Dendera, or Sohag, but also in lesser buildings such as the small cells of monks. At Bawit the doorways to the churches are decorated with engaged columns carrying an arch and tympanum correlated with a carved molding and frieze (Fig. 3.1) running at the level of the capitals around the hall and outside it (Fig. 3.2); this molding is echoed by four carved wooden bands at various levels, one just beneath the frieze. The most immediate result of this arrangement is a sense of unity in the design allied to a harmonic rhythm breaking the monotony of an otherwise plain masonry wall (Fig. 3.3). A similar arrangement is found in the monasteries at Sohag, where the subsidiary bands are of carved stone instead of wood (Fig. 3.4). The walls between the columns are articulated with niches framed with smaller columns or pilasters carrying an arch (Dendera) or a broken pediment (Sohag). It is mostly from such small pediments that the figured scenes originate, set at a very sharp slant to offer the best perspective to the onlookers below. The same is true for the figured scenes on the soffit of consoles. Needless to say the most alert among the sculptors accounted for this perceptive factor and consciously deformed the figures in order that they might achieve the required perspective from the floor. Another result of the architectonic distribution of sculpture is the carving in bold high relief to achieve a deep shadowy ground not found in monuments designed to be seen at ground level, such as the stelae. Though the distribution of sculpture can be called properly architectonic in its arrangement, it is less so in its subject, which seldom corresponds to the character of the member it decorates;[1]

1. E. Drioton, *Les Sculptures Coptes du Nilomètre de Rodah* (Cairo: 1942), p. 3. (Hereafter cited as *Nilomètre.*)

for example, meanders, used in mosaic pavements in classical art, here cover the shafts of columns, and incrustation motifs appear on friezes.

Is this distribution of sculpture into horizontal zones a Coptic invention? Hardly so if we remember the mural composition in registers and the reinforcing wood tie beams set at regular intervals found in ancient Egyptian architecture or the alternation of brick and stone courses characteristic of late-antique masonry. It is from the latter that Italian Romanesque adapted its distribution of sculpture according to a system of horizontal zones akin to the Coptic one.

3.1
South wall in Chapel A at Bawit showing the distribution of sculpture as columns on lion protomes and friezes of stone and wood (E. Chassinat, "Baouît," Vol. 1, pl. XXIV.)

3.2
East wall of Chapel B at Bawit seen from the exterior, with its round window and stone and wooden friezes. (E. Chassinat, "Baouît," pl. LXX.)

3.3
South wall of the south chapel at Bawit showing its molded and carved friezes at the level of the capitals of the door above wooden friezes. (E. Chassinat, "Baouît," pl. XXII.)

3.4
South door at Deir Ahmar with its profuse stone carving in its lintel, capitals and friezes. (G. Duthuit, *La Sculpture copte*, pl. LI.)

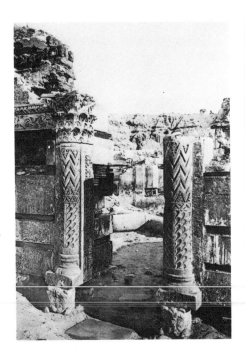

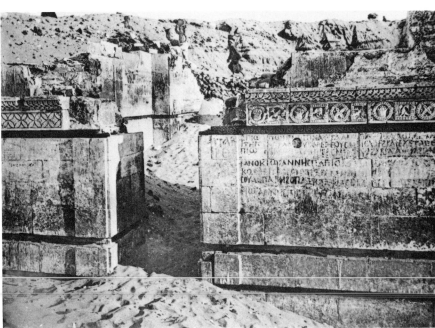

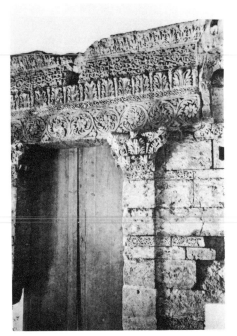

The chronological sequence of the forerunners of sculpture, unlike those of painting, is more important than their stylistic filiation, for they proceed from a varied background—imperial and sub-antique, not to mention the indigenous funerary craft. These monuments in various media belong to a period of transition between the Hellenistico-Roman style of Alexandria and the Coptic style proper. Mostly pagan, they include toward the end of the fourth and the first half of the fifth century Christian pieces that can be called proto-Coptic of purely late-antique style. It is noteworthy that Hellenistic influence appears to have been much greater on proto-Coptic sculpture than on graphic arts, where late-antique flavor predominates. Hellenistic monumental sculpture in Alexandria, Saqqara, and other centers was certainly more impressive and withstood depredation better than murals, which accounts for its being used as a model.

Imperial commissions form a special group of sculptures represented by figures and portraits of porphyry, a red crystalline rock quarried only at Mons Porphyriticus near Coptos and reserved for imperial monuments.[2] It has been suggested that the carving was done in Alexandria. In addition to the sarcophagi of the fourth and fifth centuries (Vatican, Istanbul) there are busts and figures, some colossal (Greco-Roman

Museum in Alexandria), of a forceful, stylized technique in schematized portraiture and geometrized drapery. The famous twin groups of the Tetrarchs (293–305), the earliest now abutting against the S. Marco Church, Venice (Fig. 3.5) and the later in the Vatican Library, represent the embracing figures of the bearded emperors Diocletian and Maximianus, and their Caesars Constantius and Galerius, all with large worried faces. The composition is still impressive because of its volume and light, although its clumsy proportions are achieved by simplified modeling, an essentially plastic treatment foreshadowing the Coptic one.[3] The similar treatment of the features in the Tetrarchs and the bust of Licinius (?) found at Athribis and the similarity between the ornament on the belt and saber sheaths of the Tetrarchs and the framework of the throne of Diocletian (?) found in Alexandria corroborate the attribution of the porphyry category to Alexandrian art.

A unique bronze, cast solid, represents a bearded Herkules running (Fig. 3.6; Brooklyn Museum, 36.1610.312 m.; second half of the third century A.D.), a dynamic figure with expressive head, a net around his shoulders, and carrying a hide in both arms. Although slightly modified by some concession to frontality, and stylization in the treatment of the muscles (cf. C.M. 7274), foreshadowing Coptic style, it is still more

expressive than the later ivory representing the same god. Probably from the same early period dates an ironstone statuette of a bearded man in chlamys from Akhmim in the contrapposto frontal attitude of late-antique statuary (Fig. 3.7; Walters Art Gallery, 52.82, 0.142 m.; A.D. IV). Let us mention that the treatment of the folds of the drapery is similar to that of the limestone statuettes from the Mithraic shrine in Memphis (C. M., 7262; A.D. III–IV).[4]

The ivories, a group differing drastically as to medium, technique, and purpose from the porphyry statuary, nevertheless shares with that latter group the late-antique style. These bone and ivory carvings found in the district of Alexandria had been inlaid in furniture and weapons. The small plaques represent in bold relief figures from Greco-Roman mythology (A.D. II–IV),[5] often a Nereid reclining on a sea-monster (Fig. 3.8), Adonis, Venus standing, or personages from the Dionysiac cycle and mysteries—Dionysos with young fauns, Silenus in an ecstatic dance, Pan playing the cymbals, or satyrs and maenads. Some of the pieces have artistic merit and are obviously of the Alexandrian tradition, such as the languid Dionysos (Fig. 3.9) or the aggressive, muscular Hercules, but the

2. R. Delbrueck, "Antike Porphyrwerke," *Studien zur spätantiken Kunstgeschichte*, Vol. 6 (Berlin and Leipzig: 1931). J. Strzygowski, *Koptische Kunst, Catalogue général des antiquités égyptiennes du Musée du Caire*, Vol. 12. (Vienna: 1904), pp. 3–7. (Hereafter cited as *Koptische Kunst*.)

3. G. Duthuit, *La Sculpture copte* (Paris: 1931), pp. 30–32, pls. V-VI. J. Beckwith, *Coptic Sculpture* (London: 1963), pp. 8–9.

4. J. Strzygowski, *Koptische Kunst*, p. 12, Fig. 7.
5. W. F. Volbach, "Spätantike und frühmittelalterliche Elfenbeinarbeiten aus dem Rheinland und ihre Beziehungen zu Ägypten, "*Schumacher Festschrift* (Mainz: 1930), pp. 42 ff. J. Strzygowski, "Hellenistische und Koptische Kunst in Alexandria," in *Bulletin de la Société archéologique d'Alexandrie*, No. 5 (Vienna: 1902), pp. 1–94. (Hereafter cited as "Hellenistische und Koptische.") *Koptische Kunst*, pp. 189–911. J. Beckwith, *Coptic Sculpture*. pp. 10–13.

Porphyry group of the Tetrarchs now abutting
against S. Marco Church at Venice.

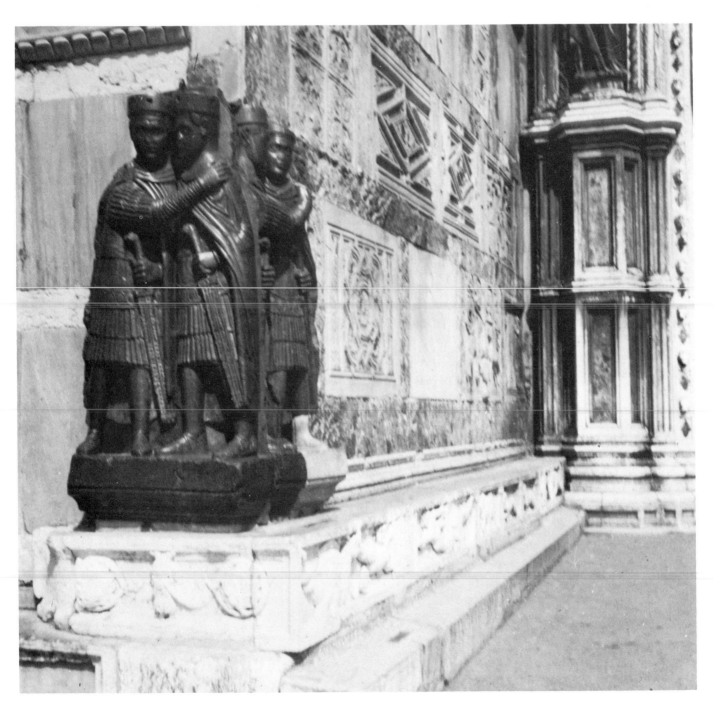

3.6
Figurine in bronze of Hercules running carrying
the lion's hide. (Brooklyn Museum, 36.161.)
3.7
Ironstone figurine of an apostle from Akhmim.
(Walters Art Gallery, 52.82.)

3.8
Ivory fragment representing a Nereid on a horse.
(Louvre.)
3.9
Dionysos in a languid posture, carved on a
pyxis of ivory. (Walters Art Gallery, 71.1099;
A.D. IV–V.)

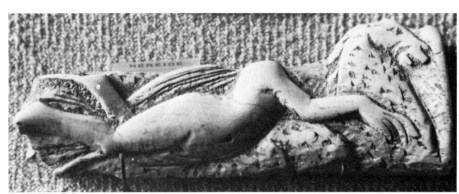

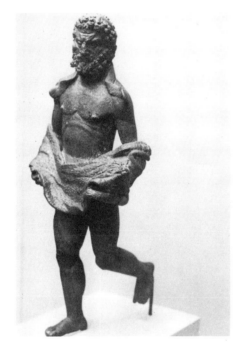

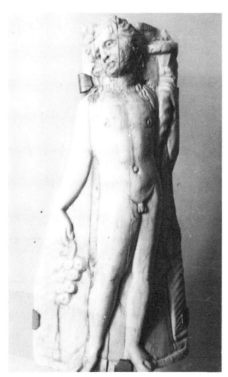

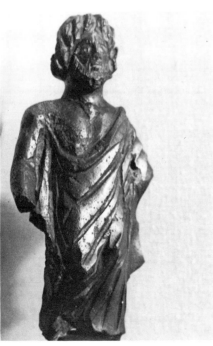

vast majority are rather sketchy figures of fluid carving emphasizing a manneristic elegance in the curves of the nude rather than achieving a naturalistic treatment. These are close relatives to the figures of dancers superimposed on the vertical bands of early Coptic tapestries of purple.

In genre scenes that demanded the talent of the better sculptors the quality denotes the characteristics of Alexandrian style—illusion of space and the picturesque allied to a masterly technique. In one group (Fig. 3.10; Dumbarton Oaks, 42.1, 21.4 × 11.5 cm.; A.D. II) one of the two figures is seated on a bench marked "of Andropolis," a district of Egypt. In front of him is a small altar decorated with a garland, and to his side stands a second male figure holding a wreath and perhaps playing on a musical wind instrument. Even in such a small-scale carving much of the emotion, not to speak of the lively naturalism, has been caught in high relief by the artist. A similar quality of bold relief with even livelier movement and excellent muscle definition is imparted to the group of a flying Bacchus and Ariadne above a bead-and-reel border (Fig. 3.11; Walters Art Gallery, 71.51; A.D. IV). A semicylindrical box of ivory shows Dionysos in smooth relief with two lotus buds in the front of his hair standing between a maenad, a panther at his feet, and a satyr above a frieze of acanthus leaves. On the sliding lid an Isis Pharia stands against a hanging, wearing a variant of the Isiac crown consisting of a disk

flanked by two horns and two feathers. She holds in her left arm a cornucopia and in her lowered right hand a rudder to which points an Eros flying above holding a mirror, a personification of the Pharos darting his light to navigators. The rays beaming from the Pharos are cleverly indicated by the folds of the hanging behind (Fig. 3.12; Dumbarton Oaks, 47.8; A.D. IV–V;). Similar representations in bronze[6] and on coins[7] are known. The excellent style with naturalistic traits, the garment folds emphasizing the elegant lines of the figure, the setting of the scene against a hanging, the illusionistic three-dimensional rendering of the personification all concur to mark the work as that of an essentially conservative classical school (Beckwith),[8] a work of Hellenistic feeling (Wessel),[9] and an achievement of the renaissance movement of the fourth to fifth centuries. The accuracy of the type even to the hair done in corkscrews according to the typical style of the Ptolemaic Isis Pharia or princesses, and the Ptolemaic subject joined to the high standard of style and technique, characterize the piece as an excellent Roman (A.D. IV–V), perhaps Theodosian, copy of an early original. That the Hellenistic tradition was maintained even in the fifth century is evident from various carved ivories supposedly worked in Alexandria; for example, the pyx representing

Discord with the apple at a banquet with Mercury and the three goddesses in an illusionistic rendering with a spirited, barking dog (Fig. 3.13; Walters Art Gallery, 71.64; A.D. V), or the panel with the Dioscuri embracing in a top register and Pasiphae and the Bull in the lower one and a broad scroll frame inhabited by quite active Erotes holding a bowl or a duck as their counterparts in the typical Nilotic scenes (Fig. 3.14; Civico Museo di Storia del Arte; A.D. V). The evolution toward more rounded forms ignoring the canonical proportions of the figures which is already apparent in the panel is even more pronounced in the Herakles still pretending at a well-developed musculature in a contrapposto stance (Walters Art Gallery, 71.4; A.D. IV–V).

Stone carving and plaster modeling are far more significant than porphyry, ivory, and wood sculpture, for they offer rich evidence about the evolution from the early Roman to the proto-Coptic periods. The characteristic proportions of Coptic figures can be traced as far back as the statues of the slender-waisted Ptolemaic queens,[10] perhaps reminiscent of the slender figures in Middle Kingdom sculpture. The shoulders are narrow, and from the emphasized navel rises a vertical furrow indicated even on the dress in statues of the Isis-serpent. A costume with harmonious though unnaturally deep folds is worn by female figures of the Roman period, while men are naked, puffy, and slightly deformed.

6. W. Froehner, *Collection Julien Gréau, Les Bronzes antiques décrits par W. F.* (Paris: 1885), No. 843, p. 169.
7. E. Breccia, *Alexandrea ad Aegyptum* (Bergamo: 1922), Fig. 186.
8. J. Beckwith, *Coptic Sculpture*, p. 11.
9. K. Wessel, ed., *Christentum am Nil* (Recklinghausen: 1964), p. 119. J. Kollwitz, "Alexandrinische Elfenbeine," in K. Wessel, ed., *Christentum am Nil*, pp. 207–220, See p. 217, Fig. 93.

10. A. Badawy, "L'Art Copte. Les Influences Hellénistiques et romaines," *Bulletin de l'Institut d'Egypte*, Vol. 35 (Cairo: 1953), Fig. 27, p. 11. After M. Roztovtzeff, *Social and Economic History of the Hellenistic World*, Vol. 2, pl. XCIX.

3.10
Ivory carving of a group representing a poet and
his attendant. (Dumbarton Oaks, Coll 42.1; A.D.
II.)

3.11
Bone carving representing a flying Bacchus and
Ariadne. (Walters Art Gallery, 71.51; A.D. IV.)

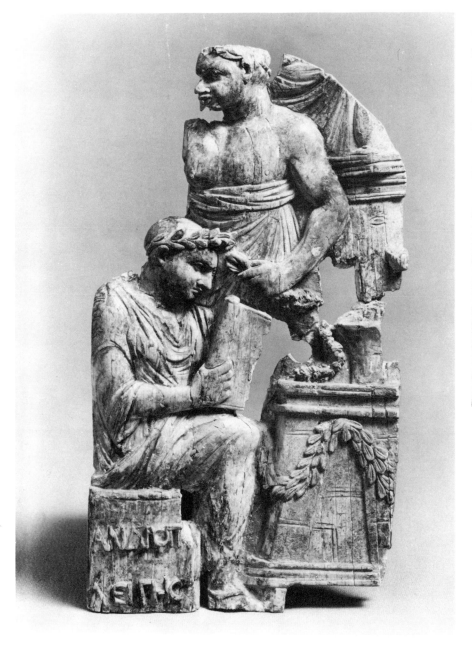

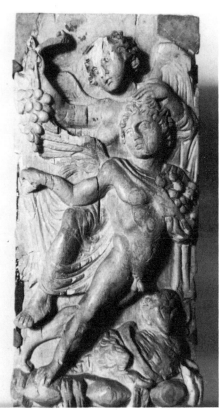

3.12
Sliding lid of the medicine box carved to represent a personification of Alexandria.
3.13
Pyx representing Discord and the apple at a banquet. (Walters Art Gallery, 71.64; A.D. V.)

3.14
Panel of diptych representing the Dioscuri and the Bull and Pasiphae surrounded by a frame consisting of a scroll peopled by Erotes in vintage and marshes scenes typical for Nilotic landscapes. (Civico Museo di Storia del Arte; A.D. V.)
3.15
Side of the figure capital representing 4 men carrying a crocodile. (Rjksmuseum.)

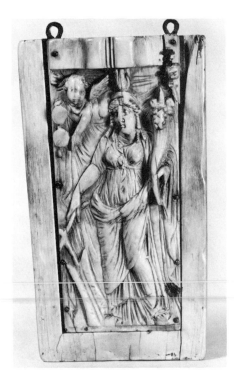

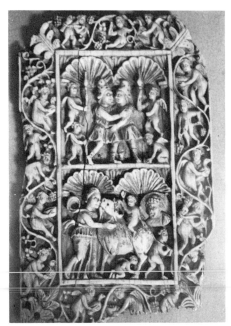

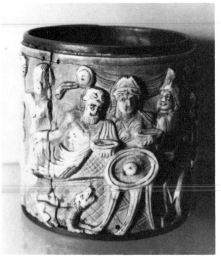

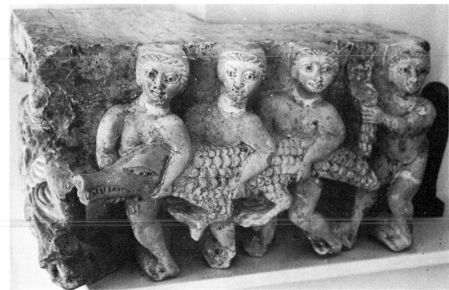

The heads are still of a refined modeling with wide-open eyes enhanced by the dark pupil and sensuous lips and nose. A most curious angle piece, perhaps a figured capital (A.D. V), represents in high relief on the small side a woman draped in sinuous folds of wedge-shaped section reclining against a sphinx similar to that of the ivory pyx at Wiesbaden (Landesmuseum, 7856; A.D. VI), obviously a personification of Egypt. On the long side four naked men—probably a procession of priests of Suchos—carry a crocodile toward the woman (Fig. 3.15). The hair of the men is parted into two series of curls. The style has not retained much of the Egyptian tradition but is reminiscent of that of the Isis Pharia ivory box; the ridged folds in the woman's dress foreshadow those of the chip-carved Coptic sculpture. Another high relief of the same type with some claim at realism represents Herakles strangling the lion (from Antinoë; Rjksmuseum). The hair above the broad face is done into a blobbed fringe, not unlike later proto-Coptic sculpture.

The aesthetic treatment of the faces, though lacking the individualistic or emotional expression achieved in pagan Alexandrian sculpture, betrays some established tradition. In fact there flourished among others in the second to third centuries a school for plaster modeling at Memphis and another at Alexandria, probably successors to the Ptolemaic one at Memphis (III–II B.C.). Male busts are endowed with individualistic features (from Alexandria; Greco-Roman

Museum, 3338–3339), while female ones can have a purely Greek face (Fig. 3.16, from Memphis; B. M., 1793) except for the incised pupils, a characteristic further emphasized by scooped-out holes filled in with black pigment in Coptic portraits. The emotional rendering that reached such culmination in Hellenistic heads, always slightly turned sideways, even from secondary metropolises of nomes (god Helios, from Oxyrhynchos; Brooklyn Museum 62.148; early II B.C.) has been toned down, except occasionally in such an unusual personification of a city as the female bust with heavy braided hair crowned with a city fortification diadem (Fig. 3.17). The figure is wearing a heavy necklace and showing deep worry in its sagging eyebrows and wide comma-shaped eyes with highly set pupil, perhaps to instill fear at the gateway of a city or public monument (from Cairo; Staatliche Museen 4133; A.D. III–IV). The evolution is well illustrated in the numerous plaster mummy masks from the beginning of the Roman period until the middle of the third century, with the addition of naturalistic elements on masks of Egyptian style such as a hair style after the fashion set by the imperial family, and the painted eyes that were later also inlaid with translucent glass (A.D. II; see Fig. 4.10). Frontality is then an essential element and this was later allied to a gradual slant given to the headpiece as if it were raised on a high pillow. It is from this heritage that the Coptic sculptured portrait emerges in rigid frontality strongly stylized with smooth flattened broad areas, large eyes bordered by heavy lids, deeply

inset, often inlaid, pupils, hair treated in ribbed style symmetrical about the axis of the face (Glyptothek Ny Carlsberg, A.E.I. N., 1734; A.D. IV?), in rows of blobs or in chipped gradated wicks and granulations (Fig. 3.18; Glyptothek Ny Carlsberg, A.E.I. N., 364, 366).

The evolution of the figure follows a different course, for the skeletal framework seems to disappear, leaving a rubbery deformed puppet with large head on a conical neck and cylindrical limbs. The stance tends gradually to become frontal, passing through a debased *contrapposto* deprived of the Lysippic balance so well marked in the hemicycle of Greek poets and philosophers of the Serapieion at Saqqara (III B.C.). Even such a dynamic personage as Nikē appears in a limestone piece as a deformed figure barely in equilibrium on flexed legs, raising both arms in an awkward gesture, the wings applied limply to the column behind the back, clad in a short kilt and a shawl stretching diagonally across the bust leaving the right breast bare (Dumbarton Oaks, 43.7, 0.712 m.; A.D. IV).

At this stage of our inquiry it seems relevant to define the forerunners of proto-Coptic figured sculpture that appear at Oxyrhynchos (A.D V) and especially at Ahnas with well-marked characteristics. The pieces form new elements of architectural sculpture used in the heads of niches or friezes of a narrative genre and a sleek, rubbery, inorganic figure style still impressive because of the large eyes with bulbous

3.16
Head of a woman. (In plaster, from Memphis;
B.M., 1793; A.D. II–III.)

3.17
Bust of the personification of a city. (Limestone,
Cairo; Staatliche Museum, 4133; A.D. III.)

3.18
Two portrait heads. (Limestone; Glyptothek Ny
Carlsberg, A. E. I. N. 364, 366.)

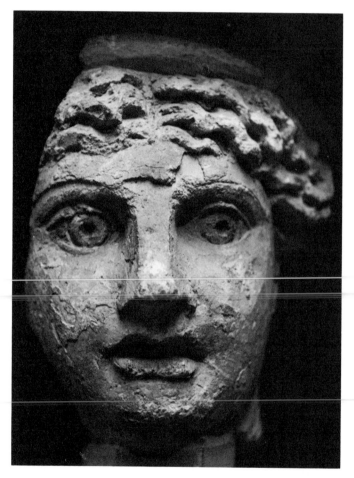

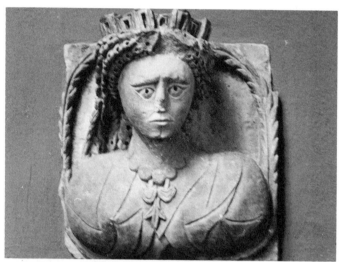

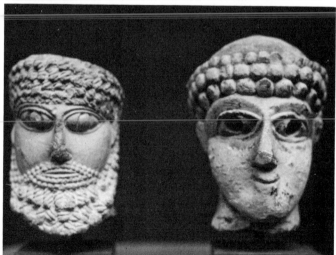

pupils protruding from deep shadows and the expressive attitudes. Of all the possible candidates—mummy masks in plaster, imperial sculptures in porphyry, ivories, and terra cotta[11]—only the two latter media are still worked in the fifth century and show the same repertory of mythological figures and legends. It should be noted that the earliest figures, those in the pediments at Oxyrhynchos, are small single figures engaged vertically onto a rich floral ornament. At Ahnas (A.D. V–VI) the same figures occur enlarged within a floral frame or overlapping it or as groups of a narrative genre, often set at a slant. The closest parallels to this hybrid style of forerunners of proto-Coptic sculpture in other areas of the late-antique production in Syria, Asia Minor, and Cyprus are those from Nabataean Khirbet el Tannur, but they are still deceptive. We are left with the terra cotta as the only plausible models, and as E. Kitzinger has clearly put it: "The mythological figures and stories which had been familiar and dear to the people for centuries, and whose in-

terpretations in small figurines had formed part of the furniture of every middle-class house in Egypt, are boldly projected into monumental stone sculpture and given a permanent place in an architectural setting."[12] It is among the Roman terra-cotta figurines produced in the provincial towns of the hinterland, blending the Greek and Egyptian civilizations and representing native genre subjects, that the closest affinities to proto-Coptic sculpture can be found.

These terra cottas found in the Greco-Roman cities of Egypt represent in the round or in relief on the upper part of lamps personages connected with religious legends or lay subjects.[13] Some elements in both categories can be traced back to dynastic periods. The nude woman in a frontal position with arms along her sides and elaborate headdress is an interpretation in Hellenistic style of the figurine set as a concubine in Egyptian tombs. Similarly the figurines of Harpokhrates nude on a lotus or wearing a chlamys, holding a shield and sword, and riding a horse are derived from Egyptian ones. The majority, however, are borrowed from Greek mythology: Aphrodite, Dionysos, Leda and the Swan, Pan pursuing a nymph, winged Eros with a shield or riding a dolphin. Accessible to the populace and widely publicized, they passed easily into the repertoire of proto-Coptic sculpture in stone.

The stelae form an important category of monuments among the forerunners of Coptic art. The tradition of erecting funerary stelae goes back to archaic Egypt, when they represented and even served as a substitute for the funerary chapel, thus insuring an eternal ritual service to the deceased,[14] an interpretation corroborated by the inscriptions and by the fact that some stelae are pierced with an axial aperture.[15] Hellenistic stelae from Alexandria borrow Attic composition and elements carved in high relief within an architectural frame representing a *naïskos* topped with a triangular pediment, usually a scene bidding farewell to the deceased, all in lateral projection. From this group derives the type in bold relief which features a Horus hawk of pure Egyptian style, a hieroglyph protecting the deceased lady in Greek costume and style (Fig. 3.19; National Museum, Florence, 7521), who is clasping the hand of another woman whose face is turned frontally. Adapting a head in frontal projection onto a body in lateral projection is characteristic of the Greco-Roman representations of Egyptian motifs such as Isis on the crocodiles (Fig. 3.20; Museo Egizio, Cat. 1668, No. 103; A.D. I–II), or later in still bolder relief in a stylized human face on the coarse body of a bird, probably the Egyptian ba-soul, mourned by the two goddesses Isis

11. E. Breccia, *Terracotte figurate greche e greco-egizie del Museo di Alessandria.* (*Monuments de l'Egypte gréco-romaine*, Vol. 2 (Bergamo: 1930), V. Schmidt, *Die Graesk-aegyptiske Terrakotter i Ny Carlsberg Glyptothek* (Copenhagen: 1911). *Choix de monuments égyptiens, IIème série (Glyptothek Ny-Carlsberg)* (Brussels: 1910). C. M. Kaufmann, *Ägyptische Terrakotten der griechisch-römischen und koptischen Epoche.* (Cairo: 1913). A. Reinach, *Catalogue des antiquités égyptiennes recueillies dans les fouilles de Coptos en 1910–1911, exposées au Musée de Lyon*, pp. 87 ff. W. Weber, *Die aegyptisch-griechischen Terrakotten* (Königliche Museen zu Berlin) (Berlin: 1914).

12. E. Kitzinger, "Notes on Early Coptic Sculpture," *Archaeologia*, Vol. 87 (London: 1938), p. 209. (Hereafter cited as "Early Coptic Sculpture.")
13. E. Breccia, *Alexandrea ad Aegyptum*, pp. 256–273.

14. Alexandre Badawy, "La stèle funéraire sous l'Ancien Empire: son origine et son fonctionnement, "*Annales du Service des Antiquités égyptiennes*, Vol. 48 (Cairo: 1948), pp. 213–243.
15. Alexandre Badawy, "La stèle funéraire égyptienne à ouverture axiale," *Bulletin de l'Institut d'Egypte*, Vol. 35 (Cairo: 1953), pp. 117–138.

3.19
Typical funerary stela of Greek style in Egypt.
(National Museum, Florence, 7521.)

3.20
Stela representing Isis on the crocodiles within
a naiskos. (Museo Egizio, Cat. 1668, No. 103;
A.D. I–II.)

3.21
The ba-soul mourned by Isis and Nephtys, (B.
M., 1651; A.D. III.)

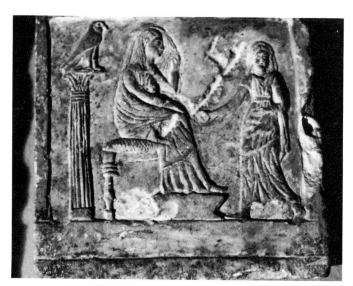

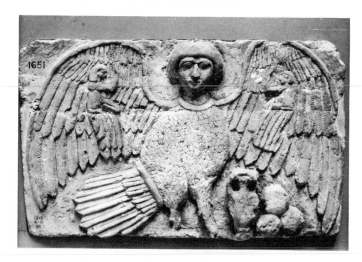

and Nephtys nesting in the heraldic wings (Fig. 3.21; B. M., 1651; A.D.; III; also a sacred hawk in Ryksmuseum). Such a mixed projection is common in other media, for example in painted murals such as the scene of the Greek lady of Chapel M 21 at Hermupolis West (A.D. II),[16] or a painted funerary bed (A.D. III)[17].

The funerary stelae of Roman soldiers in Egypt are similar to the typical one abroad representing the standing soldier holding his spear and ax or shield in a frontal attitude, though one foot is turned sideways (Fig. 3.22; Allard Pierson Stichting, Inv. 7802; A.D. II–III). The technique is in bold-relief without any architectural setting; occasionally a hawk wearing the pharaoh's double crown is perched on the shoulder of the soldier, confronting another hawk in the background. In others the figure of the soldier is carved in high relief on an arched background scooped out of the slab (Greco-Roman Museum, 252),[18] similar to Roman stelae at Ravenna (Archiepiscopal Museum).

Roman stelae of private people adopt the Hellenistic architectural setting of a pediment carried on two columns

which is also found in the *lararium* of the Vetti at Pompeii (Fig. 3.23, Agathodaimon niche). This probably represents, as in the Attic stelae, the façade of a funerary chapel within which the deceased appears in high relief reclining on a funerary bed, *klinē* (Fig. 3.24; Rjksmuseum; A.D. III–IV) similar to those built of masonry in the tombs at Alexandria and Hermupolis West or to those represented on numerous lids of Etruscan sarcophagi (Etruscan Museum, 5543). The deceased lady holds a cup in the right hand; beneath the couch are represented an amphora and a table laden with meat and bread. The style of the head is akin to that of mummy masks, and the farther leg is shown in *rabattement*, a projection device used in Egyptian graphics which foreshadows Coptic eclecticism.[19] On some stelae a sacred animal (jackal of Anubis, hawk) stands in one corner (Greco-Roman Museum, 317 b, 330 b, 272 b, 371 b). In another group of stelae of Roman Egypt the deceased appears as *orans* within the architectural setting, standing in a frontal pose, dressed in pleated chiton and himation, and extending both arms horizontally with the forearms bent upward in a gesture known to Greeks and Egyptians as expressing prayer and praise (Egyptian, *dwa, iaw* 🜚) or jubilation (Egyptian, *ḥʿj* 🜚) or mourning (Egyptian, *ha*). The figure is often flanked by two protecting jackals on stands, represented in side view as in Egyptian art (Fig. 3.25; B.M., 57358;

A.D. III). The attitude of the Christian *orans* in Egypt is probably derived from this prototype rather than from pagan models in Europe.[20] In a similar stela from Terenuthis (Kom Abu Billo in the west Delta; Kelsey Museum of Archaeology, Ann Arbor, Inv. No. 21055; end A.D. II–beg. A.D. IV), the plump forms of the lady are evident beneath the pleated himation, her forearms are raised vertically, the jackal and the hawk turn their heads curiously toward the spectator, and the columns carrying the pediment are of a composite type, papyro-Corinthian. All elements demonstrate a native influence foreshadowing the typical Coptic *orans* that is well represented in the funerary stelae from the Fayum.

The site of Terenuthis (Kom Abu Billo) on the midwestern border of the Delta has yielded a comprehensive collection of funerary stelae dated on the evidence of the coins between A.D. 268 and A.D. 340.[21] Except for a

16. S. Gabra, *Rapport sur les Fouilles d'Hermoupolis Ouest (Touna el-Gebel)*, (Cairo: 1941), pl. XIII.
17. W. Needler, "An Egyptian Funerary Bed of the Roman Period in the Royal Ontario Museum." Occasional Paper 6, Art and Archaeology Division, Royal Ontario Museum, University of Toronto, 1963.
18. E. Breccia, *Alexandrea ad Aegyptum* Fig. 41, p. 160.
19. Compare the more Hellenic style of the stela of Aurelia Artemis, daughter of Pasion, Walters Art Gallery, 26.2, A.D. III-IV, studied by P. Verdier, *Art News*, Sept. 1963.

20. A.M. Dalton, *Byzantine Art and Archaeology* (Oxford: 1911; reprint New York: 1961), p. 673, ref. quote n. 8. (Hereafter cited as *Byzantine Art.*) T. Klauser, "Studien zur Entstehungsgeschichte der Christlichen Kunst, II," in *Jahrbuch für Antike und Christentum*, Vol. 2 (Münster, Westphalia: 1959), pp. 115–145. (Hereafter cited as "Entstehungsgesch. der Christlichen Kunst.")
21. F. A. Hooper, *Funerary Stelae from Kom Abou Billou* (Ann Arbor: 1961). Zaki Aly, "Some Funerary Stelae from Kom Abou Bellou," in *Bulletin de la Société Royale d'Archéologie d'Alexandrie*, No. 38 (Alexandria: 1949), pp. 1–36. "More Funerary Stelae from Kom Abou Bellou," *Bulletin de la Société Royale d'Archéologie d'Alexandrie*, No. 40 "(Alexandria: 1953), pp.1–50. A. Hermann," Die Beter-Stelen von Terenuthis in Ägypten. Zur Vorgeschichte der christlichen Oransdarstellung," *Jahrbuch für Antike und Christentum*, Vol. 6 (Münster, Westphalia: 1963), pp. 112–128, pls. 15–19.

3.22
Funerary stela of soldier protected by the hawk Horus. (Photo courtesy of Allard Pierson Stichting, Inv. 7802; A.D. II–III.)

3.23
Painted lararium in the House of the Vettii at Pompeii representing the Agathodaimon.
3.24
Greco-Egyptian stela of a woman reclining on a klinē, (Rjksmuseum; A.D. III–IV.)

3.25
Typical funerary stela of a Greek in Egypt: the young deceased Tryphon is standing as an *orans* between the jackals Anubis and Ophois. (B. M., 57358; A.D. III.)

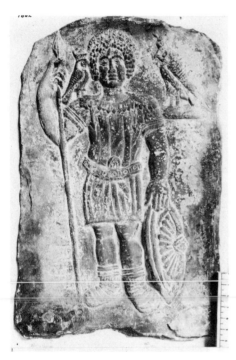

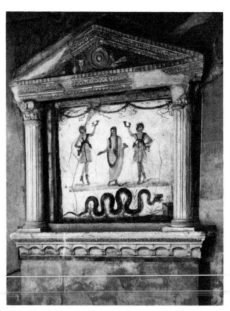

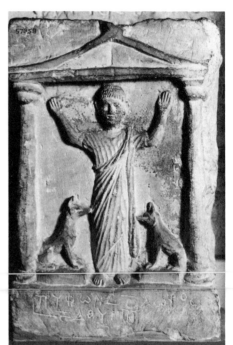

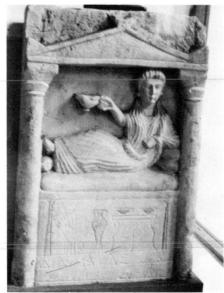

scene of the Rape of Persephone (C. M. *Journal d'entrée,* 87533) and a few stelae carved in high relief or set within an architectural frame, all the others consistently follow two types, derived either from that of the figure reclining on the *klinē* with the head inclined to the right and holding a cup in the right hand, or from that of the *orans* depicted frontally to the waist and laterally beneath, striding to the right, dressed in a chiton and a himation flung over the left shoulder, and often flanked by two jackals. While the attitudes are Greek, the technique of sunk relief, the fabrics with vertical pleats, the type of face closely reminiscent of the hieroglyph *ḥr,* ♥ "face," the lateral projection of the feet in the *orans,* and the *rabattement* of those in the reclining figure (very similar to those in the Leiden stela) are all Egyptian characteristics. In the later examples the whole body of the *orans* is frontal, the left foot being in true perspective while the right one is lateral; and in the figure reclining under a canopy the awkward *rabattement* is avoided by flexing the legs. In some variants two *orantes* appear together as father and daughter, or as a small *orans* above the reclining figure, or even as two reclining figures embracing.

The Terenuthis stelae are not an isolated phenomenon, for there are a few examples conforming to the typical standing figure in high relief flanked by two sacred animals of Greco-Roman type in Egypt, while the *orans* type is similar to that on a stela of pure Egyptian style (Fig. 3.26, Allard Pierson

Stichting, Inv. 7813; A.D. II–III) representing on *orant* girl with the upper part of the body in frontal projection over a lateral torso, legs striding to the right, and flanked by two smaller standing figures in composite projection. The face of the *orans* is derived from the hieroglyph *ḥr,* and her hands are in lateral projection with outward palms as in the other hieroglyph, *ka* (upraised arms). Moreover, her dress with its axial fold is of purely Egyptian fashion held beneath the breasts by one strap over the right shoulder.

Among the monuments of Greco-Roman Egypt the typical funerary stela from Terenuthis representing an *orans* passes on with only slight changes into Coptic art. The *orant* figure, already known in Egyptian art, is adapted to a frontal attitude, carved in sunken relief at Terenuthis (see Fig. 3.26). It acquires a three-dimensional quality with a frontal figure in bold modeling (see Fig. 3.25). It stands as a rule within the bay of an aedicula of Greco-Roman style with two columns carrying a pediment. This is already the immediate prototype of the earliest Coptic *orans* stela, hardly different but identified by its Christian emblems (looped cross, α and ω, Chrism) and inscription (see Figs. 3.198–3.200). Some Egyptianizing reminiscences appear occasionally, as the feet of Apa Shenute in side view (A.D. VII; see Fig. 3.202).

In their earliest attempts to represent Christian themes the Egyptians drew on the late Hellenistic and Roman forms, motifs, and style. Motifs that had no direct connotation of the pagan religions were adopted to serve the new creed. Such a use was made of the Nilotic scenes carved mostly in wooden friezes featuring the pervading Erotes and other nude figures amid a crowded world of cranes, ducks, fish, and lotus flanking a *crux immissa* held by two flying angels (A.D. V). The Nilotic scenes can be traced back through some fishing scenes of an Egyptianizing style to their Egyptian prototype that represented the deceased grandees hunting and fishing in the marshes, one of the essential items of the repertory of murals in private tombs since the mastabas of the Fourth dynasty. In the Coptic sculpture on a stone archivolt (Fig. 3.27; C. M., 42994; A.D. VI) more than one of the elements, such as the birds nesting on papyrus flowers, the lotus, fish, and characteristic fishing skiff, can find near parallels in the Old Kingdom mastabas of Tji, 'Ankhma'hor, and Aba.[22] The effect of the Alexandrian style was to emphasize the picturesque already alluded to in the ancient Egyptian composition, adapting it to its own repertory with dynamic Erotes within a frieze and thus creating the immediate

22. Alexandre Badawy, *L'Art Copte.* Vol. 1., *Les Influences égyptiennes* (Caire: 1949), p. 68, Fig. 53. "L'Art Copte. Les Influences hellénistiques et romaines," *Bulletin de l'Institut d'Egypte,* pp. 151–205; Vol. 35, pp. 57–120. W. de Grüneisen, *Les Caractéristiques de l'Art Copte* (Florence: 1922), pp. 57–58, pls. LI, LII. (Hereafter cited as *Caractéristiques.*) A. Hermann," Der Nil und die Christen," in *Jahrbuch für Antike und Christentum,* Vol. 2 (Münster, Westphalia: 1959), pp. 30–69, especially pp. 64 ff.

Typical stela similar to those from Terenuthis of
Egyptian style representing a female *orans*
between two relatives. (Photo courtesy of Allard
Pierson Stichting, Inv. 7813; A.D. II–III).

Part of a stone archivolt representing a Nilotic
scene. (After G. Duthuit, *La Sculpture copte*,
pl. XXXIII*c*.)

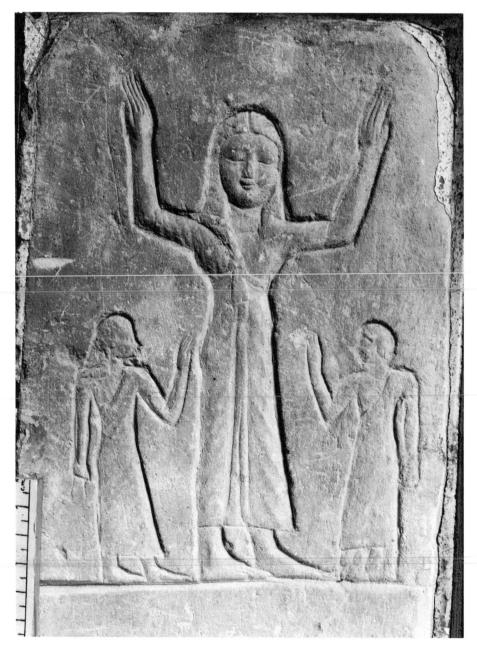

model for numerous Christian interpretations of the subject up until the late Middle Ages.

The earliest proto-Coptic sculpture of large size extant is probably a wooden lintel from El Mu'allaqa Church (Coptic Museum, Cairo, 753; 2.74 × 0.36 m.)[23] carved with four lines of Greek surmounting one register in high relief with two scenes from the Christological cycle, the Entry into Jerusalem and the Ascension. The inscription that stretches to half the height is a hymn to Christ dedicated by Abbot Theodorus and Deacon George. It was deciphered by Pierre Jouguet, who suggested as early a date as year 51 of Diocletian corresponding to A.D. 335. This is corroborated by the fact that Christ is "He in whom dwells the fullness of Divinity," a recognition of the duality of His natures which precludes a date after the Council of Chalcedon (451, Monophysite doctrine); moreover the inscription refers to the "Virgin Mary, Mother of God" as Theometor θεομή τωρ, not Theotokos θεοτόκος according to the terminology consecrated at the Council of Ephesus (A.D. 431). The hymn is an eclectic briefing of Athanasian apologetics defined at the Council of Nicaea (A.D. 325) and promulgated later (A.D. 335 or 356). The Entry into Jerusalem is composed of four personages (Fig. 3.28; 0.61 m. long from the left end): a beardless Christ riding astride an ass hastening toward the mantle spread in its path by a youth, a bearded man holding a palm and a book marked with a cross,

and a dancing woman dressed in a *maphorion*. In the background is a drawbridge and a columned portico, perhaps a representation of the interior of Jerusalem. In the Ascension (Figs. 3.29, 3.30, 3.31) Christ holding a book and blessing appears in a *mandorla* held by two angels over the symbolic animals of the Evangelists (lion, ox) and flanked by two rows of gesturing figures in *contrapposto*, the nearest to the left being the Virgin; each figure is set between the round bastions of a city wall, perhaps imitating Babylon, an arrangement akin to that on early Christian sarcophagi with a clipeus, where the architectural setting predominates over historical scenes with figures (sarcophagus from Vatican cemetery, A.D. IV; Asia Minor sarcophagus of Sidamara type, Berlin Museum, J. 2430). On the sarcophagus of Asklepia from Salona (Split Museum, A.D. IV) the illusory quality is obvious both in architectural framework and in larger and smaller figures (Fig. 3.32). Two elements are properly Coptic: the emblems of the Evangelists and the hangings symbolizing the "clouds hiding the Divinity from the Apostles" (Acts 1:9–11). These will not be necessary in later compositions of the Ascension in two superimposed registers (murals at Bawit and Saqqara, ivory of Munich, door of St. Sabina at Rome).

The style of this composition, consisting only of figures, is certainly related to the Alexandrian one as to the features, the bodies that are well-proportioned though wrapped in rhythmic drapes, the alert perspective attitudes, and the lively gestures ex-

pressing emotion in well-balanced groups. Yet the technique is harder than in the earlier ivories, especially in the angels' ridged wings and the chip carving, a stage toward conventionalized Coptic carving.

One can find affinities between the personages of the Ascension on Mu'allaqqa lintel and the figures in the lower panels of a two-leafed door from Sitt Barbara Church in Babylon (Fig. 3.33; Coptic Museum, Cairo 783; A.D. V), though in the latter they are certainly less dynamic and are set in a row without much interrelation. The center of the square panels features a small carving of Christ seated. Above each is a long panel representing a bust of Christ in a clipeus carried by two angels flanked by two figures, one almost nude in bold relief against an architectural setting of columns (Fig. 3.34). The angels are similar in style to those of ivory diptychs (Barberini diptych, A.D. 500), and the rich naturalistic foliage on the other side of the door (fig. 3.35) is comparable to that on the ivory chair of Maximian at Ravenna (Fig. 3.36; c. 540).[24] The theme of triumph before and after the Passion was adequate for an imperial gateway.[25]

A unique dark wood console in high relief from Ashmunein (Staatliche Museen, J. 4782; 0.45 × 0.22 m.;

23. Marina Sacopoulo, "Le Linteau Copte dit d'Al-Moallaka," *Cahiers Archéologiques*, Vol. 9 (Paris: 1957), pp. 99–115.

24. E. Kitzinger, "Early Coptic Sculpture," p. 212, pls. LXXV, 3, LXXVI, 1.
25. Torp, "Book Reviews," in *Art Bulletin*, Vol. 47 (New York: 1965), p. 368. (Hereafter cited as "Book Reviews,")

3.28
Carved wooden lintel from El Mu'allaqa: scene of
the Entry into Jerusalem. (C.M., 753; A.D. IV;
M. Sacopoulo, "Le Linteau Copte dit d'Al-
Moallaka," *Cahiers Arcéologiques,* Vol. 9 [1957],
pp. 99-115.)

3.29, 3.30, 3.31
The Ascension as represented on the lintel from
El Mu'allaqa. (Coptic Museum, 753; A.D. IV.)

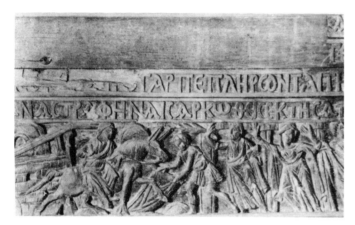

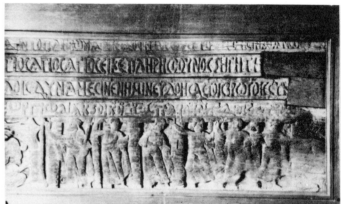

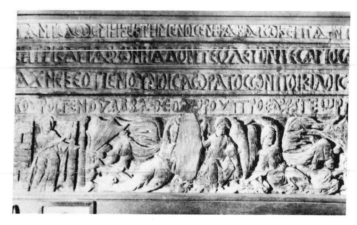

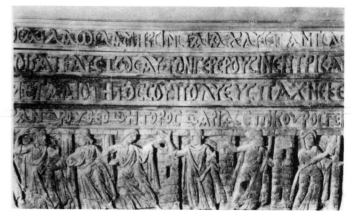

3.32
Marble sarcophagus of Asklepia from Salona
with illusory style. (Split Museum; A.D. IV.)

3.33
Leaf of a door from Sitt Barbara in Old Cairo
with carved panels. (Coptic Museum, Cairo, 783;
A.D. IV or V.)

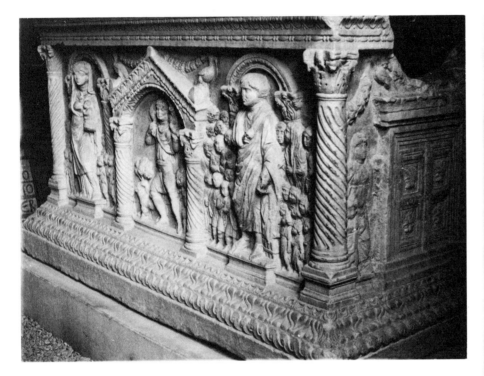

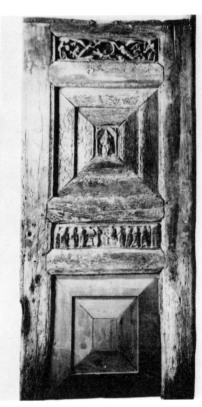

Proto-Coptic Sculpture 135

3.34
Panel from the door of Sitt Barbara representing the bust of Christ in a clipeus carried by two angels.
3.35
Panel from the door of Sitt Barbara with a foliage motif, *By courtesy of the Coptic Museum, Old Cairo.*

3.36
Part of the chair of Maximian at Ravenna. (Archiepiscopal Museum.)

3.37
Wooden carving representing the capture of a city from Ashmunein. (Staatliche Museen, J. 4782; 0.45 × 0.22; A.D. IV–V.)

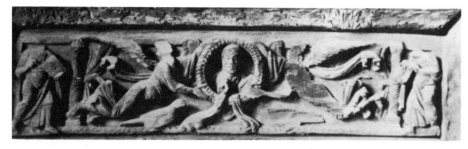

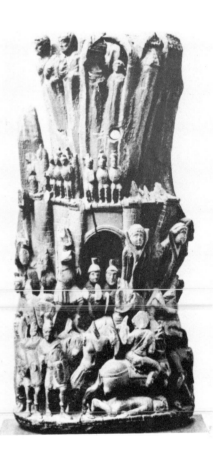

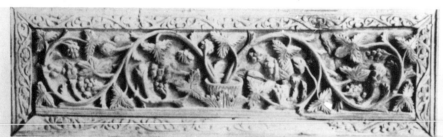

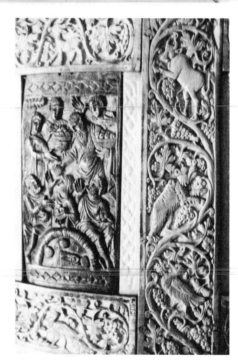

A.D. IV–V)[26] represents the capture of a city in a vertically staged composition (Fig. 3.37) with large helmeted soldiers and cavalry in lively action in the front planes—reminiscent of the so-called (heavily restored) Helena sarcophagus in porphyry (Vatican Museum; A.D. IV), a standard-bearer raising a labarum inscribed with a cross, prisoners hanging with their heads in fork-shaped gallows (furcae), and on the ramparts a row of soldiers of smaller size. Above rises a citadel fortified with bastions topped with large bearded busts and inhabited by two figures standing within the central arch. The style and elements akin to Joshua's story in the Sta. Maggiore mosaics point to a date in the fifth century, and the scene has been interpreted by Strzygowski as symbolic for the triumph of the Christian emperor (within the arch) over pagan barbarians on behalf of the Trinity (three terminal busts of bastions). As the underside is carved with alternating arcaded and pedimented niches and the back is flat, it is obvious that the piece was to be applied high upon a wall. The lintel from Mu'allaqa, the door of Sitt Barbara, and this appliqué

from Ashmunein prove that Christian sculpture in the Hellenistic tradition was still being created during the fourth and fifth centuries in the large towns outside Alexandria.

As is to be expected, the architectural sculpture from Abu Mina[27] in the Maryut does not form an intrinsic element in the history of Coptic sculpture proper, being in fact an outcome of the general tradition of late Roman style in the eastern Mediterranean during the fourth to fifth centuries. The greatest body is that of capitals, mostly of island marble treated in gradually debased forms. A few of these types are represented elsewhere in Egypt itself,[28] such as a Corinthian capital with an eagle in the center of the abacus (Ahnas; C. M., 7350, also 7351), a composite capital with a lower range of bulbous acanthus surmounted by a range of palmettes (Greco-Roman Museum, 13583) also represented in murals at Saqqara,[29] small Ionic, composite Ionic, and variants from the Corinthian to simple drums with four angle leaves. The typical column base is of the Attic type on a molded rectangular pedestal carved in one block, occasionally found in Coptic sculpture (Bawit, Saqqara). Some octagonal pedestals of this type also occur. Of the pilaster capitals,

three echo Corinthian forms characterized by the typical acanthus with leaves springing from both sides of the stem, so important in early Coptic ornament (Oxyrhynchos), or with long naked *caulicoli* (Oxyrhynchos) but still in a fluid technique. Both groups of architectural sculptures at Abu Mina (A.D. IV–V) and the neighboring Ennaton (Dekhela; A.D. V) belong to the eastern Mediterranean tradition and can hardly claim to be among the forerunners of Coptic sculpture.

It is in the earliest group of figured headpieces of niches and pediments at Oxyrhynchos representing pagan subjects that we may find the earliest stages in a development that ultimately led to the hybrid headpieces at Ahnas.[30] The prototype is the broken pediment with ornamented tympanum at Baalbek whose perspective from below when projected into one plane was interpreted as a three-horned broken pediment,[31] the internal tympanum gradually evolving into a semicircular conch. This evolution is clearly illustrated in three pediments from Oxyrhynchos. In the earliest stage (Fig. 3.38) the broken pediment has a soffit with modillions modified into alternating panels of acanthus and quatrefoils, while the inner triangle is filled in with floral ornament in high relief flanking a central rather unassuming Pan or satyr of quite Hellenistic style. In the second stage (Fig.3.39) the composition is similar except for the innermost area

26. O. Wulff, "Altchristliche und mittelalterliche byzantinische und italienische Bildwerke, *Beschreibung der Bildwerke der christlichen Epochen*, Band III, Teil I, *Altchristliche Bildwerke* (Berlin: 1909), No. 243, pl. VII. (Hereafter cited as "Altchristliche Bild werke.") J. Strzygowski, *Orient oder Rom?* (Leipzig: 1901), pl. III, p.65. H. Schlunk, Staatliche Museen in Berlin. Kaiser-Friedrich Museum, *Die Frühchristlich–Byzantinische Sammlung* (Berlin: 1937), No. 32, pp. 74–75. C. M. Kaufmann, *Handbuch der christlichen Archäologie* (Paderborn: 1913), Fig. 217, pp. 538–541. (Hereafter cited as *Handbuch*.)

27. C. M. Kaufmann, *Die Menasstadt und das Nationalheiligtum der altchristlichen Ägypter* (Leipzig: 1910), pls. 66–71. (Hereafter cited as *Die Menasstadt*.) J. B. Ward Perkins, "The Shrine of St. Menas in the Maryut," *Papers of the British School of Rome*, Vol. 17 (London: 1949), pp. 62–70. (Hereafter cited as "Shrine of St. Menas.")
28. J. B. Ward Perkins, "Shrine of St. Menas," p. 63.
29. J. E. Quibell, *Excavations at Saqqara* (1907–1908, Cairo: 1909), pl. XXII, 4–6; (1908–9,

1909–10, Cairo: 1912), pls. XL, 1–2, XLIII, 3.
30. E. Kitzinger, "Early Coptic Sculpture," pp. 194–200.
31. A. Badawy, "*L'Art Copte*, II, Les Influences hellénistiques et romaines," Fig. 19, (p. 46), p. 196.

within a slightly pointed arch framing a maenad or bacchante dancing to the music of clappers amid grapevine. In the third example (Fig.3.40), probably later in time, perhaps even dating from the end of the fifth century, the conch assumes its full curvature and encloses a Nereid riding an animal carved in high relief. This example presents a more rigid proto-Coptic style with a bare ground framed by a double band of vine and a meander with modillions, the latter shifted in from the cornice, which is reduced to a foliate band (Fig. 3.41). The cornice with decorated modillions occurs only at Oxyrhynchos and Rodah.

Other elements of architectural sculpture at Oxyrhynchos may similarly be identified as the prototypes of later Coptic elements. In the friezes one can trace the various stages of evolution from a naturalistic representation to a stylized one, even within an abstract composition. The process is well illustrated in the development of the acanthus scroll from the classical type, with naturalistic leaves on one side of the stem, to the symmetrical setting of two rows of triangular leaves on both sides typical of Ahnas and other Coptic sites, with parts of the scroll showing both stages (see Fig. 3.100). Other characteristics of properly Coptic invention appear at Oxyrhynchos; for example, the interlaced foliage with naturalistic acanthus scrolls (see Fig. 3.101) and the running vine in all its stages, from naturalistic tendrils, vine leaves, and grapes related to Syrian friezes with heavy stem or intertwined stem or vine scrolls to an abstract pattern (Fig. 3.42) common in monastic sculpture.

The practice of filling the area within the acanthus volutes with the foreparts of animals, common to both east and west since the second century A.D., or with buds and fruits shooting off the stem, described as Alexandrian in origin, appears at Oxyrhynchos (Fig. 3.43). Among the derivatives from the Roman scroll with naturalistic leaves on the main stem there is a local Oxyrhynchos type in which the main stem is nearly or utterly bare while its offshoots curling into volutes within the curve carry symmetrical leaves often inhabited by a fruit or an animal (Fig. 3.44; lion, gazelle; B. M., 1805; A.D. IV–V). Friezes where animals and other elements predominate are also extant, such as the one in a simple style representing a basket of fruit and a hare nibbling leaves (Fig. 3.45; B. M., 1804; A.D. IV–V).

It is in the architectural ornament of Oxyrhynchos that the development of late Roman art into Coptic art proper is best illustrated. One lesser group shows a style (Style II),[32] seemingly an old-fashioned late phase of the Hellenistic tradition in Egypt, exemplified by niche heads and cornice with plain modillions (Fig. 3.46), meander enclosing quatrefoils so strongly geometrized that they differ little from geometric patterns,[33] some unpublished blocks with the *crux ansata* on the console—all modeled clearly but not deeply, a sculptural adjunct to architecture. The majority of

the architectural ornament, however, conforms to another style (Style I) contemporary with the one described for the period between the fifth and early sixth centuries. The niche heads and cornices have modillions decorated with acanthus in various stages of stylization (niche of Pan) or band interlace (niche of nymph). Some of the acanthus leaf has a curly tipped leaf reminiscent of that in the atrium of Hagia Sophia rebuilt in A.D. 415 under Theodosius II.[34] Foliate motifs are preferred such as bands of vine intertwine treated in a naturalistic style (see Fig. 3.42),[35] a vine scroll with curving offshoots (Fig. 3.47)[36] evolving to a flatter, still very intricate relief.[37] Cornices display alternate naturalistic acanthus and coffers with rosettes (Fig. 3.48);[38] intertwined lancet-like acanthus with Greek key or meander (Fig. 3.49);[39] moldings with stylized myrtle and modified egg-and-dart Fig. 3.50);[40] or rinceaus inhabited by running animals, fore parts of animals, birds with fruits, flowers, and animals deriving from the late antique (doorway at Spoleto).[41] The deep indentation of the edges is accompanied by a groove running along the axis of every stem or

32. J. M. Harris, "Report of Committee on Research," in *Year Book of the American Philosophical Society* (Philadelphia: 1960), pp. 592–598. (Hereafter cited as "Report.")
33. E. Breccia, *Oxyrhynchos* I, *Municipalite d'Alexandrie, Le Musée Gréco-Romain, 1925–1931.* (Bergamo: 1932), pl. XLIX, 181. (Hereafter cited as *Oxyrhynchos* I.)

34. J. M. Harris, "Report," p.595, n.8. cf. E. Breccia, *Oxyrhynchos* II, *Municipalité d'Alexandrie, Le Musée Gréco-Romain, 1931–1932,* (Bergamo: 1933), pls. XXXIV, 97, XXXVI, 99, XLV, 118. (Hereafter cited as *Oxyrhynchos* II.)
35. E. Breccia, *Oxyrhynchos* II, 94.
36. Ibid., *Oxyrhynchos* I, 159.
37. Ibid., *Oxyrhynchos* II, 94, 95.
38. Ibid., 98.
39. Ibid., 99.
40. Ibid., 93; also *Oxyrhynchos* I, 179.
41. Ibid., *Oxyrhynchos* I, pl. LI. E. Drioton, *Nilomètre*, pp. 36–39.

3.38
Niche head from Oxyrhynchos. (Greco-Roman
Museum; *by Courtesy of the Musée Gréco-
Romain*. W. Emery, *The Royal Tombs of Ballana
and Qustul*, Vol. 2.)

3.39
Niche head from Oxyrhynchos with a maenad.
(Greco-Roman Museum; *by Courtesy of the
Musée Gréco-Romain*. W. Emery, *The Royal
Tombs of Ballana and Qustul*, Vol. 2.)

3.40
Niche head from Oxyrhynchos with a Nereid
riding (Coptic Museum, Cairo, 4775. (W. Emery,
The Royal Tombs of Ballana and Qustul, Vol. 2.)

3.41
Niche head framed within a cornice reduced to
foliate ornament. (E. Breccia, *Oxyrhynchos* I.
*Municipalité d'Alexandrie, Le Musée Gréco-
Romain*, 1925–1931 [Bergamo: 1931], pl. XLIII,
153.)

3.42
Fragments of carved bands with various motifs.
(E. Breccia, *Le Musée Gréco-Romain, 1931–
1932*, Vol. 2, pl. XXXI, 94.)

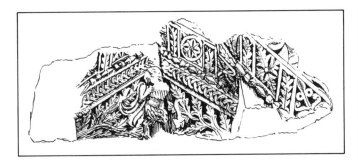

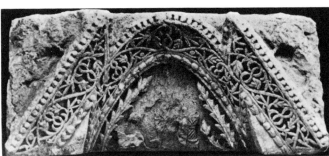

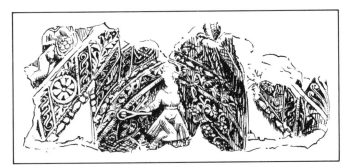

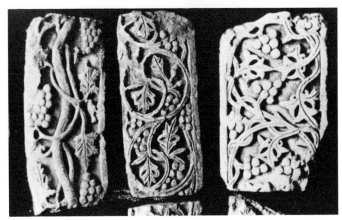

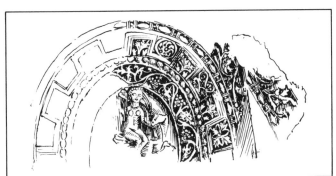

3.43,*a, b*
Bands with protomes and animals. (E. Breccia,
Le Musée Gréco-Romain, 1925–1931, Vol. 1,
190–191.)

3.44
Carved band from Oxyrhynchos with acanthus
scroll peopled with lion and gazelle. (B. M.,
1805; A.D. IV.)

3.45
Fragment of frieze from Oxyrhynchos
representing a hare nibbling leaves and a basket
of fruit. (B. M., 1804; A.D. IV–V.)

3.46
Niche head with shell and cornice with
modillions. (E. Breccia, *Le Musée Gréco-Romain,
1925–1931,* Vol. 2, pl. XLIV, 156.)

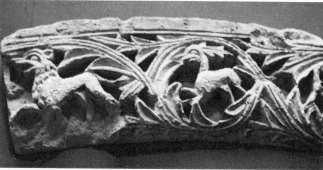

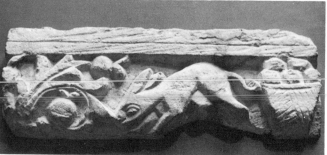

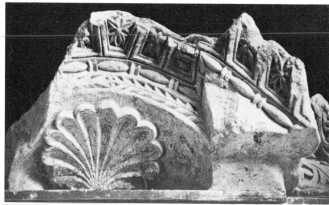

3.47
Band with elaborate naturalistic vine scroll. (E. Breccia, *Le Musée Gréco-Romain, 1925–1931,* Vol. 1, pl. XLV, 159.)

3.48
Frangments of cornices with coffers carved with acanthus and rosettes. (E. Breccia, *Le Musée Gréco-Romain, 1931–1932,* Vol. 2, pl. XXXV, 98.)

3.49
Fragments of cornices with modified egg-and-dart, intertwined acanthus, Greek key, and meander. (E. Breccia, *Le Musée Gréco-Romain, 1931–1932,* Vol. 2, pl. XXVI, 99.)

3.50
Fragments of bands with stylized myrtle and modified egg-and-dart. (E. Breccia, *Le Musée Griéco-Romain, 1931–1932,* Vol. 2, pl. XXX, 93.)

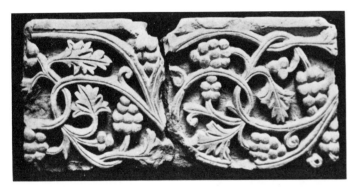

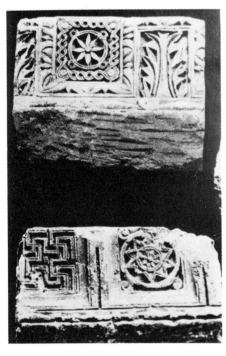

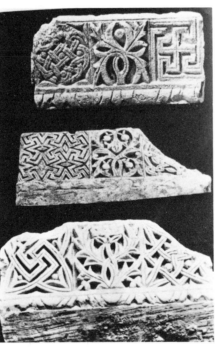

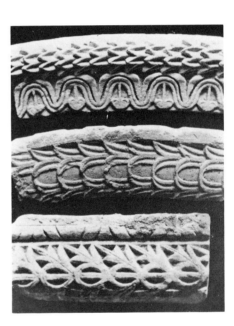

band. A later stage is characterized by a loss of naturalism in foliate design and carving which results in a lace-like quality contrasting protruding designs against a dark background, as in niches without cornice (see Fig. 3.41).[42] After a wave of inspiration from the imperial workshops, Coptic sculpture proper develops its repetitive quality at Saqqara and Bawit.

The short-lived phenomenon of Ahnas sculpture no longer appears isolated, for Oxyrhynchos provides us with many of its Roman prototypes. Ahnas, Coptic Hnes, was the successor to Herakleopolis Magna (Egyptian Hat-nen-nisut) on the right bank of Bahr Yusef at the entrance to the Fayum, mainly Coptic since 325. Its bishop attended the Council at Nicaea. It had been the seat of the pharaohs of the Eighth Dynasty (2160 B.C.), who struggled against the Thebans and evolved a style derived from the Memphite school marked with currents of freer naturalism and bolder, angular drawing and carving. While it would be an idle task to try to trace influences in Coptic sculpture back to that remote age, there is no doubt that the spirit of a style of angular carving in broad planes featuring slender-waisted figures is apparent in both Greco-Roman Herakleopolis Magna and its successor Ahnas. Most of the production represents the pagan repertory in a soft modeling, so-called "soft style," with at least one Christian monument (C. M., 45942) which evolved into a coarser sketchier type or "hard style" with occasional Christian subjects (C. M., 7285), still using Hellenistic and

Roman elements conspicuous for their sensuous nudes. The date of this episode has been variously set between the end of the fourth and the beginning of the fifth centuries (Villard, Kitzinger, Perkins, Drioton),[43] the fifth century (Beckwith, Wessel)[44] or even less satisfactorily in the sixth century (Harris),[45] when most of the Copts and Greeks had renounced paganism.[46] Although deriving its repertory from the Hellenistic and Roman, Ahnas sculpture even to its harder variety of style is evidently an outcome of classical art, though endued with enough individuality not to be identified with it nor with Coptic sculpture proper. It is a transition style. The problem presented by the pagan repertory peculiar to Ahnas has received no satisfactory solution. Pagan features such as Dionysos or Nereids occur elsewhere but not with the emphasis on sensuous stances and nudes which is evident at Ahnas. They undoubtedly belong to what has been labeled Greek provincial sculpture, perhaps a reassessment of Greek paganism in an ever-growing Christian Coptic environment ?[47] Some doubt has been raised regarding the reported occurrence of these elements in a Christian context, perhaps as reused pieces inserted in Coptic churches, since their excavator Edouard Naville claimed to have found them among the remains of the church at Ahnas. The

suggestion is not as wild as it would seem at first glance, for early Christian art in the catacombs made use of elements from the pagan repertory such as Orpheus enchanting the beasts or Isis and Harpokhrates, a borrowing that shifted later in the Romanesque to the invention of genii, demons, and fantastic creatures. In the literature of the times some echo about the mentality seems to confirm the possibility of a fashion for mythological tableaux, for Procopius (Anekdota, Lib. 9. 20–22) reports that the future empress Theodora mimed in her youth such a lurid scene as Leda and the Swan—a scene already condemned by Clemens Alexandrinus[48] and one of those represented in the sculpture at Ahnas. Coptic cenobites indeed denounce the depiction of pagan deities: "the dirty Apollo, impudic cytharid, the Jupiter and his son Ares";[49] and Shenute does not spare the contemporary pagans.[50] Without assenting to such an extreme view as Lauzière's which favors an interpretation of Leda and the Swan in terms of Christian dogma, could we not infer that the reuse of the sculptures marked symbolically the subordination of pagan mythology to the new triumphant faith ?[51] This interpretation, certainly valid for Romanesque art, is

42. E. Breccia, Oxyrhynchos I, 153–155.

43. E. Kitzinger, "Early Coptic Sculpture," pp. 188–189. J. B. Ward Perkins, "Shrine of St. Menas," p.62. E. Drioton, Les Sculptures Coptes du Nilomètre de Rodah (Cairo: 1942) p. 12.
44. J. Beckwith, Coptic Sculpture (London: 1963), pp. 19–20. K. Wessel, Koptische Kunst, p. 155.
45. J. M. Harris, "Report," p. 597, n. 16.
46. K. Wessel, Koptische Kunst, pp. 155–156.
47. Ibid., p.155.

48. Clemens Alexandrinus, Cohartatio ad gentes, Lib. 18; quoted by U. Monneret de Villard, La scultura ad Ahnas (Milan: 1923), p. 45. (Hereafter cited as Ahnas.)
49. J. Leipoldt, Schenute von Atripe und die Entstehung des national ägyptischen Christentums (Leipzig: 1903), p. 176; cf. G. Duthuit, La sculpture Copte, p.37.
50. Shenute, Oeuvres, ed E. Amélineau, Vol. 1. (Paris: 1907), p. 382.
51. G. Duthuit, La sculpture Copte, p. 37.

corroborated by the fact that the symbol of Christianity, the cross or Chrism, is carried within a wreath by two nude Erotes (Sohag; Coptic Museum, Cairo, 7030) and appears in numerous bronzes upheld in both raised arms of a nude dancing girl with crossing legs (C. M., 9101; Louvre, X 3622; Collection Berard, Paris; B. M.; Benaki Museum). A nude dancing girl also appears above a necklace with a cross pendent in a late tapestry (Brooklyn Museum), and silk fabrics with Nereids and maenads have been found in reliquaries (Sitten, Sens).

A relative chronology based on stylistic criteria is the only one that can be established for Ahnas sculpture, perhaps from soft to hard style, with a *terminus post quem* provided by two series in high relief set side-by-side and representing a youth wrestling with a bear and a lion treated in a late Roman provincial style with horror vacui (A.D. III–IV).[52] Most of the figured sculptures are set at a slant in headpieces of niches, some on slabs. Some characteristics are common to all monuments: the vivacious movements, rubbery limbs, deep shadows, linear treatment of the muscles, large heads with wide eyes showing a pupil either in green paint or as a circle incised or scooped out to receive an inlay, wedge-shaped folds of drapery, and symmetrical headdress. The most original among the female mythological figures is certainly a gracile Aphrodite (Fig. 3.51, Coptic Museum, Cairo 7052; early A.D. V) kneeling in

52. K. Wessel, ed., *Koptische Kunst*, p.147, Fig. 10.

the traditional Greco-Roman pose of the goddess and holding with upraised arms a drapery whose harmonious folds contrast in their movement with the fluted channels of the shell behind. The three-dimensional effect enhances the charm of the smiling, pointed-chin face, the curving slenderness of a bust hardly nubile, adorned with a thick collar, bulla, and armlets. Though carved in the soft style, the texture still shows the facets left by the adze along the bust and limbs, for the Coptic sculptor never cared to achieve a smooth polish as did the Egyptian or even the Alexandrian in porphyry. The same adze markings also show along the slender Daphne (Fig. 3.52, Coptic Museum Cairo, 7061, early A.D. V), holding with both arms upraised the two symmetrical stylized stems of the tree that will soon absorb her. A central recessed line marks the axis of the frontal figure from the neck to the deep navel, a remnant from the Ptolemaic type of female nude. Very similar is a variant of an axial Daphne (Fig. 3.52, Coptic Museum, Cairo, 7037; early A.D. V) whose rounded forms contrast with the angular leaves of the tree spreading its branches symmetrically at the back of the niche head (compare ivory from Ravenna, textiles). Here no axial line disrupts the smooth curvature of the bust. This stress on the axiality of the standing figure, never fashionable in Roman art but noticeable in Ptolemaic sculpture, is in fact the basic feature of an abstraction of Venus Anadyomene (Fig. 3.54; C. M., 44072; A.D. V; compare C. M., 7280) standing on the hinge of a tall shell whose deep channeling contrasts with the coils of the drapery molding

her leg or those of two heavy ropes of hair she holds in her upraised arms. The figure itself has lost most of its sensuality, already lessened by the profuse jewels, in favor of a planned geometric impact enhanced by the intertwine running horizontally above the composition. Nearly symmetrical with more tactile effect is the group (Fig. 3.55; Civico Museo di Storia del Arte, Inv. 5620; A.D. V) of two Nereids, each holding in upraised arms a scarf that curves behind her head and dancing around a singing Eros who is holding a torch and riding a dolphin. Above them a hairy Roman mask smiles on the egg-and-dart border. Nothing detracts from the harmonious curves of the singing trio, not even the huge earrings typified in the Fayum portraits, the prominent bulla, and flowing scarf. Folds are entirely avoided, even those marking the abdomen in other female nudes. Rarely has a metaphysical setting (German, *Stimmung*) been rendered so perfectly. The curving scarves held by Nereids behind their heads often occur with dolphins in classic and Hellenistic art in scenes of the myths of Dionysos and Leucothea as well as in that of Siva in India. Nereids holding a scarf are also depicted riding seahorses (Fig. 3.56, C. M., 7289; compare Coptic Museum Cairo, 7033 C. M., 44066) accompanied by an Eros on a dolphin (C. M., 7280) or two Erotes on two dolphins (C. M., 44081). According to Greek legend a dolphin had taken up the shipwrecked poet Amphion and carried him on its back to the shore—an episode borrowed by funerary symbolism where shipwreck

3.51
Niche head with Aphrodite surging from a shell.
(Ahnas; Coptic Museum, Cairo, 7052; early A.D.
V).

3.52
Daphne holding the stems of the tree that will
embody her. (Ahnas; Coptic Museum) Cairo,
7061; early A.D. V.)

3.53
Daphne stylized into a symmetrical composition.
(Ahnas; Coptic Museum, Cairo,7037; G. Duthuit,
La Sculpture Copte, pl. XXIIb.)

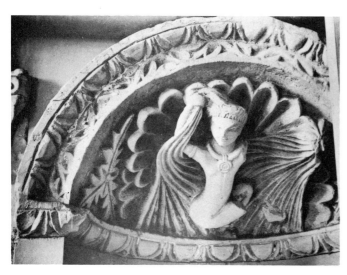

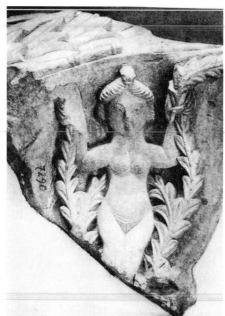

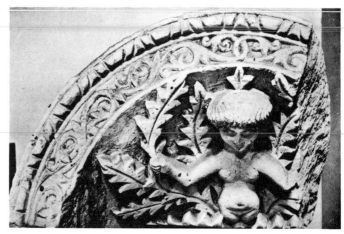

3.54
Venus Anadyomene from Ahnas, an abstract figure symmetrical against a shell. (Coptic Museum, Cairo, 44072; A.D. V–VI; G. Duthuit, *La Sculpture Copte*, pl. XXVIII*a*.)

3.55
Nereids and singing Eros riding a dolphin, from Ahnas. (Civico Museo di Storia del Arte, Inv. 5620; A.D. V; G. Duthuit, *La Sculpture Copte*, pl. XXXII*a*.)

3.56
Nereid riding a sea horse within a niche head. (Ahnas; Coptic Museum, Cairo, C. M., 7289; K. Wessel, *Koptische Kunst*, Fig. 43.)

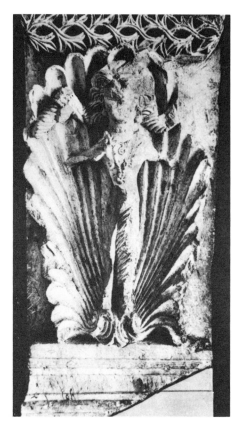

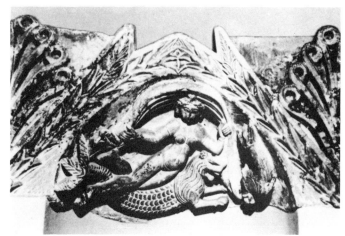

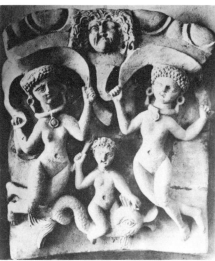

is likened to death, and the shore to immortality. Much of the supple, rounded modeling characteristic of Alexandrian rendering of the scene in ivory carving can be recognized in the Ahnas specimens, with some indications of evolution, such as the two hands across the bust derived from collars similarly worn on Alexandrian terra cottas and the sea fauna added (C. M., 7280) to comply with horror vacui. A tactile impact is conveyed by the two women (dryads ?) reclining symmetrically on either side of a basket (Fig. 3.57, Greco-Roman Museum, early A.D. V) in a balanced composition achieved by a foliage stem intertwined with figures.

The hard Ahnas style achieves lesser aesthetic satisfaction, though it is often of impressive impact. The Orpheus with his inorganic figure seated on a chair (Fig. 3.58; C. M., 3, 1, 21, 8) and holding a lyre can claim neither tactile nor abstract effect, but is conspicuous because of his large head with staring eyes and his nudity. The evolution of the hard style into folk craft is illustrated at its worst stage in the crude Dionysos (Fig. 3.59; C. M., 44073; end A.D. V–VI) flying horizontally on the soffit of the ranking course of a pediment and holding fast to an inorganic vine. The two bunches of grapes pendant on both sides of the face are borrowed from Greco-Roman iconography. Other niche heads represent Dionysos in the middle of a ground of profuse vine interlace (C. M., 7292) or crowned with a diadem of quatrefoils and grapes and holding the thyrsus (C. M., 44067) akin to the

Daphne. Perhaps a closer analogy with the latter is offered by Gaia, the personification of Earth (Fig. 3.60, C. M., 44070; mid A.D. V) as a female bust issuing from the ground, reminiscent of the archaic Greek interpretation, holding in both arms a *mappula* full of fruit. Here the impact centers around the gesture and the head with slant eyes, devised perhaps in correlation with the horizontal setting of the carving on the soffit of a pediment. One of the favorite mythological themes at Ahnas is that of Leda and the Swan (Fig. 3.61; Coptic Museum, Cairo, 7026; mid A.D. V; after Du Bourguet; compare Greco-Roman Museum Alexandria 14.140). Instead of standing, as in the Hellenistic examples, Leda is always represented at Ahnas as reclining, once even on a seahorse (Berlin Museum 4134), while she holds the neck of the swan, encouraged so it seems by a winged Eros hurrying to the scene. The expressionist posture of Leda particular to Egypt probably finds its prototype in the Alexandrian terra cottas (Fig. 3.62; Greco-Roman Museum, 14.140). It has been suggested that the scene at Ahnas could be interpreted in terms of a Christian context.[53] The modeling varies with the pieces, for it appears once amorphous for Leda and Eros (see Fig. 3.61), and elsewhere emphasizes ribs and creases (see Fig. 3.62) while the swan is treated as a geometric zigzag pattern.

Two pieces regarded as marking stages in the evolution of folk art set vertical figures in the central gable of a broken

53. J. Lauzière, "Le Mythe de Léda dans l'Art Copte," in *Bulletin de l'Association des Amis de l'Art Copte*, Vol. 2 (Cairo: 1936), pp. 38–46.

pediment bordered by an acanthus interlace and flanked by two lions above foliate acroteria. On one, Pan pursues a bacchante playing clappers (Fig. 3.63; Coptic Museum, Cairo, 7044; mid A.D. V), both well-proportioned lively figures with strongly geometrized hair and sharp plaits. Let us compare this piece with the two broken pediments from Oxyrhynchos representing separately the two figures: the figures at Ahnas now overlap the whole central area of the pediment, which has been reduced to a single stylized acanthus interlace. The same simplification in design and modeling is recognizable in the figures, still Roman, at Oxyrhynchos and in the lions foreshadowing typical Coptic sculptures. On the second pediment a man, identified as Orpheus on the evidence of the lyre, and a woman (Eurydice ?) seated caress each other (Fig. 3.64; Coptic Museum, Cairo, 7004; mid A.D. V). The process toward emphasis on ornament is obvious in the patterns spreading over the garments and the treatment of the hair as well as the lyre set between both heads, whose outline it so defines.

Many arguments can be brought against the restriction of the so-called Ahnas style to one locality, among them the existence of a closely related style at Antinoupolis (Antinoë, modern Sheikh 'Abada). This city, founded by Emperor Hadrian in 130 in remembrance of his favorite Antinous, who seemingly had voluntarily drowned himself in the Nile to avert a bad omen from his emperor, had the unique prerogative among other Greek cities of allowing mixed marriages (conubium)

3.57
Two women flanking a basket of fruit. (Ahnas; Greco-Roman Museum; early A.D. V; G. Duthuit, *La Sculpture Copte*, pl. XXXII*b*.)
3.58
Orpheus seated. (Ahnas style, C. M., 3, 1, 21, 8; G. Duthuit, *La Sculpture Copte*, pl. XVII*a*.)

3.59
Dionysos in the vine on the soffit of a niche head. (C. M., 44073; A.D. V–VI; K. Wessel, *Koptische Kunst*, Fig. 58.)
3.60
The personification of the Earth Gaia holding a *mappula* of fruit. (Ahnas; C. M., 44070; mid. A.D. V; G. Duthuit, *La Sculpture Copte*, pl. XXIII*a*.)

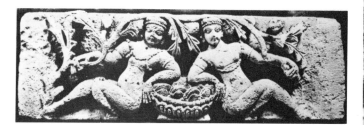

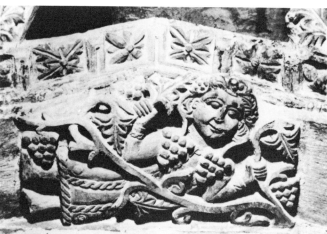

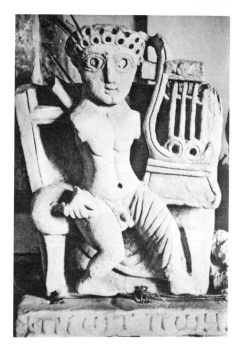

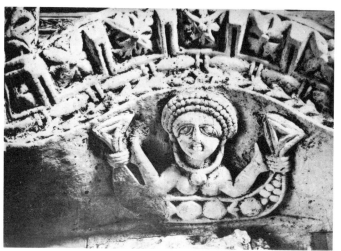

3.61
Leda and the Swan. (Coptic Museum, Cairo, 7026; mid A.D. V; G. Duthuit, *La Sculpture Copte*, pl. XXVI.)
3.62
Alexandrian terra cotta representing Leda and the Swan. (Greco-Roman Museum, 14.140; E. Kitzinger, "Early Coptic Sculpture," pl. LXXIII, 4.)

3.63
Pan pursuing a Bacchante from a niche head. (Coptic Museum, Cairo, 7044; A.D. V; G. Duthuit, *La Sculpture Copte*, pl. XXI.)
3.64
Orpheus and Eurydice caressing. (Coptic Museum, Cairo, 7004; A.D. V; G. Duthuit, *La Sculpture Copte*, pl. XX.)

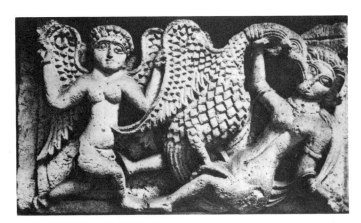

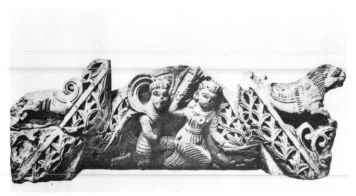

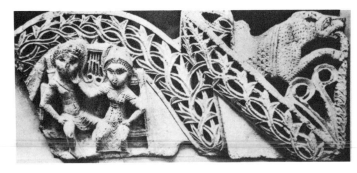

between Greeks and Egyptians. In spite of being the seat of one or even two bishops (an orthodox and a Monophysite c. 325), it seems to have remained a center of paganism well into the sixth century.[54] No wonder then that its sculpture shows strong affinities with that of Herakleopolis Magna (Ahnas). This is well illustrated by a Daphne (Fig. 3.65; Louvre, A.D. V), frontal and nude with an elaborate headdress and a huge bulla, being swallowed by the stylized bush of acanthus whose outer stems she holds in both upraised arms—a composition quite similar though perhaps more stylized in its delineation than that at Ahnas. Its torso is well defined by two lines beneath the breasts and above the hips. The headdress, reminiscent of the fashions of the third century, is similar to a more geometrized one in a bust of unknown provenance (Fig. 3.66; B. M., 36143; end A.D. V) still more similar as to hair, adjacent eyes, and flat bulla to a female head from Ahnas (C. M., 49660). The hair parts symmetrically in the middle into three plaited volutes and a pendant lock reminiscent of Hathor's single one. The characteristic hair fashion in a symmetrical arrangement appears on a head of Alexander (?) of Hadrianic date (Glyptothek Ny Carlsberg, Inv. No. Egyptian Collection 933). In a more sketchy modeling but one with good proportions are the two nude angels grouped antithetically at the angle of a pediment and carrying jointly a flabellum (Fig. 3.67; Louvre; end A.D. V–VI) instead of an imago clipeata.

Characteristic for Antinoë is a large group of high reliefs, some of doubtful autheniticity, which represent the deceased in his prime standing or seated frontally within a simple aedicula, holding in either hand a grape, pine cone, wreath, or dove symbolic of an Isis mystes (A.D V). The features are well modeled, the eyes painted black, the tunic and hair red, and the grape and dove blue. The type is similar to that of a piece from Oxyrhynchos representing a standing youth holding a roll and a pine cone (Fig. 3.68; B. M., 1795; late A.D. IV–V; compare Brooklyn Museum, 58.129; A.D. III–IV). The monument is related to the typical earlier funerary stela (National Museum, Florence, 10042; compare C. M., 37.677, from Samallut; A.D. III), but the head is too large and its naturalistic style with staring eyes is reminiscent of the mummymasks or even the anthropomorphic casings.

The group of Isis mystai in painted limestone shows a wide variety in the quality which suggests that they were carved in several workshops over a century or more. One example (William Rockhill Nelson Gallery of Art, Kansas City; A.D. III) represents a youth in a tunic painted with clavi and *orbiculae* and wearing a bulla standing in an *edicula* of late classical style with arched niche head containing a shell. It has been suggested[55] that the type represents the youthful acolytes of the goddess Isis and that the attributes are similar to those of the grape and dove held by a nude Harpokrates (?) of Alexandrian style (marble, Museum of Fine Arts, Houston; A.D. I). The iconographical attributes are also encountered in several votive terra cottas from the early Roman Period in Egypt representing Harpokrates seated on the ground and holding a bunch of grapes in his right hand and a dove in his left.

While the mystai are probably all pagan, the denomination of a sculpture from Antinoë representing a nude youth, reminiscent of Dionysos, carved nearly in the round within a vine on a niche head (Louvre, AC 122; A.D. IV) is not as clear.[56] The head and torso are too large for the legs, perhaps on purpose as an illusionistic device to emphasize still more the perspective deformation resulting from the quite inclined setting of the figure in the niche head. The style still belongs to the Hellenistic one, the wide deeply contoured eyes with abstract gaze excepted.

Another sculpture from Antinoë shows also a nude youth similar to the Dionysos, though in a slightly stiffer frontal attitude, holding a bunch of grapes and raising a cross in his right hand (Staatliche Museen, Inv. No. 5/62; similar to No. 6/62; A.D. IV). The figure is carved nearly in the round standing on a base connected to a back slab which was originally engaged in a wall. A similar setting appears in a sculpture (Fig. 3.69; Brooklyn Museum, 62.44; A.D. 350–450),[57] but the slab is carved

54. K. Wessel, *Koptische Kunst*, pp. 75–76.

55. J. D. Cooney, "An Early Christian Sculpture from Egypt," *Brooklyn Museum Annual*, Vol. 2–3 (New York: 1960–1962), pp. 36–47.

56. P. Du Bourguet, *Die Kopten*, (Baden-Baden: 1967), pp. 35–36. *L'Art Copte. Petit Palais, Paris: 1964*, No. 45, pp. 77, 78. (Hereafter cited as *Art Copte*.)

57. J. D. Cooney, "An Early Christian Sculpture," Figs. 5, 6. For the youth holding the cross see Fig. 8.

3.65
Daphne, (Sheikh 'Abade; Louvre; A.D. V–VI.)

3.66
Female head with coiffure stylized from the
Ptolemaic type, eye pupil painted green.
(limestone; B. M., 36143; A.D. V.)

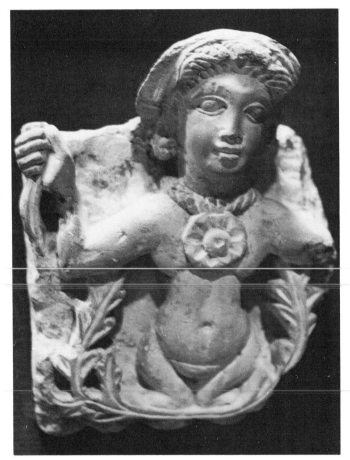

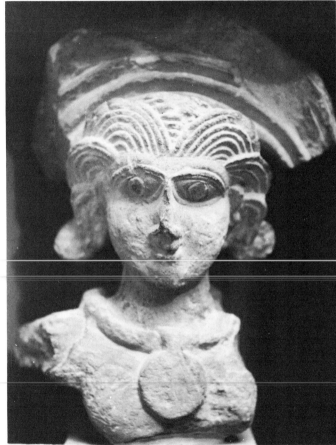

3.67
Two cherubs carrying a flabellum in the angle of a pediment. (Sheikh 'Abade; Louvre; A.D. VI.)
3.68
Youth standing in a niche and holding a roll and a pine cone. (Oxyrhynchos; B. M., 1795; limestone, A.D. IV–V.)

3.69
The paralytic rising to carry his bed. (Antinou-polis; Brooklyn Museum, 62.44; courtesy Dr. B. V. Bothmer, Brooklyn Museum of Art.)

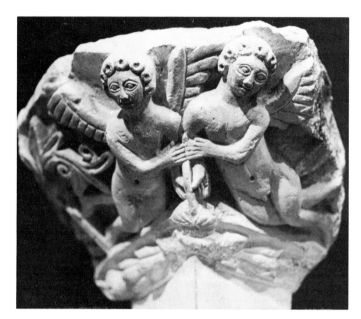

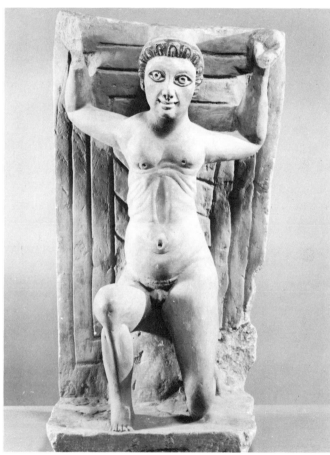

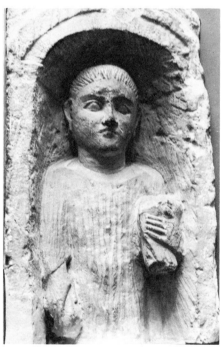

with the representation of a bed raised by a man trying to rise from a kneeling attitude. The subject was identified as the One Cured of Paralysis, here nude kneeling on his left knee, both arms upheld in the instantaneous motion of the ancient Egyptian god Shu carrying the sky. In contrast with the other nudes from Antinoë, especially the two which have a similar back slab, the torso is emaciated showing the ribs, the abdomen swollen and flabby, the feet atrophied and deformed. The realism in the anatomical detail allied to the refined smiling features and large eyes intent with faith make of this piece (61.5 cm, height, 29.7 × 28 cm. base) the most important proto-Coptic sculpture.

Early architectural sculpture from Antinoë is exemplified by an archivolt and a capital (Museum of Art, Montreal, 59.13.3; A.D. IV). The pillar capital (Fig. 3.70) shows above a geometrized bead-and-reel and a fret a bold egg-and-tongue from which projects in a curved profile two confronted lions and two rearing quadrupeds on a ground of acanthus. The beautifully modeled animals and the foliage stand out on a deep shadowy ground, giving the impression of sculpture in the round. This outstanding piece foreshadows the composite capitals to which so much inventiveness was brought by later Coptic sculpture (see Capitals, pp. 195–210). The fragmentary archivolt represents the same sequence of moldings from the bottom: bead-and-reel, egg-and-tongue, surmounted by an upper zone where appear on a setting of deeply outlined acanthus two spirited

confronted hounds seemingly ready to devour a gazelle's head between them. The axis of the composition passes between the confronted animals and is marked on the fret below by a large rosette.

Here let us consider a peculiar sandstone openwork stela (Fig. 3.71, Louvre Inv. No. X 5 130) representing in a flat modeling a hawk-headed Horus riding a horse, whose head is turned frontally, spearing a crocodile engaged between the feet of the horse. The artificiality of the composition, the Roman soldier's garb, and the style all point to a date as late as the fifth century (mid-fourth, after Du Bourguet). The motif is derived from earlier sculptured stelae representing beneath a Horus confronted horsemen armed with spears, probably related to the Dioscuri (Fig. 3.72; Museo Egizio, Suppl. 1321),[58] and served as prototype to the familiar Coptic rider saints. Later confronted horsemen in a frieze beneath a soffit with meander (Glyptothek Ny Carlsberg, A.E. I. N. 1741; A.D. VII–VIII) are already represented in the frontal projection characteristic for the Coptic rider saint.

A typically Roman torso carved frontally in a scooped out area on an Egyptian frieze as a substitute for one of the original figures (Fig. 3.73; Medinet Habu)[59] is an excellent *unicum*, proving that the proto-Copts, possibly Christians, sought in sculpture as they did in painted murals (Sebu'a) to enthrall the

pagan deities. Here the newcomer is blessed by Hathor (?) and Horus who holds his right arm.

A few monuments of this early period dependent on the Hellenistic style and repertory are marked with Christian symbols. The Maria Lactans incised in a bold pure graffito on a slab from the Fayum (Fig. 3.74; Staatliche Museen, I.4726; A.D. V) shows in a most impressive way the theme appropriated from that of the Isis Lactans, set here within an architectural frame but with a rendering of depth in the feet, the stool, and the torso. Supple lines convey the effect of movement in arms and head. Such successful aesthetic techniques can only have been achieved by a master trained in the best Alexandrian tradition, and as early a date as the fourth century has been suggested (Beckwith, Du Bourguet). Space and movement are also accurately represented in the low-relief figure of a man wearing a short tunic and burdened with goods who is leading an ass against a ground of an arch on two columns (Fig. 3.45; Glyptothek Ny Carlsberg, A.E. I.N. 883; A.D. V). The incised Greek inscription is a short epitaph: "In peace, he who rested in the Lord, Eulogis. Hathor 23." The face is the only element denoting through its frontality a proto-Coptic device in a naturalistic composition and technique. Much stronger ties with the Hellenistic tradition, even to the Lysippic stance typical of the poets and philosophers in the hemicycle at the Serapieion (Saqqara, B.C. III),[60] are

58. W. F. von Bissing, "Il Culto dei Dioscuri in Egitto," *Aegyptus,* Vol. 33, fasc. 2 (Milan: 1953) pp. 347–357.
59. U. Hölscher, *The Excavation of Medinet Habu, V* (Chicago: 1954), pl. 34 J. (Hereafter cited as *Medinet Habu,* V.)

60. J. P. Lauer and C. Picard, *Les Statues Ptolémaiques du Sarapieion de Memphis* (Paris: 1955).

3.70
Capital of a pillar. (Antinoupolis; Montreal
Museum of Art, 59.13.3.)
3.71
Openwork stela representing Horus riding a
horse and spearing a crocodile. (Louvre, Inv. No.
X 5 130; A.D. V; G. Duthuit, *La Sculpture
Copte,* pl. XVI*a*.)

3.72
Stela of two horsemen, perhaps the Dioscuri.
(Museo Egizio, Suppl. 1321.)
3.73
Egyptian block recarved to represent a figure in
Roman costume protected by two Egyptian
deities. (Medinet Habu; U. Hölscher, *Medinet
Habu, V,* pl. XXXIV J.)

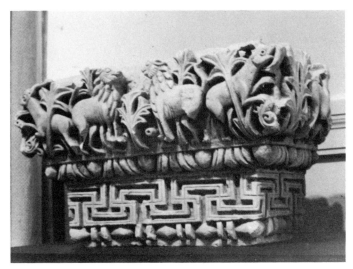

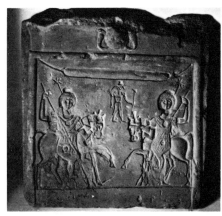

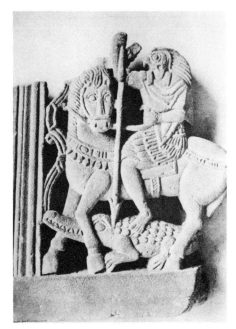

3.74
Stela from the Fayum incised with a beautiful
representation of Maria Lactans. (Staatliche
Museen, I. 4726; A.D. V.)

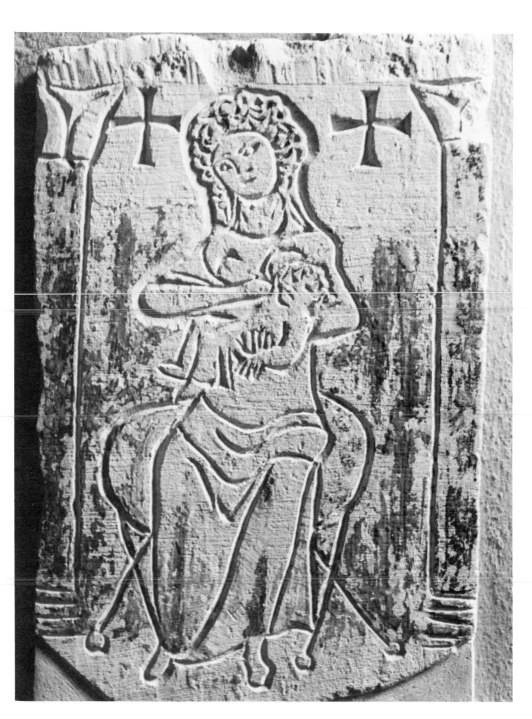

3.75
Stela representing a deceased and his ass.
(Glyptothek Ny Carlsberg, A. E. I. N. 883; A.D.
V.)

3.76
Two saint personages standing within a gabled
façade (Glyptothek Ny Carlsberg, A. E. I. N. 884.)

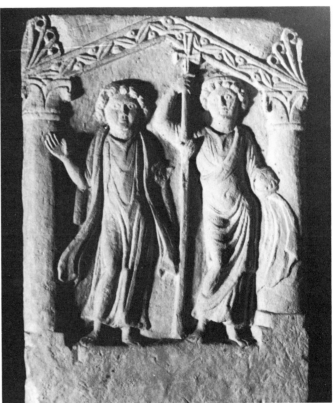

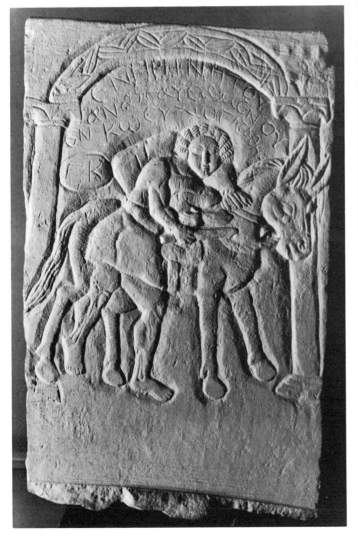

found in a beautifully carved stela representing two figures standing within a gabled façade (Fig. 3.76; Glyptothek Ny Carlsberg, A. E. I. N. 884, A.D. V); these are interpreted as Christ holding the globe and a long-handled cross with an *orans* (Koefoed-Petersen), or an archangel with a saint (Beckwith). The gesture of the *orans* akin to the typical iconography of the catacombs (Thrason, Ostrianus, St. Cyriaca), the lack of any supernatural symbol, the figure holding the cross in a manner reminiscent of the Roman soldier holding his spear or the emperor Honorius holding the globe in the left and the labarum in the right (diptych of Anicius Probus; see also medallion of Valens), as well as the curving stance and flowing robes, all point to a still vivid Hellenistic tradition. A date in the fourth century would seem adequate for this monument, which foreshadows the earliest standing figures carved at Bawit (see Fig. 3.80).

If the hinterland provenance of the pieces indicates the location of the workshops where they were carved, it would seem that excellence in Hellenistic sculpture in proto-Coptic times was not restricted to Alexandria alone; this was also true of painting, as excellent murals of Hellenistic style are found at Deir Abu Hennis. This situation existed already in the Ptolemaic and imperial periods: in sculpture, the hemicycle of the Serapieion at Memphis, porphyry statuary from Akhmim and Qena, and architectural sculpture at Oxyrhynchos; and in painting, the murals at Hermupolis West and at the *sacellum* in Luxor temple.

The gradual decline of excellence that had started in Alexandria in the late Ptolemaic period continued in the Roman period, echoing the unfavorable environment during the third to fourth centuries. The picture of flourishing semi-Hellenic metropolises evoked by contemporary papyri such as that for Oxyrhynchos[61] is corroborated by their artistic achievement, imitating and sometimes even rivaling the Alexandrian one. Popular art in Alexandria contributed as much as provincial art to the invention of Coptic art, a process already noted in the influence of terra cotta on proto-Coptic sculpture at Ahnas. In the Coptic period proper that can be defined as starting in the second half of the fifth century, Church art formerly sponsored by the Alexandrian patriarchs, both orthodox and Monophysite, is monopolized by the monastic communities thriving in the Thebaid (Armant, Dendera) and elsewhere in the valley (Sohag, Akhmim, Bawit, Antinoupolis, Saqqara) and the deserts (Wadi Natrun, Red Sea, Abu Mina). This emergence of Coptic art mainly as monastic art endowed with many of the characteristics of a native art is not so well defined for sculpture as it is for mural painting, since the monks painted the oratories of their cells as well as their churches, but the churches alone, however, are also ornamented with sculpture. At the same time ivory carving, still flourishing in Alexandria, is appreciated abroad despite the predominance of Constantinople. There is, in addition, a provincial production outside the larger towns which can be easily identified from its cruder style. This

accounts for the art trends that start in the fifth century in Alexandria and the rest of Egypt.[62]

In the absence of circumstantial evidence for most of Coptic art, the problem of dating assumes an acute complexity. Unlike epigraphic criteria, stylistic and iconographic evidence is not as reliable for Coptic work as it is for the Byzantine production, because of the wide differences that are apparent in Egypt between contemporary productions of towns with established traditions and those of the hinterland, or even within the same frieze. Moreover, as already noted in regard to the so-called Ahnas style, a differentiation of styles or schools is premature, to say the least. Most of the hard technique production of Ahnas dated to the mid-fifth century already displayed characteristics of later sculpture. A stiffer stylization with iteration and staccato movement are the stylistic criteria.

The problem resulting from this dearth is, however, minimized by comparative analysis of motifs in Coptic and other work from the Byzantine world whenever available, as is the case for ivories. Wood carving is studied in the same context, though it must be admitted that this material, except for the very hard woods, hardly allows for the same perfection of modeling as ivory.

61. E. G. Turner, "Roman Oxyrhynchus," *JEA*, Vol. 38 (London: 1952), pp. 78–93.

62. J. Strzygowski, "Hellenistische und Koptische Kunst," p. 77.

Coptic Sculpture in Ivory and Wood

As might be expected, it is in the ivories that Alexandrian contribution is prominent, although occasionally other centers (Deir Abu Hennis) compete with Alexandria in this field as noted before for the proto-Coptic production and monastic workshops (Bawit). Iconography is now mostly Christian, derived from the Old and New Testaments (pyx, comb, wooden console from Bawit), hagiography (wooden console from Bawit, door of box) or even pseudo-pagan motifs appropriated by the Copts (wooden frieze from Bawit, Nilotic scene in Brooklyn). The so-called Moggio pyx from the treasure of the Abbey church of that name in the Veneto (Figs. 3.77, 3.78; Dumbarton Oaks, 36.22; A.D. VI)[63] is carved in bold relief not unlike that of the Mu-'allaqa lintel, with two scenes from the Old Testament. Moses dynamically ascending the Sinaï peak receives the scroll of the Law from the Hand, a symbol of the Almighty found elsewhere in the same context (cf. sarcophagus in Staatliche Museen; at Bagawat, Chapel I; in S. Apollinare in Classe, etc.),[64] while three Israelites avert their heads from the glare. The second scene represents Daniel in Persian dress as an *orans* flanked by two lions seated with their backs to him, their heads held by the hands of two angels in a hurrying stance, a frequent subject in pictorial art in Egypt (Bagawat No. 38, 80, rock painting at Athribis, wood relief from Bawit) and abroad (Sta. Maria Antica, etc.). The gesture of the angels is very rare, probably a literal illustration of the text "My God hath sent his angel, and hath shut the lions' mouths, that they have not hurt me" (Daniel 6:22). Bel also appears on a column with the Dragon coiled around it. The dynamic stances and the emphasis placed on the rendering of parallel folds in dresses are also characteristic of a comb from Deir Abu Hennis near Antinoë (Fig. 3.79; Coptic Museum, Cairo 5655; A.D VI),[65] but here there is a lesser sense of composition in the row of figures in the two adjacent scenes of the Raising of Lazarus and the Healing of the Blind Man.

These two scenes are very similar to two of the four miracles depicted on the ivory leaf of a diptych (Museo Nazionale, Ravenna; late A.D. V–VI), even in such details as the frontal mummiform Lazarus within his aedicula, the gesture of Christ holding a cross, the staff in the hand of the blind man, and the swaying movement of the figures, those on the comb being an interpretation of the more elegant *contrapposto* of the diptych. The scene on the other side shows an *orans* dressed in chiton and chlamys riding on horseback within a garland held by two standing angels, reminiscent of the *crux immissa* held by two flying angels along the upper edge of the diptych. The blind man carved on the comb is smaller than the other personages, following a tradition carried out on other monuments.[66]

Several wooden carvings from Bawit illustrate the transition to Coptic sculpture proper. A frieze (Benaki Museum; A.D. VI) represents Christ seated while saints hurry toward him, each in front of a bay of an arcade; this is probably from the same monument as the smaller frieze with saints in dynamic *contrapposto* (Staatliche Museen) reminiscent of the Mu'allaqa lintel but in a flat technique. Another frieze, also from Bawit, carved in pinewood painted (Fig. 3.80; Staatliche Museen, 4784; A.D. VI) represents a row of figures each encircled by a medallion—busts of angels alternating with pairs of birds and with dynamic *putti* treading outside their circular cell—in an interlace of Sassanian type; the sequence of seven medallions is probably only half of the total number flanking a *crux immissa*. The naturalistic, lively style still shows much of the Hellenistic alertness.[67]

Similar qualities are marred by the rigidity of the figure portrayed frontally in the two *mensolae* from the same monastery. Though now set vertically in museums, the *mensola* was a console projecting horizontally from the wall so that the main carved scene representing a personage within an aedicula would show him as if flying with his feet still firmly anchored to the wall, an effect similar to some of the proto-Coptic niche heads. The genesis of this element can be reconstructed from a classical acanthus bracket (Fig. 3.81; Ostia; nymphae from Reg. II, Ins. VIII) through the composite type bearing an animal head looking down beneath a foliate scroll (Fig. 3.82; Diocletian's palace, Spalato, North gate). On one of

63. J. S. Thatcher, ed., *The Dumbarton Oaks Collection, Harvard University*, (Washington, D.C.: 1955), No. 230, p. 104.

64. C. M. Kaufmann, *Handbuch*, index. A. M. Dalton, *Byzantine Art*, index.

65. J. Strzygowski, *Koptische Kunst*, No. 7117, p. 194, pl. XVII.

66. C. M. Kaufmann, *Handbuch*, Fig. 139, p. 353.

67. O. Wulff, *Altchristliche Bildwerke*, No. 251.

3.77, 3.78
The Moggio pyx, representing (*a*) Daniel in the lions' den and (*b*) Moses receiving the scroll (Dumbarton Oaks, 36.22; A.D. VI.)

3.79*a, b*
Carved comb from Deir Abu Hennis representing Christ raising Lazarus and healing the Blind, and an *orans* horseman in a clipeus held by two angels. (Coptic Museum, Cairo, 5655; A.D. VI; *Koptische Kunst,* Essen, 1963, No. 138.)

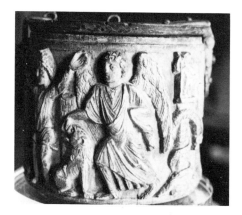

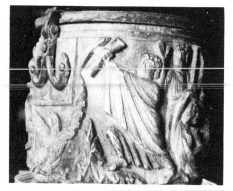

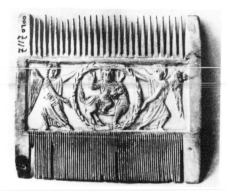

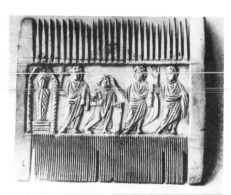

3.80
Frieze of pine wood with traces of painting carved with a *crux immissa* flanked by an interlace forming medallions with busts of angels, Erotes, and birds. (Staatliche Museen, 4784; A.D. VI.).

3.81
Typical acanthus brackets from the nymphae at Ostia. (Reg. II, Ins. VIII.)

3.82
Brackets carved with animal heads above the north gateway of Diocletian's palace at Spalato.

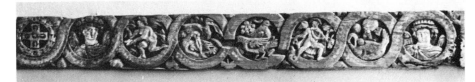

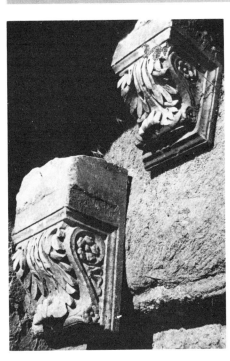

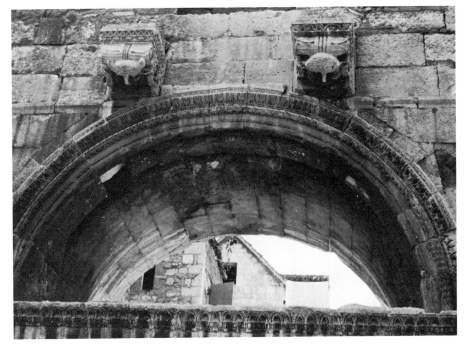

the Coptic consoles of acacia wood carved in high relief Daniel in Persian dress assumes a frontal slightly *contrapposto* stance between two asymmetrical lions within a niche composed of a shell framed by a floral archivolt on two slender columns with ornamented shafts and composite capitals (Fig. 3.83; Staatliche Museen, 3019; mid A.D. VI). Above the three free sides runs a meander with quatrefoils. The head is too large and the figure is no longer apparent beneath the profuse folds and ornament of the costume. This trend toward avoidance of the representation of the figure is not as strictly observed in the other console, one of an entire group,[68] portraying an apostle standing in *contrapposto* within an arched niche, his right hand raised in a blessing, his left holding a book. The proportions are normal and the forms of the body are rendered beneath the rope-like folds of the chiton and pallium (Fig. 3.84; Coptic Museum, Cairo, 8786; mid A.D. VI). Stylistic affinities with the friezes on Sitt Barbara door may be recognized, as well as much stronger similarities with three pilasters from Bawit, each topped with a panel enclosing a figure (see Fig. 3.169). A beam can be carved as two consoles symmetrical on either side of a central soffit left uncarved to be tenoned above a support. Others are carved with only foliate ornament or geometrical patterns, certainly better adapted to a horizontal element than the figure within a niche.

Before leaving wood carving let us mention a fragment of an Annunciation

(Fig. 3.85; Louvre, Inv. No. X 5243; A.D. V)[69] which represents in relief the Virgin seated, a basket in her left hand, her right hand raised to greet the Angel, whose leg alone is visible. While the figure is in lateral view, reminiscent of Egyptian projection, the face staring at the onlooker is typical of Coptic figures. This attitude, occurring sporadically in earlier ivories (mummy and rider on comb, Daniel), tends to become preponderant for main personages carved in an increasingly flatter relief in which incised lines replace the earlier molded folds. The rigidity of true frontality is cleverly avoided by showing some diversion in the limbs, as in the seated Hygiea holding a serpent (Dumbarton Oaks, 48.15, A.D. VI), or in the bearded Christ in a *mandorla* studded with linear stars and held by four angels (Walters Art Gallery, 71.303; A.D. VI) which contrasts sharply with the three-dimensional bold relief of the ivory panels reused in the pulpit of Emperor Henry II. These have been ascribed a date in the mid-sixth century on the basis of their representation of stirrups, which were unknown before. The style, strongly related to that of proto-Coptic ivories, though marred by deformities characteristic of later work (thin legs of Dionysos and Nereid, large heads, contorted maenad, emphasis on details of costume, horror vacui), favors a later date, perhaps even as late as the second quarter of the seventh century for some parts, because of the forceful strong though modified Hellenistic flavor in a "strongly copticized reproduction of Heraklean

prototypes,"[70] comparable to silver or textiles from that period. The debased style may be judged by comparing the personification of Isis of the Sea encumbered with symbols against a ground treated according to horror vacui (Fig. 3.86; pulpit of Henry II, Aachen cathedral; A.D. VII) with the earlier one of Alexandria Pharia on a medicine box (Dumbarton Oaks, 47.8; A.D. V) or by comparing the later, poorly proportioned horseman spearing a dragon (Fig. 3.87) to that of the Capture of a City. But this is an isolated example, and an allegedly Coptic Nativity (Dumberton Oaks, 51.30; A.D. VII?) carved in low relief is much more reminiscent of late Coptic monastic murals and Byzantine murals than of late-antique work, though it does borrow the kidney-shaped couch from the latter iconography (cf. Nativity of Dionysos on Antinoë textile). The crowded architecture in the background does resemble that in the Capture of a City and that of the throne of St. Mark (Museo Archeologico, Milan) but also the illuminations in later manuscripts.

A special mention should be made of an ivory representing the Madonna embracing the Child (Walters Art Gallery, 71.297; 26 cm. height, 11.6 cm. width, 5 cm. depth; A.D. IX).[71]

68. J. Strzygowski, *Koptische Kunst*, Nos. 8775–8776, pp. 121 ff.

69. J. Vandier, in *Bulletin Monumental* (Paris: 1945), pp. 250 ff. P. Lemerle, in *Monuments Piot*, Vol. 43 (Paris: 1949), pp. 98 ff. P. du Bourguet, in *Les Merveilles du Louvre*, Vol. 1 (Paris: 1958), p. 206; and *Art Copte*, No. 93, pp. 110–112.

70. H. Torp, "Book Reviews," p. 369.
71. P. Du Bourguet, *Die Kopten*, pp. 41, 43. *Art Copte*, No. 89, p. 107. *Koptische Kunst* (Essen: 1963), No. 136, p. 258. W. F. Volbach, *Elfenbeinarbeiten der Spätantike und des frühen Mittelalters* (Berlin: 1952), No. 254, p. 106. (Hereafter cited as *Elfenbeinarbeiten*.) For the piece at Castel Sforzesco, ibid., No. 253, pp. 105–106, pl. 51.

The Madonna is seated on a throne between two angels hardly seen from the front. The abstract expression of the wide-apart staring eyes is enhanced by the square outlines of the large faces, with unaesthetic features, and the geometric folds of the dress. The Virgin's face is not frontal as it was in an earlier Annunciation (wood, Louvre, X 5243; A.D. V). Both theme and composition are Byzantine. The piece shows a strong similarity with another ivory also claimed as Coptic but with the Child held in front of the breast (Castel Sforzesco; A.D. IX). In a small unpretentious piece in wood subservient to horror vacui, the primitive lock of the small cabinet door (25 cm.) integrates with a basket in the composition of an *orans* shown frontally overlapping the square frame (Brooklyn Museum, 30.28; A.D. VII). A similar door carved with a closely related interpretation of the same composition was found in the monastery at Bawit (Hall 41).[72]

In general, horror vacui tends to inspire Coptic graphics and especially low relief toward an ornamental style with the arrangement of well-balanced masses slightly enhanced by incised detail, as in the wooden fragments of a Nilotic scene with fish and duck (Brooklyn Museum, 4.1.978; A.D. VI–VII). The flat modeling is less impressive than in another fragment representing an ass amid luxuriant vegetation and a basket of fruit, a masterpiece of three-dimensional effect and harmonious balance of masses using very simple means (Louvre, X 5386; A.D. VII).[73] This interplay between masses and bare ground eventually leads to the technique of openwork in objects for practical use, such as a candlestick on nine columns representing a frontally placed figure topped by a bird (Walters Art Gallery, 61.124; A.D. IX or later). In more pretentious panels from an earlier iconostasis at Abu Sarga representing the Nativity, the Last Supper, and three rider saints the personages are crowding, overlapping one another in a flat fretwork incised with abundant geometrized detail. The spatial concept has disappeared and been replaced by an ornamental composition (Fig. 3.88; A.D. XI). Some of the details, such as the early Islamic columns framing the Last Supper and the trefoil arch around the head of a rider, place this group of panels in the eleventh rather than in the eighth century. This trend toward ornament is even more emphasized in a cedar panel carved with Christological scenes in a slight relief where the space between the figures is filled with unrelated ornament (from door of Sitt Mariam; B. M.; A.D. XIII). Stylized floral elements are soon combined with birds in panels within a granulated interlace carved in a bold style on small door panels (Benaki Museum, 331; A.D. VII–VIII), or in an antithetic composition of two birds or quadrupeds flanking a vase or a medallion (Louvre, A.D. X–XII).

The broad expanse of wooden iconostasis and doors offered an adequate field for low relief carving. In addition to the composition embodying small panels with scenes of historical narrative (Abu Sarga, see preceding paragraph) another concept was to design the whole as an architectural composition with rinceaus and panels of foliate Arabesque peopled with sphinxes, birds, griffons, stags, and crosses (Abu Sefein, Fatimid). Even more intricate is the representation of riders on galloping horses, confronted gazelles, monks, and presbyters framed by or applied onto the Arabesque (Sitt Barbara, Fatimid; Fig. 3.89). The principle of inhabited foliate decoration differs from the earlier Coptic one in that the figures and animals are shown in full and not partly (fore parts of lions, busts) as before. The technique achieves a two-plane contrast of lighted areas slightly carved for the main subject—little more in fact than silhouette —against a sharply edged deep shadow. It compares favorably with Islamic wood carving of the same Fatimid period.[74]

From foliate ornament folk art shifts to geometric patterns in a mechanical carving covering a small shrine on nine columns of symbolic meaning (Fig. 3.90; Aegyptologisches Institut der Universität, Heidelberg, No. 808; A.D. VII). Openwork ultimately loses even its initial balance between the masses and figures agglomerate with an utter disregard for outline definition. Such is a book cover with seven panels from the Christological cycle, arranged as in Coptic illuminated Bibles with six tableaux per page (see p. 279; Walters Art Gallery, 71.50; A.D. XIII).

72. J. Maspero and E. Drioton, "Fouilles exécutées à Baouît" *MIFAO*, Vol. 59 (Cairo: 1943), pls. LVI, C. (Hereafter cited as "Baouît.")

73. P. Du Bourguet, *Art Copte*, No. 97, pp. 114–115.

74. P. Du Bourguet, *Die Kopten*, p. 179, B.A., 21, 22.

3.83
Console of acacia wood carved in high relief with Daniel between the two lions. (Staatliche Museen, 3019; mid. A.D. VI.)

3.84
Console in wood carved with a saint standing in an archway. (Bawit; Coptic Museum, Cairo, 8786; mid A.D. VI.); (*Koptische Kunst*, Essen, 1963, No.147.)

3.85
Wooden carving representing the Annunciation, (Louvre, Inv. No. X 5243; A.D. VI.)

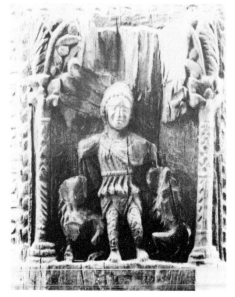

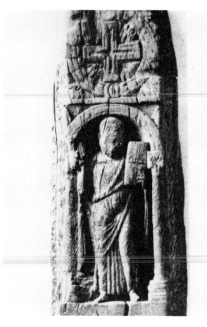

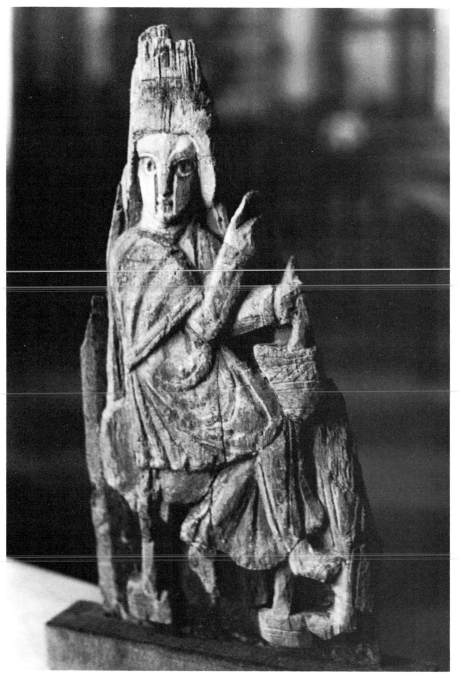

3.86
Ivory carving representing a personification of Isis of the sea. (Pulpit of Henry II, Aachen Cathedral, A.D. VII; J. Beckwith, *Coptic Sculpture*, Fig. 103.)

3.87
Ivory carving representing a horseman spearing a dragon. (J. Beckwith, *Coptic Sculpture*, Fig. 106.)

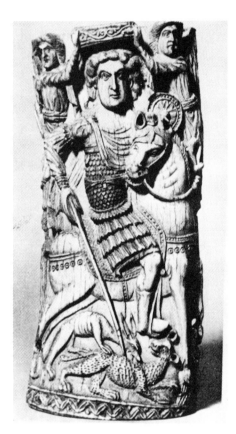

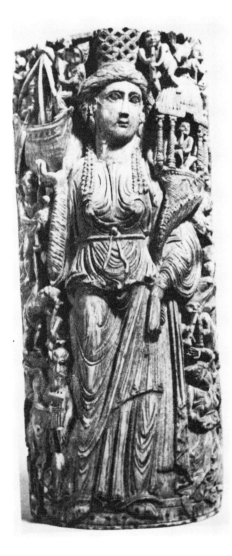

3.88
Wooden panel from Abu Sarga representing the
Nativity in an ornamental composition.

3.89
Upper part of a carved door from Sitt Barbara,
Cairo. (Coptic Museum, Cairo; Fatimid Period;
E. Pauty, *Bois sculptés d'églises coptes (Epoque
Fatimide)*, pl. II).

3.90
Wooden naos on nine columns. (Aegyptologisches
Institut der Universität, Heidelberg) No. 808; A.D.
VII); H. Ranke, *Koptische Friedhöfe bei Karâra*,
pl. XVIII.)

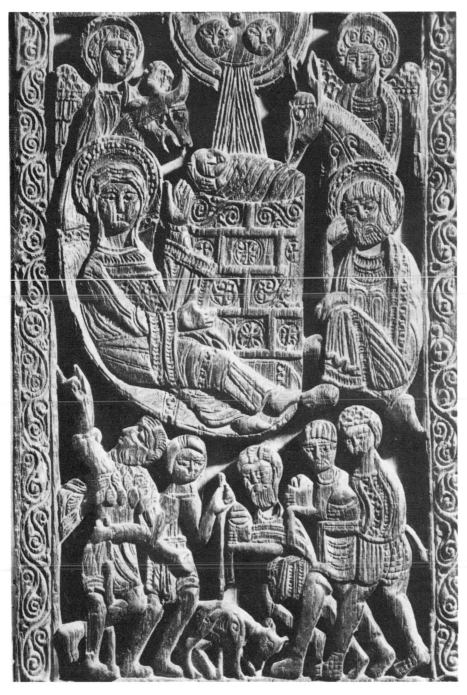

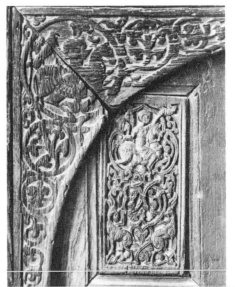

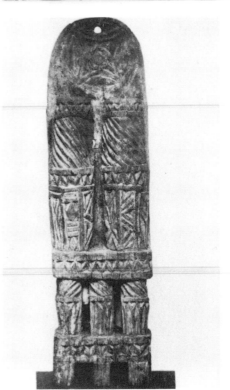

Coptic Stone Statuary

Coptic stone statuary is practically nonexistent; this, however, does not preclude the possibility that it once flourished if we remember the mass destruction of Coptic monuments by the Arabs early in the eighth century. Such a dearth enhances the intrinsic value of the few pieces attributed to that period.

The unique limestone head of unknown provenance (Dumbarton Oaks, 30.10, 15 cm.; second half of A.D. V), with its strongly stylized symmetry even to the vertical hair plaits fashionable in the mid-fifth century, the beard, the lines of the eyes and lips slanting up at their outer ends, which may be related to two personifications of the Nile, is probably a portrait that may be ascribed to the second half of the fifth century rather than to a later period.[75]

75. J. S. Thatcher, ed., *Dumbarton Oaks Collection* (Washington, D.C.: 1955), No. 39, p.17, A.D. VI–VII. J. Beckwith, *Coptic Sculpture*, No. 54, p. 51. K. Wessel, *Koptische Kunst*, pp. 90–91, compares it with a head from Ephesus in Vienna and emphasizes the hair style of the mid-fifth century. Its Egyptian origin is contested by some scholars.

Coptic Architectural Sculpture

Coptic sculpture was essentially architectural, carved on structural elements, mostly niche heads and capitals, but also on pillars and columns or lintels. Some of it represented figures as the main constituents of a composition in high relief copied from pagan models. The pagan motifs might have been adopted because they had no religious implication, or they could have been interpreted in terms of Christian symbolism. The commonest among these borrowings are the Erotes. The Nile god (Fig. 3.91; Brooklyn Museum, 41.891; second half of A.D. V) wearing a diadem of quatrefoils and holding a torch emerges on the curve of a niche head from the wedge-shaped ripples of water, and is balanced by a bust of Gaia adorned with a necklace and bulla and holding in both arms a *mappula* ornamented with rosettes and quatrefoils. The crisp sharpness of the Nile, apparent also in another frontal Nile with a beard curling into volutes reminiscent of Mesopotamian hair styles (Capital from Ahnas, Coptic Museum Cairo 7021; A.D. III–IV), contrasts happily with the round modeling of Gaia, both figures hovering horizontally above the onlooker. The similarity between the jewelry and that of Palmyra has been interpreted as a proof of Palmyrene influences at Ahnas (Du Bourguet).[76] Both sculptures represent the Nile, once reclining after the Ptolemaic type, accompanied by a female deity variously identified as Euthenia, Ge, Annona, Aegyptus, and in the other represented as a bust. The identification with the Nile is corroborated by the

76. Du. Bourguet, *Die Kopten*, p. 92.

lotus flowers in the larger scene and the Eros carrying a duck perched on the shoulder of the bust from Ahnas. Stylistic analogies indicate that the reclining Nile belongs to the Ahnas group.[77] The only large-sized sculpture of the Nile is the marble group of imperial Roman art in the Vatican Museum, representing a naked bearded man crowned with a laurel diadem, and reclining against a sphinx amid sixteen *putti* personifying the sixteen-cubit level of a bountiful inundation at Memphis. It has been assumed that this Roman treatment was the impulse to the creation of the Greco-Roman motif. In contrast to mythological themes in the sculpture from Ahnas such as Leda and the Swan, Daphne, and Dionysos (ascribed by Kitzinger[78] to a pagan opposition group in Ahnas), the personification of the Nile was acceptable to pagan and Christian alike. Popular rites to induce a high inundation or to celebrate it were performed on the river bank by all the Egyptians before and even after the conquest.

The subject appears on an ivory pyx probably from Alexandria dated to the sixth century representing a banquet and the personifications of the Nile with Erotes, a crocodile, and papyrus blossoms, and Egypt as a woman reclining against a sphinx (Landesmuseum Sammlung Nassauischen Altertümer, Wiesbaden, No. 7856;

77. A. Hermann, "Der Nil und die Christen," pp. 30–69; see p. 58. For the capital with the bust from Ahnas, see U. Monneret de Villard, *La sscultura ad Ahnas*, p. 76, Fig. 62.
78. E. Kitzinger, *Early Coptic Sculpture*, p. 192.

see p. 125).[79] The Nile and Euthenia are represented together with a Nilometer on a Coptic textile medallion (Louvre; A.D. VI). A Nilometer alone is being finished by two *putti* on a silver dish from Constantinople (Leningrad; A.D. VI).[80]

Pagan motifs are still carved in high relief on niche heads in a style akin to that of Ahnas such as in the dressed Nereid riding a sea monster whose upturned head she caresses (Fig. 3.92; Brooklyn Museum, M. 41.1226; second half of A.D. V). Contrasting with this treatment of the subject, but still with all its elements even to the caressing hand, is the flat niche head in slight relief from Oxyrhynchos. Its strong Copticizing trends comprise, besides the style, the corkscrew tail of the animal and the fish set sparsely in the background to comply with horror vacui (Fig. 3.93; Greco-Roman Museum, 23552; A.D. VI). More naturalistic are the Nereid with the scarf and the dolphin carved in high relief at the lower end of an archivolt that is decorated in a low-relief pattern of lotus, duck, and fish topped with a band of heart-shaped foliate design (Fig. 3.94; B. M., 1538; A.D. VI). A similar well-modeled Nereid holding the veil arched behind her head and caressing the head of her dolphin, a gesture reminiscent of that of Europa caressing the bull she rides,[81] appears

in a triangular pediment head flanked by two birds drinking from a basin on foliate acroteria (Fig. 3.95; B. M., 1537, A.D. VI–VII). Another flat niche head of unknown provenance exhibits a style related to that typical of Oxyrhynchos with its ornate scroll along the broken pediment flanked by two figures and enclosing a scene set *vertically*—perhaps above a doorway —representing Dionysos in a chariot driven by two bulls seen in inverted perspective toward a domed peripteral structure (Dumbarton Oaks, 43.6; A.D. V).

The only Christian sculpture from Ahnas is a fragmentary niche head representing a wreathed Chrism originally held by two flying angels (Fig. 3.96; C. M., 45942; end A.D. V), a derivation from the *imago clipeata* of the deceased held by two genii on pagan and Christian sarcophagi, prototype to the Christ in medallion held by angels appearing mostly in monastic art. Little from the earlier hard style of Ahnas is recognizable in the bold carving and full ornamental trend expressed in the deep channeling of the garment and in the bending of the wings into two to conform to the composition, a solution identical to that devised by the painter at Bawit (Hall 25 bis) for the wings of the two angels holding a clipeus with a bust of a bearded Christ.[82] When compared with this sculpture the pediment, probably from Sohag (Fig. 3.97; Coptic Museum, Cairo, 7030; beginning or second half A.D. V), in which two nude Erotes are shown standing in

a vertical plane, raising a *crux immissa* with two streamers, is nearer indeed to the spirit of Ahnas. A *crux immissa* is held horizontally in the claws of an eagle carved in the round, very impressive in its frontality and stylization, originally set perhaps above a doorway or a niche (Fig., 3.98. from Cairo; Staatliche Museen, 4699; A.D. V–VI). A symbol of Christian resurrection and triumph, it is also found as a *crux immissa* above the eagle in the murals at Bagawat and Athribis, on late Coptic funerary stelae, and abroad on South Gallic sarcophagi.[83]

Architectural sculpture at Ahnas is in many ways a development from that at Oxyrhynchos and shows the stylization process. The myrtle band three leaves broad derived from Greco-Roman gilded garlands and placed around funerary urns is still naturalistic on archivolts from Oxyrhynchos, but is interpreted as palmettes at Ahnas, where in the soft style every unit of three leaves is as broad as long, and later in the hard style its length is one and one-half its breadth (Fig. 3.99).[84] The angle palmettes forming the acroteria in Greco-Roman pediments evolve into curving ribbons as tall as the top of the pediment in Ahnas soft style, although shorter in the hard style, each group supporting the front legs of one of the two animals opposed on the raking cornice.[85] The acanthus interlace

79. W. F. Volbach, *Elfenbeinarbeiten*, p. 55, No. 105. J. Beckwith, *Coptic Sculpture*, p. 12, Figs. 31–34, dates it in the fifth century.
80. M. Mat'e-K. Ljapunova, *Chudeshestvjennïje tkani kopskovo egipta* (Moscow and Leningrad: 1951), pp. 45 ff.
81. E. Drioton, *Nilomètre*, No. 1, p. 5. U. Monneret de Villard, *La scultura ad Ahnas*, Fig. 11.

82. J. Maspero and E. Drioton, "Baouit," pl. XL.

83. Kaufmann, *Handbuch*, p. 286, Fig. 106. Compare J. Strzygowski, *Koptische Kunst*, Fig. 75, C. M., 7323.
84. E. Drioton, *Nilomètre*, p. 8. J. Strzygowski, *Koptische Kunst*, pp. 45, 47.
85. E. Drioton, *Nilomètre*, pp. 8–9. U. Monneret de Villard, *La scultura ad Ahnas*, p. 42, n. 3, Figs. 5, 24, 29, 61.

3.91
Niche head carved with a personification
of the Nile and another of Gaia. (Brooklyn
Museum, 41.891; second half of A.D. V).
3.92
Niche head carved with a representation of a
dressed Nereid riding a sea monster. (Brooklyn
Museum, M. 41.1226).

3.93
Arched tympanum carved in high relief with a
Nereid riding. (Greco-Roman Museum, 23552;
A.D. VI; E. Breccia, *Le Musée Gréco-Romain,
1925–1931*, Vol. 1, pl. XXXIX.)
3.94
Block from an arch carved with a Nereid riding
a dolphin and a ground with elements of Nilotic
scenery. (B. M., 1538; A.D. VI).

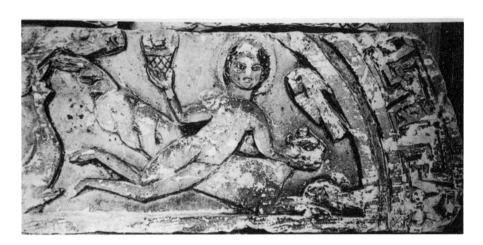

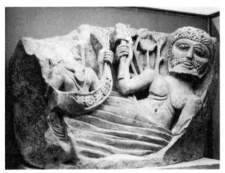

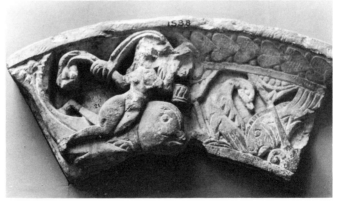

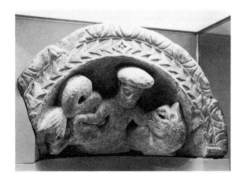

3.95

Nereid riding a dolphin in the triangular pediment flanked by a bird drinking. (B. M., 1537; A.D. VI-VII.)

3.96

Niche head with angel carrying the *crux immissa*. (Coptic Museum, Cairo, C. M. 45942; A.D. V; G. Duthuit, *La Sculpture Copte*, pl. XIII.)

3.97

Half a niche head with two Erotes carrying the *crux immissa*. (Coptic Museum, Cairo, 7030; from Sohag; A.D. V (G. Duthuit, *La Sculpture Copte*, pl. XIV).

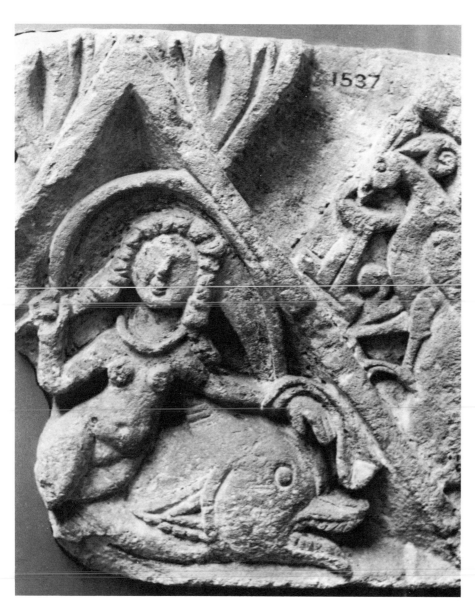

3.98
Stone bracket in the shape of an eagle standing on the *crux immissa* in a heraldic style. (from Cairo; Staatliche, Museen, 4699; A.D. V-VI.)

3.99
Bands of architectural sculpture carved with foliate and geometric patterns representing a brief grammar of Coptic sculptured ornament. (1. E. Breccia, *Le Musée Gréco-Romain, 1925–1931*, Vol. 1, No. 179; 2. from Ahnas, J. Strzygowski, *Koptische Kunst*, p. 34; 3. Ibid., p. 45; 4. Ibid., p. 49; 5. E. Breccia, op. cit., Vol. 1, 169; 6. J. Strzygowski, op. cit., Fig. 63; 7. E. Chassinat, "Fouilles à Baouît," pl. XC, 1; 8. E. Drioton, *Les Sculptures Coptes du Nilomètre de Rodah*, No. 6; 9. E. Breccia, op. cit., Vol. 2, No. 97*g*; 10. Ibid., No. 99*b*; 11. Ibid., No. 96*e*; 12. Ibid., No. 103*a*; 13. J. E. Quibell, *Excavations at Saqqara* [1908–9, 1909–10] pl. XLII, No. 9; 14. E. Chassinat, op. cit., pl. XLII, No. 3.)

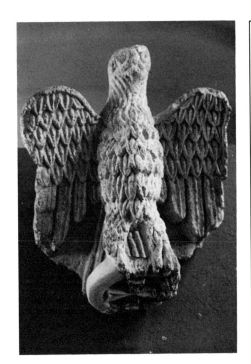

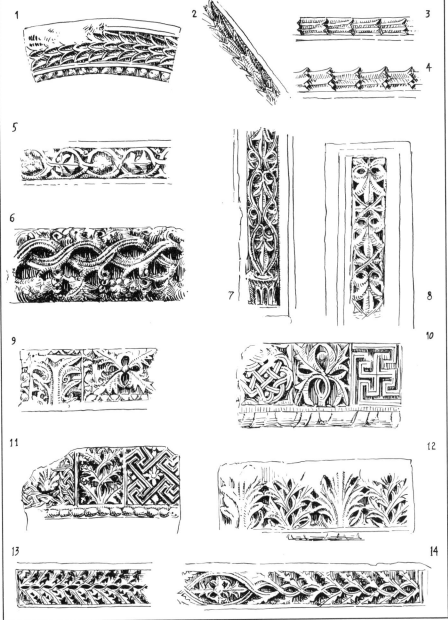

that appears in the coffers of the cornice in Roman Oxyrhynchos (A.D. IV) evolves in panels as substitutes for the modillions alternating with squares while its leaves intertwine (Fig. 3.99)[86] and become at Ahnas (hard style) as in the capitals three-dented and lancet-like,[87] a motif much in favor in monastic sculpture and later.[88] The vine motifs (Fig. 3.99: 5–8) inherited from the Greco-Roman Dionysiac symbolism have already assumed at Oxyrhynchos[89] those decorative themes of interlace and rinceaus recurring at Ahnas and in later styles with one leaf alternating with a grape and smaller leaf within each loop.[90] The same alternating elements appear once on a deep ground, each in the center of interlacing circles.[91] The rinceau, evolving from the broad Roman curves through the rhythmic flat foliage of Oxyrhynchos (Fig. 3.100: 4),[92] develops its gracile geometrized stems at Ahnas, where the main stem proceeds without any leaf while secondary offshoots with lancet-like leaves curve around the fore part of an animal (Fig. 3.100: 6).[93] A curious

development common at Ahnas and in the Nilometer of Rodah is presented by a twin leafy stem that curves parallel to the main stem, between it and the offshoot, and encloses a flower or fruit.[94] This is hardly found in monastic sculpture. To add to this repertoire let us mention the *crux florida* or quatrefoil with one, three or five lobes to each leaf (Fig. 3.101: 1–4; niche of Dionysos) and the cross with four radiating leaves.[95]

Drawing on this heritage, monastic sculpture covers the limestone walls of churches with friezes and a well-articulated design of niches and pilasters or engaged columns, as at Bawit and Dendera. During the lifetime of such a monastery, like that of Apollo at Bawit, founded ca. A.D. 385–390, renewed in the fifth century, and still populated in the twelfth century, it is natural that its sculpture echo the various trends and impacts of the often hostile outer world rather than express the artistic evolution of a local school. This can be observed in the Syrian influences in its mural painting and even more dramatically in the epigraphic evidence about later Armenian painters decorating the church of the Deir Abiad (A.D. XI–XII) and Deir Ahmar (A.D. XIII). This monastic sculpture may be called strictly architectural, typically Coptic in its distribution on the walls as well as in its style and technique. It is probably in sculpture more than in graphic arts that the monasteries succeed in creating a native style from the Hellenistic and late-antique heritage of Alexandria and

the large centers like Oxyrhynchos, where occasional influences from the eastern provinces (Syria, Transjordan) are discernible. Other centers would be Herakleopolis (Ahnas) and Antinoupolis (Sheikh 'Abada). The Byzantine impact, though restricted by political circumstances, can still influence monastic sculpture, as evident in the basket capitals at Bawit, Saqqara, and Ashmunein reminiscent of those at Ravenna and Saloniki (A.D. VI); this influence is also seen in earlier production at Ahnas and Deir Abiad. Yet some of the earliest pieces at Bawit betray affinities closer to Hellenistic than to late-antique sculpture. One of three pilasters, probably doorjambs originating from the South Church at Bawit, is carved on its main side with an inhabited vine and on a lateral side with a geometrical band of quatrefoils alternating with hexagons topped by panels with a figure in high relief (see Fig. 3.163; A.D. V–VI). The angel of the main side stands in *contrapposto* leaning on a long-stemmed cross (?) with his right, upraised arm and holding an orb in his left hand. Both the stance and the fluid curves of the drapery are strongly reminiscent of the archangel on a stela from the fifth century (Glyptothek Ny Carlsberg; see Fig. 3.76) rather than any of the ivory diptychs of Constantinople. The lateral figure, probably an evangelist striding in flowing robes, holds in both hands an open codex, a very dynamic creation though less so than a similar apostle who holds a codex in both hands and literally strides out of the picture frame (Fig. 3.102; Louvre, E 12033; A.D. V–VI). The style of these figures is related to the more formal one of the wooden

86. E. Drioton, *Nilomètre*, pp. 22–25, Fig., 6. E. Breccia, *Oxyrhynchos* I, 177; *Oxyrhynchos* II, 96, 99.
87. E. Drioton, *Nilomètre*, p. 21. U. Monneret de Villard, *Ahnas*, Figs. 17, 29, 42, 46, 61, 73.
88. E. Drioton, *Nilomètre*, pp. 14–16. J. E. Quibell, *Excavations at Saqqara* (1907–1908, Cairo: 1909), pl. XXXVI, 5; (1908–9, 1909–10) (Cairo: 1912), pl. XXXVIII, 5, XXXVI, 1. E. Chassinat, "Fouilles à Baouît," *MIFAO*, Vol. 13 (Hereafter cited as "Baouît.") (Caire: 1911), pls. LXXIV, XXLV, XLI, XLIII, LXX.
89. E. Drioton, *Nilomètre*, p. 29. E. Breccia, *Oxyrhynchos* I, 157 169, 172, 186–187.
90. J. Strzygowski, *Koptische Kunst*, Fig. 72.
91. Ibid., Fig. 70.
92. E. Drioton, *Nilomètre*, pp. 36–39, Figs. 7–8. E. Breccia, *Oxyrhynchos* I, 191–192.
93. E. Drioton, *Nilomètre*, p. 43. Monneret de Villard, *Ahnas*, Figs. 80, 82–89, 92.

94. E. Drioton, *Nilomètre*, pp. 48–51, Fig. 11.
95. J. Strzygowski, *Koptische Kunst*, Fig. 78.

3.100
Bands of sculpture with scrolls enclosing fruits or animals, (1. E. Breccia, *Le Musée Gréco-Romain, 1925–1931,* Vol. 1, No. 182; 2. U. Monneret de Villard,*La Scultura ad Ahnas,* Fig. 83; 3. E. Drioton, *Les Sculptures Coptes du Nilomètre de Rodah,* No. 11; 4. E. Chassinat, "Fouilles à Baouit," pl. XL, 2; 5. E. Breccia, op. cit., Vol. 1, No. 192; 6. Monneret de Villard, op. cit., Fig. 86; 7. J. E. Quibell, *Excavations at Saqqara,* [1908–9, 1909–10], pl. XL, 3.)

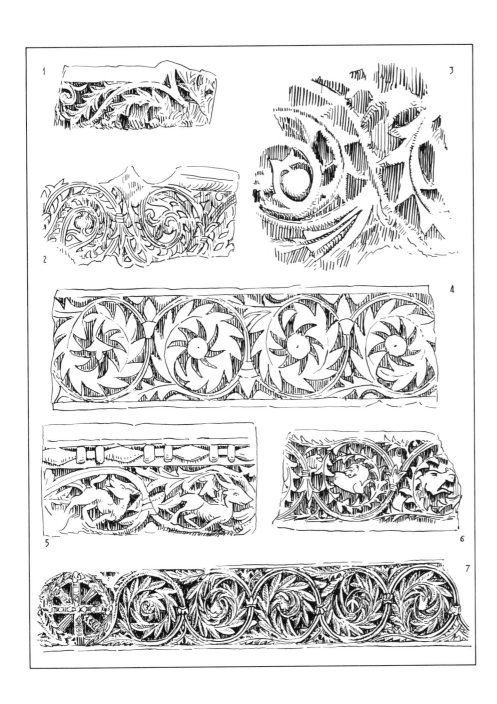

mensolae from Bawit and to the panels of Sitt Barbara and even to the lintel of Mu'allaqa. Beckwith mentions that these pilasters may provide an argument in favor of "a tradition of Hellenistic excellence still current in Egypt up to and including the Justinianic period."[96] It has been lately suggested that the exceptional style of these pieces dated to the sixth century should be understood as a renovation of late-antique style under the impetus of Constantinople, the latter opinion being based on those elements among the capitals and friezes from Bawit influenced by, or derived from, sixth-century art in Byzantium transmitted through Alexandria.[97] The fragmentary architrave in marble found by Strzygowski (Cat. No. 73211) bears unfinished carving related to the style of the sixth century. It provides a double-edged argument, for on the one hand it may prove that most of, if not all, the marble sculptures were finished in Egypt, and on the other hand, it could be invoked as evidence that the importing of carved pieces was a current custom. We know, however, that Coptic sculpture is mostly of local stone, a consideration that limits significantly the importance of the quantity imported. Be this as it may, no Byzantine carving among the best in ivory (diptychs, Chair of Maximian) or stone down to Justinian or Herakleus (sarcophagi at Ravenna) does offer the harmonious Hellenistic elegance of the figures of Bawit nor of the earlier stelae, and if there were a renovation it proceeded from Alexandria or from one of the other centers impregnated with Hellenistic traditions in Egypt itself.

96. J. Beckwith, *Coptic Sculpture*, p. 22.
97. H. Torp, "Book Reviews," pp. 366, 368.

Some of the smooth modeling is retained in a panel allegedly from Bawit in the nude Erotes holding a clipeus with an allegory of Abundance standing out against a ground of channeled drapery (Fig. 3.103, Louvre, E 17034, 50 × 97 cm.; second half A.D. VI). This channeling appears also in a related limestone high relief from Bawit (Coptic Museum, Cairo, 71110; second half A.D. VI) in the costumes of the angels holding a *mandorla* with Christ seated, a subject reminiscent of the Mu'allaqa lintel even to the hangings represented as drawn back at both ends of the scene (cf. Fig. 3.29). The stylistic differences in monastic ensembles such as in the South Church at Bawit result probably from different dates in its execution rather than from various groups of sculptors. The lion and griffin in highly stylized design carved in compact flat relief, allegedly from Chapel B of the same church, are certainly not of the excellence of the pilasters (Figs. 3.104, 3.105; Louvre, E 14018, E 17024; second half A.D. VI). Nor is the combination of the figures of a seated flutist and an angel playing cymbals at both lower ends of an archivolt (not from Bawit) carved with a flat vine meeting an interlace at the crown (Fig. 3.106; Louvre; A.D. VI–VIII according to Du Bourguet) as successful in spatial rendering as another fragment of an alert naturalism (B. M., 1538; cf. Fig. 3.94). This archivolt has been compared by U.Monneret de Villard to the one in the great portal of the church at Charlieu (1094).

Two slabs coming probably from the south church at Bawit are, despite their defaced figures, of unique interest

because they represent in high relief consecutive moments of the cycles of Daniel and David. There are the angular forms, strongly undercut lines, and staccato rhythm characteristic for this monastic style.[98] The two pieces formed part of the same frieze (0.245 m. high; 0.82 m. and 1.12 m. long) showing a sequence of moments from left to right. In one (Coptic Museum, Cairo, 37803 [7139]) appears Nebuchadnezzar as *Cosmocrator* between two bodyguards, Nebuchadnezzar inviting Daniel to worship an idol, Daniel holding a diadem before the idol, and the idol falling in the presence of the king. In the second slab (Coptic Museum, Cairo, 37797 [7125]), we have David receiving the unction from Samuel, David carrying a basket and a kid around his neck proceeding to Saul listening to David playing his lyre, and David carrying a sling and a container for his stones hurrying to confront Goliath, who comes from the far right and is then shown fallen at the feet of David. The last scene combines two distinct episodes. The other episodes are also rendered with emblematic brevity in a series of figured symbols as in early Christian art (catacombs, Dura Europos, sarcophagi) rather than as historical narrative scenes. A mural painting dated to the seventh century representing a more comprehensive sequence of episodes from David's cycle in one

98. H. Torp, "Two sixth-century Coptic Stone reliefs with Old Testament Scenes," in *Institutum Romanum Norvegiae, Acta ad Archaeologiam et Artium Historiam Pertinentia*, Vol. 2 (Rome: 1965), pp. 105–119, pls. I-VIII.

3.101
Friezes and soffits with ornamental foliage and modillions. (1. E. Drioton, *Les Sculptres Coptes,* No. 12; 2. E. Breccia, *Le Musée Gréco-Romain, 1925–1931,* Vol. 1, No. 170*b*; 3. Ibid., 177*a*; 4. G. Duthuit, *La Sculpture Copte,* pl. XVIIIa, from Ahnas; 5. E. Breccia, op. cit., Vol.2, 92; 6. E. Drioton., op. cit., No. 9; 7. E. Chassinat, "Fouilles à Baouît," pl. LXXXIV, 1.)

3.102
Saint carrying a codex. (Louvre, E 12033, A.D. V–VI.)

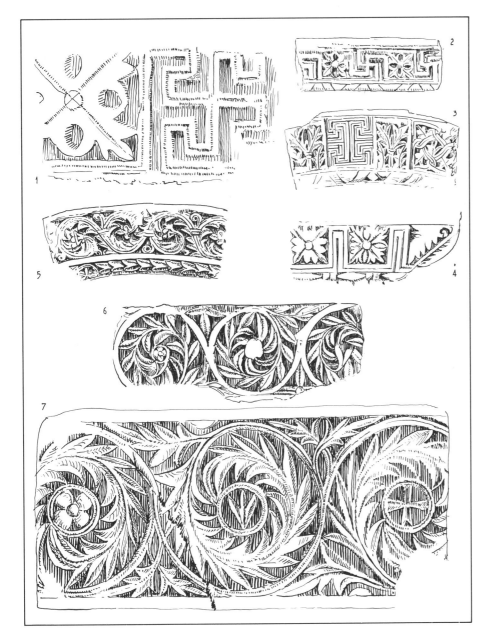

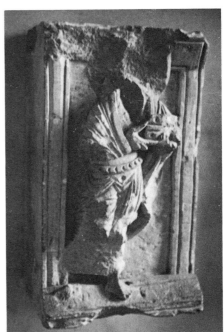

3.103
Stone panel from Bawit representing in bold carving an allegory of Abundance held by two Erotes with channeled drapery. (Louvre, E 17034, second half A.D. VI.)

3.104, 3.105
Reliefs of a lion and a griffin allegedly from Chapel B at Bawit. (Louvre, E 17024; E 17018.)
3.106
Archivolt with a flutist and cymbalist against a flat interlace. (Louvre, A.D. VI.)

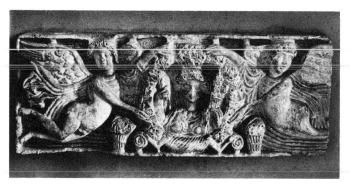

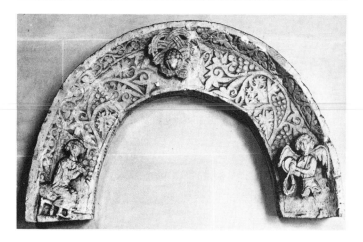

of the chapels at Bawit (III; see p. 256) also retained the two archaic elements, the containers for stones and the staff, but showed more of the background.

Nowhere at Bawit is variation in the types and carving techniques as pronounced as in mural sculpture carried out in foliate friezes inset at two levels along the walls, another argument favoring the attribution of the models to different periods or to the reuse of some earlier pieces. It should be noted that a frieze is not necessarily of one consistent pattern, but made up more often than not of stretches of different designs though of related types, sometimes starting on either side of a *crux immissa* as high as the frieze. Carved wooden beams formed independent narrow friezes or ran beneath the limestone frieze at the level of the capitals of the engaged columns. There are no fewer than fifteen different types of frieze ornament in the three halls of the South Church alone, a valuable contribution to the grammar of Coptic ornament. The vine evolves from a rich, naturalistic five-lobed leaf (Figs. 3.107, 3.108; from Bawit; Louvre, A.D. V–VI) issuing from a vessel carved on a convex ground, to a very unnaturalistic seven-lobed leaf coupled with varied fruit in a spiral scroll (Fig. 3.109; from Bawit, Staatliche Museen 4716, 4717; A.D. VI–VII), or in a more pointed shape, in a pair with two grapes in a diagonal arrangement within interconnected circles. A sterile vine (without grapes)[99] appears as two symmetrical spirals enclosing one leaf

within each oval in archivolts,[100] friezes, and pilasters (See Fig. 3.99:7). A similar motif consists of a wreath and vine stem spiraling in opposite directions to form in an archivolt a chain of ovals enclosing alternately a vine leaf or a fruit,[101] or to form a chain of hares and birds, often in pairs[102] and nibbling at grapes, punctuated at intervals by a head within a wreathed medallion, projecting from the plane of the frieze.[103] Another chain type consists of a channeled band forming a *crux gammata* (swastika) alternating with a disk or quatrefoil or a *crux florida* in a square and carved in limestone[104] or wood.[105] Similarly a granulated band is formed by interconnected squares and circles, the squares enclosing a bird and the circles surrounding a basket of fruit or a quatrefoil[106] (Fig. 3.110, Louvre, E 17009). The latter frieze runs at the level of the capitals, above a wooden band carved with modified acanthus (identical to that painted above the panels of the cycle of David and Saul, Chapel III), and below a convex molding of two stems with three-lobed, pointed leaves intertwined symmetrically. This motif appears with four-lobed leaves at Oxyrhynchos[107] and with three-lobed leaves at Ahnas,[108]

and on archivolts and pilasters (A.D. VI) at Bawit[109] and Saqqara. Broad scrolls or rinceaus follow an evolution from a rich, still organic stem with offshoots curving in opposite directions to enclose a central rosette and stylized leaves,[110] to a flatter carving with simplified triangular leaves[111] (Fig. 3.108; from Bawit? Louvre) with a terminal fruit, or numerous indented long leaves, all curving toward a central fruit or flowers.[112] The rinceau is sometimes geometrized, spiraling its sharp lancet-like leaves alternately in opposite directions around a quatrefoil or a trefoil[113] (Fig. 3.111; Louvre), the prototype of the impressive whorl flanking a radiating cross (Fig. 3.112; Louvre; A.D. VIII). Flatter spirals with rich but debased foliate design[114] or stylized ones (Fig. 3.113; Louvre)[115] derive from the rinceau. A frieze running at the level of the pilaster capitals shows above a bead-and-reel molding an imitation of the soffit of a cornice representing on a slightly tilted plane square panels with quatrefoils or rosettes separated by simplified interpretations of modillions[116] (Fig. 3.114; Louvre). Purely geometric patterns are exemplified in a diamond design alternating diagonal crosses with squares or lozenges,[117] a chain of tangent circles intertwined with half circles forming a sequence of quatrefoils filled

99. E. Drioton, *Nilomètre*, p. 31.

100. E. Chassinat, "Baouît," pls. LXXII, XLII, 2, XC, 2.
101. Ibid., pl. LXXII, 2.
102. Ibid., pls. XXIX, XXXI, LXXXVII, 3.
103. Ibid., pls. XXIII, XXXIII, 1, 2.
104. Ibid., pl. LXXVI. Cf. E. Drioton, *Nilomètre*, 12, pp. 52–55.
105. E. Chassinat, "Baouît," pl. LVIII, Nos. 2, 3.
106. Ibid, pl. XXVIII.
107. E. Breccia, *Oxyrhynchos* II, pls. XXVIII, XXX.
108. Monneret de Villard, *Ahnas*, Figs. 17, 29, 42, 46, 61, 73.

109. Chassinat, "Baouît," pls. XXXIV, LXXV, XLI, XLIII.
110. Ibid., pl. LXXXII, 2.
111. Ibid., pl. LXXXII, 1.
112. Ibid., pl. LXXXIII.
113. Ibid., pl. LXXXIV.
114. Ibid., pl. XXXII.
115. Ibid., pl. XLIV.
116. Ibid., pls. LXXIX, LXXVIII.
117. Ibid., pl. LXXVII.

3.107, 3.108
Foliate friezes from Bawit.(Louvre. A.D. V–VI.)
3.109*a, b*
Scroll and interlace from Bawit. (Staatliche
Museen, 44716, 44717; A.D. VI–VII.)

3.110
Continuous superimposed friezes in stone and
wood from Bawit. (Louvre, E 17009; X 5074.)
3.111
Highly stylized foliate frieze in a rinceau shape
from Chapel B at Bawit. (Louvre.)

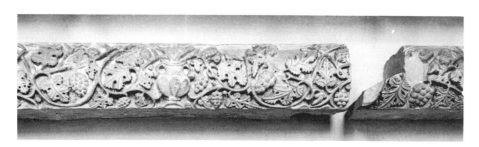

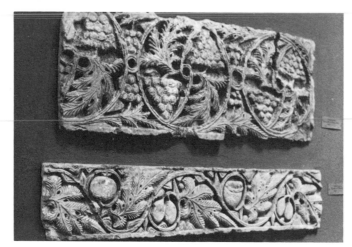

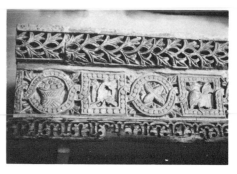

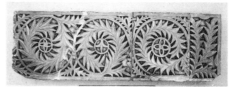

3.112*a, b*
Niche head and foliate friezes from Bawit.
(Louvre.)

3.113, 3.114
Friezes with scroll and modified modillions from
Bawit. (Louvre.)

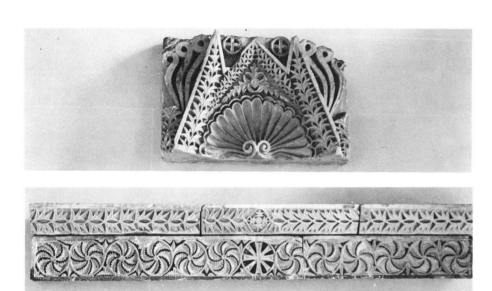

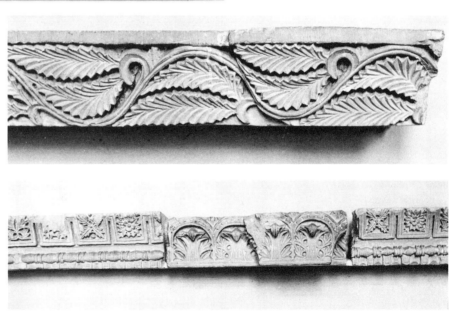

with foliate ornament[118] (Fig. 3.115; Louvre), or a band, often channeled or granulated, forming a diamond grid interlaced with interconnected circles.[119]

If we compare this grammar of sculptured ornament with that of painted ornament at Bawit itself, keeping in mind that the latter extended over a wider time span (A.D. VI–VIII) and covered vaster areas, we find that besides an occasional identical design (wooden frieze with modified acanthus as in painting of Chapel III), the vast majority of the motifs are similar, though adapted to the painting medium. The most popular ornamental motifs in painted murals are the frieze of alternating squares and circles enclosing heads (supposedly a Sassanian influence) and the diamond pattern of wreaths enclosing floral elements spreading over tall dadoes. There are as well the rinceau elements, the two spirals interlacing round busts and animals, the fret winding into a swastika, sketchy scrolls curving around large square and circular panels with animals, and quatrefoils fancifully geometrized into disks with four darts projecting diagonally. Yet painted ornament is certainly more versatile, for it renders successfully the intricacy of superimposed square and diagonal grids, intertwined bands and a spiral fret in a three-dimensional effect. Moreover, it covers vast areas of dadoes with imitations of orthostat, incrustation, and intersperse of floral elements, a feat that cannot be achieved

by sculpture, not to mention the more impressionistic style of sketchy brush strokes used sporadically in wreaths.

Before leaving Bawit let us consider two outstanding examples of architectural elements illustrating the use of the typical motifs already encountered in the friezes. The broken pediment as steep raking cornice deeply carved with stylized acanthus in a chain or twine is topped by two *crux immissa* flanked by a foliate interpretation of acroteria and encloses an elegantly articulated shell, with its outer edge duplicated to convey the illusion of a second one (Fig. 3.116; Louvre, Inv. No. X 5101, Bawit; A.D. VI). The second piece is a closure slab carved in a radiating pattern of lancet-like trefoils and band on an octagonal scheme echoing the radiating cross in its focus flanked by two sturdy columns with patterned shafts and foliate capitals, an interpretation of the larger engaged columns at the doorways of Chapel B (Fig. 3.117; from Bawit; Staatliche Museen, J. 4711, 61 × 85 cm.; A.D. VI). This masterpiece surpasses the best closure slabs of Byzantium and western Christian sculpture.

At Saqqara, the other great center of monastic art, even less statuary could be found than at Bawit, though enough friezes were discovered to give an adequate idea of mural sculpture. This is characterized by its intricate design, perhaps as an indirect result of more emphasis on horror vacui, and by stiffer and more numerous lancet-like leaves often accompanied by knobs in their angles. Moreover, this sculpture, though further from the late-antique tradition than that at Bawit, has a stronger character and brilliant originality

and is carved in a more careful technique. Yet the earliest woodwork still has the late-antique tinge. From the tomb church an example perhaps dating from the fifth century is shaped into an arcaded screen carved with a wreath along the archivolts, trefoil leaf in the angles, and a soffit with panels of *crux florida* and knobs in its angles, separated by pseudo-modillions.[120] Of a slightly later date would be the two palm wood consoles carved with a modified acanthus volute, one showing a *crux immissa* on its lower side,[121] and the two cupboard doors (0.27 m.) featuring an angel within an interlace band on a circular and diagonal design framed by a scroll of trefoil and pointed leaves.[122] There is also a wooden panel, probably from the seventh century, carved with an original composition of a channeled swastika built on the sides of an hexagon with a central flower bordered by a convex molding with a flat carving featuring a flower in a foliate cusp.[123] Two uprights featuring ivory inlaid foliate and arabesque designs are of an even later date (A.D. VIII).[124]

Whatever can qualify as figure sculpture in limestone from Saqqara forms an integrant part of architectonic members. Half a horizontal block (0.3 m. high, Fig. 3.118) represents an arcade with granulated archivolts separated by foliate stems springing from Corinthian pilasters with foliate design which

118. Ibid., pl. XXV.
119. Ibid., pls. XL, 1, LXXX.

120. J. E. Quibell, *Excavations at Saqqara* (1908–9, 1909–10), pl. LVI, 2.
121. Ibid. (1907–1908), pl. XL, 1.
122. Ibid., pl. XL, 2.
123. Ibid. (1908–9, 1909–10), pl. LVI, 1.
124. Ibid. (1907–1908), pl. XLI, 1.

3.115
Molding with interlace and flat sequence of
quatrefoils. (From Bawit; Louvre.)
3.116
Niche head with shell, broken pediment, and
stylized acroteria from Bawit, (Louvre; A.D. VI.)

3.117
Closure slab in limestone with elaborate foliate
ornament, flanked by two columns with
patterned shafts from Bawit. (Staatliche Museen,
J. 4711; A.D. VI.)
3.118
Half a sculptured band representing chiseled-
off figures of seven apostles and the Savior
(right end) beneath an arcade. (J. E. Quibell,
Excavations at Saqqara [1908–9, 1909–10], pl.
XXX, 6.)

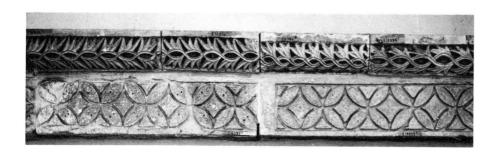

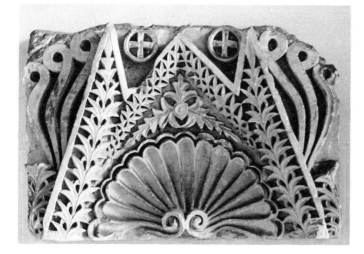

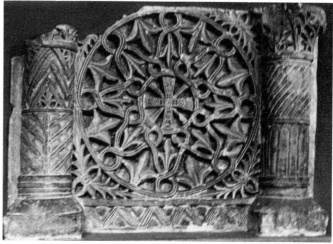

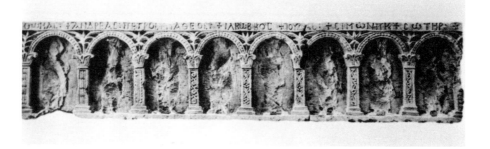

shelters eight s anding figures in high relief (chiseled off), seven apostles, and the Savior at the right end.[125] The architecture and the remains of the figures in a *contrapposto* stance are of an excellent late-antique technique. This could apply also to the two end panels of a long lintel representing two animals (chiseled off) flanking antithetically a vessel ribbed and granulated.[126] To this short list can be added what appear to have been two figures reclining on both sides of a central foliate motif, each holding a foliate interlace that curved overhead (Fig. 3.119),[127] seemingly reminiscent of the composition from Ahnas of two dryads reclining on both sides of a basket of fruit (see Fig. 3.57).

Many of the friezes are similar to those at Bawit and originate also from the churches. Among the rinceau types, that with interconnected circles each enclosing two grapes and two leaves set diagonally is perhaps the closest, though the leaves here are stylized into lancet-like shapes.[128] The rinceau with modified acanthus scroll that forms contiguous circles with offshoots curving in opposite directions is of the same type as that at Bawit except that it encloses the fore part of a lion, as at Ahnas (Fig. 3.120),[129] a bust, a medallion with a basket of fruit flanking a radiating cross.[130] Other similar

frieze motifs are the flat rinceau curving in opposite directions with triangular leaves and central fruit,[131] the scroll with grape and vine leaf stuffed in the curves[132] but evolving here into an inorganic motif even to the point of geometrizing the leaf as a heart-shaped element imitated in Islamic woodwork,[133] the two interlacing stems with three-lobed lancet-like leaves on an archivolt,[134] a lintel[135] sometimes as a convex molding,[136] or a pilaster also slightly convex.[137] The vertical stem bearing lancet leaves, two straight ones alternating with a curving one, is also found.[138] Among geometric patterns there are also the diamond design enclosing a composite quatrefoil,[139] and the swastika enclosing a composite quatrefoil.[140]

Mural sculpture at Saqqara differs from that at Bawit not only in its spirit and technique but also in the variety of its original intricate motifs. These motifs add a head or the fore parts of a bull or lion to a flat rinceau of triangular leaves,[141] a second stem spiraling parallel to the main one with lancet leaves on one side only—[142] a specifically Coptic invention also exemplified in the Nilometer at Rodah (Fig. 3.121).[143]Another of these motifs is an extremely elaborate interlace of at least two stems with offshoots ending in grapes and leaves on both sides of a central flower with six lancet petals within a wreath flanked by two reclining figures (see Fig. 3.119)[144] above a border of modified egg-and-dart. There are variants of motifs known at Bawit, such as two bands interlaced to form contiguous circles containing a leaf with 7 straight or curving lancets,[145] or an interlace of ovals with composite quatrefoils.[146] There are, in addition, original inventions like the straight wreath with flower and modified acanthus alternating,[147] the lozenge quatrefoil with knobs in the angles between its leaves alternating with a flower,[148] the zigzag filled with opposed trefoil lancets,[149] the narrow band of contiguous ornamental units (0.20 m. long) of pomegranate topped with a triangular fluted leaf and a granulated band,[150] the Greek key patterned into swastika only (see Fig. 3.119)[151] and the interlace forming a sequence of complete broad wreaths alternating with large flowers doubled with an outer ring.[152] To end this list of motifs let us mention an unexpected reminiscense of Hellenic architecture in the imitation of a Corinthian capital carved on a marble slab showing the lower

125. Ibid., pl. XXXI, 6.
126. Ibid., pl. XXXI, 1.
127. Ibid., pl. XXXIV, 1.
128. Ibid. (1908–9, 1909–10), pl. XL; (1907–1908), pl. XXXIV, 4.
129. U. Monneret de Villard, *Ahnas*, Figs. 86, 80, 82–85, 87–89, 92.
130. J. E. Quibell, *Excavations at Saqqara* (1908–9, 1909–10), pl. XL, 2–4; (1907–1908), pl. XXXV, 4.

131. Ibid. (1908–9, 1909–10), pl. XLII, 2.
132. Ibid., pl. XLII, 4, 10.
133. Ibid., pl. XLIV, 2.
134. Ibid., pl. XLI, 2; (1907–1908), pl. XXXVI, 5, 7.
135. Ibid., (1908–9, 1909–10), pl. XLII, 3.
136. Ibid., (1907–1908), pl. XXXV, 7.
137. Ibid., pl. XXXVIII, 4.
138. Ibid. (1908–9, 1909–10), pl. XLIV, 1.
139. Ibid., (1907–1908), pl. XLII, 8.
140. Ibid., pl. XLIV, 2.
141. Ibid. (1908–9, 1909–10), pl. XLIII, 3.
142. Ibid., pl. XLII, 1.
143. E. Drioton, *Nilomètre*, No. 7, pp. 32–35.

144. J. E. Quibell, *Excavations at Saqqara* (1907–1908), pl. XXXIV, 1.
145. Ibid., pl. XXXIV, 3.
146. Ibid., pl. XXXV, 6.
147. Ibid., pl. XXXVI, 2–3.
148. Ibid. (1908–9, 1909–10), pl. XLV, 3.
149. Ibid., pl. XLV, 1.
150. Ibid., (1907–1908), pl. XXXI, 4.
151. Ibid., pl. XXXI, 1.
152. Ibid., pl. XXXI, 2–3.

3.119
Elaborate double rinceaus with two figures holding a foliate interlace. (J. E. Quibell, *Excavations at Saqqara* [1908–9, 1909–10], pl. XXXIV, 1.)

3.120
Two bands with rinceaus enclosing protomes or fruit, conspicuous for the metallic quality of the geometrized leafage. (J. E. Quibell, *Excavations at Saqqara* [1908–9, 1909–10], IV, pl. XL, 2–3.)

3.121
Double flat rinceau with lancet foliage from the Nilometer of Rodah. (E. Drioton, *Les Sculptures Coptes du Nilomètre de Rodah*, No. 7.)

zone of naturalistic acanthus leaves surmounted by the *caulicoli* and the double volutes.[153]

The ornamental elements retrieved from the Nilometer at Rodah[154] belong to churches of the fifth to sixth centuries from the district of Heliopolis and show, besides a Europe riding the bull and caressing its muzzle on the vertical background of a niche head surmounted by two dolphins, several of the characteristic sculptural patterns in a good style. Among others are the vertical interlace along pilasters or flanking a niche containing a cross, sterile vine on pilasters as those at Bawit,[155] rinceau with two curving parallel stems as at Saqqara (see p. 98), or a unique rinceau featuring lancet-like scroll curving out of the main scroll in opposite directions without insets, others with fruit and flower and soffits with alternating *crux florida* and swastika.

Decorative sculpture at Deir Abiad (Sohag; A.D. 440) does not necessarily date from the period of construction, though one of the arguments based on the fact that the friezes consist of stretches with different patterns[156] is invalidated by the occurrence of similar variation at Bawit (South Church). The scroll work in the eastern apse shows in a flat relief highly conventionalized intersecting arches forming triangular areas filled with vine leaf (A.D. VI–VII) in the lower ones,

and grapes in the upper ones. Contrasting with this is the sculpture in Deir Abiad apse with its rinceau of dense foliate scrolls surmounted by a slanting soffit showing modillions and square panels with leaves and quatrefoils (Fig. 3.122; A.D. V–VI), or in the intricate though quite naturalistic friezes of rinceaus, rows of acanthus, interlace, and scrolls at the southern doorway (Fig. 3.123; A.D. V). The narrow stone friezes inserted at various levels in the walls are reminiscent of the wooden ones of a more stylized design in the South Church at Bawit.

In the basilica at Dendera the niches articulating the inner walls are crowned with shells bordered by archivolts carved with a stylized twin stem from which branch seven-lobed leaves flanking a cross at the crown (Fig. 3.124; A.D. VI) similar to headpieces from the Thebaid.[157] Other archivolts feature a scroll whose arches are inset with a vertical leaf (see Fig. 2.45), and on the lintel above the entrance doorway, a *crux immissa* is flanked by two twin scrolls enclosing vertical pendant acanthus of a naturalistic shape (See Fig. 2.45).

Fragments of an acanthus rinceau of unknown provenance (Fig. 3.125; Fogg Art Museum; A.D. V) and a vine interlace (Fig. 3.126; Dumbarton Oaks, 35.12, 40.59; A.D. VI) are of a naturalistic style similar to the first style of Oxyrhynchos. Another rinceau with triangular foliage (Fig. 3.127; Walters

Art Gallery, 26.1; A.D. V) is reminiscent of some at Ahnas (C.M., 20.1.34.3. 47113) except that it is inhabited not by fore parts but by spirited jumping animals (cf. Brooklyn Museum, 41.1266; University Museum, Philadelphia), even to the shape of the bodies and an indication of the texture of their hair. A foliate scroll with indented leaves is also inhabited by spirited animals and a hunter in a well-modeled carving (Fig. 3.128; Musée Guimet, Lyon; A.D. VI). While the two preceding friezes could well date from an earlier period than monastic sculpture, this is not the case for one inhabited by a gazelle looking back in fright at a striding lion whose mane is stylized into voluted plaits similar to the ancient Mesopotamian hairstyle and to that of a personification of the Nile (see pp. 165–166); these figures are enclosed within the oval cartouches of a formal foliate scroll (Fig. 3.129; from Fayum; Staatliche Museen, 4456, 32 cm. high; A.D. VI), which probably featured in its middle two gazelles flanking a cross (Staatliche Museen, J. 4761).[158] Fantasy introduces a dramatic note by setting near a huge human mask a jumping beast mottled with circles (Fig. 3.130; from Crocodilopolis, B. M., 1794; A.D. VI).

A group of stone consoles from Djimē,[159] fixed in pairs at the top of the niches for water-jug stands in the vestibule of

153. Ibid., (1908–9, 1909–10), pl. XLIV, 4.
154. E. Drioton, *Nilomètre*.
155. E. Chassinat, "Baouît," pls. C, 1; XCI, 1; LXXI.
156. E. Kitzinger, "Early Coptic Sculpture," pp. 191, n. 4; pl. LXXII, 7.

157. J. Strzygowski, *Koptische Kunst*, Nos. 7296, 7297.

158. O. Wulff, "Altchristliche," p. 71, No. 212. Compare J. Strzygowski, *Koptische Kunst*, No. 7320, Fig. 72, pp. 57-58.
159. Hölscher, *Medinet Habu*, V, pl. XXXVII, pp. 60–61. J. Strzygowski, *Koptische Kunst*, No. 7341, Figs. 92–93, p. 68. Alexander Badawy, "A Coptic Model of Shrine," in *Oriens Antiquus*, V (Rome: 1966), pp. 189–196.

3.122
Entablature of dense rinceau and soffit of modillions above the columns of the apse at Deir Abiad. (Photo courtesy R. Romero and H. G. Evers.)

3.123
Intricate foliate bands on the lintel of the south doorway at Deir Ahmar. (U. Monneret de Villard, *Les Couvents prés de Sohâg,* Fig. 149.)

3.124
Archivolt of a niche in the basilica of Dendera. (Monneret de Villard, *Les Convents prés de Sohâg,* Fig. 184.)

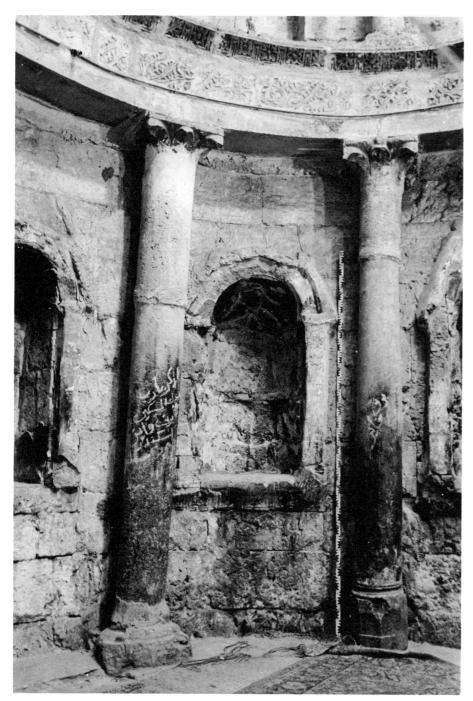

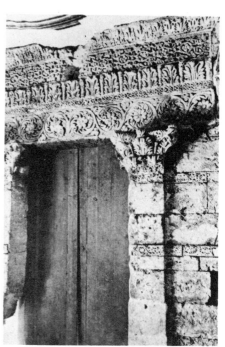

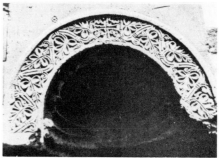

3.125
Fragment of an acanthus rinceau of unknown provenance. (Fogg Art Museum; A.D. V.)

3.126
Fragment of a limestone arch with vine interlace. (Dumbarton Oaks, 35.12; 40.59; A.D. VI.)
3.127
Frieze with rinceau and animals. (Walters Art Gallery, 26.1; A.D. V.)

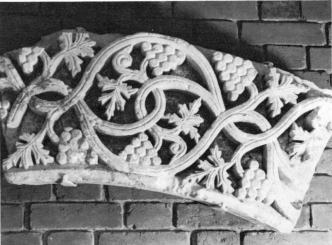

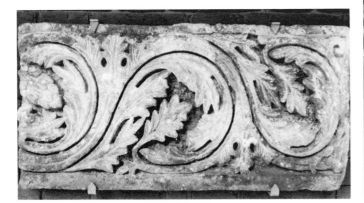

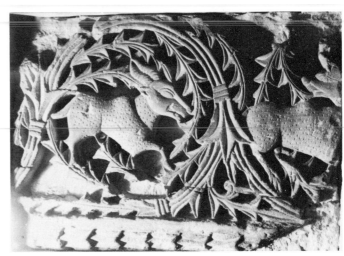

3.128
Frieze with rinceau peopled with animals.
(Musée Guimet, Lyon; A.D. VI.)
3.129
Frieze with prominent animal sculptures within
the oval cartouches of foliage. (From Fayum;
Staatliche Museen, 4456; A.D. VI.)

3.130
Human-headed beast within the spiraling foliage
of a rinceau. (From Fayum; B. M., 1794; A.D.
VI.)

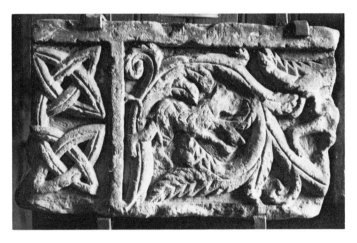

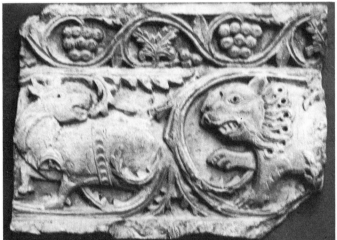

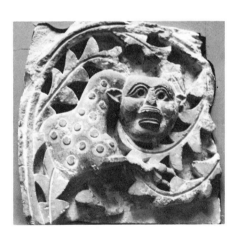

private houses, provide some good material for sculptured ornament. They have two grooves in their upper sides to stretch a line for hanging a mat or a rug in front on the water jugs. They are carved in a slight flat technique with foliate patterns, animals, interlace forming a cross, hexagon, *crux florida*, and even the façade of a shrine on the butt end (Fig. 3.131, 3.132; Museo Egizio, Schiaparelli 1668; A.D. VI–VII).

Signs of stylistic deterioration in friezes appear either as a flatter carving, still of a good design ,where both the grapes and vines of an interlace are but slightly stylized (Fig. 3.133; Musées Royaux, E 7971, A.D. VI–VII), or in a flat contouring of a less successful composition still using organic elements mixed with inorganic ones (Fig. 3.134; Musée Guimet, Lyon; from Coptos; A.D. VII). It may also appear in bold carving of debased foliate elements set unnaturally to form within the folds of a massive spiral stem an agreeable balance of masses, though the bird inhabiting it is smaller than leaf or fruit (Fig. 3.135; B. M., 1617; A.D. VII). Another instance occurs in a symmetrical composition where leaves and grapes are inorganic triangular elements attached to two thick, intertwined stems enclosing a face—a flat, mechanical smooth relief of ornamental value (Fig. 3.136; B. M., 57282; A.D. VII). And still another example shows a rich, well-modeled composition reminiscent of textiles framed by borders of swastikas alternating with quatrefoils and an interlace representing within a vine twine scenes from the late-antique repertory, with Erotes

gathering and trampling grapes—perhaps a piece dating to the Heraklean rejuvenation ? (Fig. 3.137; B. M., 1789; A.D. VII).

In an opposite trend without any attempt at symmetry or even at order the episode of Jonas rejected by the sea monster may be carved in bold relief reminiscent of Ahnas but with elements conforming to horror vacui (Fig. 3.138; Louvre, E 17007; X 5072, A.D. VI). Similarly a symbolic scene depicts in a debased style with conventionalized hide and scale patterns the crocodile of Evil attacked by a dolphin and a sea creature, obviously reminiscent of Diodorus' and Pliny's accounts of dolphins attacking crocodiles (Fig. 3.139; B. M., 1652; A.D. VI–VII). Still less satisfactory is a fragment of frieze in which a stiff high-legged crocodile and a fish appear on a ground of inorganic foliage in a coarse carving (Allard Pierson Stichting, Inv. 7812; A.D. VII–VIII). The dolphin, a favorite in pagan iconography in scenes of Aphrodite where he carries Nereids and Erotes, in the Rape of Europa, and on Christian sarcophagi, was adopted by Coptic sculpture and interpreted as a helper and a savior. A frequent composition shows him carrying a wreathed cross on his nose in a well-modeled carving on a ground of stylized foliage (B. M.: A.D. V–VI) or in a much simpler though quite impressive design (Fig. 3.140; Louvre, from Armant A.D. V–VI). Let us also mention that dolphins are associated with light; in pair they flank the main figure or subject in a symmetrical composition.

Another animal appearing commonly in early Christian iconography in North Africa, Abyssinia, and Egypt is the lion. Lion-hunting scenes probably derive from the Hellenistic models. In sculpture, apart from occasional naturalistic statues, the cubic fore parts of lions form pedestals to engaged columns at Bawit and can be regarded as forerunners of similar elements in the columned porches of Italian Romanesque churches.[160] The lion appears also in the round in limestone as a cubist rendering with flat face, columnar front legs, body ribbed transversely with deep wedge-shaped channels, a quite impressive nightmare of brutal force (Fig. 3.141; from Cairo; Staatliche Museen, 4458; A.D. VII). The face resembles that given to the waterspouts projecting from walls[161] or opening in the middle of the water-jug stands in limestone, carved on their front with foliate friezes akin in motif and style to the best elements of mural sculpture with interlace, scroll, vine, and even animals (Fig. 3.142). I have shown elsewhere[162] that this use, as well as that of the waterspout in the Maryut and at Saqqara, rather than being imported was derived from the typical libation basin of Ptolemaic date (Fig. 3.143), itself an adaptation on a small scale of the lion-shaped gargoyle at the top of the Egyptian

160. U. Monneret de Villard, "Per la Storia del Portale Romanico," in *Medieval Studies in Memory of A. K. Porter*, Vol. 1, (Cambridge, Mass: 1939) pp. 113–124.
161. J. Strzygowski, *Koptische Kunst*, pp. 94–99.
162. Alexander Badawy, "The Prototype of the Coptic Water-jug Stand," *Archaeology*, Vol. 20, (1967), pp. 56–61.

3.131, 3.132
Stone console from Djimē (?) carved to imitate the model of a shrine. (Museo Egizio, Schiaparelli 1668; A.D. VI–VII.)

3.133
Vine interlace with flat carving. (Musées Royaux, E7971; A.D. VI-VII.)

3.134
Doorjamb in flat relief ornament from Coptos. (Musée Guimet, Lyon; A.D. VII.)

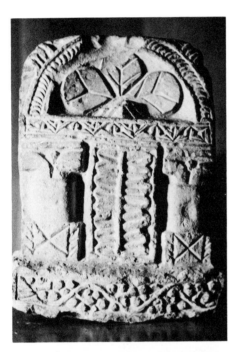

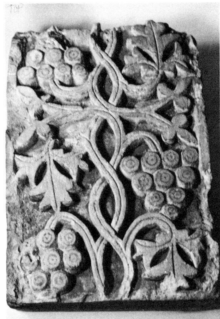

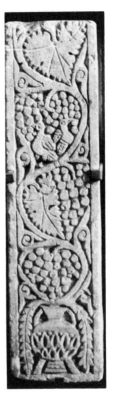

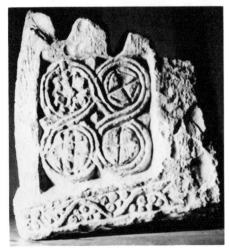

3.135
Fragment carved with debased foliate ornament
arranged in an agreeable balance with a minute
bird. (B. M., 1617; A.D. VII.)

3.136
Stela carved with a flat inorganic interlace
enclosing a face. (B. M., 57282; A.D. VII.)
3.137
Fragment of a panel with an interlace enclosing
scenes of Erotes gathering grapes and treading
them, framed within an elaborate Greek key and
quatrefoils. (B. M., 1798; A.D. VII.)
3.138
Jonas rejected by the sea monster. (Louvre,
E17007, X 5072; A.D. VI.)

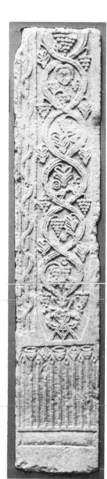

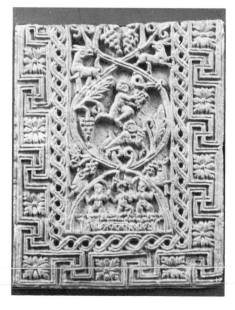

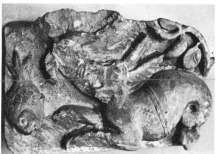

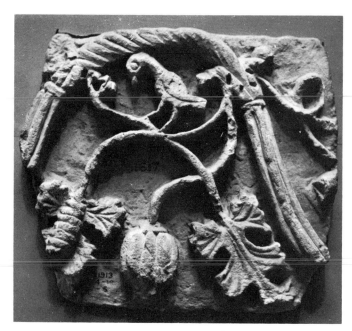

3.139
Crocodile attacked by a dolphin and a sea
creature. (B. M., 1652; A.D. VI-VII.)
3.140
Dolphin carrying a cross. (Armant; Louvre; A.D.
V-VI.)

3.141
Cubist sculpture of a lion from Cairo. (Staatliche
Museen, 4458, A.D. VII.)

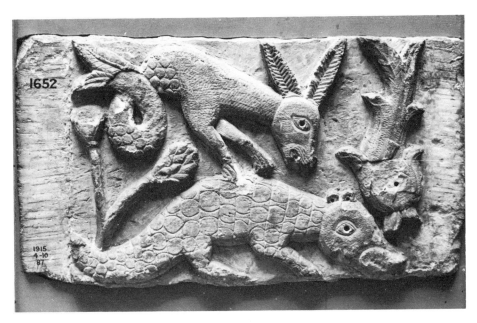

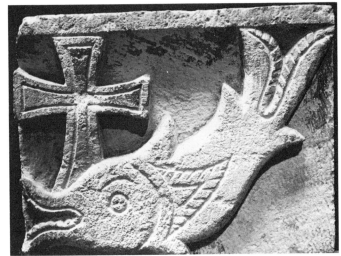

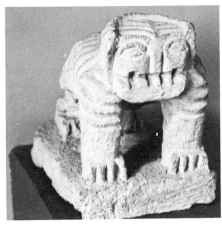

3.142
Water-jug stands carved with foliate friezes from which protrudes a central lion's head used as spout. (Author's drawings in "The Prototype of the Coptic Water-jug Stand," *Archaeology*, Vol. 20 [1967], pp. 56–61, Fig. 4.)

3.143
Typical libation basin of Ptolemaic date which formed the prototype to the Coptic water-jug stand. (B. M., 800; photograph courtesy of the British Museum.)

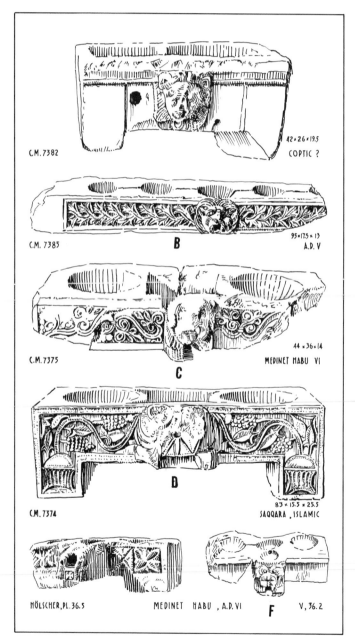

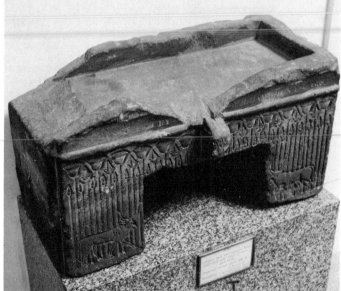

temple. When he appropriated the theme the Coptic sculptor certainly associated with it the same idea of protection as did his ancestors. A similar interpretation can be held for the two protomes of lions forming pedestals at Bawit. Theban lions are strongly conventionalized with flat face, the mouth forming the transverse arm of an inverted cross whose vertical arm is represented by the nose and the chin, flanked by the two circles of the eyes—quite an appearance indeed.[163] In post-Sassanian times the motif of two lions antithetic about a vertical stylized tree or vessel with sprouting vine appears as a Coptic interpretation of a Mesopotamian motif. The connection of the animals with the central element is clearly indicated, for they touch it with one paw (Museo Egizio, Prov. 760; A.D. VII) or they rear up applying both fore-legs to it (Fig. 3.144; Staatliche Museen, 4705; A.D. VI; Fig. 3.145; Museo Egizio, 1339; A.D. VII-VIII). The motif is treated in the lunette of a flat-arched niche or in an independent rectangular panel in bold relief. The composition did not, however, originate in Mesopotamia, for the theme of confronted elements flanking a central feature known to late antique iconography in the two flying genii holding a clipeus was borrowed by Coptic sculpture, which transformed it into two flying or standing angels holding a clipeus or *mandorla* enclosing a sacred image or a *crux immissa*.

Coptic sculptors also invented some variants like that of the two dryads re-

clining on either side of a basket or the two confronting horsemen. The central element in the shape of a vessel with sprouting plant could provide an argument in favor of a post-Sassanian date for the high-relief lunette in which two lambs are represented flanking the vessel (Fig. 3.146; from Fayum; Louvre; A.D. VI–VII). The prominent loop between the two horizontal branches is probably an indication of the *crux ansata*. The incidence of a cross flanked by two animals or angels in numerous monuments favors this interpretation. A curious variant in well-modeled relief represents a cross carried by means of a horizontal pole behind its transverse arms which is secured with cords to the necks of two stags standing between two trees above a border of myrtle[164] (Dumbarton Oaks, 40.61; A.D. VI). (Two trefoil leaves are inserted in the two upper angles of the cross, a motif frequent at Ahnas.[165] Of a debased style, but still interesting on account of its elements, is the composition in bold, simplified relief representing two angels, each holding a palm branch against a rosette within a circle—probably a symbol of Christianity—which stands on two pedestals in the center of the composition. A twisted molding surmounted by a row of palmettes frames the tablet (Fig. 3.147; B. M., 1609; A.D. VII–VIII). Setting the cross or another Christian emblem on a pedestal[166] is a frequent

163. J. Strzygowski, *Koptische Kunst*, C. M., 7393, 7394, 8742, 8743.

164. E. Drioton, *Nilomètre*, p. 8, Fig. 3.
165. J. Strzygowski, *Koptische Kunst*, p. 61, Fig. 78.
166. W. Haftmann, *Das italienische Säulenornament* (Leipzig and Berlin: 1939); H. Torp, "Monumentum Resurrectionis," in *Acta Instituti Rom Norvegiae* (Rome: 1962), Vol. 1, pp. 79–112.

feature in another category of Coptic monuments, the niches carved in relief in which a cross that appears in the headpiece against a shell with thirteen flutes is set above a sturdy engaged column surrounded by volutes which was probably used as stand for a lamp (Fig. 3.148; from Philae, Staatliche Museen, 4766; A.D. VI–VII). The cross within a wreath occurs as the central feature in a symmetrical frieze or in a panel where it is flanked by two horsemen, Apa Kene and Victor, holding a cross. Though of little aesthetic value, this relief is interesting because of the successful characterization of worry in the features of the two personages and the treatment of the chlamys flowing behind their shoulders as a wing, similar to that in a few bronze figurines also representing rider saints on galloping horses (see Fig. 5.28). As a matter of fact the long inscription commemorates the death of the heads of a religious community and the four brothers at Sohag. Here also the wreath ends in two fancy foliate volutes, spreading out at its bottom, a typically Coptic element (Fig. 3.149; from Sohag, B. M., 1276; A.D. VIII–IX).

The motif of the lion hunt can represent the fighting of Evil, since the lion in Christian context is its symbol (1 Pet. 5:8). The coarse panel of folk sculpture (Fig. 3.150; Staatliche Museen, 4706; A.D. VI–VII ?) representing a horseman spearing with his long halberd a rearing lion that has just mauled a lamb may be compared to the lively realistic composition on an ivory of Romano-Persian style (Civico Museo

3.144
Lions rearing up against a central vessel.
(Staatliche Museen, 4705; A.D. VI.)

3.145
Mottled lion and lioness rearing up to a fountain. (Museo Egizio, 1339; A.D. VII-VIII.)
3.146
Circular spandrel carved with two lambs flanking a central vessel. (Fayum; Louvre; A.D. VI-VII.)

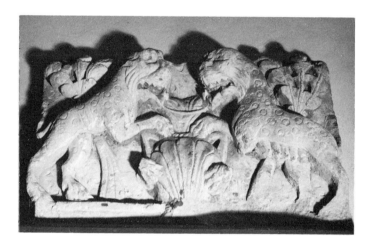

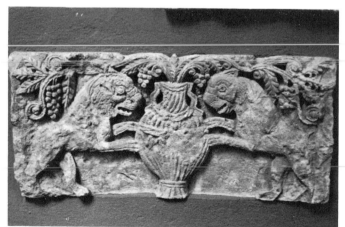

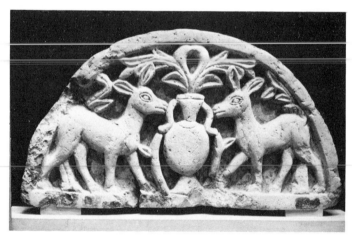

3.147
Panel with debased carving of two angels
holding a palm frond to a rosette set on two
pedestals. (B. M., 1609; A.D. VII-VIII.)

3.148
Niche with engaged colonnette carrying the
cross. (Staatliche Museen, 4766; from Philae;
A.D. VI-VII.)

3.149
Lintel carved with the confronted rider saints
Pakene and Victor from Sohag. (B. M., 1276;
A.D. VIII-IX.)

3.150
Panel representing a horseman spearing a lion.
(Staatliche Museen, 4706; A.D. VI-VII.)

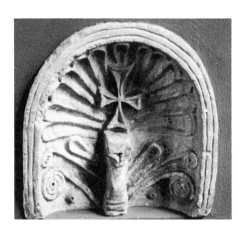

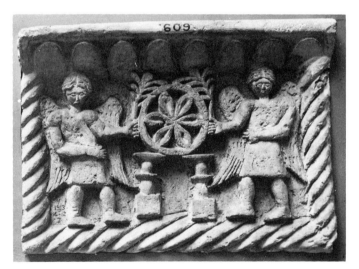

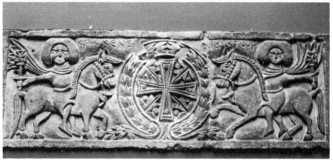

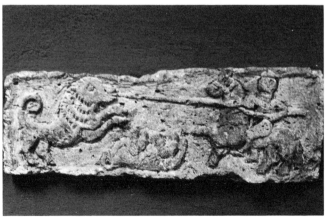

3.151
Rider saint spearing a dragon within an arch.
(From Bawit; Louvre; E 17003; A.D. VI.)

3.152
Sketch of a rider. (Museo Egizio, Suppl. 1334;
A.D. VII–VIII.)
3.153
Christ riding between two angels. (from Deir
Anba Shenute at Sohag; Staatliche Museen, I.
4131; A.D. IX.)

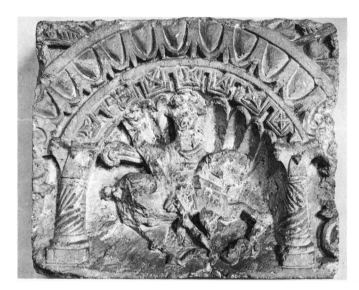

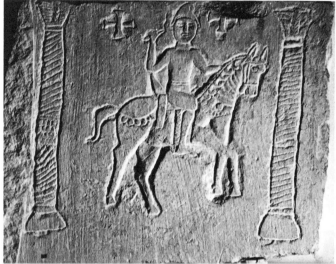

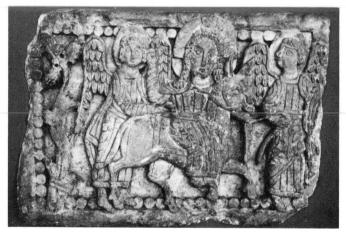

di Storia del Arte, N.S. 1564). The symbolism is even more evident in the scene of a Coptic rider saint—St. George, Theodoros, Sisinnios, or Menas—spearing an enemy prone beneath the feet of his horse (Fig. 3.151; from Bawit; Louvre, E 17003; A.D. VI), or spearing a dragon in a composition (see Fig. 4.32) quite similar to those of the Aachen ivory, the murals at Bawit (Victor, Phoibammon, Sisinnios), and the illuminations (Sisinnios, Mercurios, Theodoros; see Fig. 4.57). The attitude in all media is standardized: the saint in a Roman soldier's garb is turned from the waist in a frontal position; he holds his spear diagonally while the diminutive horse bows its head. Other types of rider saint shown sometimes as *orantes* (ivory comb from Antinoë, see p. 157) are those holding a palm frond against a background of foliage (Allard Pierson Stichting, Inv. 7800), or those raising a lighted candle in the right hand (Fig. 3.152; Museo Egizio, Suppl. 1334; A.D. VII–VIII) in a sketchy sunk relief with unusual erroneous foreshortening of the front of the horse, which is adorned with rich trappings and oriental saddle. Perhaps the most significant of the rider saints is the one identified as Christ riding an ass between two angels (Fig. 3.153; 42 × 61 cm., from Deir Anba Shenute at Sohag, Staatliche Museen, I. 4131; A.D. IX). The rider, clad in a tunic and pallium, wearing a cruciferous nimbus around his long hair, sits astride his mount and raises his right hand in a blessing. His large face with finely incised features resembles the typical staring faces in monastic murals. Of the two angels the one farthest to the rear

who is supporting the rider has the best proportions, features, and movement, though the folds of his garments show the same inorganic vertical incised lines. The ass is carved in an excellent style, though lacking the surging movement of the animal on a Mu'allaqa lintel (see p. 133). At the rear a stylized vine fills in a gap, a usual device in panel composition. Beckwith mentions a date in connection with textiles and manuscripts in the ninth century, based on the beaded border and other stylistic features.[167]

167. J. Beckwith, *Coptic Sculpture*, p. 29.

Capitals and Columns

Architectural sculpture is best represented by structural elements, capitals and columns that often provide in Coptic art some chronological evidence for allied ornament. The widespread use of niches, windows, and screens with architectonic motifs accounts for the large number of diminutive capitals on engaged columns and pilasters. Yet it has been pointed out by Drioton[168] that fourteen out of sixteen Coptic capitals derive from the Roman type of Corinthian. The latter occurs in its original form only in the marginal districts of Abu Mina and Alexandria, another corroboration if necessary of the relevance as to art of the Roman dictum "Alexandrea ad Aegyptum." Many of the capitals at Abu mina (Maryut) from the fourth to the fifth centuries[169] are of Proconnesian marble and conform to the general tradition of late Roman Corinthian in the eastern Mediterranean, exemplified elsewhere in Egypt by intrusive capitals also of the same marble (Fig. 3.154; from Ahnas, Coptic Museum, Cairo [C. M., 7350]; A.D. IV–V). Other types include a later eastern Mediterranean two-zoned capital (Greco-Roman Museum, Inv. 13583) with the upper range fluted above acanthus, also represented in a mural at Saqqara;[170]

168. E. Drioton, *Nilomètre*, p. 59.
169. C. M. Kaufmann, *Die Menasstadt*, pls. 66–71. R. Kautzsch, *Kapitellstudien (Studien zur spätan tiken Kunstgeschichte des deutschen archäologischen Instituts, No. 9)* (Berlin: 1936). J. Ward Perkins, "Shrine of St. Menas," pp. 62–66.
170. J. Ward Perkins, "Shrine of St. Menas," pl. IX, 3. J. E. Quibell, *Excavations at Saqqara* (1907–1908). pl. XX II, 4–6; (1908–9, 1909–10), pl. XLIII, 3.

debased Ionic and Ionic-Corinthian; and small-sized variants of fully articulated Corinthian to simple drums with four angle leaves, including those with wreathed cross unfurling two curly steamers, seemingly a native invention found only in Alexandrian and Coptic sculptures (see Figs. 2.39, 3.97, 3.149). Some fragments belong to the Coptic modified Corinthian characterized by the omission of the inner volutes; the springing of the acanthus leaves on both sides of the stems (German *Wedelranke*), and the naked *caulicoli*. On the evidence of the previously mentioned motif of the cross within a wreath terminating in two curling ribbons, apparently unknown outside Egypt, these contacts between the Maryut-Alexandrian capitals and those of Coptic Egypt proper would fall readily into place were it established that the Alexandrian capitals, even those of Proconnesian marble, were carved locally.[171] This would not be inconsistent with the outstanding performance of the Alexandrian school in ivory carving. Column bases are of the Attic type and molded rectangular, sometimes octagonal, pedestals carved in one block also occur.

Contrasting with this decadent pre-Justinianic Corinthian, that evolved by Coptic sculpture follows, at least in its initial stages, the general process of modification in the Orient. The acanthus of the outer ring grows taller and closer, a movement echoed in those rings behind, so that the sheath leaves are covered and disappear. At the same time the leaves become stiffer, with

three tips instead of four to a lobe, and increasingly angular and spiky. At Oxyrhynchos,[172] however, the acanthus is still naturalistic, similar to that of the Gethsemani Church at Jerusalem (A.D. 390); it is either set wide apart in two rows while the sheath leaves disappear leaving the naked volutes visible (Fig. 3.155; Greco-Roman Museum, A.D. V), or set in one row with the *caulicoli* jointed to their sheath leaves above by enormous knobs (Fig. 3.156; Greco-Roman Museum, A.D. V). The small leaf or rosette inserted in the angle where the volutes originate belongs to the eastern modified Corinthian. The general proportions become gradually squatter, and the three-dimensional arrangement of acanthus in rows one behind the other disappears in favor of a two-dimensional arrangement with the acanthus springing on one alignment but differentiated by artificial shadows. Here also prevails the same system of contrast between the masses of the elements and the dark background as seen in later friezes. A pilaster capital from Ahnas (c. M., 7349; A.D. VI) shows the proportions of a rectangle 2:1 set flat on its long side so that there is room only for the sheath leaves without volutes and for their spherical joints with the *caulicoli* just emerging from the boldly curving spiky acanthus. The latter is similar to that appearing sporadically in figured sculpture of the hard style, probably dating from the sixth century. One aspect of the disintegration shows where the sheath leaves disappear to make place for leaves springing from the inner side

of the *caulicoli* to the level of the volute.[173] The Corinthian capitals from the basilica at Ashmunein and some from Deir Ahmar fall into place between the extreme stages in the evolution, allowance being made for local variations. While the main capitals at Ashmunein[174] belong to the Vitruvian Corinthian type, those of the pilasters show a disintegration in the omission of the volutes, though the sheath leaves are retained and the acanthus is still naturalistic. A stage in the stylization process is exemplified by the only remaining capital of the church of Kom Ombo (Fig. 3.157). Contrasting with this style, the capitals at Deir Ahmar are deprived of volutes, characterized by the spiky, deeply undercut, flat leaves and a cross encircled in the sheath leaves.

It has been noticed by Drioton that the Vitruvian type of Corinthian capital predominant among the fragments found in the Nilometer at Rodah, probably originating from a church at Heliopolis, and also among those found at Bawit, occurs but rarely at Saqqara, where of sixty-nine published examples four are Vitruvian, fifteen modified Corinthian, fifteen of the type of the Tholos at Epidauros, and four of the type of the Tower of Andronikos, while twenty-one are carved with vine elements and ten are of other types.[175] At Bawit the main capitals[176] are again

171. J. Ward Perkins, "Shrine of St. Menas," pp. 66–68, pls. IX, 6, X.

172. E. Kitzinger, "Early Coptic Sculpture," pp. 186–190, 199, pl. LXVIII.

173. E. Breccia, *Oxyrhynchos* II, pl. XLIII, 110c; *Oxyrhynchos* I, pl. XLI, 151.
174. A. J. B. Wace, A. H. S. Megaw, and T. C. Skeat, *Hermopolis Magna, Ashmunein, The Ptolemaic Sanctuary and the Basilica* (Alexandria: 1959), pp. 64–68, 78–79, pls. 23, 24, 27.
175. E. Drioton, *Nilomètre*, pp. 69–71.
176. E. Chassinat, "Baouît," pls. XCIV-XCVII.

3.154
Marble capital from Ahnas of the late
Corinthian type. (Coptic Museum, Cairo,: C. M.,
7350; A.D. IV-V; J. Strzygowski, *Koptische Kunst*,
Fig. 102).
3.155
Capital of pilaster from Oxyrhynchos. (Greco-
Roman Museum, Alexandria. A.D. V. W. Emery,
The Royal Tombs of Ballana and Qustul, Vol. 2.)

3.156
Evolved capital of pilaster from Oxyrhynchos;
(Greco-Roman Museum, Alexandria, A.D. V. W.
Emery, *The Royal Tombs of Ballana and Qustul*,
Vol. 2.)
3.157
Capital in the ruins of the church in the temple
at Kom Ombo.

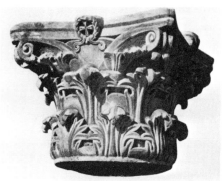

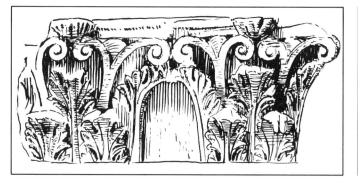

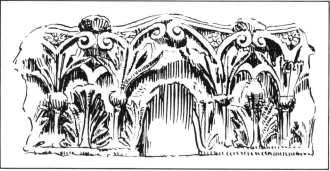

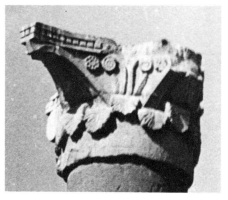

closer to the Vitruvian prototype with three tips to the lobe (Fig. 3.158; Louvre) than are the simplified pilaster capitals, where the volutes merge with the sheath leaves often issuing from a single *caulicoli* in the axis,[177] with leaves having only three or two tips to the lobe (Fig. 3.159, 3.160; Louvre). While the earlier acanthus curves smoothly,[178] the later leaves become narrower and stiffer with their median uppermost lobe curving.[179]

As for the column, the only shafts retrieved at Bawit are those of engaged columns carved with two zones of imbricated pattern, known in Roman mosaics (Pompeii) and with zigzag flanked on the doorjamb by a sterile vine with interlaced stems growing out of a vase (Fig. 3.161, south door from Chapel A to B, Louvre, E 17026, E 17809). The symbolism of the pair of lion pedestals and its historical importance have already been discussed. In another engaged column (Fig.3.162; north end of east façade of Chapel B; Louvre) a swastika or meander and lozenge pattern is flanked by a vine and modified acanthus interlace. It has been noted that all the patterns crowding on the shafts are designs for flat floors or ceilings that can only weaken visually the structural aspect of a column. The same remark holds true for the sides of pilasters treated as vertical panels of very rich naturalistic foliate interlace inhabited by birds adjacent to

an hexagonal pattern. It must be admitted, however, that the excellent ornamental effect agrees well in its deep modeling with the perfect fluid style of the figures in the top panels (Fig. 3.163; Louvre, E 16963, A.D. V–VI). Even a vine design on the main face of a pilaster allied to a swastika pattern on the lateral face (Fig. 3.164; Louvre, E 17063) or a more conventionalized acanthus scroll on the main face (Fig. 3.165; Chapel B, Louvre) enrich the structural member with rhythmic movement. The type of scroll is identical to that in contemporary friezes, contrasting foliate masses and dark ground.

Twin pilaster capitals are rare at Bawit and in the Nilometer group but are more common at Saqqara (six found not *in situ*), where they were probably set at the top of pilasters flanking twin windows, niches, or bays in screens (Fig. 3.166).[180] Few of the modified acanthus at Saqqara have supple lines,[181] the vast majority being wiry, even stiffer than that at Ahnas,[182] though still sometimes conforming to the full modified Vitruvian type. Spherical joints between *caulicoli* and sheath leaves are decorated with ribs, once even treated as fist and arm instead of *caulicoli*.[183] Broad pilaster capitals with several acanthus to a row occur (Fig. 3.167; Museo Egizio; A.D. VI),[184] de-

riving from the late-antique types[185] imitated in the Nilometer group and in Syrian churches.[186] Simple yet quite effective derivatives from the Corinthian include a chalice core carved with four acanthus.[187] Though they are carved with patterns similar to those at Bawit, the shafts of engaged columns at Saqqara (Fig. 3.168) produce a disquieting effect resulting from the deeper carving and the occasional applied wreathed cross or panel with a scene in high relief, perhaps reminiscent of the more harmonious panels on Egyptian columns? Pilasters at Saqqara are literally crowded with panels of intricate vine or interlace on their vertical sides, with *crux florida* in squares surmounted by a molding of vine on their bases (Fig. 3.169).

From the canonic Corinthian are derived more elaborate forms featuring a closely knit acanthus interlace covering the whole capital (Bawit, C. M., 35820; A.D. VI–VII),[188] or fancy though still richly curving foliage obscuring the elegance of the original scheme (Coptic Museum, Cairo, 173, from Roman fortress of Babylon; A.D. IV).[189] Another form shows a simplified composition, chalice-shaped with angle acanthus set on a larger smooth leaf;[190] or smooth leaves at the angles and center of a pilaster capital flanking

177. Ibid. for two *caulicoli:* pls. LIII, 2, LIV, LXV, CIV, CV, CVII-CIX.Compare E. Drioton, *Nilomètre*, No. 22. For a single *caulicoli:* pls. XLVI-LIII, XVI.
178. E.Drioton, *Nilomètre*, pp.92–95. E. Chassinat, "Baouît," pls. XXXIV, XCII, XCIV, XCVI, XCVII.
179. E. Chassinat, "Baouît," pls. XVIII, XIX, CIV.

180. E. Drioton, *Nilomètre*, pp.104–107.
181. J. E. Quibell, *Excavations at Saqqara* (1907–1908), pl. XXVI; (1908–9, 1909–10), pl. XXXIII, 5.
182. Ibid. (1907–1908) pls. XXVII, 4, XXVIII, 1, XXX.
183. Ibid. (1908–9, 1909–10), pl. XXXIII, 1.
184. W. F. Petrie, *Roman Ehnasya*, (London: 1905), pl. LXX, 4.

185. J. E. Quibell, *Excavations at Saqqara* (1907–1908), pls. XXXII, 2, 3, XXXIII, 2, 5.
186. E. Drioton *Nilomètre*, p. 108.
187. J. E. Quibell, *Excavations at Saqqara* (1908–9, 1909–10), pls. XXIII, XXIV, XXVII, 1.
188. G. Duthuit, *La Sculpture Copte*, pls. XLI, a, XLII, a.
189. Ibid., pl. XLIV, a.
190. J. E. Quibell, *Excavations at Saqqara* (1907–1908), pl. XXIII.

3.158
Capital close to the Vitruvian Corinthian type from Bawit. (Louvre, A.D. V.)

3.159, 3.160
Four capitals of pilasters from Bawit where the volutes merge with the sheath leaves. (Louvre)

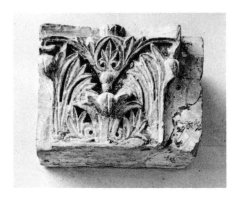

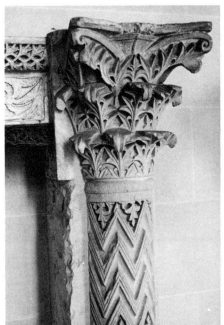

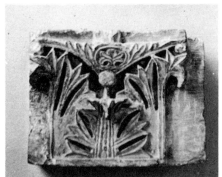

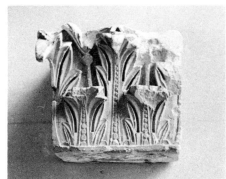

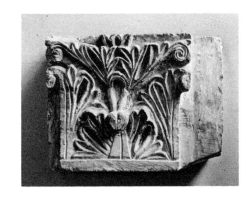

The Coptic Period 199

3.161
The two columns which flanked the south door from Chapel A to Chapel B at Bawit. (Louvre, right: E 17026; left: E 17809). Note the deeply carved elegant patterns on the shafts and the setting of the columns on the protomes of lions.

3.162
Engaged column at the north end of the east façade of Chapel B at Bawit with geometric patterns carved on the shaft. (Louvre.)

3.163
Pilaster with beautiful figures in the top panels and naturalistic interlace below. (Bawit; Louvre, E 16963.)

3.164
Pilaster with Corinthian capital and stylized ornament carved on its sides. (Bawit; Louvre, E 17063.)

3.165
Pilaster with conventionalized acanthus scroll on its front face. (Bawit, Louvre. Chapel B.)

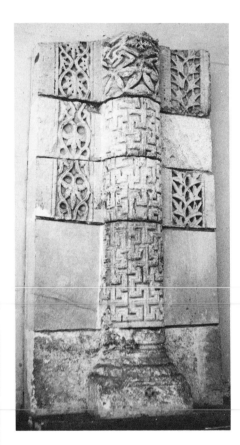

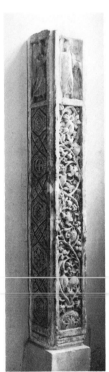

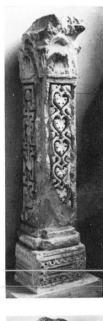

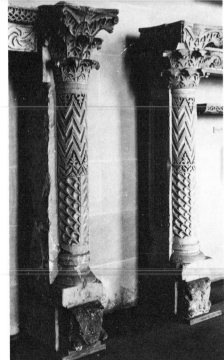

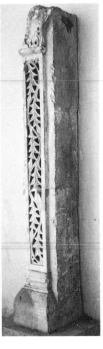

3.166
Small capitals of twin windows from Saqqara.
(J. E. Quibell, *Excavations at Saqqara*, [1907–1908], pl. XXXV, 5.)

3.167
Broad capital with several acanthus leaves.
(Museo Egizio; A.D. VI.)

3.168
Shafts of engaged columns from Saqqara carved with profuse geometrized patterns. (J. E Quibell, *Saqqara*, [1908–9, 1909–10], pl. XXXVII, 1–2.)

3.169
Pilaster decoration at Saqqara, (J. E. Quibell, *Saqqara*, [1908–9, 1909–10], pl. XXX.)

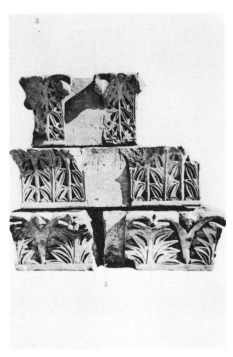

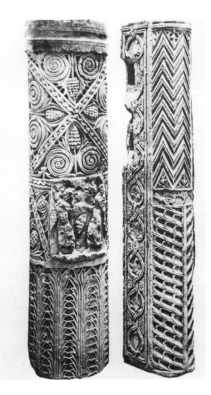

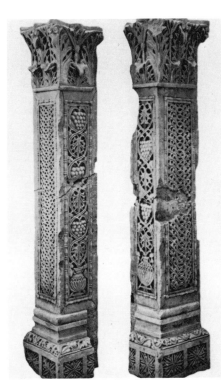

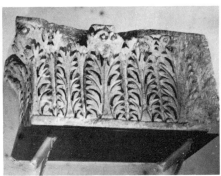

two *caulicoli* formed as thick torsaded columns;[191] or angle-smooth leaves framing a large wreathed cross on each side;[192] o two ranges of smooth leaves[193] deteriorating into four flat round leaves with median stem rising to four lugs instead of volutes.[194] Local variations in the southernmost district of Egypt have tended toward a drastic simplification and flat carving ever since pagan times (Fig. 3.170; Aswan; Glyptothek, Munich, 85) and in typical Christian Nubian capitals of granite (Fig. 3.171; from Qasr Ibrim, University Museum, Philadelphia, E 15222, ca. A.D. 540).[195]

In addition to the great variety of capitals of the Corinthian type (Bawit, Saqqara), there are numerous capitals, mostly from Saqqara, all different in their shapes and patterns, proving the versatile creative imagination of Coptic sculpture. There is the isolated flamboyant capital with acanthus leaves twisted as if by a violent wind (Fig. 3.172; Saqqara; A.D. VI),[196] more effective than a similar one in St. Demetrius and St. Sophia (Saloniki). There are also the composite capitals with a lower range of acanthus from

which spring Egyptian palmettes (Saqqara, C. M., 39938, A.D. VI)[197]—a form later stylized in marble into a stepped tronconical profile (Islamic Museum, Cairo, A.D. VI–VII),[198] a bowl with fruit between the fore parts of rams set at the four corners, or a wreathed cross flanked by animals set on a basket (Saqqara; Coptic Museum, Cairo; 8688 A.D. VI).[199]

The so-called basket type occurs at Bawit, Deir Mawas, Ashmunein, and Saqqara, and also occasionally in the shape of the capital of an engaged column consisting of a tall tronconical band twine on a bead-and-reel (Fig. 3.173,[200] or in a large marble tronconical shape broadening into a quadrilateral band twine (impost type) and featuring on each face a foliate panel (from Alexandria; Coptic Museum, Cairo, 7178 A.D. VI),[201] regarded as a Byzantine import very similar to those at Ravenna. The vast majority, however, are of the two-zone type decorated as the one already mentioned with the fore parts of four rams set over a flat basket[202] (Fig. 3.174; Deir Mawas; Musées Royaux, E 8041, also E 8042; A.D. VI–VII), or in a much

taller basket shaped as an elegant chalice (Fig. 3.175; Bawit, Louvre; A.D. VI), with the wickerwork band twining into a delicate lozenge lace.

Another type, also called basket capital, shows the convex profile of a vase, sometimes ribbed vertically and entirely covered with deeply carved foliate ornament. Here again both design and elements offer a wide variety ranging from a vine or vine leaves arranged within the fanciful interlace of stems (Fig. 3.176)[203] to a composition featuring an interlace issuing from a minute vessel inhabited by rosettes, cross, and leaf at regular intervals along the vertical ribs (Fig. 3.177),[204] with the stems often branching off horizontally to form an orderly array of compartments, each occupied by a vine leaf hanging down (Fig. 3.178).[205] This motif will appear on a post-conquest capital as two rows of square panels formed by a band enclosing twin lancet-like leaves.[206] At Bawit a similar design uses a stylized long acanthus leaf instead of the vine, leaving most of the ground visible (Fig. 3.179; from Bawit, Chapel B, 53 cm. high; Louvre N. X 5067; end A.D. VII).[207] Also at Bawit an original

191. Ibid., (1908–9, 1909–10), pl. XXXV, 5. Tree trunks in Coptic Museum, 4604. H. Zaloscer, *Une Collection de pierres sculptées au Musée Copte du Vieux-Caire*, (Cairo: 1948), pl. 36. XXXVI. (Hereafter cited as *Collection de pierres sculptées*.)
192. J. E. Quibell, *Excavations at Saqqara* (1908–9, 1909–10), pl. XXXV, 1.
193. Ibid., pl. XXXV, 4; (1907–1908), pl. XXVII, 2.
194. Ibid. (1908–9, 1909–10), pl. XXXV, 4; (1907–1908), pl. XXVII, 5, 6.
195. G. S. Mileham, *Churches in Lower Nubia* (Philadelphia: 1910), p. 7.
196. J. E. Quibell, *Excavations at Saqqara* (1908–9, 1909–10), pl. XXXII, 5.

197. Ibid., pl. XXXV. 4; (1907–1908), pl. XXII, 4–6.
198. Museum of Islamic Art, Cairo, No. 4039. G. Duthuit, *La Sculpture Copte*, pl. XLV a.
199. G. Duthuit, *La Sculpture Copte*, pl. LVI, a. J. E. Quibell, *Excavations at Saqqara* (1908–9, 1909–10), pl. XXXII, 6.
200. J. E. Quibell, *Excavations at Saqqara* (1908–9, 1909–10), pl. XXXVI, 4.
201. G. Duthuit, *La Sculpture Copte*, pl. XLVII. J. Strzygowski, *Koptische Kunst*, Fig. 105. J. Beckwith, *Coptic Sculpture*, p. 21.
202. J. Strzygowski, *Koptische Kunst*, No. 7345, with a cross over a peacock and a duck (Coptic Museum, Cairo, 3507).

203. J. E. Quibell, *Excavations at Saqqara* (1907–1908), pls. XVI, 2, XVII, XXI, 1–4, XXII; (1908–9, 1909–10), pls. XXXII, 1, 4. Coptic Museum, Cairo, 4315. For a smaller capital with freer design, cf. E. Drioton, *Nilomètre*, No. 27, pp. 120–123.
204. J. E. Quibell, *Excavations at Saqqara* (1907–1908), pls. XVI, 1, XXV.
205. Ibid., pls. XVIII, XIX, XX, XXII, 2, 3; (1908–9; 1909–10), pl. XXXII, 2.
206. Coptic Museum, Cairo, 49, from Fustat.
207. E. Chassinat, "Baouît," pls. XCVIII, CI. P. Du Bourguet, *Art Copte*, No. 81, dated A.D. VII J. Beckwith, *Coptic Sculpture*, No. 79, dated mid-A.D. VI

composition stages prismatic acanthus leaves in four horizontal staggered rows as a beehive within a stepped convex vase profile, achieving with this simple means an articulated interplay of light and shadows (Fig. 3,180, from Bawit, Chapel B; Louvre, X 5060; end A.D. VII).[208] Only one example of a deeply carved acanthus capital with vertical inhabited interlace along its ribs has been published (see Fig. 3.177).[209] Several smaller capitals feature a lancet-like acanthus, either in vertical stems around the convex vase shape,[210] or as a geometrized triangular-leafed myrtle branching symmetrically from a vertical interlace or a band twine (Fig. 3.181)[211] in a riotous pattern not unlike that of the acanthus one at Bawit. An abstract derivative emphasizes a sequence of superimposed arches and triangles between vertical flat strips.[212]

The astounding variety in original compositions in the basket and vase capitals, allied to virtuosity in the in the technique comparable to those of the best imperial art of Byzantium, has led Strzygowski to surmise that both types were invented by Coptic sculptors, exported to Byzantium and thence to Ravenna,[213] a thesis accepted by G. Duthuit[214] and vindicated by Grüneisen[215] but rejected by the majority of scholars.[216] Yet it should not be dismissed so lightly, for there is much in favor of a parallel development of these types in Coptic Egypt and in Byzantium, another proof that the dogmatic secession did not extend to art. The prominent achievement of Hellenistic art in Egypt echoed in the repertory and stylistic elements borrowed by Roman art, the parallelism between Alexandrian and Roman Christian symbolism, and the fact that dressed marble blocks rather than finished carvings were exported from Cyzicos are some factors in favor of the parallel development in Egypt, Syria, Byzantium, and Rome.

As for the basket capitals, the best examples of the vase subgroup are enriched with figures. An ancient Egyptian invention[217] with the Hathor and Bes capitals, the figured capital was frequent in the Hellenistic and late-antique times, producing such astonishing masterpieces as those composite Ionic examples bearing the mask of Dionysos[218] from Dionysias (Fig. 3.182; Fayum; A.D. I–II 3.182), comparable only to those at Suweida. The same use of a mask occurs in a later Corinthian capital (Fig. 3.183; Greco-Roman Museum, 3851; A.D. II–III). A figure in a style reminiscent of that at Ahnas holds as Aphrodite the flowing scarf in both hands and rises between the angle acanthus of a pseudo-Corinthian pilaster capital (Dumbarton Oaks, 34.4; A.D. V). On another block, perhaps a voussoir, Dionysos holding the tyrsus leans on a torsaded column amid vine (Fig. 3.184, Dumbarton Oaks, 40.60; A.D. V). The setting of both figures can be compared to the composition of figured niche heads and friezes, and is found in a broad capital of a pilaster decorated with the motif of two winged angels, conspicuous for their nudity, holding a mask carved still in a Hellenistic style, though the acanthus beneath is strongly stylized (Fig. 3.185; from Ahnas, C. M., 44069; A.D. VI), obviously inspired from some early pagan model. Where the fore parts of animals appear at the four corners (lion, eagle, griffin, ram) one is reminded of the Justinianic type of two-zoned capitals with symbolic implication from Salona, Parenzo, and Mount Athos. Yet the limestone vase capital with vine surmounted by four naturalistic lions flanking a wreathed cross or a basket is certainly a local work (Fig. 3.186, from Cairo; Staatliche Museen, 6159; A.D. V–VI). In a bolder composition the four lion heads surge from the foliate ornament (Fig. 3.187; Dumbarton Oaks, 35.5; A.D. VI); in a more naïve one the stiff-legged imbricated fore parts of rams flanking a heraldic eagle project above a row of acanthus (Fig. 3.188; Coptic Museum, Cairo, 4682; A.D. VII).[219] The argument favoring a Constantinople origin

208. E. Chassinat, "Baouît," pls. CII-CIII. P. Du Bourguet, Art copte, No. 82, dated A.D. VII. J. Beckwith, Coptic Sculpture, No. 80, dated mid A.D. VI.
209. J. E. Quibell, Excavations at Saqqara (1907–1908), pl. XXV.
210. Ibid., pl. XXIX, 1. Also Coptic Museum, Cairo, 31.
211. Ibid., pl. XXIX, 2–3.
212. Ibid., (1908–9, 1909–10), pl. XXXII, 3.
213. J. Strzygowski, Koptische Kunst, p. 69.
214. G. Duthuit, La Sculpture Copte, pp. 48–49.

215. W. de Grüneisen, Caractéristiques, pp. 141–161.
216. E. Drioton, Nilomètre, p. XVII.
217. E. von Merklin, Antike Figuralkapitellen (Berlin: 1962). (Hereafter cited as Figuralkapitellen.)
218. Alexander Badawy, "Greco-Roman Figure Capitals from Dionysias," Gazette des Beaux-Arts (Paris: 1968), pp. 249–254.

219. H. Zaloscer, Collection de pierres sculptées, No. 32, pp. 55–56, pl. VII.

3.170
Capital from Aswan. (Glyptothek, Munich, 85.)

3.171
Granite capital from Qasr Ibrim. (Pennsylvania University Museum, E 15222; Philadelphia, ca. A.D. 540.)

3.172
Wind-blown acanthus capital from Saqqara. (J. E. Quibell, *Saqqara*. [1908–9, 1909–10], pl. XXXII, 5.)

3.173
Basket capital from Saqqara. (J. E. Quibell, *Saqqara*, [1908–9, 1909–10], pl. XXXVI, 4.)

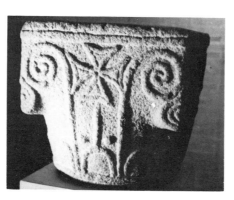

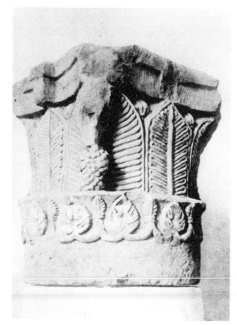

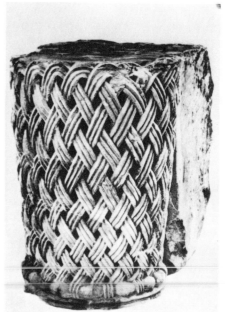

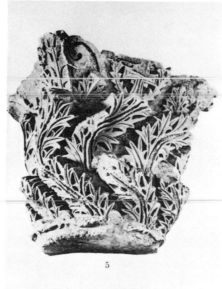

5

3.174
Figure capital with four protomes of rams above
a basket. (From Deir Mawas; Musées Royaux,
E 8041; A.D. V–VI.)

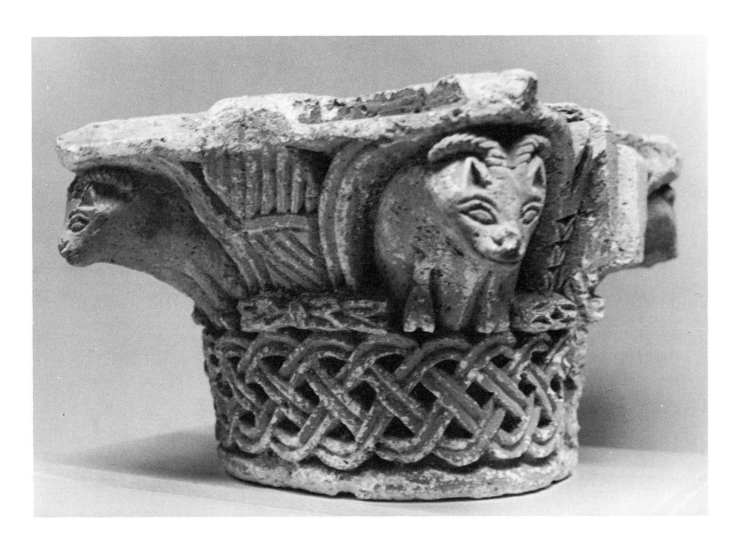

3.175
Elegant basket capital from Bawit. (Louvre; A.D. VI.)

3.176
Capital with vine interlace and convex profile from Saqqara. (J. E. Quibell, *Saqqara*, [1907–1908], pl. XVI, 2.)

3.177
Capital with convex profile, ribbed, and geometrized foliage. (J. E. Quibell, *Saqqara*, [1907–1908], pl. XXV.)

3.178
Capital with orderly array of vine leaves and interlace. (J. E. Quibell, *Saqqara*, (1907–1908], pl. XVIII.)

3.179
Capital with sparse thin foliage showing the ground behind it. (From Bawit; Louvre.)

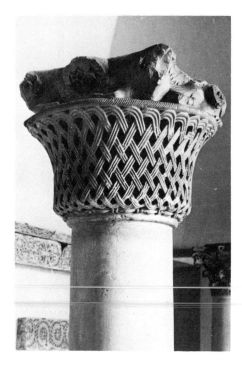

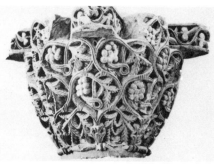

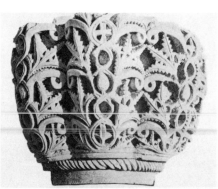

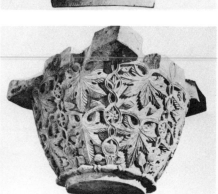

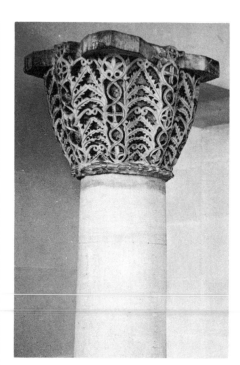

3.180
Capital with four staggered stages of acanthus leaves, a sophisticated beehive effect. (From Bawit, Chapel B; Louvre, X 5060; end A.D. VI.)
3.181
Capital emphasizing the interplay of light and shadow in a geometrical pattern. (J. E. Quibell, *Saqqara*, Vol. 3, pl. XXIX, 2.)

3.182
Composite Ionic capital of limestone from Dionysias in the Fayum, reused in the late Roman fortress. Note the Dionysiac head and the spirals recalling the angle volutes, replaced by grapes. A.D. I–II.
3.183
Figure capital. (Greco-Roman Museum, 3851.)

3.184
Voussoir carved with Dionysos leaning on a column and holding the thyrsus, against a vine. (Dumbarton Oaks, 40.60; A.D. V.)

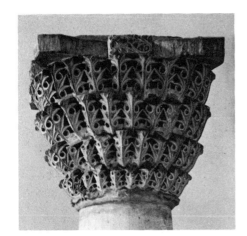

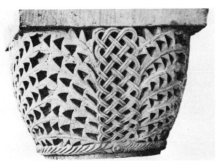

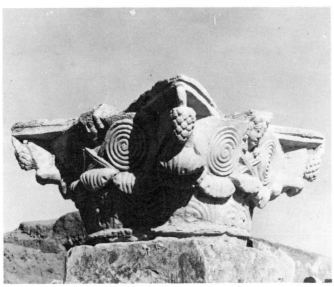

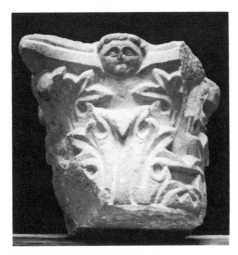

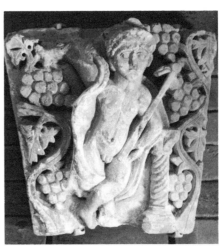

3.185
Broad capital of the acanthus type with two
flying angels holding a mask. (From Ahnas;
Coptic Museum, Cairo, C. M., 44069; J.
Strzygowski, *Koptische Kunst*, p. 75.)

3.186
Limestone capital with four protomes of lions
flanking central baskets above an elaborate
foliate interlace. (From Cairo; Staatliche Museen
6159; A.D. V.)

3.187
Small limestone capital of the vine type with two
heads of lions.(Dumbarton Oaks, 35.5; A.D. VI.)

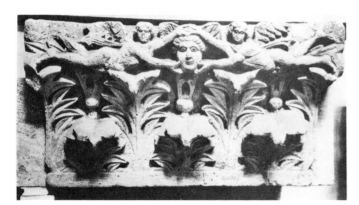

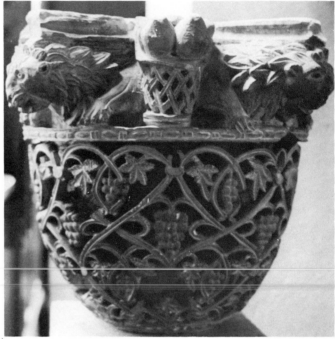

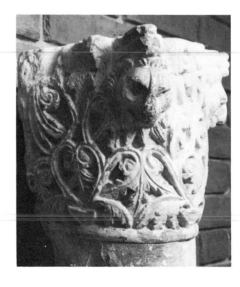

3.188
Composite capital of the acanthus type with upper zone representing the four protomes of rams flanking central heraldic eagles. (Coptic Museum, Cairo, 4682; A.D. VII.)

3.189
Large capital of pilaster with faces issuing from the leafage. (Greco-Roman Museum, 17014.)

3.190
Small capital with sketchy face between the angle leaves. (Aswan Muesum, A.D. VII.)

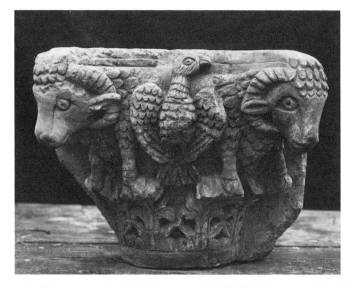

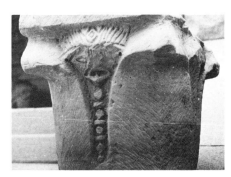

for the large marble twin capitals of pilasters with foliated masks at the corners flanking a composition of birds and acanthus is based on the treatment using the drill[220] (Fig. 3.189; Greco-Roman Museum, 17014). The trend toward combining a mask with the capital scheme was a strong one; it appears in a grotesque geometrized interpretation between the two smooth angle leaves of a capital at Aswan (Fig. 3.190; Aswan Museum, A.D. VII), and as a human face with radiating leaves above a debased foliate capital (Coptic Museum, Cairo, 4317; A.D. IX).

220. J. Ward Perkins, "Shrine of St. Menas," p. 65, n. 147. E. von Merklin, *Figuralkapitellen,* no. 365, dates it in A.D. VI. F. W. Deichman, "Zu einigen spätantiken Figuralkapitellen," *Δελτ.* (1964), pp. 71–81.

Stelae

Whoever reads these lines. pray on her behalf.

T. Mina, *Inscriptions,* p. 40

The majority of the Coptic limestone stelae were erected in the vicinity of the grave and were carved with a biographic epigram and a demand for prayer and remembrance, reminiscent of Greece and Egypt.[221] There is no doubt that some stelae are commemorative of a saint—Menas, Shenute, Pachomius—perhaps presented as ex-voto or carved with symbolic ornament. The great majority of them represent an architectural façade of various types interpreted as that of chapels,[222] usually abstracted into the entrance doorway, in much the same way as were the false-door and funerary stelae in ancient Egypt. The concept behind both the Egyptian stelae and the Coptic chapels is very similar indeed: to afford a means of communication between the deceased and this world. While such an ideology would at first seem to borrow too heavily from the ancient Egyptian dogma of hope that the deceased be allowed to partake of the funerary offering and ritual through the false door, it is corroborated by several factors: the demand for prayer from the passer-by, again very similar to that of ancient Egypt; the consistent appearance of the deceased

221. Alexandre Badawy, "L'idéologie et le formulaire païens dans les épitaphes coptes," *BSAC,* Vol. 10 (Cairo: 1946), pp. 1–26.
222. Alexandre Badawy," La Stèle funéraire Copte à motif architectural," (Hereafter cited as "La Stèle funéraire Copte.") *BSAC,* Vol. 11 (Cairo: 1947), pp. 1–25.

as *orans* on the stela; and the fact that some stelae are shaped like an altar slab, deriving from the ancient Egyptian offering table, which resembles the hieroglyph *hetep* ⚍ ,"offering." Let us remember in this instance that the early Christian of the Roman catacombs did practice an offering ritual whereby the actual offering was meant to reach the remains of the deceased through an aperture in the funerary casket. Moreover it is noteworthy that the Coptic stelae surpass both in number and excellence whatever was produced elsewhere in the entire Christian world. Reference has often been made by archaeologists to the models of houses or of offerings placed on Coptic and Islamic graves, a persistence not particular to Egypt if we regard the custom just described for St. Sebastian Catacomb and others, as pertaining to this ideology that tends to let an offering reach the deceased. The recurrence of similar motifs on stelae from the same locality proves the existence of local types, if not styles, a situation also found in other fields of sculpture. Though these idiosyncrasies have their own importance, it is perhaps more relevant to classify the stelae[223] according to the general significance of their

223. W. E. Crum, *Coptic Monuments, Catalogue général des Antiquités égyptiennes du Musée du Caire,* (Caire: 1902). (Hereafter cited as *Coptic Monuments.*) H. R. Hall, *Coptic and Greek Texts of the Christian Period in the British Museum* (London: 1905). O. Wulff, "Altchristliche." D. Zuntz, "Koptische Grabstelen. Ihre geistliche und örtliche Einordnung," in *Mitteilungen der Deutschen Instituts Kairo,* Vol. 2 (Cairo: 1931), pp. 22–38. M. Cramer, *Archäologische und epigraphische Klassifikation koptischer Denkmäler des Metropolitan Museum of Art, New York, und des Museum of Fine Arts, Boston, Mass.* (Wiesbaden: 1957). (Hereafter cited as *Klassifikation.*)

design rather than according to topographical distribution. Such a classification would include stelae with architectural motif, round-topped with architectural motif and eagle, elaborate flat patterns, wreathed cross, composite, cippus, altar slabs, and rectangular panels.

The stela with architectural motif has been analyzed earlier in this work and its invaluable contribution to the study of architectural design duly appraised (see Chapter 2, Fig. 2.67). Let us, however, examine its intrinsic aesthetic value as to composition and style. The central element of the architectural façade is a doorway, easily recognizable in most instances, which imitates the doorway of a chapel like the funerary chapels at Bagawat. The whole composition is reminiscent of the Hellenistic *naiskos* that served as prototype to late-antique and Coptic *naoi* and to the carved ivories of consular diptychs. In some stelae the doorway forms a niche for a lamp (Fig. 3.191; Musée Guimet, Lyon; A.D. VI). It is surmounted by a shell within an archivolt which is decorated with a continuous scroll and set on two pilasters with palmettes capital; the larger columns, partially torsaded, carry the broken pediment topping the façade of the chapel. The relief is flat and the design regular. A few examples show a more sophisticated composition within a rectangular frame topped by dentils. A shell on two columns forms what can probably be interpreted as the entrance to a *paradisos*;[224] two vines sprouting

from two amphorae on stands on either side of the doorway flank a *crux ansata* containing a Greek cross in its loop (Fig. 3.192; from Fayum, Staatliche Museen, 4721; A.D. VI–VII). The smooth curves and carving are more strongly reminiscent of late-antique sculpture than is the former type. A similar stela features in the intertwine of the two vines a female bust flanked by two eagles on the globe (C.M., 8624; A.D. VI–VII).[225]

The most numerous and impressive stelae typical for the Fayum show a figure as a standing *orans*, and once a woman holding a child on her left arm and making the praying gesture with her right.[226] Now the *orant* standing figure, a direct descendant from the Romano-Egyptian one as exemplified at Terenuthis (Fig. 3.193; Kelsey Museum of Archaeology, Ann Arbor, Acc. No. 21055), symbolizes in a Christian funerary context the soul of the blessed.[227] When represented in murals without a funerary context it may have some narrative significance like the three figures with well-modeled features in a Coptic style, one of whom stands on a rock, another in the sea, and the third in a boat (Fig. 3.194; from Meydum; Staatliche Museen, 9625; A.D. VI), or the woman Gerosa in a *contrapposto* stance (Fig. 3.195; Museo Egizio, Suppl. 1335). In general the *orans* in Christian iconography represents a Biblical personage, or the

Church, or a saint.[228] Strong analogies are found between the architectural composition of the last piece and that of an anepigraphic stela representing in the bay of the façade a spirited gazelle beneath a hanging lamp of a remarkably well-modeled carving (Fig. 3.196; Musée Guimet, Lyon).

On the stelae the *orans* stands beneath a pediment, a gabled or arched entrance on two columns of the Egypto-Corinthian type with angle scrolls instead of acroteria, often topped by two confronting birds. A shell appears just above the head of the figure. The motif is obviously identical to that of the niches. The style of the carving varies from a soft high relief as for Theodora (Fig. 3.197; from Fayum, Staatliche Museen, 4723, A.D. VI–VIII; compare C. M., 8687, 8685) to a stiffer frontal attitude and carving in which the head of Rhodia is wrapped within the loop of her scarf in a clear attempt to make it appear within the loop of a *crux ansata*, the symbol of eternal life (Fig. 3.198; from Bultya; Staatliche Museen, 9666; A.D. VI), actually carved in the pediment above flanked by α and ω and enclosing a *crux florida*. The bold relief is not a criterion of stylistic excellence, for both the architectural frame and the figure itself can be in slight low relief, though the well-modeled face and the elegant *contrapposto* stance and drapery denote a strong affinity with late-antique tradition (cf. Stela at the Hermitage,

224. E. Drioton, "Portes de l'Hadès et portes du Paradis," *BSAC*, Vol. 9 (Cairo: 1943), pp. 59–78.

225. W. E. Crum, *Coptic Monuments*, pl. XXXVIII.
226. Ibid., No 8702.
227. C. M. Kaufmann, *Handbuch*, p 267.

228. T. Klauser, "Entstehungsgesch. der Christlichen Kunst," II, pp. 115–145. H. Leclercq, "Orant," in *Dictionnaire d'Archéologie Chrétienne et de Liturgie*, Vol. 12, tome 2, col 2297, Fig. 9077.

3.191
Stela with architectural motif and small niche for lamp. (Musée Guimet, Lyon; A.D. VI.)
3.192
Stela with elaborate decoration consisting of an architectural frame enclosing a *crux ansata* and two vines growing from vessels. (From Fayum; Staatliche Museen 4721; A.D. VI–VII.)

3.193
Stela with *orans* standing in an aedicula between the jackal of Anubis and the hawk of Horus. (From Terenuthis; Kelsey Museum of Archaeology, Ann Arbor, Acc. No. 21055.)
3.194
Fragment with three figures from Meydum. (Staatliche Museen, 9625; A.D. VI.)

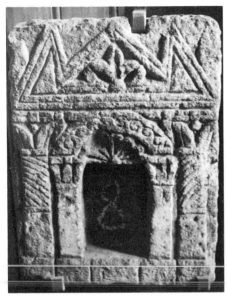

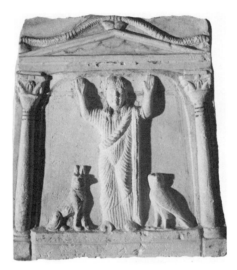

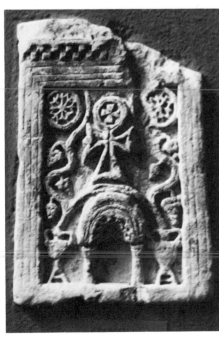

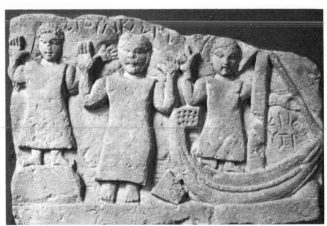

3.195
Stela of the woman Gerosa representing as *orans*. (Museo Egizio, Suppl. 1335.)

3.196
Stela with architectural face showing in its bay a gazelle and a hanging lamp. (Musée Guimet, Lyon.)

3.197
Stela of Theodora as *orans* in an aedicula surmounted by two doves. Note the remarkable soft style of the carving technique. (From Fayum; Staatliche Museen, 4723; A.D. VI-VII.)

3.198
Stela of Rodia from Bultya. The deceased woman stands as *orans* under a pediment and her head shawl curves around in the shape of the loop of the *crux ansata*. (Staatliche Museen, 9666: A.D. VI.)

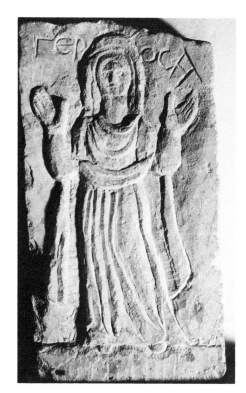

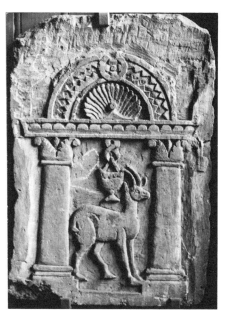

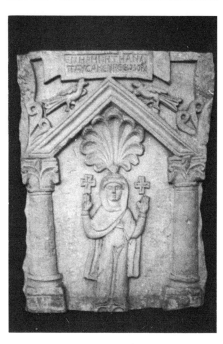

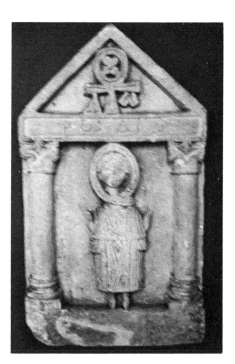

Leningrad). Usually, however, lesser architectural motifs correspond to a debased style in the figure, even when the main *orans* is accompanied by two servants (Fig. 3.199; Staatliche Museen, 9624; A.D. VI?). Yet there is always an attempt to endow the features with some individuality (Fig. 3.200; Museo Egizio, Suppl. 1333; compare Staatliche Museen 10786, A.D. VI–VII). An epitaph is exceptional (National Museum, Florence, 7644), and it is often difficult to determine the funerary purpose from the name alone, especially when a hunter appears on horseback accompanied by two gazelles (Coptic Museum, Cairo, No. C. M., 8682). The case is easily settled in the unique anepigraphic stela representing a head on a pedestal within the aperture of the façade (Fig. 3.201; from Luxor; Staatliche Museen; A.D. VI–VII), a curious survival across the centuries of the similar motif in some Egyptian false-doors of the Old Kingdom.[229]

Unless the actual funerary stelae of Apa Pachom and an anonymous presbyter have reached us through improbable luck, it is safer to interpret the two stelae as commemorative for the founders of monasticism. Commemorative marble stelae of St. Menas represent him in the same iconographic composition publicized so widely by the innumerable terra-cotta ampulae sold to pilgrims in the Maryut, an *orans* standing frontally between two kneeling camels. There is more life to the tall

bearded figure named Shenute, clad in a heavy robe with vertical folds and holding a long staff, though the sketchy relief hardly conveys any detail (Fig. 3.202; from Sohag, Staatliche Museen I. 4475; A.D. VII). Yet in its coarse provincial simplicity it is much more impressive than Apa Pachomius' *orans* richly dressed in church vestments and completely symmetrical within a frame of vine (Fig. 3.203; from Apa Jeremias' monastery; B. M., 1533; A.D. VII; compare, also from Saqqara Apa Dorotheus; B. M., 1523; A.D. VIII). An anonymous presbyter in a simple frame of quatrefoils and Greek key is certainly the best articulated with extremely delicate rendering of features and hands (Dumbarton Oaks, 35.11; A.D. VI).

Another type of stela from the Fayum shows the Maltese cross within an architectural frame, usually an arched structure with a shell on Egypto-Corinthian columns surmounted by an archivolt with imbricated rings; beneath the shell is the cross flanked by two censers above an epitaph asking the Lord God Pantokrator to have pity on the soul of Hanna (Fig. 3.204; Institut d'Egyptologie de l'Université, Strasbourg, Inv. No. 1687; A.D. VIII; compare Staatliche Museen, 4728; A.D. VI–VII). A similar well-designed architectural façade in flat relief indicating the vertical axes of the columns topped with two birds and foliate ornament encloses a *tabula ansata* set vertically and dedicated to Viktor (Fig. 3.204a; from Coptos, Musée Guimet,

Lyon; compare Museo Egizio, Torino, Suppl. 1338). Only a slight architectural frame topped by a triangular pediment sometimes occurs in one of the types of Armant stelae, enclosing a wreathed cross above an eagle (Fig. 3.205; B. M., 1619; compare C. M., 8636),[230] or a triumphal *crux immissa* (Museo Egizio, Suppl. 1137; compare Metropolitan Museum of Art, 08.246, 18.5.5),[231] or a monogram with open *rho* flanked by α and ω and two *crux ansata* as in the stela of Abraham the perfect monk (B. M., 1257; compare B. M. 1352,1764).[232] One stela from Armant (Fig. 3.206; National Museum, Florence 8498)[233] deserves special mention because of the excellent carving of its architectural frame as a fancy-shaped modified Corinthian with basal leaves and an elegant vine rinceau in lieu of the upper half of its entablature. Sometimes several of these motifs combine as in the stela of Pleinos the reader, where a wreathed monogram is flanked by ω and α [*sic*] above a *tabula ansata* and a cross flanked by two *crux ansata* (Fig. 3.207; B. M., 679; A.D. V–VII). In another stela a foliate *crux ansata* in an aedicula is separated by two running hares from a lower square panel containing a wreathed eagle (Victoria and Albert Museum, N. 220–1894; A.D. VII–VIII). In the group at Armant an epitaph starting with $\epsilon\iota\varsigma\ \theta\epsilon o\varsigma\ o\ Bo\epsilon\theta\omega\nu$ ("One is God, the Helper"), attested also at Assiut, Esna, and Coptos, is usually inscribed just beneath the pediment or on a *tabula ansata*.

229. Alexandre Badawy, "La Stèle funéraire Copte," Fig. 10, pp. 13–14. Cf. J. Capart, *L'art égyptien*. Vol. 1, *L'Architecture* (Brussels: 1922), pl. 54.

230. W. E. Crum, *Coptic Monuments*, pls. XLI ff.
231. Ibid., pls. VIII ff.
232. Ibid., pls. XXVI ff.
233. A. Pellegrini, "Stele funerarie copte del museo archeologico di Firenze," *Bessarione*, Vol. 22 (1907). fasc. 97–99, n. 11, pp. 22–24.

Typical for Esna[234] is the small round-topped stela carved to represent an arched (B. M., 680) or triangular pediment on two columns enclosing an eagle with pendent wings wearing a bulla and standing under or beside a cross as in Theutora's stela (Fig. 3.208; B. M., 669); this type of stela may also feature a combination of both pediments (B.M., 54353). The eagle stands also with upstretched wings, a cross on its head, in front of an alter between two modified Corinthian columns, probably forming the lower part of an architectural façade (Fig. 3.209; B. M., 606). The architectural motif sometimes surmounts the eagle within a debased foliate border (Allard Pierson Stichting, 779; compare M.F.A., 04.1845, 04.1847), or is reduced to one column upon which stands the eagle (B. M., 667). Antithetic birds often appear on the pediment and in a lower panel as in Theutora's. Whether the symmetrical duplication of birds and beasts with foliate tails within the horseshoe facade of the stela of Jacob (Fig. 3.210; B. M., 1801; A.D. VII–VIII) is indicative of a provenance from Esna or Thebes is debatable. Antithetic birds flanking a tree of life of orientalizing style appear also on a stela from Ravenna (Museo Nazionale, Ravenna, N. 438).

Somewhat similar is the Theban stela, though taller and filled with a flat relief of richer design,[235] but still marked by a hovering eagle holding a wreath above a pedimented aedicula enclosing a crux ansata (Fig. 3.211; from Luxor, Staatliche Museen, 4482; A.D. VII–VIII; compare M. M. A., 11.80.73). Rich ornamental foliate and other patterns in flat relief prevail in the composition of the stelae at Edfu[236] (Fig. 3.212; B. M., 1520; A.D. V–VIII; compare Allard Pierson Stichting, 7797). The motif of the wreathed cross already encountered in an architectural setting (stelae from Armant) occurs also alone as a radiating cross on the round-topped stela of Moses (Allard Pierson Stichting; compare from Esna and Coptos: M. F. A., 04.1846, 04.1848; M. M. A., 10.176.31, 10.176.25, 10.176.27); it appears on a rectangular stela as a Maltese cross with foliate elements radiating in the angles (Fig. 3.213; from Balaizah; Musées Royaux, E. 5871), or as a crux ansata containing either a quatrefoil in its loop (Fig. 3.214; from Badari, B. M., 1812; A.D. V–VI) or a mask—an exceptional composition that should be interpreted as symbolizing the "deceased in eternal life" (from Akhmim; M. M. A., Acc. No. 10.176.29; A.D. V–VI). Exceptional also is the composite stela where the frontal bust of Gaia wearing a foliate diadem and holding the mappula appears between two tall crosses in bold relief above an aedicula enclosing an eagle that wears a bulla and presents the crux ansata with its beak (Fig. 3.215; B. M., 1522).

A smaller category of stelae consist of cippi profiling a crux immissa on a stand vaguely outlining a bust (Fig. 3.216; Glyptothek Ny Carlsberg, A. E. I.N. 1544). This profiling may assume various shapes, as in a cross in openwork (Fig. 3.217; B. M., 1757), or in the marble altar slabs reused in the postconquest period as funerary tombstones (C. M., 8756) inscribed with a long text in Coptic or Arabic (C. M., 8706, dated A.D. 786; Greco-Roman Museum, 110, dated A.D. 796; Islamic Museum, Cairo, 3710, 13514) or with two orant figures (C. M., Journal d'entrée, 35184). They were also used as tablets above a public suction fountain outside the Roman fortress Qasr el Sham' at Babylon inscribed in Coptic and Arabic with the propitiatory text: "In the name of God, the Compassionate. Anyone who will drink from the water, that I will give him will never thirst" (John: 4, 13–14).

There are numerous simple rectangular slabs bearing an epitaph in Greek or Coptic within a frame of beads, Greek key, or scroll with rosettes and often ornamented with one or two wreathed crosses (Fig. 3.218; Louvre, X 5049); similar slabs may have no frame but present an invocation on behalf of the deceased.[237]

237. M. Cramer, Klassifikation, pp. 18–35. Nos. 33–59.

234. W. E. Crum, Coptic Monuments, Nos. 8512, 8544, 8662, 8665, 8667.
235. Ibid., Nos. 8605, 8625, 8666.
236. Ibid., Nos. 8628 ff, pl. XXXIX.

3.199
Stela of an *orans* accompanied by two retainers on an architectural background. (Staatliche Museen 9624; A.D. VI.)

3.200
Simple stela representing an *orans* between two columns. (Museo Egizio, Suppl. 1333.)

3.201
Stela with modified architectural frame enclosing a head on a pedestal—a treatment reminiscent of some Egyptian stelae from the Old Kingdom. (From Luxor; Staatliche Museen, 4491; A.D. VI-VII.)

3.202
Stela of Apa Shenute from Sohag, representing a tall bearded figure of monk within an elegant architectural façade. (Staatliche Museen, I, 4475; A.D. VII.)

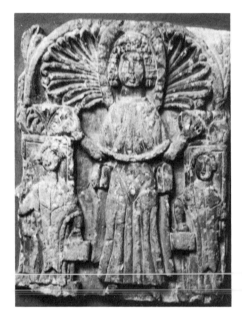

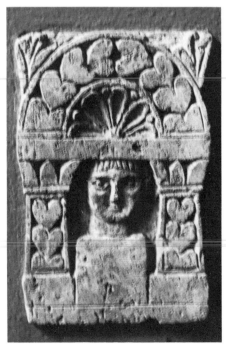

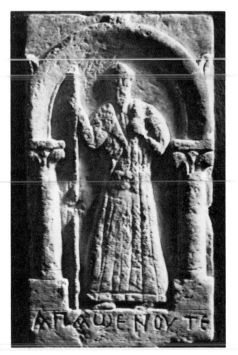

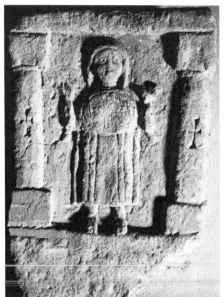

3.203
Stela of Apa Pakhom as *orans* within a flat
frame of vine ornament, (From Apa Jeremias'
monastery at Saqqara; B. M., 1533; A.D. VII.)

3.204
Stela representing the cross from which hang
two lamps within an architectural façade. The
text is an epitaph for Hanna. (Institut d'Egyp-
tologie de l'Université, Strasbourg, 1687; A.D.
VIII.)

3.205
Upper half of a stela from Armant. The main
element is the eagle crowned with a *crux
immissa,* carved in a flat technique. (B. M.,
1619.)

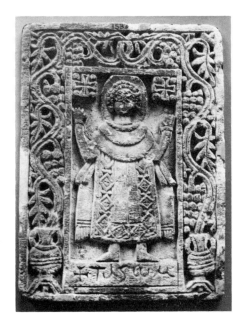

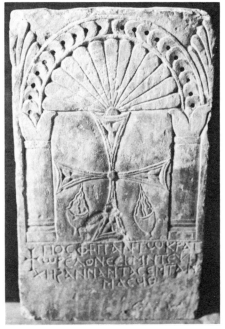

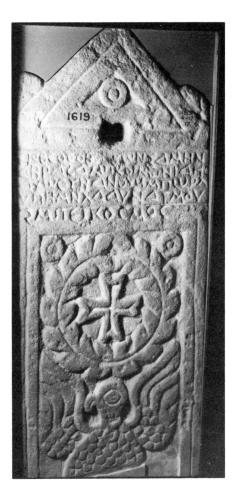

3.206
Stela from Armant with outstanding architectural frame enclosing the monogram. (National Museum, Florence, 8498.)
3.207
Stela of Pleinos the reader showing symbols of Christianity within a slight frame having only two small pilasters. (B. M., 679; A.D. V-VII.)

3.208
Stela of Theutora showing the typical composition common at Esna: the eagle wearing a huge bulla stands in the bay of an architectural façade above two birds and beneath two others. (B. M., 669.)
3.209
Lower half of a stela with the eagle between the two columns of the aedicula. The background was painted yellow and the elements of the architecture outlined in black, (B. M., 606.).

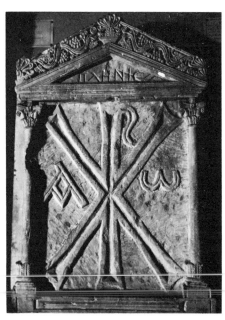

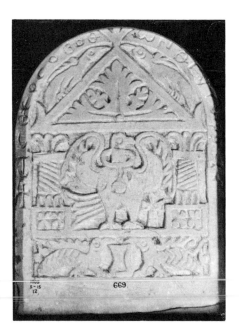

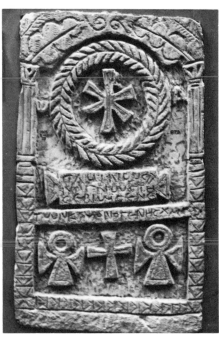

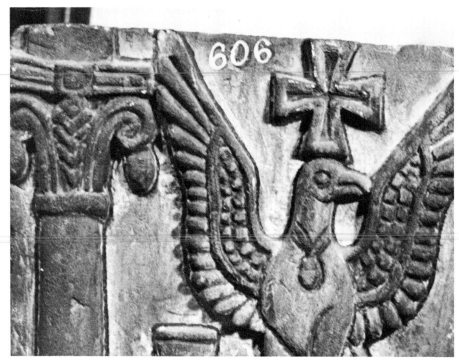

3.210
Stela of Jakob representing two beasts with foliate tails confronted within an aedicula surmounted by a horseshoe archivolt. (B. M., 1801; A.D. VII-VIII.)

3.211
Typical stela from Luxor: elaborate ornamental frame enclosing an architectural façade surmounted by an eagle. The carving is flat and mechanical. (Staatliche Museen, 4482; A.D. VII-VIII.)

3.212
Stela from Edfu with rich foliate ornament surrounding a large cross.(B. M., 1520; A.D. V-VIII.)

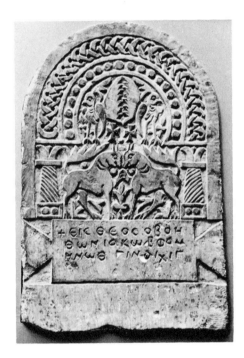

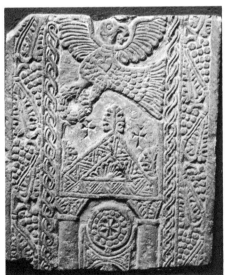

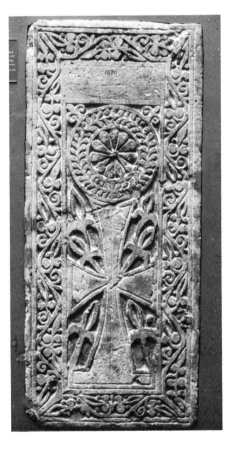

3.213
Small stela from Balayza decorated with a *crux immissa* and four rosettes at the angles. (Musées Royaux, E 5871.)

3.214
Small memorial stone carved with a looped cross within a wreath, still preserving some painting. (From Badari; B. M., 1812; A.D. V-VI.)

3.215
Composite stela showing the eagle within an architectural façade, surmounted by the personification of Gaia holding the *mappula* and rising between two tall crosses. (B. M., 1522.)

3.216
Stela profiled as a *crux immissa* and perhaps a human being. (Glyptothek Ny Carlsberg, A. E. I. N. 1544.)

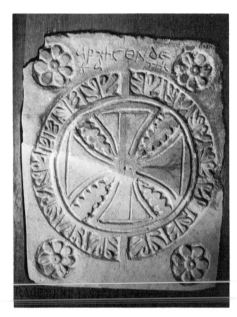

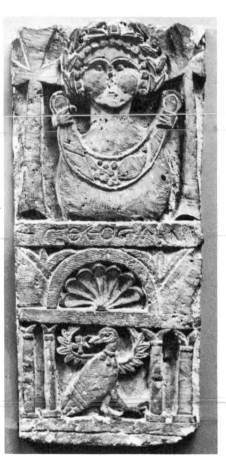

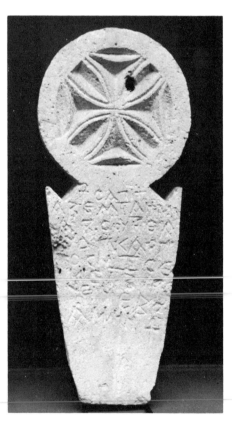

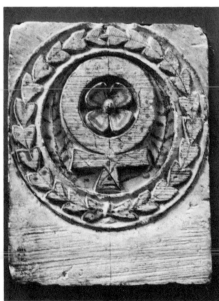

3.217
Stela profiled in openwok as a Coptic cross.
(B. M., 1757.)

3.218
Stela with a long inscription framing a small
crux immissa. (Louvre, X 5049.)

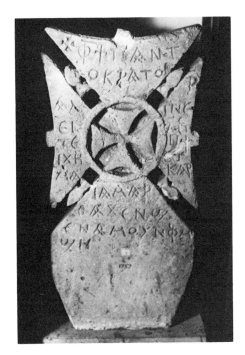

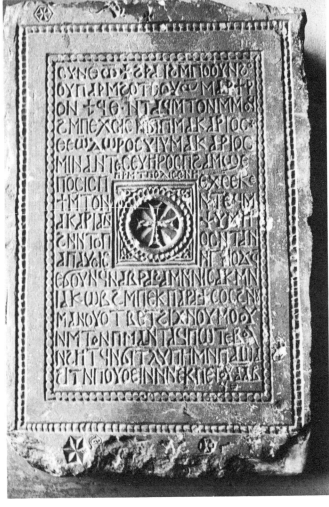

Early Christian sculpture in Egypt derived its themes, as did architecture, from the Hellenistic repertoire. The majority of the Egyptians of the proto-Coptic period were still pagan and they often sought a deep philosophical interpretation of Greco-Roman mythology.[238] There appear scenes from the cycles of Dionysos and the Bacchants, Aphrodite with Nereids and Tritons, the personification of the Nile and Erotes, the Parthian rider, the *imago clipeata* upheld by two victories, the personifications of the seasons, and bucolic scenes.

Some episodic scenes such as Leda and the Swan (see Fig. 3.61), Daphne in her tree (see Figs. 3.52, 3.53, 3.65), and Orpheus playing his lyre (see Fig. 3.58) appear mostly in the sculpture at Ahnas. There is variety in the themes of one cycle: Aphrodite coming forth from her shell (see Fig. 3.68), or Aphrodite at her toilet; Dionysos with Ariadne riding his chariot, Dionysos leaning on a pillar (see Fig. 3.184), Dionysos in a vine arbor (see Fig. 3.59). Very often only the secondary acolytes such as Nereids, Erotes, dancers, shepherds, or the element of the shell are represented. The subject is still recognizable as a symbol of resurrection often through a syncretism of Osiris—Dionysos, Isis—Aphrodite, or Ha'py—Neilos.

It is perhaps the Alexandrian trend toward religious esoterism that led the Christian Copts to adopt pagan themes

and interpret them in a new context. While none of the Gnostic concepts and *intaglia* that flourished in the fourth century seems to have influenced Coptic art, new interpretations evolve from the repertoire acquired from the pagans. The most familiar is the Virgo Lactans (see Fig. 3.74), obviously derived from the Isis Lactans which enjoyed such a broad diffusion throughout the Greco-Roman world. As important is the *orans* which appears on Egyptian stelae nearly in Egyptian projection at Terenuthis (see Fig. 3.26) and is soon appropriated by the Christian Copts for their representations of the Virgin, saints, and monks. The standing soldier holding his spear (see Fig. 3.22) after the attitude of Jupiter or the Emperor forms a prototype to Christ and saint (see Fig. 3.76). Horus riding a horse and spearing a crocodile (see Fig. 3.71) or the Dioscuri (see Fig. 3.72) become the typical rider saint (see Fig. 3.151).[239] The *imago clipeata* carried by two winged victories serves as a model for the *crux immissa* upheld by two Erotes (see Fig. 3.97) or two angels (see Fig. 3.96). The very common representation of St. Mena as an *orans* standing between two camels on thousands of ampulae, stelae, and other monuments found throughout the early Christian world echoes the pagan theme of the *orans* flanked by two Anubis jackals on funerary stelae (see Fig. 3.25). The cross now marks several of the scenes.

Christian themes of the early period are carved in wood (lintel, door), and represent two narrative scenes from the Christological cycle: the Entry into Jerusalem and the Ascension (lintel of El Mu'allaqa church; see Fig. 3.31); Christ in the *mandorla*, the Virgin among the Apostles, the bust of Christ in a clipeus carried by two angels flanked by two figures (door of Sitt Barbara; see Figs. 3.33–3.35). These compositions are stylistically related to Alexandrian sculptures, for they represent Christian themes in a Hellenistic idiom.

The creative ability of this early sculpture is restricted to adapting Hellenistic themes or using their elements for Christian themes. Yet the style, still dependent upon the Alexandrian one at the start, with nearly symmetrical composition (two Nereids and cross; see Fig. 3.55) or balance (El Mo-'allaqa, Sitt Barbara), alert attitudes, and flowing curves, soon shows deformed proportions in the figures. The heads become too large, the faces triangular with wide staring eyes, the torsos elongated into cylindrical shapes over broad haunches and short legs. Modeling evolves from a soft technique (Oxyrhynchos, Ahnas, Antinoë) related to the Hellenistic one to a harsher sharp contouring (Ahnas, mid fifth century A.D.) foreshadowing monastic carving. The fact that wood carving retains affinities with the Alexandrian style longer than does stone sculpture is explained by the different nature of the material. Originality in iconographical moments is exemplifed by the unique representation of the paralytic rising to carry his bed (see Fig. 3.69).

238. P. Du Bourguet, *Die Kopten*, pp. 83–96. Alexandre Badawy, "L'Art Copte. Les Influences hellénistiques et romaines," pp. 57–72.

239. J. Strzygowski, *Der Reiter des Hellenistischen und Koptischen Kunst* pp. 21–33.

Stone sculpture enlarges themes borrowed from terra cottas or ivories into a hard material, with a new visual concept of volume, repartition of light and shade, allied to a tactile concept of folds. Sculptured architectural ornament derives all its forms from the Greco-Roman repertoire. The evolution of the Corinthian capital—a variant of the Vitruvian—follows the same lines as in other countries toward the Theodosian type (A.D. V). The acanthus foliage stiffens into a metallic shape. Niches, conches, pediments, columns, and pilasters as well as their rinceaus, often of the peopled variety, bands, and panels of modillions derive from the Hellenistic repertoire (Riegel, Duthuit, Grüneisen) rather from Syrian, Mesopotamian, or Iranian prototypes (Strzygowski).

The hard style of Ahnas forms in the fifth century the transition to Coptic sculpture proper, that of the monasteries (A.D. VI), and of the *bourgeoisie*. As might be expected the pagan themes decrease and are now represented only by the secondary acolytes or attributes[240] such as Nereids on dolphins (see Fig. 3.95), victories, hunters, Pan and Bacchantes, the personification of Gaia, and the allegory of Abundance within a clipeus upheld by two winged Erotes (Bawit, A.D. VI; see Fig. 3.103).

Christian themes flourish into a varied repertoire drawing on the Christological cycle mostly in isolated scenes such as the Madonna and Child, the Virgin and saints, miracles (see Fig. 3.79), and the Annunciation (see Fig. 3.85). Standing figures of angels and saints appear at the top of pilasters (Bawit; see Fig. 3.102), or on the underside of wooden consoles or *mensolae* (Bawit; see Fig. 3.84), or within the bays of an arcade (Saqqara; see Fig. 3.118). The cross forms the main element of symbolic composition, as *crux immissa* upheld by Erotes or flanked by two horsemen (see Fig. 3.149), or borne by two stags, or raised on a column in a niche (see Fig. 3.148). The *crux ansata*, exclusively Coptic, appears mostly on funerary stelae (see Fig. 3.192). Episodes from the Old Testament such as Moses receiving the Law and Daniel flanked by the two lions (pyx; see Fig. 3.77, 3.78); *mensola*, see Fig. 3.83) and narrative cycles such as that of David (Bawit) are treated.

The *orans* forms the favorite element of funerary stelae with architectural motifs (see Fig. 3.203), often in a combination with the looped cross (see Fig. 3.198) or doves (see Fig. 3.197).

That pagan themes find their way inside monasteries is proved by the sculpture of nude Erotes raising a *crux immissa* or the painting of a winged nude Eros riding a griffin (Bawit), running between the busts of personifications of virtues (Bawit), or hunting the hippopotamuses (Bawit).

The style evolves[241] from the tactile concept to the visual one, as in other countries of the eastern Mediterranean. Sharp-edged volumes replace the soft modeling of the classical type through a transitional stage showing apparent touches. Relief flattens in a strongly undercut outline contrasting lighted areas bearing polychromy with deep shadows. Even narrative themes crystallize in emblematic brevity with hardly any background. Figures are cylindrical; faces are conventionally triangular with globular eyes staring between stylized eyelids. Some figures from pilasters at Bawit form a special category still affiliated both in subject and in technique to Hellenistic models.

Sculptured architectural ornament in the monastic production reaches an astounding variety using crowded stiffer Hellenistic elements. Grapes disappear from the vine interlace; a finely indented slender acanthus or palmette is arranged in an interlace; the central fruit of the spiraling stem in a rinceau is replaced by a *crux immissa* or a quatrefoil, which in turn disappears.

The type of the Roman Corinthian capital develops in a rich variety at Bawit, probably because of the vicinity of several Roman metropolises. At Saqqara, however, with lesser Roman models at Memphis, the capitals depart from the Vitruvian Corinthian and show affinities with the Corinthian of the Tholos of Epidauros and the Tower of Andronikes,[242] already known to and imitated by the architect of the western colonnade at Philae. The acanthus stiffens into a thorny leaf with staged

240. Du Bourguet, *Die Kopten*, pp. 115–127.

241. Alexandre Badawy, "L'Art Copte. Les Influences hellénistiques et romaines," pp. 72–78.

242. E. Drioton, *Nilomètre*, pp. 116–119. "De Philae à Baouît," in *Coptic Studies in Honor of Walter Ewing Crum* (Boston: 1950), pp. 443–448.

lobes or fingerleaf. In capitals of pilasters the uppermost acanthus row is sometimes replaced by figure sculpture (see Figs. 3.185–3.189). Broad pilasters are crowned with broad capitals (see Fig. 3.167) or are articulated as twin pilasters with twin capitals (see Fig. 3.166). Foliate capitals borrow their design from Roman sculpture bands (see Fig. 3.176), often windblown (see Fig. 3.172) and marked with a cross (Saqqara). The basket capital shows a thematic variety and technical ability unsurpassed by Byzantine sculpture.

The shaft of the column in monastic architecture is always carved with two superimposed zones of different patterns (checker, zigzag, foliate, scale) sometimes with a central panel representing a scene (see Fig. 3.168). The sides of the pilasters are ornamented with a vertical foliate or checker band (see Figs. 3.164, 3.165).

Though less easily inserted in its original context, the sculpture commissioned by the laity is mainly known from an abundant crop of funerary stelae, water-jug stands (see Fig. 3.142), and consoles for curtains in front of niches (see Fig. 3.131, 3.132). Suffice it to say that the Coptic stelae, by far the largest body of such monuments, show rich versatility and remarkable aesthetic sense allied to symbolic abstraction.

Paganism ultimately died in the sixth century at Philae, but pagan motifs continued to be used in the sculpture of the Copts at least until the twelfth century,[243] admittedly allied to Christian symbols such as the nude dancing girl holding a *crux immissa* above her head (bronze, A.D. VIII; see Fig. 5.23). Pagan themes had disappeared, leaving only motifs such as dancers, Nereids, conches, and Erotes. In general themes are abstracted, a trend which allows greater freedom in the deformation of elements toward decoration.

The figure, tolerated in the mural decoration of Umayyad palaces, appears stiff though with a renewed elegance in an archivolt carved with a flat rinceau and angels in high relief at either bottom end and a fruit at the crown (see Fig. 3.106). Sculptured architectural ornament in the art of the Copts is further stylized. Vine without grapes covers the side of pillars with seven-lobed leaves within the superimposed ovals of twined stems. Pilaster capital and basket capitals reach an unprecedented crystallization of modified foliate elements (see Fig. 3.179). The ribs of conches stiffen into radiating ridges. In rinceaus the fruit hanging in the eye of a whorl within spiraling stems is replaced by a *crux immissa* or even disappears (see Fig. 3.112).

In the Tulunid Period (A.D. 868–905) influences from Samarra, the birthplace of Aḥmad ibn Tulūn, find their way in Islamic and Coptic arts. The stucco reliefs in Deir Suryan in Wadi Natrun with their geometrized palmettes and spotted texture are very similar to those in Samarra (Gawsaq el Khaqani, A.D. 830). Friezes from Bawit with a sequence of panels framed with laurel or beaded bands (see Fig. 3.110) are reminiscent of Samarra.

The stylization process is most evident in the vertical folds of dresses, simplified features, flattened relief, and straight contouring (see Fig. 3.153).

In the Fatimid Period (A.D. 967–1171) an elegant style that can be called Copto-Islamic, because of the similarity implied, represents living creatures with crowded foliate motifs on wooden screens and doors (see Fig. 3.89). A second trend shows an ultimate development of Coptic decoration.

Sculpture shows perhaps better than other art the reaction of the native spirit to the Greco-Roman intrusion and its ability to adapt the incoming forms and even to create new ones independently from Byzantine sculpture of an aesthetic quality often unsurpassed elsewhere.

Mainly architectural in scope, Coptic sculpture shows interesting stylistic divergences. From the proto-Coptic foliage of Oxyrhynchos and the mythological nudes of Ahnas with sensuous modeling of stylized forms, to the conventionalized foliate rinceau carved in the typical clear-cut two-layered technique at Bawit and Saqqara, to the abstract rhythmic interplay of light and shade in the crystalline shapes of the foliate or basket capitals at Bawit and

243. P. Du Bourguet, *Die Kopten*, pp. 161–181.

Saqqara there elapsed less than two hundred years, from the fifth to the seventh century.

To the Egyptian legacy the Coptic sculptor owes but little, but he does borrrow from it the frontal attitude he gives to most of his figures, especially those formally presented within the architectural setting of a funerary stela. It is mainly from the Hellenistic and Roman heritage that he derives the shapes of his earliest nudes and the grammar of foliate ornament. For ornament is indeed his primary pursuit and he subjects it to horror vacui and a strong stylization gradually increasing into geometrization. Under his chisel and his bow drill the foliate elements, sometimes peopled, soon lose contact with nature, assuming stiff metallic shapes arranged into a rhythmic design with an increasingly flatter two-layered carving. The balance between light and deep shade in the later sculpture of the sixth and seventh century achieves an abstract effect as impressive as that of the basket capitals of Ravenna and Constantinople, if not more so, an effect within the range of appreciation of the Arab conquerors. Already before the conquest the Arabesque had been invented with the Coptic band interlace, guilloche, and meander.

An art deprived of any directed eclecticism, an art of the people, Coptic sculpture derives its originality from the native spirit nearly impervious to alien influence except perhaps sporadically and then in secondary media like the ivories echoing Constantinople during the Heraklean rejuvenation (A.D. VII) or stuccoes reflecting Samarra during the Tulunid period (A.D. IX).

As is the case for graphic arts, the true Coptic spirit asserts itself in the sculptural achievement of the monastic schools that could express the eternal continuity of mystical life through the rhythm of their friezes, wind-blown foliage, or crystalline harmony of their capitals, indeed perfect "traps for light."

Four

Coptic Graphic Arts: Painting, Textiles, and Ceramics

Take heed lest ye strive to ornament the work of your hands overmuch.

Pachomius, A.D. 296–346

Like his Egyptian ancestors and his more immediate predecessors in the Greco-Roman period, the Copt lavished color on his architecture, sculpture, furniture, and personal attire. It is an unbroken tradition that could have found its incentive in the bright sunlight of the valley. Styles have evolved, however, and while certain traits of Coptic graphic arts can be traced back to earlier achievements, an unprecedented horror vacui now prevails, probably an expression of folk production. Of the various aspects of this production —murals, illumination, painted ceramics, and textiles—the latter group is undoubtedly the best represented, having been buried in graves thus escaping the wanton destruction that followed the Arab conquest.

The great majority of Coptic structures were of mud brick plastered and whitewashed. A white wall seems to require graphic treatment, and except for essentially functional architecture in densely built towns (Djimē) Coptic walls are decorated at least partially with murals of religious character. Here an Egyptian tradition might be responsible: however, whereas Egyptian murals illustrated the rites performed in the various rooms of the temple or the destiny of the deceased in the tomb, Coptic ones seldom represent any of the rites of Christian liturgy, except in the earliest period when the Eucharist is the subject of one of the scenes in the Alexandrian catacomb at Karmuz. Nearly the whole of Coptic painting is "monastic," the work of monks in their churches and cells. This explains the local character that very soon after the fifth century prevails over the earliest style, still obviously derived from the Egyptian or the Greco-Roman, and the earlier iconography which borrowed heavily from the Old Testament (Bagawat, A.D. V). After an isolated instance of historical cycles from the New Testament at Deir Abu Hennis (end of A.D. V) the monks built up an iconographical repertoire of their own which showed their preference for the apocryphal texts and hagiography. Christ in glory surrounded by angels as the one God, Christ blessing, scenes from the Christological cycle—especially Mary as *Madonna Lactans* or standing amid the Apostles beneath the Ascension—and rider saints are the more frequent subjects. The scenes tend to be arranged in one register, more rarely two, above a dado imitating an

orthostat of colored marbles, incrusted panels, or geometric and floral patterns —a mural composition borrowed from Hellenistic style, itself derived from the ancient Egyptian one.

Tempera is the only technique employed for murals, and its use of secondary colors combined from blue, red, and yellow applied mostly in flat washes emphasizes the characteristic two-dimensional effect of a design ignoring perspective. The style, still reminiscent of the Hellenistic alertness and supple lines in the earlier examples (Karmuz, Bagawat, Abu Hennis), soon presents the unswaying frontality and rigidity of design (Bawit) gradually increasing (Saqqara) into schematic effects.

After the Arab conquest iconography is enriched and the style becomes more ornamental with increasing influences from Constantinople and Syria (Deir Suryan), Mesopotamia and Armenia (Deir el Abiad, Esna), imported by painters from these countries. The Coptic painters who decorate Fatimid mosques and palaces introduce in the murals of their churches stylistic elements acquired from contacts with a broader Islamic world (Wadi Natrun).

The withdrawal of patronage from the Copts prevented any renewal in painting, either in imaginative concept or style. Decadence was inevitable (St. Paul, St. Anthony on the Red Sea). The later painters offer servile imitations of Constantinople (A.D. XVIII–XX).

Forerunners of Coptic Painting

Egypt assumed a prominent share in the creation of the new Hellenistic style partly derived from native sources. The annexation by Rome did not impede the artistic trends that were adopted by the new masters together with other cultural aspects even to the point of having Alexandrian themes of mural painting imitated in the patrician villas and Egyptian shrines of Italy. On the other hand, it was only natural that early Christians should borrow in Egypt as they did elsewhere from the fashionable techniques and repertoire of late Roman painters rather than have recourse to the mysterious hieratic art of their ancestors. It is among these immediate forerunners, exemplified by murals and mosaics of the second and third centuries in houses and tombs and by painted shrouds and mummy portraits, that we find many of the basic elements and themes adopted, even within their pagan context, by the Christians.

The material found in Alexandria is rather scanty, consisting of murals in Ptolemaic rock tombs and paintings on loculus slabs and on vases that evidence a continuous stylistic development corresponding to what occurred in other Hellenistic centers.[1] The subjects of scenes with figures are three horsemen with two standing women (Mustafa Pasha, Tomb I; III B.C.), Herakles (Ras el Tin, Tomb III; I B.C.), ceiling rectangles containing figured scenes (Anfushy, Tomb II; II B.C.), and

date palms between pilasters in a very cursive linear sketchiness (Anfushy, Tomb V; I B.C.). The style of the date palms is reminiscent of that in some of the Egyptian tombs from the New Kingdom in Thebes (Deir el Medina). Egyptian religious themes were also represented in the traditional style (Anfushy, Tomb II). A tomb uncovered in 1960 at Wardian (west Alexandria)[2] yielded several murals of an excellent style characterized by "breath-taking dash and freedom of stroke" representing a shepherd carrying a sheep flanked by two lions, a herma, and a water wheel (Arabic, saqya) driven by two oxen to the music of a boy blowing pipes on the border of a water stretch peopled with a duck and a wild hen. In the burial chamber, above an orthostat imitating veined marble, appears a scene of Dionysos reclining beneath an arched bower of vine. It is interesting that the two motifs of the shepherd, Criophoros and that of Dionysos or Endymion, were appropriated by Christian art. The Criophoros, a pagan allegory for Philanthropy,[3] was interpreted as Christ. The scene of Dionysos under the vine was the prototype of Jonas recuperating under a gourd arbor.[4]

Mosaic pavements uncovered at Thmuis in the Delta (180 km. from Alexandria)[5] represent personifications of Alexandria ("made by Sophilos," III B.C.; another II B.C.), Erotes hunting a stag within a frame of real and mythological animals striding, very similar to that found in Pella as to design and pebble technique (III B.C.), and a scene of a banquet on the Nile with a rich Nilotic background (A.D. I).[6] The composition features sparse elements—ducks, cobras, fish, hippopotamuses, Erotes, and aquatic plants—filling the background without any third-dimensional naturalism. Could this treatment that is also exemplified in the murals at Hermupolis West have been the "shortcuts" compendiariae[7] described by Petronius in his Satiricon (2.9) as an Egyptian invention corrupting Roman art, "postquam Aegyptiorum audacia tam magnae artis compendiariam invenit"? Or was it rather the linear sketchiness of the style of mural painting, also evidenced later at Hermupolis West? The reference by Quintillian (Inst. 12.10.6) to the facilitas of Antiphilos and the description by Pliny (35.114) of the special effect of light in Antiphilos' painting might apply better to the technique of painting than to that of mosaic.

1. B. Brown, Ptolemaic Paintings and Mosaics and the Alexanarian Style (Cambridge, Mass.: 1957), p. 94. (Hereafter cited as Ptolemaic Paintings.)

2. H. Riad, "Tomb Paintings from the Necropolis of Alexandria," Archaeology, Vol. 17 (1964), pp. 169–172.
3. T. Klauser, "Studien zur Entstehungsgeschichte der Christlichen Kunst, VIII," in Jahrbuch für Antike und Christentum, Vols. 8/9 (Münster, Westphalia: 1965–1966). pp. 126–170. (Hereafter cited as "Entstehungsgesch. der Christlichen Kunst.")
4. E. Stommel, "Zum Problem der frühchristlichen Jonasdarstellungen," in Jahrbuch für Antike und Christentum, Vol. 1 (Münster, Westphalia: 1958), pp. 112–115, pl. VIII. T. Klauser, "Entstehungsgesch. der Christlichen Kunst, III," in Jahrbuch, Vol. 3 (1960), pp. 116–117, pl. VI.

5. B. Brown, Ptolemaic Paintings, pp. 67–82, pls. XXXVIII-XLV.
6. E. Breccia, Oxyrhynchos, I, Municipacité d'Alexandrie. Le Musée Gréco-Romain, 1925–19 31 (Bergamo: 1932), p. 101, pl. LII, 193. A. Hermann, "Der Nil und die Christen," in Jahrbuch für Antike und Christentum, Vol. 2 (Münster, Westphalia: 1959), pp. 54–65, pl. VII a.
7. B. Brown, Ptolemaic Paintings, pp. 88–90. A. Hermann, "Der Nil," p. 65, n. 249.

Most of the mural painting in the Ptolemaic tombs of Alexandria[8] was, however, concomitant with their architectural decoration. Well represented are the zone system, whose presence had been contested before, and the Fist Style. Some later examples can be attributed to the Second Style (Mustafa Pasha, Tomb IO), the Third Style (so-called Sieglin Tomb), and even post-Pompeian of the second century (Gabbari Tombs in Alexandria Museum). Soffits and ceilings are painted with coffers, lozenges and hexagon patterns, or illusionistic representations of a tent (Sidi Gaber) or an awning with an inner ring of figures and an outer one of cycle scenes (Anfushy, Tomb II, Chamber 1). Garlands appear frequently in painted tombs.

There seems to have been an increase in the Egyptianizing scenes during the Roman period, either in stucco relief (Kom el Shugafa, first half of A.D. II) or in painting (Kom el Shugafa Caracalla hall). Rows of hieratic deities surmount a sarcophagus of Roman type (Kom el Shugafa Sieglin Tomb, Nebengrab; two tombs from Gabbari), or the walls imitate an alabaster plinth surmounted by ashlar masonry *opus isodomum* roofed with a coffered flat vault (Anfushy, Tomb V; A.D. II), or a checker pattern of black and white squares alternating with narrow alabaster courses and embodying panels with Egyptian deities (Anfushy, Tomb V). The vault is painted with coffers representing mythological scenes.

8. A. Adriani, *Repertorio d'arte dell'Egitto Greco-Romano* (Palermo: 1966), series C, Vol. 1, pp. 31–32.

In the Roman town of Karanis in the northeast Fayum a few houses show murals of outstanding significance for the study of prototypes of Coptic paintings. The scene representing the Thracian god Heron riding astride a diminutive horse in House B 50,[9] dating from the late second or early third century (Fig. 4.1) may have been one of the models for the numerous rider saints so popular in Coptic iconography, the other being the type of Ptolemaic king carved on official stelae bearing bilingual decrees.[10] In the same house another painting represents Isis suckling Harpokhrates (Fig. 4.2), a theme appropriated by the Copts for their *Virgo Lactans*, another popular motif. The late-antique style characterized by its emphasis on the outline and a variety of maroon hues here exhibits a hieratic design with a strict frontal view of the persons. In yet another house a Harpokhrates painted frontally in late-antique style is represented with the sphinx-like beast of Serapis or god Tithoes[11] in composite projection (frontal head on body in side view) and two bulls of purely Egyptian type. Another mural from a private chapel at Karanis[12] depicts the three Eleusian deities with Greco-Roman gods in a

9. A. E. R. Boak and E. E. Peterson, *Karanis, Topographical and Architectural Report of Excavations during the Seasons 1924–1928.* (Ann Arbor: 1931), pp. 34, 56, Figs. 48, 49, 71.
10. H. Gauthier and H. Sottas, *Un décret trilingue en l'honneur de Ptolémée IV* (Caire: 1925), pls. I, II.
11. A painted limestone statue of a similar composite deity in the Brooklyn Museum.
12. K. Parlasca, *Mumienporträts und verwandte Denkmäler* (Wiesbaden: 1966), p. 212, pl. 46, 1. (Hereafter cited as *Mumienporträts.*)

row in frontal attitude but retaining the Lysippic stance in Persephone's figure and for all other personages, whether standing or seated, one foot in side view and the second in foreshortened front view, as in some of the stelae from Terenuthis.

The necropolis of Hermupolis West on the desert plateau above Hermupolis (Ashmunein) in Middle Egypt grew from the third century B.C. south of a large complex sacred to Thot, god of writing and knowledge. It comprises a temple with well, nymphaeum, garden for the baboons and ibises bred within the precincts, and extensive underground galleries where the mummies of the animals were deposited as ex-votos. The tomb chapels range from the third century B.C. well into the Roman period. The mural decoration is akin in many ways to that in Alexandrian tombs, with architectural motifs in stucco and painted murals. Exemplified are the zone system in a plinth imitating alabaster surmounted by registers of Egyptianizing deities (Chapel M 21); imitation of orthostats of marquetry panels with geometric designs surmounted by the Dionysiac crater and thyrsus (Chapel M 4), vine trees with garlands; vine scroll with axonometric checker; polygonal grid enclosing Medusa heads and flying Erotes; composition with sparse plant elements in linear design on a white ground; decorative composition with peacocks and wreaths, surmounted by curtains; and panels with an Eros or a lion hunting on an impressionistic background of rocks.

4.1
Mural representing the god Heron. (Karanis, House B 50, A.D. II–III; A. E. R. Boak and E. E. Peterson, *Karanis, Topographical and Architectural Report of Excavations during the Seasons 1924–1928* [1951], Fig. 48.)

4.2
Mural representing Isis suckling Harpokhrates. (Karanis, House B 50, A.D. II–III; A. E. R. Boak and E. E. Peterson, *Karanis,* Fig. 49.)

4.3
Mural in a tomb chapel of the Roman period at Hermupolis West representing the deceased lady in Greek dress being purified by Thot and Horus. (Chapel M 21; A.D. II; S. Gabra and E. Drioton, *Peintures à fresque et scènes peintes à Hermoupolis-Ouest(Touna El-Gebel),* pl. XIV.)

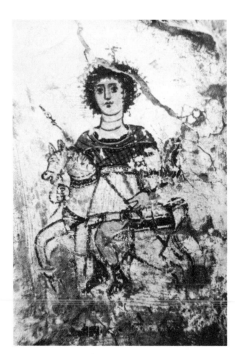

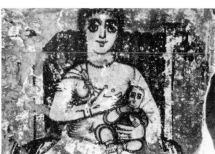

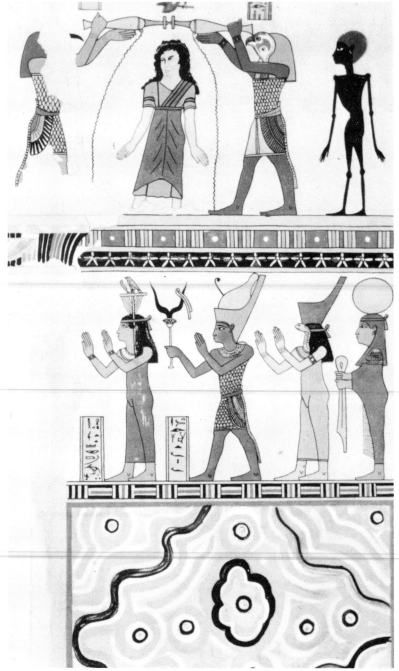

A mixture of Greco-Roman and Egyptianizing figures occurs in Tomb Chapel 21,[13] entirely covered with religious scenes in registers above a dado imitating alabaster (front room). Flanking the doorway to the inner room are a few representations in three-quarters of the deceased lady standing in Greek dress (Fig. 4.3) and in Egyptian costume among standing figures of Egyptian deities drawn according to the Egyptian composite projection (dated A.D. II). The differentiation in the projection is also echoed in the corresponding colors, pink for the fleshy areas when the lady is depicted in the Greco-Roman style, instead of the conventional yellow ocher used in the Egyptian portrayal.

A similar mixture of figures in Egyptian projection and late Roman projection occurs on a funerary lion-bed dated to the third century A.D. originating perhaps from Deir el Bahari (Royal Ontario Museum, Toronto).[14] The deceased Herty appears several times wearing a tunic or toga and his wife Senteris a lady's tunic with clavi in a late "naturalized" type of frontality among deities drawn according to the Egyptian traditional style (Fig. 4.4) The figures of the deceased are not, however, in three-quarters view as at Hermupolis.

The tradition of a mixed style at Hermupolis West still quite close to the Greek goes back to the third and second centuries B.C. in the scenes in low relief in the funerary chapel of Petosiris,[15] which employ a brilliant hybrid style blending both Egyptian and Greek in subjects, projection, modeling, composition, dress, and colors. Many of the funerary chapels at Hermupolis West, some two-storied and imitating houses, were painted with mythological scenes. Some of the Greek subjects refer to the theme of death such as the Rape of Proserpine by Pluto (Chapel M 3);[16] others are connected with the mysteries of Dionysos (Chapel M 4)[17]; still others represent (Chapel M 16), unexpectedly, Elektra mourning in front of the chapel of her father while Orestes and Pylades are approaching.[18] The most elaborate shows two moments in the drama of Oedipus, the murder of Laios, and Oedipus standing in one of the seven gateways of Thebes answering the question of the Sphinx (Fig. 4.5). Two allegorical female figures stand for "Error" (*Agnoia*) and "Problem" (*Zetema*), related respectively to the murder by error and the problem set in the Sphinx's question. A third male figure represents Thebes in

Beotia. Such subjects with personifications derived from Hellenic literature which a sophist, intent upon moral interpretations, caused to be painted in his funerary chapel anticipate the cycles from the Bible, the "book" par excellence, in the early Christian funerary chapels at Bagawat. Personifications and allegories occur in the Coptic murals at Bagawat, Bawit, and Saqqara.

The style at Hermupolis West could be called impressionistic, with a supple rendering of figures in perspective against a background reduced to a bare minimum of shadow and ground lines, once, however, displayed in a stage setting (Oedipus). It is still Alexandrian, probably dating between the second and third centuries A.D., and there is yet no trace of the frontality that characterizes the figures in the murals at Karanis. The scenes are set above a dado imitating an orthostat[19] reminiscent of the ancient Egyptian ones and of Style II at Pompeii, treated as veined marble plaques alternating with granite or breccia. Sometimes in the later chapels marble marquetry is imitated in the orthostat or above it in framed panels of so-called incrustation style[20] similar to Alexandrian examples of geometric designs (Mural 4) (Fig. 4.6). Only a few paintings represent scenes, most of the murals consisting of floral decoration[21] such as a whole vine with garlands or vine scroll combined with isometric fret pattern on an external façade, in a garland, or in a

13. S. Gabra, *Rapport sur les Fouilles Hermoupolis Ouest (Touna El-Gebel)* (Cairo: 1941), pls. XIII, XIV. (Hereafter cited as *Hermoupolis Ouest.)*
14. W. Needler, "An Egyptian Funerary Bed of the Roman Period in the Royal Ontario Museum," Occasional Paper No. 6, Art and Archaeology Division, Royal Ontario Museum, University of Toronto, 1963, especially pp. 23–25, and note 147 mentioning the Hermupolis West scenes, dated to the second century.

15. G. Lefebvre, *Le Tombeau de Petosiris,* 3 parts (Cairo: 1923–1924).
16. P. Perdrizet in S. Gabra, *Hermoupolis Ouest,* pp. 73–75. S. Gabra and E. Drioton, *Peintures à fresque et scènes peintes à Hermoupolis-Ouest (Touna El-Gebel)* (Cairo: 1954), pl. 14. (Hereafter Cited as *Peintures.)*
17. P. Perdrizet in S. Gabra, *Hermoupolis Ouest,* pp. 76–78, pls. XXXVI-XXXVIII. S. Gabra and E. Drioton, *Peintures,* pls. 8–10.
18. P. Perdrizet in S. Gabra, *Hermoupolis Ouest,* pp. 97–100, pls. XLIV-XLVI. S. Gabra and E. Drioton, *Peintures,* pls. 15, 17.

19. S. Gabra and E. Drioton, *Peintures,* pls. 22, 23.
20. Ibid., pls. 4, 8, 9, 10, 21.
21. Ibid., pls. 2, 6, 11, 18, 23.

4.4
Part of frieze on the funerary bed of Herty
representing him in Egyptian and in Greek
projections. (Royal Ontario Museum, Toronto;
A.D. III; courtesy Miss W. Needler.)
4.5
Mural from a tomb chapel at Hermopolis West
representing two moments in the drama of
Oedipus. (S. Gabra and E. Drioton, *Peintures*.
p. 115.)

4.6
Painted dado imitating orthostat marquetry.
(Hermupolis West; S. Gabra and E. Drioton,
Peintures, pl. XXI.)

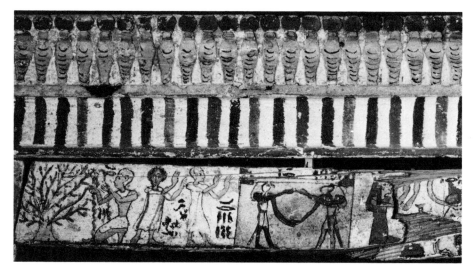

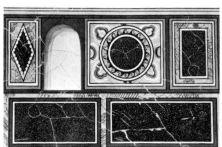

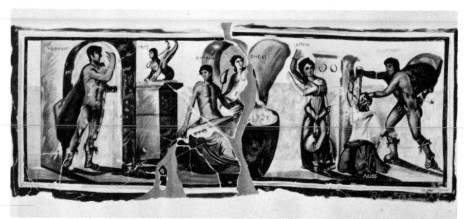

polygonal grid with a Gorgon and flying Erotes. A light outdoor effect[22] is achieved with the representation of birds, wreaths, and sketchy leaves interspersed on a white ground with panels bordered by bands and linear faces and figures comparable to the mosaics on the vaults of St. Constanza in Rome (A.D. IV). Decorative senes[23] with peacocks, pheasants, wreaths and curtains, or a lion pursuing two mammals on an impressionistic background of rocks are akin to those in the Naples Museum (A.D. 130–160). Panels[24] framed in red, each with an Eros or a lion pursuing a stag shown in an instantaneous moment of action set alternating in a zone composition could be compared to similar motifs at Eleusis (A.D. 200) and Ostia (A.D. 195). Curiously enough, though isolated on the desert plateau, Hermupolis West is nevertheless crossed by the main caravan road Nag Hammadi–Ashmunein–Memphis (Cairo). It must have had a prominent impact on Coptic painting, for the chapels were certainly accessible to visitors from the neighboring sites of Ashmunein (Hermupolis), and Bawit, and those opposite on the east bank Sheikh 'Abada (Antinoë) and Deir Abu Hennis, all extremely significant in the history of Coptic painting.

Nilotic scenes depicting, in the picturesque style of Alexandria, ducks and characteristic red-legged flamingo wading in waters full of fish and pink lotus decorated walls and pavements in thermae and fountains of the Hellenistic and Roman ages.[25] The Egyptianizing murals of the Pompeian Third and Fourth Styles emphasize the light aspect of life on the riverbank with traits of caricature such as pygmies, *putti* fishing and fowling in water teeming with Nile fish, waterfowl, and occasionally crocodiles and hippopotamuses. It seems that it is because of this experession of euphoria rather than symbolism that the Nilotic scenes were adopted since the fourth century in church art.[26] To the Christian Egypt was the land of Jesus' childhood, a reverberation of the *caelestis patria*, a *locus amoenis* where peace could be found in an ever-green ideal paradise.

Nilotic scenes appear in the apses of the Roman basilicas of Santa Maria Maggiore, the Lateran and St. Clement, in Rome. This tradition lived on in Christian art in Sta. Constanza in Rome (A.D. IV), at Tabga and Capharnaüm in Palestine (A.D. V), in pavements at Antioch, in a cistern at Salamis of Cyprus (A.D. VI), at St. Peter and Paul at Jerah (A.D. 540), and at Khirbet el Mekhayyat (Jordan).[27] It is remarkable that Nilotic scenes, though originating from Egypt, are relatively rare in its Christian graphic art. Except for a single mural at Abu Girga, near Alexandria,[28] representing an *orans* standing in the middle of a water stretch teeming with fish, water plants, and nude figures, they occur on textiles and carved wooden friezes and caskets.

Used in the monumental architecture of Roman Egypt, the zodiac that was carved on the roof of the second room in the shrine of Osiris on the terrace of the temple of Hathor at Dendera could have been a prototype of painted compositions on Coptic domes arranged in concentric zones with figures radiating, such as in those at Bagawat.[29]

Some most valuable evidence about monumental painting under the tetrarchy—the only available with a few frescoes in the catacombs of Rome and Syracuse—is provided in the copies of the murals, now destroyed, in the pronaos of the temple of Amun at Luxor, transformed into a *sacellum* for the legionary standards and insignia and a temple of the imperial cult.[30] The eight columns had been dismantled and reused in the filling beneath a new floor 50 cm. higher than the earlier one, made accessible by three steps in front of the north doorway. The south doorway (2.75 m. span) was blocked into a semicircular niche preceded by a canopy or *kibwrion* on four granite

22. Ibid., pl. 7.
23. Ibid., pl. 5.
24. Ibid., pl. 19.

25. G. E. Rizzo, La Pittura ellenistico-romana, (Milan: 1929), pl. 188.
26. A. Hermann, "Der Nil," pp. 66–69.
27. Marina Sacopoulo, "La fresque chrétienne la plus ancienne de Chypre," in *Cahiers Archéologiques*, Vol. 13 (Paris: 1962), pp. 81–82.

28. A. Grabar, *Martyrium. Recherches sur le culte des reliques et l'art chrétien antique* (Paris: 1946), pl. LX, 3; after Dölger. (Hereafter cited as *Martyrium*.)
29. W. de Grüneisen, *Les Caractéristiques de l'Art Copte*, (Florence: 1922), Fig. 37, pp. 71–72. (Hereafter cited as *Caractéristiques*.)
30. U. Monneret de Villard, "The Temple of the Imperial Cult at Luxor," in *Archaeologia*, Vol. 95 (London: 1953), pp. 85–105, pls. XXX–XXXIII.

columns 4.45 meters high with composite capitals (Fig. 4.7). It seems probable that the columns carried a wooden vault on a line with the semicircular arch of the niche. A statue of *tychē* similar to that in the castrum at Dionysias might have stood beneath the canopy. The hall must have had a wooden roof (10.5 m. span), for all its walls were painted. According to the copies made by J. G. Wilkinson in 1859 a painted dado 86 cm. high imitating panels of *opus sectile*, a circle within a square alternating with vertical rectangular ones, ran at the bottom of the walls. Above was a miniature band of squares and triangles. The colors were white, black (basalt), purple (porphyry), green (*verde antico*), blue (lapis lazuli), and golden yellow (gilding). The wall above was painted with a continuous scene slightly taller than the dado and bands representing a procession starting on either side of the north door and moving toward the niche in the opposite wall. On the east wall was a spirited group of at least seven dismounted horsemen armed with lances and circular shields and leading richly caparisoned horses (Fig. 4.8). On the west wall, perhaps, were personages richly dressed in tunics decorated with *orbiculae*, clavi, and borders of a type characteristically Egyptian which spread throughout the Roman world in the third and fourth centuries (see Textiles, pp. 282–305). One of the personages carries a T-shaped staff (*baculus*) similar to the one represented on a monument dated to 303 in the Forum Romanum, an

attribute of authority which was taken over by the heads of Coptic monasteries. The scene on the south wall was much taller and represented two rows of magistrates and high officials, the front one reaching to the waist of the rear one, and containing figures dressed in flowing robes, some in fringed chlamys, one with a rich belt, and holding cylindrical objects. All are closely shaved, have short hair, and turn in three-quarter view with foreshortened feet wearing various types of *campagi*. The niche was painted with four figures showing a blue nimbus around the heads, identified as Diocletian with the orb and spear of Jupiter and Maximian Daia, erased when his memory was condemned, flanked by the two Caesars Constantius Chlorus and Galerius.

It is this sanctuary of the Imperial cult, where perhaps the Christians were ordered by Diocletian and Maximian Daia to sacrifice to the divinity of the Emperor, that provides evidence about monumental painting not available any longer in Alexandria. The murals exemplify the type of dado imitating *opus sectile* or marquetry similar to what is found in Greco-Roman chapels in Alexandria, Hermupolis West, and Kom el Ahmar near Dirwa, and later in Coptic painting; the historical narrative of Hellenistic style (east wall) as that at Hermupolis West imitated in the cycles of proto-Coptic and Coptic painting; and the groups of personages in frontal view at two levels after the eastern style and imitated in Coptic monastic painting.

Another group of possible forerunners of Coptic painting are the linen shrouds enveloping mummies (A.D. I–IV).[31] The shroud is painted in encaustic with a full-length representation of the deceased flanked on his left by the jackal-headed anthropomorphic god Anubis and on his right by his mummy shown standing. Another type of shroud emphasizes the portrait of the deceased flanked by smaller figures of Isis and Nephtys, and still a third one represents the mummy with a portrait in front of the head, flanked by a diminutive Anubis and a miniature three-quarter painting of the living lady. In all cases the deceased is depicted in the late-Roman style, a figure clad in Greek garb nearly frontal, the right leg flexed, the face slightly turned left, the hands holding a roll or a wreath (Fig. 4.9; Moscow, Pushkin Museum, Inv. 4229/I Ia 5749). Behind the head and framing it in contrasting light is the portal of an Egyptian temple, shown in much detail and flanked by the two towers of its pylon. The symbolic implication is clear: as the god appeared (*kha'j*) according to Egyptian mythology through the portal of the temple so does the deceased "appear" in light as a resurrected Osiris through the portal of the nether world.[32] In some shrouds the deceased "appears" in the aperture of a doorway painted on either side with small superimposed scenes of gods in imitation of the two doorjambs of a temple portal (shroud of Tarintho; Berlin, Äg. Inv. 13277) crowned with

31. W. de Grüneisen, *Caractéristiques*, pp. 33 ff, pls. XIII-XV.
32. K. Parlasca, *Mumienporträts*, BSAC, pp. 175–177. E. Drioton, "Portes de l'Hadès et portes du Paradis," *BSAC*, Vol. 9 (Cairo: 1943), pp. 59 ff., pls. XXXV-XLIII.

4.7
Restored perspective of the canopy in front of
the apse in the *sacellum* in the temple at Luxor,
and sketches of Wilkinson's copies of the murals
on the north and east walls. (U. Monneret de
Villard, "The Temple of the Imperial Cult at
Luxor," *Archaeologia,* Vol. 95 [1953], pls. XXX–
XXXIII.)

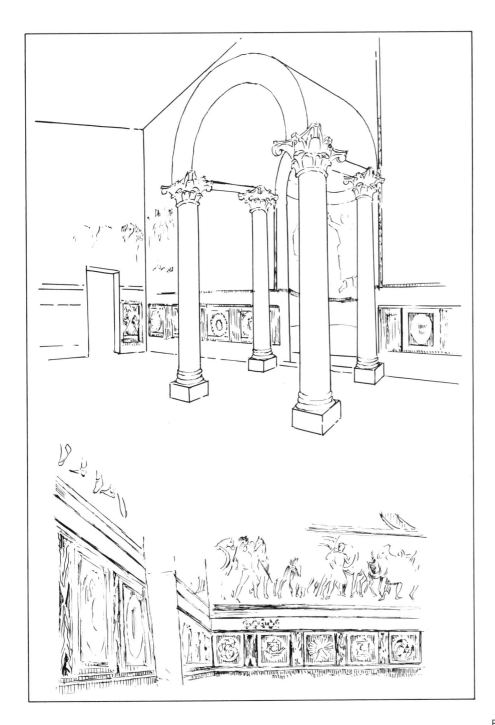

4.8
Wilkinson's copies of the murals on the walls of Diocletian's *sacellum* in Luxor temple, and restored elevation of part of its dado on the west wall. (U. Monneret de Villard, "Temple of the Imperial Cult," pls. XXX–XXXIII.

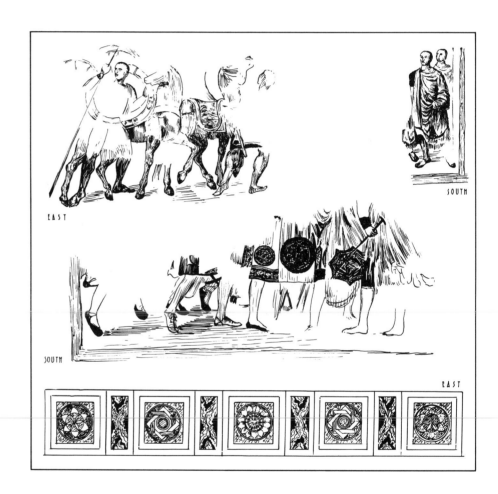

Painted shroud representing the deceased in Greek dress attended by Anubis and as a mummy. (Pushkin Museum, Moscow, Inv. 4229/I la 5749; courtesy E. Shurinova.)

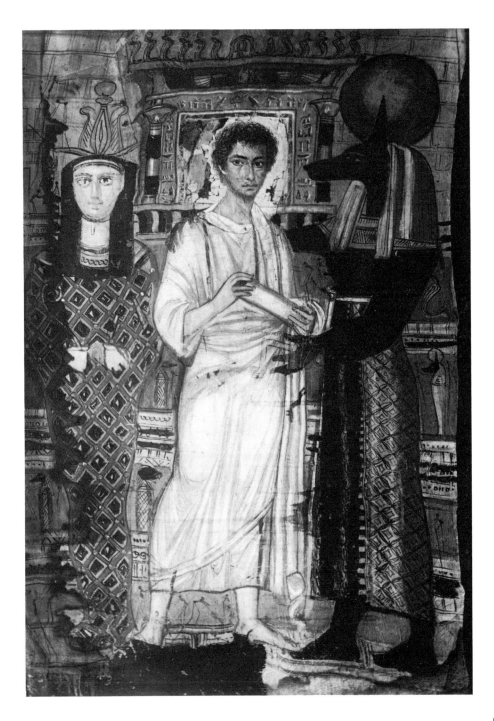

a winged disk (shroud of Dion; Samm-lung Niessen). On other shrouds only the head is painted, in imitation of the mummy portraits. The head appears in the bay of a window shaped as an aedicula consisting of two columns carrying a lintel decorated with the winged sun disk (Louvre, AF. 6482, 6484, 6486, 6488), once surmounted and delimited at the bottom by an inlaid frieze of *uraei* (shroud of Markos; Louvre, AF. 6490 A.D. 117). On later shrouds the portal is simplified (Louvre, Inv. N. 3076) into a square of lighter color, a rectangle framed within a gilded scroll, also oval or horseshoe—accord-ing to U. Monneret de Villard the proto-type of the square nimbus, the *tabula circa verticem*.[33] At least one shroud (Pushkin Museum, Moscow, No. 5749; mid-A.D. II) shows a circular nimbus, not necessarily Christian, encircling the head of a mummified lady and top-ped by a winged scarab, flanked by Anubis, a small female figure in three-quarters pointing to the mummy and representing the lady while in life, and at the bottom an offering table. It has been suggested that the origin of this circular nimbus could be the representa-tion of the circular hypocephalus placed by the Egyptians under the heads of mummies.[34] This does not explain the origin of the majority of the squares of light or dark color behind the head. It seems that its interpretation as deriving from the architectural context in which

some deceased are made to appear is more concomitant with Egyptian sym-bolism than the one explaining it as a variant from the circular nimbus of pagan Roman art.

Egyptian deities are always in the Egyp-tian composite projection, and Anubis embraces the deceased with his right arm around his shoulders and his left on his torso in a familiar gesture of protec-tion and family relationship, which ever since the Old Kingdom was used to depict a man embraced by his wife or a Pharaoh by a god. Christ will use the same gesture when embracing St. Menas on an icon from Bawit (A.D. VI–VII). Numerous skeletic longlegged figurines busy around the deceased are perhaps beneficent *daemons* remini-scent of the mixed style of the mural painting in the chapel of the Greek lady at Hermupolis West (Chapel M 21). The name of the deceased is often inscribed on the breast.

This type of shroud derived from the Egyptian mummy case, which at the same time was evolving into a simpler version consisting of the mummy wrap-ped up in wands on geometrical pattern with a mummy portrait[35] painted in wax on cypress board set over the face replacing the molded mask of anthropo-

morphic cases (Fig. 4.10; University Museum, Strasbourg, No. 10). Here also the style[36] still conforms to the late-antique type in the earliest por-traits—three-quarters perspective, lively realism in the treatment of the eyes and features in an impressionistic technique with gradation of colors, shading, and high-lighting—but soon evolves in the later portraits in tempera on thick boards dating from the fourth century into a formal frontality, wide-eyed staring gaze, straight mouth with pursed underlip, stylized features and hair, and flat rendering.

In addition to the portraits of aesthetic value, though less dependent than earlier ones on classical forms, there gradually appear poorer productions.[37] The first phase of this deterioration starts in the Severan period. The crude rendering of brutal features in the third century echoes the general trend of graphics at the time. An appreciable number of good portraits date from the fourth century, though most of the production does not follow the tradi-tional norms. With the edict of Theodo-sius (A.D. 392) forbidding pagan cults, the tradition of mummy portraits seems to have died out. Despite cer-tain attributes appearing on shrouds from Antinoupolis such as the *crux ansata*, which could be interpreted as Christian, these shrouds have enough pagan elements to contradict this affiliation.

33. W. de Grüneisen, *Caractéristiques*, p. 38. Cf. P. du Bourguet, *L'Art Copte. Petit Palais, Paris: 1964*, No. 24, pp. 66–68.
34. A. Hermann, "Ägyptologische Marginalien zur spätantiken Ikonographie," in *Jahrbuch für Antike und Christentum*, Vol. 5 (Münster, Westphalia: 1962), pp. 75 ff, pl. II.

35. W. F. Petrie, *Roman Portraits and Memphis (IV)* (London: 1911). W. F. Petrie, *The Hawara Portfolio* (London: 1913). E. Coche de la Ferté, *Les Portraits romano-égyptiens du Louvre* (Paris: 1952). H. Zaloscer, *Porträts aus dem Wüstensand*, (Vienna: 1961). A. F. Shore, *Portrait Painting from Roman Egypt* (London: 1962). K. Parlasca, *Mumienporträts*. V. V. Pavlof, *The Egyptian Portrait, I–IV Centuries* (Moscow: 1967).

36. A. F. Shore in I. E. S. Edwards, *A General Introductory Guide to the Egyptian Collections in the British Museum* (London: 1964), p. 228.
37. K. Parlasca, *Mumienporträts*, pp. 193 ff. H. Drerup, *Die Datierung der Mumienporträts* (Paderborn: 1933).

4.10
Mummy mask painted pink with black hair and inlaid blue-and-black eyes. (University Museum, Strasbourg, No. 10.)

4.11
Mummy portrait in tempera on wooden tablet. (Fayum; B. M., 63397; A.D. IV; A. F. Shore, *Portrait Painting from Roman Egypt*, pl. IV.)

4.12
Mummy cartonage in painted stucco on linen. (Brooklyn Museum, 52.128; A.D. 350; pink flesh, purple frame, light green and blue, black Anubis.)

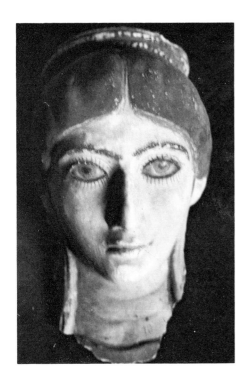

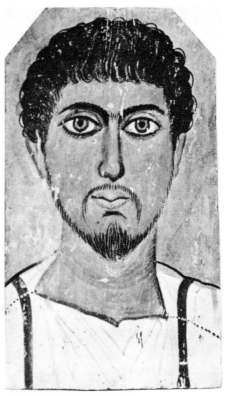

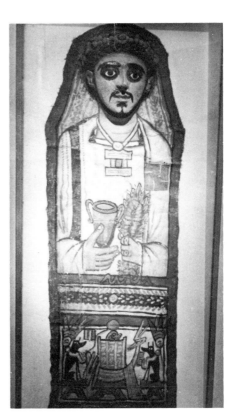

While the earlier examples of the mummy portraits were certainly life portraits, as is proved by the memoranda about features and colors inscribed in Greek and even by the painter's sketches, the later ones cannot claim much individuality (Fig. 4.11; B. M., 63397). The later portraits are conspicuous for their round faces, a phenomenon paralleled in the independent evolution of sculpture in the late Roman empire toward the end of the fourth century. These may be considered as the prototypes of the abstract faces with intense gaze so familiar in Coptic iconography, identified only by accompanying names. That most of these portraits are from the Fayum (some Thebes and Antinoë) is perhaps due to the preponderantly Greek and Jewish communities which commissioned them.

The anthropomorphic mask evolved into a plaster portrait headpiece mostly in Middle Egypt and was painted with naturalistic details in the Egyptian style; these were simplified in later examples from the Theban district (Fig. 4.12; Brooklyn Museum, 52.128; A.D. 350). The head, modeled and adapted to the flat cartonnage of the mummy, foreshadows the abstract faces of the Coptic saints. While the Romano-Egyptian mummy portrait had its origin in the funerary mask and painted shroud and constituted the essential part of the mummy's equipment, it was paralleled in Rome by the ancestors' portraits (*imagines majorum*) which, according to Pliny, were hung around the atrium.

Though Coptic mummies and mummy-labels are known, there is no Coptic mummy portrait. The Coptic portraits which are closest in style to mummy portraits are the icons of saints on wooden tablets of similar size and stylistic character such as that of Abbot Abraham (see Fig. 4.35), two portraits in the Bibliothèque Nationale (Cabinet des Médailles, Collection Froehner, Nos. 1129 a, 1129 b), and the seven tablets found in a pot in the necropolis of Antinoupolis (see next section).

The Earliest Christian Murals

The only evidence of the earliest mural painting in Christian Egypt survives in funerary monuments, the catacombs in Alexandria, and the funerary chapels at Bagawat. There is no doubt that the martyria and early churches in Alexandria and elsewhere in Egypt were adorned with murals, but they have all disappeared and only reports testify to such outstanding paintings as that in the Tetrapylon, or the mosaics in Abu Mina.

The *orans* is attested in an anonymous martyrium at Abu Girge (A.D. V–VI)[38] near Alexandria, proving the funerary character of this iconographical type in the east and in the west. This type, derived from the *orans* of funerary stelae, had been adopted for the justified since the second century in the catacombs of Rome. In the tomb chapel of Theodosia, a girl of a rich Greek family who died when only fifteen years old at Antinoë (A.D. V)[39] is represented as an *orans* between St. Colluthius and St. Mary. The scene is painted on the south arcosolium (1.85 m. high, 0.9 m. deep). Two confronted peacocks plucking at pomegranates flank the upper edge of the arch, decorated at its crown with a face and a sequence of circles, semicircles, and stylized palmettes. The soffit of the arch has a spiraling band. On the back wall between two stylized trees with large indented leaves Theodosia stands with

38. A. Grabar, *Martyrium*, Vol. 2, pp. 24, 28, pl. LX, 3.
39. *Ibid.*, p. 34, Fig. 136; E. Breccia, "Le prime ricerche italiane ad Antinoe," *Aegyptus*, Vol. 18, Nos. 3–4 (Milan: 1938), pp. 285–310. M. Salmi, "I dipinti paleocristiani di Antinoë," *Scritti dedicati alla memoria di Ippolito Rosellini* (Florence: 1945), pp. 159–169.

St. Colluthius (*Kollouthoc*) to her right and St. Mary to her left, identified by their names written near the head after the Hellenistic custom (Fig. 4.13). Theodosia is in the frontal attitude of an *orans*, wearing sumptuous garments and jewelry. Over her white tunic with clavi, *gammulae*, and square insets on the shoulders and ankles an ample mantle is hung on the left arm and shoulder. The face is conspicuous for its refined features expressive of the personality, emphasized by the heavy mass of dark hair adorned with strings of pearls and a transparent veil forming a kind of nimbus. The costume of Theodosia is akin to that of the angel in an Annunciation from Abu Girga. St. Colluthius, an Egyptian who was martyred in Hennis under Maximinus, stands in *contrapposto* stance slightly turned toward Theodosia. He holds his left hand on her arm in a gesture of protection and introduction. His white-bearded face surrounded by a nimbus has an intense expression. St. Mary is dressed in a monastic dark tunic, black mantle, and white hair scarf. She holds in her left hand a round metallic disk inscribed with a cross to which she points with her right hand. She may be tentatively identified as Pachomius' sister, who founded an order of nuns. The burial beneath the arcosolium, that of a young woman, had a cylindrical mass of salt in the basin, a peculiarity which, concomitantly with the burial of a baby nearby, has been interpreted as a proof that she died in childbirth. On the eastern arched wall appears a Christ in glory between two angels. Two palm trees, each on its ground line, flank the scene. The throne is of carved wood with a high back and a thick purple cushion. Christ with nimbus and beardless is seated in frontal view, dressed in a purple tunic and mantle. He holds the book in the left hand and blesses with the right. The left foot is raised on a high footstool. The two angels stand, their heads surrounded by a nimbus slightly turned toward Christ. They are dressed in white tunics with square insets at knee level. There is no ground line, a clear connotation that the group does not stand on earth. A delicate frieze of palmettes alternating with curving stems and dots runs at the bottom of the composition, above a dark band and white dado. The style of the painting, dated sixth century, is characterized by its assured draftsmanship and excellent proportions as well as thorough modeling. It can be considered as showing a transition between the late-antique style, still retaining much of the Alexandrian refinement, and the monastic style. Theodosia forms a link between the funerary *orans* proper and the iconography of Roman basilicas and Coptic chapels.

On the external walls of Theodosia's tomb chapel was a register of saints now too defaced for any study. Quite interesting and unusual was a vigorous sketch in red ocher of a bearded head on a pilaster of the doorway, a reminiscence of the Alexandrian black *Dipinti*, also apparent in some of Hermupolis West chapels.

In a terra-cotta jar from the necropolis east of Theodosia's tomb were seven wooden tablets (C.M., 68824–68826) with encaustic paintings of angels, heads of a youth and bearded men, and female figures. They are dated on stylistic grounds to the fifth or sixth centuries. In these earliest icons of Egypt the heads without nimbus have summarily treated features, though brush strokes achieve a realistic depiction of the eyes and hair.[40]

The tradition of painted murals in pagan catacombs, perhaps inspired from mural decoration of Egyptian funerary chapels and tombs, was transmitted to the Christians in Alexandria who buried their dead in the same catacombs (Gabbari). Those at Karmuz[41] (now destroyed) provided several scenes from the Christological cycle endowed with symbolic implication. On the apse a long frieze (Fig. 4.14) represented, from the left, Christ and the Virgin standing behind a group seated at meal on the ground, probably the feast at Cana, separated only by a tree from a seated Christ flanked symmetrically by Peter and Andrew (with square halo) hastening with bread and fishes, evidently the miracle of the Multiplication, and to the right three reclining figures described by the legend as eating eulogies. The symbolism clearly indicates the Eucharist, a renewable form of the Epiphany of God.[42] Yet the painter created an illu-

40. P. du Bourguet, *Die Kopten* (Baden-Baden: 1967), p. 128, Fig. 50.
41. G. B. De Rossi, *Bolletino d'archeologia Cristiana*, series 1 (1865). P. R. Garrucci, *Storia dell' arte cristiana* (Prato: 1873–1880), Vol. 2, pl. 105 B, No. 5–9, pp. 128–131. Cabrol and Leclercq, *Dictionnaire d'archéologie chrétienne et de liturgie*, Vol. 1, part 1 (Paris: 1924), cols. 1127–1138. (Hereafter cited as *Dictionnaire*.)
42. A. Grabar, *Martyrium*, Vol. 2, pp. 245–246.

4.13
Mural from the tomb chapel of Theodosia
representing her as an *orans* introduced by St.
Colluthius and St. Mary. (Antinoë; A.D. VI; E.
Breccia, "Le prime ricerche italiane ad Antinoe,"
Aegyptus, Vol. 18, Fig. 6.)

4.14
Mural frieze representing scenes from the
Christological cycle at Karmuz. (P. R. Garucci,
Storia dell' Arte Cristiana Vol. 2, pl. CVB.)

4.15
Part of dado imitating marble marquetry from a
Coptic tomb chapel at Bagawat, (A. Fakhry, *The
Necropolis of El-Bagawat in Kharga Oasis,* pl.
III.)

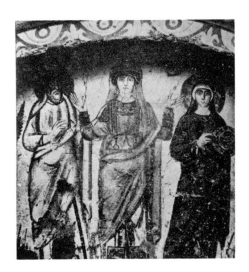

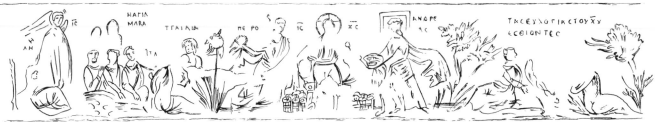

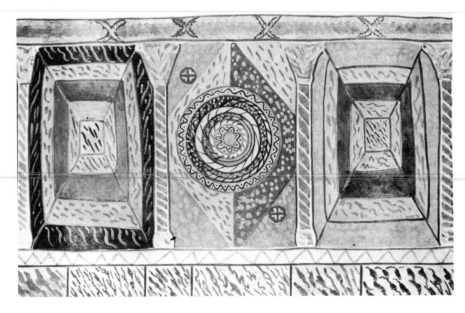

sionistic style with excellent three-quarter figures and attitudes, even a half naked woman akin to Alexandrian models set in a symmetrical composition with many evanescent phases in a realistic environment. It contrasts advantageously with Roman catacomb painting of more static stance and ornamental trends.[43] Other scenes represented the women at the sepulcher with a winged angel and reclining Roman soldiers, St. Mark, God the Father above Christ standing on a lion, and a crocodile, evidently a motif adapted from the magical carved stelae of Horus on the crocodiles. In the arcosolium were eleven apostles and on its vault two winged figures kneeling before Christ. The style is hardly different from that of Hellenistic painting in Alexandria.

Not many of the 263 funerary chapels at Bagawat[44] have retained their paintings, but there is evidence that the

emphasis laid upon their main façade consisted not only in blind arcading and niches, some in sophisticated composition, but also in paintings which could range from a simple *crux ansata* over the entrance and at its sides to an elaborate pilaster decorated with a standing figure (Chapel 175). The significance of the painted decorations at Bagawat is due to their early date (A.D. IV) and to the contrast between both traditions represented, the native one (Chapel 30) and a rather high aspect of the late-antique one (Chapel 80). The location of the oasis on two caravan routes—the Darb el Arba'in from the Sudan to the Nile valley and the route from the Red Sea to North Africa, its relative proximity to the urban centers of Upper Egypt such as Thebes and Chenoboschion, and the prosperity it enjoyed under the Roman emperors, even to having its own bishop, would explain the artistic sense in the funerary chapels. In two of the smallest chapels the dome is painted with scenes from the Old Testament. Just north of the church the chapel of the Exodus (No. 30), so-called after its most important scene, dates from the fourth century and is painted throughout. At the bottom of the walls runs a dado imitating incrustation panels separated by helicoid shafts with Corinthian capitals. (Fig. 4.15). The intrados of the arched niches have a chain of triangular elements and their archivolts, floral patterns of grapevine scroll or wreath each in two segments ending at the crown against a *crux ansata*. In the spherical triangles (not pendentive) between the arches at the corners of the room are four *cruces ansatae* forming as it were the foundations "in eternal life" of the Biblical scenes on the dome above—

certainly four apotropaic representations (In Hagia Sophia a Cherubim appears on each of the four pendentives.) There are no ground lines, and the horror vacui has led to a combination rather than a composition of three undelimited zones. The lowest zone features the following themes with no apparent chronological order: starting from the south entrance westward, the story of Jonah, Rebecca, the torture of Isaiah, the three Hebrews in the furnace, Daniel in the lions' pit, Adam and Zoë about to leave Paradise, Noah's ark, the façade of the temple of Jerusalem toward which the seven virgins proceed, the sacrifice of Isaac by Abraham, the martyrdom of Thekla of Seleucia, and Jeremias in front of the temple of Jerusalem. In the central zone (moving counterclockwise) Pharaoh on horseback pursues with his soldiers the Israelites, who are proceeding behind Moses to a monumental temple symbolizing the Promised Land or, according to Grabar, the Constantinian complex on the Golgotha.[45] Names of personages and titles of scenes are written above after the Hellenistic fashion. The uppermost zone is covered with grapevine interspersed with birds. The trunk of the vine shoots up in the axis of the southern arch, forming an axis of symmetry. The style is naive, even primitive, though successful in representing movement (horses, figures); it shows attempts at naturalism in the fair hues given to hair, and at originality in the imaginative rendering of the Promised Land as a palace with arcaded porticoes in the late-antique style. It is noteworthy that the Hebrews are repre-

43. W. de Grüneisen, *Caractéristiques*, p.95, Fig. 23; citing Gayet. Alexandre Badawy, "L'Art Copte. II. Les Influences hellènistiques et romaines, *Bulletin de l'Institut d'Egypte*, Vol. 35 (Cairo: 1953), p.39, Fig. 52.
44. W. de Bock, *Matériaux pour servir à l'archéologie de l'Egypte chrétienne* (St. Petersburg: 1901). (Hereafter cited as *Matériaux*.) C. M. Kaufmann, *Ein altchristliches Pompeji in der libyschen Wüste* (Mainz: 1902). C. M. Kaufmann, *Handbuch der christlichen Archäologie* (Paderborn: 1913), pp. 161–164, 258, 278–280. (Hereafter cited as *Handbuch*.) A. Fakhry, *The Necropolis of El-Bagawāt in Kharga Oasis* (Cairo: 1951). (Hereafter cited as *Bagawāt*.) H. Stern, "Les peintures du Mausolée de l'Exode à El-Bagawāt," *Cahiers Archéologiques*, Vol. 11 (Paris: 1960), pp. 93–119. J. Schwartz, "Nouvelles études sur les fresques d'El-Bagawāt," in *Cahiers Archéologiques*, Vol. 13 (Paris: 1962), pp. 1–11. (Hereafter cited as "Fresques d'El-Bagawat.")

45. A. Grabar, *Martyrium*, Vol. 2, pp. 20–21.

sented on the east side proceeding northward, while the pursuing Egyptians are on the west, conforming to their actual orientation, a trait characteristic of ancient Egyptian compositions. The consistent use of projection devices that could pertain to the primitive character of this style or to debased reminiscences from Egyptian draftsmanship, such as the showing of cross sections (Noah's ark, Daniel in the den, Hebrews in the furnace); the composite architectural projection (side views adjoining the façade of the temple of Jerusalem); the preponderance of lateral views of figures drawn in line with flat coloring reminiscent of the typical Egyptian stance—all should be interpreted as characteristics of an art more conversant with native sources than with late-antique ones. This interpretation is corroborated by the Egyptian type of the façade. The repertory is entirely derived from the Old Testament, except for the seven virgins and Thekla's martyrdom from the Apocrypha. The scenes of Rebecca at the well and Isaiah's martyrdom are unique in funerary murals throughout the early Christian world, but the others occur in pre- and post-Constantinian Roman catacombs (A.D. I–III),[46] Alexandria or even Thebes seem very far away indeed. The symbolism of Christian salvation is implied in most themes, as in the cycle in the catacombs and on the sarcophagi.

The second chapel (80), as small as that of the Exodus, located at the southern edge of the necropolis with a southern entrance, is here called the

"Chapel of Personifications" after the three figures labeled Peace, Righteousness, and Prayer that appear among Old Testament scenes. The orderly composition of its dome paintings, which consists of concentric rings delimited by red bands, contrasts with that in the Exodus chapel. No such bold composition is known elsewhere in early Christian art; the single zone of radial figures in the catacomb of SS. Pietro and Marcellino (Rome, early A.D. IV) forms a cruciform design with compartments echoing the illusionistic architectural schemes in Pompeian painting. The two inner rings (Fig. 4.16) are decorated with grapevine scroll on a pentagonal pattern and a floral wreath, while the outermost ring consists of scenes from the Old Testament and figures of Mary, Paul, and Thekla set radiating and juxtaposed without separating elements. The figures are standing or seated, occupying the full height of the zone, their names in white in the upper border. An outer ring of wreath frames the entire cupola, springing from four spherical triangles, each painted with a peacock fanning out its circular tail while standing on a globe. The effect of this well-designed structural scheme, in which the four dark-red peacock tails balance adequately the red outermost zone and form a contrast with the buff inner zones and the whitewashed walls, must have been impressive. The figures in a rather static *contrapposto* stance are reminiscent of Lysippus' statuary and of the early Ptolemaic hemicycle of the Greek poets and philosophers near the Serapieion at Saqqara, or of the style to be found in murals in Hellenistic (tombs in Alexandria) and Roman (Hermupolis West, Alexandria) Egypt.

Moreover, there is here also no apparent sequence: starting with Adam and Eve, who are standing on either side of a slender plant with the serpent, and proceeding clockwise, one encounters Abraham ready to sacrifice Isaac while a diminutive Sarah in the background stretches a pleading arm balanced by the large red hand of God, *Eirenē* ("Peace") as a woman naked except for a kilt and holding a *crux ansata*, Daniel in the den flanked by two lions, *Dikaiosunē* ("Righteousness") as a fair-haired woman clad in purple holding a balance and a cornucopia, *Euchē* ("Prayer") as a praying woman in white garments and veil, a much smaller frontal Jakob praying, Noah's ark and its dove, Mary shown frontally at prayer, and Paul seated writing on the tablet of Thekla in front of him. The repertory includes a few scenes already found in the chapel of the Exodus to which is added that of Sarah, with figures predominating over dramatic representations. All the figures are frontal, even Paul and Thekla, the only two seated, who, however, are represented with the lower limbs in side view. Those at prayer are symmetrical, holding both hands with palms turned outward in front of the breast (Daniel, "Prayer," Jakob, Noah's family, Mary). The others in *contrapposto* stance show varied calm gestures, even Abraham and Isaac, both clad in white after the typical Roman treatment contrasting with the Syrian and Egyptian violent action pervading the whole scene as represented on Egyptian and Syrian monuments. The rendering follows the Greco-Roman modeling of forms enhanced by darker hatching. The only sporadic effects of perspective, found

46. C. M. Kaufmann, *Handbuch*, pp. 299–300, 310–312, 329. A. Grabar, *Martyrium*, Vol. 2, p. 21. T. Klauser, "Entstehungsgesch. der Christlichen Kunst IV," Vol. 4 (1961), pp. 133–135.

in the two stools and Thekla's tablet, do not enliven the hieratic effect of the composition, emphasized by the representation of two cross-sectional interiors (lions' den, ark) and by the absence of background setting, which is replaced by a uniform red brown with a sprinkling of quatrefoils and stylized slender stems sprouting from the ground. Here also the hair is uniformly fair. The mixed personifications of a virtue (Righteousness) and abstractions (Peace, Prayer) derive from the classical representations in murals and mosaics of cardinal virtues of Plato and Aristotle, official virtues of the emperor, abstractions such as "Error" and "Problem" at Hermupolis West), or seasons.[47] Allegory, allegoristic,[48] and personification were used in Egyptian literature and illumination, and personifications appeared in Egyptian figural scenes to represent estates, nomes, or abstract concepts such as Knowledge (sia) and Truth (maʿt). The splendid peacock adds to its decorative value the symbolic implication for eternity in paradise, derived from the apotheosis of the pagan emperor[49] and prominent personages (as in the Ptolemaic hemicycle at Saqqara). The various episodes are to be interpreted in terms of Christian salvation. The Personifications Chapel ranges among the outstanding achievements of Early

Christian painting in Egypt, still pertaining stylistically to the best late-antique art though related ethically to the early Christian world. It compares favorably with contemporaneous Early Christian art abroad. The interpretation of Mary's Annunciation through a dove near Noah who receives the good tidings of the end of the flood from a second dove fluttering in a direction opposite that of the former one has been considered symbolic of the revival of the covenant of God with His people. Whether the representation of "Peace" just above the entrance is meant to convey her message and may be regarded as the earliest personification of the funerary peace formula, or whether that of "Prayer" is an initiation to a funerary spell expressed by the whole cycle are matters of controversy.[50] It has been suggested that the painters at Bagawat copied from glass cups decorated with golden scenes.[51] The quick diffusion of the catacombs' repertory, essentially copied at Bagawat, to the East and the West—for instance the scenes of Adam and Eve, the paralytic, and the Samaritan woman at the well appearing concurrently in the Roman catacombs and in the Christian chapel at Dura Europos—has been ascribed to the use of models from engraved gems that could be transported easily.[52]

Other mural paintings of lesser importance exist at Bagawat. In one of the chapels (25), sometimes interpreted as a monastic complex, there is besides

the scant remains of a scene with an antelope in a niche an impressive geometric pattern on the apse in the front hall (Fig. 4.17); this pattern is composed of red quatrefoils in an isometric mesh of red and yellow squares imparting an illusionistic effect already known in Hellenistic mosaic pavements in Egypt and abroad.[53] The painted decoration of the inner hall was never finished, but on the walls are the poorly preserved sacrifice of Abraham and probably Thekla and Paul, a subject recurring thrice in the necropolis. The dome springs from above phoenixes with outstretched wings standing on a globe in the four spherical triangles (Fig. 4.18), and its outer ring shows a wreath with quatrefoils around a central circular area of radiating imbricated pattern treated also in an illusionistic three-dimensional way in yellows, blue, and red-browns, a motif known in mosaics of Hellenistic and Roman Egypt,[54] Pompeii, and later in Coptic monasteries (Bawit). Floral motifs, mostly grapevine in wiry tendrils and leaves, in one example simplified into Christ's monograms, and inhabited by flying Erotes (No. 210)[55] occur on vaults (Nos. 172, 173, 175) and niches (No. 210), while vine interlace curves along the archivolts (No. 210). In addition to an unidentified defaced scene (No. 210) and the external one already studied (No. 175), the crux ansata and the phoenix (Nos. 175, 210) occur independently or above the head of a saint

47. G. Downey, "The Pagan Virtue of Megalopsychia in Byzantine Syria," Transactions of the American Philological Association, Vol. 76 (1945), pp. 281–286. C. M. Kaufmann, Handbuch, pp. 276–280.
48. J. G. Griffiths, "Allegory in Greece and Egypt," JEA, Vol. 53 (London:1967), pp. 79–102.
49. C. M. Kaufmann, Handbuch, pp. 283–284

50. Ibid., pp. 278, 280.
51. J. Schwartz, op. cit. "Fresques d'El-Bagawāt."
52. T. Klauser, "Entstehungsch. der Christlichen Kunst, IV," pp. 139–140.

53. B. Brown, Ptolemaic Paintings, pls. XXXVIII-XXXIX.
54. Ibid., pl. XLI, pp. 74–76.
55. C. M. Kaufmann, Handbuch, p. 292, Fig. 113. Erroneous drawing and description, as vine leaves only in A. Fakhry, Bagawāt, Fig. 83, pl. VIII, middle right, p. 97.

4.16
Paintings on the cupola of the Personifications
Chapel at Bagawat, (Chapel 80; A. Fakhry,
Bagawāt, pl. I.)
4.17
Mural with geometric pattern at Bagawat.
(Chapel 25; A. Fakhry, *Bagawāt*, pl. VI.)

4.18
Painting of imbricated pattern on cupola and a
phoenix in one of the four spherical triangles
beneath.(Chapel 25; A. Fakhry, *Bagawāt*, pl.
VII.)

4.19
Mural representing St. Peter painted over
Egyptian relief in the cella of the temple at Wadi
El Sebu'a. (U. Monneret de Villard, *La Nubia
Medioevale*, Vol 2, pl. XLII.)

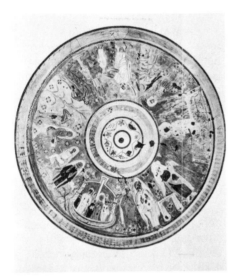

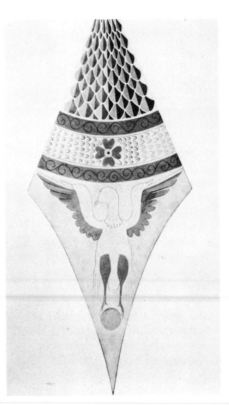

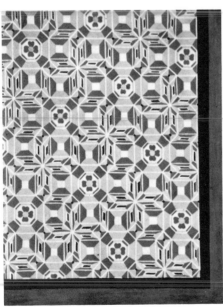

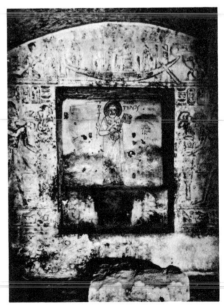

(No. 210). The colors are mostly yellows, red-browns, dark purple, sometimes greenish blue on a creamy or white ground.

The repertory of the murals at Bagawat forms a valuable link between the funerary figures of the oratories and the decoration of monastic oratories deprived of any funerary purpose. The portraits of Biblical patriarchs and Paul and Thekla foreshadow the dense rows of saints represented at Bawit and Saqqara.[56]

From the early period, especially in the reign of Theodosius (A.D. 379–395), date also some of the paintings with which the Copts covered the walls and columns of the Egyptian temples where they installed their churches after covering their low relief with a coat of plaster. The columns offer an adequate vertical field for full-length figures of saints (Thutmose III festival temple at Karnak), a motif that was retained in the basilicas they built later (Saqqara). The figures were always frontal, often in a careful draftsmanship and coloring. More often than not the coat of plaster entirely hid the Egyptian figures, or only their faces, while the rest of the decoration was respected. It seems, however, that in certain cases the Coptic artist tolerated the *status quo* and incorporated his paintings into the Egyptian murals in such an expedient composition that the saints now receive the offerings presented by Pharaoh to the former gods (St. Peter at Sebu'a; Fig. 4.19). This Coptic compromise with Egyptian murals is proved by an Egyptian scene in relief where the central figure only was recarved into

the frontal bust of a saint still flanked by the protecting Horus and Hathor in the composite lateral projection (Fig. 3.73).[57] Such a procedure left its impact upon Coptic art in the characteristic juxtaposition of vertical elements, usually standing figures, and in the fusion of Egyptian and late-antique styles (frontal figures with lateral ones),[58] as in the Baptism of Christ at Bawit.

We have seen how the anchorite who settled in converted Egyptian tombs (see Fig. 2.6) and caves painted on the walls Christian motifs, sometimes only a row of crosses (El Bersha) or line drawings of boats and desert animals (Abydos D 69), at other times quite elaborate scenes of an excellent style with symbolic implications, such as unicorns and rider saints spearing dragons (tomb of Urarnu at Sheikh Said), a large bird with threefold wings and a halo around its head, vertical bands of foliate ornament in a sophisticated naturalistic late-Roman style, and an angel (tomb of Panehsy at 'Amarna.)[59] Often, however, the style is little but folk art, including sketchy frontal figures and lateral views of animals in a hasty line painting (tomb near Sohag),[60] similar to those intrusive sketches occasionally daubed on the walls of his cell by some monk ignorant in the art of painting (Saqqara, Aswan).

56. A. Grabar, *Martyrium*, Vol. 2, p. 24.

57. U. Hölscher, *The Excavation of Medinet Habu, V.* (Chicago: 1954), pl. 34 J. (Hereafter cited as *Medinet Habu, V.*)
58. W. de Grüneisen, *Caractéristiques*, p. 39.
59. Alexandre Badawy, "Les premiers établissements chrétiens dans les anciennes tombes d'Egypte," *Publications de l'Institut d'études orientales de la Bibliothèque Patriarcale d'Alexandrie*, No. 2 (Alexandrie: 1953), pp. 16–17, 20, Figs. 9, 11–13, 20.
60. W. de Bock, *Matériaux*, pl. XXIX, 1, 2.

Monastic Painting

A new era starts with the decision of the Christian Church in Egypt to secede from Constantinople, a decision resulting from disagreement with the decrees of the Council of Chalcedon in 451 and the gradually increasing dislike of Byzantine rule. The monks and with them the whole native population followed Dioscorus, patriarch of Alexandria and protagonist of the Monophysite doctrine of Eutyches, though bishops of the orthodox Church of Constantinople were still sent by the emperors. Art had to live upon its own traditions, deprived as it was of any revival or creative impulse from Constantinople. The Gnostic movement, which found a favorable environment in Upper Egypt (at Chenoboschion), and Manicheism introduced from Persia—the Persians ruled ten years from 619—brought in oriental elements, mostly Sassanian. The secession proved, however, to be a minor factor that did not impede the native art in its vigorous growth from the middle of the fifth century, characterized by a modified provincial style, upheld by the nationalist Church clinging to its liturgy of St. Basil. This self-recognition of an independent ethnical and cultural entity, called Coptic after the Arabic name, manifests itself in painting with the formation after the fifth century of an iconography that develops fully in the next two centuries.

The extant evidence of Coptic painting does not in any way represent the achievement of the period, for most of the churches were damaged or even destroyed more than once after the Arab conquest and their paintings were the first to suffer. The only ones to survive

are those in the monasteries uncovered through excavation.

The earliest painted underground church at Deir Abu Hennis,[61] 4 km. south of Antinoë opposite Hermupolis, consists of three halls in an ancient quarry. In one hall a continuous frieze bordered at its bottom by bands, one with an illusionistic scroll in red, yellow, and blue, and at its top by a floral pattern, runs along the undressed walls just beneath the ceiling. Though badly defaced and partially destroyed, the scenes can be identified as those of the Massacre of the Innocents in a continuous narrative, followed by the Slaying of Zacharias kneeling, the Appearance of the angel to Joseph, and the Flight to Egypt (Fig. 4.20). Opposite are twelve saints. In the second hall is a scene representing Christ with a baton changing water into wine at Cana and the Resurrection of Lazarus—a simplified version of Prudentius' twenty-five scenes from the New Testament (A.D. V).[62] The colors were applied on a yellow ground on coarse bedrock graded to blue for the sky, first the local tone followed by the red outline and finally by the details. This coloring has been termed "oriental" (Grüneisen). The figures are conspicuous for their good proportions and alert movement and the scenes for their chronological sequence and composition. They stand the full height of the frieze in rapid pace (Massacre, Flight to Egypt) or in a

frontal slightly *contrapposto* stance (even Herod on his throne, kneeling women). The baton, set also in the hand of the prophet Samuel choosing David (Bawit, Chapel III),[63] is a characteristic sign of authority in Coptic iconography, as it had been in ancient Egyptian murals and statuary. The perspective of the hall at Cana with its excellent foreshortening in the radiating pattern of the dome, the pillars, and hangings around the circular area, as well as the setting of the personages, is indeed a unique achievement *per se* to which the scene of Lazarus is second. The latter is more naturalistic than those representing this event in the Roman catacombs.[64] The least impressive is the cycle of Zacharias, obviously inspired as was that of the Massacre from the Apocrypha. The importance ascribed to the scenes from the infancy of Christ and especially those representing Zacharias, even including the episode in which he is slain by the servants of Herod in front of the mountain refuge of his wife Elizabeth and his son John, is specifically Coptic and reminiscent of another, though later, monastic art in the rock-cut churches and cells in Cappadocia (A.D. VIII).[65] It is believed that the Cappadocian style, so different from the Byzantine tradition and relying heavily on the Apocrypha with the representation of Mary and the saints, the

use of inverted perspective, was inspired by the illuminated manuscripts of Syria.[66] As for Deir Abu Hennis, a date of the sixth or seventh centuries,[67] ascribed on the evidence of the twelve saints, could hold good for these and for the second hall, but it is too late for the Christological cycles, which still pertain both as to style and iconography to late-antique traditions, perhaps fifth century, derived from an illuminated papyrus.[68]

Lingering late-antique influences are also apparent in the mural paintings staged over three centuries of the Coptic monastery of St. Apollo at Bawit (A.D. VI–VIII),[69] twenty kilometers south of Hermupolis West, southwest of Deir Abu Hennis and Antinoë. From the remains of the sparse groups of buildings (p. 43) one can only imagine the profuse mural painting that had once covered plastered mud brick and even part of the stuccoed limestone in both north and south churches. In the south church above a dado imitating incrusted panels and geometric patterns and framed at the top and bottom by carved wooden inset beams are a

61. J. Clédat, "Notes archéologiques et philologiques," *Bulletin de l'Institut Français d'Archéologie Orientale*, Vol. 2 (Cairo: 1902), pp. 44–54, pls. I–V. W. de Bock. *Matériaux*, pl. XXXIII.
62. C. M. Kaufmann, *Handbuch*, pp. 439–440.

63. J. Clédat, "Le Monastère et la Nécropole de Baouît," *MIFAO*, Vol. 12 (Cairo: 1904), p. 18.
64. C. M. Kaufmann, *Handbuch*, Figs. 86, 87, 89.
65. S. Der Nersessian, "Some Aspects of Coptic Painting," in *Coptic Egypt* (Brooklyn: 1944), p. 45. (Hereafter cited as "Coptic Painting.") O. M. Dalton, *Byzantine Art and Archaeology* (Oxford: 1911; reprint, New York: 1961), pp. 267 ff. (Hereafter cited as *Byzantine Art*.)

66. P. Lemerle, *Le Style Byzantin* (Paris: 1943), p. 82.
67. J. Clédat, "Notes"; C. M. Kaufmann, *Handbuch*, p. 461; P. du Bourguet, *L'Art Copte*, p. 39.
68. W. de Grüneisen, *Caractéristiques*, p. 96. See also G. Steindorff, *Egypt* (Baedeker) (Leipzig: 1929), p. 222.
69. J. Clédat, "Le Monastère." E. Chassinat, "Fouilles à Baouît," Vol. 1. *MIFAO*, Vol. 13 (Cairo: 1911). J. Maspero and E. Drioton, "Fouilles exécutées à Baouît," *MIFAO*, Vol. 59 (Cairo: 1932, 1943). (Hereafter cited as "Baouît.") Cabrol and Leclercq, *Dictionnaire*, Vol. 2, part 1, cols. 220–250. Throughout the text the numbers between parentheses indicate the excavator's designation of the rooms.

series of standing figures for the most part poorly preserved except for the representation of Christ flanked by two groups of disciples, just beneath the round window in the rectangular apse, and in the northern apse the bust of the Virgin inside a medallion, the floral interlace on the archivolt, and the band interlace on the lower frieze. In the north church columns are painted with saints, Christ, the Virgin and Child, King David, St. George in military garb, and the archangels Michael and Gabriel. Church painting, as exemplified here, is characterized by an able technique, a search for expression, ample accurate draftsmanship, and elegant supple lines, though figures are strictly frontal and juxtaposed. The rooms, many being oratories, uniformly labeled "chapels" by the earlier excavator Clédat, sometimes have walls articulated with niches often opposed symmetrically (XXVIII, XXXII, XLIII). Only a few of these, covered with half a cupola, oriented east, and decorated with Christ Pantocrator above the Virgin and Apostles can be called altar apses (6, 20). Dadoes are the most extensive painted areas; these feature geometric patterns (Fig. 4.21) topped with a frieze sometimes combining scenes or animals in separate panels (III, VII, XXXVII, XXXVIII, 18), busts within floral interlace (XII), busts in medallions alternating with birds in lozenges (XVIII) or within circular or octagonal medallions applied on a geometric background (XVIII). The pattern of the dado may be a diamond grid enclosing leaves (III, XXXVIII) or extremely intricate geometric designs derived from incrustation in independent panels (6), always flat; illusionistic scroll, fret (see Fig. 4.20), or floral

bands and intertwines are reserved for the upper frieze (XXVIII, XXXIV, XXXV, XXXVIII, XXX, III, VII, XIX, 40) or the intrados of niches (XXXII Fig. 4.22). There is often one or more bands between dado and upper frieze treated as a low orthostat and an intricate guilloche combined with rings represented plastically with one edge hatched (XIX, XXVII; Fig. 4.23) or continuous scroll interlace topped with a floral scroll (XIX). Walls may be whitewashed, while the lower parts of vault and cupolas are painted. Constrasting with Deir Abu Hennis, there is no apparent scheme underlying the distribution of subjects. Series of saints and monks appear with Biblical scenes or genre motifs characterized by their movement and perspective borrowed from Alexandrian picturesque repertory: lion hunt (XII), gazelle (XXXVII; Fig. 4.24), hippopotamuses (XXXVII), winged Eros playing with panther (XXVIII). Both scale and motifs are flexible items adapted to the architectural lines defining the painted area. In scenes on tympanums (XXVI) or broad archivolts (XVII) figures—Gospel personages, always barefoot—or riders decrease in stature toward the angles which are occupied by an animal (lion, XXVI, stag, elephant, duck) or a vase planted with vine (XIX), and less successfully by a bust (XVII) or a medallion (XXVI). Rider saints fill adequately the spherical triangles of pendentives (XVII), and two flying angels carrying a medallion appear in the spandrel above the arch (XVIII). Most of the backgrounds are left white with a slight indication of a brownish band for the ground from which sprout

slender stems (XVII, XVIII) or, surprisingly, Egyptian lotus flowers (XVII west) between the figures and horses. Elsewhere a solid green screen rises to shoulder level behind the figures (XXVIII), also treated as spotted shrubs (XVII, XXVIII) or even imitating an orthostat (XXVIII).

Though less varied, the iconography conforms to the Byzantine themes consisting of representations from the Old and New Testaments, saints, fathers, using real and symbolic elements such as the dove, peacock, stag, elephant, duck, serpent, and lamb (only once). It appears that scenes including bloodshed, such as the Crucifixion or martyrdoms, are taboo, while the Massacre of the Innocents appears only once (XXX). As in Prudentius' canon the scene of Christ in majesty, or theophany-vision, in several variants is reserved for the apse.[70] In five examples the composition is in two registers. In the upper one Christ holding the gospel and blessing is seated on a gemmed throne within a circular *mandorla* from which radiate four oval protrusions enclosing within their layers the symbols (*zodia*) of the four evangelists (after the vision of Ezekiel, 10: 9–14); this latter is perhaps a Coptic invention,[71] since the Book of Revelation had been included by St. Athanasius and St. Cyril in the

70. A. Grabar, *Martyrium*, Vol. 2, pp. 207, 234.
71. *Byzantinische Zeitschrift*, Vol. 15, p. 702. They occur on the mosaic of S. Pudenziana (A.D. IV), S. Sabina, S. Maria Maggiore, Galla Placidia at Ravenna.

4.20
Painted frieze with continuous narrative from the
Christological cycle at Deir Abu Hennis. (J.
Clédat,"Notes archéologiques et philologiques,"
BIFAO, Vol. 2 [1902], pls. I–V.)
4.21
Restored perspective of Hall 8 at Bawit.

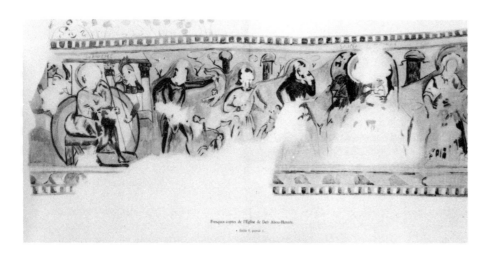

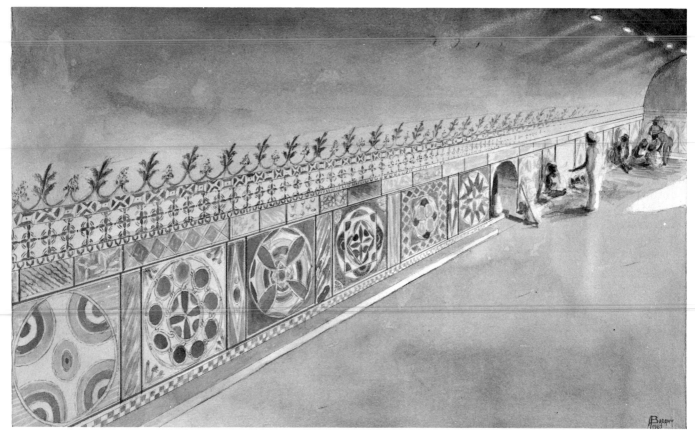

4.22
Types of painted bands on intrados of niche.
(Bawit, Chapel XXXII; J. Clédat, "Le Monastère,"
MIFAO, Vol. 39 [1916], Vol. 2, part 1, pl. XI.)

4.23
Band with guilloche above dado. (Bawit, Chapel
XIX, W; J. Clédat, "Le Monastère," Vol. 1, part
2, pl. LXXVIII.)

4.24
Mural representing a gazelle hunt. (Bawit,
Chapel XXXVII, W; J. Clédat, "Le Monastère,"
Vol. 2, part 1, pl. XVII.)

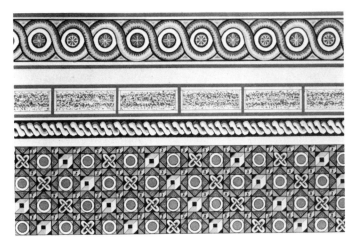

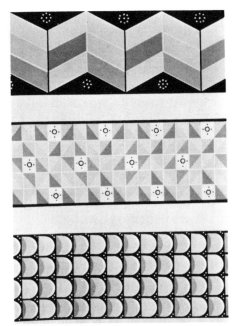

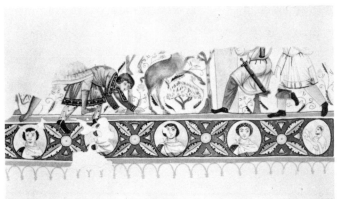

canon of Alexandria before it was accepted by Constantinople. Christ is usually bearded after the oriental type (XLV, LI, 6, 20; Fig. 4.29), except in two scenes: in one (XVII) He is alone flanked by the busts of the sun and the moon on a sprinkling of stars (20)[72] with two bowing angels presenting a crown, as in the Rabula codex only (Acts 1: 9–11; in XVII, 6); in the other (III) He is accompanied by St. Peter holding the Host and by St. Paul with the chalice, a scene reminiscent of the presentation of eulogies in Karmuz (p. 241) and in Roman catacombs. In the lower register a seated Virgin holds the Child accompanied by the archangels Michael and Gabriel; Apa Apollo, "friend of the angels" (III); or among the Apostles and two monks (6). The Virgin stands also as an *orans* among the Apostles against a high background of greenery (XVII; Fig. 4.26), or in one front row behind which appear the torsos of other personages and the two archangels (20; Fig. 4.27). In the latter variant there is no separating line, both scenes of Christ and the Virgin's group forming a single composition with some claim at perspective through its staging of figures, probably an interpretation of the Ascension after the Syrian tradition or of the Eucharistic prayers with the intercession of the angels, the Virgin, and the saints. The upper scene in the apse represents the direct epiphany-vision, recalled in the bottom register by the essential theophany of Incarnation expressed by the Virgin Theotokos.[73] Beneath the

scene of the eulogies (XLV) the prophet Ezekiel in Thracian or Iranian garb instead of the Virgin ascends with head upraised, his right arm outstretched toward Christ, while the Apostles express their awe in a variety of spirited gestures forming a unifying factor.

Second to this subject of the apse and replacing it as a variant of God's manifestation is that of the Virgin seated suckling the Child against a background of stylized stems and giant flowers (30) or holding the Child, accompanied by Gabriel and holy fathers (among them Apollo and Jeremias) holding a crown and a cross (Chapel III), or in an interesting variant where the Virgin presents an oval medallion portraying the Child (XX-VIII; Fig. 4.28; A.D. V–VI), a symbol of the Incarnation. The origin of this treatment, also found at Saqqara (1723), can be traced back to imperial iconography, where a seated Victory holds on her knee an oval shield sculpted with the portrait of a magistrate (diptych of the consul Basil in Milan, A.D. 480).[74] One of the best scenes at Bawit represents the Virgin seated near a beardless Christ explaining the law to a group of saints (LIX).

Christological scenes are relatively rare. There seems to have been in one chapel (XXX) a cycle similar to that at Deir Abu Hennis: Massacre of the Innocents, Annunciation to Joseph, Baptism, Last Supper and Miracle at Cana (rest of register destroyed). Here

also there is a strong late-antique flavor in the attire, natural postures, harmonious hues, character in faces, and expressive realism, especially in the massacre. In the two scenes of the Baptism of Christ, though Christ once appears bearded (XVII) instead of as a young man (XXX, Fig. 4.29), there are common features as to elements (Roman personification of the Jordan, archangel holding garments, Christ smaller in stature than other figures) and in composition (Egyptian device of the *rabattement* of a water creek, Christ in frontal view while St. John and the archangel are in lateral views). Compared to the interpretation in the catacombs, these at Bawit are full of originality and vigor, a comparison that holds for the Last Supper similar to that in St. Apollinare Nuovo. The early personification of the Jordan in the West occurs in the mosaics of the Baptistery at Ravenna. Also represented are the Annunciation (LI), Visitation (LI), Departure from Elisabeth's house (LI), Nativity (LI), and Transfiguration (XIII).

Scenes from the Old Testament are rare, mostly from the cycle of David represented as a young cupbearer (Chapel XXXII) filling a cup with a ladle, a rare item probably derived from some lost Apocryphal text. Twelve small square panels one cubit side in the upper frieze above a dado (III) deal with David's youth. Here appear Samuel near Isaiah, father of David, the choice made by Samuel of David (Fig. 4.30), the introduction of David to Saul, Saul threatening with his lance David, who plays the lyre, Saul encouraged by David to enter the combat, the

72. About stars, sun, and moon, cf. Cabrol and Leclercq, *Dictionnaire*, Vol. 1, part 2, cols. 3013–3033.
73. A. Grabar, *Martyrium*, Vol. 2, p. 213.

74. *Ibid.*, pp. 176, 227. R. Delbrück, *Konsulardiptychen und verwandte Denkmäler*. (Berlin and Leipzig: 1929), pl. VI.

4.25
Painting in niche head representing Christ in majesty. (Bawit, Hall 6, E; J. Maspero and E. Drioton, "Fouilles exécutées à Baouît," *MIFAO,* Vol. 59 [1932, 1943], pl. XXII.)

4.26
Painting in apse representing Christ in majesty above the Virgin and the Apostles. (Bawit, Chapel XVII; J. Clédat, "Le monastère" Vol. 1, part 2, pl. XLI).

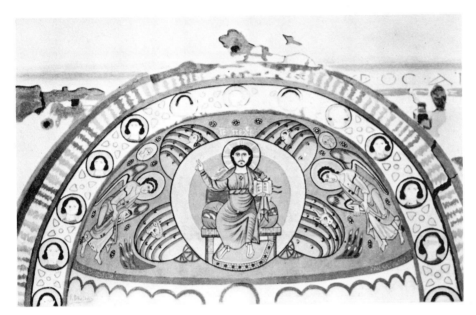

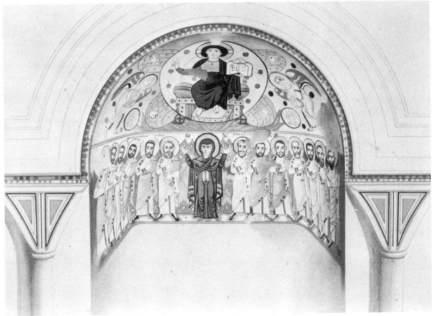

4.27
Painting in apse representing Christ in the *mandorla* above the Virgin and the Apostles. (Bawit, Hall 20; J. Maspero and E. Drioton, "Baouît" pl. XXXII).

4.28
Painted flat niche head representing the Madonna holding an icon of the Child. (Bawit, Chapel XXVIII; east apse; J. Clédat, "Le Monastère," Vol. I, part 2, pl. XCVIII).

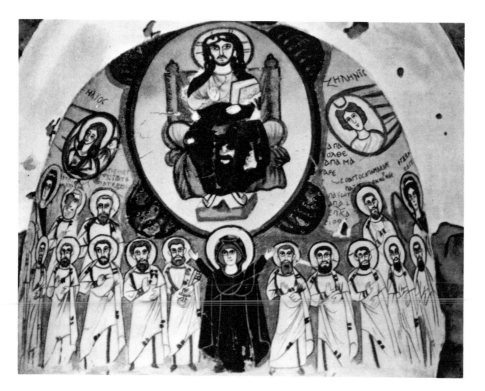

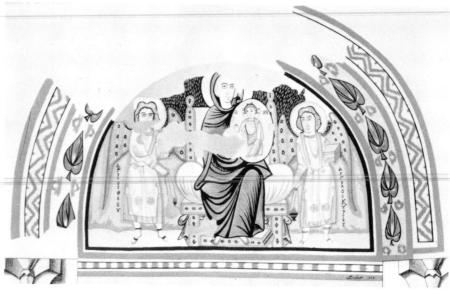

4.29
Mural representing the Baptism of Christ.
(Bawit, Chapel XXX, N.; J. Clédat, "Le
Monastère," Vol. 2, part 1, pl. IV.)

4.30
Mural painting representing Samuel choosing
David. (Bawit, Chapel III, N; J. Clédat, "Le
Monastère," Vol. I, part 1, pl. XVII.)

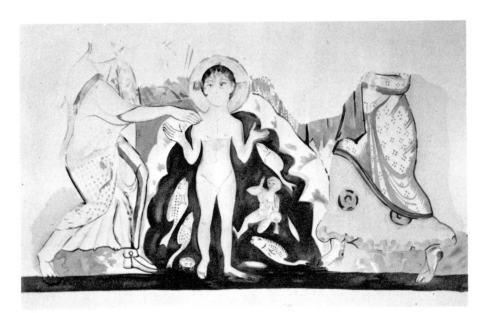

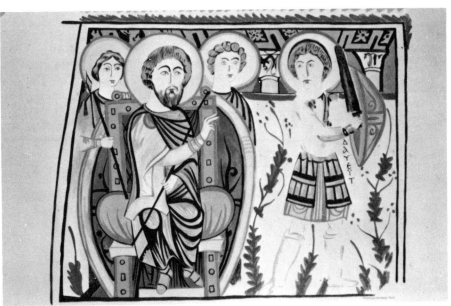

fight between David and Goliath, the victory of David over Goliath and the meeting with the priest Abimelek, (3 destroyed scenes), Jonathan informing David of his father's intention against his friend. The cycle is dated to the eighth century on such stylistic grounds as the schematic composition, garish color, floral interlace separating the scenes similar to that in Umayyad pavillion at Quseir 'Amra, and also by other features such as the pointed beard characteristic for Arab faces, the pendant mustache of Goliath and the onlookers, the Byzantine weapons of Saul and David, the Persian costume of Goliath, as well as surrounding the scenes with a wooden frame as at Khirbet el Mefdjer.[75]

The importance of this cycle is marked by another scene representing David as an aged king addressing three young men standing in front of the palace portico (XXXIV). The typological value of David's victory appeared as early as the third century in the baptistery at Dura. A similar date in the eighth century might also be ascribed to the scene of the prophets, each of whom is standing and holding in his left hand a scroll inscribed with David's prophecies and raising his right hand in a blessing; in the background slender stems (XII) flank a larger figure (Christ?) above a frieze of busts personifying virtues. This is quaintly allied with a lion hunt or the allegorical figure of St. Sybil (XLII). An unusual interpretation of the cycle of the Three Hebrews shows them as three children whom the large angel who rescued them holds in front of his

75. P. Du Bourguet, Die Kopten, pp. 166–167.

breast (30), a unique and quite original[76] composition, symmetrical and conforming to native monastic painting using a conceptual approach akin to that of Egyptian art. The closest parallel would be that in the Nubian chapel at 'Abd el Gader, where the angel appears behind the young men standing in the fire in a pyramidal symmetrical composition (see Fig. 2.34).[77]

Mythological subjects (XVIII) are illustrated with Orpheus in Thracian costume playing a lyre. Pagan elements from the late Roman repertoire are a child with a gazelle against an octagonal arabesque or a winged Eros riding a griffin and Erotes hunting the hippopotamuses, a frequent scene in late-Roman iconography.

Most numerous are saints, martyrs, and monks represented as isolated figures holding the gospel, juxtaposed mechanically, their haloes and feet even overlapping one another (Fig. 4.31). To reduce monotony the painter has, however, alternated a white-haired figure in yellow mantle with a dark-haired one in purple. Rider saints occur frequently in groups of four flanking antithetically an *orans*, a male (XXVI) or female Amma Askla (LVI), or two riders (LI), or isolated on pendentives (XVII) as Victor and Phoibammon

76. Cf. C. M. Kaufmann, Handbuch, pp. 323–324. Alexandre Badawy, L'Art Copte. Vol. 1. Les Influences Egyptiennes (Cairo: 1949), p. 55, Fig. 42.
77. W. F. von Bissing, "Die Kirche von Abd el Gadir bei Wadi Halfa und ihre Wandmalereien," Mitteilungen den deutschen Instituts für Altertumskunde in Kairo, Vol. 7 (Cairo: 1937), pp. 128–183; see p. 174, pls. 23 b, 24 a, (Hereafter cited as "Die Kirche.") Alexandre Badawy, L'Art Copte. I. Les Influences égyptiennes, p. 50, Fig. 37.

receiving the crown of martyr. The most impressive is St. Sisinnios[78] spearing a half-naked woman, Alabasdria, prone beneath his horse. (Fig. 4.32). She is the personification of evil. This group is flanked by sparse elements symbolic of Hellenic paganism (right: centaur, winged nymph, "daughter of Alabasdria") and of Egyptian paganism (left: lion and cheetah, canopus, crocodile, ibis plucking at two serpents and a scorpion pinned down by a knife, obviously inspired by the theme carved on the popular stelae of Harpokhrates mastering the serpents, scorpions, and crocodiles). This Sisinnios shown here in Thracian costume had revealed to Archelaus the secret of Manichean teachings, thus enabling him to defeat Mani in a debate. Could this episode be hinted at in the representation of Sisinnios defeating both aspects of paganism ? The theme has been considered as Syro-Palestinian. Other personifications similar to those displayed in imperial Rome on low reliefs, statuary, and coins represent the Jordan as a man in three-quarters (XVII, XXX) emptying a water jug, reminiscent of the Danube on Trajan's column, and the Holy Mother Church as a bejeweled female bust (XVII) in the angle of a tympanum, or virtues and abstractions in a floral frieze. The popularity of the motif of the rider has been attributed to the importation by the imperial army of

78. W. de Grüneisen, Caractéristiques, pp. 65 ff. A. Badawy, L'Art Copte. I. Les influences égyptiennes, pp. 57–59, Fig. 43. P. Perdrizet, "Peregrinatio perambulans in tenebris," in Publications de la Faculté des Lettres de l'Université de Strasbourg, Vol. 6 (Strasbourg: 1922), pp. 13 ff.; "Coptic Painting," S. Der Nersessian, pp. 46–47; A. Grabar, Martyrium, Vol. 2, p. 302.

4.31
Mural representing two apostles and a monk.
(Bawit, Hall 6, E; J. Maspero and E. Drioton,
"Baouît," pl. XXIV.)

4.32
Mural representing the rider St. Sisinnios
spearing Alabasdria. (Bawit, Chapel XVII, W,; J.
Clédat, "Le Monastère," Vol. I, part 2, pl. LVI.)

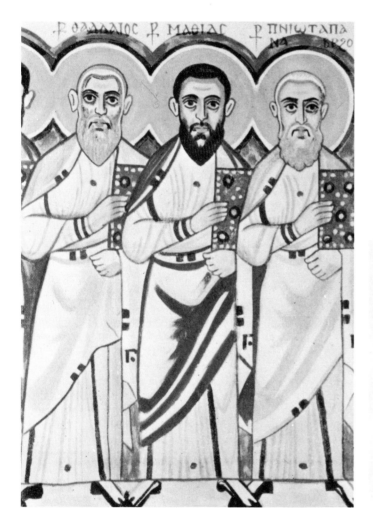

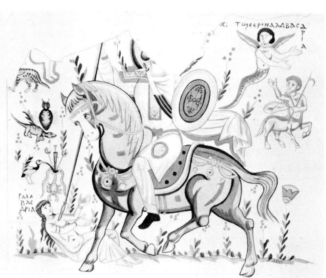

numerous contingents from Thracia who would have brought in the Thracian rider-god Heron. There is no reason to seek such a farfetched explanation; the Ptolemaic kings, true Macedonians, are represented on their edict stelae[79] riding horses, and even the Egyptian god Horus rides one when spearing his primeval enemy, the god of evil Seth in the shape of a crocodile. This is certainly the prototype of the Coptic rider saints.

In one of the rooms in the nuns' quarter (42) an excellent line drawing represents three rats appearing as ambassadors well-equipped with flag, papyrus scroll, authority staff, wine ewer, and decanter, before a highly suspicious cat—a spirited scene well in the tradition of Egyptian grotesque in Ramesside illuminations.[80]

The painting technique at Bawit,[81] using distemper with slight gum resulting in scaling and discoloring, featured an initial sketch in yellow on a white, rarely yellowish, ground further outlined in red, onto which were added the fleshy areas, costumes, shadows in green and blue, and drapes and modeling in red, black, or yellow.

For an idea of the distribution of paintings let us consider Hall 1, perhaps the refectory chapel, which though atypical and probably late (A.D. VIII) is interest-ing because of its original decoration. Only the east wall is painted. What remains is not the earliest scheme and does not show a strict composition. The niche is surrounded by a slightly protruding frame featuring two engaged colonnettes carrying simplified capitals (Fig. 4.33). It is the densest area in the decoration. On the semicupola are represented (from the left) a seated Virgin accompanied by a standing angel holding a green globe or disk and a red staff; a sturdy monk, obviously intrusive, for he overlaps the ground line; a saint; and a second angel. The upper center was found broken, and the excavator assumed that it could have held a window of stained glass. This part actually protrudes onto a stairway beyond the wall and its flimsy construction would have predestined it to be easily broken. Several bands, among which are debased dentils, egg-and-tongue, and acanthus, run along the facets of a stepped archivolt surrounded by free-flowing scrolls. On both sides of the central frame are a few panels, each filled with a different pattern (quatrefoils, sketchy marble veining ?) set haphazardly. The colors are garish—red, green, yellow, dark purple—in flat spreads lined with dark brown. The mural decoration although lacking composition still has the charm of folk art found in the modern murals representing various episodes from the pilgrimage to Mecca on the façades of Egyptian rural houses of *Hadj*.

Analyzing briefly the style and composition of mural painting at Bawit, we should mention the conformation of composition to the architectural design; the elements are chosen and adapted through intrusive artificiality to the shape and area to be covered (tympanum, spandrel, broad archivolt), the distribution in registers, the pyramidal scheme (three Hebrews, the Virgin flanked by two figures), the excellent representations of animals, the differentiation of similar figures in a row by conventional alternation of colors in dress and hair (6), the grotesque genre—all characteristics belonging to an Egyptian heritage.[82] From a post-Hellenistic background[83] come the use of pagan elements (winged busts, personifications, baskets of fruit, lion and gazelle hunts, Nilotic scenes), stylized floral ornament, a restricted use of perspective in the representation of structures (XVII, XXVIII), three-quarter views of figures (Jordan personification, XVII, XXX; demon, XVII; angels, 6, XXXII; reader, XXXVII; eagle, XXXII), personifications (virtues, Jordan, Church), staging of personages on several planes without ground lines (XXXIV, XXXVII), Hellenistic portraiture and expression of emotions (sad-faced demon, XVII; grieved Philistines in David's cycle, III), all to be interpreted as part of the late-antique repertoire. This mixture of stylistic elements and methods is allied to an original local style different from Byzantine art and characterized by the strict frontality of the figures (6); large heads with stark staring eyes and uniform features tending to monotony, occasionally relieved by some ethnic individualism (red hair of Andrew, 6); and the representation

79. H. Gauthier and H. Sottas, *Décret trilingue*, pls. I, II.

80. Alexander Badawy," Le Grotesque: Invention Egyptienne," in *Gazette des Beaux-Arts* (Paris: 1965), pp. 189–198.

81. Cabrol and Leclercq, *Dictionnaire*, Vol. 2, part 1, col. 233.

82. Alexandre Badawy, *L'Art Copte*. I. *Les Influences égyptiennes*, pp. 26–64.

83. Alexandre Badawy, "L'Art Copte. II. Les Influences hellènistiques et romaines," pp. 40–60.

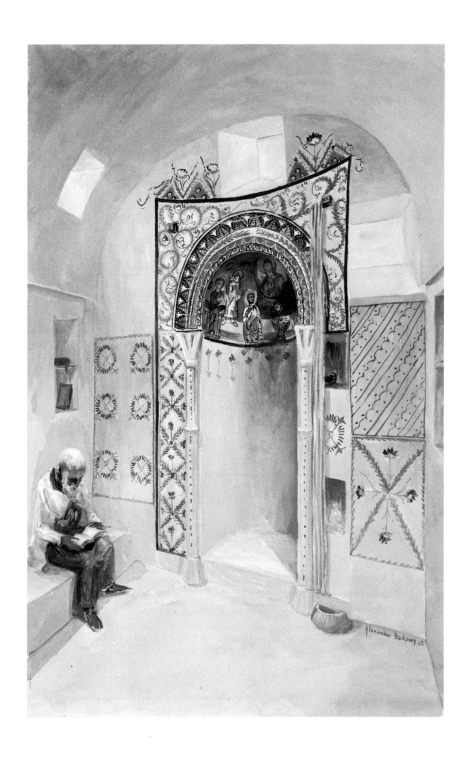

of movement, sometimes violent (hunt, XXXVII; galloping cheetah). The staring gaze imparts a metaphysical life which the saint diffuses and asks for response. Several styles can be recognized, as many of the cells were repainted as late as the eight century. The occurrence of a classicizing style in some chapels, among others XVII, which has a *terminus ante quem* of A.D. 735, has been interpreted as evidence for a period characterized by a rejuvenation of the Hellenistic tradition.[84]

Before leaving Bawit let us study three distemper panels of wood that were found in the monastery and may be labeled icons. One of these deserves special admiration (A.D. VI–VII). Of small size (57 × 57 × 2 cm.), it represents Christ holding a bejeweled gospel and placing His right arm on the Abbot Menas' shoulders; both figures are standing frontally (Fig. 4.34). The Abbot, slightly smaller than Christ, holds a roll in his left hand and raises his right in a blessing. Both heads are larger than normal, surrounded by a yellow nimbus with a cross design for Christ. The unique gesture is borrowed from the ancient Egyptian repertory of statuary and relief in which a god embraced a Pharaoh, or a wife her husband. It was a gesture of acceptance and family relationship and obviously it has preserved here this double implication. The contrast of light and dark colors and the system of concentric curves rippling around the wide eyes and echoed in the plaits of Menas' pallium emphasize the metaphysical

world of the soul[85] much more than does the occasional emphasis on individual traits in the most naturalistic portraits like that of Phoibammon. The two other icons from Bawit represent the busts of Hor the chanter (found defaced in 5)[86] and the abbot Bishop Abraham (Berlin Museum),[87] a geometrized curvilinear abstraction in a harmony of white, yellow, and purple. (Fig. 4.35). The ubiquitous air of stylistic relationship between these icons and the last of the mummy masks and portraits adds one more element to the Egyptian and late-antique legacy in Coptic art.

Monastic murals at Bawit use a repertory drawing on the Ancient Testament with additions from the Apocalypse. To the subject represented, usually a theophany, are added crosses as apotropaic elements (Chapel XLV). Because of certain similarities between the treatment of the theophany at Bawit with those on Palestinian ampulae (at Bobbio, Monza) and in a miniature of the Rabulensis (A.D. 586) Grabar suggested that it originated from the repertoire of Hellenized Jewish art.[88] This hypothesis applies, however, with better chances of credibility to the iconography of Bagawat.

84. H. Torp, "Book Reviews," *Art Bulletin*, Vol. 47 (New York: 1965), p. 368.

85. P. Du Bourguet, *L'Art Copte*, pl. No. 144, pp. 40, 143. Louvre, Inv. No. X 5178.
86. J. Maspero and E. Drioton, "Baouît," pl. LVI *b*.
87. O. Wulff, "Altchristliche und mittlelalterliche Byzantinische und Italienische Bildwerke," *Beschreibung der Bildwerke der christlichen Epochen*, Band III, Teil 1, *Altchristliche Bildwerke* (Berlin: 1909), No. 1607, p. 301. K. Wessel, *Koptische Kunst* (Recklinghausen: 1963), pl. XV, pp. 187–188.
88. A. Grabar, *Martyrium*, Vol. 2, pp. 230–234, pl. LXII, 1–3.

Painting is rather poorly represented in the monastery of Apa Jeremias at Saqqara.[89] On the stuccoed limestone columns of the main church,[90] full-length frontal figures of saints holding the gospel on a sacred wand stand above a frieze consisting of three rows of birds within ovals, perhaps unhatched chicks in the eggs, and a lower hanging. Here the cells are more uniform than at Bawit and each has on its ground floor a private oratory recognizable from the semicircular apses in the middle of its east wall. The distribution of the paintings does not follow a fixed canon: on the east wall in addition to the apse and its flanking niches sometimes appear one or two scenes (Three Hebrews in cell F, palm tree and decorated cross in Cell 709), while on the other walls above an ornamented dado of variable height there appear rows of figures (in B; personifications of virtues in 709) at times interspersed with niches and windows (west B). The subject of the painting in the apse is, as at Bawit, Christ in glory above busts of the Virgin and two angels, each within a medallion (Cell B; Fig. 4.36) or Christ in glory above a series of closely juxtaposed standing prophets and monks on both sides of the Virgin, who is holding the Child on her lap (Cell F). In both scenes Christ is within a *mandorla* with the four radiating protrusions enclosing the

89. J. E. Quibell, *Excavations at Saqqara* (1906–1907, Cairo: 1908); (1907–1908, Cairo: 1909); (1908–9; 1909–10, Cairo: 1912). Numbers between parentheses in the text refer to rooms as indicated in the excavator's publication.
90. J. E. Quibell, *Excavations at Saqqara* (1907–1908), pp. 4, 6, Figs. 1, 2, pl. XI, 1, 2.

symbols of the four evangelists and the eyes of Ezekiel's vision (Cell F) or seraphim's wings interspersed with eyes on a dark green ground with white stars (B). Two busts flank the bottom of the scene, one red on white with beams darting from its eyes (B). But there are variants with only the bust of Christ within a *mandorla* (1723) or flanked by two busts in medallions (1727). In the lower register the Virgin appears within a medallion (B), or as a Madonna flanked by two standing figures of local saints (F) or by two angels and two saints (1727), or seated between two angels and holding a round *mandorla* with the portrait of an adult, a symbol of the Incarnation (1723). The common occurrence of this theme in two zones, symbolic of the heavens where Christ sits in glory above the world of the intercessors with the Virgin, angels, and saints, shows how popular it was with St. Jeremias' monks —as it was at Bawit and abroad.

There are, however, other subjects appearing in the altar niche of the oratories: a bust of Christ holding the gospel and blessing flanked by two ministering angels with outstretched hands (1795); or Christ, eyes raised, seated on a cushioned low stool, making the ritual blessing gesture with the fingers of the right hand represented on a ground sprinkled with rosettes within an oval *mandorla*, seemingly a late work (Cell 733); or Christ similarly seated within a *mandorla* with the four protrusions flanked by two upper faces (*Sol* and *Luna*) within medallions, one (*Sol*) darting rays from its eyes turned

toward Christ, and by two other medallions with winged busts (709; Fig. 4.37). In the latter niches the archivolt painted with a bold continuous scroll springs from above imaginative acanthus capitals of columns also painted with foreshortening, modeling, and shadows. A huge date palm stands outside the niche shooting from its massive ringed trunk a symmetrical array of enormous bunches of dates, one even vertical, alternating with slender stems —a conceptual creation of ornamental trend.

As is typical for monastic painting, the Virgin is also a frequent subject, appearing thrice as Madonna Lactans, once seated frontally on a high-backed chair flanked by two angels (cell A; Fig. 4.38) and another time inclining her head and looking to one side between two busts of saints above two angels (1725; Fig. 4.39), a treatment defined as Byzantine.[91] The third one-zone scene was badly damaged (1807). In both scenes the suckling Infant holds the left arm of the Virgin with both hands. The tripled archivolt is painted with scalloped acanthus, a series of haloed faces whose eyes glance playfully at one another, and a crenelated border. The persistence of the motif at such a late date, as indicated by the style (seventh or eighth centuries), is another reminder of its native character, deeply rooted since the ancient Egyptian *Isis Lactans*. Still another altar niche represents the Virgin holding the Child, accompanied by two angels with gesturing hands, Abbot Jeremias and

91. K. Wessel, *Koptische Kunst*, p.180, pl. II.

Enoch (1719). All personages are nimbed except the two angels (cf. Panagia Kanakaria in Lythrankomi, Cyprus, A.D. VI).

Of the Christological cycle no single scene is extant, but two from the Old Testament—the Sacrifice of Abraham and the Three Hebrews—give some clue as to the composition and style. The latter scene, adjacent to an altar niche (Cell F), differs from the interpretation at Bawit and 'Abd el Gadir, animated as it is by the angel at one end, who with one foot overlapping the picture frame bends to stretch the long cross horizontally as an effective barrier against the flames in which the three young Hebrews as frontal juxtaposed *orantes* jump rather tamely. The composition is known in a Coptic mural painting (Wadi Sarga, A.D. VI), a low relief A.D. VII), and in Western Europe (Murano, A.D. VI); but the angel at Saqqara is by far the liveliest. In the scene of the sacrifice of Abraham the patriarch stretches his sword horizontally toward a small Isaac who is standing frontally with both arms bound behind him on the pedestal of the altar, while the ram waits behind. The frontal projection in the torsos of the two figures with their legs and the ram in side view and the total absence of movement and of third dimensional setting are signs of a simplified style carried out in emphasized outlines on the north wall of the refectory, at one time hidden behind a screen wall built for that purpose, probably after some Islamic decree prohibiting the representation of human figures. There were other scenes above the scalloped frieze,

Distemper painting on wooden panel representing Christ protecting St. Menas. (Bawit; K. Wessel, *Koptische Kunst*, pl. XIV.)

Icon from Bawit portraying Bishop Abraham. (Berlin Museum.)

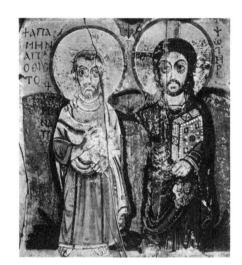

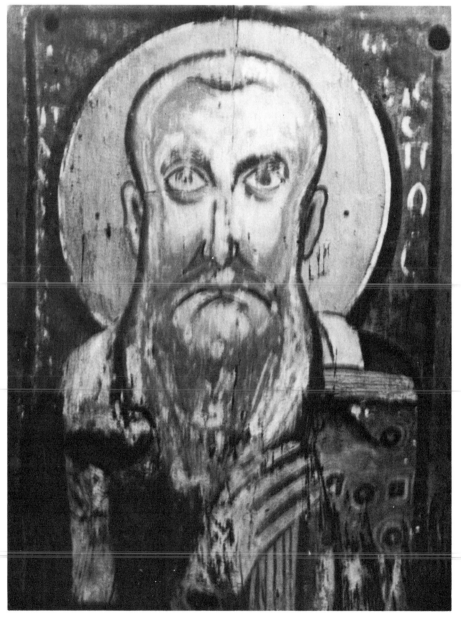

4.36
Painted frieze with medallions. containing busts of the Virgin and an angel.(Saqqara, Chapel B; J. E. Quibell, *Excavations at Saqqara* [1906–1907], pl. XLVII.)

4.37
Painted niche representing Christ within the *mandorla* flanked by four medallions. (Saqqara, Cell 709; J. E. Quibell, *Excavations at Saqqara* [1907–1908], pl.VIII.)

4.38
Mural portraying the Madonna Lactans. (Saqqara, Chapel A; J. E. Quibell, *Excavations at Saqqara* [1906–1907], pl. XL.)

4.39
Mural portraying the Madonna Lactans between two angels. (Saqqara, Cell 1725; J.E. Quibell, *Excavations at Saqqara* [1908–9, 1909–10], pl. XXII.)

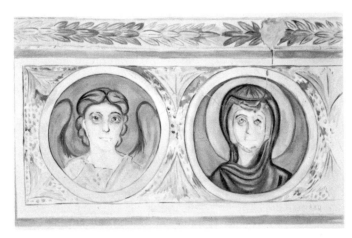

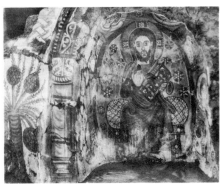

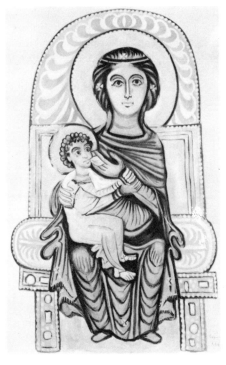

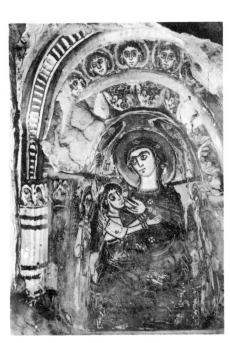

but the scant remnants showing the legs of standing figures are no proof that they belonged to cycles from the Old Testament, though the names of "Nebuchadnezzar" and "slave" may justify such an assumption (Jeremias' room 773). Yet the most beautiful painting was in the refectory (727), a bust of an angel (Fig. 4.40) treated in a three-dimensional soft style even to light dots in the pupils, strongly reminiscent of the Fayum portraits.[92]

In the same cell, representing Christ (Cell 709), there is a frieze of winged haloed busts of angels wearing long hair and earrings shaped as *crux ansata* and holding in both hands a patera (Fig. 4.41). The bold design emphasizes the contours and the geometrized features of the eyes, tubular nose, and straight mouth. The inscriptions beside each inform us that they are personifications of virtues, the Pauline Triad—Faith, Hope, and Charity (on the south wall)—Patience, Prudence, Fortitude, and others whose labels have disappeared. Beneath there are an interlace band and two peacocks confronting each other.

Here, as at Bawit, the scenes representing rows of figures seated or standing formed the majority but they are not preserved. The walls beneath are always painted with a floral frieze (red scallop enclosing a stylized vine leaf, wreath, interlace of cord) above a dado. The latter may be an elaborate floral diamond grid interspersed with vine leaves over a stylized hanging (F), a

92. J. E. Quibell, *Excavations at Saqqara* (1907–1908), pl. XI, 4; p. 11 (destroyed since).

sequence of square panels with intertwined band forming circles with rosettes or triangles with quatrefoils (B), or a diamond grid of wreaths enclosing circular patterns treated with light impressionistic touches (Cell J; Fig. 4.42). A denser design of panels with intertwined circles filled with quatrefoils on a dotted ground (B) or intricate interlace of circles and squares topped with a meander (1714) is akin to, though less refined than, some at Bawit. In the founder's room (773) an illusionistic scene representing a portico with four columns on foreshortened bases, drawn curtain, and central pedestal in perspective with details of the mottled marble and tapestry forms one panel in an elaborate dado where floral grid panels alternate with pseudo-incrustation with floral decoration, intertwined stems sprouting from ribbed vases after the Byzantine motif. Elsewhere (726) the dado is a simple imitation of a wooden framework, a motif also found at Bawit.

Let us examine the composition of one specific example, Chapel B, which because of its style and a screen in front of its east end ranks higher than the typical monk's oratory. The east wall is marked by the central altar niche with a thin marble slab upheld on a wooden bar (1 m. above floor). Christ in glory wearing red garments appears in a dark-green sky with white stars, flanked by the eyed wings of Ezekiel's vision. Beneath are medallions enclosing the busts of the Virgin and two angels (Fig. 4.43). Two engaged pillars and pilasters carrying the archivolt frame the niche; the pillar is painted with linear floral patterns, the

pilaster with an imitation of *opus sectile*, and the archivolt with wreaths. On both sides beneath the molding stretching from the archivolt are large cupboards. Opening in the south wall, in addition to the entrance doorway, are two cupboards and two windows with steeply sloping sills; there is also a dado of red marble imitation decorated with rectangle-lozenge panels enclosing yellow quatrefoils. On the north wall runs a dado (1.5 m. high) of red square panels with red dots, decorated with an interlace forming circles dotted black or, alternatively, a diamond composition dotted black or red enclosing yellow quatrefoils. On the walls above the dado was a series of standing figures, larger on the west wall and carried over the springing of the vault on the north wall. The repertory includes more one-zone scenes of Christ or the Virgin and a few representations of the busts of Christ and the Virgin in the two-zone niches instead of Christ in glory and the Virgin seated or standing, a substitution exemplified abroad during the eleventh to the twelfth centuries in Greece (Daphnae) and Sicily (Cefalu, Monreale).

The technique at Saqqara is related to that at Bawit, the outline being defined by a brown line with apparent brush strokes. The eyes (Fig. 4.44) are rounder than at Bawit and always bordered below by a dark eye-pouch, the mouth a simple straight line ending in two vertical black dots, the underlip marked by a similar black dot tangent to an accurate circle for the chin (A). Though features are conventionalized, a clear differentiation between figures in a row is achieved through certain

individual traits in the attitude (an *orans* alternating with a figure holding a book in both hands), the beard, and the costume. Schematization, however, is no consistent rule, and treatment varies with the dates, some linear style combining with more modeling in the faces (F). Youthful models such as the Virgin and the angels are usually closer to late-antique style, once even (727) comparable to the best. Even character portraiture is exemplified in the portrait of the founder Apa Jeremias (Cell D), a noble white-haired head with the delicate features of an ascetic and the intense burning eyes of mystic devotion. The head is framed within a combined square and round nimbus (Fig. 4.45). The style has been defined as more two-dimensional and linear than that at Bawit,[93] probably also more ornamental in the rendering of details without background. Ornament proper ranges from an astonishing impressionism strongly late-antique in flavor with able brushwork (vine and floral diamond pattern in Cell J) to flat geometrized floral patterns encumbered by mechanical dots (B, 773).

Mosaics covered the semidome of the apse in the main church,[94] for just beneath was found a mass of glass cubes (tesserae)—yellow, white, light blue, red, dark colored, dark blue, and abundant transparent green gilt with gold leaf covered with a slip of clear glass 1/3 mm. thick. The backs of the pictures were certainly golden, as were those of early Christian mosaics abroad (Church of St. George in Salonica, late A.D. IV; Ravenna, A.D. 547). Golden mosaics with figured scenes formed part of the original decoration of the domed chapel above the tomb chamber of St. Menas in the Maryut (A.D. 400–410).[95]

Grabar maintained rightly that both the variety in the choice of the personages and the legends of the theophany, and the representation of theophanies from the New Testament (Baptism and Childhood of Christ) proved that the murals at Bawit and Saqqara did not receive their inspiration from the liturgy celebrated in their oratories. The repertory aimed at enabling the Coptic monk to contemplate God through His appearances and through certain episodes in Christ's life, and also to approach the saints.[96] This purpose differed radically from that of the wall scenes in Egyptian temples.

The fashion of representing the cross as an apotropaic element of decoration set in rows at the top of blank walls in oratories originated in the propaganda which accompanied this cult in the fourth century, especially after the appearance of a luminous cross in the sky of Jerusalem in 351. Such crosses are arrayed on a white ground above cartouches inscribed with prayers and a dado imitating polychrome marbles (Bawit XIX, A.D. VI; XX). The intention of placing the chapel under the protection of the cross is evidenced by the accompanying legend Emmanuel or Nika. In Chapel XXVII (A.D. VI) an 'ankh-cross appears with the eagle surmounted by the letters α and ω, repeated thrice, a rare symbol of the Trinity.[97]

We have encountered rock tombs and chapels decorated with crosses, or with a long inscription running around the upper part of the walls. The inscription contains invocations or, as in the chapel at Assiut, names of the figures of saints painted underneath. At Bawit and Saqqara the invocations mention the names of the protectors: the Trinity, prophets, apostles, Mary, all the saints, and the local saints. Nowhere in the Christian world are the inscriptions or graffiti as abundant as in Coptic chapels, probably following local pagan tradition.[98]

From a private house at Wadi Sarga, south of Assiut (B. M., G. 1.14),[99] a mural more like a drawing than a painting represents the Three Hebrews, in Parthian garb and Phrygian caps, originally flanked by Cosmas and Damian and three anonymous busts. As in the earlier interpretation of the theme at Bagawat (Chapel of the Exodus, A.D. IV) the angel stands behind, though he extends his staff forward onto the flames (Fig. 4.46). This composition marks an intermediate stage in the shift of the angel toward

93. W. F. Volbach, "Die koptische bildende Kunst," in *Koptische Kunst* (Essen: 1963), p. 144.
94. J. E. Quibell, *Excavations at Saqqara* (1907–1908), p. 6.

95. C. M. Kaufmann, *Die Menasstadt und die Nationalheiligtum der altchristlichen Ägypter* (Leipzig: 1910), Fig. 16.
96. A. Grabar, *Martyrium*, Vol. 2, pp. 306–308.

97. Ibid., pp. 280–282.
98. Ibid., pp. 296 ff.
99. E. Drioton "Trois Documents pour l'étude de l'art copte," *BSAC*, Vol. 10 (1944) (Cairo: 1946), pp. 80–85, pl. III.

4.40
Mural painting representing the bust of an angel within a medallion. (Saqqara, refectory, No. 727; J. E. Quibell, *Excavations at Saqqara* [1907–1908], pl. XI, 4.)

4.41
Painted frieze with busts of angels. (Saqqara, Cell 709; J. E. Quibell, *Excavations at Saqqara* [1907], pl. IX.)

4.42
Mural ornamental painting of Hellenistic style. (Saqqara, Cell J; J. E. Quibell, *Excavations at Saqqara* [1906–1907] pl. LIII.)

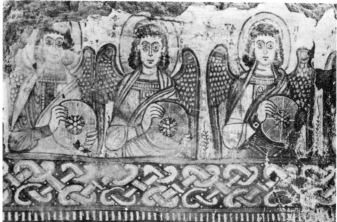

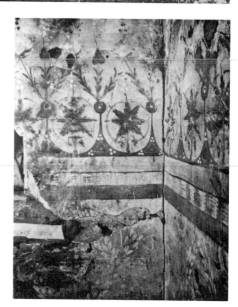

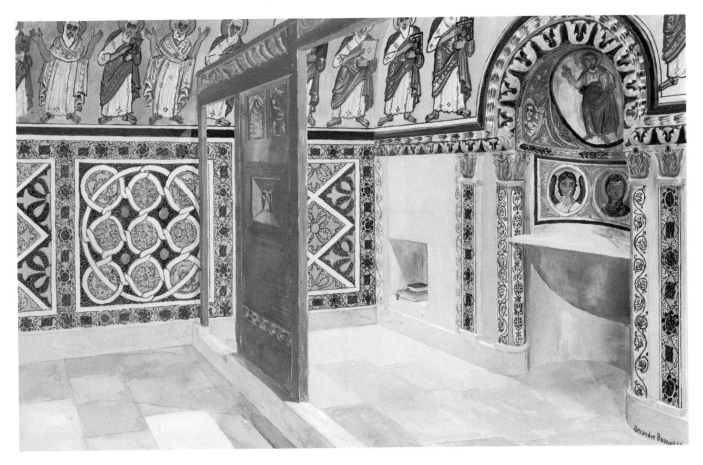

4.44
Mural on north wall of Cell A at Saqqara, (Coptic
Museum Cairo.)

4.45
Portrait of Apa Jeremias in his Cell, D. (Saqqara;
J. E. Quibell, *Excavations at Saqqara* [1906–
1907], pl. LX.)
4.46
Mural from a house representing the Three
Hebrews in the Fire. (Wadi Sarga; B. M., I.14;
courtesy Dr. I. E. S. Edwards, British museum.)

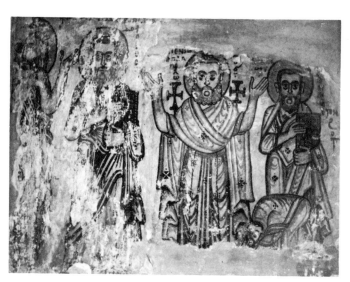

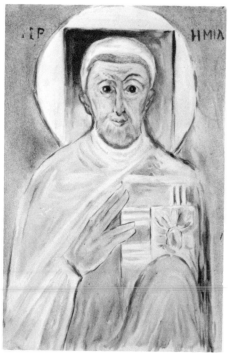

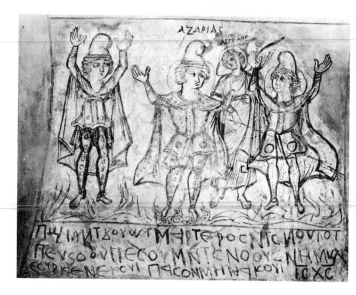

the left, in which the angel is the same stature as the Hebrews (low relief, A.D. VII) and ultimately moves in the front plane to the left end (Saqqara, A.D. VII; cf. low relief at Murano, A.D. VI).[100] None of the personages is truly frontal, and their freedom of movement, the slight *contrapposto* stance, the eyes looking beseechingly at the angel, and the supple lines are features reminiscent of the Alexandrian style favoring a date in the fifth century for the original and the sixth for the present copy. Line designs of this alertness are seldom found in Coptic murals, which except for the spirited representation of animals (lion pursuing bubalis at Bawit, humoristic graffito at Bawit) are as decadent in their style as the red graffiti at Athribis (A.D. VII-VIII).[101]

In the conceptual interpretation of the theme of the Three Hebrews, symbolism replaces realism, the angel appearing as the savior holding the three diminutive young men (Bawit) or standing behind them as in the small chapel of 'Abd el Gadir near Wadi Halfa in Nubia (Fig. 4.47).[102] This richly painted monument cannot be considered as Coptic but it offers an interesting comparison. From the Christological cycle there is a Nativity representing the Virgin reclining on a slightly modified Byzantine

kidney-shaped couch; before her are St. Joseph, seated frontally, and two shepherds, with three riders above. Besides there are numerous rider saints on horses with rich trappings—popular with the Nubians—saints, angels, Christ, and the eparch. The style differs from the Coptic in its lack of composition, ground line, and depth of background. Most of the figures are frontal (faces or whole figures); the rest are in side view with frontal faces in a folk design employing strong, variegated, even garish artificial coloring (red, white, orange with black outline) on a dark brown ground.

One of the beneficent results of the Arab conquest, if this term be allowed, was to offer Coptic art a new scope of creative possibilities in Islamic projects in architecture and sculpture of decorative type. This hardly applies, however, to painting, since the representation of living creatures was supposedly forbidden. Yet even this canonic rule had its exceptions in Egypt and in Jordan. Coptic artisans were commissioned for Islamic projects abroad, and the impact of their broadened vistas allied to their contacts with foreign schools, which were also asked to cooperate in Egypt, account for an enriched iconography and increased freedom in composition and style. The Rūm of Constantinople had contacts with Egypt and were defeated near Tarsus (A.D. 883) by Ibn Tulun, who carried away valuable spoils of gold, silver, crucifixes, sacred vessels, and vestments, not to mention artisans. He was a great builder and

commissioned a Coptic architect to build his mosque and his aqueduct. Ibn Tulun's son adorned his "golden house" with painted images of himself and his wives and singers.[103]

Syrian, Armenian, and Cappadocian influences can be traced in later Coptic painting, especially in the murals of the Wadi Natrun monasteries. The best preserved are on the semidomes of the choir in the church of El 'Adra at Deir Suryan.[104] The dome with round-topped windows set on pendentives, arches, and twisted columns is strangely reminiscent of a Byzantine church. The murals depict the Annunciation, the Nativity, the Ascension, and the Dormition and Assumption of the Virgin, and are dated to the first half of the tenth century. They show in their three-dimensional composition a strong contrast with the murals at Saqqara and even those at Bawit. The Annunciation and the Nativity share the southern semidome (Fig. 4.48). The Virgin, clad in dark red over a green undergarment, stands with the hand on her chin in a gesture of perplexity (a gesture also shown in the cathedral of Parenzo, A.D. VI) at the news brought to her by Gabriel, who is greeting and looking at her; the angel here is of the same stature as the Virgin. In the scene to the right the Virgin reclines on the typical kidney-shaped couch, and the

100. A. Badawy, *L'Art Copte, I. Les Influences égyptiennes*, pp. 55–56, Figs. 35, 39, 40, 41.
101. J. Clédat in Cabrol and Leclercq, *Dictionnaire*, Vol. 1, p. 22. W. F. Volbach, "Die Koptische bildende Kunst," p. 144.
102. U. Monneret de Villard, *La Nubia Medioevale*, Vol. 1 (Cairo; 1935), pp. 214–217; Vol. 3 (Cairo: 1957), pls. CLXXIV-CLXXX. W. F. von Bissing, "Die Kirche," pp. 128–183; Alexandre Badawy, "L'Art Copte. II. Les Influences hellénistiques et romaines," pp. 46–47, Fig. 58.

103. S. Lane-Poole, *A History of Egypt in the Middle Ages* (London: 1936), p. 74. (Hereafter cited as *History of Egypt*.)
104. H. G. Evelyn-White, *The Monasteries of the Wadi Natrun*, Vol. 2 (New York: 1933), pp. 183–193, pls. LVII, LXI, LXII. (Hereafter cited as *Monasteries*.)

4.47
Mural of the Three Hebrews. ('Abd el Gadir; U.
Monneret de Villard, *La Nubia Medioevale,*
Vol. 3, pl. CLXXVIII.)

4.48
The Annunciation and the Nativity painted on an
apse head in El 'Adra church at Deir el Suryan.
(A.D. X; H. G. Evelyn-White, *The Monasteries
of the Wâdi Natrûn,* Vol.2, pl. LXI.)

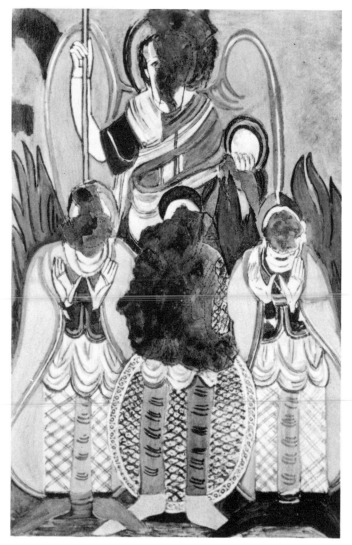

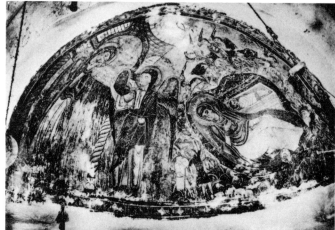

Infant, tightly wrapped in swaddling clothes, lies in a manger within the black mouth of a cave in a rocky setting. A minuscule Joseph sits head on arm while the wise men approach behind him, and on the opposite side the shepherds point to the star twinkling in the dark blue of a sky filled with angels. In both scenes all the figures are three-dimensional, interrelated by gestures and glances, and well modeled on a plastic background. The representational approach supersedes the ornamental trend reached at Saqqara, though some elements such as Joseph thinking and the Virgin reclining on the typical couch recur, the latter probably adopted from the pagan scene of Dionysos' birth.[105] Byzantine and later parallels abound (cathedral at Parenzo, A.D. VI; S. Biagio at Brindisi, A.D. XII).

In the Ascension, Christ makes the ritual blessing while seated in a pointed *mandorla*—white, green, and blue as a "rainbow round about the throne" on a blue background flanked by the sun and the moon. But the *mandorla* is carried by two winged beings above the Virgin in frontal view, who is accompanied by the twelve apostles, black-haired except for Andrew, most of them turning their heads upward or gesturing in surprise. The composition is a unified whole.

The scene of the Dormition and Assumption of the Virgin is also akin to

Byzantine examples derived from Theodosius' description. The Virgin lies on a couch with hangings in conventional folds, Peter and John at either end; Christ in the center, flanked by two medallions with angels and by two groups of apostles, holds the soul of the Virgin as a white-swathed infant. The upper part of the hall is open to the sky sprinkled with rosettes and crossed strokes. The color scheme features white, pale yellow, red-brown, blue, and black. In Byzantine and later pictures all these elements occur, though in a more formal style (Toledo church, A.D. XII; Martorana mosaic in Palermo, A.D. XII; Peribleptos church mural painting at Mistra, A.D. XIV; St. George chapel, monastery of St. Paul on Mount Athos, 1423).

In the monastery of Apa Makarius at Wadi Natrun[106] the northern sanctuary preserves its whole scheme of murals, providing excellent evidence for the typical repertory of mural decoration in a chapel of the Fatimid period (969–1171). Themes from the Old Testament such as Daniel in the lions' den and the Three Hebrews, here with Michael, are allied to the small motifs in the spandrels, such as Isaiah and the Seraph, Abraham and Melchisedech, Jacob's dream, and the sacrifice of Abraham. From the Christological cycle there are the Annunciation to Zacharias (in a spandrel), the Annunciation, the Nativity, the Disciples at the sepulcher, and the Dormition and Assumption of the Virgin, a choice echoing that of late Byzantine iconography

except for the Crucifixion, which is never represented in Coptic art (cf. panel from Toledo church, A.D. XII; panel in Vatopedi monastery on Mount Athos, A.D. XIII). The subjects are strictly Christian, and the earlier fashion for late-antique elements seems to have died out. In addition to its importance in the study of the typical iconographical repertory, this chapel is of unique value in assessing the style, not to mention the fact that it has kept the signature of its painter, "Monk John the Limner, the son of Apa Bishoi." Its composition is marked by an adequate relation of the elements to the whole, well-adapted to the architectural space and lines of decoration, accurately proportioned as seen from the floor below. The coloring is certainly more pronounced and variegated than in earlier monastic murals, with delicate treatment of the features of the angels. Though strongly Byzantine in spirit, the style of painting in the Wadi Natrun monasteries compares favorably with the best in Europe, still retaining some of the native qualities but having shed those characteristics that could justify the description of earlier monastic painting at Bawit and Saqqara as provincial.

The only paintings in St. Simeon's monastery at Aswan[107] occur in the church, in the grotto behind it, and as traces in the gallery of the *qasr*. There are several coats of paint and dating is based on stylistic grounds ascribing

105. Alexandre Badawy, L'Art Copte, II. "Les Influences hellènistiques et romaines," pp. 47–48, Figs. 58–60.

106. H. G. Evelyn-White, *Monasteries*, pp. 101–110, pls. XXVIII–XXXI.

107. U. Monneret de Villard, *Il monastero di S. Simeone presso Aswan*, Vol. 1 (Milano: 1927), pp. 34–36, 65, 103, Figs. 64–73, 130–131.

those of Grotto 13 to the sixth to seventh centuries, the others later. Three of the walls in Grotto 13 represent seventy-two personages standing in two registers. On the ceiling, busts (Fig. 4.49) in square and octagonal frames are set against a geometrical design of fretwork curiously similar to one at Bawit (III, XVIII), allied to a radiating zigzag pattern reminiscent of that at Bagawat (Chapel 25). In the church, over the central niche of the sanctuary, a Christ in glory (Fig. 4.50) is represented raising his right arm far outside the *mandorla* held by two angels depicted frontally who are flanked by two other personages, all of whom appear above a series of haloed seated figures; in the north niche the Virgin is depicted standing between two bowing angels. A tentative dating in the eleventh century has been proposed. On the west wall of the great gallery in the *qasr* (94) was one-half of a symmetrical frieze representing Christ enthroned, an angel, and six apostles within a red frame. On the north wall just above a basin accessible from three steps were simple but lively sketches of hunting scenes.

Large monumental churches with well-articulated walls, even though built of stone such as Deir Abiad and Armant (after Jomard, *Description*), were plastered and painted, a process reminiscent of mural decoration in ancient Egyptian temples. In Deir Abiad[108] an inscription ascribes the earliest murals

to an Armenian painter (after 1076), the year of the accession of Gregorius, bishop of the Armenians in Egypt), and a second to Theodorus of Terbedide (Tarfa near Qolosna) in 1124. The most important cover the semidomes of the apses. In the east apse Christ in glory appears within a *mandorla* richly ornamented with rosettes along its border and set on the four symbols of the evangelists, who are treated as winged heads (yellow, blue). This interpretation of the vision of Ezekiel differs, however, from those at Bawit and Saqqara, in Cappadocia and Armenia, in the appearance of two flanking medallions representing the evangelists writing, a motif known in S. Vitale at Ravenna (A.D. VI) and later in a form similar to those at Deir Abiad in western illuminated manuscripts (Gospel Book of Charlemagne before A.D. 800; Ebbo, A.D. 816–835). Along the archivolt are medallions enclosing busts of the Virgin, St. John, and the angels. On the south apse (Fig. 4.51) are paintings by another hand: a blue cross with a red drapery across its horizontal arm appears within a *mandorla* carried by two angels. Above them are the sun and the moon, and below are the Virgin and St. John in three-quarter with frontal faces, both extending their hands. On the archivolt medallions with crosses alternate with prophets. The motif of the *crux clipeata*, an abstraction from that of Christ in the *mandorla* or clipeus, is frequent in Coptic sculpture on capitals (Maryut), stelae and pediments, and semidomes of niches, where it is carried by two nude figures or angels facing the cross. Here, however, the two angels turn outward as if they were carrying the

mandorla on their backs. Before the restoration at the turn of the century the brick wall facing the apse was still covered with two rows of saints holding a book and standing frontally in niches.

At Deir Ahmar[109] profuse painted decoration covers columns (full-length St. Mark), pilasters, and walls (Fig. 4.52). Figures of *orantes* on pilasters combine with panels of geometric and floral patterns, while flying angels holding a globe of fire allied to diamond and circle friezes are adapted to spandrels (south apse). On the tympanum above the doorway between the north apse and the east chamber is a frontal bust of Apa Theophilos, perhaps the twenty-third patriarch and a contemporary of Shenute. This painting may date from the seventh or eighth century (U. Monneret de Villard). In the east chamber on a western tympanum Christ stands between two kneeling angels, perhaps a work by the painter Merkurios known from the inscription dated 1301 in the same chamber and from another in Deir Abiad.

Let us mention here a large mural fragment from Umm el Beregat (Fayum; C.M., 3962) representing in a naïve provincial style Adam and Eve in two moments of a narrative before and after the fall, standing nearly frontal as dark outlined figures against dense dotted growth. In both moments the two turn their faces slightly toward each other, and emotion is expressed by the play of their eyes and gestures of their hands.

108. U. Monneret de Villard, *Les Couvents près de Sohâg*, Vol. 2 (Milan:1926), pp. 25–26, 132–134, Figs. 201, 203–207, 209, 214. (Hereafter cited as *Sohâg*. "Una pittura del Deyr el-Abiad," in *Raccolta di Scritti in onore di Giacomo Lumbroso* (Milan: 1925), pp. 100–108.

109. U. Monneret de Villad, *Sohâg*, pp. 131–132, Figs. 35–38, 208, 210–213, 216–217.

4.49
Ceiling painted in Grotto 13 in St. Simeon's monastery at Aswan representing busts on a geometrical pattern. (U. Monneret de Villard, *Il monastero di S. Simeone presso Aswan,* (Vol. 1, Fig. 65.)

4.50
Central apse in St. Simeon representing Christ in glory between two angels and two personages. (U. Monneret de Villard, *Il Monastero,* Fig. 71.)

4.51
South apse painted with a cross in a *mandorla* carried by two angels. (Deir Abiad; U. Monneret de Villard, *Les Couvents près de Sohâg,* Fig. 209.)

4.52
Painted decoration at Deir Ahmar. (U. Monneret de Villard, *Les Couvents près de Sohâg,* Vol. 2, Fig. 212.)

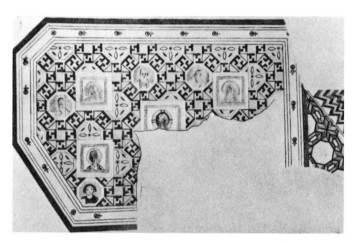

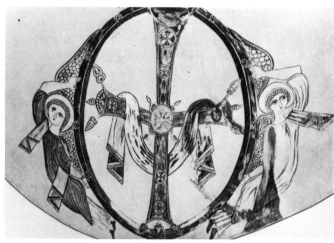

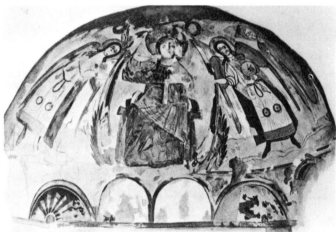

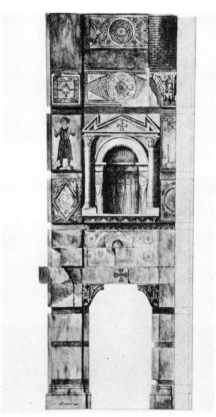

The Style of Mural Painting

Mural painting was essential to Coptic religious architecture in much the same way as it was to similar Egyptian architecture, for it appears not only on the walls and vaults of churches but also in funerary chapels and even in private oratories. Not all Coptic murals were of religious character; we find as late as the sixth to eighth centuries at Saqqara elements from late-antique repertory. The earliest murals represent themes from the Old Testament with such occasional additions as local saints, the Virgin, and personifications of virtues (Bagawat). In the catacombs of Alexandria, however, the themes from the Christological cycle symbolize the Eucharist, and the representation of Christ borrows the attributes of Horus on the crocodiles. The earliest historical murals, a rare genre in Coptic painting, illustrate the Christological cycle (Abu Hennis), where the partiality for the Apocryphal text, characteristic of Coptic art, appears in the emphasis laid on Zacharias' cycle. Though this earliest group does not rely much on pagan themes, its style can be called late Hellenistic, setting animated picturesque three-dimensional figures on an illusionistic background (Abu Hennis) or against a conventional one (Karmuz). In southernmost Upper Egypt, however, a formal rigid frontality prevails (Bagawat) foreshadowing the consistent aspect assumed by figures in Coptic painting. Yet the linear treatment is still supple and the modeling is rendered by coloristic effect, while the aesthetic value of the female nude is still recognized (Karmuz, Bagawat,

Chapel 80). A unique chapel uses a primitive folk style with ancient Egyptian flavor enhanced by specifically Egyptian devices, as showing the interior within a cross-sectional view, composite projection of figures, and the ubiquitous hieroglyph *ankh*, now the *crux ansata* symbolic of eternal life (Bagawat, 30). We should remember that in Europe the symbolic decor derived in part from pagan Alexandria prevailed even in catacombs, encouraged officially by the Council of Elvira (A.D. 300), which forbade cult representations. It was not until the end of the fourth century that Christian pictorial art acknowledged a properly Christian repertory as evidenced by a letter of St. Nilus advising the exarch Olympiodorus to represent on the walls of his church the cross and scenes from the Bible instead of hunting and fishing. It is also in the fourth century that the realistic style of Anatolian murals does not cringe at showing bloodshed in the martydom of St. Theodorus, an aspect carefully avoided by Coptic painting.

The estrangement of the Coptics from the Greek world is revealed by the murals in both repertoire and style. From the late antique the monastic painter adopts, besides an entire grammar of ornament which he reinterprets, such elements as the horseman for his saint destroying evil, accompanied occasionally by subsidiary symbolic items (centaur, nymph, Egyptian nefarious animals at Bawit), the Madonna Lactans after the Isis Lactans, the Erotes and their activities in Nilotic scenes, a sad-faced spirit (Bawit), personifications (Bawit, Saqqara), symbolic animals (stag, dove,

peacock, lion), and hunting scenes. He loves such themes as David the cupbearer, or Christ in glory above the Virgin and twelve apostles (Bawit, Saqqara), or the twenty-four elders of the Apocalypse (Aswan), symbolic of sacrifice and incarnation. Hagiography is also a source of themes, and the figures standing frontally reiterated in long rows, sometimes in a pseudo-unified composition in which their feet and haloes overlap, their intent gaze inviting the onlooker to their mystical world, are among the most impressive murals. Though features are stylized, there is occasional portraiture (St. Jeremias at Saqqara) and expression of emotions through the features (Bawit). To reduce monotony figures are of two alternating types. To this ancient Egyptian graphic device are added others from the same heritage—variation in scale to adapt a composition to the architecture, combination of elements in front and side views in the same scene, and the representation of the interior within a cross-sectional view. The Coptic painter is always skilled in depicting animals, as was his ancestor. The stylization process achieves a two-dimensional rendering without background which enhances the ornamental effect, using dark delineation and flat coloring hardly affected by a fossilized attempt at modeling with additional emphasis on outline or hatching (Bawit, Saqqara). The stylization soon verges on schematization in which the features are simplified into geometric lines (Saqqara), and more than ever the accent is on ornament. It is paralleled by the abstract trend in sculpture. Meanwhile in

Europe the iconoclastic movement has changed churches into "orchards and aviaries" with scenes of flowers, landscapes, hunts and circuses, or historical events replacing Christian themes.

The breach with Constantinople that had led to closer relations with the Monophysite Syrians and the Manichaeans who appeared in Upper Egypt after the third century may have introduced Sassanian elements even before the Persian occupation (616–618). These pre-conquest contacts of the Copts may have predisposed them to adapt more readily to the abstract art evolved by Islam. In Coptic murals of the seventh century and later Syrian and Sassanian elements appear (David cycle at Bawit) and geometric patterns invade the panels of the dadoes (Bawit). From contacts with Constantinople under the Tulunids may have come the new trend toward a three-dimensional rendering with deep coloring (Wadi Natrun), naturalistic gestures, unity in composition, in short a representational approach superseding the ornamental one. Late-antique elements have completely disappeared. Coptic mural painting is now more closely associated with the Byzantine tradition, though preserving its own personality with minor traits introduced occasionally by foreign painters (Annunciation at Deir Abiad).

Painted Caskets and Coffins

A small group of wooden caskets painted in encaustic[110] with Christian busts (angels, women, Beardless Christ defined as Savior) within medallions allied with a wavy line ornamented with dots or stylized acanthus shows a strong Hellenistic accent. The faces are entirely frontal, still reminiscent of the Fayum portraits, though composed of more strongly stylized features, wider eyes, and only slight modeling (woman's face on lid, C.M.). Some light brushwork denoting a hand well-trained in the late-antique technique adds an impressionistic touch (angel, Dumbarton Oaks, fifth century) not achieved in later caskets decorated in a more linear style (Savior in Berlin Museum; casket of the mid-sixth century in Berlin Museum representing on each side two medallions with St. Luke, Thomas, Faustus, Cosmas). This trend toward abstraction is still more pronounced on a fragment (Berlin Museum) painted in tempera representing in two yellow squares framed in red the face of a man and a woman completely frontal and symmetrical, their noses and mouths represented as straight lines, the outline in geometrized curves with slight modeling dated from the Justinian type of headdress to the middle of the sixth century. Wood furniture and equipment (chalice holder, feretory of reliquaries, pulpits in Wadi Natrun)[111] were often painted with ornament and various scenes. Here should be mentioned a painting, perhaps in encaustic, on a wooden tablet from Edfu (40 ×

20 cm.)[112] which cannot qualify as an icon, for it presents a frontal view of a young lady in the style peculiar to properly Coptic murals: oval face, wide-eyed gaze surrounded by a purple line, black hair, pink cheek, nose and lips bordered by a purple line. She wears a hair net with pearls, trefoil earrings, a tunic with lozenge pattern, and a purple mantle. On either side is a column of large Greek letters in red, topped by a cross. The poorly preserved painting was reused as a writing tablet covered with incised lines of Coptic script. The date could be sixth to seventh centuries A.D.

A unique wooden coffin found wrapped in a rug within linen, bound with black and red straps at Karāra[113] imitates the prismatic protrusion built up in palm fronds and bandages over the heads of the Coptic mummies in other local burials. Here, however, the wood is entirely painted in tempera with floral ornament of a linear style. A continuous green scroll with red flowers runs along the four sides of the shallow coffin (15 cm.). On the flat vaulted lid are two rows of contiguous medallions with floral arabesques, two green and yellow alternating with two white and blue on black ground. Each of the two slant faces of the prismatic gablelike

110. K. Wessel, *Koptische Kunst*, pp. 182–185, pls. XI–XIII, pp. 102–103.
111. H. G. Evelyn-White, *Monasteries*, Vol. 3, index, p. 269.
112. H. Henne, *Rapport sur les fouilles de Tell Edfou (1921–1922)* (Cairo:1924), pp. 34–35, pl. XIX.
113. Now in Heidelberg, Ägyptologisches Institut der Universität, Inv. No. 500. H. Ranke, *Koptische Friedhöfe bei Karâra* (Berlin: 1926), frontispiece, pp. 3–4, pl. I. *Koptische Kunst* (Essen: 1963), p. 264. P. Du Bourguet, *L'Art Copte*, pl. 99, pp. 115–116.

protrusion represents on a golden yellow ground a greyish blue peacock in side view standing on one leg, its red tail curving up into an elegant if artificial shape, and holding in its beak a string of red and blue pearls (Fig. 4.53). The design is highly sophisticated, even mannerist in its emphasis on the curvature of the body, tail and string repeating that of the oval medallion itself. On both triangular ends of the prism a circular medallion with three looping protrusions features a sacred tree arabesque, red on yellow. Sassanian influences, perhaps from a textile, can be detected in the peacock and the twin palmette motif in the four spandrels around the peacock medallion, while the wiry style of the floral arabesques points to an Umayyad date in the eighth century.

Illuminated Manuscripts

Here, as in other realms of Christian art, Egypt leads in the production of several illuminated manuscripts of Alexandrian tradition if not craftsmanship. The earliest manuscript is a small vellum (125 × 117.5 mm.; Pierpont) of the Coptic Acts of the Apostles datable about A.D. 400.[114] This Glazier Codex preserves its original binding with its wooden boards, leather backstrip, thongs, straps, and bone pegs. Its last folio, 156, is painted with a full-page miniature representing in yellow, red, and brown the *crux ansata* on a stand of the common terra-cotta type with concave sides flanked by two peacocks. A bird perches on one leg at each end of the branch of the cross, while within its circular loop is a dove holding an olive twig. Two large olive branches flank the cross as if they were intended as two diagonal struts between the foot and the extremities of the branch. The whole composition is pregnant with symbolism: the peacocks for Resurrection, and the dove holding the olive twig within the loop as a charade for "Heavenly peace in eternal life." The latter pictographic combination is akin to that of the cross or Chrism within the loop of the *crux ansata* (Coptic textile from Akhmim; Victoria and Albert Museum, No. 309; (A.D. V) for "Christ in eternal life," or the face of a deceased within the

loop (from Akhmim: M. M. A., Acc. No. 10.176.29; A.D. V) for "The deceased so-and-so in eternal life." The band interlace or guilloche which fills the cross shows discontinuous coloring of the ribbons to have an even repartition of the three colors, yellow, red, and brown. It is also "discordant" in that it consists of two distinct ribbons of different length. Because of these two facts the interlace of this miniature, the earliest known, is interpreted as a link between the classical type and the Hiberno-Saxon one characterized by "discordance" and discontinuity in color or pattern of ornament as represented by the earliest surviving insular example, the Durham Gospel Book (Durham Cathedral Library, Mo. A. II.10; mid A.D. VII) and the more developed Book of Durrow (Trinity College, Dublin, Ms. 57; last third of A.D. VII).

Of an early date are secular manuscripts on papyrus rolls (*rotulus*). Of the "Christian Topography of Cosmas Indicopleustes," written by an Alexandrian author in about A.D. 547, there are several later copies, a curious mixture of secular and Christian themes illustrated with maps and miniatures of animals, plants, and Biblical scenes marking the parallelism between the Old and the New Testaments. This work copied the new monumental style, including that of mural mosaics and other original features, thus helping in its diffusion and marking an evolution toward stylization. Religious works of later date are gospels illustrated in the picturesque elegant style of the Alexandrian school, only paralleled by that

114. H. Bober, "On the Illumination of the Glazier Codex. A Contribution to Early Coptic Art and Its Relation to Hiberno-Saxon Interlace," in *Homage to a Bookman, Essays on Manuscripts, Books and Printing, Written for Hans P. Kraus, on His 60th Birthday, Oct. 12, 1967* (Berlin: 1967), pp. 31–49. J. Kebabian, "The Binding of the Glazier Manuscript of the Acts of the Apostles (IV or IV/V Century)," *ibid.*

4.53
Painted wooden coffin from Karâra. (A.D. VIII;
H. Ranke, *Koptische Friedhöfe bei Karâra,*
frontispiece.)

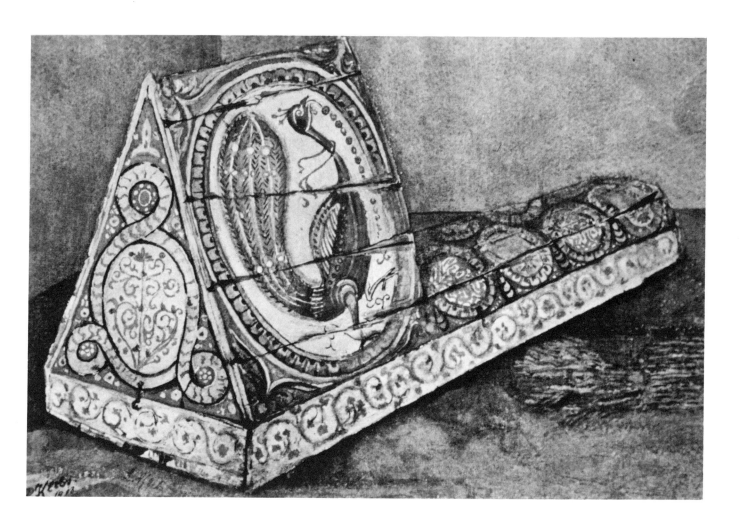

at Antioch, and better known through early manuscripts such as the Gospels of Rabula, a Mesopotamian monk (A.D. 586), and through the Codex Rossanensis (A.D. VI).

The earliest Coptic manuscripts of religious content are the Gnostic Papyrus codexes from Nag' Hammadi (A.D. IV); these are enclosed in leather cases, one of which is marked with the hieroglyph 'ankh, also found on a page of Codex Brucianus (A.D. V–VI). Only slight ornament such as *paragraphos*, *coronis*, or headpiece appears. Whether or not a fragment of papyrus representing, in a realistic Alexandrian style of line drawing, the frightened group of the apostles while Christ (beardless) sleeps in the boat on Tiberiade lake is from Egypt is not apparent (Fig. 4.54; Museo Archeologico, Florence, 8682; A.D. V–VI). In addition to the obelos and *diple* signs borrowed from Greek paleography,[115] a bird appears in the fourth century as an adjunct to the *coronis* (Thimotheus Papyrus, Abusir), a scissors-like band of lozenges separating chapters (Gospel of Truth, A.D. IV) and the common *paragraphos*, also drawn in the margin as a pair of spirals connected by a broken line ornamented with floral elements in its internal angle (Fig. 4.55).[116] Soon a bird hovers about the lower end of the entirely floral element (A.D. VI), to which an ornamented majuscule serves now as initial letter (Papyrussamlung, Albertina Collection, Vienna, K.9.428). Chapter headpieces filled in with interlace or zigzag, sometimes very intricate in

blue, red, and yellow (A.D. VIII), assume various shapes (rectangular with a vertical or triangular jamb at either end) sometimes allied to vertical marginal columns. Floral and geometrical patterns are used on the same page with interlace bands (Albertina Collection, Vienna, K.9.428) later combined under Fatimid influence (A.D. XII) into an abstract arabesque similar to those in Coranic manuscripts, which also spread over whole pages or in a cross and rosette motif on frontispieces and in bindings (A.D. XIII). Ever since the sixth century the antithetic motif of a vase flanked by two birds is used at the beginning of a gospel or in a fully colored hagiographic text. It is noteworthy that the Coptic manuscripts, unlike the Byzantine ones, do not combine fabulous contorted animals with their ornamented lettering, except in the *alpha*, whose upper volute suggesting a floral terminal was soon further interpreted as a bird's head holding a leaf—a theriomorphic juncture that developed into an ornithomorphic design (Fig. 4.56).[117] Occasionally another letter, *epsilon* or *pi*, circumscribes in its two halves (Fig. 4.55) the geometrized features of a face (A.D. IX–X).

Later parchment manuscripts, occasionally on papyrus (Homilies, A.D. 650), are Bibles (A.D. VII–VIII), commentary on Prophet Zacharias (A.D. VI–VII), and Eulogies, of the Apostles Peter and Paul (A.D. VII–VIII), in which ornament features, besides the paragraph markers already

mentioned, floral bands, some with doves.[118] A unique work is the Book of Job (National Library, Naples) in which a line composition on two-thirds of a page still retains in the elegant naturalism of its four frontal figures much of the Alexandrian style and would point to a date in the seventh rather than in the ninth century. "The Chronicle of the History of the World" (A.D. VII),[119] in Greek of Alexandrian redaction, has text illustrations deprived of depth or perspective arranged in rows in a rough color scheme of red and yellow, perhaps an Upper Egyptian work. Most of the manuscripts come from the Fayum and Wadi Natrun monasteries. Those from the ninth century are hagiographic (Pierpont, Mss. 579, 580, 583, 596, 608, 612), liturgical (Pierpont, Ms. 577), or a gospel (B. M., Ms. Or. 8812). At the beginning of the ninth century linear schematic single figures (St. John, David) or animals appear at the lower edge of pages in addition to earlier motifs. A hare or even a lion or an eagle preying upon an ox or an oryx are lively sketches that claim no symbolic value. Crosses in interlace flanked by elegant stags, lions, and hares are still later inventions and ultimately at the turn of the tenth century compositions on historical themes such as Maria Lactans and angels (Pierpont, Ms. 612; A.D. 893; Ms. 577; A.D. 895) or St. Stephen and angels (ibid.) or two monks, usually strictly frontal in full

115. M. Cramer, *Koptische Buchmalerei* (Recklinghausen: 1964), pp. 18 ff.
116. W. de Grüneisen, *Caractéristiques*, p. 132, Fig. 71.

117. M. Cramer, *Den Christlich-Koptische Ägypten einst und heute* (Wiesbaden: 1959), Fig. 127. W. de Grüneisen, *Caractéristiques*, Fig. 72, p. 133.

118. W. de Grüneisen, *Caractéristiques*, p.100, n. 1, pl. XLV.
119. A. Bauer and J. Strzygowski, "Eine Alexandrinische Weltchronik," *Denkschriften of the Vienna Academy* (philosophic-historical section), Vol. 51 (Vienna: 1906), pp. 169 ff.

colors on a whole page (A.D. VIII–IX), present a faint claim to hagiographic portraiture. Meanwhile, however, paragraph marks achieve a refined elegance (Vatican Library, Copt. 1; 69).

At the beginning of the tenth century strict frontality allies with a greater ability to achieve more convincing naturalism (Maria Lactans and Christ in clipeus with four evangelists; Pierpont, Ms. 600; A.D. 906) and some forceful portraiture (Michael; Pierpont, Ms, 603; 903 A.D.; also Moses; Vatican Library, Copt. 1, A.D. IX–X). It is then that interpretation of the Christological cycle begins in illuminations still featuring full-page frontal figures that are seemingly unrelated, as in the Annunciation (Pierpont, Ms. 597; A.D. 914). Hagiographic subjects in line drawing show riders such as St. Theodorus (Fig. 4.57; Vatican Library, Copt. 66, Fol. 210 v; A.D. 1000) and St. Mercurius on horses in lateral projection, both front legs crossed as they trample some personification of evil (Vatican Library, Copt. 66; A.D. 1000). A later St. Menas as an *orans* on horseback is also depicted frontally (Rylands, Coptic Ms. 33; A.D. XI).

In the second half of the twelfth century a marked evolution occurs with the introduction of the type of seated evangelist writing the gospel under the inspiration of an angel, a motif obviously derived from the pagan custom of placing the author's portrait at the beginning of a manuscript as in the early Virgil (Vatican Library) or Dioscorides and the personification of Discovery (Euresis; Albertina Collection, Vienna, Cod. med. gr. 1; A.D. 500),

itself inspired from Hellenistic murals (House of Menander at Pompeii; A.D. 70). The same type had appeared in the eighth century in Western illuminated manuscripts (Gospel Book of Charlemagne). In Coptic manuscripts each evangelist is represented in a full-page illustration at the beginning of his gospel seated facing right on a high chair accessible from a three-stepped stool before a large cross and Christ (Fig. 4.58; Matthew; A.D. 1173) or beneath an Islamic trefoil arch for Mark, semicircular for Luke, and pointed for John (Bohairic-Arabic Gospel; Bodleian Library, Oxford, Ms. Copt. Huntington 17; A.D. 1173).

A slightly later manuscript of the four gospels in Bohairic (Bibliothèque Nationale, Ms. Copte 13; A.D. 1180) is illuminated with 77 scenes within the text from the Christological cycle, usually one per page in a three-dimensional composition strongly reminiscent of Hellenistic style without background, though occasionally framed within an Islamic arch on columns (scene of Cana). The figures are alert, well-proportioned, full of movement and accurate foreshortening. Plants are used sparingly as terminal elements at one or both ends, or in a stylized frieze along the ground line (Miraculous Draught of Fishes, Resurrection of Lazarus, Descent from the Cross, A.D. 1180; Fig. 4.59 Christ distributing Communion). Similar friezes occur in monastic murals (Bawit). The palette features soft blue, red, green, yellow, and gold. Contrasting with this is the strong coloristic style with dark blue backgrounds, vivid reds, buffs, and greens (Bohairic-

Arabic; Vat., Copt. 9; A.D. 1205) in the portraits of the four evangelists and a monochrome golden arabesque composition. A special mention should be made of a Bohairic-Arabic manuscript of the four gospels (Institut Catholique Paris, Ms. Copte-Arabe 1; A.D. 1250) illuminated with full-page portraits of the evangelists seated on an Islamic *diwān* within a trefoil Islamic arch with a hanging, both profusely ornamented with floral arabesques. There are also ten golden folio plates, each subdivided into six squares containing scenes from the Christological cycle treated in an Islamic Mesopotamian style with hardly any background. The impact of this masterly composition must have been such that it was imitated four centuries later in 1663. Completely different and of a strictly native style are the portraits of Luke and John standing frontally and symmetrically within an arched portal with rich floral ornament of Greek type, obviously a resurgence of an indigenous trend (Vatican Library, Copt. 8; A.D. XIII). Ornament has by now assumed an Islamic flavor very similar to that used in Coranic manuscripts, featuring titles and text in one of the Arabic scripts (four gospels in Arabic; C.M., Ms. Arab. 91, Bibl.; A.D. XIV). One manuscript (Bohairic-Arabic; B. M., Or. Ms. 1316; A.D. 1663) imitating that of 1250 also derives inspiration from European Renaissance painting, admittedly not always very fortunate, for the evangelists appear now in perspective accompanied by their symbolic animals on a confused background of ornament. In its Christological scenes inserted separately within the text, one or sometimes two to a page, Islamic

4.54
Line drawing on papyrus representing the frightened apostles and Christ sleeping on the Lake of Tiberiade. (Museo Archeologico, Florence, 8682; A.D. V–VI.)

4.55
Typical *paragraphos, coronis, diple,* and *obelos.*
(M. Cramer, *Koptische Buchmalerei*, Figs. 1, 5, 6.)
Illuminated page of a codex. (Albertina, Collection Vienna, K. 9.428.)
4.56
Ornithomorphic initial letter ALPHA.

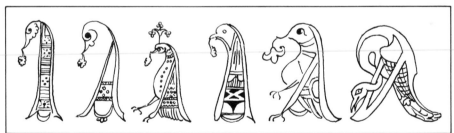

4.57
Line drawing depicting St. Theodoros the Stratelates spearing the Dragon. (Vatican Library, Copt. 66, fol. 210 v; A.D. 1000; W. de Grüneisen, *Les caractéristiques de l'art copte*, pl. XLVI.)

4.58
Full-page illustration of the Bohairic Gospel of St. Mathew. (Bodleian Library, Oxford, Ms. Copt. Huntington 17, fol. 1 v; A.D. 1173; M. Cramer, *Koptische Buchmalerei*, pl. XI.)

4.59
Ilumination representing Christ distributing Communion. (Bibliothèque Nationale, Paris, Ms. Coptes 13; A.D. 1180; M. Cramer, *Koptische Buchmalerei*, Fig. 129.)

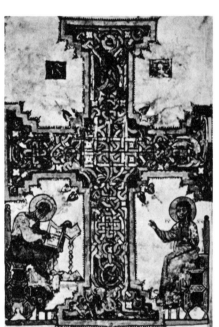

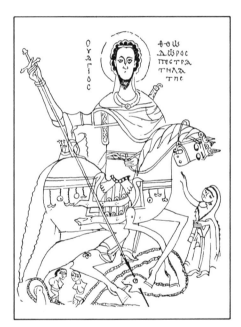

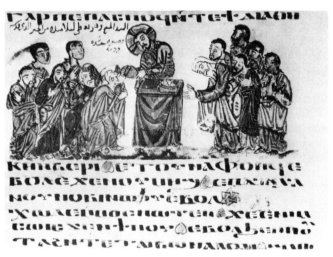

influence is predominant in the round whiskered faces, the flowing robes with loose folds, some landscape background, the persistent frontality and lack of vitality, though the themes are still those of earlier manuscripts. The colors are subdued red, emerald, yellow, grayish blue (faces), and black, a palette that differs from the Coptic one. The effect is close to that of contemporary folkloric prints.

While the Greek World Chronicle on papyrus still may be related to the pagan Egyptian illuminated manuscripts on papyrus with a poor palette, no ornament, stiff figures with coarse faces and inexpressive eyes, perhaps marking Egyptian feeling around A.D. 400 against Hellenic art, the Codex of Cosmas Indicopleustes shows abstraction and survival of late-antique spirit with brilliant colors and delicate modeling. Very little evidence concerning illumination is available until the end of the ninth century, when the style presents all the characteristics of native production, probably monastic of high provinciality with coarse frontal draftsmanship and staring gaze, though borrowing occasionally an ancient Egyptian feature, as in the upper corner of a composition in which angels appear with wings bent at right angles like those of the bird deities Horus or Nekhebet shown protecting Pharaoh in Egyptian murals. Ornament is, however, used as margin markers, headpieces, or separating bands. This void in the production of religious manuscripts is perhaps fortuitous, or it may reflect an unfavorable environment until the Tulunids and especially under the Fatimids, when ornamental and re-

presentational miniatures find new impulses from the cultural contacts with Mesopotamia, Syria, and Armenia. The illumination that bloomed through this renaissance offers many traits that can be traced back to late-antique pictorial art—lack of background, three-dimensional figures in instantaneous motion, Hellenistic themes like the semicircular arrangement, and Roman triclinia. The facial features occasionally interpret emotion (mourning women at the Descent from the Cross, Bibliothèque Nationale, Ms. Copte 13). The consistent use of the halo may point to an influence from Syria. The style compares favorably with the post-Iconoclastic Byzantine[120] of Alexandrian tradition (Laurentianus, Lib. 6. cap. 23) though not as elaborate in the details and three-dimensional modeling, and to the Byzantine of Antioch tradition in its simplification of the figures on a blank background and the increase in the number of scenes of the Christological cycle (77 in Bibliothèque Nationale, Ms. Copte 13, compared to 350 in Parisianus 74). The marginal paintings invented by Byzantine monastic illumination (Chudov Psalter; A.D. IX) are not common in Coptic manuscripts. An isolated instance in a strictly frontal style richly ornamented (Coptic Museum, Ms. Arab. 95; A.D. XIII) is reminiscent of monastic murals further abstracted. Such elements common to both Coptic and Byzantine illuminations could well have derived from common sources (writing evangelist derived from earlier author's portrait in Greek manuscripts).

Ever since the predynastic period (c. 3500 B.C.), the Egyptians had been a nation of weavers. Vertical looms were worked in front of the workmen's houses at 'Amarna East (c. 1375 B.C.) and in the basement of the town house of Thutnefer at Thebes (c. 1482 B.C.). Predynastic textiles painted with boats are known. Fine linen fabrics with insets were spread over canopies protecting beds (Hetepheres, Fourth Dynasty), and tapestry was known under Thutmose III.[121] Egyptian flax was renowned, and in Roman times weavers formed a hereditary caste apart from the guilds of other weavers under the supervision of "masters of looms."[122] There were quarters of linen weavers in Arsinoë and Theadelphia; Arsinoïte weavers as well as others known by their district names, either Egyptian (Theban, Oxyrhinchite, Cynopolite) or foreign (Laconian, Iodix for Laodicea), were in demand for foreign trade in the West (Spain, Italy, Dalmatia) and the East, especially Arabia and India. Wool had been used extensively under the Ptolemies, and Roman customs at Oxyrhynchos report a considerable trade in wool. In Diocletian's Edict Alexandrian linen was ranked fifth, and the edict mentions a linen imitating the fabrics of Tarsus.[123] There is much evidence

120. P. Lemerle, *Le Style Byzantin.* J. Ebersolt, *La Miniature Byzantine* (Paris: 1926).

121. A. C. Johnson, *Roman Egypt to the Reign of Diocletian,* Vol. 2 of T. Frank, *An Economic Survey of Ancient Rome* (Baltimore: 1936), pp. 332–333, 338–339. Hereafter cited as *Roman Egypt.*
122. E. Wipszycka, *L'industrie textile dans l'Egypte romaine* (Wroclaw: 1965).
123. A. C. Johnson and L. C. West, *Byzantine Egypt: Economic Studies* (Princeton: 1949), pp. 119–125. (Hereafter cited as *Byzantine Egypt.*)

that weavers of Byzantine Egypt imitated foreign styles and colors. Wool was of importance for the domestic market only. Cotton occasionally used in Roman Egypt put in a later appearance after Justinian.

Coptic two-faced textiles were probably woven on looms with four heddles and vertical looms, possibly 2 × 3 meters, with foot treadles (monastery of Epiphanius in Western Thebes),[124] though draw looms must have been used for special weaves. The majority of fibers are spun to the left (S). Types of Coptic weaves from the sixth century include tapestry (woolen brocade), woven galloon, and looped woolen brocade, some on linen. In wool Coptic weaves imitate (A.D. V–VI) Sassanian silks or Syrian silks (A.D. VI–VII), and Coptic silk imitates those of Syria (Akhmim, Qaw; A.D. VI). Sketches on papyrus (Berlin Museum, Fouquet collection) were designed by special artists as cartoons for tapestry weaves. The most exclusive of dyes, purple manufactured from shellfish but also from cheaper substitutes such as acacia pods and safflower, appears until the fourth century in woolens but later in silks (A.D. VI).

The huge amount of Coptic textiles represented in collections throughout the world come from rubbish heaps and burial grounds in the vicinity of monasteries and towns. Linen showing signs of wear and repair, woollen robes with insets of tapestry bands and panels, shrouds, cushions, tablecloths,

and hangings were ultimately used as wrappings for corpses after the custom of mummification ceased in the second half of the third century. The main centers of textile finds are Akhmim, Sheikh 'Abada, Deir Abu Hennis, Bawit, Ashmunein, Karanis, and Saqqara. Dating the textiles proves to be difficult, for most were dissociated from their archaeological context, and stylistic analogies from other arts such as painting and sculpture are inaccurate because cartoons may have been copied and textile styles lived longer than in other disciplines. There were also two or more aesthetic standards, as for Coptic art in other media; those for larger textile factories with established traditions and technical means were higher than those of house looms. Some finds, however, are dated, such as the plain cloths of Kharga (A.D. III–IV, in the Metropolitan Museum), patterned weaves from Karanis (A.D. IV–V, in Ann Arbor), and the Saqqara group (A.D. 615–618, Theodor Graf finds in Vienna). In the later Islamic period, both dating and place of original workmanship are given by the *tiraz* inscriptions woven into the fabrics. The chemist Pfister, who made a special study of the textiles, found that Islamic red was of lac dye while earlier Coptic fabrics used vegetal dyes.

The techniques of Coptic weaving have been studied recently by P. du Bourguet in his Catalogue of the Louvre, excellently illustrated with macrophoto-

graphs.[125] The earliest textiles until the fourth century are tabby weaves of linen, either solid or forming a small frame or figure in tapestry by interrupting the original thread of the woof and inserting instead in the warp other threads of different color. In general the warp in tapestry weave has a thicker threading than that in tabby weave. In the second period, from the fourth to the seventh century, the tapestry weave is developed by weaving the colored tapestry onto an area itself of tapestry thicker than the rest of tabby-weave textile. After the seventh century the whole fabric is of tapestry weave onto which the decorated tapestry is woven.

In addition to decorative effects resulting from variation in the pattern of the woof in the tabby weave itself, the passage to the ornamental motif is done by inserting colored thread to fill the area of this motif left vacant in the woof. The warp can be curved in the process, an obvious advantage of the hand loom. The ornamental motif is in wool, while the flesh areas, the skin of animals, and the background are in linen. Though hatching is known, it is only rarely used and disappears after the seventh century. Instead the motif is composed of masses, often contrasting, by means of a woof shuttle that fills the ground and the general outline of the subject, complemented by a second shuttle winding its thread around the warp or the woof. The subject partially woven is finished with the addition of color blots and delineation of features and folds, with

124. H. E. Winlock and W. E. Crum, *The Monastery of Epiphanius at Thebes*, 2 vols. (New York: 1926), Vol. 1, p. 68.

125. P. du Bourguet, *Musée National du Louvre, Catalogue des Étoffes Coptes.* Vol. 1 (Paris: 1964), pp. 8–17. (Hereafter cited as *Catalogue*.)

much the same effect as impressionistic brush strokes, using a third shuttle called the "flying shuttle" because it does not follow vertical or horizontal directions.

The majority of the finds are tunics, the common vestment inherited from imperial Rome. The tunics are richly ornamented with two vertical tapestry bands (*clavi*) running over the shoulders front and back from both sides of the slit for the neck down to the hem (Fig. 4.60). In richer garments there are roundels (*orbiculae*) or squares inset on the shoulder and at the level of the hips both front and back; these are sometimes accompanied by angular bands ending in a leaf (*gammulae*) and by two bands on the short sleeves. The shorter tunic is no longer a sign of social rank, for both the lord and the serf depicted in the mosaic of Piazza Armeria (Sicily, C. A.D. 300) wear it, the clavi of the serf being short and ending on his chest, a fashion in all tunics. Most of the garments worn by the angels and personages represented in murals, however, reach slightly above the ankles (Fig. 4.61). This is corroborated by a study of the beautifully preserved pieces in the Egyptian Collection of the Berlin Museum, taking into consideration their length, which I have shown in perspective sketches (Fig. 4.62). Quite often a large cloth is draped over the shoulder as a pallium held by a fibula on the right shoulder. A cloak cost 5,000 dr. and a tunic 4,000 dr. in A.D. 314 at Karanis, the same price as an embroidered one in the Fayum.[126] The solid

126. A. C. Johnson and L. C. West, *Byzantine Egypt*, p. 186.

purple of the clavi is now replaced by polychrome ornament harmonizing with that on the sleeves or around the neck slit. Servants could wear a short tunic with a slit along the side covered by an overlapping broad band. This costume ornamentation provides a unique material for the study of a special aspect of graphic arts—the design and evolution of motifs framed within narrow bands and square or round panels and their interpretation in the special medium of tapestry, but rarely in embroidery.

For the purpose of study the textiles[127] may be classified into three periods: proto-Coptic, until the second half of the fifth century; Coptic until the second half of the seventh and later Coptic and Islamic when the Copts worked also for the new rulers and the style gradually was debased until it disappeared in the twelfth century. There are no clear-cut criteria that help to differentiate groups in relation to time brackets, and both theme and style spread in time as a result of the variety of local industries.

127. P. du Bourguet, *L'Art Copte*, pp. 35–36, 41–42, 46–48. P. Du Bourguet, *Catalogue*, pp. 22–35. W. F. Volbach, "Koptische Stoffe," in *Koptische Kunst* (Essen: 1963), pp. 147–152. J. Beckwith, "Coptic Textiles," *Ciba Review*, Vol. 12, No. 133 (Basle: 1959), pp. 2–27. K. Wessel, *Koptische Kunst*, pp. 195–246, 254–255.

Proto-Coptic Textiles

The earliest textiles are probably the easiest to identify, because their designs are closer in their naturalistic elegant style to Hellenistic prototypes than to late-antique graphics. Two groups may be labeled as polychrome and purple fabrics. In polychrome weaves the modeling of the figures represented in three-quarters tries to imitate by means of hatching and color gradation the impressionistic brush strokes found in mural paintings of Hellenistic tradition. The subjects are reminiscent of late-antique themes: fishing scenes, pagan figures (Herakles, Dionysos and Pan, Meleager, Tritons and Nereids, Erotes), personifications (Nile, Gaia), and masks always surrounded by, or even integrated with, floral bands. Most of these fabrics are linen and wool hangings of relatively large size. The earlier polychrome textiles are comparable in more than one respect to contemporary mosaics (Antioch); for both techniques conform to a design on a geometric mesh, and modeling is effected by an analytic process decomposing shaded areas into contiguous stripes of graded colors. The earliest seem to be large hangings printed by reserve, usually blue on uncolored linen, probably after the method described by Pliny (Nat. Hist., Lib. 35, cap. 42). The pagan motifs of the Dionysiac cycle show in the unique painted piece from Antinoë (Fig. 4.63)[128] whose design, still purely late Hellenistic with boldly curving nudes, is closely imitated in those of the textiles representing

128. E. Guimet, *Les Portraits d'Antinoë au Musée Guimet*, in *Annales du Musée Guimet* (Paris: [1912?]), pl. XIII, pp. 19–21.

4.60
Tunics in the Victoria and Albert Museum,
London. (A. F. Kendrick, *Catalogue of Textiles
from Burying-Grounds in Egypt*, Vol. 1, pl. I, 4,
1; Vol. 2, pl. XIII, 334; pl. XVI, 337; Vol. 3, pl. III,
619.)
4.61
Representation of costumes in murals. (J. Clédat,
"Le Monastère," Vol. 1, part 1, pls. XCVI, XLVIII;
Vol. 2, part 1, pl. XVI; E. Breccia, "Le prime
ricerche italiane ad Antinoe," p. 294, Fig. 6.)

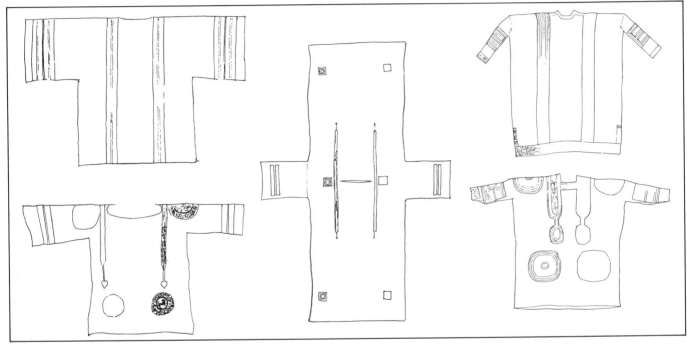

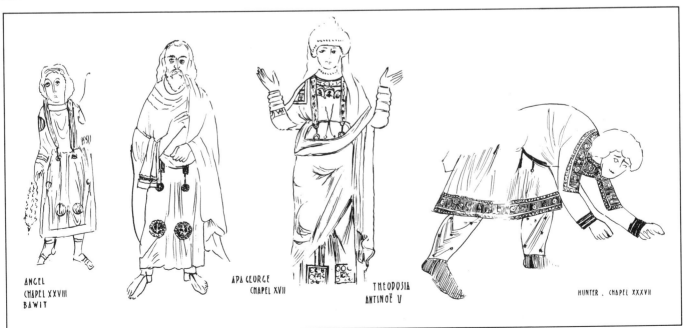

Coptic garments from the Egyptian Collection,
Berlin Museum: top left, 15076, Antinoë, A.D.
IV–V,1.23m. high; top middle, 11421, A.D. V–VI,
1.22m. high; top right, 10829, A.D. 1.31 m. high;
bottom left, 17521, Akhmim, A.D. VI–VII, 0.97m.
high; bottom middle, 14243, Antinoë, A.D. VI–
VII, 1.12m. high; bottom right, 14231, woolen
caftan, Antinoë, A.D. VI–VII, 1.15m. high.)

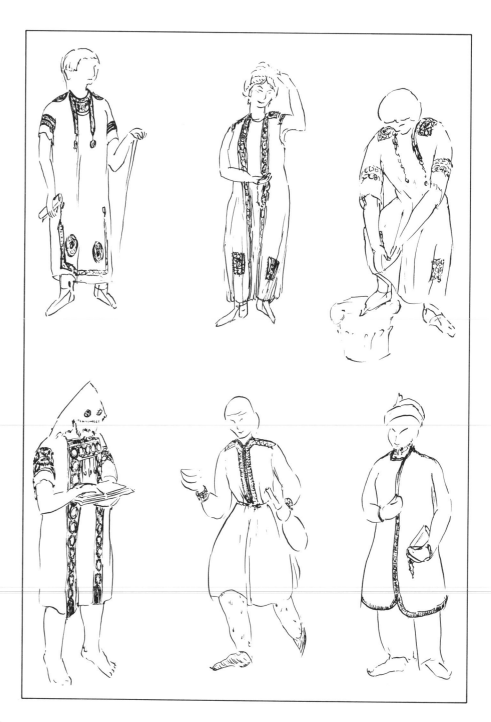

in a stiffer style from the Christological cycle[129] the Annunciation, the Nativity, and the Bath of Christ. These form the prototypes of the murals ('Abd el Gadir, Deir Suryani).[130] A large loop tapestry in colored wool on linen (Akhmim; B. M., 20717; A.D. IV) represents a boat with a winged Eros at the rudder and another fishing (Fig. 4.64). The crowded ground containing the boat's reflection in the water, with ducks and fishes, the surrounding guilloche frame and masks at the corners in delicate gradation and modeling, as well as the lively naturalistic design and coloring of the figures, all compare favorably with Nilotic scenes and mosaics and suggest a date toward the middle of the fourth century. Among costume insets are two roundels with busts representing personifications of the Nile (Moscow; 31 cm.; A.D. II) and the Earth (Leningrad; 25.5 cm.; A.D. II) within a naturalistic floral frame. Naturalistic also are Neilos' vigorous white-haired head and strongly muscled bust, partly hidden by a cornucopia (Fig. 4.65), as is the softer portrait of Gē with plaited hair and flower diadem. The excellent modeling is rendered by graded colors further emphasized by hatching, an imitation of the painting technique of Fayum portraits, though with more depth in the three-quarters projection of the faces.

As excellent in portraying animals as was any ancient Egyptian and Coptic

artist in other media, the weaver represents fish sailing in turquoise waters casting deep shadows that give a thrilling effect of depth (from Antinoë; Louvre, Inv. No. G.U. 1242; A.D. II–III) or a stylized dolphin swimming between two floral borders (Victoria and Albert Museum; A.D. IV–V). The wounded lioness spitting blood is a masterpiece of realism in design and modeling (Fig. 4.66; Pushkin Museum, 5199 Moscow). Another well-modeled fish, mottled with a looped tail fanning out, dates perhaps from the end of this early period (Fig. 4.67; Pushkin Museum, Moscow, I.Ia.5164). Even square insets may represent an extremely naturalistic bird in several colors (Fig. 4.68; Cluny). A shoulder square inset with Nereids, Tritons, and Erotes, evidently influenced by the principle of horror vacui and showing also naturalistic traits is woven in woolen warps in gold on a silk core and woolen wefts in brown, yellow, green, blue, pink, and purple (M.F. A., 46. 401; A.D. V).[131] Beckwith points out that fabrics woven in gold, silk, and wool are rare.

The style evolves toward less interest in a three-dimensional ground with an emphasis on the figures more stylized though still indulging in dancing postures. A large tapestry (Fig. 4.69; B. M. 43049; 2 × 1.5 m. wide; A.D. V) represents on a plain ground studded with rosettes two figures separated by a medial vertical band and bordered by two other ones. The male figure wears a pointed Phrygian cap, a green kilt, and red cloak, and holds a spear

(Actaeon, Orion, or Meleager), while the female in green skirt and spotted red cloak, probably Artemis, seems to be striding hurriedly while stretching her bow. Along the vertical bands are superimposed small dancing figures, mostly nude, with shields, staffs, and flowing robes woven in purple over a background of tendrils (borders) or within a scroll (medial). The emphasis on the outlines of the nude body and face, the white eyebrows and eye, and the importance of purple are characteristic of later Coptic fabrics.[132] A similar tapestry hanging (C. M., M. E. No. 4/3/22/2; A.D. IV–V) represents on an open ground a piper wearing a red kilt with a green cloth over his left shoulder, and along a vertical panel, riders and dancers.[133] The head of a large-eyed girl wearing a diadem that imitates the fortified enclosure of a town is less naturalistic than that of Neilos or Gē and dates perhaps from the fourth or fifth century (Fig. 4.70; Pushkin Museum, Moscow).

The second group consists of small monochrome insets usually embellished by ornamental patterns woven in purple wool and undyed linen (S) with linen threads for inner details. Intricate geometric designs form the earliest such patterns (A.D. IV) and are often

129. In Victoria and Albert Museum, London. Cf. O. M. Dalton, *Byzantine Art*, Fig. 381, p. 604.
130. A. Badawy, "L'Art Copte. II. Les Influences hellènistiques et romaines," pp. 48–49, Figs. 58–60.

131. J. Beckwith, "Coptic Textiles," p. 7.

132. A. F. Shore, in *Introductory Guide to the Egyptian Collections* (The British Museum: 1964), pp. 238–239, Fig. 88. K. Wessel, *Koptische Kunst*, p. 207, Fig. 118.
133. A. J. B. Wace, in A. J. B. Wace and E. Drioton, *Exposition d'Art Copte*, Décembre 1944. Guide (Cairo: 1944), p. 26, pl. IV.

4.63
Painted textile representing motifs from the Dionysiac cycle. (Antinoë; E. Guimet, *Les portraits d'Antinoe au Musée Guimet*, in *Annales du Musée Guimet*, 1900, pl. XIII.)

4.64
Loop wool tapestry representing erotes in a boat. (Akhmim; A.D. IV; B. M., 20717; courtesy Dr. I. E. S. Edwards, British Museum.)

4.65
Bust of Neilos, pink on a blue ground within a green and pink wreath. (Pushkin Museum, Moscow, 25.5cm. diam; A.D. II; courtesy R. Shurinova.)

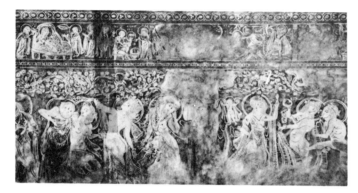

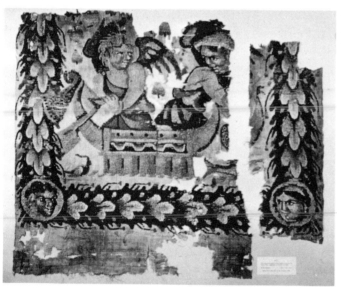

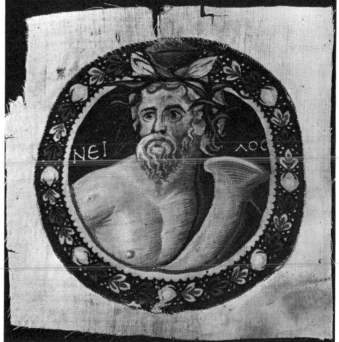

4.66
Polychrome textile fragment representing a
wounded lioness. (Pushkin Museum, Moscow,
5199; courtesy R. Shurinova.)

4.67
Polychrome textile representing a fish. (Pushkin
Museum, Moscow, I. Ia. 5164; courtesy R.
Shurinova.)

4.68
Square polychrome inset with a bird. (Cluny.)

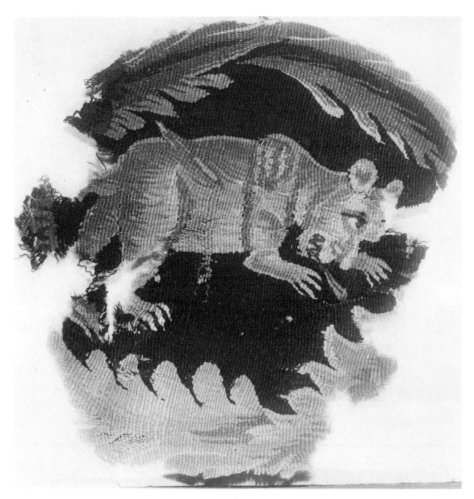

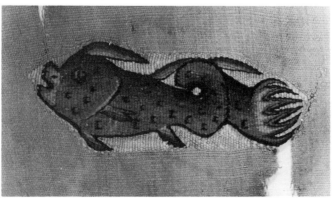

4.69
Large tapestry with figures bordered by vertical bands. (B. M., 43049, 2 × 1.5m.; A.D. V; courtesy Dr. I. E. S. Edwards, British Museum.)

4.70
Polychrome inset with head of personification of a town. (Pushkin Museum, Moscow, A.D.; IV–V; courtesy R. Shurinova.)
4.71
Monochrome inset with a horseman and four dancers. (B. M., 21802; A.D. V–VI.)

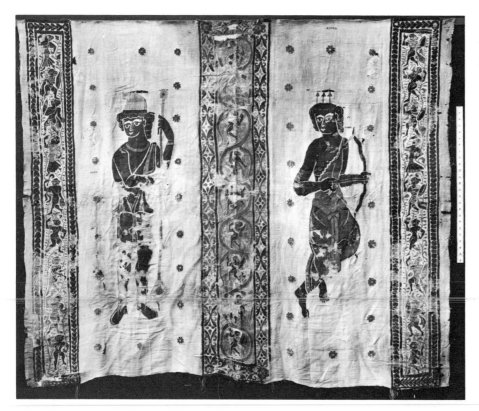

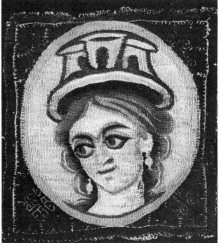

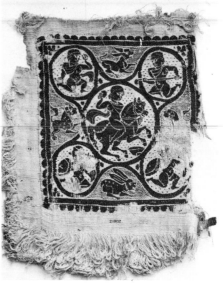

wrapped around the warp in an "overlaid" technique instead of being woven through it.[134] Some patterns, however, depict draped or nude figures of the flaccid, contorted late-antique type borrowed from classical mythology; these are set along clavi, alternating with small lions and hares within floral medallions, or with square insets composed of a rider and an Eros, each framed within medallions forming a chain in a floral scroll. This type survived, though evolving into stiffer shapes in the fifth and sixth centuries. None of the earlier textiles displays any definite Christian symbolism, for the nimbus surrounding the heads of some personages is a pagan element. Specifically Coptic work is perhaps recognizable by an alternation in the proportions of the figures, stricter stylization in the lines, and simplification in the modeling. It also shows the use of additional heddles in the warp to emphasize the outlines of the motifs, defining their masses against the background rather than modeling them. The monochrome weaves seem to consist mostly of costume ornament. A square inset (Fig. 4.71; B. M., 21802; A.D. V or VI) shows a horseman in a central medallion flanked by four floral scroll medallions, each containing a dancing figure of good proportions in dark purple or blue on a linen background. Between the lobes of the quatrefoil thus formed are jumping animals (dog, lion, hare). The scheme

134. L. M. Wilson, *Ancient Textiles from Egypt in the University of Michigan Collection* (Ann Arbor: 1933), pp. 28–29.

is not unlike the *mandorla* from which radiate four projecting evangelists' emblems in Coptic murals. As for the clavi, a frequent composition alternates standing figures—male and female, dancers or shepherds with crook holding a lion by the tail—with small running animals, each set vertically within a floral medallion (Victoria and Albert Museum, 1028–1901; B. M., 18198). Such a trend, which emphasized outlines toward an ornamental effect, makes excellent use of details from the late Hellenistic repertory such as fish, a basket of fruit, trees, often a vine stem growing out of a vase or amphora, a current motif from Roman to Byzantine times. Patterns feature the fret, guilloche, acanthus, vine and continuous scroll often inhabited by running animals, and along the outer edge the scallop with floral elements and the merlon.

Coptic Textiles

In this later period the repertory does not vary much from that of the earliest textiles. Large tapestry hangings still represent personifications of virtues in a symbolic composition like that of Hestia Polyolbos (Dumbarton Oaks Collection, 29.1; 1.13 × 1.37 m.), isolated moments of a mythological legend like Samson (or Herakles) fighting the lion presented in an iterated sequence (Dumbarton Oaks, 34.1; 96 × 40 cm.; silk, perhaps not Coptic?), or again hunting scenes similar to those found in late-antique designs (boars' hunt, Dumbarton Oaks Collection, 37.14), and Nereids (Dumbarton Oaks, 32.1). Also of late-antique influences are the smaller figures borrowed from the Dionysiac cycle and shown singly on a square inset within a framing scroll inhabited by hares, lions, etc. (B. M., 1771), or standing under the arcades of a columned portico (Fig. 4.72; B. M., 21789) in a border around the neck slit of a tunic, or in pairs as a nude man and a woman in a tree, probably Apollo and Daphne (B. M., 21791). Though paganism had not yet disappeared by the sixth or even the seventh century, it may be questioned whether any pagan symbolism was still attached to the motifs or if they were rather interpreted in the light of the new Christian symbolism? The hieroglyph *'ankh* appears now on liturgical hangings near the chrism between the *alpha* and the *omega* or in the still simpler design of rows of red *crux ansata* alternating with quatrefoils (Fig. 4.73; Brussels, N. 290). A large piece found around the neck of Aurelius Colluthius of Antinoë (A.D. VI-VII) shows on a diamond pattern of

blue lines red quatrefoils within squares alternating with red and blue crosses (Fig. 4.74; Musées Royaux, N. 2465). The style pursues the evolution started in the fifth century toward stronger stylization, mostly apparent in the emphasis laid on frontality. The female haloed figure of Hestia Polyolbos (Fig. 4.75; Dumbarton Oaks, 29.1; A.D. VI)[135] personifying the "Hearth rich in blessings"—allegedly from Egypt— is seated frontally on a throne, staring at the onlookers while she grasps with either hand at two among the six disks inscribed wealth, joy, praise, abundance, virtue, and progress offered her by six Erotes hurrying toward her on both sides. Two standing figures, also haloed, one holding Light, are in a *contrapposto* stance on either side of Hestia, the head slightly turned toward her. The blue-green ground is dense with elegant palmettes and flowers in rose, green, and buff. The figures are colored in naturalistic tones of buff, rose, blue, and green. Though the figures are slightly deformed, especially around the neck and shoulders and in the limbs of the Erotes, they still pertain to the late-antique type, perhaps Justinian. In its composition, hieratic stance, and even symbolic implication as a source of blessings the whole is reminiscent of Christian scenes with Christ in glory or the Virgin between two angels in contemporaneous murals at Bawit and Saqqara. The tapestry is, however, far above the provincial style of the murals and it

probably originates from Alexandria. Movement still characterizes Hellenistic figures in Coptic textiles, as in that depicting two hunters (Fig. 4.76; Dumbarton Oaks, 37.14; A.D. V)[136] each aiming his arrow at a wild boar, though the two puffy men are again in frontal attitude. The strongly stylized floral bands and the vine leaves in the ground point to a late date (A.D. VII). More naturalistic gestures and better proportions are seen in the encounter of two Nereids (Fig. 4.77; Dumbarton Oaks, 32.1; A.D. IV-V),[137] one riding a sea-bull reminiscent of the legend of Europa, a frequent motif in Coptic sculpture (Ahnas). The flowing scarf above the head of each Nereid is an element also found carved in Coptic Aphrodites. The date of the seventh century ascribed on the evidence of the headdresses and the acanthus border inhabited by birds, reminiscent of Gerasa mosaics, proves the long preservation of late Hellenistic motifs and style into a Coptic environment. These motifs had formerly led students to date the whole group of hangings to the fifth century, but Beckwith has lately suggested their relation to the Heraklean renaissance movement in the early seventh century.

Further evidence of an evolution toward a Coptic feeling for ornamental composition is found in a silk compound twill, perhaps not Coptic, iterating along superimposed registers a hero (Samson

rather than Herakles)[138] wrenching the jaws of a lion, the scene being duplicated in symmetrical pairs along each register (from Alexandria; Dumbarton Oaks, 34.1, A.D. VI-VII). This regularity, paralleled by that of the strongly stylized floral bands repeated above and below each register and emphasized by their rhythmic undulation, is far from Hellenistic impressionism. It is related to the iteration of figures in murals drawn by tracing the same element side by side. Yet the forceful, well-proportioned though linear figures and lions would mark this silk compound twill on red background from Alexandria as another of the renaissance tapestries woven in the time of Herakleus (A.D. VII) rather than as an Umayyad production. All the colors are still from a naturalistic palette though less softly graded than in the earliest tapestries. In a large square textile in the Louvre (58 × 55 cm.) a scene of Dionysos and a smaller female cymbal-player in a boat achieves an effect of depth with a clever contrast of the light pink nudes against a scarlet sky and green foliage around Dionysos, and a dark blue with brilliant yellow for the other half of the composition around the boat. In terms of Egyptian religion the scene could be interpreted as symbolizing Osiris and Isis in the funerary boat. The modeling is rendered by a graded band that follows the contour of the figures, but deforms the volumes.[139] The haloed Nereid (Fig. 4.78; Cleveland Museum of Art, Inv. No. 53.18; 65.7 × 64.8 cm.;

135. J. S. Thatcher, ed., *The Dumbarton Oaks Collection.* Harvard University (Washington: 1955), pp. 155, 160. E. Kitzinger, "The Horse and Lion Tapestry at Dumbarton Oaks," *Dumbarton Oaks Papers No. 3* (Cambridge, Mass.: 1946). (Hereafter cited as *Dumbarton Oaks.*)

136. *Dumbarton Oaks*, pp. 154, 159. J. Beckwith, "Coptic Textiles," pp. 12–14. K. Wessel, *Koptische Kunst*, pp. 213–214.
137. *Dumbarton Oaks*, pp. 154, 158. J. Beckwith, "Coptic Textiles," pp. 12, 14. K. Wessel, *Koptische Kunst*, p. 213.

138. *Dumbarton Oaks*, pp. 156–157, 164. K. Wessel, *Koptische Kunst*, pp. 219–220. Fragments of the same tapestry are also in Cluny, No. 3054, and Österreichisches Museum für Angewandte Kunst.
139. P. du Bourguet, *Die Kopten*, pp. 135, 141.

4.72
Monochrome weaves with figures. (B. M., 21789, below, 21791; courtesy B. M.)

4.73
Ornamental rows of *crux ansata* alternating with quatrefoils. (Akhmim; Brussels, N. 290; A.D. IV–V.)

4.74
Diamond pattern of red quatrefoils alternating with red and blue crosses, Musées Royaux, N. 2465.)

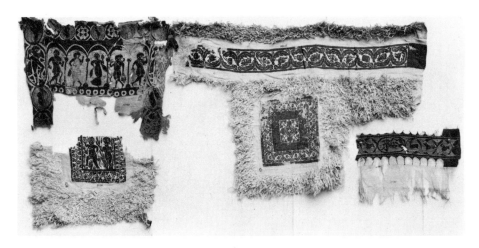

4.75
Hestia Polyolbos wool tapestry from Egypt.
(Dumbarton Oaks, 24.1; A.D. VI; courtesy
Dumbarton Oaks Collection.)

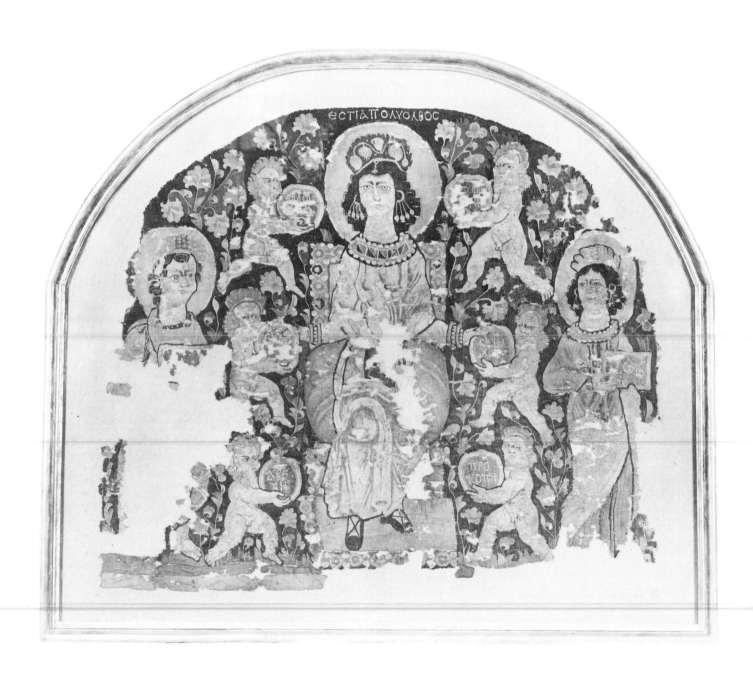

4.76
Boar hunt; wool and linen tapestry from Egypt.
(Dumbarton Oaks, 37.14; A.D. IV–V; courtesy
Dumbarton Oaks Collection.)

4.77
Encounter of two Nereids (Egypt; Dumbarton
Oaks, 32.1; A.D. IV–V; courtesy Dumbarton
Oaks Collection).

4.78
Polychrome inset with haloed Nereid. (Cleveland
Museum of Art, No. 53.18, 65.7 × 64.8 cm.; A.D.
VII; du Bourguet, *L'Art Copte*. p. No. 163.)

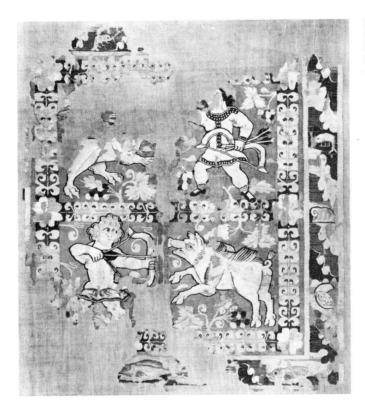

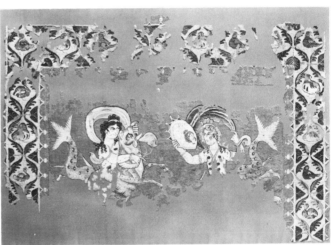

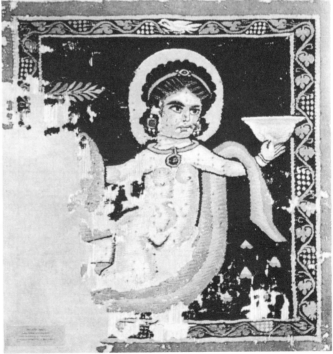

A.D. VII) swimming on a deep-blue ground above an orange drapery she holds in both arms preserves much of the late-antique tradition, though the modeling of the body and the large head are less naturalistic than the Neilos. This deficiency, added to the stylization of the vine frame, led to a dating in the seventh century,[140] though there is much in favor of the earlier dating in the fifth. Very similar is the haloed female head (Fig. 4.79; Detroit Institute of Art, No. 35.103; 17.2 × 12.1 cm), possibly from the fifth century,[141] in which the features are marked by a simple shade line, an early stage in the evolution toward circumscribing flat colors with thick black lines as in the Erotes and Nereids of Nilotic scenes. This graphic technique is similar to that used in monastic mural painting.

In dealing with the textiles in the Louvre collection, P. du Bourguet[142] defines certain characteristics of the pieces he dates to the sixth century such as wide-eyed figures, peopled rinceaux, bucolic scenes, and leaves in three-quarters projection in the rinceaux. To the seventh century he ascribes the wide-open leaf, the curving of the stems of the rinceau to form medallions that are soon independent, the broad squarish eyes of the figures and the animals, and the scalloped border.

140. J. Beckwith, "Coptic Textiles," p. 12. Compare P. Du Bourguet, *L'Art Copte*, p. 157 (A.D. V–VI) and W. F. Volbach, "Koptische Stoffe," pp. 149, 307 (A.D. III–IV). P. Du Bourguet, *Die Kopten*, p. 143.
141. J. Beckwith, "Coptic Textiles." P. du Bourguet, *L'Art Copte*, p. 147 (A.D. IV–V). W. F. Volbach, "Koptische Stoffe" (A.D. III–IV).
142. P. du Bourguet, *L'Art Copte*, pp. 22–24. *Die Kopten* (under textiles).

The majority of the fabrics are costume ornaments in purple tapestry, similar in technique to those of the earlier period in which the inner designs are delineated in white thread, but more Coptic in their style, often adding red or another color to a few elements. The former dynamism recedes into static postures of instantaneous motion, even in the motif of the rider (Fig. 4.80; Musées Royaux, N. 277; A.D. V or VI; also N. 274) on a galloping horse in a central medallion from which protrude four smaller radiating medallions that encircle kneeling Erotes playing the flute or holding a duck or other items. Between the medallions are conventionalized baskets of fruit and trefoil in variegated color instead of the earlier rearing lions. The background is dotted as before, sometimes with branches spreading horizontally in the upper part (Musées Royaux, N. 274). A similar composition may display a centaur in the central medallion flanked by four griffins (Kunsthistorisches Museum, Vienna). Horsemen also appear in a roundel with monochrome frame (ibid.) or in a square (Musées Royaux, N. 2476) surrounded by polychrome quatrefoils or by alternating running men and animals (Musées Royaux, N. 278; A.D. VI), a spirited motif reminiscent of the earlier violent movement. Numerous animals surround in a double frame a haloed rider but they are here conventionalized into plump bodies on thin legs inhabiting the curves of a simplified scroll; they are little more in fact than mere symbols, showing Near Eastern influence.

In another motif for costume insets which features two figures the evolution tends toward an increasingly frontal representation and an invasion of the background by floral elements. In an early piece with purple design (Fig. 4.81; Cluny, 13166, A.D. V) a seated man glances away while a standing woman tries to evade the vicious bite of an irate goose, one of those humoristic traits found elsewhere in tapestries and murals. More static and completely frontal is the piece framed by baskets and trefoils which represents Daphne being transformed into a tree to escape the pursuing Apollo (B. M., 21761; A.D. VII) or the graceful nude (Kansas University Museum; A.D. VII) with flowing red cape within a border of red and purple crosses and scallop. The frame assumes more importance, either as interlace with trefoils forming a chain of medallions each containing a running animal set vertically (B. M., 17171), or sometimes alternating with Erotes (Fig. 4.82; Osterreichiches Museum fur Angewandte Kunst, No. 633; A.D. VII). The hair of the figures now assumes a moplike appearance, the features are squared, the posture is little more than conventional, and the proportions have deteriorated. The decorative trend has nearly stamped out naturalism with an undeniably effective result, as in the crouching hare (Fig. 4.83; Cluny, 13175; A.D. VI). Symmetrical composition, which will be frequent in post-conquest textiles, already appears with a modified motif derived from the Mesopotamian sacred

4.79
Polychrome haloed head. (Detroit Institute
of Art, No. 35.103, 17.2×12.1cm.; A.D. V; J.
Beckwith, "Coptic Textiles," *Ciba Review*,
Vol. 12, No. 133 [1959], p.18.)

4.80
Polychrome inset with horseman and Erotes,
(Brown, purple, red, yellow baskets, green
leafage; Musées Royaux N. 277; A.D. IV-V.)

4.81
Monochrome inset with humoristic scene.
(Cluny, 13166; A.D. V.)

4.82
Inset with purple figures surrounded by interlace
enclosing Erotes, hare, and lion. Weapons and
scarf are in red. (Österreichisches Museum für
Angewandte Kunst, No. 633; A.D. VII.)

4.83
Inset with purple hare, green lines, and frame.
(Cluny, 13175; A.D. VI.)

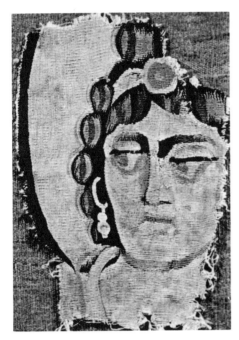

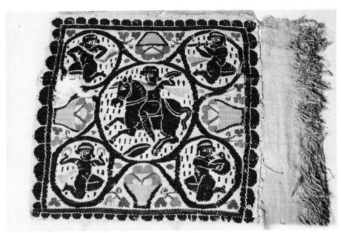

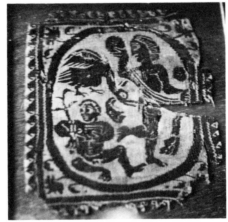

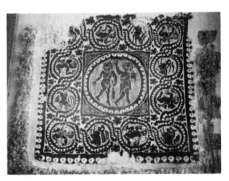

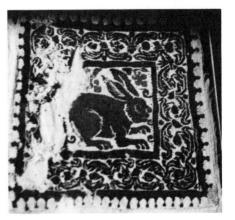

tree, a pretext for an ornamental pattern. An ornamental vase is planted with a tree that branches off into two double volutes forming four medallions inhabited by Erotes or stags (Fig. 4.84; Musées Royaux, N. 618; A.D. V or VI; also N. 268, A.D. VI). A popular motif for the neck border features in the arcades of a columned portico three to six figures borrowed from pastoral scenes—a dancing girl flanked by four men with a hook, a lyre, or a flute (see Fig. 4.72; B. M., 21789; A.D. V). The proportions are excellent though the stance is marked now by the crossed legs that will become characteristic of later standing figures. In the clavi similar figures alternate with animals and symmetrical stylized plants. The style of the figures evolves with more thickly-set nudes with large quadrangular heads and with moplike hair dancing beneath an arcade, allied to two clavi with increasing floral ornament (Fig. 4.85; Musées Royaux, N. 261, A.D. V; Walters Art Gallery, 83.485; A.D. VI–VII), or with a geometric pattern of crosses (Osterreichisches Museum für Angewandte Kunst, identical to Musées Royaux, N. 254).

The stylization, or, better, the schematization process that soon will lead to abstract geometrization affects the borders more than the figures. It is an effect of masses which in the better designs can convey movement or emotion even though not specifically delineated by the weaver.

Later Textiles of the Copts

As characteristic of the eighth century P. du Bourguet[143] mentions the increasingly stylized rinceau in red on black, the bird of Islamic type in a rinceau, the large square-eyed figures, the Erotes with one leg hidden behind a scarf, and mop hair. For the ninth century the same scholar lists a row of flowers in full projection alternating with half flowers on either side; grid patterns, usually diamond-shaped; heart-shaped compartmented flowers; and in the textiles with Byzantine influence, the band of juxtaposed round flowers.

Many of the motifs in "overlaid" technique evolved earlier for costume ornament are gradually modified. The geometric patterns in white thread on purple reappear in square insets with lateral overlaps enclosing palmettes (Fig. 4.86; Oesterreichisches Museum für Angewandte Kunst; A.D. VI–VII). Figures are consistently depicted frontally with deformed proportions, an elongated torso, and crossed legs for the women (Fig. 4.87, Kansas University Museum; A.D. VI), a posture characteristic of the sacred dancing girls (apsara) in Indian statuary. The subject in monochrome fabrics appears now in white on a purple ground. True purple dye is replaced by madder and indigo. There is a definite blur even in polychrome tapestrie where several colors strictly delimited by a black line are here and there goaded to model an element. The figure holding a peacock and standing frontally on an orange background

143. P. du Bourguet, L'Art Copte, pp. 24–30.

within a stylized floral pattern in green, red, and white (Fig. 4.88; Musées Royaux, N. 293; A.D. VII–VIII) is little more than a static ornamental composition. Some pieces are chaotic, especially Nilotic scenes (Louvre, 372) in which an Eros in a boat, crocodile, fishes, and floral elements are shuffled together, a mere pretext for violent clashes of coloristic effect (Fig. 4.89). Slurred details and geometrized outlines are sometimes accompanied by spirited movement, as in a buff and red square representing four busts, perhaps personifying the seasons, issuing from plant stems and alternating with Erotes hurrying with fruit baskets and ducks (Fig. 4.90; Kansas University Museum; A.D. VII).

Another type of composition reminiscent of Mesopotamian antithetics may be ascribed in general to post-Sassanian times, especially where the elements are obviously copied from Iran. A good example is the silk roundel with white subjects on dark-purple background representing two amazons on rearing horses aiming their arrows at two leopards within an intricate band of palmettes. Though it is of good style and comes from Alexandria, this piece should be dated in the seventh or eighth century rather than earlier. The appearance of silk tapestries, most found at Antinoë, always in compound twills with a single warp, first in small strips with a red or dark blue background, may coincide with the Persian occupation of Egypt (615–618). A later group patterned in red and buff lozenges and stronger in texture may belong to the eighth and ninth centuries according to Beckwith who derived this date from

4.84
Square inset with four Erotes in dark purple, red
vase within green scroll surrounded by frame.
(Akhmim; musées Royaux, N. 618; A.D. V-VI.)
4.85
Band beneath neck-slit representing four dancers
in an arcade, and two clavi. (Musées Royaux,
N. 261; A.D. V.)

4.86
Square purple inset with geometric patterns in
white thread, and four overlaps with palmettes.
(Österreichisches Museum für Angewandte
Kunst; A.D. VI-VII.)

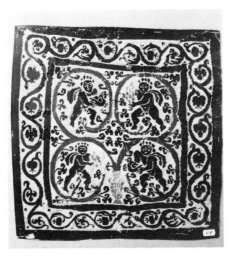

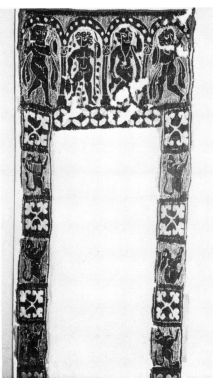

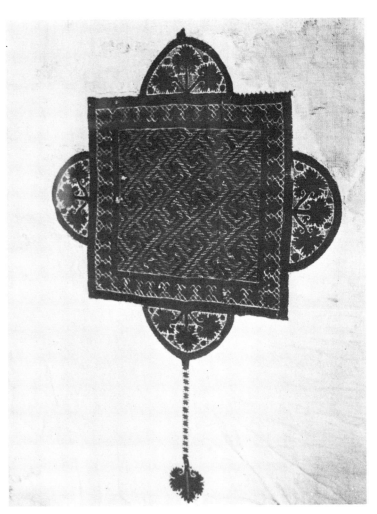

4.87
Monochrome bands with nudes alternating with lions. (Kansas University Museum; A.D. VI.)

4.88
Polychrome inset representing on an orange ground a figure carrying a peacock within a double frame. (green, red, white), (Akhmim; Musées Royaux, N. 293; A.D. VII-VIII.)

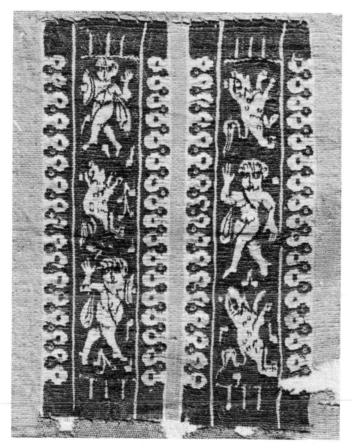

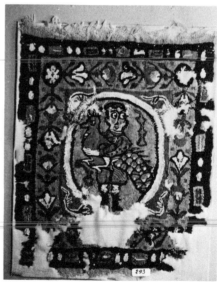

4.89
Orbiculum with a Nilotic scene. (Panopolis; Louvre.)

4.90
Polychrome inset with four busts personifying the seasons, and Erotes. (Kansas University Museum; A.D. VII.)

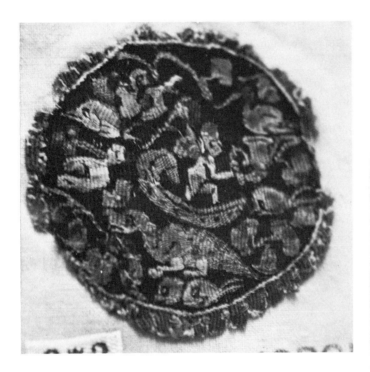

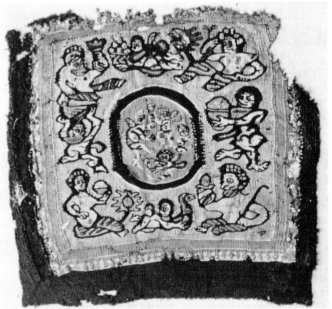

comparative evidence in reliefs on the Dome of the Rock and mosaics in Hagia Sophia and the Umayyad Great Mosque at Damascus.

P. du Bourguet[144] cites as characteristic for the tenth century further deformation in the wiry or skeletal figures with moplike hair, the sequence of full flowers and half flowers, the common use of red lac dye ground, and the importance of Byzantine influence as exemplified in the broad trousers of figures, composite flowers enclosing smaller ones, and borders with angular or square elements.

Silk patterns were imitated in wool tapestry, using symmetry, antithetic composition, and wiry plant ornament of Umayyad style. A date before the eighth century could be contested for an Eros with rectangular eyes in a medallion flanked symmetrically by four lions (Musées Royaux.) Symmetry occurs also in polychrome compositions featuring as central element a tree with horizontal branches flanked by two antithetic birds within a frame of geometrized sepals (Musées Royaux, N. 289, A.D. VIII). Both this type of tree, evolved from the Babylonian sacred volute tree, and the birds are elements derived from Sassanian art. The bird is perhaps a species of guinea fowl with plump body on tall legs, curving comma-shaped wing, and wearing around the neck a ring often ornamented with a cross. The birds are usually set antithetically in horizontal rows or superimposed in double columns

144. Ibid., pp. 30–31.

(Oesterreichisches Museum für Angewandte Kunst, A.D. X) the heads alternatively opposed or looking away from each other, a successful arrangement forming a rhythmic balance of masses and background, again a characteristic of Sassanian decorative art. In a splendid blue and brown silk the birds are opposed in pairs at the foot of ornamental palmette trees that spread out into huge rosettes (Fig. 4.91; Cluny; A.D. VIII ?). The whole design, both its composition and its elements, is unique and could well be an import. Birds and palmette tree may alternate within the diamond compartments of a lozenge mesh, yellow and red on dark blue (Cluny; A.D. X). The tree with horizontal winglike branches and a lotus head is, like the bird, a perfect example of Sassanian balance of areas of red ground. The tree is often depicted with antithetic birds at its foot or nesting in its branches spied by two eager quadrupeds that could be cats (Fig. 4.92; Kansas University Museum; A.D. IX). The tree is ultimately abstracted in another piece into several superimposed symmetrical curves ending in elegant volutes (Kansas University Museum; A.D. X).

In Coptic iconography (sculpture, textiles) the bird with outstretched wings wearing around the neck a bulla sometimes inscribed with a cross symbolizes the soul freed by Christian faith and ready to fly, probably a late metamorphosis of the *ba*-bird of the ancient Egyptians, or perhaps Christ himself. A Tulunid monochrome textile represents it as a heraldic bird, still wearing the bulla and flanked by a basin and a cross within a dense arabesque

cruciform framework (Fig. 4.93; Kansas University Museum; A.D. VIII–IX). The cruciform design appears more clearly in another inset in which a Nereid and fishes appear in the central square on a red ground with lozenges (Fig. 4.94; Kansas University Museum; A.D. VIII).

In Fatimid silks the heraldic bird is hardly more than an ornamental unit iterated in dense band alternating with a band of griffins (Cluny A.D. X-XI), or isolated in hexagonal panels, a prototype of the heraldic coat of arms of the Middle Ages. It may also alternate with antithetic deformed lions (from Fayum; Cluny; A.D. X), another of the heraldic animals. Bands with haloed figures in procession flanking a central personage or a *crux ansata* and bordered by a wiry scroll enclosing birds' heads on a red ground show a similar balance between masses characteristic of Tulunid style .The two trends, complicated elegance and abstraction through geometrized line, are characteristic of Fatimid textiles whether produced for the Copts or for the Islamic conquerors. According to Muqaddasi (A.D. 985) the textile craft was the specialty of the Copts: "The Copt may not weave anything without an authorization from the government."[145] Specific products for the Moslems are often identified from the eighth century by bands of Kufic inscriptions expressing an elaborate blessing such as: "In the name of Allah, blessing from Allah" (Museum of Islamic Art, Cairo, No. 14277), sometimes stating also the place where it was woven (Qays, Bahnasa influenced by Samarra style; A.D. IX–X).

145. Mukkadasi, "Géographie," *BGA* (Vol. 3), p. 213.

4.91
Silk with birds in pairs at the foot of palmette trees—perhaps an imported design. (Cluny; A.D. VIII?)

4.92
Orbiculum representing a Sassanian tree with birds nesting flanked by two cats. (Kansas University Museum; A.D. IX.)

4.93
Monochrome square inset with a heraldic bird and dense Arabesque in white thread. (Tulunid; Kansas University Museum.)

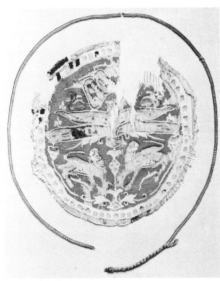

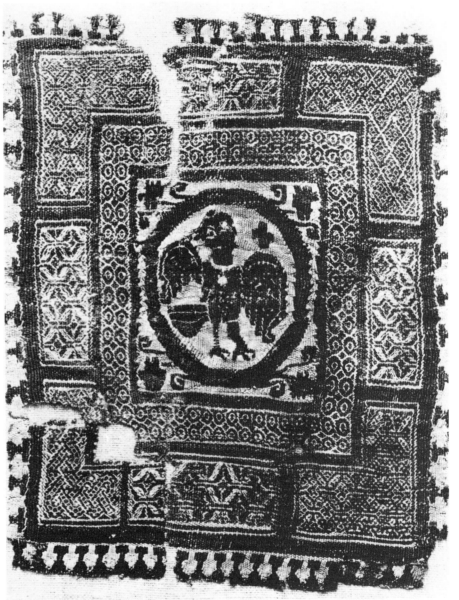

4.94
Square inset with a cruciform design around a
central round panel representing a Nereid and
fishes. (Kansas University Museum; A.D. VIII.)

4.95
Abstract design of figures beneath an arcade
alternating with square or rounded panels.
(Dumbarton Oaks, 33.15; courtesy Dumbarton
Oaks Collection.)

4.96
Embroidery border with motifs of hunters, rider
saints, and geometrized foliage. (Benaki
Museum, 7123; Middle Ages).

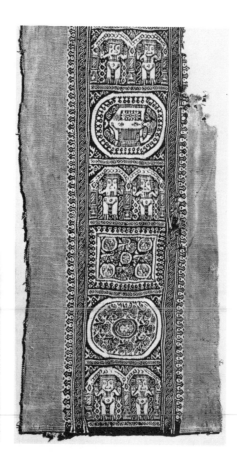

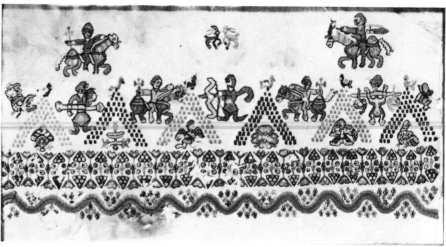

Some woven bands even imitate Kufic mural inscriptions (Museum of Islamic Art, Cairo, No. 13042). While the Delta factories pursued purely Islamic trends, those in Upper Egypt were still worked by private industry to meet the needs of the local Copts who dressed in the linen tunic ornamented with woolen tapestries. Late-antique motifs were no longer understood though still copied by Coptic folk art.[146] The trend toward broader lines and schematic design invents a type of figure consisting of offset vertical stripes, appearing also in miniature before being completely flattened into geometrized figures and conventional ornament often mixed with undecipherable Coptic and Arabic inscriptions and fantastic disordered forms (so-called Fayum style; A.D. X). Two of these fabrics are known to have been woven in 913 and 985 in a court *tiraz* in the Fayum. which implies that the Tulunids (868–905) had founded, in addition to their factories working for Baghdad, others for the Coptic population, as one aspect of their broad-minded policy of tolerance. This situation must have continued under the Fatimids, for there existed other *tiraz* factories producing other types in Upper Egypt also worked by Copts at Bahnasa for white woolens, at Akhmim, and at Assiut for woolen turbans. Alexandria, Cairo, and Debik were renowned for silks, Damietta for dimity, and Tinnis royal factory for cambric and irridescent stuffs.[147]

The textiles of the Fatimid period are conspicuous, according to P. du Bourguet,[148] for their shuffled design or horror vacui, the rows of animals, and the peopled intertwines. It is at the end of the Fatimid period that abstractions produce a typical white on purple design of frontal geometrized figures of *orantes* (called "Peruvian dancers" by P. du Bourguet) allied to the Sassanian cock, the cross, the rosette with eight sepals, geometric ornament in hexagons, or panels with interlace often bordered by scallops (Fig. 4.95; Dumbarton Oaks, 33.15). *Tiraz* weaves obliterate the highly unnaturalistic forms hardly related to nature into the elements of an arabesque.

It is only after the Fatimids that embroidery appears in Coptic liturgical vestments, influenced by Byzantine style representing the Virgin and the Apostles superimposed (Louvre, No. AC 828), or on dalmatics decorated with the scene of the Virgin on a throne between angels above rider saints (Mainz Museum, No. 0.7860). Even secular motifs like that of a hunt appear in isolated elements allied to a decorative setting (Fig. 4.96; Benaki Museum, No. 7123; Middle Ages).

148. P. Du Bourguet, *L'Art Copte*, pp. 31–32.

It would be illogical to dissociate the study of ornamented ceramics, intrinsically one of the media of graphic arts, from that of undecorated pottery. Those ornamented artifacts made for everyday use show secular rather than religious motifs, and it is this aspect of a popular craft not essentially religious that gives Coptic ceramics its special value. There is no evidence that pottery was exported from Egypt during Roman times, except for that of Coptos, where perfumes were mixed with the clay before it was baked and perhaps also for that of Naukratis, praised by Athenaeus (480).[149] Some Arretine and Gnathian pottery was imported and perhaps imitated locally.

Practically none of the forms manufactured by the Copts[150] can be traced farther back than Greco-Roman ones, for the Copt preferred the flat-bottomed, ring-based, broad-haunched types, the amphora for his wines and flat forms with thick rims and ridges protruding at mid-height for his bowls and dishes. There are more than twenty varieties of shapes named in Byzantine papyri,[151] and a homogeneous group of finds such as that from the town of Djimē gives a good idea of the types (Fig. 4.97). As was the case for ceramics in the Roman period and for Coptic textiles, some cities specialized in the production of certain types—saite jars in Oxyrhynchos and water jugs at Qena, found in the monastery of Epiphanius, until now a center with Ballās for the same products (*qulla, ballās*). Much pottery was also made in the monasteries, especially those featuring a

146. E. Kühnel, "Koptische Kunst im Islamischen Ägypten," in *Koptische Kunst* (Essen: 1963), pp. 153–154. (Hereafter cited as "Koptische Kunst.")
147. S. Lane–Poole, *History of Egypt*, p. 112.

149. A. C. Johnson, *Roman Egypt*, p. 341.
150. U. Hölscher, *Medinet Habu, V*, pl. 48.
151. A. C. Johnson and L. C. West, *Byzantine Egypt*, p. 114.

4.97
Typical pottery from Djimē. (U. Hölscher, *The
Excavation of Medinet Habu, V*, Figs. 87–98,
pl.48.)
4.98
Variety of shapes in utilitarian pottery. (Louvre.)

4.99
Fragment of the shoulder of a jar painted with
a band enclosing panels with busts and heart-
shaped leaf. (Luxor; University Museum,
Strasbourg, No. 679; A.D. VII-VIII.)

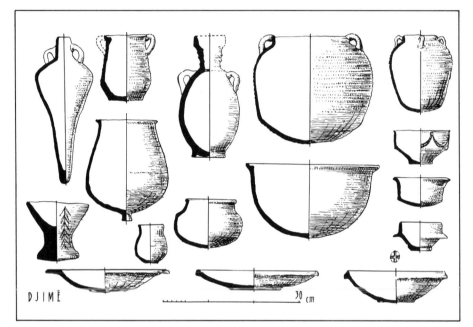

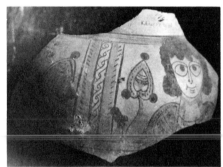

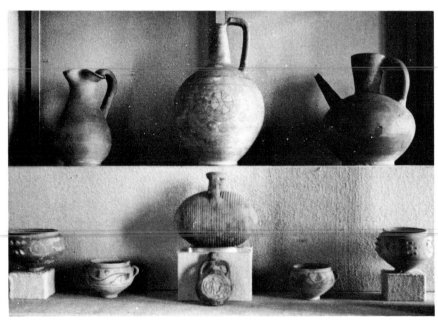

pilgrimage center, such as Abu Mina in the Maryut. The quantity of pottery in Byzantine Egypt must have been enormous if one judges by the finds; that it was probably made in huge plants is implied by a lease specifying a yearly rental of 2,400 jars at Aphrodito in A.D. 565 and by the mention of export tax as municipal revenue for Alexandria in Justinian's Edict (13, Ch. 15).[152] All this strictly utilitarian pottery—whether in unbaked or baked clay ranged in wares from coarse red, scarlet, and orange to yellow, pink and lemon imitation of terra sigillata or terra sigillata, and ranged in type from huge storage jars often sunk in the floor to broad wine jars and amphorae coated internally with resin or asphalt, cooking pots, spouted vessels, or ewers often ribbed—would hardly ask for ornament (Fig. 4.98). Yet ornament is often found in painted, sunken, or applied motifs. There is a wide variety of slips ranging over as many colors as the wares, with crimson and white in addition, but the red washes are the most common and are applied even on imitation of terra sigillata. As on Roman pottery, whitish washes form a suitable ground for painted decoration in red and black. The ware is usually of red or brownish clay, sometimes fine yellowish. Terra sigillata or pseudo terra sigillata known in countries bordering Egypt was not produced in Upper Egypt before the fourth century, and then usually as dishes stamped with Christian emblems in their floor or as cups and bowls. Its ware is a fine-grained, hard, well-baked reddish type often covered with a Pompeian red slip of red burnished iron oxide.

Painting on pottery[153] offers much variety and originality, displaying themes with human, animal, floral, or abstract elements. The distribution of the painting varies with the shape of the pottery, human and animal motifs forming a tall band around the haunch, obviously inspired by the registers of mural paintings, while floral and abstract motifs are either allied to it as borders or are set in several narrow bands superimposed along the whole height. Curiously enough, painted vases from the New Kingdom also offered two similar types of distribution. If the dating of the painted ceramics from Armant may be regarded as typical, the animals, except some of the fishes, are fifth century, or later for the flamboyant types. The vine may have appeared in the third century and was popular in the fourth with continuous spirals, cross-hatching, and lines, while the Arabesques of different coloring and broken design belong to the Arab period.

Some examples of a tall band with representations of a bust, strictly frontal and rigid within a square panel separated by three vertical strips of hatching or rope pattern from the next panel enclosing a bird (Louvre) or a huge heart-shaped leaf (Fig. 4.99; University Museum, Strasbourg, N. 679; from Luxor; A.D. VII or VIII), belong to the most elaborate types. Though the busts are reminiscent of the angels or personifications of virtues at Bawit and Saqqara, the faces have lost every relation to nature, the features being geometrized into a wiry black outline of huge eyes with small pupil, a thin nose and mouth with no three-dimen-

sional indication.[154] There is no halo, and a subsidiary heart-shaped leaf with three blobs on a slender stem fills in the vacant space. Some areas within the black design are painted red with black dots on the pink ground of the pot. Though the composition is derived from Greek pottery of Alexandria, it is so akin to that of the metope and triglyphs that these terms may be borrowed for its description. A similar composition appears on the vertical walls of a broad jar which contained a codex dated to the seventh century. A bird in side view or heraldic front view, yet spirited, fills each panel in a bold sure design overlapping the base border (Fig. 4.100, Semna; courtesy Dr. L. Zabkar).

Animals are the most common motifs, with fishes, doves, hares, and chameleons appearing in a realistic style and evolving into flamboyant creatures probably imitated from Syrian and Persian types, the forerunners of Arab designs as exemplified in the ceramics at Fustat (peacocks, fishes). It is noteworthy that the animals are nearly always proceeding counterclockwise on pots and clockwise in a ring on dishes. Lions, ducks, fawns, and gazelles inhabit the curves of a spiral, glancing at one another as if hiding within the intricate folds of stylized plants (Fig. 4.101; Staatliche Museen, A.D. V). Bands of rope interlace, dots, and solid color contrast with the spirited movement of the lively procession outlined in thin black filled with purple and black dots. The dynamic composition[155] is reminiscent of the foliage

152. Ibid., p. 115.

153. R. Mond and O. Myers, *Temples of Armant* (London: 1940), pp. 95–98.

154. Similar pots from Saqqara; cf. J. E. Quibell, *Excavations at Saqqara* (1906–1907), pl. LXII, 4.
155. Ibid. (1908–9; 1909–10), pl. LI.

4.100
Jar painted with a metope-triglyph band
enclosing spirited birds. (Semna, VII A.D.;
courtesy Dr. L. Zabkar.)

4.101
Red slip vase painted with a broad zone
representing a gazelle and a lion on a scroll
surmounted by two guilloche. The design of the
motif is in fine black line on purple (Staatliche
Museen; A.D. V.)

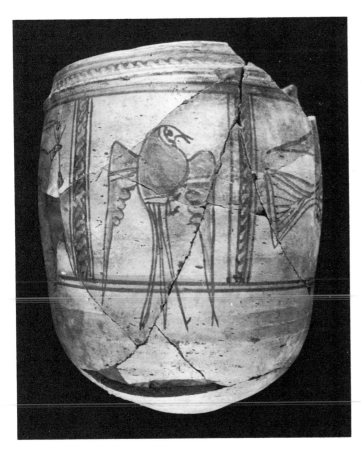

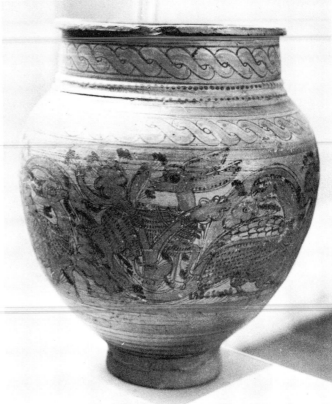

scrolls inhabited by animals in carved friezes. Less sophisticated is the band on the shoulder of a pink vase which represents a stylized fish separated from a hare by black wiry plants (Fig. 4.102; Armant, PAP. 6).[156] The design in thin black outline and inner detail is enhanced by a thick red contour in the fish. A debased attempt at the same theme depicts a row of static lions alternating with stags and bulls between an upper sequence of heraldic birds with a galloping hare and a lower sequence of hares and wolves painted in red dotted black without background or ground line (Fig. 4.103; Armant, PAM. 1).[157] Elsewhere there appears the less imaginative arrangement of triglyphs and metopes enclosing a flamboyant bird (Städtlisches Galerie Liebighaus, Frankfurt, Inv. No. 480; A.D. VII–VIII) or a striding griffin alternating with a conical tree (Louvre; A.D. VIII) or a fantastic horse and birds in black.[158] The circular area of a dish is most appropriate for a decorative composition in rings or with elements radiating from its center. Dishes with fishes are not uncommon, whether as two lonely white specimens swimming one above the other on a red ground (Louvre); as a large *bolti* with two smaller fishes,[159] very similar to the one sucking at a weed (Fig. 4.104; C. M., 67564); or as four identical *bolti*, red with black outline and scales, pursuing one another clockwise on a white ground (slip)

surrounded by a wavy wiry vine below the rim itself and decorated with a twist (Fig. 4.105; Brooklyn Museum, 42408; A.D. VI), a composition strikingly akin to that on a bowl from the New Kingdom (Moscow). Two fishes alternate with two birds (clockwise) in the almond-shaped compartments surrounding a rectangular panel in a richly decorated composition on a dish with scalloped rim (Louvre). Unrestrained red hares showing only one pair of legs run happily (clockwise) together with birds along blobs and indented circles around a central floral ring (Fig. 4.106; from Luxor; University Museum, Strasbourg, 678 A-B.) In a thick bowl on an openwork socle three red geometrized birds without feet are placed head-to-tail, forming with the grayish ground a balance of masses characteristic of Tulunid art (Fig. 4.107; Staatliche Museen, A.D. IX). Radial schemes feature four fishes, their heads around the central root of four lotuses separating them, a pattern akin to that on an Egyptian bowl of glazed faience in which three fishes share one common triangular head and are separated by three lotuses.[160] A symmetrical composition decorating a yellow glaze ceramic dish consists of a purple cross flanked in its lower angles by two blue antithetic pelicans sacrificing their hearts and by two green curving stems radiating in the two upper angles.

Floral ornament complementing bands with human or animal motifs features stylized plant shapes within the panels of the busts, or more often thin bands of grapevine. Sometimes an impressionist ear of wheat in white within

black outlines fills the shoulder of a jug decorated with a broad band of sketchy birds that are alternately black and white (Fig. 4.108; Museo Egizio). The whole decoration often consists of floral patterns, rosettes, or continuous spirals and scallops of a sketchy style, black and purple on white ground (Fig. 4.109; from Luxor; Musée Guimet, Lyon); or on a dish in a careful and rich design a scroll with grapes and palmettes is allied to a hatched ring and a central medallion of superimposed square grids with wavy lines and blobs, black and white on red (Fig. 4.110; Louvre). The scroll with a small bird can even invade most of a jug (Fig. 4.111; Museo Egizio; black and red). There is no doubt that the spirals, wavy lines, dots, and blobs derive from the vine motif (amphora at Tübingen, Archäologisches Institut der Universität, Inv. No. 3777), and it is often difficult to determine, especially in a sketchy design like the one in yellow and black on a buff-colored amphora (Fig. 4.112; Staatliche Museen; A.D. VII), whether it still belongs to the floral repertoire or rather to abstract ornament. While many elements of the latter, such as spirals, continuous loops, scallops, festoons, wavy lines with dots, and blobs, derive from plant ornament others are geometric patterns of lines, concentric circles, chevrons, crosshatching, rope patterns, and ultimately arabesques, usually in red and black on buff, or in red, black, and white on yellow or even in black only (Fig. 4.113; Museo Egizio) spreading over the upper part or the shoulder.

A whole group of finely levigated white ware in a style derived from the water jug, with one or two handles

156. R. Mond and O. Myers, *Temples of Armant*, pl. LXXII. Similar is J. E. Quibell, *Excavations at Saqqara* (1908–9; 1909–10), pl. XLVIII, 4.
157. Ibid.
158. J. Cooney, *Pagan and Christian Egypt* (Brooklyn Museum: 1941), No. 125.
159. *Fouilles Franco-Polonaises*, Vol. 2, *Tell Edfou 1938* (Cairo: 1938), pls. XXVIII, XXIX.

160. W. de Grüneisen, *Caractéristiques*, p. 122, Fig. 64.

4.102
Shoulder band with stylized hare and fish.
(Armant, PAP. 6; R. Mond and O. Myers,
Temples of Armant, pl. LXXVII.)

4.103
Bowl painted with three superimposed rows of
animals in a debased style. (Armant, PAM.1; R.
Mond and O. Myers, *Temples of Armant*, pl.
LXXII.)

4.104
Dish painted in black and white representing a
fish sucking at a weed. (Armant; C. M.; 67564;
R. Mond and O. Myers, *Temples of Armant*,
pl. LXXV.)

4.105
Dish painted on a white slip with four fishes
bordered by a wiry vine and twist. (Brooklyn
Museum, 42408, 70 cm. diam.; A.D. VI; yellow
fill, blue lines, and red dots.)

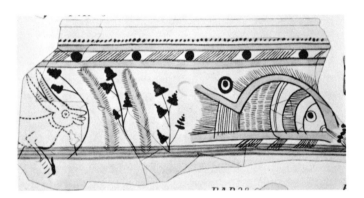

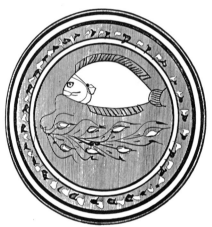

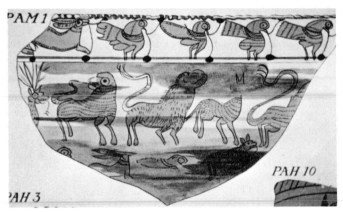

4.106
Fragment of dish painted with two rows of unrestrained hares and birds around a central floral motif. (Luxor; University Museum, Strasbourg, 678 A-B; 47 cm. in diam., black and red on pink.)

4.107
Thick bowl painted with three red geometrized birds on gray ground, bordered with a scallop. (Staatliche Museen, A.D. IX.)

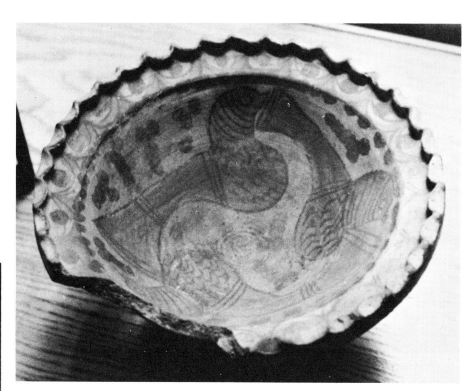

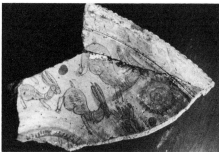

4.108
Red jug painted with a broad zone of birds,
alternately black and white, and on the shoulder
a white ear of wheat. (Museo Egizio.)

4.109
Jar painted in black and purple on a white slip
with a continuous spiral between two scallops.
(Luxor; Musée Guimet, Lyon.)

4.110
Red dish painted with black and white geometric
and stylized foliate ornament. (Louvre; 40 cm.
in diam.)

4.111
Jug painted in red and black with a sketchy
scroll enclosing a small bird. (Museo Egizio.)

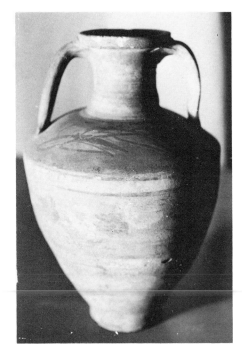

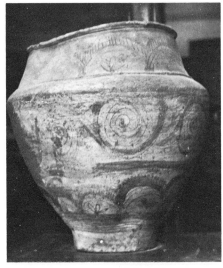

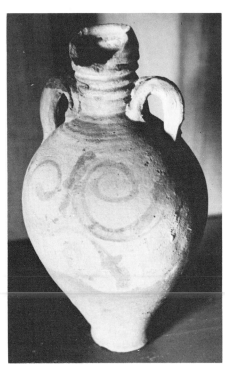

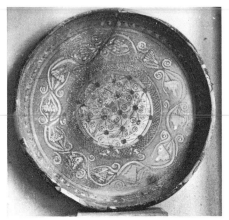

4.112
Amphora painted with a sketchy spiral design in yellow and black line. (Staatliche Museen; A.D. VII.)

4.113
Water jug with sieve in neck. Around the shoulder is painted a black line ornament with dots and parallels. (Perhaps Islamic; Museo Egizio.)

4.114
Red slip dish stamped with a lion preying on a gazelle. (Musées Royaux, E 7978), 50 cm. in diam.)

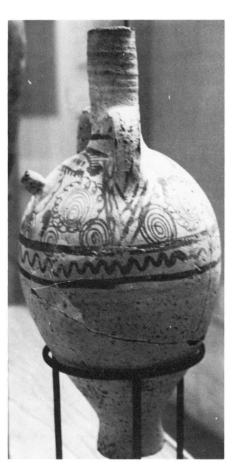

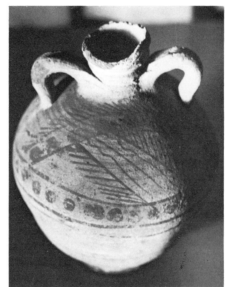

clumsily attached to the tubular neck and a short spout, are supposed to have been used chiefly for ecclesiastical purposes and date from the medieval period.[161] One square or circular panel of decoration with black lines of abstract design featuring the cross is painted just beneath the spout.

Sunken designs, whether impressed, incised, rouletted, or stamped, have perforce a restricted scope of representation and evolve their own grammar of ornament. Terra sigillata or pseudo terra sigillata offers a compact hard clay that can take a representation in outline stamped on the floor of large dishes of simple shape with or without ledge. Even with such restricted technical means there is an astonishing variety of motifs, both Christian—the Chrism, a cross flanked by two heads (Musées Royaux,), or a double cross with double ends (Musées Royaux, E 7980)—and secular—the lion preying on a gazelle (Fig. 4.114, Musées Royaux, E 7978, 0.5 m., red slip) or a standing figure holding a palm branch (Musées Royaux, E 7976,) probably of symbolic implication. Rouletted rings frame the central motif (Musées Royaux, E 7980) or form a central radiating pattern (Musées Royaux, E 7979, red slip) reminiscent of similar designs in murals (Bagawat, Bawit). Less impressive are the floral designs or geometrical hatching impressed or incised (Fig. 4.115; Musée Guimet, Lyon).

Decoration in relief is turned, molded, modeled, and applied, and consists

usually of geometrical patterns of chevrons or rows of large tear-shaped or round blobs bordered by smaller straight or wavy rows of dots applied in creamy clay onto a darker ground (Fig. 4.116; Musée Guimet, Lyon). Some of the smaller pots bear a striking similarity to shells. Faces are modeled in relief on the neck of a vase, either one large face immediately under the rim, or a row of heads in high relief around the neck of a large vase above the painted representation of an arched portico topped with cross and Chrism (Fig. 4.117), or faces in square panels alternating with a band featuring a group of three vertical panels enclosing standing personages. Except for the row of heads in high relief, the other faces are round, painted, or modeled in slight relief, the nose protruding and the eyes indicated as concentric circles.[162] The paint is in black line over a coarse ware. The perforated sieves at the bottom of the cylindrical necks in the smaller water jugs of early Islamic date show a variety of designs, some of which can be interpreted as cruciform symbols (Fig. 4.118; University Museum, Strasbourg). Coptic tradition,[163] and probably also craftsmanship, lived on into early Islamic ceramics, lamps, seals for bread loaves, and also in the lusterware of the Fatimids. Christian figures with slight Byzantine features are represented on luster dishes, as, for example, the Coptic priest holding a censer signed by the potter Sa'd, himself a Christian (Fig. 4.119; from Luxor; Victoria and Albert Museum, 0.224 m. in diam.; first half of A.D. XII).

In building up an iconography, Coptic graphic arts appropriated several themes—less so than did sculpture—from mythological subjects, some of which were readily Christianized, such as Daphne in her tree offering Apollo a cruciform flower (textile, Louve, A.D. VI) and a Nereid wearing a cruciform nimbus (*orbiculus*, Louvre, A.D. IX).[164] There is very little evidence of mosaics, and this lack is the more astonishing in the context of the flourishing of this medium in most other Christian countries. Perhaps this technique, new to Egypt, could not acclimatize in such a traditionalist environment?

Painting, the least expensive of the graphic techniques, had always been at home in pharaonic as well as in Greco-Roman Egypt in murals representing both historical narrative (Karmuz, Bagawat) and personifications (Bagawat). The Alexandrian method of representation of cycles, akin to the pharaonic one, was adapted by the Copt to Christian themes from the Bible (Christological cycle at Deir Abu Hennis; see Fig. 4.20). The theme of the Madonna Lactans, derived from that of the Isis Lactans, is certainly a Coptic invention, for catacomb painting represents mostly the Virgin and the Child receiving the Magii.[165]

The Copts inherited the weaving industry, as old as Egypt itself, to which a new material, wool, had been adapted

161. M. A. Murray, "Coptic Painted Pottery," in *Ancient Egypt and the East* (London: 1935), p. 13, pl. VII.

162. Ibid., p. 2, pls. I, II, III, IX. J. E. Quibell, *Excavations at Saqqara* (1908–9; 1909–10), pl. XLVIII, 5.
163. E. Kühnel, "Koptische Kunst," p. 155.

164. P. du Bourguet, *Die Kopten*, pp. 97–98, B. A. 7, Fig. 15.
165. P. du Bourguet, *Early Christian Painting* (New York: 1965), pp. 17–18, Fig. 88.

4.115a, b
Pottery fragments with incised motifs. (Musée Guimet, Lyon.)

4.116a, b
Pottery fragments with relief and appliqué decoration. (Musée Guimet, Lyon.)

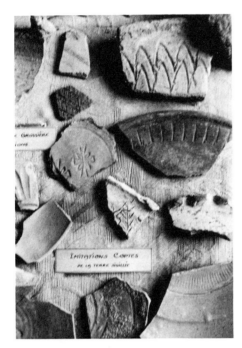

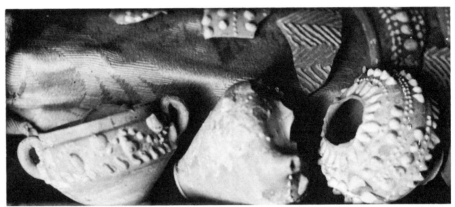

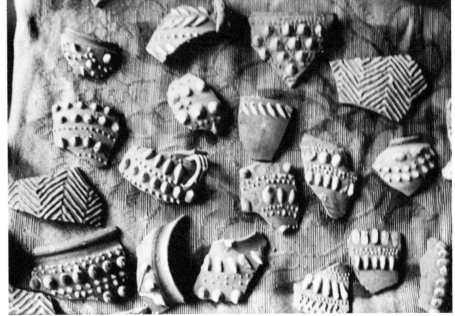

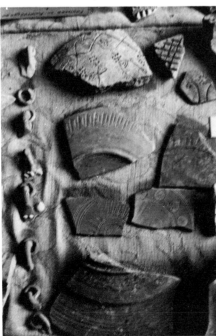

4.117
Shoulder of large jar painted on its shoulder
with an arcade and decorated along its neck with
heads in relief. (M. A. Murray, "Coptic Painted
Pottery," in *Ancient Egypt and the East* [1935],
pl. III.)

4.118
Perforated sieves with cruciform designs. (Early
Islamic; University Museum, Strasbourg, 3 cm.
in diam.)

4.119
Luster bowl representing a Coptic priest. (A.D.
XII; D. T. Rice, *Islamic Art*, Fig. 91.)

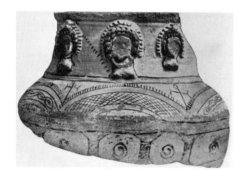

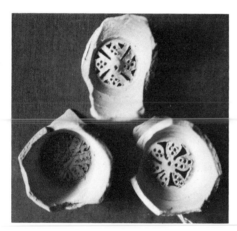

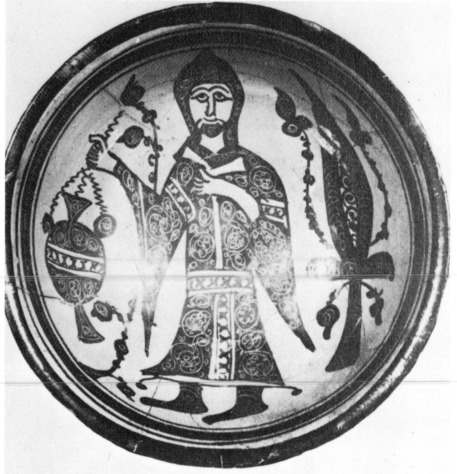

by the Ptolemies. It was destined to play a leading role in graphic arts, for many textiles of lay use were decorated with scenes. First appeared figures of dancers, male and female (Berlin Museum; A.D. II) less slender than the Alexandrian ones, with prominent color but still lively, or a dancing girl holding above her head a veil (Louvre), or bands of stylized flowers (Staatliche Museen; Louvre; A.D. IV).[166] Early *orbiculae* and square insets were woven with the flying shuttle, a technique that was to remain in use concurrently with others until the Tulunid period, when it waned.

The earliest murals still extant in the chapels at Bagawat (A.D. IV–V) are sometimes not considered as Coptic but as made for Christian Greeks of Alexandria, perhaps banished to that oasis.[167] Admittedly they lack in their iconography and in their style the characteristics of later Coptic painting. They form, in fact, a link between early funerary painting and monastic painting. Nearly all the themes are from the Old Testament with the addition of the personifications for Prayer, Righteousness, and Peace (in Egyptian costume) (Chapel of Personifications see Fig. 4.16), and St. Paul and St. Thekla (Chapel of Personifications, Chapel of the Exodus), and the Torture of Isaiah (Chapel of the Exodus). Though undoubtedly Christian they show no scenes from the New Testa-

ment, a fact which is reminiscent of the predominance of scenes from the Old Testament in the pre-Constantinian catacombs. The scenes most represented are those of Jonah expelled by the whale and resting in the arbor (unknown at Bagawat), Daniel in the lions' den, the spring miracle of Moses, the Three Hebrews, and Susanna and the Elders. In post-Constantinian catacombs other scenes appear such as Job and his friends, the Israelites crossing the Red Sea, and Moses receiving the Law.[168] While the style of catacomb painting might reflect glyptic art of the third century from Jewish gems, themselves dependent on pagan ones, Bagawat painting is directly related to Alexandria. It invents the scenes of the Torture of Isaiah, of Thekla, and the Personifications of the Virtues. It shows two contrasting styles, the one folkloric (Chapel of the Exodus), the second derived from the Alexandrian one marked by isocephaly, an array of frontal figures in a stiffened Hellenistic attitude and costume foreshadowing those in monastic murals.

Monastic painting is properly Coptic. It forms the largest body of murals on the walls and columns of churches, or in the apses of oratories or in halls (see Fig. 4.19). Historical narrative is not represented in cycles as in earlier examples, but only in isolated episodes with symbolic implication. The figures are stiffened into a frontal attitude and the faces are given a uniform oval outline with features deriving from Roman portraiture. In fact, the few icons known, such as the seven encaustic

tablets from Antinoë and the two tempera scenes of Bishop Abraham (see Fig. 4.35) and Christ with Abbot Menas (see Fig. 4.34), might well form the initial stages of portraiture in murals.[169]

The predominant type of composition consists of a row of figures standing or seated representing Christ accompanied by his disciples (south Chapel B at Bawit), or between two angels (Thedosia's chapel at Antinoë, A.D. VI), or as a half-figure between two worshiping angels (Saqqara 1795). Rows of monks appear at Saqqara accompanying the founder, Apollo. It is, however, in the apse of the oratories that the basic scenes of Coptic iconography occur. This importance of the semicircular apse arranged in the eastern wall of the monks' oratories reflects perhaps that of the apse as a niche of appearance in the mysteries,[170] or the comment of Origen that east is the place of rising of true light.

There is no scene of the Transfiguration or of the cross as Parusia—common in sculpture—except much later (Deir Abiad, see Fig. 4.51), or of the Crucifixion. Most of the scenes feature one or the other type of *Majestas* based on a Theophany, taken over from Palestine (A.D. VI).[171] The iconography of the apse comprises the liturgic *Majestas* the Virgin's *Majestas*, the Ascension, and saints. The liturgic *Majestas*,

166. P. du Bourguet, *Die Kopten*, p. 102, B. A. 11, Figs. pp. 44, 99, 100.
167. Ibid., p. 82. H. Stern, "Quelques problèmes d'iconographie paléochrétienne et juive," *Cahiers Archéologiques*, Vol. 12 (Paris: 1962), pp. 99–113. J. Schwartz, "Nouvelles études sur des fresques d'El-Bagaouat," *Cahiers Archéologiques*, Vol. 13 (Paris: 1963), pp. 1–11.

168. T. Klauser, "Entstehungsgesch. der Christlichen Kunst, IV," Vol. 4 (1961), pp. 128–145.

169. P. du Bourguet, *Die Kopten*, p. 130.
170. U. Rapp, *Das Mysterienbild* (Münsterschwarzach: 1952), pp. 89 ff.
171. C. Ihm, *Die Programme der christlichen Apsismalerei vom vierten Jahrhundert bis zur Mitte des achten Jahrhunderts* (Wiesbaden: 1960), p. 126. (Hereafter cited as *Die Programme*).

derived from the court and triumph ceremonial as represented in imperial iconography, appears in mosaic in Hosios David at the Latomos monastery (Salonica, mid A.D. V to end of A.D. VI) and in the chapels (A.D. VI–VII) at Bawit (XLV ?, XLVI, LI) and Saqqara (709, 733). The scene is similar to that of the Ascension: Christ seated within a *mandorla*, sometimes on a fiery chariot surrounded by personages (angel, lion, bull, eagle) with six wings each and numerous eyes. The motifs are derived from relations of visions in Isaiah (6: 1–3), Ezekiel (1: 4–28), and the Apocalypse of St. John (4: 2–10). The Apocalypse was not a canonical book of the New Testament in the eastern Church except in Egypt. In western iconography four personages appear around the *mandorla* as if carrying or pulling the throne. The theme is thought to have been invented in Egypt and diffused from there.[172]

The cult of Mary was always a favorite in the Orient. It is not astonishing to meet a portrayal of the Virgin, especially that of the Virgin Lactans—the *Galaktotrophousa* of Byzantine iconography (cf. Pantokrator grotto on the Latmos near Herakleia, A.D. VII)—between Jeremias and Enoch at Saqqara (A, 1725, 1807), and at Bawit alone (XXX), or in the midst of the Apostles (XLII), or seated holding the Child between two angels or saints at Bawit (I, VII, VIII). It is not a genre scene but is indued with symbolism, a graphic representation of the praises of Mary, Mother of life, who bestows health. Clemens Alexandrinus (Paidagogos, Lib. 1, cap. 6) equates Mary with the Church and interprets the milk of the

suckling mother as the Logos. The theme was at home in Egypt where Isis Lactans appeared on the temple wall scenes suckling Horus or the Pharaoh.[173] There is no need to search for a prototype in the *intaglia*:[174] it appears as a mural in a Greco-Roman house at Karanis (see Fig. 4.2) and was certainly broadly diffused with the Isis cult in the world. Occasionally the Virgin holds on her left knee a *mandorla* representing the Child (Bawit XXVIII, see Fig. 4.28; cf. Saqqara 1723), a scene comparable to the Victoria holding the portrait of Consul Basil.

The Ascension can be considered as a derivative from the liturgic *Majestas* that appears in an upper zone above a lower one representing the *orant* Virgin in the midst of the Apostles (Bawit VIII, XX; see Fig. 4.27, XLVI), or the Virgin seated on a throne and holding the Child on her left knee (Bawit VI, C.M., 1220), or as Madonna Lactans (Bawit XLII), or surrounded by local saints or two archangels and saints, or two archangels (Bawit III; Saqqara D, F, 1727, 1723, 1740, B; see Fig. 4.36 1733 destroyed). It has been thought that the lower zone represents the Church whose personification appears once (Bawit XVIII, see Fig. 4.21) above the apse. The composition would represent, not only the abstract *Maj-*

estas above the historical manifestation of the Incarnation,[175] but the Descent and the Ascent of the Son of Man (according to Ihm, Mersch), an interpretation based on Clemens Alexandrinus, Origen, and Irenaeus. This iconographic type was invented in Jerusalem, where Ascension and Pentecost were originally connected.[176]

Saints are relatively rarely represented, for the relics were kept outside the church. Shenute opposed the transfer of relics to his community church. The numerous hieratic figures appearing in rows are local worthies, founders, abbots, and personages connected to the monasteries, Apa Apollo, Phib, and Anup at Bawit, or Apa Enoch and Apa Jeremias at Saqqara. Scenes analogous to that of the introduction of founders of a church by the Apostles or the angels to Christ occur in tomb chapels in Egypt such as that of Theodosia standing between St. Mary and St. Colluthius (see Fig. 4.13), or in icons like that representing St. Menas standing near Christ, who protects him with his arm (see Fig. 4.34). The personage was thus accepted among the justified in Paradise, an interpretation corroborated by the mural from a tomb chapel at Abu Girga near Alexandria representing an *orans* in a meadow of plants and flowers among which nude figures are playing. We are reminded of the Paradise of flowers to

173. Ibid., pp. 57–61. J. Leclant, "Le Role de l'allaitement dans le cérémonial pharaonique du couronnement," in *Akten des XXIV. Internationalen Orientalisten-Kongresses* (Wiesbaden: 1950), pp. 69–71. J. Leclant, "The Suckling of the Pharaoh as Part of the Coronation Rites in Ancient Egypt," in *Proceedings of the IXth International Congress for the History of Religions* (Tokyo: 1960), pp. 135–145.
174. P. du Bourguet, *Die Kopten*, p. 131.

175. A. Grabar, *Martyrium*, Vol. 2, p. 213.
176. C. Ihm, *Die Programme*, pp. 101 ff. For parallels in western art: Pantokrator grotto on the Latmos, St. Ermete in Rome, Cathedral of Monreale. Derived scenes in other media: wooden doors of St. Sabina in Rome, A.D. 432, ampula 13 in Bobbio, ampulae 11, 14, 16 of Monza.

172. Ibid., pp. 42–50, 124.

which the martyr Petronilla introduces the matron Veneranda (tomb of Veneranda near the basilica of SS. Nereo and Achilles, mid A.D. IV) and other similar scenes in the catacombs.[177] The idea was at home in Egyptian funerary scenes where the deceased is introduced by Anubis or Thot to Osiris to be accepted in the realm of the justified. It appears in Greco-Roman iconography (Chapel 21 at Hermupolis West, shrouds, funerary beds) as a continuation of ancient Egyptian themes in tomb chapels and in illuminations of the Book of the Dead.

To this brilliant achievement in iconography during the Coptic period proper corresponds the achievement in the textile industry. Its technique is marked by the use of vivid color and the flying shuttle developed since the fourth century which allows for detailing features independently from the warp and the woof—a characteristic of the Coptic style. Another technique producing loops and already known in ancient Egypt gives an illusion of relief to curtains. A graded band of color along the contour of the figures gives some modeling to the body but deforms its volumes. Pagan scenes are adapted to an Egyptian environment and appear as lay motifs in *orbiculae*. Such are the cycle of Dionysos, Aphrodite, bucolic scenes often allegorical for the seasons, and hunting scenes surrounded by a foliate frame. The earlier theme of dancers from the Dyonisiac cycle evolves with stiffer deformed figures and bulging eyes.[178]

Illumination is a relative late-comer, with the Alexandrian World Chronicle (A.D. VII) showing black line drawings of hieratic though well-draped figures of women saints or Theophilus standing on the ruins of the Serapeum of Alexandria, and the Gospel in the Freer Collection (A.D. VII) having a style similar to the Saqqara murals.[179] In the later art of the Copts (A.D. VIII–XII), after the conquest, iconography is characterized by a prominence of Christian themes, perhaps as a result of coercive measures (according to Du Bourguet). The themes depicted are the same episodes as before with what seems to be a unique depiction of David's cycle at Bawit (see Fig. 4.30). Pagan motifs occur until the twelfth century. The abstract treatment of the theme encourages freedom of proportion with the object of emphasizing the symbolic implication. The size of the paintings is reduced. The result is a trend toward ornament.[180] The figures at Bawit become stiffer but acquire a certain elegance—longer oval faces, Byzantine costumes, and simplified features, still softer than those of Byzantine figures.[181]

The naturalism of Umayyad graphic arts evolves to large composition under the Tulunids (A.D. 868–905). Motifs and style of Islamic textiles are strongly influenced by Coptic ones. They are similar, using thick thread in the depiction of coarse portraits, dancers, birds, and rinceaux. Yellow predominates, and portraiture becomes a schematic arrangement of broad areas of color.

The flying shuttle is still used occasionally.[182]

Under the Fatimids (A.D. 967–1170), art produces, according to Du Bourguet,[183] an elegant Coptic-Islamic style for the upper classes, and a second style closer to Coptic art characterized by horror vacui leading to an association of compact masses. Mural painting declines with the increasing use of Byzantine elements (El 'Adra at Deir el Suryani; see Fig. 4.48). Illumination uses Islamic costumes and attitudes. In the textiles the arabesque style is the commonest, with themes from Hellenistic sources and deformed figures using blue, violet, and deeper ground (see Fig. 4.95).

In conclusion, Coptic graphic arts can be described as having made a very extensive use of the Hellenistic technique of *opus sectile* until a late date. Its iconography built up its own characteristics with the predominant beardless figure of Christ, the round clipeus, and borrowings from the Apocalypse. It invented the Madonna Lactans, the *Majestas*, the Torture of Isaiah, Thekla, and Paul. Among the best known features is the outstanding proficiency and excellence of the textile industry in design, originality, and weaving techniques. This art outlived Coptic art and survived in Islamic silks. Another minor art that was very influential on Islamic art is painted pottery, which showed much creativeness and contributed to the invention of Islamic luster ceramics.

177. A. Grabar, *Martyrium*, Vol. 2, pp. 24, 105. C. Ihm, *Die Programme*, p. 116. P. du Bourguet, *Early Christian Painting*, p. 25, Fig. 31.
178. P. du Bourguet, *Die Kopten*, pp. 132–142.

179. Ibid., p. 133.
180. Ibid., pp. 161–164.
181. Ibid., p. 167.

182. Ibid., pp. 172–176.
183. Ibid., p. 178.

No other country has yielded so much material for the study of Christian crafts as has Coptic Egypt. Many of the characteristics of sculpture and graphic arts may be recognized, though of lesser style and technique, in these minor productions for everyday use. Here we are again reminded that Coptic objects of daily use as well as larger monuments were not destined for a princely court as were those of Pharaonic Egypt or Byzantium. Yet much of the inventiveness and originality that forms part of the charm and versatility of Coptic sculpture and textiles occurs also in the crafts. To an even greater extent than other aspects of Coptic art its crafts belong essentially to folk production and styles. Of the various categories of objects in wood, bone, ivory, leather, terra cotta, glass, and metal, those in bronze are the most refined.

Despite the lack of metal ores, except perhaps for copper and iron, metal crafts flourished in Roman Egypt[1] and later in the Coptic period. The objects are intended for everyday life: bronze bowls, ladles, braziers, incense burners, censers, lamps, ornaments for trappings, crosses, and jewelry. Many of the later incense burners, lamps, and ornaments are theriomorphic, a type found in Egyptian folk art ever since the prehistoric period. Flat bowls in cast bronze, used as braziers rather than for ablutions, have a fluted exterior and two handles and are set on four lion's legs (Fig. 5.1; J. Strzygowski, *Koptische Kunst*, Nos. 9040–9042); they are reminiscent of ancient Egyptian examples in copper, which, however, have no legs. One rim extends horizontally into scallops (Fig. 5.1; 9047; C. M., 29203). Another type consists of a shallow cylinder carried on miniature lions tangent or transverse to the lower edge (Fig. 5.1; lower left, 9048–9049). Dancing girls appear beneath an arcade on the outer wall. These crude figurines appear also, one to each bay of an arcade on the exterior of cylindrical bronze bottles with conical neck from Thebes (Strzygowski No. 25926; 7001; A.D. IV–VII). Similar figurines in bold relief represent nude male musicians in frontal and static poses with arms protruding in the round and holding a drum or flute (Fig. 5.2; C.M., 5088; Strzygowski, No. 9083; A.D. V–VI). This figure composition within arcades is of the same type as that designed for textiles, wood (Mu'allaqa) and stone lintels (Saqqara), illuminations, and murals. It is

the successor to a late-antique device well-known on sarcophagi. More beautiful in their simple, though original, shapes are other cylindrical pots on four legs with one handle shaped as a linear lion (Fig. 5.3, 1; C. M., 26997), or bottles with an articulated profile imitating that of terra cotta turned on the wheel or on glass (Fig. 5.3, 2; C. M., 28413), or pear-shaped bottles with a narrow neck (Fig. 5.3, 3), or perfume flagons as polydron (Fig. 5.3, 4; C. M., 27544) or diminutive amphora (Fig. 5.3, 5; C. M., 27886). More sophisticated is the bronze cup with silver inlay bearing a Coptic inscription and a zigzag design filled with crosses (Fig. 5.4; from Fayum ?; Walters Art Gallery, 54.2288; A.D. IV–VI), or a vessel on legs with silver inlay bearing a one-line inscription surmounted by crosses,[2] or a brazier with shallow wall in openwork representing a rinceau of vine (Fig. 5.5; Louvre; 0.65 m.).

Bronze ladles offer a variety of types, from the four-edged bar with a hemispherical bowl at the lower end and a curved upper handle ending in a duck's head (C. M., 34736, from Thebes; Oriental Institute Museum, Chicago, 14412, from Djimē), a motif akin to that in ancient Egyptian spoons, to adjustable handles consisting of two overlapping sliding bars with chiseled decoration or two twisted bars held overlapping at the required length by chains.[3] The use of such a *simpulum* is illustrated in a unique mural at Bawit

(Chapel XXXII) representing David as cup-bearer filling a cup from two large wine amphorae hung with garlands and placed on a stand,[4] again a setting derived from ancient Egypt.

The refined practical design of the adjustable ladle is paralleled in the handle of an open suspension lamp of the echinus type, set at a slant so that it would assume horizontal equilibrium when suspended from its upper hook that ends in a duck's head (Fig. 5.6; Museo Egizio, 4344). An open papyrus capital forms the juncture of the duck neck to the irregular shaft, which is connected to the body of the lamp by two dolphins. This is a typical instance of the use of the dolphin as a strut for handles and also of its close symbolic association with light. Basically derived from the Hellenistic echinus lamp in terra cotta, the bronze lamps were given fancy shapes by the Coptic craftsmen, who knew how to exploit the possibilities afforded by casting and chiseling the hard metal. Whether the container is freestanding or suspended by three chains or set on a stand, it is given a wide range of shapes. The simplest is the echinus with one or two spouts as represented at Bawit (Chapel XIX), and a ring handle upholding a cross (Fig. 5.7; Museo Egizio) or modeled into the rearing fore part of a griffin.[5] A hinged

1. A. C. Johnson and L. C. West, *Byzantine Egypt: Economic Studies* (Princeton: 1949), pp. 116–119. (Hereafter cited as *Byzantine Egypt*.)

2. J. D. Cooney, *Pagan and Christian Egypt* (Brooklyn Museum: 1941), No. 82.
3. U. Hölscher, *The Excavation of Medinet Habu, V* (Chicago: 1954), p.64, Fig. 75, pl. 38, 18. (Hereafter cited as *Medinet Habu, V.*)

4. J. Clédat, "Le Monastère et la Nécropole de Baouît," *MIFAO*, Vol. 39 (Cairo: 1916), pl. IX. (Hereafter cited as "Le Monastère.")
5. J. Strzygowski, *Koptische Kunst, Catalogue général des antiquités égyptiennes du Musée du Caire*, Vol. 12 (Vienna: 1904), pl. XXXIII, 9144. (Hereafter cited as *Koptische Kunst*.) O. M. Dalton, *Catalogue of Early Christian Antiquities in the British Museum* (London: 1901), n. 503. (Hereafter cited as *Catalogue*.)

lid occasionally shaped like a dove's head covers the intake hole. Folk art, deep-rooted in Egypt since prehistoric times, flourishes again with a rich variety of theriomorphic bronze lamps, mostly standing birds, which had the advantage of offering their slender neck as an elegant handle and their tail as an adequate bed for the wick-spout. The clumsy broad-beaked, roundheaded duck (Fig. 5.8; Museo Egizio), the fiery cock sporting his scalloped crest (Fig. 5.9; Museo Archeologico, Florence, 7565), the sophisticated peacock, symbol of paradise, carrying on his haughty head an elegant trefoil (Fig. 5.10, 3; Fig. 5.11; Dumbarton Oaks, 40.21; A.D. IV–VII); or the gentle dove, symbol of eternal peace, turning its head sideways (Fig. 5.10, 4; Recklinghausen Ikonenmuseum, No. 515; A.D. V)[6]—these are the most common among such birds of light. But other animals lend their shapes to this purpose also: the dolphin, friendly to man, as it were pushing the light with its round head (Fig. 5.10, 5; Louvre); a camel saddled with four wicks, a bell hanging from its lips (See Fig. 5.10, 6; Louvre, Nr. X 5248, A.D. XI);[7] a gazelle with bound legs, as those carried by the hunters in Egyptian murals (Fig. 5.12; Museo Egizio, 4356); and a conventionalized lion presenting two lights with his forelegs (Walters Art Gallery, 54.2354; A.D. VI). Even more

imaginative is a warship complete with mast, crew of five, and a dog watching on the bow above the ram-headed spear flanked by three lights on either side and a seventh in the bow (Fig. 5.10, 7; from Cairo; Staatliche Museen, J. 4228; A.D. IV–V).

When the lamp is doweled onto a stand, its handle can be treated without danger of upsetting its equilibrium with a hinged shell as a reflector,[8] once copied in a stone lamp on a stand.[9] The handle is sometimes an elaborate foliate composition of spiraling rods (Fig. 5.13; Dumbarton Oaks, 30.9a-b; A.D. VI) occasionally peopled with a seated figurine pulling a thorn out of its foot, a favorite motif of late-antique popular sculpture (Fig. 5.14; Museo Egizio, but here flanked by two crosses. The stand may be designed in the shape of a wooden baluster turned on the wheel, which is surmounted by a disk and spike and supported by three lion's legs or three sleek rearing lionesses (Dumbarton Oaks, 33.3; A.D. VI); or it may be shaped like a fluted shaft topped with a Corinthian capital (Dumbarton Oaks, 30.5). Lamps differing but little from those carried by hand can be suspended by two or three chains from rings secured at the base of the neck and back of the animal as represented in a mural painting at Bawit.[10]

Bronze lamps outside Coptic Egypt show the same variety and originality,

shaped as a dragon,[11] a boat with Christ at the rudder and an *orans* in the bow (Museo Archeologico, Florence, from Valerius' palace),[12] or even a model of a basilica from Orleansville.[13] Lamps of precious metal, such as that in gold and crystal from the tomb of Maria, the wife of Honorius, may also have existed in Coptic Egypt. The smaller lamps that lit the catacombs were not adequate for basilicas, where large bronze *polycandelon* in the shape of pierced disks or coronae holding glass receptacles for oil were suspended horizontally by chains. Those in Coptic churches, some still suspended in Deir Baramus, Deir Suryan, and Muharraq are smaller disks in openwork (*polycandelon*)[14] or a shallow cylinder with twelve dolphin-shaped brackets for lamps hinged along its upper edge forming a *polyluchnion* (Fig. 5.15; C. M., 26742; A.D. V–VI).[15] These are very modest luminaries indeed when compared to the large ones with 80 or 120 branches in Old St. Peter's in Rome or those in Hagia Sophia as described by Paulus Silentiarius.

Censers in bronze range from the unassuming bowl[16] on a conical leg, like the one held by angels in a mural at Bawit (Chapel XXVIII; See Fig. 4.28) or hexagonal container always set on legs with suspension rings (Fig. 5.16;

6. J. Strzygowski, *Koptische Kunst*, pl. XXXIII, 9139. O. Wulff, *Altchristliche und Mittelalterliche byzantinische und italienische Bildwerke, Beschreibung der Bildwerke der christlichen Epochen*, Vol. 1, No. 772, Taf. 36. (Hereafter cited as "Altchristliche Bildwerke.")
7. J. Strzygowski, *Koptische Kunst*, Fig. 324, from Fayum, C. M., 27898,

8. Ibid., pl. XXXIII, 9124, 9125. C. M., 26999, 29205.
9. J. E. Quibell, *Excavations at Saqqara* (1908–9, 1909–10, Cairo: 1912), pl. L, 3.
10. J. Clédat, "Le Monastère," pl. LXXV.

11. O. M. Dalton, *Catalogue*, n. 502.
12. C. M. Kaufmann, *Handbuch der christlichen Archäologie* (Paderborn: 1913), Fig. 117. (Hereafter cited as *Handbuch*.)
13. P. R. Garrucci, *Storia dell' arte cristiana*, (Prato, 1873–1880), tav. 486.
14. J. Strzygowski, *Koptische Kunst*, Fig. 335.
15. Also Louvre, X 5266, A.D. X.
16. J. Strzygowski, *Koptische Kunst*, pp.280–283, pl. XXXII.

5.1
Typical bronze bowls. (J. Strzygowski,
Koptische Kunst, pl. XXVII.)

5.2
Bronze bottle with bold relief figures of
musicians in an arcade. The legs are in the shape
of lions. (Coptic Museum Cairo 5088; A.D.
V–VI; *Koptische Kunst*, Essen, 1963, No. 175.)

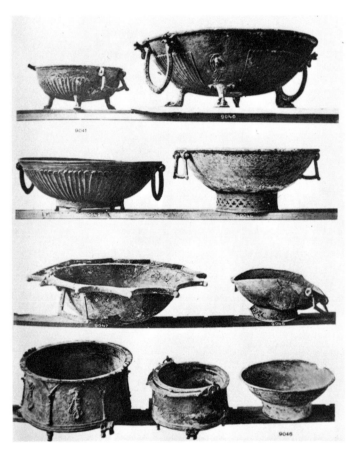

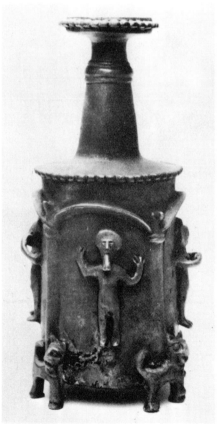

5.3
Typical bronze vessels: pot (1), bottles (2–5),
censers (6, 7, 9), pans (10–12). 1. J. Strzygowski,
Koptische Kunst, No. 9079; 2. Ibid., No. 9085; 3.
Ibid., No. 9091; 4. Ibid., No. 9097; 5. Ibid., No.
9100; 6–8. C. M. Kaufmann, op. cit. Fig. 240; 9.
Dumbarton Oaks Collection, 40.56; 10. J.
Strzygowski, op. cit., No. 9106; 11. Ibid., No.
9103; 12. Ibid., No. 9102.
5.4
Silver inlaid bronze cup. (Walters Art Gallery,
54.2288; A.D. IV–VI.)

5.5
Bronze brazier. (Louvre, 65 cm.)
5.6
Open bronze lamp with two dolphins at the foot
of the suspension terminating in duck's head.
(Museo Egizio, 4344.)

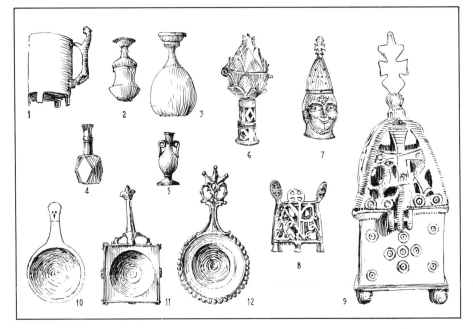

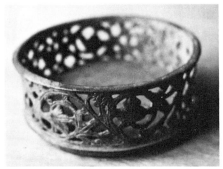

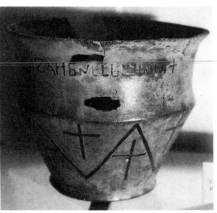

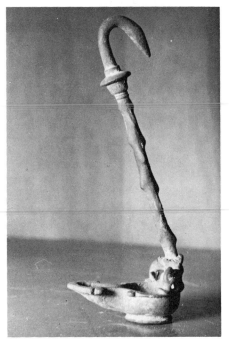

5.7
Two bronze lamps with a cross on the handle.
(Museo Egizio.)
5.8
Two bronze bird lamps. (Museo Egizio.)

5.9
Bronze cock lamp (Museo Archeologico,
Florence, 7565.)

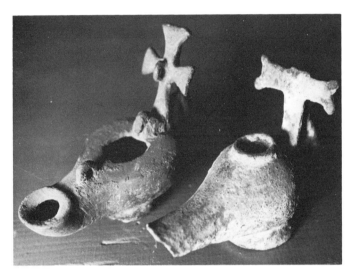

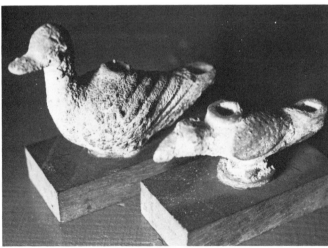

Bronze theriomorphic lamps (1–6) and warship
polycandelon (7).

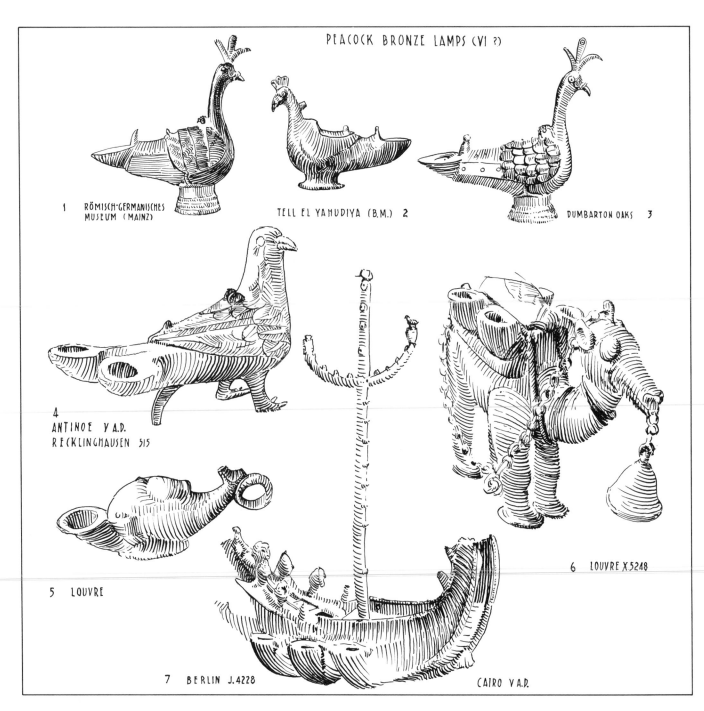

PEACOCK BRONZE LAMPS (VI ?)

1 RÖMISCH-GERMANISCHES MUSEUM (MAINZ)

TELL EL YAHUDIYA (B.M.) 2

DUMBARTON OAKS 3

4 ANTINOE V A.D.
RECKLINGHAUSEN 515

5 LOUVRE

6 LOUVRE X 5248

7 BERLIN J.4228

CAIRO V A.D.

5.11
Bronze peacock lamp. (Dumbarton Oaks, 40.21;
A.D. IV–VIII; courtesy Dumbarton Oaks
Collection.)

5.12
Bronze lamp shaped as a bound gazelle. (Museo
Egizio, 4356.)
5.13
Bronze lamp with foliate handle on stand.
(Dumbarton Oaks, 30.9a-b; A.D. VI.)

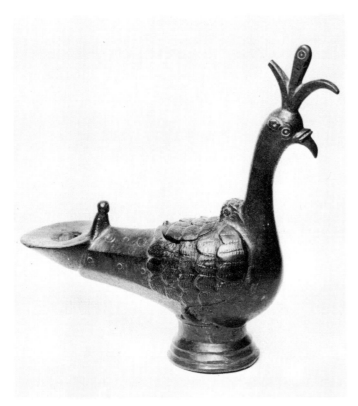

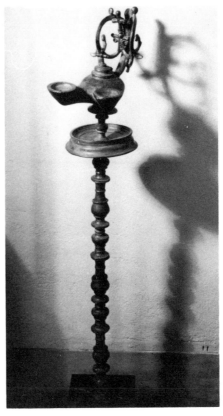

5.14
Bronze lamp with a figurine pulling a thorn out
of its foot. (Museo Egizio.)

5.15
Bronze *polyluchnion*. (J. Strzygowski, *Koptische
Kunst*, pl. XXXIII.)

5.16
Bronze censer with suspension. (Walters Art
Gallery, 54.2357; A.D. V.)

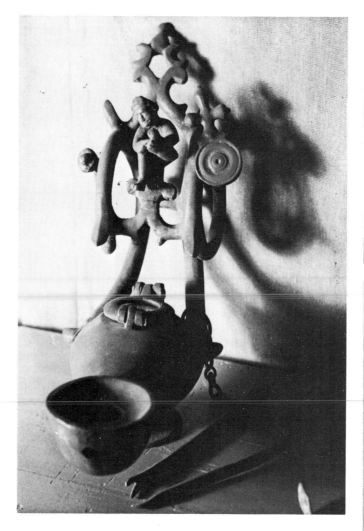

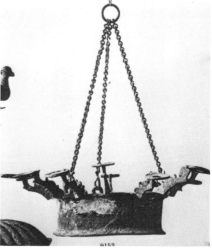

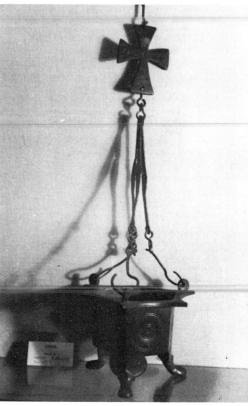

Walters Art Gallery, 54.2357; A.D. V), to more elaborate shapes with a hinged openwork lid, some borrowing stylistic elements from architecture (Fig. 5.17; Dumbarton Oaks, 40.16, A.D. VI–VII). The most magnificent of the type imitates a cupola in openwork of foliate design decorated with heads, topped by a small aedicula and set on three others (Fig. 5.18; Louvre). A modest derivative of this type is the chalice on a tall leg covered with an openwork hemispherical lid topped by a cross (C. M., 25928) similar to the one shown in the hand of a priest represented on a ceramic bowl of the twelfth century (see Fig. 4.119). Among fancy forms, many of which are symbolic, we find the fish (Fig. 5.19, Walters Art Gallery, 54.1386; A.D. V–VI), the pine cone on cylindrical openwork leg (Fig. 5.3, 6), the human smiling head wearing a conical cap (Fig. 5.3, 7), the casket with openwork sides repeating a monogram (see Fig. 5.3, 8),[17] or a most elaborate openwork casket topped by a sliding lid representing a lion overpowering a hog and cast in such a way that smoke would emanate from the mouth and ears of both animals (Fig. 5.20; Walters Art Gallery, 54.1674; similar ones are Louvre, X 5247; A.D. XIII;[18] M.M.A., 89.2.551; and one found above the oven in the west court of Epiphanius monastery).[19]

Incense burners not intended to be carried about are simple boxes with a pyramidal lid in openwork (see Fig. 5.3, 9; Dumbarton Oaks, 40.56; A.D. VI) representing two confronted lions and vine scrolls, or a lion's head protruding on each side of the pyramid (Staatliche Museen, J. 10778; A.D. VI–VII), or it might be shaped as a horse with simple triangular apertures in its neck (Fig. 5.21, Museo Egizio, 595; compare Hermitage, Leningrad, 208, 9), a theriomorphic motif frequently employed in Islamic Egypt, especially as lions entirely worked in chiseled intricate openwork arabesques.[20] Some globular censers with embossed scenes from the New Testament were found in Egypt and seem to belong to a considerable group of bronze censers made in Syria or Palestine from the sixth to the seventh centuries.[21] The Copts do not seem to have decorated the walls of their censers with low reliefs like those of Syria or Cyprus.[22] Derived from the same pagan prototypes as the censers and incense burners are the bowls on balusters imitating a small horned altar of the Hellenistic type adopted by the Copts[23] (Staatliche Museen, J. 9629; A.D. V–VI) or a hemispherical bowl with a scalloped openwork rim surmounted by doves of a type very similar

to the ones in embossed gold in a necklace.[24]

Pans derive from Alexandrian beak-handle types,[25] some circular with a simple handle (Fig. 5.3, 10), others or a more elaborate broad-ledged shape bordered with beads and held from an elegant handle terminating in a volute and floral composition (see Fig. 5.3, 12) and still others containing a circular depression within a square held from a fish handle (see Fig. 5.3, 11, C. M., 27543). The artists vied in creating original designs for these handles, such as galloping animals (Fig. 5.22, Benaki Museum) or a nude dancing girl with legs crossed and arms upholding a *crux immissa*, flanked by two dolphins (Fig. 5.23; Louvre, X 3622; A.D. VIII).[26] This special emphasis on the treatment of the handle is certainly reminiscent of ancient Egyptian unguent spoons and is apparent in a fragmentary handle decorated with the same dancing girl holding a wreath and a palm frond, standing on a lion within a loop bordered by four birds topped by a cross (Fig. 5.24; Benaki Museum, No. 5; A.D. VIII).[27] A bust of a woman wearing collar and Phrygian cap and holding curved objects behind her head may have formed the important

17. O. Wulff, *Altchristliche Bildwerke*, Nos. 379, 978, 989.
18. A. Piankoff, "Les deux encensoirs coptes du Musée du Louvre," *BSAC*, Vol. 7 (Caire: 1941), pp. 1 ff., pls. I-II. H. E. Winlock and W. E. Crum, *The Monastery of Epiphanius at Thebes*, Vol. 1 (New York: 1926), p. 95, pl. XXXV. (Hereafter cited as *Monastery of Epiphanius*.)
19. H. E. Winlock and W. E. Crum, *Monastery of Epiphanius*, p. 95, pl. 35.

20. D.T. Rice, *Islamic Art* (New York: 1965), p. 75, Fig. 72.
21. O. M. Dalton, *Byzantine Art and Archaeology* (Oxford: 1911; reprint, New York: 1961), p. 622; Fig. 393. C. M. Kaufmann, *Handbuch*, pp. 597–598, Fig. 241.
22. O. M. Dalton, *Byzantine Art and Archaeology*, p. 573, Figs. 351–352.
23. J. Strzygowski, *Koptische Kunst*, pp.101–102, Figs. 154–155. Also represented on a Coptic stela; cf. C. M. Kaufmann, *Handbuch*, Fig. 51.

24. J. D. Cooney, *Pagan and Christian Egypt*, No. 85.
25. J. Strzygowski, *Koptische Kunst*, p. 278, pls. XXX, XXXI.
26. J. Vandier, in *Revue des Beaux-Arts de France*, Vol. 7 (Paris: 1943), pp. 12 ff., Fig. 14. Similar handles are in the Cairo Museum; cf. Strzygowski, *Koptische Kunst*, No. 9101, pl. XXXI.
27. A similar one is described by P. du Bourguet, *L'Art Copte. Petit Palais, Paris: 1964*. No. 114, A.D. VIII (Hereafter cited as *Art Copte*.)

5.17
Bronze censer of an architectural shape with hinged openwork lid. (Dumbarton Oaks, 40.16; A.D. VI–VII; courtesy Dumbarton Oaks Collection.)

5.18
Bronze openwork censer imitating a cupola. (Louvre.)

5.19
Bronze fish-shaped censer. (Walters Art Gallery, 54.1386; A.D. V–VI.)

5.20
Bronze censer in the shape of a lion overpowering a hog. (Walters Art Gallery, 54.1674; A.D. V–VI.)

5.21
Bronze incense burner in the shape of a horse. (Museo Egizio, 595.)

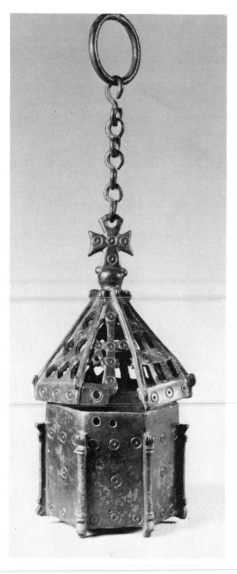

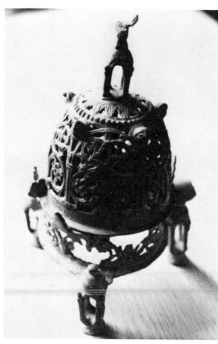

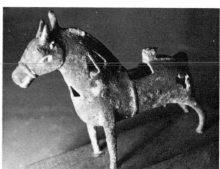

5.22
Bronze pan with lion handle. (Benaki Museum.)
5.23
Bronze pan with handle in the shape of a
dancing girl carrying a *crux immissa*. (Louvre, X.
3623; A.D. VIII.)

5.24
Bronze handle in the shape of a dancing girl on
a lion within a loop. (Benaki Museum.)

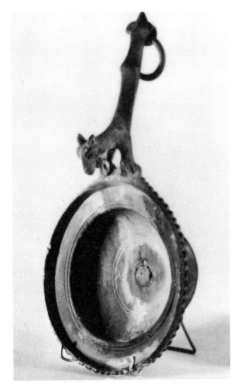

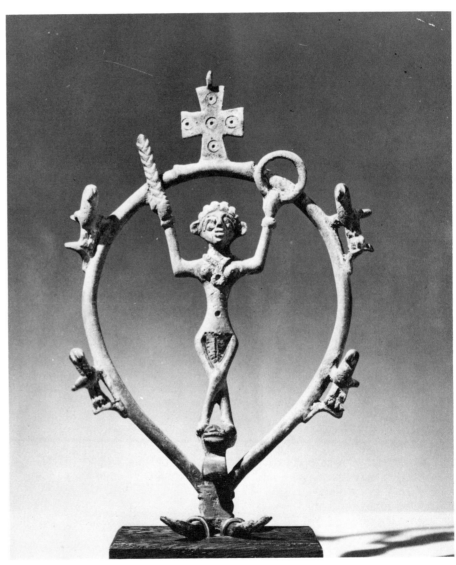

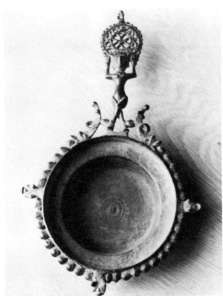

Metalcrafts 331

element in the handle of a lamp (Fig. 5.25; Benaki Museum).[28] A horse head of an excellent realism could well have been the handle of a lamp (Fig. 5.26; Museo Egizio, Cat. 7170; compare Strzygowski, 9144), while a conventionalized lion formed an ornament to a chariot (Fig. 5.27; Walters Art Gallery, 54.2353; A.D. VI). A tantalizing problem of interpretation is set by a group of ornaments, each mounted on a vertical screw representing a sea horse (C. M., 27131) or a galloping horse mounted by a rider saint holding a long-handled cross and a shield, his mantle flowing behind him (Fig. 5.28; Museo Egizio, 11 cm. in height).[29] He is very similar to the riders saints in the murals at Bawit (Chapels XXVI, XVII).

Bronze was also used for crosses more than was silver or wood. A few are ornamented with busts cast in relief (C. M., 25483)[30] or are inscribed, but the vast majority are simple flat crosses of various dimensions, some stamped with circles, even the very minute ones (Fig. 5.29, Museo Egizio). Others are ceremonial crosses for processions with a tenon to fix them at the top of the long staffs that are seen in the hands of saints (Fig. 5.30, Musées Royaux, E 7617), or they are modeled with chamfered edges and a small cross cut through in the center (Fig. 5.31, B. M., 49097).

The Copts were as partial to jewelry of gold and silver and also of semipre-

cious stones, glass, and even iron as their forefathers had been to gold, semiprecious stones, and faience. The commonest designs for bracelets consist of disks engraved with a cross or an *orans* and St. Menas which are connected by a band with crosses and doves (Fig. 5.32, 3) or alternating with ovals, or simple wire curving into a circle in bronze,[31] or silver ending in flowers inlaid with carnelian calyxes and black lined petals (Fig. 5.32, 1).[32] A few, however, compare favorably with the most elaborate bracelets from Syria, Cyprus, and other districts of the Byzantine Empire. A simple design consists of a thick gold ring with flutes and cartouches alternating between beaded edges (Walters Art Gallery, 57.1737; A.D. VI-VII). Another is a tubular ring attached to the central pieces mounted with five gold coins of Maurice Tiberius, Phocas, and Heraklius (Fig. 5.33; Dumbarton Oaks, 38.64–65; A.D. VII), a design including imperial coins as in Byzantine jewelry. The bracelet with two confronting panthers holding a boxlike setting intended to be inlaid with a cabochon stone,[33] if really originating from Egypt. would prove that Coptic jewelry could surpass any other (Dumbarton Oaks, 38.66; A.D. VII).

Necklaces are worn by female deities, sometimes in the nude, by symbolic eagles, and by female personifications as well as by ordinary womenfolk. Still as common as in the late-antique period

is the ever popular *bulla*, a ring or torqué from which hangs a huge disk rosette, the only ornament besides earrings worn by the nude Nereids, Daphnae and Leda. Another version featuring a broad collar in two bands bordered by three rows of beads with three pendant bullae is worn by a symbolic eagle at Bawit (Chapel XXVII; see Fig. 5.32, 4). A more refined piece consists of two strings of oval beads alternating with two pearls worn by the beautiful female personification of the Church at Bawit (Chapel XVII; Fig. 5.34). It is interesting to mention that the ladies in the funerary portraits from the Fayum (A.D. II–IV) also usually wore two necklaces, one of gold with a gold medallion or crescent and a second of green beryl oblong stones with gold spacers, occasionally only one gold chain with a large medallion of gold.[34] An original creation features a band of upright lotuses of Egyptianizing style encircling tightly the neck of an *orant* lady (see Fig. 5.32, 5; C. M., 8697; A.D. VI–VII) whose headdress is similar to that traditional to Hathor. The real necklaces surpass aesthetically those represented in murals or sculpture. Such are a simple row of ducks in embossed gold similar to those swimming on the rim of an incense burner and spaced by single pearls (Fig. 5.35, b; Walters Art Gallery, 57.1727; A.D. IV–V), or a more sophisticated string of gold and lapis lazuli biconical beads from which hangs a pendant shell of

28. Similar is C. M., 26465, cf. J. Strzygowski, *Koptische Kunst*, No. 7001, pl. XXXI, p. 324.
29. Similar is the one described by P. du Bourguet, *Art Copte*, No. 113.
30. J. Strzygowski, *Koptische Kunst*, pp. 304–307, pl. XXXIV.

31. Ibid., pp. 330–333, pl. XXXVIII.
32. U. Hölscher, *Medinet Habu, V*, Fig. 76, p. 65.
33. J. S. Thatcher, ed., *The Dumbarton Oaks Collection*, Harvard University (Washington, D.C.: 1955), Nos. 187, 188.

34. A. F. Shore, *Portrait Painting from Roman Egypt* (London: 1962). (Hereafter cited as *Portrait Painting*.) H. Zaloscer, *Porträts aus dem Wüstensand* (Vienna: 1961). (Hereafter cited as *Porträts*.)

lapis-lazuli bordered in gold with an appliqué gold figurine of Aphrodite (Dumbarton Oaks, 28.6; A.D. VII). Allying religious symbolism to aesthetic purpose is the pectoral cross in embossed gold representing Christ, with a medallion encircling the bust of an Apostle at every one of the four ends. (Dumbarton Oaks, 37.24). Occasionally an *orant* saint wears a broad collar.

Earrings form an essential item in the jewelry worn by female personifications, such as the Church adorned with three pearls (see Fig. 5.34; Bawit, Chapel XVII) or Alexandria wearing two large disks with relief and a border of granulation (Aachen ivory; A.D. VII). The Copts seem to prefer earrings richer than the simple gold foil crescent shape of their predecessors from the late dynastic age (Twenty-fifth to Twenty-sixth dynasties),[35] adding to the hoop a knob-ended stem with funnel-shaped casing (see Fig. 5.32, 6–7; from Medinet Habu; Oriental Institute, Chicago, 15189, 15209), or a floral pendant derived from the lily of Roman prototypes (C. M., J. 59649), or a geometrized tear in gold foil (see Fig. 5.32, 18; A.D. VI);[36] similar to those worn by the Nereids (Trieste; see Fig. 3.55). They work[37] small rings, even in bronze or silver, with drop-shaped pendants (see Fig. 5.32, 9; Strzygowski, 7043) such as those worn by many a

Nereid and bacchante, or large hoop with biconical openwork pendant (see Fig. 5.32, 11; Strzygowski, No. 7034) or a tear-shaped glass within a bronze frame of filigree (see Fig. 5.32, 10; Strzygowski, No. 7041). A more elaborate pendant is mounted on a gold ring with three pyramidal protrusions of flattened pellets, the lower ending in a boss and possibly a bead (Fig. 5.32, 14; Brooklyn Museum; A.D. VI). Another one features a filigree zigzag bar within the torque hoop and a brown bead (see Fig. 5.32, 12; Strzygowski, No. 7040). Let us also mention a filigree disk enclosing a cross (see Fig. 5.32, 13; Strzygowski, No. 7039) and perhaps also the typical Byzantine crescent with Christian symbols. One of the techniques for making earrings was to cast the metal through a duct in a stone mold consisting of two halves carved with the matrix and well-adjusted by means of two rivet holes. One such mold contains elegant designs, circular, beaded, floral, and tear-shaped (Fig. 5.36; Johns Hopkins University Archaeological Museum; A.D. V–VII). The analogy with the earrings of the ladies from the Fayum portraits is evidenced by recurring types, especially the large hoop set with a pearl or three stones, or the smaller hoop with a spherical pendant of gold.[38]

Finger rings are made of base metal, as inconspicuous signet rings engraved with a rider saint, or in an inferior silver alloy with an open bezel, each end in the shape of a flower (Djimē; Oriental

Institute, Chicago, 15190).[39] Mural paintings and reliefs introduce us to a category of jewelry of which nothing has survived, hair ornaments. While some derive from the laurel diadems of the Roman emperors, others consisting of alternating quatrefoils and rosettes (see Fig. 5.32, 18) are reminiscent of the ancient Egyptian diadems. The diadem varies in shape from simple laurel wreaths as symbols of blessedness above the brow of a deceased man or woman (Fayum portraits), once with a central cabochon (stela of Olympios; Brooklyn Museum, 40.301; A.D. V), to a band of quatrefoils sometimes alternating with rosettes on the hair of a bearded personification of the Nile (see Fig. 5.32, 18; Coptic Museum, Cairo, 7021; A.D. V; compare Brooklyn Museum, 41.891; A.D. V) or a crown with foliate relief held above the head of an emperor by two victories (Aachen ivory). In monastic murals[40] appear simple diadems, such as a headband with beads (see Fig. 5.32, 15; St. Phoibammon; Bawit, Chapel XVII) or a central medallion (see Fig. 5.32, 16; Bawit, Chapel XX), or a tiara with three medallions surmounted by a frontal rosette (see Fig. 5.32, 15; St. Phoibammon; Bawit, Chapel XVII), or gemmed crowns topped either with medallions (see Fig. 5.34; personification of Church, Bawit, Chapel XVII) or with a frontal floral piece (see Fig. 5.32, 17; saints at Bawit, Chapel III). It is more than probable that social conditions never allowed the Copts to indulge themselves with even the simplest of these

35. U. Hölscher, *Medinet Habu, V*, pl. 39A 20–22 (25th to 26th Dynasty).
36. J. D. Cooney, *Pagan and Christian Egypt*, Nos. 139–140.
37. J. Strzygowski, *Koptische Kunst*, pl. XXXVIII, pp. 333–336.

38. A. F. Shore, *Portrait Painting*. H. Zaloscer, *Porträts*.

39. U. Hölscher, *Medinet Habu, V*, p. 65, pl. 39 A 23.
40. J. Clédat, "Le Monastère," Vol. 1, part 2, pls. XLV, LIII, LXXIV; Vol. 1, part 1, pl. XXI.

5.25
Bronze fragmentary bust. (Benaki Museum.)

5.26
Bronze fragmentary horse head. (Museo Egizio,
Cat. 7170.)
5.27
Bronze lion. (Walters Art Gallery 54.2353; A.D.
VI.)

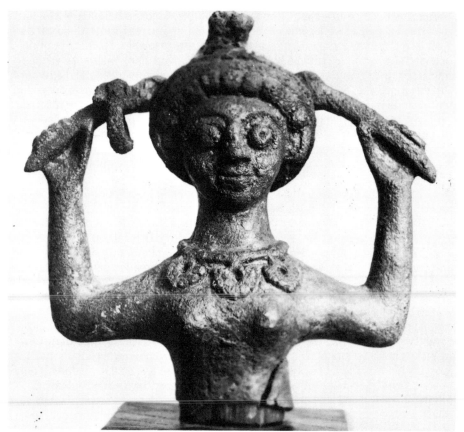

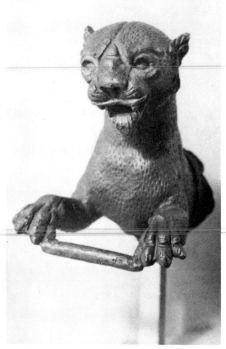

5.28
Bronze rider saint holding a cross. (Museo Egizio, 11cm. high.)

5.29
Two bronze crosses. (Museo Egizio; the smallest cross is in wood.)

5.30
Bronze ceremonial cross. (Musées Royaux, E 7617.)

5.31
Bronze ceremonial cross. (B. M., 49097.)

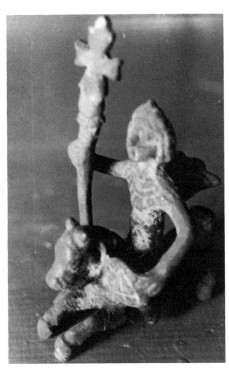

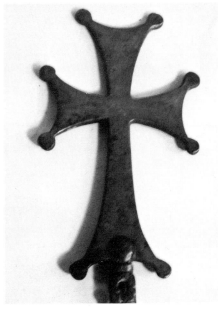

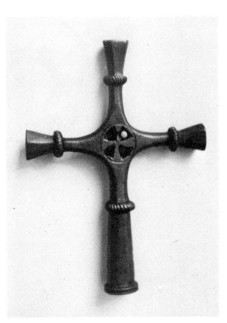

5.32
Jewelry pieces (1–14) and representations of jewelry (15–18); 1. silver bracelet (Chicago, 14479; U. Hölscher, *The Excavation of Medinet Habu, V,* Fig. 76); Oriental Institute 14479, 2. Ibid.; 3. (J. Strzygowski, *Koptische Kunst,* 7022); 4. Painting from Bawit, Chapel XXVII; 5. relief from stela (C. M. 8697); 6–7. bronze earrings (Oriental Institute, Chicago 15189, 15209); 8. gold earring (Brooklyn Museum; J. Cooney, *Pagan and Christian Egypt,* No. 139); 9. (J. Strzygowski, op. cit., 7043); 10. (Ibid., 7041); 11. (Ibid., 7034); 12. (Ibid., 7040); 13. (Ibid., 7039); 14. gold earring (Brooklyn Museum; J. Cooney, op. cit., No. 138); 15. St. Phoibammon from a mural at Bawit, Chapel XVII; 16. painting from Bawit, Chapel XX; 17. Bawit, Chapel III; 18. statue personifying the Nile (Coptic Museum, Cairo 7021, A.D. V.)

5.33
Gold bracelet with imperial coins. (Dumbarton Oaks, 38.64–65; A.D. VII; courtesy Dumbarton Oaks Collection.)

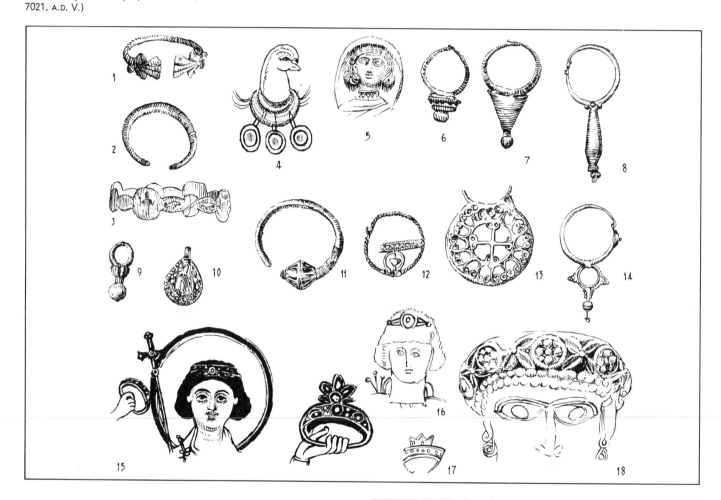

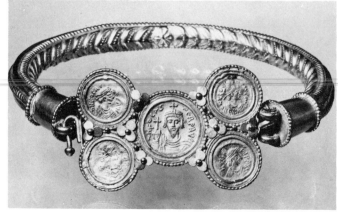

5.34
Mural painting representing a female personification of the Church. (Bawit, Chapel XVII; J. Clédat, "Le Monastère," Vol. 1, part 2, pl. XLV.)

5.35
Gold and pearl necklace with ducks. (Walters Art Gallery, 57.1727; A.D. IV–V.)

5.36
Half a stone mold for casting four pendants. (John Hopkins University Archaeological Museum; A.D. V–VII.)

5.37
Bronze and iron large keys (44 cm.) of Deir Abiad (left and top) and three others. (J. Strzygowski, *Koptische Kunst*, pl. XXXV.)

5.38
Black stone half mold for metal buttons. (Walters Art Gallery, 41.1; A.D. V–VI.)

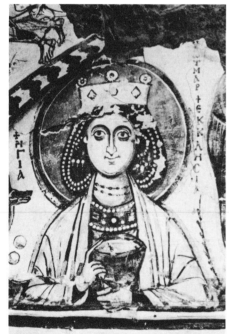

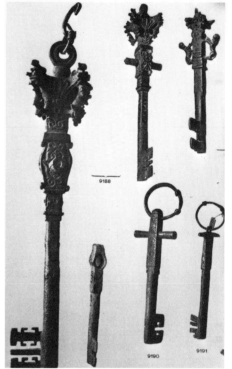

diadems, very modest though they were when compared to those of the ancient Egyptians.

Another category of metal ornaments known from murals is that of horse trappings. These consist of roundels, probably in leather studded with copper beads, set as pendants, usually one on the breast and one on each hip (Bawit, Chapel XVII),[41] and allied with curved horns hanging from garlands and a brow band with disks (Bawit, Chapel XVII). Richer trappings may feature as many as three round pendants hanging from broader bands on the breast and on each hip (Bawit, Chapel XXVI), or a continuous series of medallions (emperor on Aachen ivory; St. Menas illumination on parchment; John Rylands Library, Manchester: Coptic Ms. suppl. 33; A.D. XI), or a series of medallions alternating with lilies (St. Theodoros the Stratelates and St. Merkurios; Vatican Codex 66; A.D. X). Such trappings echo the oriental trends that became fashionable during the late-antique period, probably deriving from Persia and represented in the murals for the god Heron.[42] The custom of using rich horse trappings spread southward among such horse enthusiasts as the Nubian kings of the X-group period (A.D. V) as evidenced at Ballana and Qustul,[43] and later

among the Islamic rulers in Khorasan (A.D. X).[44]

Though not qualifying intrinsically as jewelry pieces, a few large ceremonial keys present such artistic achievements in metalcraft that they may be studied here. The two most splendid keys of Deir Abiad at Sohag[45] are certainly masterpieces of their kind. The largest (Fig. 5.37; 44 cm. long), of bronze and iron with silver niello, bears above the iron shaft a bronze head with foliate ornament and two protruding cylindrical iron arms. This is topped by a capital of modified Corinthian type with four dolphins holding a ball in their mouths set upside down at the angles just beneath four reclining lions. On the smaller key (35 cm. long) a lion and a lioness climb on opposed sides of the square head toward a capital.

Some light is shed on the technique of metal casting from the steatite molds carved with one matrix or more of an earring[46] or medallion on either face of twin slabs, which are connected to inlet channels and secured to each other by bolts passing through two holes at each edge (Fig. 5.38; Walters Art Gallery, 41.4; A.D. V–VI). On the obverse of one mold is a conventionalized Crucifixion in which the cross topped by the bust of Christ is flanked by two haloed saints on two crosses (Brooklyn Museum of Art, 16233, A.D. X).

Carved wood appears not only in architectural members such as consoles, lintels, and doors, but also in furniture[47] consisting of a framework carved with foliate bands and with panels in relief representing scenes of a flying figure, a standing soldier, a horseman, a lion preying on a hare, or plant motifs in a geometric pattern (Fig. 5.39; from Kom Eshkaw; C. M., 34744; A.D. VI).[48] The usually flat technique compares favorably with stone sculpture or with the splendid pieces of architectural sculpture in wood. The legs are usually similar in outline to the conical ones of the Egyptian period, but they are now turned, a technique probably adopted during Greco-Roman times in imitation of the legs of the *klinē* and other furniture. A type of woodwork[49] exemplified in the monasteries of the Wadi Natrun shows stylized foliate patterns in a chamfered technique reminiscent of the stucco mural panels from Samarra (A.D. IX).

Among smaller items the bridal casket in wood representing a gabled palatial structure with ivory or bone panels inside the window frames offers the most original design. The panels are engraved, painted, inlaid with pastes, or carved in low relief with single standing figures, either of the lady and her attendants (from Saqqara; C. M., 5664–

41. Ibid., Vol. 1, part 2, pls. XXXIX, LIII, LV.
42. A. E. R. Boak and E. E. Peterson, *Karanis, Topographical and Architectural Report of Excavations during the Seasons 1924–1928* (Ann Arbor: 1931), Fig. 48. J. D. Cooney, *Pagan and Christian Egypt*, No. 7, A.D. III.
43. W. Emery, *Egypt in Nubia* (London: 1965), pp. 64, 67, 73, pls. VII-IX.

44. D. T. Rice, *Islamic Art*, p. 51, Figs. 43, 66.
45. J. Strzygowski, *Koptische Kunst*, pp. 307–309, pl. XXXV.
46. J. D. Cooney, *Pagan and Christian Egypt*, pp. 141–143.

47. J. Strzygowski, *Koptische Kunst*, pp. 126–136.
48. Ibid., pp. 153–159, pl. IX. Wooden screens from Saqqara; cf J. E. Quibell, *Excavations at Saqqara* (1908–9, 1909–10), pl. LVI.
49. J. Strzygowski, *Koptische Kunst*, pp. 159–161, Figs. 228–229.

5669; A.D. III–IV)[50] or of dancing girls, Pan, and Erotes of Alexandrian type (Fig. 5.40 *a*, *b*; Walters Art Gallery, 71.41; A.D. V–VI). Though of a simplified technique, the engraving usually succeeds in conveying a lively picture of the spirited figures (Fig. 5.41, Louvre; compare C. M., Maspero 5699–5702). Simpler caskets are covered with rows of incised concentric circles.[51]

Numerous bone figurines representing schematic women with cylindrical body, stumpy arms, and spherical head to which was attached a wig (Fig. 5.42; Glyptothek Ny Carlsberg, A.E.I.N. 864–867) are vaguely reminiscent of ancient Egyptian dolls of various materials which were buried with the deceased to serve as concubines. Similar figurines of cocks, hands, fruit, or a vase form the head of thin hairpins or kohl appliers. A broader wooden item richly carved with geometric patterns and sailing boats, and terminating in a head could be a spatula or an ornamental pin (Fig. 5.43 *a*, *b*; Museo Archeologico, Florence, 9591; compare C. M., 29071–29074, A.D. V–VI). Also made of bone are the spindle whorl disks decorated with concentric circles, rows of circles, or hatched triangles alternating with circles (Fig. 5.44; Walters Art Gallery, 71.545–547),[52] all very modest descendants of the elaborate Egyptian designs.

Among the essentials of toilet equipment are wooden combs[53] of a type familiar in Egypt from the predynastic period until modern times, mostly of a tall shape and embodying some artistic element, crosses with a wreath indicated in stamped circles, a foliate band, or even one or more openwork panels outlining figures and animals (Fig. 5.45; B. M., 51070, 54473, 54475; A.D. VI–VIII). Ivory combs[54] are of a broad shape, though still edged by one row of finely meshed teeth and an opposing row of thicker teeth. Certainly luxury items, these ivory combs are decorated on each side with an oblong panel in low relief depicting banquet scenes and nudes (C. M., 27453), or scenes from the Christological cycle with the Raising of Lazarus and the Miracle of the Blind on one side and on the reverse a saint *orans* on horseback within a wreath held by two angels in a mannerist Alexandrian style (from Antinoë, C. M., Cat. 1895: 1386). Carding combs, pulleys, spoons, castanets or clappers, and stamping seals not totally deprived of artistic value appear among other products in carved wood (Fig. 5.46; Glyptothek Ny Carlsberg, A.E.I.N. 877).

Bags, girdles, sheaths for calamus, saddles, sandals, and shoes are all made of leather with stamped ornament, often colored. The Thebaid monks of Epiphanius wore an apron of black kid leather with a lower fringe (see Fig. 1.5). A peculiar item is the crescent-shaped cushion stuffed with hair or textiles[55] and decorated with three openwork crosses symbolizing the Trinity which was (Fig. 5.47; B. M., 26565; A.D. V) placed beneath the head of the deceased to provide him with a softer headrest than the transverse wooden bar found in the graves at Djimē (see Fig. 2.66). This leather cushion derives from the one that the ancient Egyptian bound to his headrest, a late descendant of which is still used among the Bisharin tribes south of Aswan.

Leather shoes in the shape of moccasins could be very ornate. One piece (Deutsches Ledermuseum, Offenbach Main, Inv. Nr. 4962; 23 cm.; A.D. IV) is made of white goatskin with circles punched through to show the red underlying layer, each circle stamped with a gilded square. Between the inner and outer soles is a third one of papyrus.[56] Other shoes are so richly overlaid with gilded roundels and lacework that they seem to have had a ceremonial rather than a utilitarian purpose.

The loose pages of codex books had to be kept in order within leather port-

50. Ibid., pp. 172–175, pls. XI-XIII.
51. J. D. Cooney, *Pagan and Christian Egypt*, No. 98, in The Museum of Fine Arts, Boston, A.D. IV–VII.
52. J. Strzygowski, *Koptische Kunst*, pp. 207–210, pl. XIX.

53. Ibid., pp. 144–147, pl. VIII.
54. Ibid., pp. 193–195, pl. XVII.

55. Ibid., p. 165, pl. X; C. M., 27056, 27057, 27556.
56. *Koptische Kunst* (Essen: 1963), p. 291, No. 228. For the Coptic Museum shoe, see M. H. Simaika, *Guide sommaire du Musée Copte* (Cairo: 1937), pl. LXXXI. J. Strzygowski, *Koptische Kunst*, p. 167, pl. X.

5.39
Carved wooden casket. (C. M., 34744; A.D. 600;
J. Strzygowski, *Koptische Kunst,* No. 7211.)

5.40a, b
Bridal casket imitating a structure in wood with
ivory panels. (Walters Art Gallery, 71.41; A.D.
V–VI.)

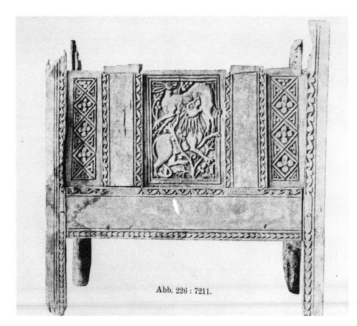

Abb. 226 : 7211.

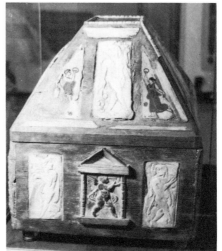

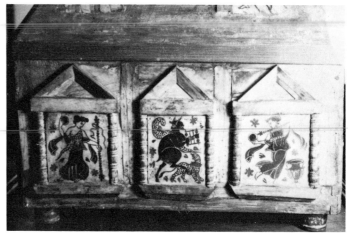

5.41
Ivory panel engraved and stained. (Louvre.)
5.42
Bone figurines. (Glyptothek Ny Carlsberg.
A.E.I.N. 864–867.)

5.43
Carved wood implement. (Museo Archeologico,
Florence, 9591.)

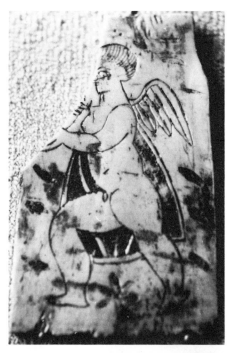

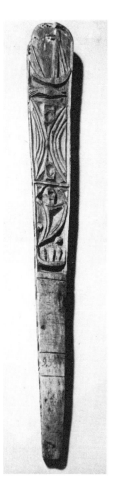

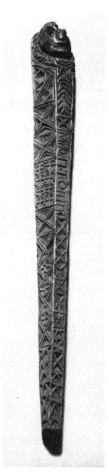

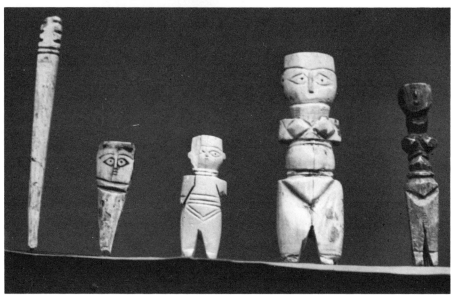

Leather 341

5.45
Wooden combs stamped, carved, and in open-
work. (B. M., 51070, 54473, 54475; A.D. VI–VIII.)
5.46
Wooden stamping blocks. (Glyptothek Ny
Carlsberg, A.E.I.N. 877.)

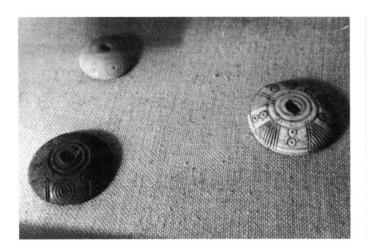

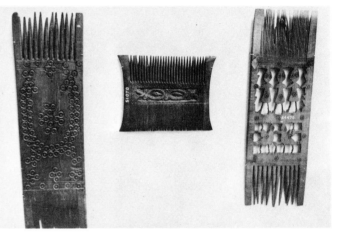

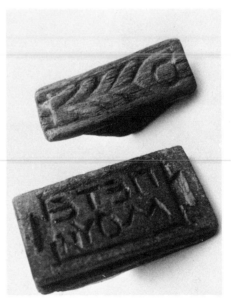

folios. The ten bindings of the Gnostic papyrus codex discovered in a jar in 1946 at Nag' Hammadi, north of Luxor, are the earliest Coptic bindings known today (A.D. IV) (Coptic Museum, Cairo, 10546). They are made of a strip of goatskin folded so as to cover the papyrus sheets, with the end rebate cut into a triangle and secured by means of a leather thong to be wound round the book. No decoration appears except for one folder which shows a *crux ansata*—possibly a Gnostic emblem—with a squarish loop and foliate decoration framing the shaft of the cross.

The earliest decorated leather binding (B. M., Or. Ms. 5001; A.D. 650)[57] shows a pattern enclosed within a square as wide as the cover formed on one side by a Greek checker, and on the other by a Latin cross twined with a square on end on a ground interspersed with small stags and pelicans within medallions around a dove (Fig. 5.48). The band forming the pattern is dotted with a sequence of circles. Along the top and bottom margins runs a frieze of scroll elements alternating with small animals within rectangles. We are reminded that two squares twined diagonally form the basic scheme of ancient Egyptian geometric patterns and survive in bindings of Coptic books.

In later designs the square still forms the central element within a rectangular frame adapted to the form of the book.

Within the square a circle is once inscribed (Fig. 5.49; Pierpont, Ms. 569; A.D. VIII), filled with an intertwining band designing a smaller circle, with a cross enclosing a smaller one. Circular leather insets representing pearls accentuate the arms of the cross and the perimeter of the geometric pattern. At the top runs a scroll and at the bottom a sequence of three squares with a cross and two rosettes separated by rectangles. The design is impressed so as to create some embossed elements. The basic scheme of a square on end within the principal square lends itself to a variety of compositions determining a quatrefoil and ivory inlaid cross with ivory dots in the background (Pierpont, Ms. 600; A.D. 906), or a more schematic design worked in a row of dots imitating a string of pearls (ibid., 597; A.D. 917). This impressed design hardly shows embossing. An allegedly Coptic binding departs from the square scheme (40 × 31 cm.; A.D. VIII, presumably later)[58] to become a vertical rectangle consisting of a broad band imprinted with a geometric pattern surrounding the star of David within a lozenge in openwork on a gilded background. Much similarity can be found between intertwines of squares and circles on bindings and in illuminated manuscripts.

In Islamic bookbinding, Coptic ornament was adapted to the more minute arabesque characterized by elegant stylization and more abstract composition of floral elements (Gospel, B. M., Or. Ms. 1316; A.D. 1663).[59]

Containers for gospels were worked in silver embossed with rich foliate ornament as a band running around a square featuring a cross sometimes enriched with precious stones. Above and below runs a band of ornamental script quoting from the gospel (Coptic Museum, Cairo, Nos. 1526, 1527: 38.5 × 29 cm, 1565; A.D. XV).[60] No modeling is used but a third-dimensional effect contrasts the protruding design against a deep ground.

59. T. Petersen, "Early Islamic Bookbindings and their Coptic Relations," in *Ars Orientalis*, Vol. 1 (University of Michigan: 1954), pp. 41–64.
60. M. Cramer, *Koptische Buchmalerei*, Figs. 152, 153. *Koptische Kunst* (Essen: 1963), pp. 270–271, No. 169.

57. M. Cramer, *Koptische Buchmalerei* (Recklinghausen: 1964), pp. 125–127, Figs. 147–151.

58. *Koptische Kunst* (Essen: 1963), p. 290, No. 226.

5.47
Openwork leather cushion stuffed with hair.
(B. M., 26565; A.D. V.)
5.48
Leather binding of codex decorated with
geometrical patterns interspersed with animals.
(B. M., Or. Ms. 5001; A.D. 650); M. Cramer,
Koptische Buchmalerei, Figs. 147–151.)

5.49
Leather binding of codex with cruciform decora-
tion. (Pierpont, Ms. 569; A.D. VIII.)

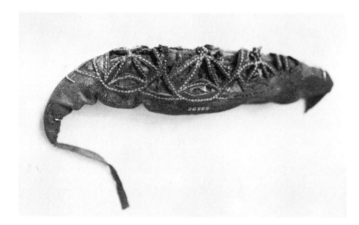

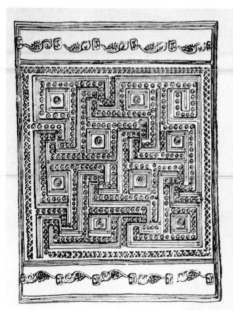

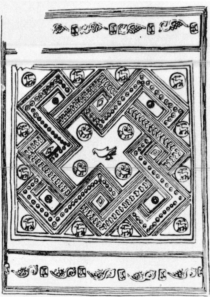

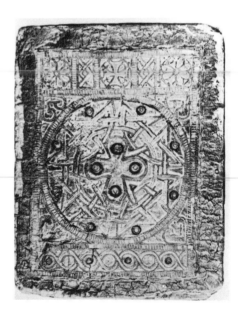

Pottery vessels were certainly the cheapest items of household equipment. Decoration in red iron-oxide burnished wash, painted motifs (see above, Ceramics), and relief was not uncommon. Terra-cotta lamps deriving from Greco-Roman types show a general trend toward slenderer forms with richer ornamentation in the shape of dots strokes, and pellets spread on the top. The Copts adopt Roman production methods of light-pink or gray ware cast in two halves in molds (Fig. 5.50, 1),[61] adding their own types of jug lamps made on the wheel or poor handmade types featuring an increasing use of red and brown clays. Lamps are found in towns like Djimē, Armant, or Edfu and in necropolises (Bagawat), where they were placed in the peculiar triangular wall niches or elsewhere in terra-cotta aediculae, or suspended from wooden brackets secured in square holes in funerary stelae.[62] The finds from Djimē[63] allow us to study the continuous evolution of types in one site from the Greco-Roman to the Coptic periods. Such types may be differentiated according to shapes: round or angular echinus lamps with spout (Fig. 5.50, 2; Oriental Institute Museum, Chicago 14332; A.D. V–VI); shouldered lamps with

one shoulder (Fig. 5.50, 3; Oriental Institute Museum, Chicago, 14349; A.D. IV–V); frog lamps (Fig. 5.51; Bode Museum); oval lamps with hook-like handles (Fig. 5.51; Staatliche Museen); round lamps with handle (Fig. 5.50; Oriental Institute Museum, Chicago, 14335, A.D. V); beak-shaped lamps with grooves (Fig. 5.50; Oriental Institute Museum, Chicago, 14367, 14364, 14362; A.D. VI–VII) or without grooves (Fig. 5.50; Oriental Institute Museum, Chicago, 14353) or with parallel grooves (Fig. 5.50; C. M., J 59687; A.D. VI–VIII); jug lamps made on the wheel (Fig. 5.50; Oriental Institute Museum, Chicago, 14372, A.D. V; 14370, A.D. VI–VIII); and one lamp that suggests a sitting hen with upright tail as a grip (See Fig. 5.50, 15; Oriental Institute Museum, Chicago, 14375; A.D. IV). Some lamps have five or more spouts for burners (see Fig. 5.51).[64] A lamp modeled like a wreath bordered on its outer edge by seven spouts, with a special hole for filling in oil (C. M., 26355, 26414–26416, 26486–26488), and often to be held by a handle, is still used in the rite of extreme unction called *qandīl*. The seven burners are lighted gradually as the priest proceeds with the recitation of seven prayers, and they are finally put out with one breath.[65] A few lamps have inscriptions that run counter-clockwise round the neck and give some short dedication, such as those

from Armant[66] to the Holy Trinity, the holy Father Askla, and to Father Shenute the archimandrite. The lamps in the monastery of Epiphanius in Western Thebes are usually simple cups (7 to 8 cm. in diameter). Less often these lamps may be of an elongated oval type with the words *agape* or *irenē* in raised letters on the handle, or of a round type without handle but with a frog or lizard on the top, or of a deeper shape with higher handle and raised rim that can be regarded as a transition stage between the classical and the Islamic glazed lamps of Fostat.[67] Late lamps are decorated with stamped animals (Fig. 5.52) of a type akin to those painted on contemporary and early Islamic pottery.[68] Judging by the variety of theriomorphic bronze lamps it could be surmised that other shapes besides that of the hen (see Fig. 5.50) were imitated in the terra-cotta medium. The marks at the bottom of the lamps are not as interesting as the seal impressions, either rectangular or round (4 to 7 cm.) or both, made on the conical clay stoppers of ancient Egyptian type (Fig. 5.52) which were colored by dipping the seals of limestone, clay, or wood into red or white pigments.[69] Some of these impressions are

61. Ibid., pp. 228–229, Figs. 281–282. W. F. Petrie, *Roman Ehnasya* (London: 1905). F. W. Robins, "Graeco-Roman Lamps from Egypt," *JEA*, Vol. 25 (London: 1939), pp. 48–51. R. Mond and O. Myers, *Temples of Armant* (London: 1940), pp 100–101, pl. 28.
62. C. M. Kaufmann, *Handbuch*, p. 601, Fig. 188, citing C. M. Kaufmann, *Ägyptische Terrakotten*.
63. U. Hölscher, *Medinet Habu, V*, pp. 67–71, Figs. 87–98, pl. 40.

64. J. E. Quibell, *Excavations at Saqqara* (1908–9, 1909–10), pl. L, 1.
65. G. Legrain, "Notes d'inspection, I. Sur les lampes à sept becs et la prière 'Qandil,'" *ASA*, Vol. 9 (1908), pp. 253–254, Fig. 2.

66. R. Mond and O. Myers, *Temples of Armant*, pp. 100–101.
67. H. E. Winlock and W. E. Crum, *Monastery of Epiphanius*, p. 88, Fig. 38, pl. XXXII, A.
68. R. Mond and O. Myers, *Temples of Armant*, p. 100, pl. XXVIII, 6.
69. U. Hölscher, *Medinet Habu, V*, pp. 61–62, Fig. 68. Also: R. Mond and O. Myers, *Temples of Armant*, pls. LXVII, 2–4, labeled "bread stamps." H. E. Winlock and O. Crum, *Monastery of Epiphanius*, p. 80, Fig. 33.

not without aesthetic interest (see Fig. 5.52) representing St. Menas flanked by two camels, a rabbit, a galloping stag, bird (dove, eagle) hiding part of a stylized plant, a cross, or one of those monograms so popular in Byzantine times and often impossible to unravel, such as *proestos* or *Apa Ieremias gewrge*.[70] Mention should here be made of a type of open lamp carved of limestone in the shape of a leaf with serrated edge with the wick set at the pointed end, found in Jeremias' monastery at Saqqara.[71]

Among other types of terra-cotta containers decorated in relief is the flat circular ampula with tall neck flanked by two handles, a type derived from the larger New Year bottle of the Egyptian period. Those of St. Menas surpass in number all others throughout the Christian world. They were made in the Maryut but probably were also available in the sanctuaries of the saint all over the Mediterranean.[72] Varying in volume between 30 and 500 cubic centimeters, they were used as containers for the sacred oil of the martyr and water from the spring at Abu Mina. They bear, stamped on both sides or on the front with an inscription on the back, a standard scene of the saint standing with outstretched arms as an *orans* between two camels kneeling with their heads near the feet of the figure in a

kind of antithetic composition (Fig. 5.53). The saint is represented in a slight *contrapposto* stance, the head surrounded by a nimbus, a mantle over the shoulders, and a kilt from his waist to his knees. A short inscription, *O Agios Menas*, runs above the shoulders, sometimes backward or complemented by another inscription instead of by the chevrons or the 26 to 29 beads that form the circular frame "Eulogy of St. Menas." Other less typical scenes represent the saint as a rider or as a negro head, occasionally also accompanied by another saint or a symbol. It is noteworthy that the shops of the Maryut offered for sale to the pilgrims other terra cottas of a lay character, such as miniature amphorae, lamps, figurines of apes and other animals, votive heads, and female figurines. The latter represent a transitional stage between the nude figurines of the pagan concubines found in Greco-Roman tombs[73] and conventionalized Coptic figurines in painted terra cotta (Fig. 5.54; Brooklyn Museum, 16.161; A.D. VI–VII) with blurred limbs and stumpy arms sometimes, however, raised in the *orant* gesture.[74] The filiation process, with a possible stage as ex-voto to Isis-Aphrodite,[75] has kept the main characteristics: the breasts, a huge bulla now substituting for the unusually large navel of the pagan nudes, and the triangular hair style as a standardized type instead of the variety of elaborate tall hair structures of the earlier pagan women.

Terra cotta was also used to model stands for water jugs[76] and sarcophagi,[77] as well as in smaller items—panels of diptych,[78] bottles of various shapes stamped with a *crux ansata*[79] or a cross,[80] and a vast group of stamps for sacred bread similar to those of wood also found outside Egypt. The design often consists of foliate ornament (Fig. 5.55; University Museum, Strasbourg, 2778 A), such as a central rosette within a frame of scalloped lotus flowers and buds in a strong Egyptian tradition or of an animal sometimes within a circular frame, a hexagram, a rosette, or a monogram.[81] It may also be a simple cross (Fig. 5.56; Museo Egizio, Cat. 7265) or an oblong inscribed panel (Fig. 5.57; University Museum, Strasbourg, 2775 A, 2776 A).

76. J. Strzygowski, *Koptische Kunst*, pp. 240–241.
77. Ibid., pp. 242–244.
78. Ibid., 8978, pp. 227–228, Fig. 280.
79. Ibid., 8981, p. 229, Fig. 283.
80. Ibid., 7146, pp. 249–250, Figs. 311–312.
81. Ibid., pp. 230–233, pl. XXII.

70. J. E. Quibell, *Excavations at Saqqara* (1908–9, 1909–10), pls. XLVI–XLVII. Also: H. E. Winlock and O. Crum, *Monastery of Epiphanius*, p. 81, Fig. 33.
71. J. E. Quibell, *Excavations at Saqqara* (1906–1907), pl. LXIII, 1.
72. J. Strzygowski, *Koptische Kunst*, pp. 223–226, pl. XXI. C. M. Kaufmann, *Handbuch*, pp. 614–617.

73. E. Breccia, *Alexandrea ad Aegyptum*, (Bergamo: 1922), p. 268, Fig. 132.
74. J. Strzygowski, *Koptische Kunst*, 7131, p.245, Fig. 298. R. Mond and O. Myers, *Temples of Armant*, pp. 98–99, pl. LXIX.
75. M. Alliot, *Rapport sur les Fouilles de Tell Edfou (1932)* (Cairo: 1933), p. 21, pl. XV, 1.

5.50
Types of terra-cotta lamps and mold: 1. mold. (J. Strzygowski, *Koptische Kunst,* No. 8979); 2. from Djimē (Oriental Institute, Chicago, 14332, A.D. V–VI; U. Hölscher, *The Excavation of Medinet Habu, V,* Fig. 87c); 3. from Abydos (A.D. V; C. M. Kaufmann, *Handbuch der christlichen Archäologie,* Fig. 242c); 4. from Djimē (U. Hölscher, op. cit., Fig. 88g); 5. from Akhmim A.D. IV; (C. M. Kaufmann, op. cit., Fig. 242f); 6. from Medinet Habu (U. Hölscher, op. cit., Fig. 91d); 7. (Ibid., Fig. 92 2; Oriental Institute, Chicago, 14355, A.D. V); 8. (Ibid., Fig. 94f; Oriental Institute Chicago, 14362, A.D. VI–VII); 12. from Coptos (C. M. Kaufmann, op. cit., Fig. 242d, A.D. V); 13. (U. Hölscher, op. cit., Fig. 95a; Oriental Institute, Chicago, 14372, A.D. V); 14. (U. Hölscher, op. cit., Fig. 85e; Oriental Institute, Chicago, 14370); 15. (Ibid., Fig. 97b; Oriental Institute, Chicago, 14375, A.D. IV.)

5.51
Seven terra-cotta lamps. (Staatliche Museen, A.D. V–VII.)

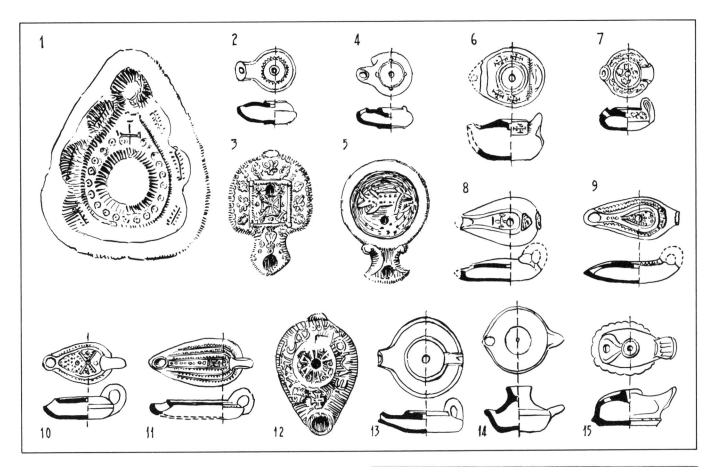

5.52
Lamp marks and seal impressions on mud jar-stoppers: 1. lamp marks from Armant. (R. Mond and O. Myers, *Temples of Armant*, pl. XXVIII, 6); 2–3. (Ibid.); 4. terra cotta-stamp and its impression from Armant (Ibid., pl. LXVII, 2); 5–9. Seal impressions from Djimē (U. Hölscher, *The Excavation of Medinet Habu, V*, Fig. 68); 11–19. seal impressions from St. Jeremias' monastery at Saqqara. (J. E. Quibell, *Excavations at Saqqara* [1908–9, 1909–10], pls. XLVI–XLVII.)

5.53
St. Menas' ampulla with stamped scene. (Städtiche Galerie Liebighaus, Frankfurt; *Koptische Kunst*, Essen, 1963, No. 219.)

5.54
Painted terra-cotta figurines. (Brooklyn Museum, 16.161; A.D. VI–VII.)

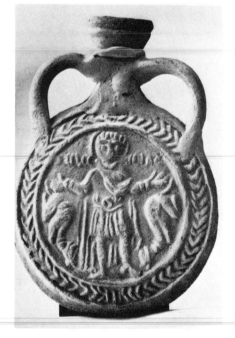

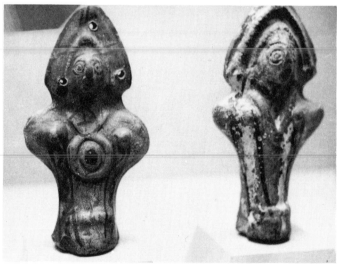

5.55
Terra-cotta stamp for bread. (University Museum, Strasbourg, 2778 A; 12.6 cm.)

5.56
Terra-cotta cross. (Museo Egizio, Cat. 7265.)
5.57
Terra-cotta stamp and its impression. (University Museum, Strasbourg, 2775 A, 2776 A; 11.5 × 3 cm.)

5.55
Terra-cotta stamp for bread. (University Museum, Strasbourg, 2778 A; 12.6 cm.)

5.56
Terra-cotta cross. (Museo Egizio, Cat. 7265.)
5.57
Terra-cotta stamp and its impression. (University Museum, Strasbourg, 2775 A, 2776 A; 11.5 × 3 cm.)

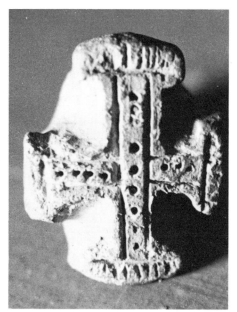

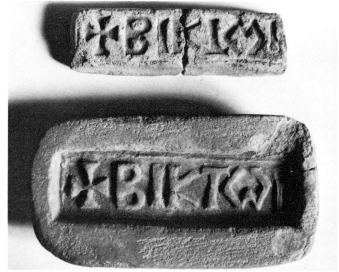

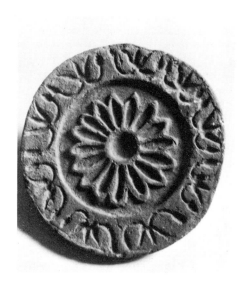

The scarcity of Coptic glass is probably accounted for by its fragility, for the material preserved exhibits a high technique to be expected in the country that had invented it. In the Roman period glass was the most important production in Alexandria, a fact partially explained by the proximity of the excellent sand of the Maryut.[82] A group of intact glassware found in a large amphora in a Christian structure at Oxyrhynchos (Fig. 5.58)[83] and the remnants of monastic glass at Saqqara (A.D. VI–VIII) and Western Thebes[84] prove that the tradition of excellence and originality as exemplified in the late-antique site of Karanis (A.D. IV–V)[85] was still maintained; it was perhaps even developed by the Copts, though the quality may have deteriorated and some types of ware disappeared[86] to revive again after the Islamic conquest. Glass colored various hues of green, mostly pale emerald but also darker emerald, brownish or yellowish green, and ultramarine, as well as blue or purple hues replaced the earlier colorless ware and was often decorated with geometric designs scratched on the surface or in relief. The remnants at Saqqara provide a good idea of what Coptic glass was like. The commonest type is a cylindrical tumbler (Fig. 5.59, 1; ca. 10 cm. tall) drawn in slightly at the top and rounded at the base of light blue-green or purple glass with lozenges, curves, and dots made "by pinching the red-hot glass with pliers armed with specially shaped jaws."[87] Also numerous are very thin (1/2 mm.) drinking cups on stems (so-called wineglasses) in light green or light blue, shaped like a lotus (Fig. 5.60; Staatliche Museen; green) and reminiscent of the ancient Egyptian faïence cups or lotus-shaped chalices. One curious example proving the technical skill of the craftsman as well as "some festive element in the monastic life," not to mention the inventiveness of the designer, is a crocodile in blue glass with green eyes, ears, and feet, held inside the glass by weeds twisted round his body (see Fig. 5.59, 5).[88] Large (24 cm. in diameter) and smaller bowls on a hoop-shaped base with one handle (see Fig. 5.60; Staatliche Museen; purple) and a folded-over rim are also common.

Among the other pieces are large flasks for table use, bottles, two-handled flasks (see Fig. 5.60; Staatliche Museen; yellowish green) ,one set of nine bottles with short necks and no handles, one-handled jugs and toilet bottles with a long neck and squat hemispherical body, a very thin long tube (30 cm. long) twisted near the upper third and ending at the bottom in a pointed blob (see Fig. 5.59, 3). Saltcellars of clear glass are ornamented with a row of large circles, each containing a ring of knobs, beneath a blue rim (see Fig. 5.59, 7). Round disks of clear or colored glass (dark blue, purple) up to 40 cm. in diameter are luted with mud to window frames of plaster forming colored panes similar to those in later monasteries (Wadi Natrun) and used until recently in Egypt. *Millefiore* glass, known in the Roman period at Armant (A.D. IV), is worked in wavy designs with a white ribbon sunk into the outer face of a dark bottle of blown glass while the glass was still glowing, or with red and blue streaks on a green ground, or with rods of variegated glass intended to be cut into disks for inlay. Colored or gilded glass cubes for mosaics were found at Saqqara and in the basilica of Arcadius in the Maryut. Also at Saqqara are glass vessels engraved and painted on the inside. A similar technique produces masterpieces of refined designs, such as the antelope in a floral environment, the *orans* (Louvre), or the lively head (Fig. 5.61; Museo Egizio) in black line with yellow hair on a turquoise halo against a transparent ground. Though the technique of gilded engravings enclosed between two glass sheets, famous from the Roman remains of early Christian times, has been ascribed to Alexandria, there is no evidence of any such find from Egypt. Inlays of glass pastes originate far back in dynastic Egypt.

82. A. C. Johnson and L. C. West, *Byzantine Egypt*, pp. 107, 111–113.
83. E. Breccia, *Oxyrhynchos* II, *Municipalité d'Alexandrie, Le Musée Gréco-Romain, 1931–1932* (Bergamo: 1933), pls. XLVIII–XLIX, pp. 37–38.
84. J. E. Quibell, *Excavations at Saqqara* (1906–1907), pl. LXIII, 2, p. 68; (1908–9, 1909–10), pl. LII, pp. 42–44. H. E. Winlock and O. Crum, *Monastery of Epiphanius*, Vol. 1, pp. 94–95. C. C. Edgar, *Graeco-Egyptian Glass, Catalogue général des antiquités égyptiennes du Musée du Caire* (Cairo: 1905).
85. D. B. Harden, *Roman Glass from Karanis* (Ann Arbor: 1936). "The Glass," in R. Mond and O. Myers, *Temples of Armant*, pp. 117–123.
86. A. C. Johnson and L. C. West, *Byzantine Egypt*, p. 112.
87. J. E. Quibell, *Excavations at Saqqara* (1909–9, 1909–10), pp. 42, 141, pl. LII, 5.
88. Ibid., p. 140, pl. LII, 2.

5.58
Group of intact glassware from Oxyrhynchos. (E. Breccia, *Le Musée Gréco-Romain, 1931–1932*, Vol. 2, pl. XLVIII, 125.)

5.59
Glassware from St. Simeon's monastery at Saqqara: 1. decorated tumbler. (J. E. Quibell, *Excavations at Saqqara* [1908–9, 1909–10], pl. LII, 5); 2. flagon from Oxyrhynchos. (E. Breccia, *Le Musée Gréco-Romain, 1931–1932*, 128); 3. perfume flagon. (J. E. Quibell, op. cit., pl. LII, 1); 4. tumbler (ibid. [1906–1907], pl LXIII, 2); 5. modeled crocodile inside a wine glass (ibid. [1908–9, 1909–10], pl. LII, 2); 6. bottle (ibid. [1906–1907], pl. LXIII, 2); 7. salt cellar (ibid. [1908–9, 1909–10], pl. LVI, 4.)

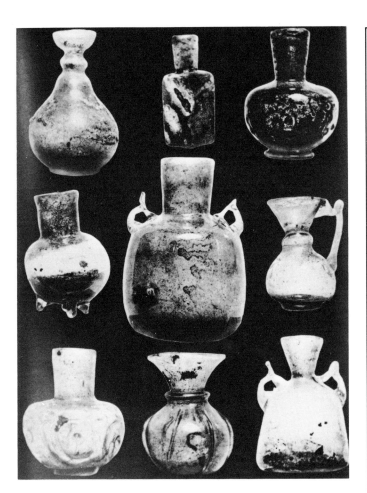

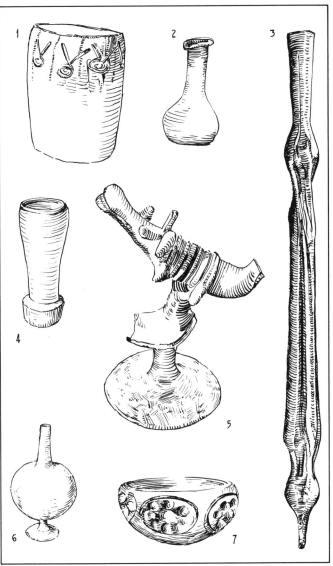

5.60
Three glass vessels. (Staatliche Museen.)

5.61
Transparent glass painted with a guilloche and a
haloed head in black line with yellow hair and
turquoise halo. (Museo Egizio; 1mm. thick.)

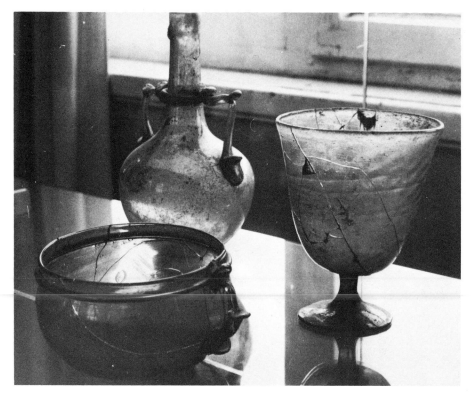

The crafts show more clearly than do any of the major Coptic arts a characteristic duality in style: to what is essentially a folk style of Egyptian filiation is superimposed a rather pretentious interpretation of late-antique. This dual aspect is well exemplified in the theriomorphic metal vessels belonging undoubtedly to a tradition reaching far back into the prehistory of Egypt. It is also seen in those flagons ornamented with figures within arcades (see Fig. 5.2), in a brazier with an openwork foliate wall derived from the classical rinceau (see Fig. 5.5), in a domed incense burner imitating an architectural composition (see Fig. 5.18), or in those ceremonial keys of Deir Abiad shaped as columns with figure capitals (see Fig. 5.37).

In work of bone or wood the same duality appears in the native style of dolls (see Fig. 5.42), spindle heads (see Fig. 5.44), combs (see Fig. 5.45), clappers ornamented with geometric patterns and animal heads (Fig. 5.53), and in caskets, some with carved panels reminiscent of dynastic types (see Fig. 5.45), and a smaller group that borrows from late-antique architecture allied to Alexandrian carved ivory plaques (Fig. 5.40).

Curiously enough, pottery, the folk craft *par excellence*, proves to be the most evolutionary of all, borrowing widely from Greco-Roman shapes (ribbing, lamps) and techniques (pseudo terra-sigillata), though the modeling of pots in unbaked clay (bins) and the use of incised and stamped potter's marks can be traced back to dynastic methods.

The invention of the Greco-Roman bow drill was a significant technical factor that revolutionized the style of woodworking, enabling an indiscriminate use of local hardwoods easily turned into balusters, legs, and stands adapted to latticework. The popularity of this mechanical style achieved through the contrast of spherical and superimposed bulbous shapes extended far beyond its original medium, for it was readily imitated in bronze for lamp stands, incense burners (see Fig. 5.38), vessels (see Fig. 5.3), and in glassware.

Music and
Musical Instruments

Coptic music, used essentially in Church liturgy, is of special interest to the study of the history of music because it shows many survivals of ancient Egypt.[1] It also provides musicology with data about the pre- and early Gregorian styles. It is presumed that among the constituents of Coptic music were elements from ancient Egyptian, Greco-Roman, and Near Eastern cult rituals, to which other derivatives from Byzantine, Jewish, and Syrian liturgies were later integrated.

Several periods in the development of music have been differentiated, the second marked by a manuscript of the third century found at Oxyrhynchos giving the earliest notation of a chanted hymn in eastern melody. This notation makes use of Greek letters according to the Greek system.[2] A unique series of six parchment sheets dated between the fifth and seventh centuries is inscribed with rows of circles of varying diameter and color and a few notes in Greek, Coptic, and Persian.[3] They are tentatively interpreted as a graphic representation of a synthesis of a cosmological and musical system, such as the *Harmonia Mundi* of Ptolemy.

1. H. Hickmann, "Koptische Musik," in *Koptische Kunst* (Essen: 1963), pp. 116–121. R. Menard, "Koptische Musik," in *Die Musik in Geschichte und Gegenwart*, Vol. 7 (Kassel: 1958), pp. 1618 ff.
2. A. S. Hunt and H. S. Jones, in B. P. Grenfell and A. S. Hunt, eds., *The Oxyrhynchus Papyri*, Vol. 15 (London: 1922).
3. H. Hickmann, *Musicologie pharaonique* (Kehl: 1956), pp. 72–77.

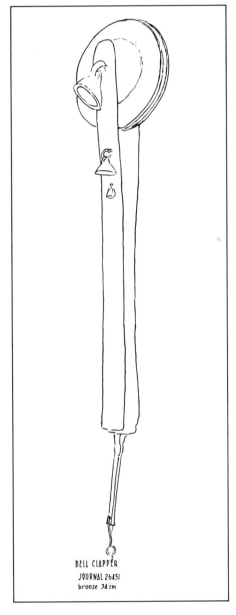

BELL CLAPPER
JOURNAL 26451
bronze 34 cm

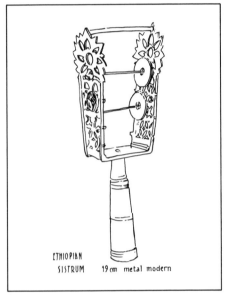

ETHIOPIAN
SISTRUM 19 cm metal modern

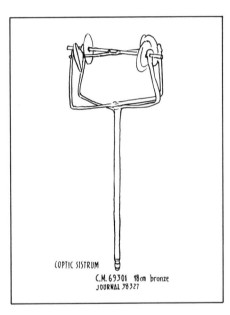

COPTIC SISTRUM
C.M. 69301 18cm bronze
JOURNAL 58327

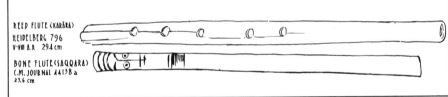

REED FLUTE (KARĀRA)
HEIDELBERG 796
V-VIII A.D. 29.4 cm

BONE FLUTE (SAQQARA)
C.M. JOURNAL 44138 a
23.6 cm

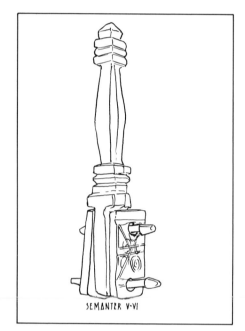

SEMANTER V-VI

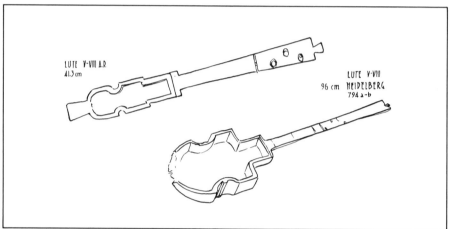

LUTE V-VIII A.D.
41.3 cm

LUTE V-VIII
96 cm HEIDELBERG
794 a-b

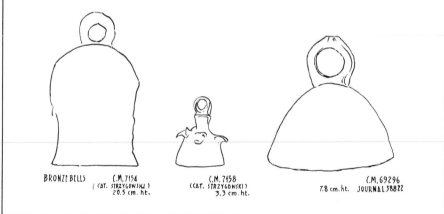

BRONZE BELLS C.M. 7154
(CAT. STRZYGOWSKI)
20.5 cm. ht.

C.M. 7158
(CAT. STRZYGOWSKI)
3.3 cm. ht.

C.M. 69296
7.8 cm. ht. JOURNAL 58822

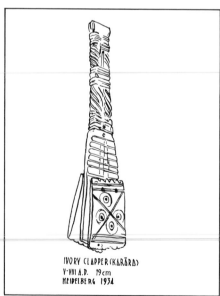

IVORY CLAPPER (KARĀRA)
V-VIII A.D. 19 cm
HEIDELBERG 1934

Several Coptic papyri (A.D. X–XI)[4] are inscribed with notations showing that attempts in this field were made parallel to the Greek and Byzantine systems.

Information about the style of chant is provided by Abbot Pambo, who mentions chironomy[5] and Zozimos of Panopolis (Akhmim). Alternating music and chant as practised in Antioch and Constantinople, a novelty introduced by Ambrosius of Milan, and the use of percussion instruments certainly derive from Coptic music.

The last flourishing period of music, c. A.D. 1000, saw the integration of folk chants, lay, and cult musics into what can be called Coptic music. It was transferred orally and subsists now only as sacred music of the orthodox rite, while its lay manifestations were absorbed and superseded by the so-called Arabic music.

Chants by the priest follow certain melodies but can vary with flexible improvising. The deacon (shammās from Egyptian shemes, "serve") recites in a syllabic modulation. Most important is the church chanter (Arabic, 'arīf), usually blind, trained to chant as a soloist to the accompaniment of a cappella music. The 'arīf holds one hand over one ear and cheek to help him with his modulations,[6] a device inherited from the blind musicians of ancient Egypt as represented in the wall scenes since the Old Kingdom.

Tones are differentiated into adam, bartos, joyful kiyahki of Advent, sorrowful lahn hazayni of the Passion, comparable to the maqamat in the Near East, the nomos of Greece, and the raga- or patet- systems of India and Java. Special forms of church music are the psali, turuhat, and psalmos, the aspasmos sung by the assembly and the vohem by a soloist. The hos (Egyptian hesi, "to sing") is an ode.

The musical system, often strongly improvised, is based on a 7 1/2 rhythm formula similar to that of Egyptian folk singing—a fact which points to a common heritage from ancient Egyptian music. This heritage is further defined from a study of the instruments, (Fig. 6.1), mostly of the percussion type.[7] Small Coptic bells derive from the temple bells of Horus, Hathor, Anubis, Sebek, or Serapis, where figures often appear on the outside of the instrument. The naqus (Arabic name) is a bell held with one hand and struck with a hammer, and it also derives from a late Egyptian model. The origin of the semanter, castanets, clappers, round drums (Coptic hwc) played in Upper Egyptian villages, and the sistrum can be easily traced back to ancient Egypt. Triangles and cymbals are later additions. Most of the names of the instruments were adopted from the Greek. The clapper of wood or ivory[8] consists of two small plaques attached with string or sliding on pegs and flapping against the flat end of a decorated handle. It could have been used as a semanter for warning signals in monasteries. The waisted long neck lute carved in one piece of wood, with a sound box faced with leather and three strings plucked by means of a plectrum forms a link between the early Mesopotamian lute of Uruk (2000 B.C.) and the medieval Mediterranean type through the Egyptian lute of the New Kingdom (fourteenth century B.C.).[9]

The secession of Coptic Egypt from Constantinople (451) and the conquest by the Arabs mark the adaptation of liturgy to the Egyptian spirit and a renewal of folk music. New instruments appear, such as single pipes of bone and the lute with waisted sound box. Single or double piped wooden blowing instruments akin to clarinets belong to the ancient Egyptian heritage.

4. W. E. Crum, Catalogue of the Coptic Manuscripts in the Collection of the John Rylands Library (Manchester: 1909). H. Hickmann, Musicologie pharaonique, pp. 84–89, Figs. 18–23.
5. H. Hickmann, "Sur les survivances de la chironomie égyptienne dans le chant liturgique copte, "in Miscellanea musicologica, Vol. 3 (Cairo: 1949).
6. A. Hermann, "Mit der Hand singen. Ein Beitrag zur Erklärung der Trierer Elfenbeintafel," in Jahrbuch für Antike und Christentum, Vol. 1 (Münster: Westphalia: 1958), pp. 105–108, pl. VII.
7. H. Hickmann, Catalogue général des antiquités égyptiennes du Musée du Caire. Instruments de Musique (Cairo: 1949).
8. H. Hickmann, "La cliquette. Un instrument de percussion égyptien de l'époque copte," BSAC, Vol. 13 (Cairo: 1951), pp. 1–12.
9. H. Hickmann, "Un instrument à cordes inconnu de L'Egypte copte," BSAC, Vol. 12 (Cairo: 1949), pp. 63– 80.

It has been recently proved that Coptic art, or rather the art of the Copts, persisted though restricted in scope under Islamic rule until the end of the Fatimid Dynasty in the twelfth century.[1] The textile industry provides clear data about the existence of Court weaving factories (*tiraz*) of typical Coptic style in the Fayum between the ninth and the tenth centuries. The *tiraz* itself was probably the successor of the imperial factory or *gyneceum* at Alexandria.[2] Some textiles have deformed Arabic inscriptions or slight Coptic ones framing ornamental friezes, occasionally with figures or abstract motifs.[3] Two dates, 913 and 985, on fabrics from the Fayum imply that the Tulunids (868– 905) had founded there a weaving industry to meet the needs of the Coptic segment of the population. Similar *tiraz* are known in Bahnasa, Akhmim, and Assiut. The Copts worked also for their new masters, bringing their techniques, themes, and style to all fields of architecture, sculpture, painting, and crafts. In many instances the products fashioned for the Moslems are very similar to those intended for the Copts themselves, though the latter always show their own distinguishing characteristics, such as more freedom of

1. P. du Bourguet, "L'Art Copte pendant les cinq premiers siècles de l'Hégire," in K. Wessel, ed., *Christentum am Nil* (Recklinghausen: 1964), pp. 221–232. (Hereafter cited as "L'Art Copte.") P. du Bourguet, *L'Art Copte. Petit Palais, Paris: 1964*, pp. 42–48. (Hereafter cited as *Art Copte.*)
2. E. Kühnel, "La Tradition Copte dans les tissus musulmans," *BSAC*, Vol. 4 (Cairo: 1938), pp. 79–89.
3. E. Kühnel, "Koptische Kunst im islamische Ägypten," in *Koptische Kunst* (Essen: 1963), pp. 153–155.

expression and lesser geometrization and monotony.[4]

Of the basic elements of early mosques, the basilican plan and the shape of the concave *mihrāb* are probably adapted from the Coptic basilica and its apse. According to Duqmaq and Maqrizi the earliest mihrāb appears in the part of the Mosque of Madina rebuilt in 708 by Coptic workmen under 'Umar ibn 'Abd el 'Aziz. The second example in Islam was that in the form of a niche in the mosque of 'Amr which was rebuilt from 710 to 712. If we believe El Suyuti (A.D. XV), "At the beginning of the second century (after A.D. 715) it was forbidden according to the Traditions, to make use of it, as it was a feature of the churches."[5] The *minbar* probably derives from the Coptic pulpit as exemplified in the one in stone abutting on the main church at Jeremias' monastery at Saqqara or as the monolithic stairway at Deir Abiad. The Egyptian prototype of the Coptic pulpit has been recognized as the dais, accessible from a short flight of steps, where Pharaoh sat in state during one phase of his jubilee festival *Heb-sed*.[6]

The Copts were proficient in the building crafts and were hired especially at the beginning of Islamic rule to help construct mosques, palaces, and aqueducts in Egypt and abroad. Eighty Greek and Coptic artisans worked on the Madina Mosque (according to Baladhuri), and the Copts erected its santuary (according to Samhudi). In the Aphrodito papyri (dated Nov. 709) there are records of the wages and maintenance of workmen from Egypt who were engaged on the construction of the Great Mosque at Damascus (706–715).[7] This dispatch of Egyptian workmen abroad followed an earlier tradition, for Modestus (629) sent thousands to Jerusalem to rebuild the churches destroyed by the Persians in 614.[8]

Islamic construction owes much to the Coptic model, having borrowed besides the common use of brick, the method of roofing with vaults and domes, and arcades on piers or columns connected at the top of their capitals by wooden tie beams often carved as the Coptic ones with patterns or inscriptions. Islamic columns engaged at both edges of an aperture, as well as their capitals derived from the Corinthian, are borrowed from Coptic architecture. The combination of the trefoil apse with the basilican hall as carried out in the Umayyad palace of Mshatta (743–744)[9] has been identified by Creswell as an influence from Coptic architecture, three of the five earliest examples of this feature occurring, in the Coptic basilicas at Deir Abiad, Deir Ahmar, and Dendera, the two others being that at Nola (Basilica of Paulinus, 401–403) and at Bethlehem (Church of the Nativity altered by Justinian before 565). Creswell has also pointed out that the elaborate stone sculpture at Mshatta shows peculiarities in the shape of three little grapes at the junction of the leaves with the stalks and the rosette at the second and last intersections of undulating vine stems found only in Coptic work such as the door of Sitt Barbara. He deduces that Coptic sculptors were responsible for the vine foliage and birds in one group of triangular elements in the decoration at Mshatta.[10] Similar Coptic characteristics are found on bone carvings from the Umayyad period (A.D. VII–VIII).[11] It is significant that there is an entire and reciprocal adaptation of Coptic and Islamic motifs and style of sculpture, for some of the panels of Sitt Barbara borrowing from lay genre motifs represent personages sitting in frontal positions served by attendants in postures and garbs similar to those in contemporary Islamic works, animals inhabiting rinceaus, animal fights, scenes of hunt and war, horsemen with falcons, and musicians. This aspect of interconnection does not interfere with the

4. P. du Bourguet, *Art Copte*, p. 44.
5. K. A. C. Creswell, *A Short Account of Early Muslim Architecture* (Harmondsworth: 1958), p. 44.
6. Alexandre Badawy, *L'Art Copte. I. Les Influences égyptiennes* (Cairo: 1949), p. 22, Fig. 12.

7. K. A. C.Creswell, *A Short Account of Early Muslim Architecture*, pp. 43–45; referring to H. I. Bell, *Greek Papyri in the British Museum, IV, The Aphrodito Papyri*, pp. 75–76.
8. K. A. C. Creswell, ibid., p. 43, n. 2; referring to Leontius of Neapolis: H. K. G. Gelzer, *Leontios' von Neapolis Leben des heiligen Iohannes des Barmherzigen, erzbischofs von Alexandrien* (Freiburg and Leipzig: 1893), p. 37, notes, pp. 137–138.
9. Ibid., pp. 144–147.

10. Ibid., pp. 148–150. Also: *Early Muslim Architecture*, Vol. 1 (Oxford: 1932), p. 388, Fig. 483. K. A. C. Creswell, "Coptic Influences on Early Muslim Architecture," *BSAC*, Vol. 5 (Cairo: 1939), pp. 29–42, pls. I–VII.
11. E. Kühnel, "Koptische Kunst," p. 154.

filiation of a vigorous Coptic style.[12] Both Coptic and Islamic products show a balance between masses of light and shade still found in Tulunid time, and they explain the similarity between the carved stuccoes at Samarra and those of El 'Adra church at Deir Suryani.[13] The parallel evolution of the ornamental trend toward geometrization in both productions is exemplified in the motifs of the diamond mesh, the opposed half-flowers, and the dancing girls.

The influence of Coptic tradition is clear in early Islamic ceramics,[14] lamps, bread stamps, and sieves of *qulla*. In the Fatimid luster faience of the tenth to twelfth centuries there appear Christian figures of slight Byzantine flavor, like the one of the Coptic priest censing (see Fig. 4.119).

In glassware it is difficult to differentiate between Coptic and Islamic products before the tenth century, while Coptic bronze work maintains its characteristics until the tenth century when Fatimid metal work appears with many of the Coptic influences, as in the theriomorphic censers (see Fig. 5.21).

The illumination of manuscripts shows at an early stage (A.D. VII) a strong stylization of the paragraph signs into rounded leaves, later adapted to theriomorphic junctures (see Fig. 4.56) with Persian traits that foreshadow the imaginative Arabic calligraphy. Heads of chapters in Islamic manuscripts adopt foliate or geometric interlace in intricate arabesques. Scenes borrowing the Byzantine frontal figure surrounded by Islamic motifs appear, while the favorite motif is that of the rider saint honored by Copts and Muslims alike. The Coptic style of bookbinding with impressed leather representing patterns derived from meanders with beads and filling roundels or interlace was maintained until Cairo developed its own elegant style under the Mamluks.

The most striking among Coptic influences on Islamic crafts in Egypt are those technical innovations of the Roman period which were passed on through the centuries and helped to create modern life. Though they belong to the most modest among crafts, such as carpentry and pottery, they still preserve some aspects of the Coptic aesthetic ability down to our own days. One of the most popular is turning local wood of poor quality into balusters and latticework for *mashrabiya* screens, partitions, and furniture. These Coptic influences are most common in such utilitarian crafts as pottery—water jugs, *qulla, ballās*; water-wheel, *qādūs*—or carpentry, the wooden lock, whorl-spindle heads, and combs.

Coptic Egypt and Palestine were the most visited among the Christian countries of the southeastern Mediterranean during the first centuries of Christianity. Not only did pilgrims, priests, and monks voyage to judge *de visu* the astonishing feats accomplished by ascetics and coenobites, but many came to share in their ideal of mysticism. Coptic bishops accompanied by retainers and monks sailed abroad to attend congresses and more often than they wished were sent into exile, even, like Athanasius, as far as Trier. In this instance it is significant that stylistic differences have been noted in the remains of the ceiling paintings in the church at Trier. Those paintings ascribed to 320–326 are still reminiscent of Hellenistic traditions, with rich variegated palette and illusionistic three-dimensional rendering, while those dated after 340 in the Baptistery or in the east part of the northern church (340–350) feature geometric articulation on white ground and refined subtle detail.[15]

Mention has already been made of the Coptic influences on early Islamic architecture abroad which resulted from the numerous groups of Coptic craftsmen commissioned to work on mosques and palaces. Other influences resulted mainly from the export of smaller products of crafts as gifts or through trade. The Coptic patriarch of Alexandria occasionally bestowed, as did Theophilus (384–412) and Cyril (412–444), rich gifts on the Byzantine emperor and

12. P. du Bourguet, "L'Art Copte," p. 231, Figs. 98–99. E. Kühnel, "Koptische Kunst," p. 155.
13. P. du Bourguet, *Art Copte*, p. 46.
14. E. Kühnel, "Koptische Kunst," p. 155.

15. T. K. Kempf, "Berührungen und Fernwirkungen ägyptischen Christentums im Rheinland," in *Koptische Kunst* (Essen: 1963), p. 165.

his Court. As for exports, there was a consistent trade of textiles and of other craftsmanship products such as bronzes. In the fifth century Alexandria was still the main port of trade, and its exports were much more important to Egypt and the Mediterranean than its Imports. Jerome mentions, "Once more with the return of spring I enrich you with the wares of the east and send the treasures of Alexandria to Rome."[16] Among the exports,[17] some manufactured of raw materials brought in, were fine silver plate and glassware sent to the Far East until the fifth century; pottery, arrows, and hydroscope sent to Cyrene; garments of camel's hair worn, according to Severus, by monks in Gaul, and, of course, prepared papyrus, which was exported to the whole world. Textiles and ready-made tunics ornamented with clavi and bands were provided in the late-antique period to the Roman armies garrisoned in the German provinces.[18] The motifs on these fabrics were probably the source of numerous influences, undoubtedly of Coptic origin, which can be detected in European art in various media.

Between the fifth and sixth centuries imports from Egypt and East Asia reached the Campania mainly through Naples.[19] Not only were products imported but also people emigrated to Italy, especially to Rome, from Egypt, Syria, Greece, and Armenia between the mid-sixth century and the mid-eighth century.[20] Many Italian elements of geometric ornament, palm, palmette, and spiny acanthus are reminiscent of Syria and Coptic Egypt. On the Adriatic Ravenna imitated the East as did Byzantium; suffice it to mention the Adriatic tendency to mask the protruding apse of the church inside a polygonal or rectangular massif, or even to include it within the rectangular perimeter (St. Mary at Grado, 571–586).

Coptic influence on Christianized Western Europe is denied by Du Bourguet,[21] except for the theme of the Majestas, Christ in a *mandorla* upheld by the four evangelists above the Virgin and the Apostles, on a sarcophagus from La Ferté-sous-Jarre, Charlieu in Burgundy, Moncherrand in the Jura, and in the paintings at Lavandieu (Auvergne). Du Bourguet surmises that this influence found its way from Umayyad Spain where Coptic artists were commissioned.

The recent discovery of the Glazier Codex decorated with a *crux ansata* filled with an elaborate guilloche dated fourth century sets forth the undeniable proof that both elements were in use in proto-Coptic art. In this instance the argument about significant influence of Coptic ornament, especially the guilloche, on Merovingian art (481–751)

as proposed by Holmqvist[22] and Åberg[23] finds additional evidence and renewed impetus. Several motifs showing affinities or parallelisms to Coptic art can be recognized in the artifacts in metal, ivory, and textiles produced by intinerant craftsmen. Crosses overlaid with gold, disk fibulae, and dagger hilts of the Lombards and their neighbors as, well as the Anglo-Saxons and the Scandinavians, were often ornamented with interlace and guilloche.

As many as thirty-three parallel groups of Coptic and Germanic guilloche on various media were differentiated by Holmquist. Though guilloche was used in Syria and Palestine it never reached the intricacy developed by Coptic art, in painting (Saqqara, Bawit), weaving, and stone carving. Of the other motifs thought to have been suggested by Coptic models that of the equestrian saint appearing on so many Merovingian artifacts is the second most plausible. In religious sculpture Coptic parallels are suggested for the *transenne* slabs in relief of St. Peter at Metz (613). One slab, representing a saint within an architectural frame of torsaded columns carrying a steep pediment, is similar to some Coptic stelae. Other slabs are ornamented with crosses and arches of Coptic type. A pilaster is carved with interlace. Coptic affinities appear also in the guilloche enclosing whorls in

16. St. Jerome, Epist. 91. 1 (A.D. 402), quoted by A. C. Johnson and L. C. West, *Byzantine Egypt: Economic Studies* (Princeton: 1949), p. 143. (Hereafter cited as *Byzantine Egypt.*)
17. A. C. Johnson and L. C. West, *Byzantine Egypt*, pp. 110–131.
18. K. Wessel, *Koptische Kunst* (Recklinghausen: 1963), p. 249.
19. F. Benoit, *L'Architecture. L'Occident Médiéval, Du Romain au Roman* (Paris: 1933), p. 92.

20. Ibid., p. 13.
21. Du Bourguet, *Die Kopten*, p. 188.

22. W. Holmqvist, *Kunstprobleme der Merowingerzeit* (Stockholm: 1939). "Einflüsse der koptischen Kunst in Westeuropa," in *Koptische Kunst* (Essen: 1963), pp. 157–162.
23. N. Åberg, *The Occident and the Orient in the Art of the Seventh Century*. Vol. 3, *The Merovingian Empire* (Stockholm: 1947). (Hereafter cited as *The Occident.*)

transenne slabs and capitals of S. Vitale at Ravenna (526–547), on the sarcophagi of southern France (Aquitaine), in the crypt of St. Laurent in Grenoble (A.D. VI–VII), in marble ornaments from the cathedral of Chur (Switzerland), and on a slab of St. Jon in Mustair. Marseilles might have been the port of entry along the trade route from the southeastern Mediterranean. Numerous Coptic bronze vases were found in Lombard graves.

Other affinities are suggested between Coptic art and Irish[24] metalwork and especially Irish manuscript illumination, with its ornamental design and abstracted animal motifs. Irish monks lived in Carthage in the seventh century. Though it has recently been denied that Copto-Irish relations ever existed,[25] the more recent discovery of the Glazier Codex again provides the missing link for the early Coptic use of guilloche, especially as filling for crosses. The typically Irish ornaments of dot contouring, dotted background, and two-ribbon plaiting are paralleled in Coptic art. They appear with the ring chain motif in the illumination of the Book of Durrow (mid–A.D. VII) and others produced in Ireland (A.D. VI–VII) and in Italy (A.D. VII), mostly in Bobbio. Other affinities are suggested for Northumbrian stelae carved with a cross with

24. W. Holmqvist, "Einflüsse der Koptischen Kunst in Westeuropa," p. 160. N. Åberg, *The Occident*, Vol. 1, *The British Isles* (Stockholm; 1943). *The Relics of Saint Cuthbert*. Studies by various authors collected and edited with an historical introduction by C. F. Battiscombe (Oxford: 1956).
25. J. Raftery, "Irische Beziehungen zum Koptischen Ägypten," in *Christentum am Nil*, ed. K. Wessel (Recklinghausen: 1964), pp. 260–265.

meander pattern (A.D. VII). The date suggested for the introduction of Coptic elements in Irish art is the mid-seventh century.

Later influences on the art of Western Europe can be classified according to their geographical origin, such as pagan and Christian Rome, the Barbarians, Ravenna, and the East, comprising Coptic Egypt, Syria, Byzantium, pagan Mesopotamia, Persia, and even India, China, and the Islamic world. Until the seventh century, visits by clerics and pilgrimages accounted for personal contacts. The importing of books, pictures, reliquaries, and instruments from Byzantium, Sassanian Persia, and, since the eighth century, from the Islamic world provided models for minor arts. The conquest of Syria (638) and Egypt (640) and the iconoclastic controversy in Byzantium (725–843) sent some of the ablest artists and monks out of those lands seeking a new creative life in western Europe.

Romanesque art adopted many elements from the Eastern Mediterranean at a time when the characteristic styles of Islamic art had already evolved. Here, again, we can speak of affinities only rather than of definite influences. Most of these affinities are evidenced in the Romanesque portal. The shallow porch formed by two columns on lions such as those at Modena (first half of the twelfth century), Burgo San Donnino (second half of the twelfth century), Parma, Ferrara, Bari, St. Gilles du Gard, Schwarzrheindorf, Ják (Hungary, mid-thirteenth century) is reminiscent of the two engaged columns on the fore parts of lions flanking the entrance

to the south church at Bawit (see Fig. 2.57). The Coptic entrance is not identical to the Romanesque portal; neither are the Romanesque variants for this design which appears in the upper zone of a façade (Troja. A.D. XII) or with two seated lions (cloister of St. John of Lateran, 1220–1230).

Twin engaged columns form a common type of Romanesque support in Normandy (Santa Cristina de Lena), England, the southwest of France, and Spain. In Coptic architecture twin pilasters were quite common (Saqqara, see Fig. 3.166). The Romanesque archivolt is more often than not jagged into a multi-arched stepped design. This admittedly does not occur in the typical Coptic archivolt, though it seems to be evidenced at least once in a fragmentary example from Bawit (C. M., 35823). The string of medallions enclosing scenes decorating the archivolt (St. Madeleine in Vezelay, 1120–1132) or formed by a stem spiraling along the face of a pilaster (St. Michel at Paire) is paralleled by typical Coptic sculpture. The Romanesque lunette is carved with a scene framed by an ornamental band, while the Coptic lunette can be similarly carved or only painted. It has been suggested by U. Monneret de Villard that the prototype of the sculptured lunette might be sought in the acroteria of Indo-Bactrian stupas (Gandhara) or as crowning elements of doorways (Grotto 10 at Ellura, Ananta at Khandagiri, 150–100 B.C.)[26] A unique Coptic archivolt dated to the eighth century from Coptos (see Fig. 3.108) is

26. U. Monneret de Villard, "Per la Storia del Portale Romanico, "in *Mediaeval Studies in Memory of A. Kingsley Porter* (Cambridge, Mass.: 1939), pp. 113–124.

carved with a flat vine motif and shows in high relief a musician angel at either lower end and a fruit at the crown. Monneret de Villard mentions as parallel the two musician angels and Lamb appearing in similar locations and also in high relief on the outermost archivolt of the portal at Charlieu. The same scholar suggested that a parallel to the Romanesque *trumeau* could be found in the twin doorways arranged in the remodeled temples at Sebu'a and Luxor.

Similarities between the Romanesque figure capitals and the Coptic ones might also be added to the listing of affinities between both architectures. Analogies both as to motifs and style are recognizable between the Mozarabic *Biblia Hispalense* (A.D. X–XI),[72] and Coptic, or even proto-Coptic, illumination. The prophet Mikha standing at the beginning of his book, according to a style invented in Egypt, shows many iconographic similarities to that of the prophet Nahum in the earliest proto-Coptic manuscript, the Alexandrian World Chronicle (A.D. V). Stylistic analogies are also recognized between the features and dress-folds of the three standing prophets of the *Biblia Hispalense* and earlier Coptic illumination. Since these traits were no longer extant in Coptic illumination of the tenth century, it is assumed that the earlier Coptic tradition (A.D. VI-VII) reached tenth-century Spain through western Gothic art.

Christianity introduced into Nubia by Julian, who was sent by the Empress Theodora in 542, after the temple of Philae was closed, was established within forty years. During the first two centuries (A.D. VI-VII) Christian Nubia preserved cultural links with Coptic Egypt. Vaults were readopted for houses and early churches in stone with open *haikal* of Byzantine influence. Monolithic columns, stone capitals, and lintels were still carved with classical vine wreaths and hawks. Pottery and wine were imported from Egyptian monasteries. Egyptian influence declined, however, and with the persecution of the Copts by the Abbassids Nubian cultural autonomy grew, apparent in the type of small church decorated with frescoes instead of sculpture. The newly discovered well-preserved frescoes at Faras[28] show closer affiliations to Greek art, with classical proportions and forms, than to the abstract Coptic murals. In general Nubian art developed under the impulse of Byzantium, though it occasionally betrayed some Coptic influences such as spreading a scene of the Three Young Men in the Fire on a window sill (narthex of church below the Faras citadel, A.D. X) and the crossing glances of personages as in late Coptic miniatures.

Of the several sources of influences—Syrian, Anatolian, Armenian Byzantine—that can be traced in Ethiopian churches, none goes back to Coptic Egypt, despite the religious affiliation of the Ethiopians.[29] In the illumination of Ethiopian manuscripts, however, iconographical affinities with that of other Monophysite lands—Armenia, Syria, and Egypt—can be found, introduced through the Ethiopian monks of the Holy Sepulcher in Jerusalem.[30]

The few similarities between churches in North Africa and Coptic Egypt such as the basilican plan with apse and counter-apse (Orleansville, 324, 475; Matifou, A.D. IV-VI) and the trefoil sanctuary (Tebessa, Khirbet Abu Ad-dufen, Damous el Karita) derive from the Greco-Roman heritage common to both architectures.

Coptic art is one of the few folk arts that developed and subsisted despite adverse circumstances throughtout ten centuries (A.D. III-XIII). Was this endurance perhaps an aspect of the traditionalist spirit inherent to the race, or can it be accounted for because it was created by the *bourgeoisie* and the monks ? At the juncture when it had achieved enough symbolism and abstraction to flourish into one of the major historical styles of Christian art, it became the art of a minority subject to persecution. It found an outlet in the innate genius of the Copt for ornament, producing despite adverse circumstances some most original and attractive achievements in various media. Gradually Coptic art merged with the new trends, infusing into Islamic art some of its most abiding qualities before it came to an end in the thirteenth century.

27. O. K. Werkmeister, "Die Bilder der drei Propheten in der *Biblia Hispalense*," in *Madriden Mitteilungen*, Vol. 4 (Heidelberg: 1963), pp. 141–188.

28. K. Michalowski, "Altchristliche Kunst in Nubien," in *Koptische Kunst* (Essen: 1963), pp. 173–177.

29. A. Mordini "Die äthiopischen Kirchen," in *Koptische Kunst* (Essen: 1963), pp. 193–197.
30. J. Leroy, "Äthiopische Malerei," in *Koptische Kunst* (Essen: 1963), pp. 188–192.

Short Bibliography of Coptic Egypt

In addition to monographs, outstanding articles and relevant books on Greco-Roman Egypt are also included.

Bibliography

Kammerer, W.
A Coptic Bibliography, Ann Arbor: 1950.

Simon, J.
Annually in *Orientalia*. Rome: 1940–1968

General Studies

Coptic Studies in Honor of W. E. Crum. Boston: 1950.

Cooney, J. D.
Coptic Egypt. Papers read at a Symposium, 1941; reprint Brooklyn: 1944.

Cramer, M.
Das christlich-koptische Ägypten einst und heute. Wiesbaden: 1959.

Leclercq, H.
"Egypte." In F. Cabrol and H. Leclercq, *Dictionnaire d'Archéologie Chrétienne et de Liturgie*, fasc. 43. Paris: 1921, pp. 2408–2571.

Monneret de Villard, U.
"Christian Art in Egypt." In G. Steindorff, *Egypt*. Baedeker, Leipzig: 1929, pp. clxxxvii-cixl.

Worrell, W. H.
A Short Account of the Copts. Ann Arbor: 1945.

Geography

Amélineau, E.
La Géographie de l'Egypte à l'époque copte. Paris: 1893.

Ball, J.
Egypt in the Classical Geographers. Cairo: 1942.

Gauthier, H.
"Les nomes d'Egypte depuis Herodote jusqu'a la conquête arabe." *Mémoires de l'Institut d'Egypte*, Vol. 25 (Cairo: 1935).

Maspero, J. and Wiet, G.
"Matériaux pour servir à la géographie de l'Egypte." *MIFAO*, Vol. 36 (Cairo: 1919).

Articles:

Butzer, K.
"Remarks on the Geography of Settlement in the Nile Valley during Hellenistic Times," *Bulletin de la Société de Géographie d'Egypte*, Vol. 33 (Cairo: 1960), pp. 5–36.

Munier, H.
"La géographie de l'Egypte d'après les listes Coptes-arabes." *BSAC*, Vol. 5 (Cairo: 1939), pp. 201–243.

History

Bell, H. I.
Egypt from Alexander the Great to the Arab Conquest. Oxford: 1948.

'Abd al-Masiḥ, Y., Burmester, O. H. E., and Atiya, Azia S., editors and translators. *History of the Patriarchs of the Egyptian Church*, known as *The History of the Holy Church*, by Sawirus Ibn al-Muḳaffa'. Cairo: 1943–1959.

Abu Salih, al-Armani.
The Churches and Monasteries of Egypt and Some Neighbouring Countries, attributed to Abu Salih, the Armenian; ed. and tr. by B. T. A. Evetts with added notes by Alfred J. Butler. Oxford: 1895; reprint, 1969.

Butcher, E. L.
The Story of the Church of Egypt. 2
vols. London: 1897.

Butler, A. J.
The Arab Conquest of Egypt. Oxford:
1902.

Chaîne, M.
*La chronologie des temps chrétiens
de l'Egypte et de l'Ethiopie.* Paris: 1925.

Diehl, C.
L'Egypte chrétienne et byzantine."
In G. Hanotaux, *Histoire de la Nation
Egyptienne,* vol. 3. Paris: 1933.

Maspero, J.
*Histoire des Patriarches d'Alexandrie
(518–616).* Paris: 1923.

Munier, H.
*Recueil des listes épiscopales de
l'Eglise copte.* Cairo: 1943.

——— and Wiet, G.
"L'Egypte Byzantine et Musulmane."
In *Précis de l'Histoire d'Egypte par
divers historiens et archéologues,* vol.
2. Cairo: 1932.

Roncaglia, M.
Histoire de l'Egypte Copte, vol. 1.
Beyrouth: 1966. vol. 2. Beyrouth,
1969.

Wiet, G.
"L'Egypte arabe," In G. Hanotaux,
Histoire de la Nation Egyptienne.
Paris: 1937.

Industry and Trade

Johnson, A. C. and West, L. C.
Byzantine Egypt: Economic Studies.
Princeton: 1949; reprint, Amsterdam:
1967.

West, L. C. and Johnson, A. C.
*Currency in Roman and Byzantine
Egypt.* Princeton: 1944; reprint,
Amsterdam: 1967.

Language

Černy, J.
Coptic Etymological Dictionary.
Cambridge: 1969.

Chaîne, M.
*Eléments de grammaire dialectale
copte: bohairique, sahidique, achmi-
mique, fayoumique.* Paris: 1933.

———.
Les dialectes coptes assioutiques A².
Paris: 1934.

Crum, W. E.
A Coptic Dictionary. Oxford: 1939;
reprint, Oxford: 1962.

Devaud, E.
Etudes d'étymologie copte. Fribourg:
1922.

Kasser, R. and Vycichl, W.
*Dictionnaire auxiliaire, étymologique
et complet. de la langue copte.* Geneva;
1967–.

Mallon, A.
*Grammaire Copte. Bibliographie,
chrestomathie et vocabulaire.* 4th ed.,
revue par Michel Malinine. Beyrouth:
1956.

Plumley, J. M.
An Introductory Coptic Grammar.
London: 1948.

Spiegelberg, W. *Koptisches Handwör-
terbuch.* Heidelberg: 1921: reprint.

Steindorff, G.
*Kurzer Abriss der koptischen Gram-
matik.* Berlin: 1921; reprint, 1964.

———.
Lehrbuch der Koptischen Grammatik.
Chicago: 1951.

Stern, L.
Koptische Grammatik, Leipzig: 1880.
reprint: 1970.

Till, W.
Akhmîmisch-Koptische Grammatik.
Leipzig: 1928.

———.
*Koptische Grammatik (Saidischer
Dialekt).* Leipzig: 1955. 3rd ed. Leip-
zig: 1966.

———.
Koptische Dialektgrammatik. Munich:
1961.

Westendorf, W.
Koptisches Handwörterbuch. Heidel-
berg: 1966–1969.

Worrell, W. H.
Coptic Sounds. Ann Arbor: 1934.

Literature

Amélineau, E.
*Contes et Romans de l'Egypte Chréti-
enne.* 2 vols. Paris: 1888.

Budge, E. A. T. W.
*Coptic Apocrypha in the Dialect of
Upper Egypt.* London: 1913.

———.
*Coptic Homilies in the Dialect of Upper
Egypt.* London: 1910.

———.
*Coptic Martyrdoms, etc., in the Dialect
of Upper Egypt.* London: 1914.

Chaîne, M.
*La vie et les miracles de Saint Syméon
Stylite l'ancien*. Cairo: 1948.

Crum, W. E.
*Coptic Manuscripts Brought from the
Fayyum by W. M. Flinders Petrie*. London: 1893.

―――.
*Coptic Ostraca from the Collection of
the Egypt Exploration Fund, the Cairo
Museum and Others*. London: 1902.

―――.
*Catalogue of the Coptic Manuscripts
in the British Museum*. London: 1905.

―――.
*Catalogue of the Coptic Manuscripts
in the Collection of the John Rylands
Library*. Manchester: 1909.

―――.
*Short Texts from Coptic Ostraca and
Papyri*. London: 1921.

Doresse, J.
*Les Livres secrets des Gnostiques
d'Egypte*. Paris: 1958.

Drescher, J.
*Apa Mena. A Selection of Coptic Texts
Relating to St. Menas*. Edited with
translations and commentary. Cairo:
1946.

Horner, G. W.
ed. and trans., *Coptic Version of the
New Testament in the Northern Dialect,
otherwise called Memphitic and Bohairic*. 4 vols. London: 1898–1905; reprint, 1969. *Coptic Version of the New
Testament in the Southern Dialect,
otherwise called Sahidic and Thebaic*. 7
vols. Oxford: 1911–1924; reprint, 1969.

Junker, H.
"Koptische Poesie des 10. Jahrhunderts." In *Oriens Christianus 1906–
1908*: Vol. 6, pp. 319–411; Vol. 7, pp.
136–253; Vol. 8, pp. 1–109.

Lefort, L. T.
Oeuvres de S. Pachôme et de ses disciples. Louvain: 1956.

―――.
*Les vies coptes de saint Pachôme et de
ses premiers successeurs*. Louvain:
1943.

Mina, T.
Le martyre d'Apa Epima. Cairo: 1937.

―――.
*Inscriptions coptes et grecques de
Nubie*. Cairo: 1942.

Morenz, S.
ed. and trans. *Die Geschichte von
Joseph dem Zimmermann*. (Berlin:
1951.

Munier, H.
*La scala copte 44 de la Bibliothèque
Nationale de Paris*. Transcription et
vocabulaire. Cairo: 1930.

Pseudo-Shenoute.
On Christian Behavior. Edited and
translated by K. H. Kuhn. 2 vols.
Louvain: 1960.

Stefanski, E. and Lichtheim, M.
Coptic Ostraca from Medinet Habu.
Chicago: 1952.

Till, W.
Datierung und Prosographie der koptischen Urkunden aus Theben. Vienna:
1962.

―――.
Koptische Heiligen- und Martyrerlegenden. Texte, Übersetzungen, und
Indices. 2 vols. Rome: 1935–1936.

―――.
*Die koptischen Ostraka der Papyrussammlung der Österreichischen
Nationalbibliothek*. Vienna: 1960.

de Vis, H.
Homélies coptes de la Vaticane. 2 vols.
Hauniae: 1922–1929.

Worrell, W. H.
ed. *The Proverbs of Solomon in Sahidic
Coptic According to the Chicago
Manuscript*. Chicago: 1931.

Law

Crum, W. E. and Steindorff, G.
*Koptische Rechtsurkunden des achten
Jahrhunderts aus Djême (Theben)*.
Vol. 1. Leipzig; 1912. Reprint, Hildesheim: 1967.

Schiller, A. A.
Ten Coptic Legal Texts. Published
by the Metropolitan Museum of Art,
the Department of Egyptian Art. New
York: 1932.

Schmidt, C.,
ed. *Acta Pauli*. 2 vols. Leipzig: 1904–
1905; reprint, 1965.

Steinwenter, A.
Studien zu den koptischen Rechtsur-kunden aus Oberägypten. Leipzig: 1920.

―――.
"Das Recht der koptischen Urkunden." In *Handbuch der Altertumswissen-schaft,* 10. Abtlg., 4. Teil, 2. Band (Munich: 1955).

Till, W.
Erbrechtliche Untersuchungen auf Grund der koptischen Urkunden. Vienna: 1954.

―――.
Die koptische Rechtsurkunden der Papyrussammlung der Österreichischen Nationalbibliothek. Corpus Papyrorum Raineri IV. Vienna: 1958.

Magic

Chassinat, E.
Le Manuscrit magique Copte No. 42573 du Musée égyptien du Caire. Cairo: 1955.

Kropp, A. M.
Ausgewählte Koptische Zaubertexte. 3 vols. Brussels: 1930, 1931.

Lexa, F.
La Magie dans l'Egypte Antique. 2 vols. Paris: 1925. Vol. 1, pp. 139–153; Vol. 2, pp. 154–183, 207–230.

Stegemann, V.
Die koptischen Zaubertexte der Sammlung Papyrus Erzherzog Rainer in Wien. Heidelberg: 1934.

Medicine and Pharmacology

Chassinat, E.
"*Un papyrus médical Copte.*" MIFAO, Vol. 32. Cairo: 1921.

Till W.
Die Arzneikunde der Kopten. Berlin: 1951.

Religion

Abdallah, A.
ed., *L'ordinamento liturgico di Gabriele V, 88e. Patriarca Copto, 1409–1427.* Cairo: 1962.

Apa Athanasios,
Osterbriefe. Aus der Koptischen uber-setzt und erläutert von P. Merendino. Düsseldorf: 1965.

Bell, H. I. and Crum, W. E.
Jews and Christians in Egypt. London: 1924.

Böhlig, A. and Labib, P.
Koptisch-gnostische Apokalypsen aus Codex V von Nag Hammadi im Kopti-schen Museum zu Alt-Kairo. Halle: 1963; reprint, 1968.

Burmester, O. H. E.
The Rite of Consecration of the Pa-triarch of Alexandria. Cairo: 1960.

―――.
The Egyptian or Coptic Church. A Detailed Description of Her Liturgical Services and the Rites and Ceremonies Observed in the Administration of Her Sacraments. Cairo: 1967.

Crum, W. E.
Theological Texts from Coptic Papyri Anecdota Oxoniensia. Oxford: 1913.

Giamberardini, G.
La consecrazione eucaristica nella chiesa copta. Cairo: 1957.

―――.
Il natale nella chiesa Copta. Cairo: 1958.

Grant, R. M. and Freedman, D. N.
Geheime Worte Jesu. Das Thomas-Evangelium. Mit einem Beitrag von J. B. Bauer: *Das Thomas-Evangelium in der neuesten Forschung.* Frankfurt: 1960.

Guillaumont, A.
L'asceticon de l'abbé Isaïe. Fragments sahidiques éd. et trad. Cairo: 1956.

―――.
"Copte" (littérature spirituelle). In *Dictionnaire de la spiritualité,* Vol. 2 (Paris: 1953), pp. 2266–2278.

―――. Puech, H. Ch., Quispel, G., and Till, W.
L'Evangile selon Thomas. Texte Copte établi et traduit, et accompagné d'une traduction, d'un commentaire et des indexes. Leiden: 1962.

Hammerschmidt, E.
Die koptische Gregoriosanaphora. Syrische und griechische Einflüsse auf eine ägyptische Liturgie. Berlin: 1957.

―――.
Kultsymbolik der koptischen und der äthiopischen Kirche. A. "Die koptische Kirche." In *Abhandlungen des Deut-schen Archäologischen Instituts, Abtei-lung Kairo. Koptische Reihe,* Vol. 1. Cairo: 1963.

Husselmann, E. M.
The Gospel of John in Fayumic Coptic.
P. Mich. inv. 3521, Ann Arbor: 1962.

Kasser, R.
L'evangile selon Thomas. Présentation et commentaire théologique. Neuchâtel: 1961.

————.
Papyrus Bodmer XIV–XV. Geneva: 1961.

Kopp, C.
Glaube und Sakramente der koptischen Kirche. Reprint, Rome: 1963.

Krause, M. and Labib, P.
Die drei Versionen des Apokryphon des Johannes im Koptischen Museum zu Alt-Kairo. Cairo and Wiesbaden: 1962.

de Lagarde, P.
Pentateuch. Koptisch. Reprint, Osnabrück: 1967.

Lefort, L. T., Wilmet, M., and Draguet, R.
Concordance du Nouveau Testament sahidique. 5 vols. Louvain: 1950–1960.

Muller, C. D. G.
Die Bücher der Einsetzung der Erzengel Michael und Gabriel. 2 vols. Louvain: 1962.

Robinson, F.
Coptic Apocryphal Gospels. Texts and Studies. Vol. 4, no. 2 (Cambridge.; 1896).

Spuler, B.
"Die Koptische Kirche." *Handbuch der Orientalistik,* 1. Abtlg., 8. Band, 2. Abschn. Leiden-Köln: 1961, pp.269–303.

Monasticism

Amélineau, E.
Oeuvres de Schenoudi. 2 vols. Paris: 1907, 1914.

————.
Monuments pour servir à l'histoire de l'Egypte Chrétienne au IVe. siècle: Histoire de Saint Pachôme et de ses communautés. Documents coptes et arabes inédits. Paris: 1889.

Farag, F. R.
Sociological and Moral Studies in the Field of Coptic Monasticism. Leiden: 1964.

Festugiére, A.-J.
Les Moines d'Orient. Vol. 1. *Culture et Sainteté, Introduction au Monasticisme oriental.* Paris: 1961.

Leipoldt, J.
Shenute von Atripe und die Entstehung des national ägyptischen Christentums, Leipzig: 1903.

Walters, C. C.
Monastic Archaeology in Egypt. Warminster: 1974.

Guidebooks

Badawy, Alexandre.
Guide de l'Egypte Chrétienne. Cairo: 1952.

————.
The Coptic Museum. Cairo: Egyptian State Tourist Department, 1950.

Burmester, O. H. E.
A Guide to the Monasteries of the Wadi'N-Natrun. Cairo: 1954.

————.
A Guide to the Ancient Coptic Churches of Cairo. Cairo: 1955.

Simaika, M.
Guide Sommaire du Musée Copte. Cairo: 1937.

Wace, A. J. B. and Drioton, E.
Exposition d'art Copte. Cairo: 1944.

Art

Badawy, Alexandre.
L'Art Copte. Les Influences égyptiennes. Cairo: 1949.

————.
"L'Art Copte. Les Influences Hellènistiques et romaines." *Bulletin de l'Institut d'Egypte,* Vol. 34 (Cairo: 1951–1952), pp. 151–205; Vol. 35 (Cairo: 1953), pp. 57–120.

du Bourguet, P.
L'Art Copte. Petit Palais, Paris: 1964.

————.
Koptische Kunst. Einfuhrung zu einem Dia-Band. Baden-Baden: 1967.

Grüneisen, W. de
Les caractéristiques de l'art copte. Florence: 1922.

————.
Koptische Kunst. Christentum am Nil. Essen: 1963.

Strzygowski, J.
Koptische Kunst. Catalogue général des antiquités égyptiennes du Musée du Caire. Vienna: 1904.

"Hellenistische und koptische Kunst in Alexandrien." *Bulletin de la Société archéologique d'Alexandrie*, No. 5. Vienna: 1902.

Wessel, K.
Koptische Kunst. Die Spätantike in Ägypten. Recklinghausen: 1963. (Eng. trans. by Jean Carroll and Sheila Hatton; *Coptic Art*. London and New York: 1965).

Articles:

du Bourguet, P.
"Die Koptische Kunst als mögliche Erbin der pharaonischen Kunst." In *Koptische Kunst*. Essen: 1963, pp. 122–130.

Architecture

Badawy, Alexandre
"Les premières églises d'Egypte jusqu'au siècle de Saint Cyrille." In *Kyrilliana. Etudes variées à l'occasion du XVe centenaire de Saint Cyrille d'Alexandrie*. Cairo: 1947, pp. 321–380.

Badawy, Alexander,
"A Coptic Model of Shrine," in *Oriens Antiquus*, V. Rome: 1966, pp. 189–196, pl. LI.

Benoit, F.
"L'Architecture de l'Egypte Copte." In *L'Architecture. L'Orient mediéval et moderne*. Paris: 1912, pp. 106–115.

Butler, A. J.
The Ancient Coptic Churches of Egypt, 2 vols. Oxford: 1884; reprint, 1969.

Clarke, S.
Christian Antiquities in the Nile Valley. Oxford; 1912.

Articles

Müller-Wiener, W.
"Koptische Architektur." In *Koptische Kunst*. Essen: 1963, pp. 131–136.

Torp, H.
"Some Aspects of Early Coptic Monastic Architecture." *Byzantion*, Vols. 25–27 (1955–1957), fasc. 2 (Brussels; 1957), pp. 513–538.

Monneret de Villard, U.
"La basilica Cristiana in Egitto." *Atti del IV. Congresso Internazionale di architettura cristiana* Vol. 1 (Rome; 1940), I, pp. 291–319.

Sites

Butler, A. J.
Babylon of Egypt. Oxford; 1914.

Chassinat, E.
"Fouilles à Baouît," Vol. 1. *MIFAO*, Vol. 13 (Cairo; 1911).

Clédat, J.
"Le Monastère et la Nécropole de Baouît," *MIFAO*, Vol. 12 (Cairo: 1904); Vol. 39 (Cairo: 1916).

Evelyn-White, H. G.
The Monasteries of the Wadi Natrun, 3 vols. New York: 1926–1933.

Fakhry, A.
The Necropolis of El-Bagawāt in Kharga Oasis. Cairo: 1951.

Hölscher, U.
The Excavation of Medinet Habu, V. Chicago: 1954.

Kaufmann, C. M.
Die Menasstadt und das Nationalheiligtum der altchristlichen Ägypter, Leipzig: 1910.

—————.
Die heilige Stadt der Wüste. Unsere Entdeckungen, Grabungen und Funde in der altchristlichen Menasstadt, weiteren Kreisen in Wort und Bild geschildert. Kempten: 1924.

Maspero, J. and Drioton, E.
"Fouilles exécutées à Baouît," *MIFAO*, Vol. 59 (Cairo: 1932, 1943).

Mond, R. and Myers, O.
Temples of Armant. London: 1940.

Monneret de Villard, U.
Les Couvents près de Sohag. 2 vols. Milan: 1925–1926.

—————.
La Chiesa di Sta. Barbara di Vecchio Cairo. Milan: 1922.

—————.
Il Monastero di S. Simeone presso Aswan Vol. 1. Milan: 1927.

—————.
Deyr el Muharraqah. Milan: 1928.

—————.
Les églises du Monastère des syriens au Wadi'n Natrun. Milan: 1929.

Quibell, J. E.
Excavations at Saqqara. 1906–1907, Cairo; 1908; 1907–1908, Cairo: 1909; 1908–9, 1909–10, Cairo: 1912.

Ranke, H.
Koptische Friedhöfe bei Karara. Berlin: 1926.

Winlock H. E., and Crum, W. E.
The Monastery of Epiphanius at Thebes, 3 vols. New York: 1929–1933.

Articles:

Daumas, F.
"Rapport sur les travaux scientifiques de l'I. F. A. O. durant l'année 1964–1965." *In Académie des Inscriptions et Belles-Lettres, Comptes Rendus 1965.* Paris; 1966, pp. 383–390.

———.
"L'activité de l'Institut Français d'Archéologie Orientale durant l'année 1965–1966." Ibid., 1966. Paris; 1966, pp. 298–309.

Badawy, Alexandre.
"Les premiers établissements chrétiens dans les anciennes tombes d'Egypte." In *Publications de l'Institut d'Etudes Orientales de la Bibliothèque Patriarcale d'Alexandrie,* No. 2. Alexandria; 1953.

Evers, H.-G. and Romero, R.
"Rotes und weisses Kloster bei Sohag, Probleme der Rekonstruktion." In *Christentum am Nil.* Recklinghausen: 1964, pp. 175–199.

Krause, M.
"Die Menasstadt," In *Koptische Kunst.* Essen: 1963, pp. 65–70.

Torp, H.
"Murs d'enceinte des monastères coptes primitifs et couvents-forteresses." Ecole Française de Rome. *Mélanges d'archéologie et d'histoire,* Vol. 76 (Paris: 1964), pp. 173–200.

———.
"La date de la fondation du monastère d'Apa Apollô de Baouît et de son abandon." Ibid. Vol. 77 (Paris: 1965), pp. 153–177.

Sculpture

Beckwith, J.
Coptic Sculpture, London; 1963.

Breccia, E.
Oxyrhynchos I, Municipalité d'Alexandrie. Le Musée Gréco-Romain, 1925–1931. Bergamo: 1932. *Oxyrhynchos II. Municipalité d'Alexandrie. Le Musée Gréco-Romain, 1931–1932.* Bergamo: 1933.

Cramer, M.
Das Altägyptische Lebenszeichen im christlichen (Koptischen) Ägypten. Wiesbaden: 1955.

———.
Archäologische und epigraphische Klassifikation koptischer Denkmäler des Metropolitan Museum of Art, New York, und des Museum of Fine Arts, Boston, Mass. Wiesbaden: 1957.

Crum, W. E.
Coptic Monuments. Catalogue général des antiquités égyptiennes du Musée du Caire, Cairo: 1902.

Drioton, E.
Les Sculptures Coptes du Nilomètre de Rodah. Cairo: 1942.

Kitzinger, E.
"Notes on Early Coptic Sculpture." *Archaeologia,* Vol. 87 (London: 1938), pp. 181–215.

Monneret de Villard, U.
La Scultura ad Ahnas. Milan; 1923.

Strzygowski, J.
Koptische Kunst. Vienna: 1904, pp. 3–112.

Zaloscer, H.
Une Collection de pierres sculptées au Musée Copte du Vieux-Caire. Cairo: 1948.

Articles:

Badawy, Alexander.
"A Funerary Stela with Coptic Cryptogram," in *Bibliotheca Orientalis,* Vol. 18, No. 1/2, pp. 18–18. Leiden: 1961.

———.
"Greco-Roman Figure Capitals from Dionysias," in *Gazette des Beaux-Arts,* Paris: 1968, pp. 249–254.

———.
"The Prototype of the Coptic Water-jug Stand," in *Archaeology,* Vol. 20 (New York: 1967) pp. 56–61.

———.
"La stèle funéraire copte à motif architectural." *BSAC* Vol. 17 (Cairo: 1947), pp. 1–25.

Drioton, E.
"De Philae a Baouit." In *Coptic Studies in Honor of Walter Ewing Crum,* Byzantine Institute, Inc., Boston: 1950, pp. 443–448.

———.
"Un bas-relief copte des trois Hébreux dans la fournaise." *BSAC,* Vol. 8. Cairo: 1942, pp. 1–15.

———.
"Portes de l'Hadès et Portes du Paradis." Ibid., Vol. 9 (1943), pp. 59–78.

"Trois documents pour l'étude de l'art copte." Ibid., Vol. 10 (1944; Cairo: 1946), pp. 69–89.

Torp, H.
"Two sixth-century Coptic Stone Reliefs with Old Testament Scenes." *Institutum Romanum Norvegiae, Acta ad Archaeologiam et Artium Historiam pertinentia*, Vol. 2. Rome; 1965, pp. 105–119, pls. I–VIII.

Zaloscer, H.
"Zur Entwicklung des Koptischen Kapitells," *BSAC*, Vol. 10 (1944; Cairo: 1946), pp. 97–114.

Painting

Coche de la Ferté, E.
Les Portraits romano-égyptiens du Louvre. Paris: 1952.

Ihm, C.
Die Programme der christlichen Apsismalerei vom vierten Jahrhundert bis zur Mitte des achten Jahrhunderts, Wiesbaden; 1960.

Parlasca, K.
Mumienporträts und verwandte Denkmäler. Wiesbaden: 1965.

Petrie, W. F.
Roman Portraits and Memphis (IV). London; 1911.

———.
The Hawara Portfolio London; 1913.

Shore, A. F.
Portrait Paintings from Roman Egypt. London: 1962.

Zaloscer, H.
Porträts aus dem Wüstensand. Vienna; 1961. Vom Mumienbildnis zur Ikone, Wiesbaden: 1969.

Articles

Coche de la Ferté, E.
"Du portrait à l'icone." *L'Oeil*, No. 77 (Paris: 1961), pp. 24–31, 78.

Piankoff, A.
"Peintures au monastère de Saint-Antoine." *BSAC*, Vol. 14 (1950–1957), pp. 151–163.

Schwartz, J.
"Nouvelles études sur les fresques d'El-Bagawat." *Cahiers Archéologiques*, Vol. 13 (Paris; 1962), pp. 1–11.

Stern, H.
"Les Peintures du Mausolée de l'Exode à El-Bagawat." *Cahiers Archéologiques*, Vol. 11 (Paris; 1960), pp. 93–119.

Manuscripts and Illumination

Cramer, M.
Koptische Buchmalerei, Recklinghausen: 1964.

———.
Koptische Paläographie. Wiesbaden; 1964.

Articles:

Bauer, A. and Strzygowski, J.
"Eine alexandrinische Weltchronik." *Denkschriften der Wiener Akademie* (philosophisch-geschichtliche Abteilung), Vol. 51 (Vienna; 1906), pp. 169 ff.

Bober, H.
"On the Illumination of the Glazier Codex. A Contribution to Early Coptic Art and Its Relation to Hiberno-Saxon Interlace." In *Homage to a Bookman, Essays on Manuscripts, Books and Printing, Written for Hans P. Kraus, on His 60th Birthday, Oct. 12, 1967*. Berlin: 1967, pp. 31–49.

Textiles

Akashi, K.
Coptic Textiles from Burying Grounds in Egypt. Kanegafushi Spinning Company Collection.

Apostolaki, A.
Ta Koptika hyphasmata tou en Athenais Mouseion Kosmeticon technon. Athens: 1932.

Beckwith, J.
"Coptic Textiles." *Ciba Review*, Vol. 12, No. 133 (Basle: 1959).

Bellinger, L.
Textile Analysis. Early Techniques in Egypt and the Near East. Part 3, "Workshop Notes (The Textile Museum)," Paper No. 6 (Washington; 1952).

du Bourguet, P.
Musée National du Louvre. Catalogue des Etoffes Coptes. Vol. 1. Paris: 1964.

Bröker, G.
Koptische Stoffe. Leipzig: 1967.

Donadoni, S.
"Stoffe decorate da Antinoe." In *Scritti dedicati alla memoria di I. Rosellini*. Florence: 1945,

Errera, I.
Catalogue d'étoffes anciennes et modernes. Brussels; 1907.

———.
Collection d'anciennes étoffes égyptiennes. Brussels; 1916.

Kendrick, A. F.
Catalogue of Textiles from Burying Grounds in Egypt. Vols. 1–3. London; 1920–1922. Victoria and Albert Museum, Department of Textiles.

Kybalová, L. and Neubert, K.
Koptische Textilkunst. Prague: 1967.

Guerrini, L.
Le Stoffe copte del Museo archeologica di Firenze. Rome: 1957.

Kühnel, E.
Islamische Stoffe aus ägyptischen Gräbern, Staatliche Museen zu Berlin. Berlin: 1927.

Matie, M. and Lapounoff, K.
Textile Art in Coptic Egypt. Moscow-Leningrad; 1951; in Russian.

Pfister, R.
Tissus Coptes du Musée du Louvre. Paris; 1932.

———.
"Teinture et Alchimie dans l'Orient hellénistique" *Seminarium Kondakovianum*, Vol. 7 (1935), pp. 1–59.

———.
"Les Débuts du vêtement Copte." In *Etudes d'Orientalisme* Paris; 1932, pp. 434–459.

Thompson, D.
Coptic Textiles. The Brooklyn Museum: 1969.

Volbach, W. F.
Koptische Stoffe. Städtliches Museum München-Gladbach ,Munich: 1959.

———.
Catalogo del Museo Sacro della Biblioteca Apostolica Vaticana. III, 1: I Tessuti. Vatican: 1942.

Wulff, O. K. and Volbach, W. F.
Spätantike und koptische Stoffe aus ägyptischen Grabfunden in den Staatlichen Museen. Berlin: 1926.

Articles:

du Bourguet, P.
"La fabrication des tissus coptes a-t-elle largement survécu à la conquête arabe ?" *Bulletin de la Societé archéologique d'Alexandrie*, Vol. 40 (Alexandria; 1953), pp. 1–31.

Kühnel, E.
"Nachwirkungen der koptischen Kunst im islamischen Ägypten." In *Christentum am Nil*. Recklinghausen; 1964. pp. 257–259.

M. Th. Picard-Schmitter,
"Une tapisserie hellénistique d'Antinoë au Musée du Louvre." *Monuments Piot* Vol. 52 (Paris: 1962), pp. 27–75.

Shepherd, D.
"An Early Tiraz from Egypt." *Bulletin of the Cleveland Museum of Art* (Cleveland: 1960), pp. 8 ff.

Volbach, W. F.
"Koptische Stoffe." In *Koptische Kunst*. Essen: 1963, pp. 147–151.

Ceramics and Glass

Strzygowski, J.
Koptische Kunst. Vienna: 1904, pp. 223–250.

Articles:

Coche de la Ferté, E.
"Un fragment de verre copte et deux groupes de verrerie mediévale." In *Cahiers de la céramique, du verre et des arts du feu*. Sèvres: 1961, pp. 264–274.

Piankoff, A.
"Un plat copte au Musée du Louvre." *BSAC*, Vol. 8 (Cairo: 1942), pp. 25–27.

Ivories and Woodwork

Pauty, E.
Bois sculptés d'églises coptes (Epoque fatimide). Cairo: 1930.

Strzygowski, J.
Koptische Kunst. Vienna: 1904, pp. 115–219.

Volbach, W. F.
Elfenbeinarbeiten der Spätantike und des frühen Mittelalters. Mainz: 1952.

Cecchelli, C.
La Cattedra di Massimiano ed altri avorii romano-orientali. Rome: 1936–1940.

Articles:

Lemerle, P.
"Un bois sculpté de l'Annonciation." *Monuments et Mémoires publiés par l'Académie des Inscriptions et Belles-Lettres*, Vol. 43 (Paris: 1949), pp. 89–118.

Sacopoulo, M.
"Le Linteau copte dit d'Al Moallaka."
Cahiers Archéologiques, Vol. 9 (Paris: 1957), pp. 99–115.

Metalwork

Strzygowski, J.
Koptische Kunst. Vienna: 1904, pp. 253–347.

Articles:

Piankoff, A.
"Les deux encensoirs coptes du Musée du Louvre." *BSAC*, Vol. 7 (Cairo: 1941), pp. 1–7.

Ross, M. C.
"Byzantine Peacock Lamps." *Archaeology*, Vol. 13 (New York: 1960), pp. 134–136.

Music

Hickmann, H.
Catalogue général des antiquités égyptiennes du Musée du Caire. Instruments de Musique. Cairo: 1949.

————.
Musicologie pharaonique. Kehl: 1956.

Articles:

Hickmann, H.
"Koptische Musik." In *Koptische Kunst*. Essen: 1963, pp. 116–121.

————.
"La cliquette. Un instrument de percussion égyptien de l'époque copte."
BSAC, Vol. 13 (Cairo: 1951), pp. 1–12.

————.
"Un instrument à cordes inconnu de l'Egypte copte," Ibid., Vol. 12 (Cairo: 1949), pp. 63–80.

Interconnections

Aberg, N.
The Occident and the Orient in the Art of the Seventh Century. 3 vols. Stockholm: 1943–1947.

Creswell, K. A. C.
A Short Account of Early Muslim Architecture. Harmondsworth: Penguin Books, 1958.

Holmqvist, W.
Kunstprobleme der Merowingerzeit. Stockholm: 1939.

Krautheimer, R.
Early Christian and Byzantine Architecture. In *The Pelican History of Art*. Harmondsworth: 1965.

Monneret de Villard, U.
La Nubia Medioevale. 4 vols. Cairo: 1935–1957.

Zaloscer, H.
Quelques considerations sur les rapports entre l'art copte et les Indes. Cairo: 1947.

Articles:

Drioton, E.
"Art Syrien et Art Copte." *BSAC*, Vol. 3 (Cairo: 1937), pp. 29–40.

Holmqvist, W.
"Einflüsse der koptischen Kunst in Westeuropa." In *Koptische Kunst*. Essen: 1963, pp. 157–162.

Kempf, T. K.
"Berührungen und Fernwirkungen ägyptischen Christentums im Rheinland." In *Koptische Kunst*. Essen: 1963, pp. 163–168.

Monneret de Villard, U.
"Per la Storia del Portale Romanico." In *Mediaeval Studies in Memory of A. Kingsley Porter*. Cambridge, Mass.: 1939), pp. 113–124.

Abbreviations

Museums Referred To

Benaki Museum, Athens

B.M.: British Museum, London

C.M.: Cairo Museum (Egyptian antiquities)

Coptic Museum, Cairo

Dumbarton Oaks Collection, Washington, D.C.

Glyptothek Ny Carlsberg, Copenhagen

Greco-Roman Museum, Alexandria

Louvre: Musée National du Louvre, Paris

Musées Royaux d'Art et d'Histoire, Brussels

Museo Egizio, Turin

Rjksmuseum, Leiden

Walters Art Gallery, Baltimore

Serial Publications

ASA *Annales du Service des Antiquités de l'Egypte* (Cairo)

BIFAO *Bulletin de l'Institut Français d'Archéologie Orientale au Caire* (Cairo)

BSAC *Bulletin de la Société d'Archéologie Copte* (Cairo)

MIFAO *Memoires publiés par les membres de l'Institut Français d'Archéologie Orientale du Caire* (Cairo)

Short Citations for Books and Articles

A. Adriani, *Repertorio d'Arte.* *Repertorio d'Arte dell Egitto Greco-Romano.* Palermo: 1966.

M. Alliot, *Tell Edfou* *Rapport sur les Fouilles de Tell Edfou (1932).* Cairo: 1933.

E. Amelineau, *Géographie.* *La Géographie de l'Egypte à l'époque copte.* Paris: 1893.

Alexandre Badawy, "Premières églises." "Les premières églises d'Egypte jusqu'au siècle de St. Cyrille." In *Kyrilliana. Etudes variées à l'occasion du XVe centenaire de Saint Cyrille d'Alexandrie*, pp. 321–380. Cairo: 1947.

Alexandre Badawy, "Les premiers établissements Chrétiens." "Les premiers éstablissements Chrétiens dams les anciennes tombes d'Egypte." *Publications de l'Inatitut d'Etudes Orientales de la Bibliothèque Patriarcale d'Alexandrie*, No. 2. Alexandria: 1953.

Alexandre Badawy, "La Stèle Funéraire Copte." "La Stèle Funéraire Copte à motif architectural."*BSAC*, vol. 11, pp. 1–25.

H. I. Bell, "Athanasius." "Athanasius: A Chapter in Church History." *Congregational Quarterly*, vol. 3 (1925), pp. 158–176.

H. I. Bell, *Cults.* *Cults and Creeds in Graeco-Roman Egypt.* Liverpool: 1957.

H. I. Bell, *Egypt.* *Egypt from Alexander the Great to the Arab Conquest.* Oxford: 1948; reprint, 1956.

H. I. Bell, *Jews and Christians in Egypt.* *Jews and Christians in Egypt. The Jewish Troubles in Alexandria and the Athanasian Controversy.* London: 1924.

W. de Bock, *Matériaux.* *Matériaux pour servir à l'archéologie de l'Egypte Chrétienne.* St. Petersburg: 1901.

P. du Bourguet, *Catalogue.* *Musée National du Louvre. Catalogue des Etoffes Coptes.* vol. 1. Paris: 1964.

E. Breccia, *Oxyrhynchos I.* *Oxyrhychos I. Municipalité d'Alexandrie. Le Musée Gréco-Romain, 1925–1931.* Bergamo: 1932.

B. Brown, *Ptolemaic Paintings.* *Ptolemaic Paintings and Mosaics and the Alexandrian Style.* Cambridge, Mass.: 1957.

E. W. Budge, *Paradise.* *Coptic Chronicle: The Paradise of the Holy Fathers.* London: 1907.

A. J. Butler, *Arab Conquest.* *The Arab Conquest of Egypt and the Last Thirty Years of the Roman Dominion.* Oxford: 1902.

A. J. Butler, *Coptic Churches.* *The Ancient Coptic Churches of Egypt.* Oxford: 1884.

F. Cabrol and H. Leclercq, *Dictionnaire.* *Dictionnaire d'archéologie chrétienne et de liturgie.* Paris:1924.

E. Chassinat, "Baouît." "Fouilles à Baouît." *MIFAO*, vol. 13. Cairo: 1911.

S. Clarke, *Christian Antiquities.* *Christian Antiquities in the Nile Valley.* Oxford: 1912.

J. Clédat, "Flousiyeh." "Fouilles à Khirbet el-Flousiyeh (Janvier-Mars 1914)." *ASA*, vol. 16. Cairo: 1916, pp. 1–32.

M. Cramer, *Klassifikation.* *Archäologische und epigraphische Klassifikation koptischer Denkmäler des Metropolitan Museum of Art, New York, und des Museum of Fine Arts, Boston, Mass.* Wiesbaden: 1957.

K. A. C. Creswell, *Early Muslim Architecture.* *A Short Account of*

Early Muslim Architecture. Harmondsworth: 1958.

W. E. Crum, *Coptic Monuments. Coptic Monuments. Catalogue général des antiquités égyptiennes du Musée du Caire.* Cairo: 1902.

C. Diehl, "L'Egypte." "L'Egypte chrétienne et byzantine." In G. Hanotaux, *Histoire de la Nation Egyptienne.* vol. 3. Paris: 1933.

E. Drioton, *Nilomètre. Les Sculptures Coptes du Nilomètre de Rodah.* Cairo: 1942.

H. G. Evelyn-White, *Monasteries. The Monasteries of the Wadi'n Natrun.* 3 vols. New York: 1926–1933.

H.-G. Evers and R. Romero, "Kloster bei Sohag." "Rotes und Weisses Kloster bei Sohag. Probleme der Rekonstruktion." In *Christentum am Nil*, pp. 175–199. Recklinghausen: 1964.

A. Fakhry, *Bagawat. The Necropolis of El-Bagawat in Kharga Oasis.* Cairo: 1951.

S. Gabra, *Hermoupolis Ouest. Rapport sur les Fouilles d'Hermoupolis Ouest (Touna El-Gebel).* Cairo: 1941.

S. Gabra and E. Drioton, *Peintures. Peintures à fresque et scènes peintes à Hermoupolis-Ouest (Touna El-Gebel).* Cairo: 1954.

A. Grabar, *Martyrium. Martyrium. Recherches sur le culte des reliques et l'art chrétien antique.* Paris: 1946.

W. de Grüneisen, *Caractéristiques. Les caractéristiques de l'art Copte.* Florence: 1922.

J. M. Harris, "Report." "Report of Committee on Research." In *Year Book of the American Philosophical Society*, pp. 592–598. Philadelphia: 1960.

U. Hölscher, *Medinet Habu. The Excavation of Medinet Habu*, vol. 5. Chicago: 1954.

K. M. Kaufmann, *Handbuch. Handbuch der christlichen Archäologie.* Paderborn: 1913.

K. M. Kaufmann, *Die Menasstadt. Die Menasstadt und das Nationalheiligtum der altchristlichen Ägypter.* Leipzig: 1910.

E. Kitzinger, "Early Coptic Sculpture." "Notes on Early Coptic Sculpture." *Archaeologia*, vol. 87, pp. 181–215. London: 1938.

T. Klauser, "Entstehungsgeschichte der christlichen Kunst." "Studien zur Entstehungsgeschichte der christlichen Kunst." In *Jahrbuch für Antike und Christentum*, vols. 8/9. Münster, Westphalia: 1965–1966.

P. Ladeuze, *Etude sur le cénobitisme. Etude sur le cénobitisme pachomien pendant le V^e et la première moitié du VI^e siècle.* Louvain: 1898.

S. Lane-Poole, *History of Egypt. A History of Egypt in the Middle Ages.* London: 1936.

L. T. Lefort, *Les vies coptes. Les vies coptes de saint Pachôme et de ses premiers successeurs.* Louvain: 1943.

J. Maspero and E. Drioton, *Baouît. Fouilles exécutées à Baouît. MIFAO*, vol. 59. Cairo: 1943.

E. von Merklin, *Figuralkapitellen. Antike Figuralkapitellen.* Berlin: 1962.

U. Monneret de Villard, *Sohag. Les couvents près de Sohag.* 2 vols. Milan: 1925–1926.

U. Monneret de Villard, "Temple of the Imperial Cult." "The Temple of the Imperial Cult at Luxor." *Archaeologia*, vol. 95. London: 1953.

U. Monneret de Villard, *Ahnas. La scultura ad Ahnas.* Milan: 1923.

H. Munier, "L'Egypte byzantine." "L'Egypte byzantine de Dioclétien à la conquête arabe." *Précis de l'Histoire d'Egypte par divers historiens et archéologues*, vol. 2. Caire: 1932.

T. D. Neroutsos bey, *L'ancienne Alexandrie. L'ancienne Alexandrie: Etude archéologique et topographique.* Paris: 1888.

K. Parlasca, *Mumienporträts. Mumienporträts und verwandte Denkmäler.* Wiesbaden: 1966.

W. F. Petrie, *Oxyrrhynkhos. Tombs of the Courtiers and Oxyrrhynkhos.* London: 1926.

H. Ranke, *Karara. Koptische Friedhöfe bei Karara.* Berlin: 1926.

G. Steindorff, *Egypt. Egypt. Baedeker.* Leipzig: 1929.

J. Strzygowski, *Koptische Kunst. Koptische Kunst. Catalogue général des antiquités égyptiennes du Musée du Caire*, vol. 12. Vienna: 1904.

H. Torp, "Murs d'enceinte." "Murs d'enceinte des monastères coptes primitifs et couvents-forteresses." *Ecole Française de Rome. Mélanges d'archélogie et d'histoire*, vol. 76, pp. 173–280. Paris: 1964.

W. F. Volbach, *Elfenbeinarbeiten. Elfenbeinarbeiten der Spätantike und des frühen Mittelalters.* Berlin: 1952.

J. B. Ward Perkins, "Shrines of St. Menas." "The Shrines of St. Menas in the Maryut." *Papers of the*

British School of Rome, vol. 17, pp. 62–70. London: 1949.

G. Wiet, "L'Egypte Musulmane." 'L'Egypte Musulmane de la Conquête Arabe à la Conquête Ottomane." *Précis de l'Histoire d'Egypte par divers historiens et archéologues*, vol. 2. Cairo: 1932.

O. Wulff, *Altchristliche Bildwerke. Altchristliche und Mittelalterliche Byzantinische und italienische Bild-werke, Beschreibung der Bildwerke der christlichen Epochen*, vol. 1.

H. Zaloscer, *Collection de pierres sculptées.* *Une collection de pierres sculptées au Musée Copte du Vieux-Caire*. Cairo: 1948.

Glossary

agape (Gr.): ceremonial banquet

ambo (Gr.): pulpit

arabesque: design in broken lines forming a geometric pattern, used in Islamic art

arcosolium (Lat.): square room with arched sides

ballas (Ar.): trinconical earthenware jug

basilica discoperta (Lat.): rooflees basilica

bema (Gr.): stepped part of church containing the altar and synthronon

bulla (Lat.): thick medallion with embossed sides used as a pendant

castrum; fossatum (Lat.): fort

caulicoli (Lat.): stems with leaves

cella memoriae (Lat.): chamber in a catacomb where relatives of the deceased met

cenobiae (Lat.): contiguous cells in the Maryut

chora (Gr.): rural district, contrasting with *metropolis*

clipeus: pointed oval enclosing a scene

coenobium (Lat.): communal establishment of monks (Pachomius)

coenobiarches (Lat.): head of coenobium; also *pater, praestos*

contrapposto (Ital.): stance of human figure that throws the weight of the body on one leg

crux ansata (Lat.): looped cross derived from the Egyptian 'ankh

crux clipeata (Lat.): cross within a clipeus

crux florida (Lat.): quatrefoil

crux gammata (Lat.): swastika

crux immissa (Lat.): cross within a wreath or medallion

deir (Ar.): "enclosure," monastery

diaconicon (Gr.): sanctuary on the north side of the bema

embrimion (Coptic *ēmron*): papyrus bundle used as a pillow

gamalon (Ar.): wooden truss, gable-shaped

haikal (Ar.): chancel formed by three contiguous chapels in a row in a Coptic church

heb-sed (Eg.): jubilee feast to mark the thirtieth year of a reign

hegoumenos (Gr.): head of a monastery (till mid-fifth century)

higāb (Ar.): screen separating chapels of the *haikal* from the transverse room in a Coptic church

hilani: North Syrian columned entrance facade and hall

homra (Ar.): mortar of pounded red brick and lime

horror vacui (Lat.): tendency avoid vacant area in design

hypaethral: roofless, open to the sky

imago clipeata (Lat.): scene within a clipeus

katochoi (Gr.): recluses of a god living in or near the temple

kellia (Gr.): independent cells of anchorites in the western desert, northwest of Wadi Natrun

klinē (Gr.): couch or bed on or in which a corpse was buried in a Greco-Roman tomb

komē (Gr.): village

lavra (Gr.): group of cells or caves inhabited by cenobites

lēnos (Gr.): upper basin for treading grapes in a wine press

limes (Gr.): continuous belt of fortifications around a Byzantine district

madonna lactans (Lat.): madonna suckling

mammisi (Coptic): Champollion's term for the birth-house in front of the main temple (Greco-Roman)

mandorla (Ital.): oval enclosing a scene

manshubeh (Coptic): "place of living," housing unit

mappula (Lat.): broad, elongated bag

martyrion (Gr.) = martyrium (Lat).: monument marking the place of martyrdom

mashrabiya (Ar.): wooden openwork or lattice screen

mensola (Lat.): horizontal bracket carved with a scene

mihrāb (Ar.): niche oriented toward Mecca in a mosque

minbar (Ar.): pulpit in a mosque

monasterion (Gr.): hermitage

Mozarabic: art made by Spaniards for Arab conquerors

mulqaf (Ar.): ventilator opening in the roof of an Islamic house

naiskos (Gr.): small statue shrine of Hellenistic times

narthex (Gr.): entrance hall to a basilica, transverse or along the main body

norag (Ar.): threshing cart

nosokomeia (Gr.): hospitals provided by the church

orans (Lat.): frontal figure with arms raised in oration

Osiride pillar: statue of a mummiform Osiris abutting against a pillar in an Egyptian temple

paradisos (Gr.): "garden"

pithos (Gr.): collecting basin in a wine press

polis (Gr.): fortified city

prostas and *oikos* (Gr.): antechamber and chamber in a Greek house

prothesis (Gr.): sanctuary on the side of the bema, balancing the diaconicon, where bread and wine were placed

putti (Lat.): boys peopling scenes (cf. Gr. *erotes*)

pyrgocastellon (Gr.): tower castle

qadus: ovaloid water wheel pot

qasr (Ar.): "castle," keep of monastery

qulla (Ar.): porous earthenware water jar with long neck

rabattement (French): projection device used in Egyptian pictorial art whereby an element is turned 90 degrees into the picture plane.

sacellum (Lat.): chamber or shrine of the legion's insignia in a Roman *castrum*

saqya (Ar.): water wheel

semneion (Gr.): sanctuary

shaduf (Ar.): wooden machine with weighted lever arm to pump water

synthronon (Gr.): built-in bishop's throne flanked by clergy's stalls behind the altar

tablye (Ar.; cf Gr. *tryblion*): common platter around which monks sat at a meal

tabula ansata (Lat.): broad rectangular plaque with a trapezoid lug at each small side

topos (Gr.): "place," early settlement of monks around the cave of the order's founder

transenna (Lat.): enclosure or screen around a shrine

tribelon (Gr.) three doorways connecting narthex to main body of church

via porticata (Lat.): porticoed street

virgo lactans (Lat.): Virgin suckling

xenodocheia (Gr.): hostels for guests provided by the church

Index of Authors

Page numbers in italics refer to illustrations.

Index of Historical Terms

Index of Subjects

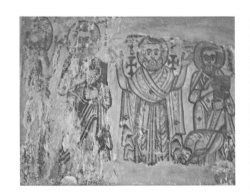

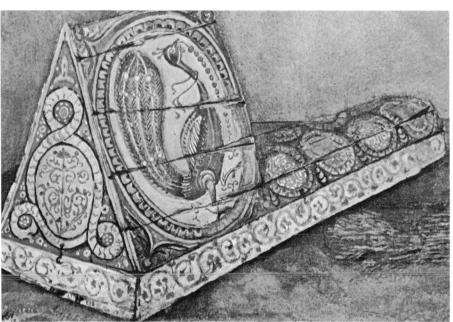

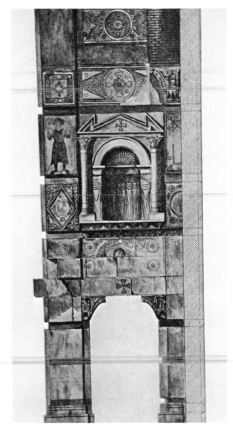

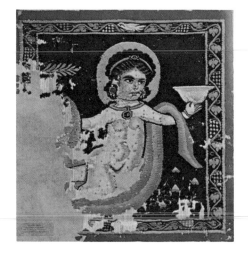